IMAGES OF THE WORLD

Photography at the National Geographic

...GES WORLD

Photography at the National Geographic

Images
of the World

Published by
The National
Geographic Society

Gilbert M. Grosvenor
President

Melvin M. Payne
*Chairman
of the Board*

Owen R. Anderson
*Executive
Vice President*

Robert L. Breeden
*Vice President,
Publications and
Educational Media*

Prepared by
National Geographic
Book Service

Charles O. Hyman
Director

Kenneth C. Danforth
Assistant Director

Staff for this book

Thomas B. Allen
Editor

David M. Seager
Art Director

Anne Dirkes Kobor
Illustrations Editor

Anne Elizabeth
 Withers
Chief Researcher

Greta Arnold
Illustrations Research

Charlotte Golin
Layout

Robert Arndt
Edward Lanouette
Elizabeth L. Newhouse
David D. Pearce
Robert M. Poole
David F. Robinson
Margaret Sedeen
Verla Lee Smith
Editor-Writers

David S. Boyer
Contributing Editor

Melanie Patt Corner
Suzanne P. Kane
Lise M. Swinson
L. Madison Washburn
Editorial Research

Paulette L. Claus
Teresita C. Sison
Editorial Assistants

Robert C. Firestone
Production Manager

Karen F. Edwards
*Assistant Production
Manager*

Richard S. Wain
Production Assistant

John T. Dunn
Ronald E. Williamson
Engraving and Printing

Contributions by
Polly Bryson
Molly Jackson
Eugene Ostroff

*The principal source for
the historic material
in this book —much of
it previously
unpublished—was a
Master of Arts thesis
written by Priit J.
Vesilind of the
National Geographic
Magazine staff.*

First edition
405,000 copies.

326 photographs.

*For the title page and
dust jacket of this book,
James A. Sugar made
a photograph showing the
essence of photography:
color and light.*

CONTENTS

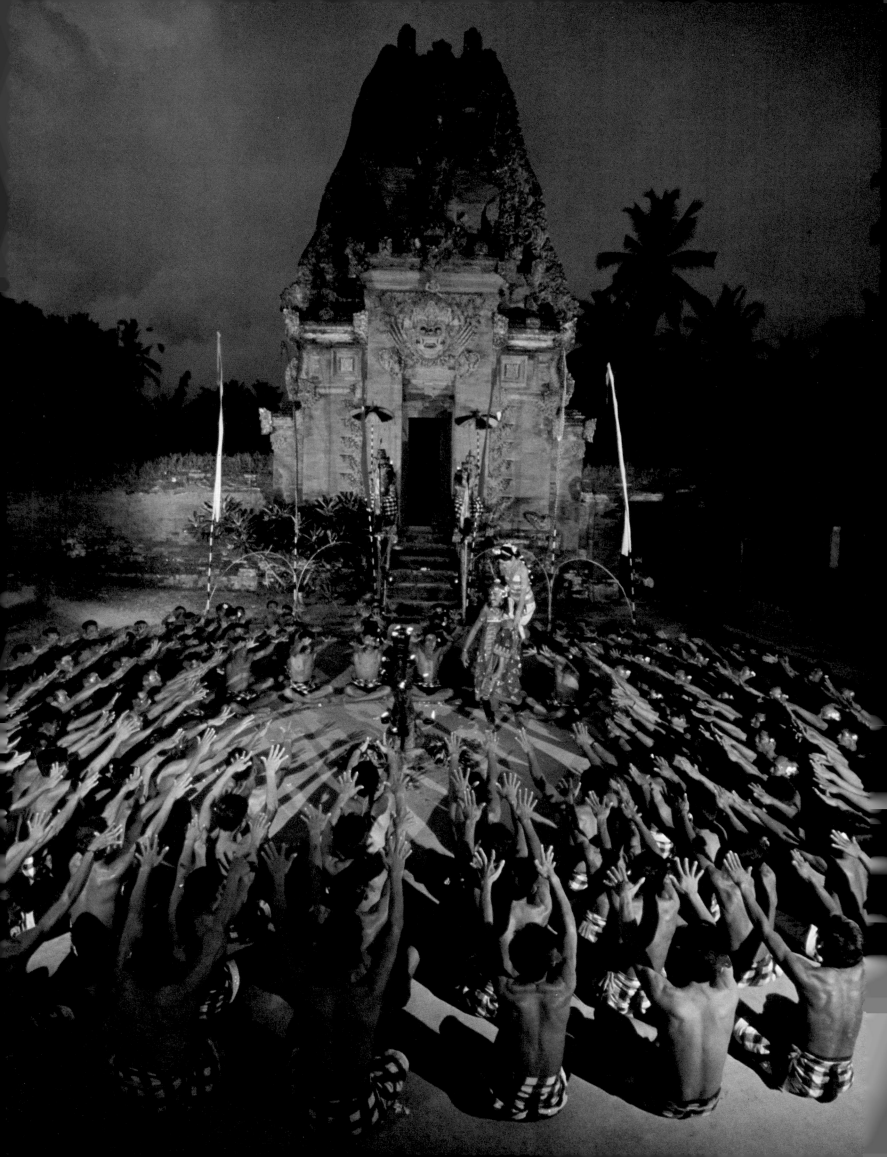

In the Geographic Image

By Gilbert M. Grosvenor
*President,
National Geographic Society*

"I knew that this Bali religious epic would not photograph well under blue skies. The emotional power was not coming through. Then came a threatening storm—and with it the shadow of the emotion I wanted. Adverse weather can frequently add drama to a scene."

I had waited three weeks for my audience with Marshal Tito, President of the Federal People's Republic of Yugoslavia—and an avid amateur photographer. Knowing this, I had taken along far more photographic equipment than I needed. My plan was to soften up the Communist leader with small talk about photography and then bore in with pointed questions about the Yugoslavian economy.

We met at his island hideaway, where he received me graciously but sidestepped my questions. I then decided to try my photography maneuver.

I opened my aluminum camera case, and my gunstock tripod fell out. Burly security men materialized all around me. An aide leaped in front of Tito to shield him. Tito, seeing the cause of the panic, roared with laughter. "You almost ended badly," he said.

I introduced him to the errant gunstock, explaining how it steadied the camera for telephoto lenses. "Show me what else you have in there," he said, pointing to my case. We talked about photography, and soon I was able to interview him.

Marshal Tito's fascination with the equipment of photography is typical of the non-professional. Not that everyone doesn't care about the newest technical breakthrough. But the professional knows that the eye and the brain and the soul of the photographer make the picture; the camera merely records.

Professionals usually say that they *make* a photograph. I think that comes from the idea that professionals do not just snap; they imagine what they want, create a plan, and then *make* it.

In this book you will learn what photographers think about when they make a picture. Tom Nebbia, for instance, explains his powerful portrait of three Jamaican women (page 29). He saw two elements, the faces and a wall. "I put the two elements together according to my vision," he says.

His vision. He does not mention the f-stop or the shutter speed. He tells you about his feelings. You will see insights like that throughout *Images of the World.* You can learn from this book, just as you can from the accompanying *Field Guide.* The books complement each other, but they do not divide photographic lore evenly. You won't just find f-stops in the *Field Guide* and emotion in *Images.* "Create new picture ideas," the *Field Guide* says. ". . . Use your imagination." I hope we get that message across.

We published these books because members said they wanted to know how to make better pictures. Better technically? Yes. You'll learn new tricks and get some tips that will improve your pictures technically.

But I hope these books will give you a new way of looking at what you want to photograph. If you have an automatic camera, you no longer have to worry about most technical matters. That doesn't mean, however, that your new automatic camera has made you a better photographer.

Geographic photographs are images created for publication. They are not made to hang in galleries—though many of them have. Our photos are made to be published. What begins as an image in the mind of a photographer becomes an image on film . . . then an image selected by an illustrations editor . . . then an image made into an engraving . . . then an image inked and printed. The image you see in a Geographic publication is the work of many skills and many talented people.

Your pictures have a different mission. Typically, they are images that preserve memories. Remember that future generations will want to see you as you were. At one time, people had to pose and look unnatural. Today's films and cameras let you capture moments instead of poses.

On page 96 of the *Field Guide* is what at first glance is an ordinary picture. But as you look at it more deeply, you share the emotion conveyed by the three women in the photo. They are sisters, and, says the caption, their "direct gaze out of the frame unifies them and links them to the viewer." The caption gives you instruction, just as Nebbia's words gave you insight about a similar picture. Two books, one message: The image comes from you, not from the camera.

Photographers Who Have Something to Say

By Robert E. Gilka
Director of Photography

What is a National Geographic photographer? He or she is a person of:

Dedication. Jim Stanfield climbed a rugged hill in Syria on nine different nights to get just the right dawn light to make a dramatic photograph of Malula, an ancient citadel of Christianity. Each climb took 45 minutes.

Resourcefulness. While Tom Abercrombie was driving a Land-Rover over rugged terrain in Afghanistan, a sharp rock punctured the oil pan. He was miles from help. How to patch the hole with what was at hand? Abercrombie did it with a bar of soap.

Innovation. Bruce Dale, assigned to a story on aviation safety, wanted an "airliner's view" of a landing at night. To get the picture, he had cameras mounted at the tip of the plane's vertical fin, then triggered them from inside the plane by remote control (pages 180-181).

Courage. George Mobley was thrown into the icy waters of a river in Lapland when a motorboat overturned in a rapids. Mobley and three others were swept downstream about 1,000 feet. Soaked and chilled by freezing weather, they were weakening fast by the time they made it to shore. With gasoline from a spare can grabbed as it floated by—and a match from deep inside Mobley's parka—they got a life-saving fire going.

Sensitivity. After Robert Sisson's article, "The World of My Apple Tree," was published, a reader wrote, "This is the first love letter I have ever written to a magazine. . . . Thank you so very much for putting into words and delightful photographs what I have always felt about apple trees. . . . I live on a small farm overlooking Cayuga Lake, surrounded by gnarled old apple trees—uncared for but loved by me and all of the wild creatures that live among them."

Our photographers often are called on to make exciting images of the commonplace. This takes extraordinary creativity, which the camera insatiably consumes. Creativity makes good photographers.

If I walk west for a block along M Street toward Connecticut Avenue outside the Society's office here in Washington, I see flowers in containers in front of a florist's shop; jewelry stores, a bank, fast-food storefronts, pedestrians in varied dress and moods. I see them in a very literal way, not in a creative or imaginative way. If I were to photograph these subjects, I would make literal and visually dull photographs. That's not what we want. We expect visual excitement in the most ordinary scenes.

Our image-maker is expected to come back from Paris with a new, provocative look at the Eiffel Tower, or from Africa with a shot of Victoria Falls to end all pictures of the falls—at least until the next Geographic photographer gets there.

The hallmark of a fine photograph is its memorability. When I think of the many photographs I've seen of the pyramids of Egypt, the one I remember best was made by Winfield Parks, a staff photographer who died a few years ago of a heart attack while preparing to go on a new assignment. Parks captured the mood and majesty of the pyramids by photographing a robed Egyptian on the top of one when the evening light was shining almost directly into the camera lens and in just the right position to model the carved stones dramatically (page 104).

Parks achieved this effect without using any optical gimmicks. Our photographers are expected to work without colored filters, lenses that make multiple images, vaseline-smeared lenses, texture screens, or any other such devices. They must perfect a pure technique involving only camera, lens, film, and a masterful sense of light and what it will do to make an ordinary subject something special. Light is the photographer's most important tool.

Assignments keep Geographic photographers in the field about six months of every year. Their long absences—up to three or four months at a time—sometimes put a strain on family relationships. But, with few exceptions, Geographic photographers are married and family ties are very strong. Between assignments, many of them put their creativity to work in other ways.

Bates Littlehales is an excellent wood carver, musician, and maker of musical instruments. David Doubilet is a banjo player of professional ability. Bruce Dale is a first-class cabinetmaker and does his own automobile repair.

James Sugar and Otis Imboden are licensed multi-engine pilots. Imboden also flies balloons. Tom Abercrombie, fluent in five languages, has sailed in the Fiji Islands, countless miles on Long Island Sound, and in his home waters of Chesapeake Bay. He has sailed all the Baltic—except for the far eastern end, where the Russians would not allow him. Emory Kristof and Bob Madden also know well the vagaries of Chesapeake Bay. And Bianca Lavies sailed from South Africa to Florida in a small boat.

In the field, they are all on their own. It is their responsibility, for instance, to hire transport (which may be a camel on one assignment and a chartered boat with a crew of 20 on the next). Bob Sisson once rode in a C-130 for 40 hours with 54 screaming sea otters. Bob Madden once shared aircraft cabin space with 15 musk oxen. Linda Bartlett escaped with one camera, a flight bag of exposed film, and the shorts and T-shirt she was wearing when her boat burned and sank in the Gulf of Guinea.

Hippos charged Joe Scherschel's small boat on the Victoria Nile. "The engine failed," he reported later, "and we started to fend off the animals with paddles. . . . luckily the current picked up and swept us out of reach of those big jaws."

When Gordon Gahan's Land-Rover bogged down in Australia, he and the native driver began walking back to the nearest village, 11 miles away. "I tried to make small talk," Gahan said later, "but the driver showed a strong inclination to converse about survival. This was right after a yellow snake struck at him and missed. 'No get bit by snake,' the driver said. 'Four minutes to live. Die. No eat fruit of cactus plant. Too salty. Make thirsty. Die. No have spear or knife. Die. No run after emu or wallaby. Heart beat too fast. Die.'" They reached the village.

Jim Amos was making aerial photographs of the Great Salt Lake in Utah from about 2,500 feet when the control linkage failed and the helicopter crashed into the lake. The pilot was killed.

Amos, strapped in the passenger seat with the door off for photography, was thrown into the water when his safety harness snapped on impact. His right leg was broken in several places. In pain and shock from this and other injuries, he managed to paddle on the buoyant water to a nearby causeway where a railroad repair crew was at work. The crew summoned a helicopter by radio, and Amos was soon in a hospital.

Weeks later Amos was released on crutches. The first thing he did was grab a couple of his spare cameras—the others were lost in the crash—and head for the airport. He hired a plane and flew over the Great Salt Lake to make more aerial photographs. "It was something I just had to prove to myself," he said.

Geographic photographers are generalists, ready to go anywhere and work on any kind of story. Jim Stanfield is typical. One string of his assignments included the Potomac River, Syria, Pakistan, rats, a comprehensive essay on Windsor Castle which demanded much painstaking work with a view camera, and a story on a shock trauma unit at a Baltimore hospital.

Most National Geographic photographers got their start on visually strong newspapers. There they learned to photograph many kinds of subjects under many kinds of conditions. There they polished technical skills. And there they learned how to deal with people. A good photographer can establish a rapport with a trash collector on one assignment and the grand dame of local society on the next.

Perhaps most important is a special sense that young photographers learn on newspapers, the sense of value of picture content. Paul Strand, one of the first Americans to achieve distinction as a photographer in this century, once said in a fit of impatience with the undisciplined: "The world is full of picture makers who have nothing to say."

Photographers who work for the National Geographic must have something to say, and they must know how to say it.

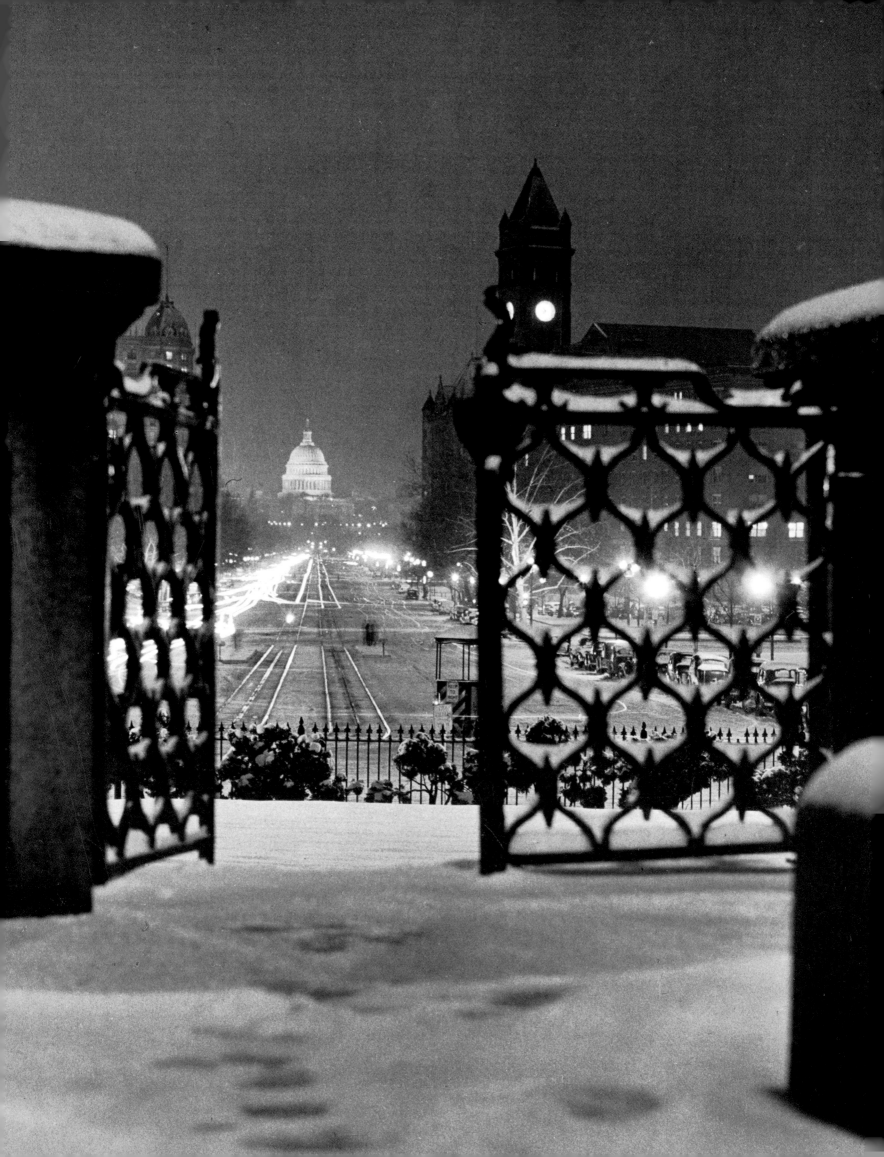

Memories in Black and White

By Volkmar Wentzel

In a way it was Eleanor Roosevelt who got me started. In 1935, en route to a federal poverty project in West Virginia, she dropped in at the Youghiogheny Forest tavern along U. S. 50. On its log walls, I had displayed my first photographs, developed and printed in an old pumphouse converted to a darkroom. For tourists I had postcards on sale. To my delight, the First Lady bought several cards—a view of an old water mill, some wagon wheels leaning against a barn plastered with circus posters, and close-ups of ferns and toadstools.

This ego boost, so important to youngsters, inspired me to go to Washington, D. C., to seek my fortune. With little money to spend in those Depression days, my sightseeing was limited only by the size holes I could patch in my shoes. I had time on my hands, especially at night. I trudged along with my Speed Graphic and Crown tripod slung across my shoulder, enchanted by the witchery of night.

Night photography became a labor of love. I made my own enlargements and was thrilled when the Royal Photographic Society in London awarded gold stickers to some of my prints. Above all I was pleased when, on their strength, National Geographic asked me to join its photographic staff in 1937.

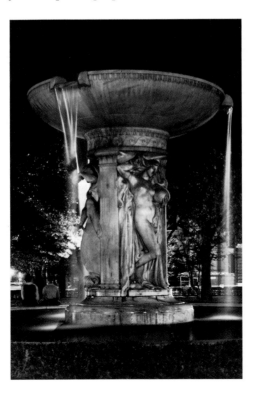

The tracery gates of the Treasury Building frame Pennsylvania Avenue and open a glowing portfolio of Washington by night. This artistry of Volkmar Wentzel graced the National Geographic Magazine in April 1940.

"There was a certain elegance about the city, a mixture of French formality and southern charm. That's what I tried to catch," recalls Wentzel. This classic fountain honors Admiral Samuel Du Pont.

Great changes were underway when I reported to my new chief, Edwin L. Wisherd, successor to Charles Martin. Highly respected for his knowledge of chemistry, optics, and color photography, Martin had founded the photographic laboratories in 1915. Now the Geographic had a new laboratory, complete with air-conditioning.

In a studio two stories high I met Willard R. Culver, known for his theatrical sets and his mastery of lighting. Among cat fanciers he is still remembered for his photographs of feline aristocrats. He took these on Dufaycolor cut film with an open-shutter synchronizing technique that fired several grapefruit-size flashbulbs with a blinding explosion. Cardboard "stand-ins" protected the highstrung cats from the heat and glare of the lights while the shots were set up.

The Geographic's reputation for pioneering in color photography and in four-color engraving is based largely on the ingenious Autochrome plate. This glass-plate process had been first marketed in 1907 by the brothers Auguste and Louis Lumière, the fathers of practical color photography.

For nearly three decades the Autochrome plate brought faraway places and events to Geographic readers—Buddhist morality plays from the mountains of western China, folkways from Europe, and the first color views of underwater life. But the Autochrome was slow. For a sunlit landscape around noon, the rule-of-thumb exposure was one to two seconds at f8.

Because the Autochrome was so slow, it was phased out in the mid-1930s in favor of the Finlay plate and Dufaycolor, both produced in England. Though faster, these processes required an exposure of $\frac{1}{5}$ to $\frac{1}{10}$ of a second, which was still not fast enough to stop motion.

Geographic photographers were tied to cumbersome cameras and tripods. Our shop fitted each camera with interchangeable standard, wide-angle, and telephoto lenses. Photographers had to reload the plate-holders or cut-film magazines every night inside a changing bag or under the stifling blankets of a hotel bed. A day's shooting usually

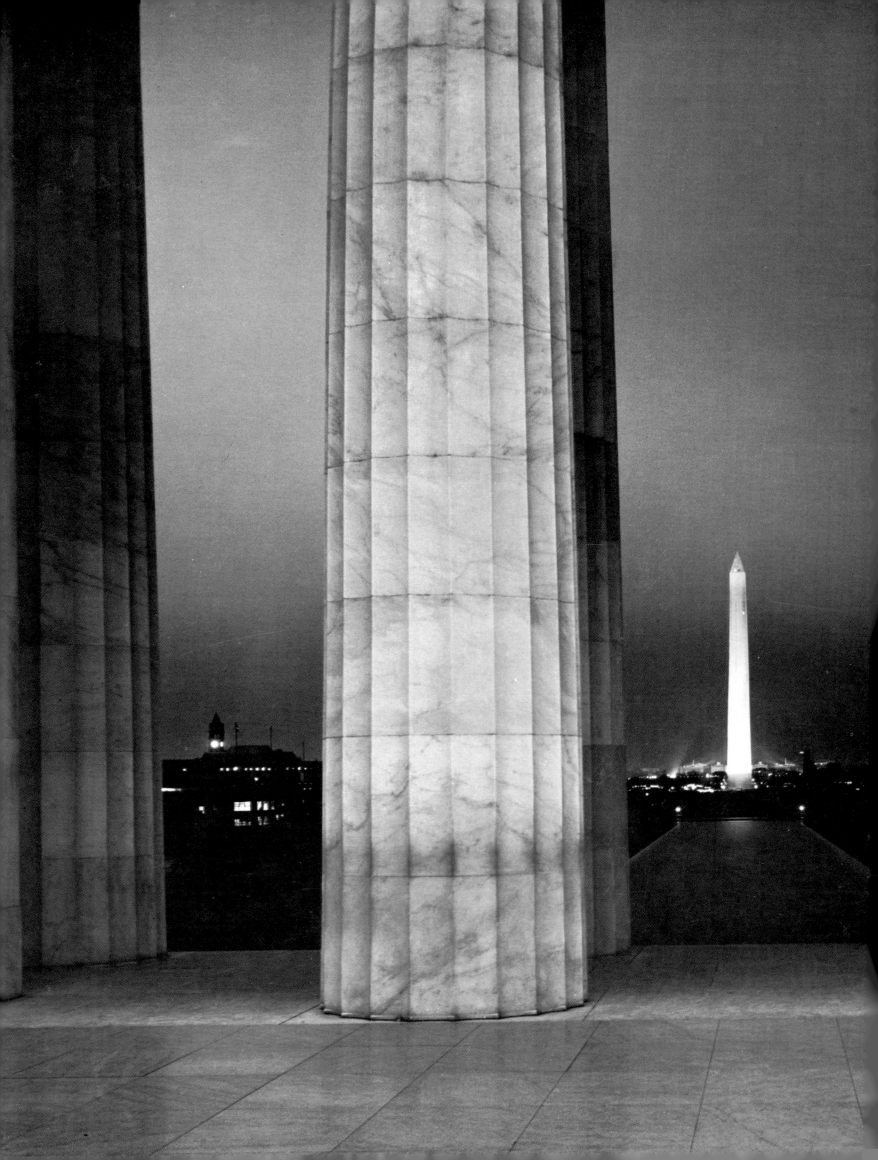

"It's wrong to distort a classical facade. It's meant to be looked at in a certain way." Wentzel framed the Washington Monument with the fluted columns of the Lincoln Memorial.

Rewarded with prints, a night watchman at the Lincoln Memorial became an enthusiastic helper as Wentzel tried various lighting effects. "Photographers have to resort to a little bribery sometimes."

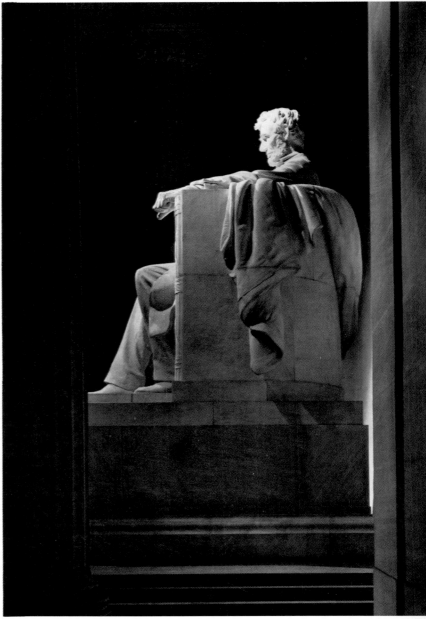

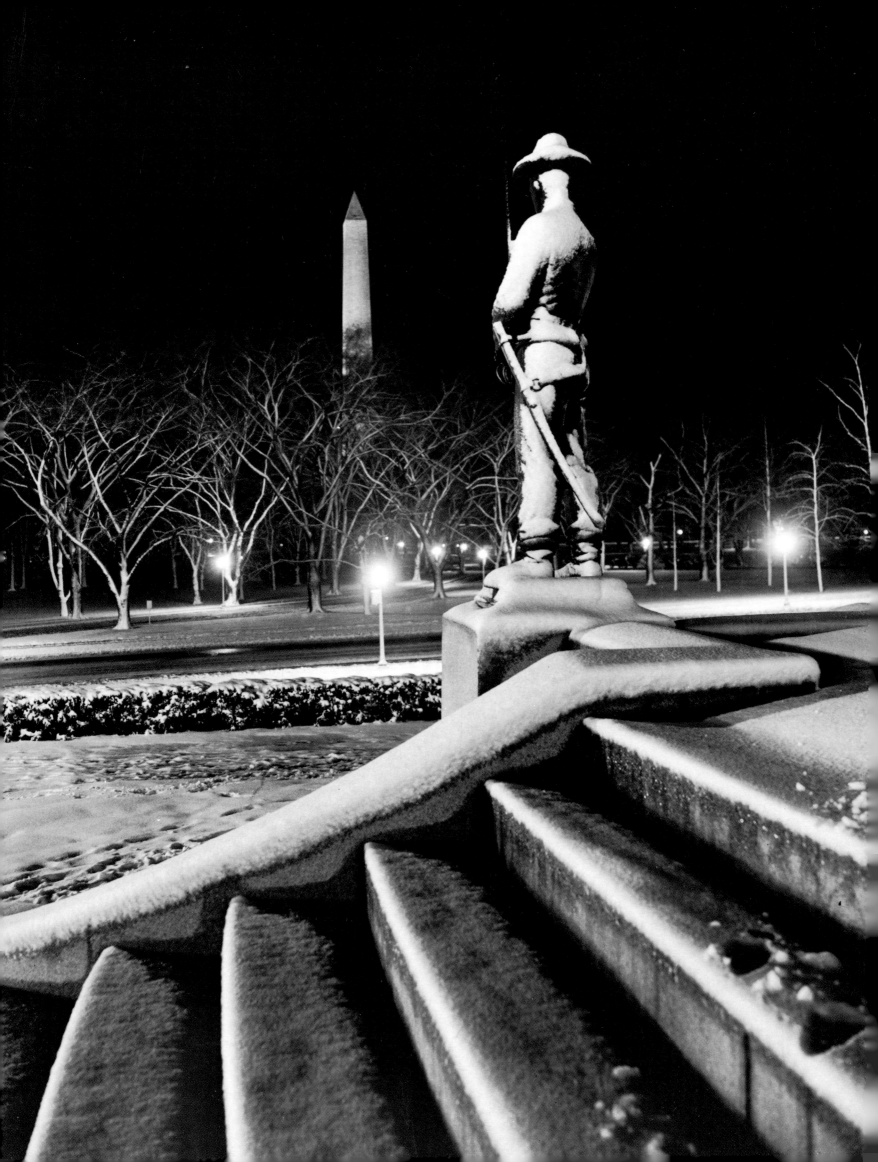

amounted to less than the equivalent of three rolls of Kodachrome.

The large-format cameras were well-suited for the kind of pictures that Franklin Fisher, the magazine's illustrations editor, was seeking. "The ideal Geographic picture should command attention," he said. ". . . It should tell the story, actually give information about the place it portrays. . . . People are primarily interested in other people, so 'human interest' subjects, pictures of people doing things, rank high. . . ."

He required all pictures to be in sharp focus from front to back and show no subject movement. We were also advised that our color photographs must indeed show plenty of color. As a result of his edicts, assortments of bright scarves, colored clothing, even paint, became standard field equipment. Some of the same props appeared in pictures of different lands.

During my apprenticeship in this large-format era, I developed and printed many plates and negatives shipped from all ends of the earth. By the dim inspection light of my darkroom I caught my first glimpses of the exciting world outside.

Through the decades, I have witnessed incredible changes in almost every aspect of photography. The most revolutionary was the introduction of the Leica camera and 35mm Kodachrome film. This powerful new combination liberated photographers from the restraint of the tripod and gave birth to the dynamic photographs we publish

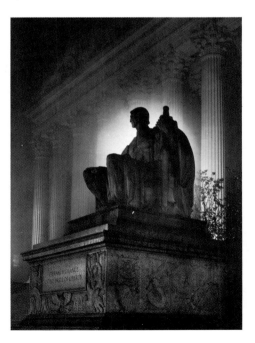

today—images of reality heretofore impossible. Pictures could be taken almost anywhere, under almost any condition, capturing the mood, atmosphere, and fleeting expressions of man and beast.

Luis Marden was first to envision the possibilities of the Leica-Kodachrome combination in the service of the Geographic. Having shot Finlay plates regularly for the *Boston Sunday Herald*'s color roto-section, one of the first in the country, Luis fully understood the advantages of the small camera. His experiments with Filmcolor (an Autochrome emulsion coated on 35mm film) led him to write a remarkable little handbook, "Color Photography with the Miniature Camera." Published in 1934, it was the first on the subject.

In that same year, at the age of 21 and with his Leica dangling around his neck, Luis came to Washington to join National Geographic's photographic staff. But it was not his Leica experience that interested Mr. Fisher; rather, it was Luis' skill with the Finlay plate. Mr. Fisher, in fact, summarily dismissed the Leica as a toy, not suitable for the serious work being done at the Geographic.

The turning point came in 1935, when Luis and Willard Culver, strolling in downtown Washington, noticed a display in a camera shop advertising something new in color—a 16mm motion-picture film called Kodachrome. "There were only two or three color processes in the world at that time," Luis relates. "So we went in and talked to the man, and he projected the film for us. Beautiful! The colors were pure and brilliant, and the whites were white. I got a magnifying glass. The film was grainless and of continuous tone, no mosaic and no flecks of red, green, and blue!"

The potential of Kodachrome, grainless and faster than any color film known, was clear to Luis Marden. With the invention of Kodachrome, his "toy" became the tool that now produces a mind-boggling 1.5 million images for the Society each year. From that unequaled collection come the color photographs that enhance this book. Each one still passes Mr. Fisher's first test. They command attention.

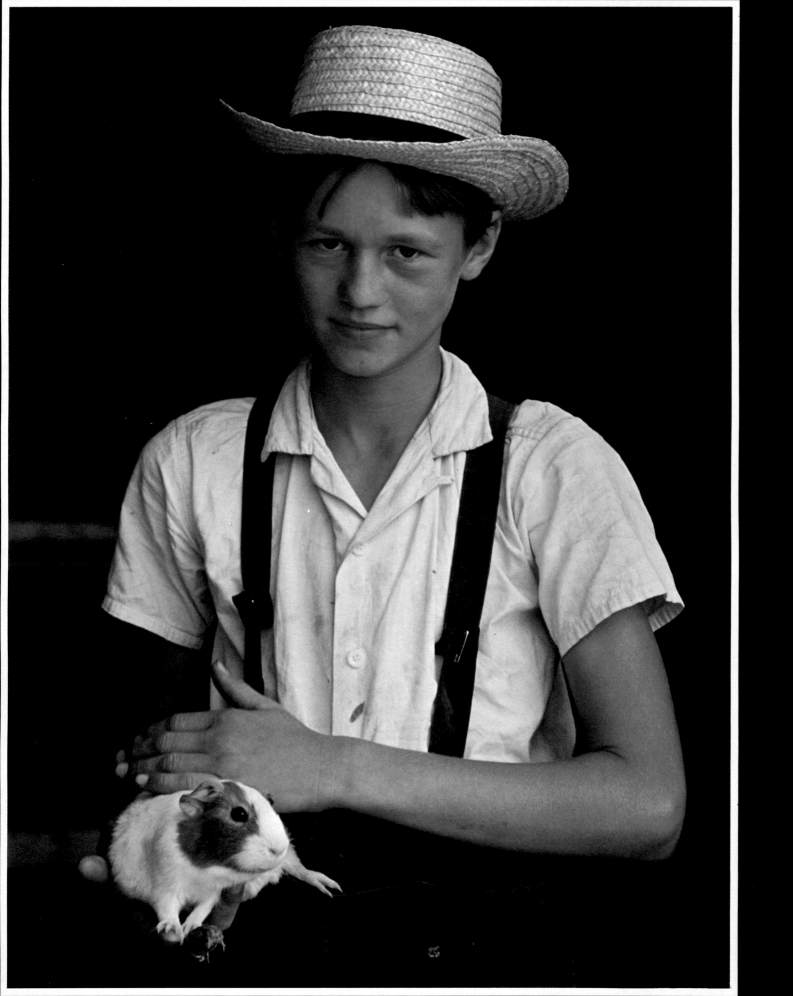

THE HUMAN DIMENSION

Amish farm boy and his pet guinea pig. By William Albert Allard.

Geography, declared the journal of the newborn National Geographic Society, encompasses more than land, sea, and air. "One of the departments of this society is the geography of life," the journal said in its second issue in 1889. "At the head of all life stands man: it is therefore within our province to investigate those questions which more intimately concern and influence his welfare." The statement interrupts an otherwise reportorial article on Africa. Then the article resumes—with impassioned disclosures about the slave trade, which "is carried on more extensively and more cruelly to-day than at any previous time."

The belief in human geography did not show through quite so dramatically in the next few years. "Life" was only one of several kinds of geography that concerned the Society, and in those early pages the traditional topics usually pushed people aside. Pictures of human beings rarely appeared in the small, irregularly issued journal. Ordinary people just did not fit in such articles as "The Work of the United States Board on Geographic Names" or "On the Telegraphic Determinations of Longitude by the Bureau of Navigation."

The journal began devoting more of its pages to photographs soon after the arrival of Gilbert Hovey Grosvenor, who took over in 1899. "In those days," he later wrote, "many publications scorned photographic illustrations. . . . I rejected the conservative view."

His first acquisitions showed places more often than people. Typically, they merely posed in their native costumes. Yet those photographs of stiff, staring people often were eloquent. An article on immigration, published in 1905, was illustrated by lineups at Ellis Island: weary old men, a young black man, a barefoot woman wearing a babushka. In photos they are what they would become in poetry—the tired, the poor, the huddled masses yearning to breathe free.

In the early 1900s the Geographic began to go beyond displays of exotic people in their colorful costumes. In words and pictures the magazine showed not only how people looked but also how they lived. On a zoological collecting expedition in New Guinea, Thomas Barbour laid aside his butterfly nets and picked up his camera. One of his photographs shows, at first glance, a typical lineup of natives in loincloths or less. These men of Tobadi Village "wear boars' tusks in their noses, feathers in their hair, and in their ears almost anything." But the fierce-looking men are not portrayed as savages. Shy young boys stand amid them. One man holds a boy's hand; another man paternally clasps a boy's shoulder. There is humanity here.

Barbour visited villages, asked questions, and produced a vivid report about native life. He took chances, as did his wife, the first white woman many of the New Guineans had ever seen. One day the Barbours approached a temple. "When we tried here, several times, to persuade the crowd to admit Mrs Barbour," he wrote, "a single gesture gave a final answer; that gesture was the swift passing of the hand across the throat."

The magazine's explorations of primitive lands often put scantily clad men and bare-breasted women in front of the camera. A few such photographs had been published by the time Gilbert Grosvenor became Editor. But not until 1903 did he set down a policy.

As he told of the decision years later, he had "some pictures of Filipino women working in the fields, naked from the waist up. . . . The women dressed, or perhaps I should say undressed, in this fashion; therefore the pictures were a true reflection of the customs of the times in those islands."

Asked for advice, Alexander Graham Bell, president of the Society, said, "Print them." Ever since, "true native dress" has won out over prudery on Geographic pages, and a study of those photos has been a rite of passage for American boys—and girls.

Color added another dimension to the photography of people. But the portrayal of colorful people often lessened the impact of reality. In

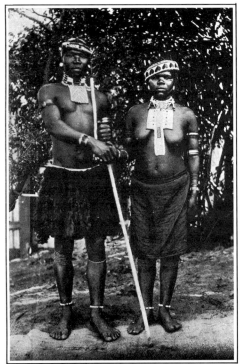

"Zulu Bride and Bridegroom," which illustrated an article on South Africa, was the first Geographic photograph to show a bare-breasted woman. "These people," the article said, "are of a dark bronze hue, and have good athletic figures."

Photographer unknown. National Geographic Magazine, November 1896.

18

A young Japanese flower gatherer smiles at the busy camera of the roving foreign secretary of the National Geographic Society, the only woman on its board of managers. Eliza R. Scidmore also went on a royal elephant hunt in Siam while exploring "the wonders of the East." Her black and white photos of Japanese people were tinted in delicate colors that captured the land's soft beauty.

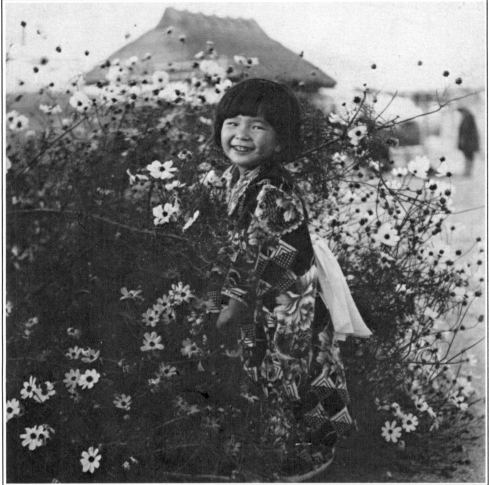

Eliza R. Scidmore. National Geographic Magazine, July 1914.

Dancers garbed as demons whirl around the courtyard of a Tibetan lamasery. Photographer-explorer Joseph F. Rock spent two years learning about the lives of people who at first fled from his camera. In extraordinary color photographs he documented life in a land few Westerners had known.

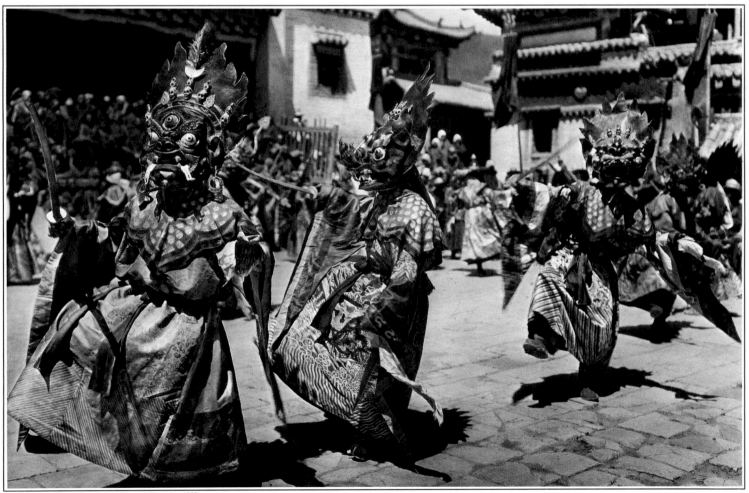

Joseph F. Rock. National Geographic Magazine, November 1928.

19

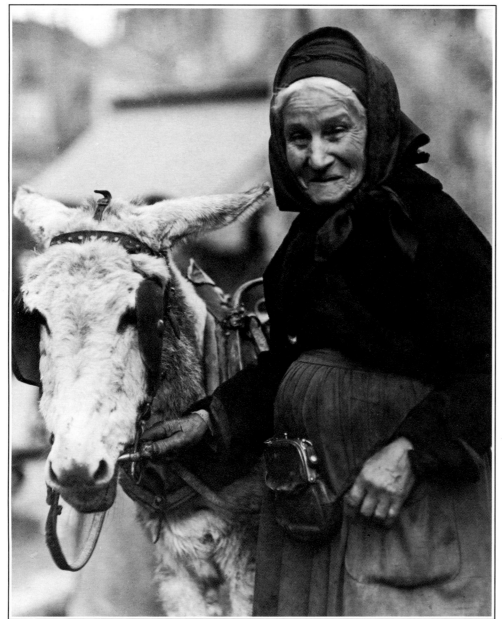

Portraits such as this could reveal the character of a people. The woman and her donkey gave readers a special image of life in the 1920s in southern France— "that neat, measured-out countryside" where oxen had "mild-eyed dignity," and people walked home from market "with squirming rabbits and cackling chickens under their arms."

November 1910 the magazine published an unprecedented 24-page color spread, "Scenes in Korea and China." The photographs were made in black and white; a Japanese artist tinted them, working from the photographer's color notes. The photographs show ordinary people— a Korean farmer in a raincoat of straw, men and women bent under their burdens, prisoners in shackles, Buddhist nuns in conical hats.

Looking at them, we want to know more about them. But the captions are labels, not descriptions. And the text treats the people as curios, objects to be viewed at arm's length. "The street scenes of Seoul," the author-photographer writes, "offer great variety for the kodak, the burden-bearers of both sexes furnishing a constant change of scene; most of them being willing victims, entirely satisfied with a small tip."

In their search for color, the roving photographers usually were satisfied with finding costumes. In 1918, when one could not, he sent the Geographic an explanation: "Unfortunately, concerning costumes . . . they are becoming very scarce in Brittany, as in Spain and everywhere. . . ." People, he complained, were not as "credulous and obedient" as they used to be.

Maynard Owen Williams did not think that way. The Geographic's first staff writer-photographer, he saw his job as seeking "through photography to show the folks at home how the other half of the world actually lives." He seemed not to have realized that he was setting precedents and developing a photographic philosophy that would endure. His feeling about people became a creed for all good photographers: "one can't get friendship without giving it, and a portrait is not a mechanical thing. . . ."

In what Williams called the other half of the world, photographers aimed at what was there—usually the exotically beautiful and sometimes the exotically grim. A series of color photographs published in 1922 begins with a landscape of Mongolia and ends with two pictures of people: a man in chains and a woman whose head and left arm jut from a wooden box. The picture's label simply says, "A Mongolian woman condemned

to die of starvation." Rarely did the Geographic publish sights so horrible. But a discerning reader often could see despair in the eyes staring back from the other half of the world.

On our side of the world, in the United States of the 1920s and 1930s, the ordinary was usually the subject: New England ski trails, the Great Smoky Mountains. In planning for coverage of southern California, however, illustrations editor Franklin L. Fisher realized that there was one place that needed careful treatment: Hollywood.

Writing to the photographer who had the California assignment, Fisher approved the idea of showing how a movie star was made up. But, he added, be sure to "pick someone with whose name scandal has not been connected. Possibly Joan Crawford might be suitable."

The photographer replied that "the only actress out here who hasn't indulged in scandal seems to be Minnie (Mrs. Mickey) Mouse."

The Geographic settled for a black and white picture of an actress having an artificial eyelash adjusted. Color photos concentrated on flowers and oranges, while the text tried to live up to its title, "Southern California at Work." But the basic fact of life in America—the Great Depression—could not be avoided. "Men without work walk the streets here now, as everywhere else. . . ."

The Geographic did not show people struggling through the Depression. And during World War II, battle scenes rarely appeared. As the world became dark, the magazine bloomed with more and more color. In an era so memorably documented by black and white photography, color sometimes seemed shallow.

But the Geographic, which had labored long and well on the techniques of publishing color, could not abandon it. In 1938, the magazine averaged 23 color photographs per issue. The average rose to 63 in 1948, the first year the Geographic published more color photos than black-and-whites.

The Geographic's use of color became symbolized by what critics dubbed "the red shirt school." Dots of red popped up in many pictures— a shirt, a cap, a sweater. Some photographers carried red shirts or

For an article on famine, the Geographic gave image to hunger: An Indian family starves to death before the camera's unblinking eye. Decades later, the camera still bore witness (pages 36-37). For an illustration of "Human Emotion Recorded by Photography," the

Geographic turned to classics that included Lewis W. Hine's study of New York City newsboys. As a "conscience with a camera," he exposed slum and sweatshop. Blending word and image, he pioneered photojournalism.

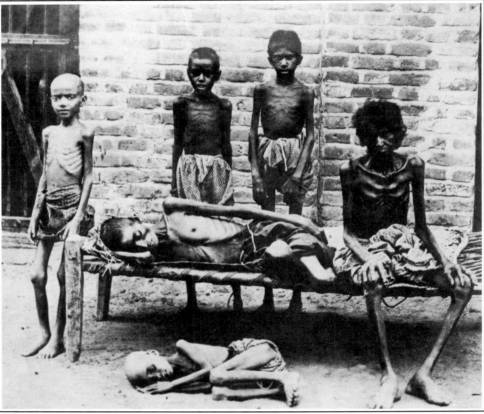

Underwood & Underwood. National Geographic Magazine, July 1917.

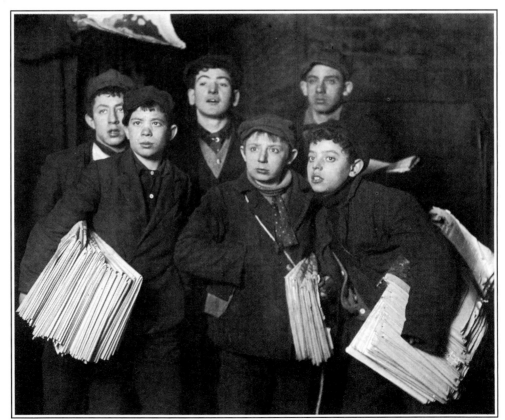

Lewis W. Hine. National Geographic Magazine, October 1920.

21

Maynard Owen Williams. National Geographic Magazine, July 1921.

A Buddhist monk takes a look at what had been taking looks at him and other suspicious Buddhists. The photographer urged reluctant subjects to peek into his black box to dispel fears. A portrait, Williams believed, is "a collaboration between subject and photographer."

In a warehouse of an Afghan bazaar Williams sensed a great group portrait. But he needed to tell his subjects—by gesture alone—to stand still for three seconds. They did. Across the language barrier they also sensed the picture, a portrait of understanding.

jackets as props, much as one of the pioneers had taken a trunkful of colorful scarves on his photo-seeking trips through Europe.

Color in the 1940s and 1950s went to colorful places, and the people in photographs were often made more colorful by putting them in costume. So in stories of the modern South readers met George and Martha Washington, couples in colonial attire, or belles in antebellum gowns. In a wartime story, Smith College girls toiled in a field to ease a labor shortage. They wore work clothes (including one red sweater), and the legend seemed to apologize: "Slacks and dungarees may be seen even on the campus. . . ."

The color photos of those days could deliver emotion or drama: a Mennonite woman striding to market, her long gray dress giving witness to plain faith in a gaudy world . . . the bloody decks and gory wake of a seal-hunting ship. But the human face was best etched in black and white: a scowling fortuneteller, a Chinese peasant gazing on "barren fields in a year of famine."

By the end of the 1950s color was winning out—in quantity and often in quality. In February 1962 the magazine's first all-color issue launched an era when color would no longer be a novelty or fillip. Around the same time came the first wave of the photographers whose work dominates this book.

They developed a style—the "Geographic eye," some called it. The photographer was there, but not as an arranger of a scene. In the Geographic eye, people acted naturally, did not pose, did not wear costumes. They were real—and color was part of reality.

One of the photographers who had that eye was Win Parks. To get close to people, Parks sometimes adopted their mannerisms and even their dress. He photographed in some 40 countries, and nowhere was he an intruder. Asked once what made a Geographic photographer, he said, ". . . a great deal of patience, a sound knowledge of photographic technique, a good sense of humor, but, above all, a love of all peoples, and a desire to record life in a significant manner."

Parks died in 1977. Some of his legacy enriches this book.

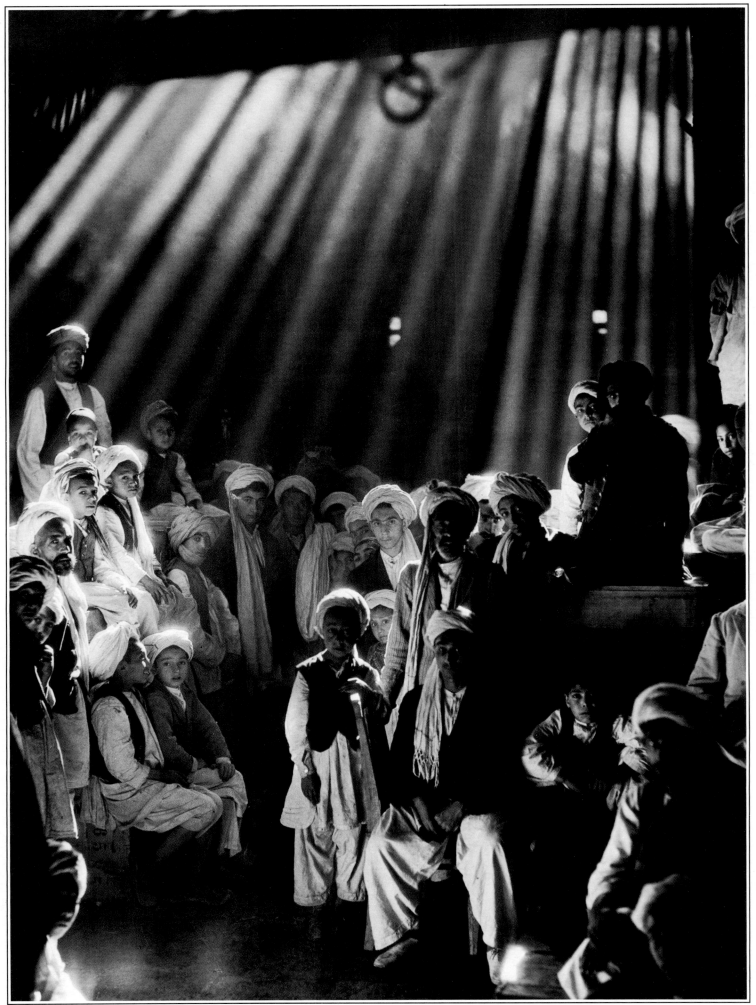

Maynard Owen Williams. National Geographic Magazine, December 1933.

On a desert road: "It's really kind of desolate out there. Then I came to his place with its no-trespassing sign. I stopped my motorcycle and said hello and told him who I was and that I was doing a story on the border. He invited me in to drink cold water. We just sat and talked, and he told me he had problems. He said the U. S. Government was trying to ease him off his land. 'This is all I know,' he said. 'Ranching is my life.' That was just about the time I took this picture."

WILLIAM ALBERT ALLARD

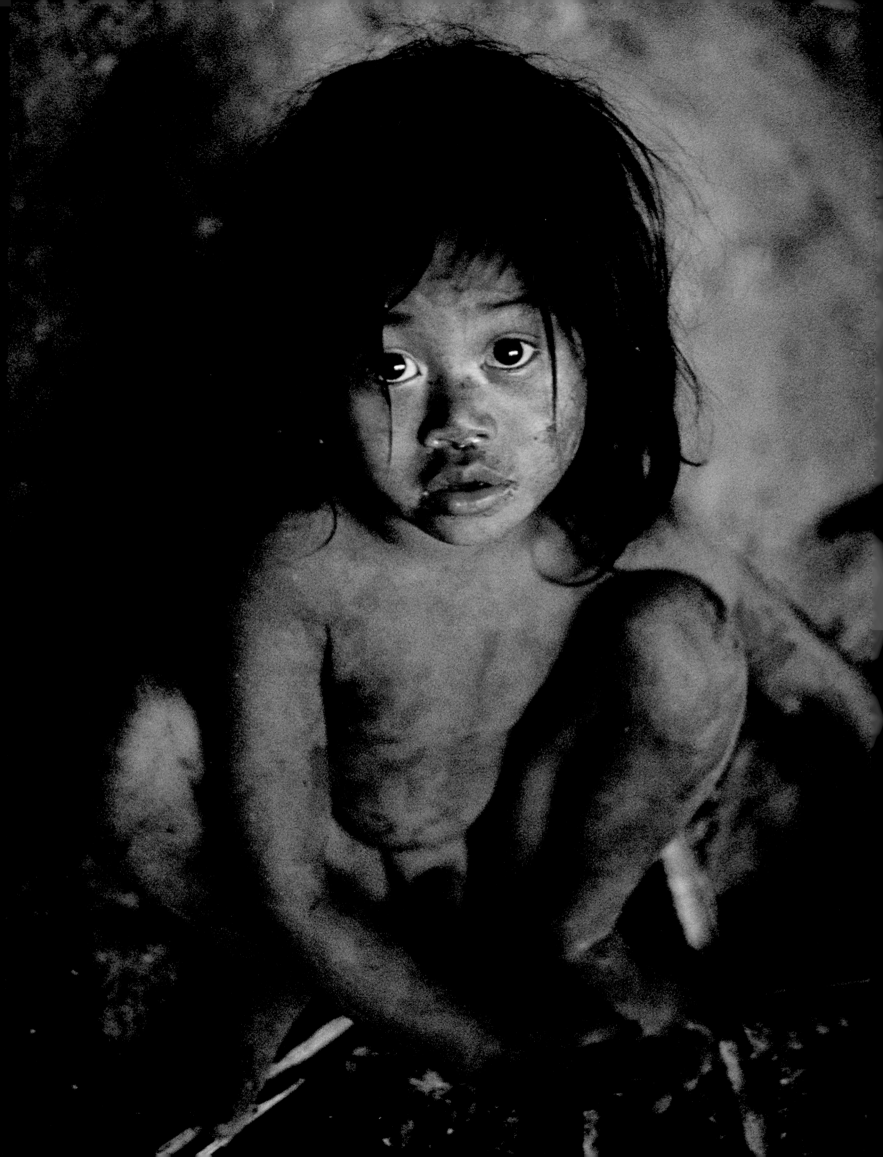

To fly from New York City into the Stone Age reaches of Mindanao was unusual. "But what really impressed me was the gentleness of the Tasadays, the incredible innocence reflected in this child's eyes."
JOHN LAUNOIS

"It was strictly a chance encounter. I had stopped along the road to Potosí, in the Andes, and this woman walked out of a building. I popped a couple of pictures and was on my way a minute later. She never realized it."
LOREN McINTYRE

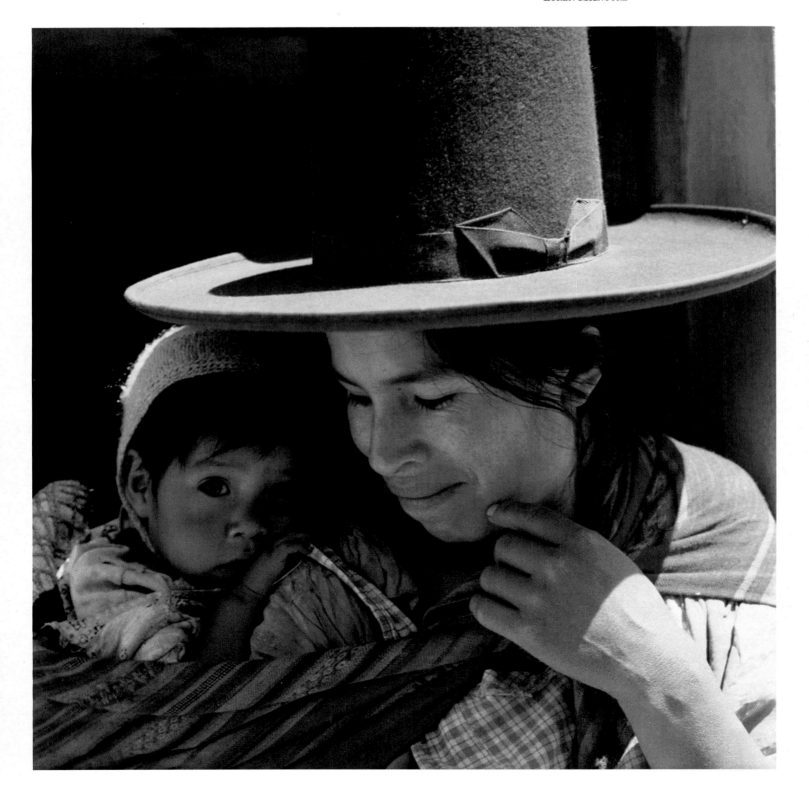

27

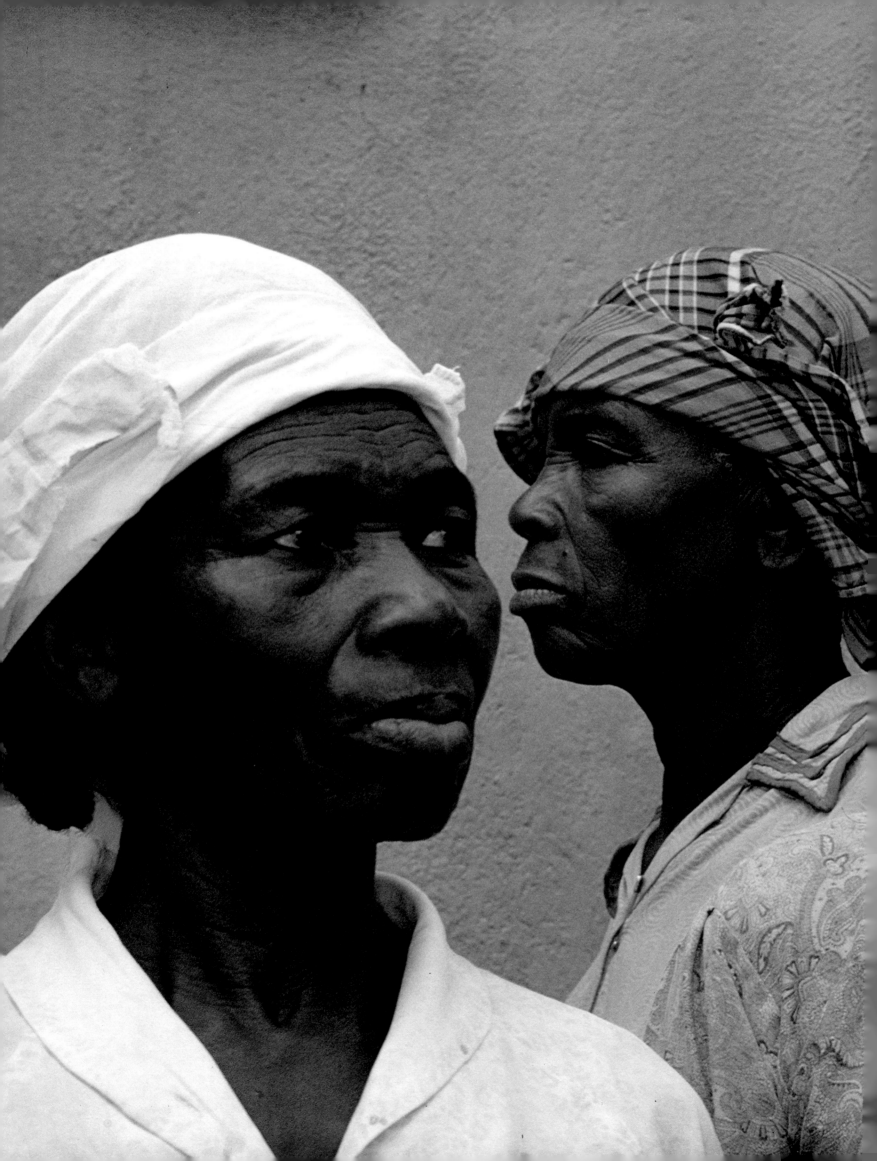

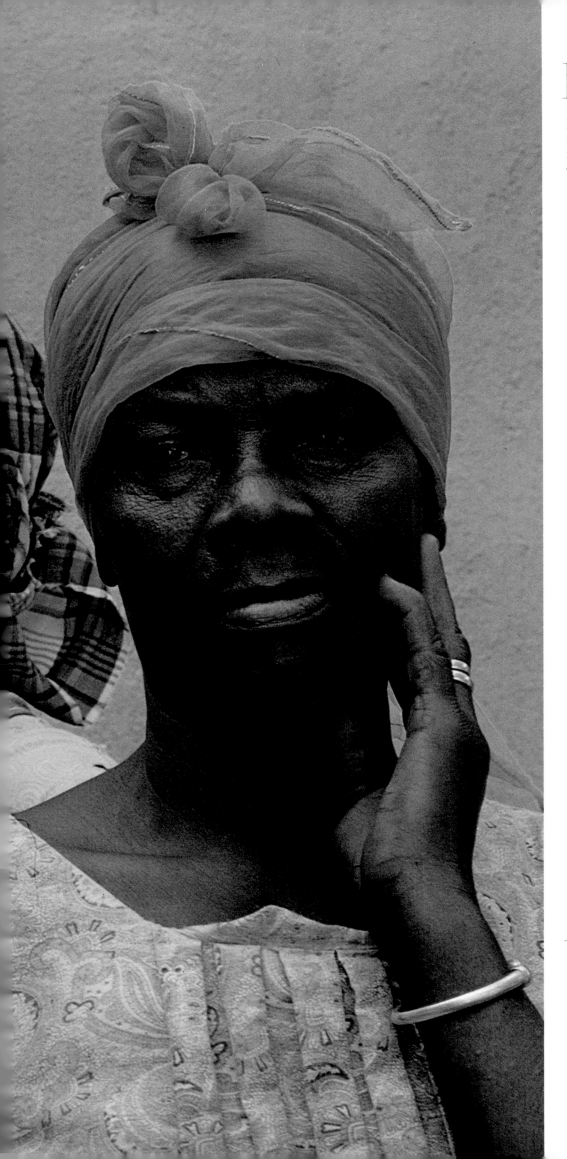

M oore Town, Jamaica: "It's a sleepy
little town where people aren't
doing anything. I saw these
women and this particular colored wall.
I put the two elements together
according to my vision. I call it a study
in dignity. The faces take over."
THOMAS NEBBIA

A ran Islands homecoming
(overleaf): "All the elements were
there—dogs, men, women,
handkerchief, boat, casket. The fellow
had died on the Irish mainland and they
were bringing his body back to be
buried. These people consider a funeral
a very private thing. I was an intruder,
and I tried to keep myself as
inconspicuous as I possibly could."
JAMES A. SUGAR

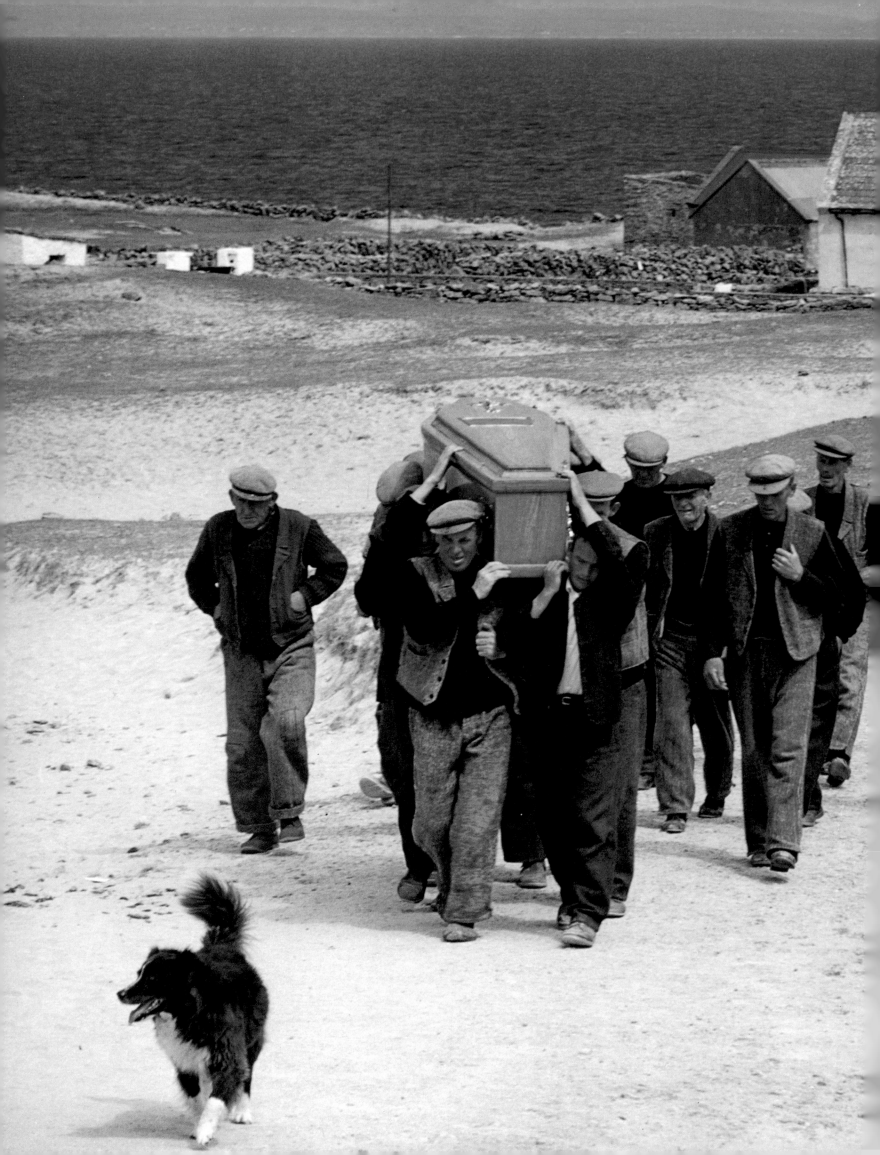

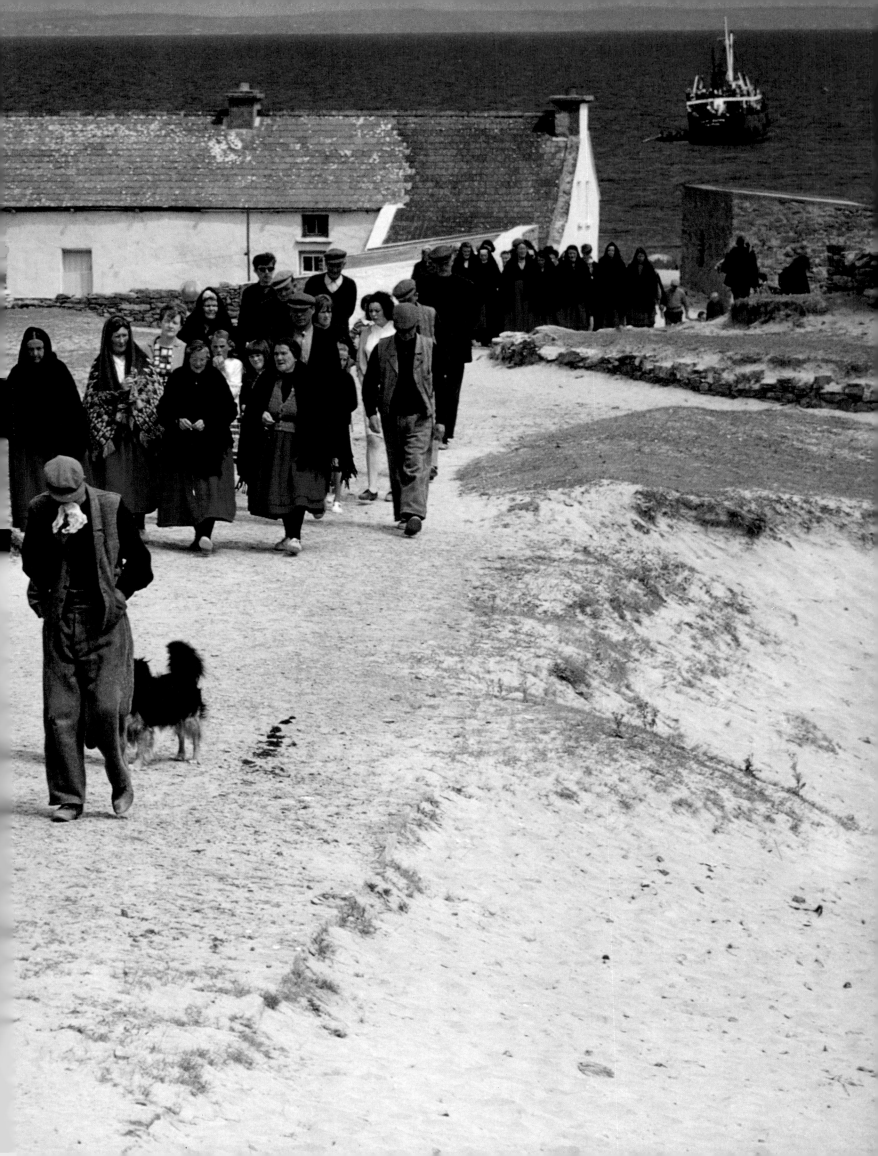

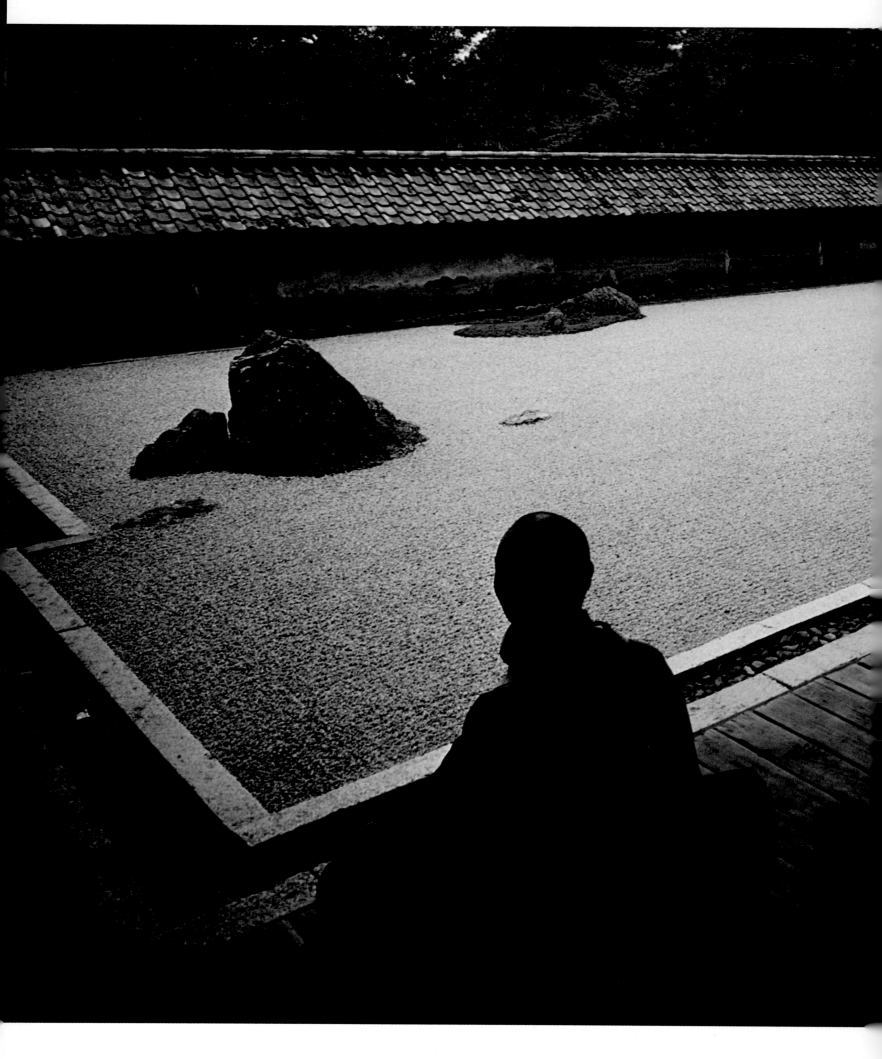

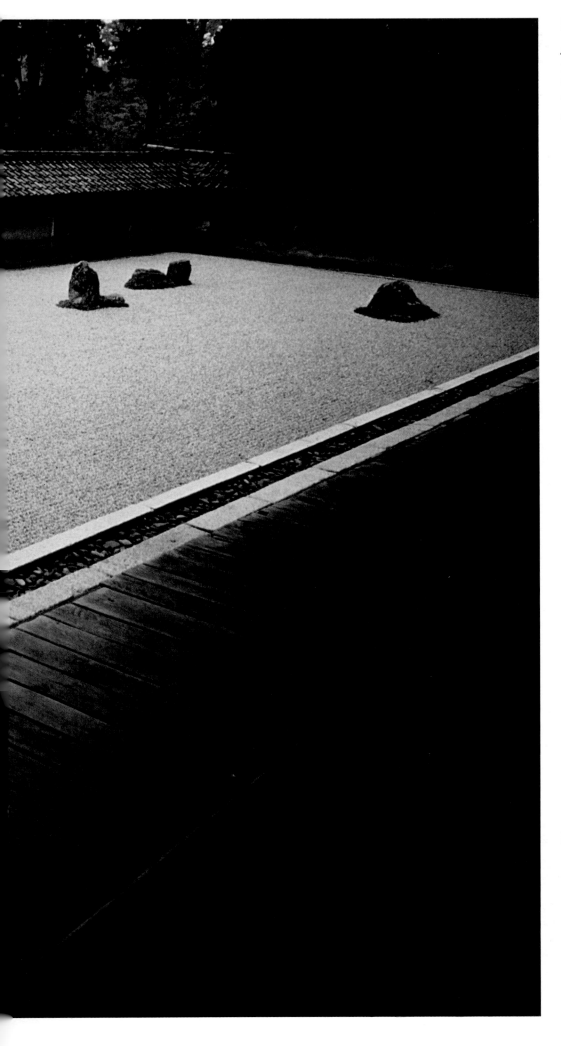

Zen's austere beauty suffuses the rock garden of a monastery in Japan. "I call this a monochrome picture. Even the light obliged—it was overcast, and the monk himself becomes an island of tranquillity."
JOHN LAUNOIS

The Mennonite girls were bashful about being photographed (overleaf). "So I withdrew from the scene and used a telephoto lens. I was trying to capture some of the grace and beauty with which these people carry themselves, even in their daily chores. To me the picture has an almost dance-like aspect. I took several shots and I knew that one of them would be just right—a feeling you get three or four times in hundreds of rolls, thousands of pictures."
SAM ABELL

33

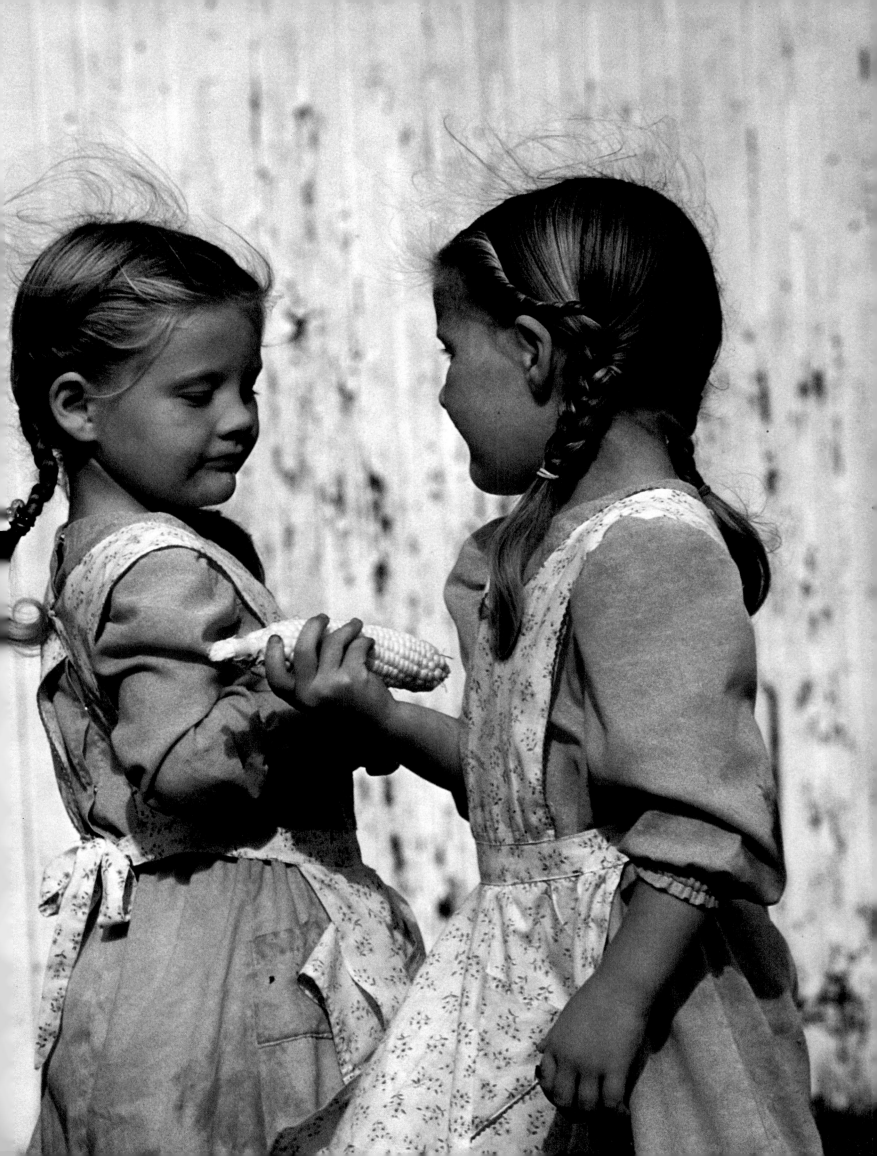

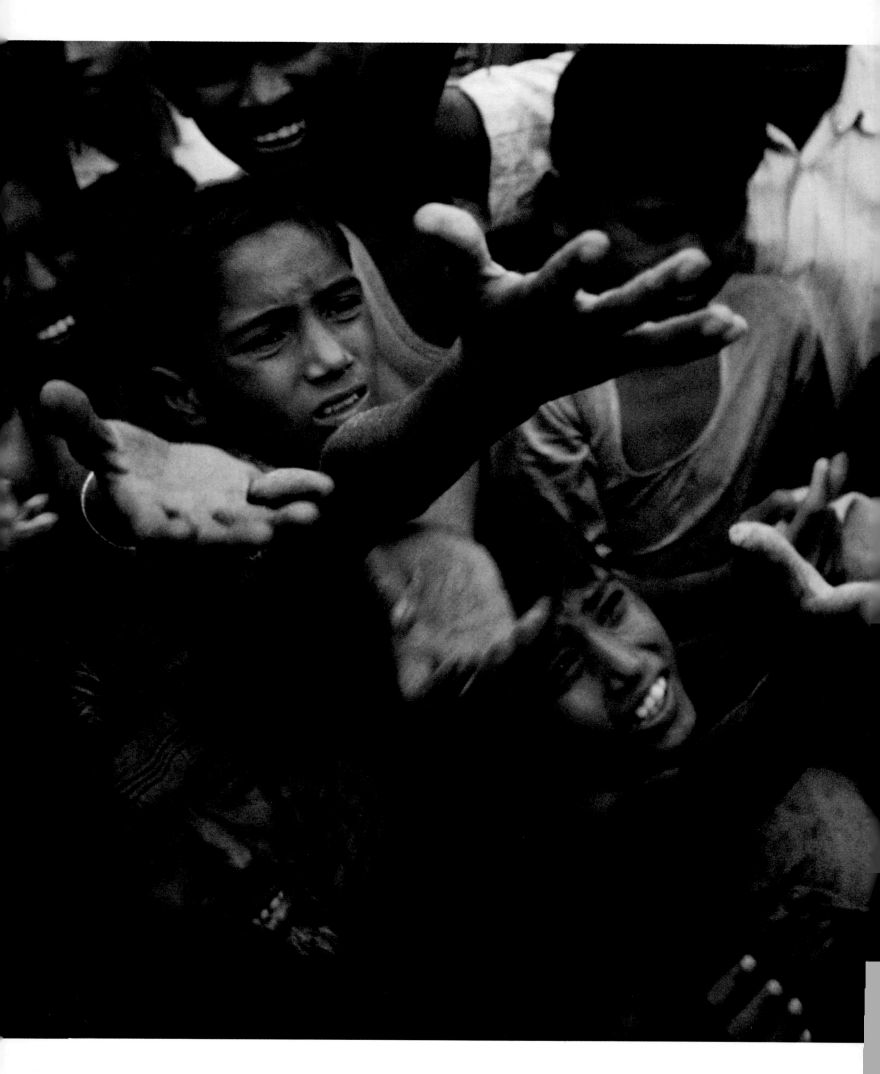

"My God, these people were starving! Their hands clawed for a few scraps of food. A frail woman with leathery skin ripped open my shirt looking for food. I saw a boy, a walking skeleton with only days to live. That night—Thanksgiving Day back home—I sat down to dinner with a young American couple. I could only pick at my plate. I'll never forget the agony on the desperate faces of Bangladesh's starving thousands that day."

STEVE RAYMER

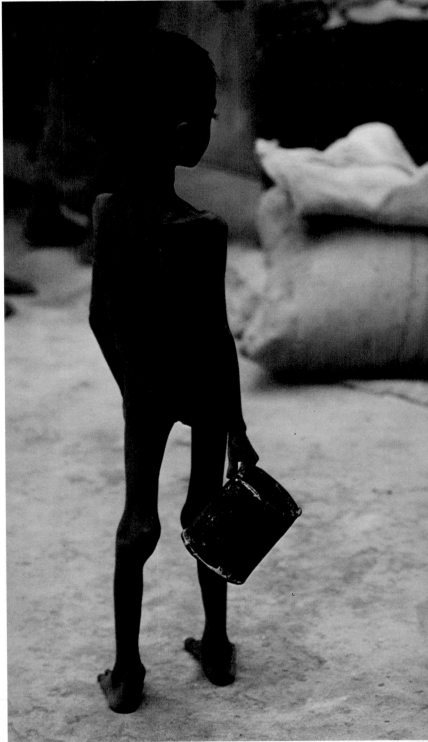

37

In Lanzhou, "I saw the man and I knew he had the potential for a nice portrait. In China there is usually a three-second lag between the time someone knows you are taking his picture and the time he turns away. Three seconds is a pretty long time."
BRUCE DALE

"People of the Micronesian islands have been under American administration since 1947. Only on remote islands do original costumes persist—grass skirts or lava-lavas for women, thūs for men. High school students staged this traditional stick dance."
DAVID S. BOYER

Evening prayer service begins. "I was in a place I wasn't supposed to be. These are Hutterites, and it's very much against their beliefs to allow photographs. But I had worked with the colony for awhile and had established a rapport. . . . I remember not taking very many pictures and trying not to intrude. I had to convince them to let me document their way of life."

WILLIAM ALBERT ALLARD

On his way to photograph an Arkansas wood-carver, Bruce Dale acquired a jelly doughnut, which wound up in his camera case. "In the afternoon everybody went swimming. She said, just as I was to make this picture, 'What have you got in that case?' I said, 'A jelly doughnut.' She said, 'Come *on*.' So I opened my case and pulled out the jelly doughnut. I think that was partly responsible for her expression."
BRUCE DALE

Alarm and consternation play on the faces of children who see what the photographer does not see. "I was in Denmark on the Hans Christian Andersen assignment when I saw the little shepherdess and chimney sweep. Perfect! I lay down on the ground to take their picture. What I didn't know was that a bicyclist, skidding out of control, was about to run me over."
SISSE BRIMBERG

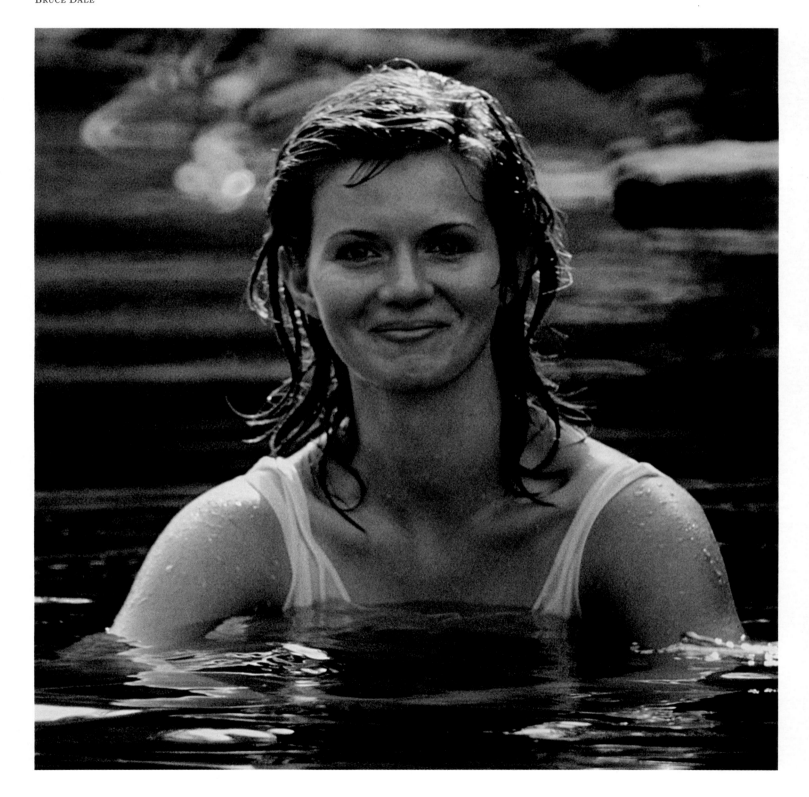

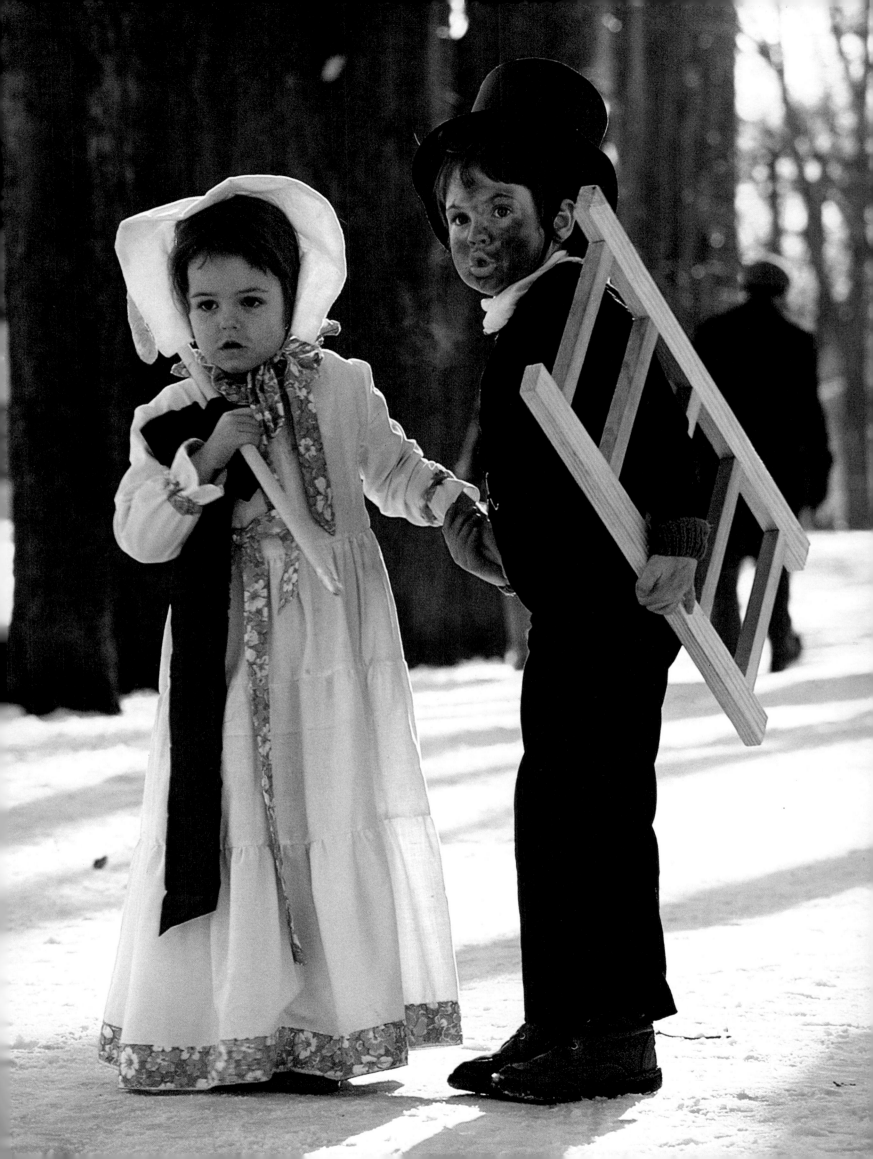

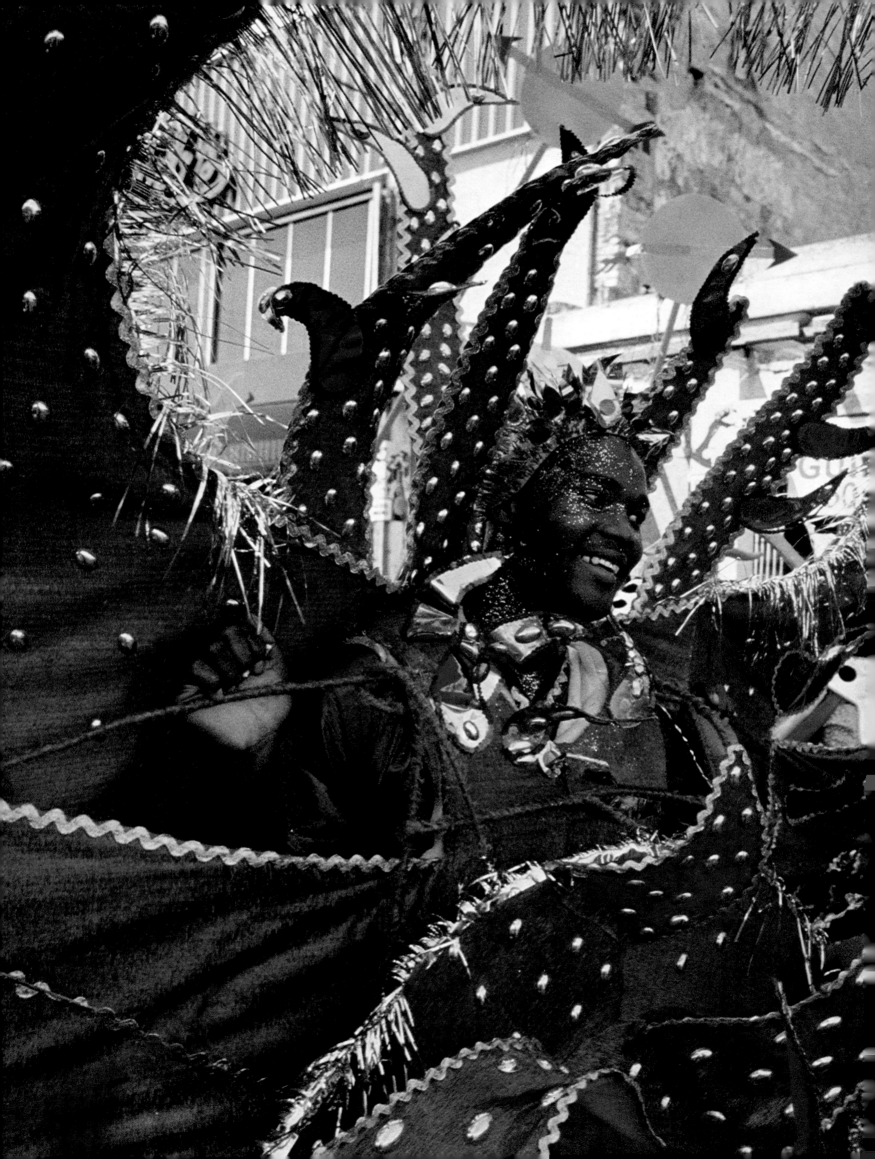

Carnival begins at dawn on the Monday before Ash Wednesday. Revelers have been dancing—"jumping up" they call it—all night. Now, a parade of sound and fantasy, they swirl into downtown Port of Spain, Trinidad. "You've got to understand, mon," a reveler says, "this is a real art—our art. We gave it to the world from these streets."

WINFIELD PARKS

"It was very quiet. I made about four or five frames in this small house in Transkei, where the women and children scratch out an existence while their men are far away, working in South Africa's mines or sugar fields. The grandfather, who is too old and sick to work, is the only adult male left. The best of the pictures I took that day had the quality I like to get in a photograph, which is that without artifice, without control, without interference, the picture comes together and makes a statement that shows the problems these people face."

JAMES P. BLAIR

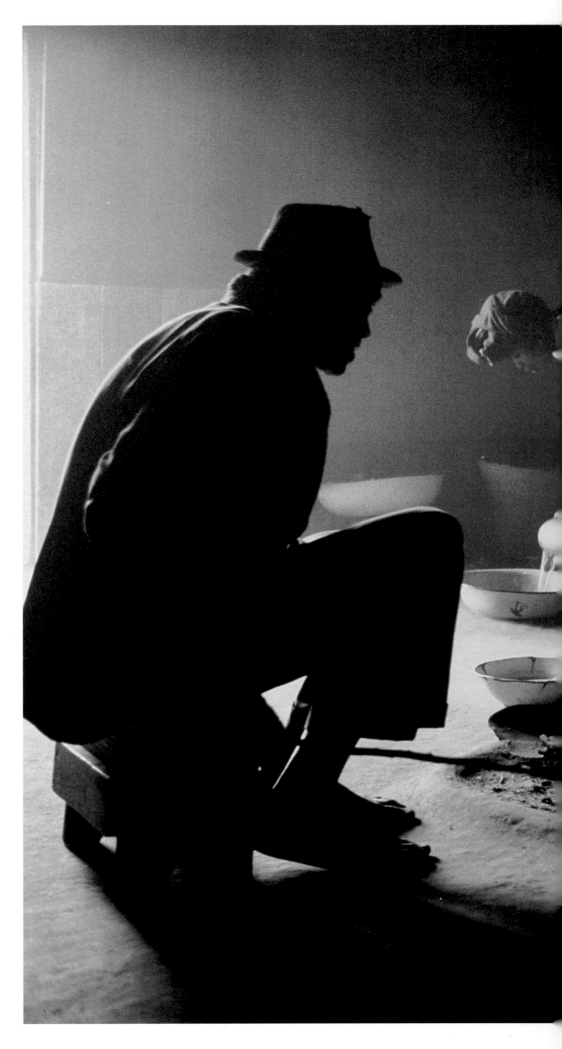

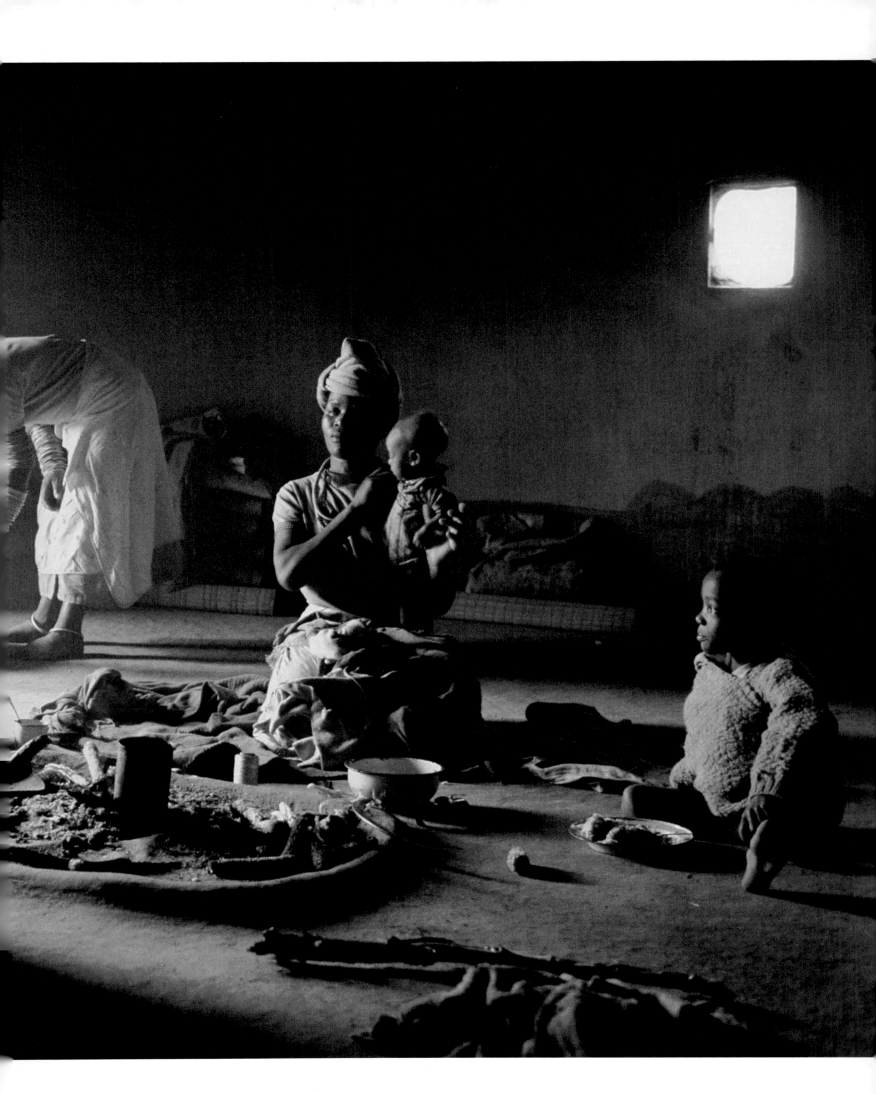

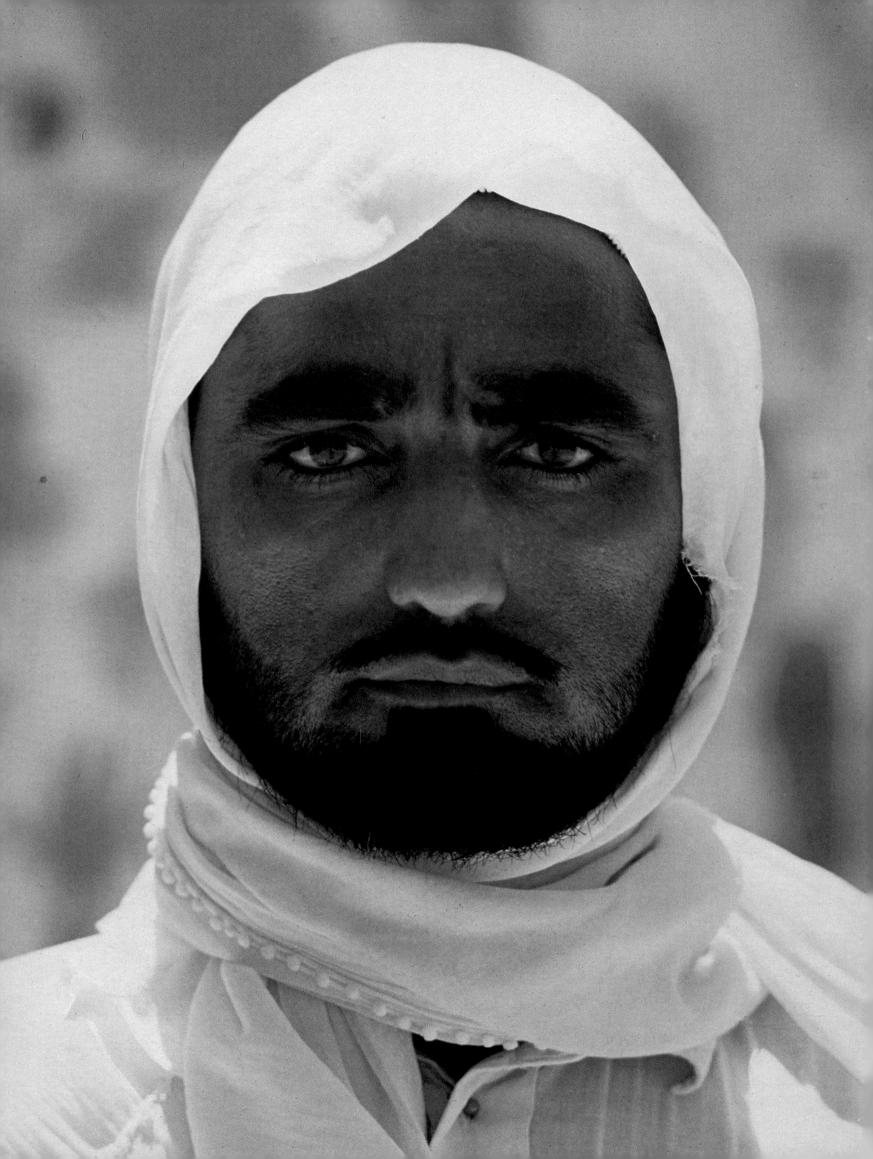

He was a face in the crowd at Mecca. "I just took his picture—one shot—and walked on to something else. I didn't know him or talk to him. But his gaze is arresting and captures the fervor of Islam."

THOMAS J. ABERCROMBIE

It happened so quickly the photographer shot only one frame. "She came up behind him and hugged him. Her eyes were closed. Her face radiated this magnificent expression of love. It's something you don't see very often in the Arab world. Then it was gone. Just like that."

JAMES L. STANFIELD

49

"I had been photographing this woman for about an hour as she walked with her cattle along the side of a road in Malaysia. I had what I thought were some good pictures. Then, as I was leaving, it really started to rain. She got inside the conduit, and it was then I realized *this* was the picture. I must have shot a roll and a half."

DAVID ALAN HARVEY

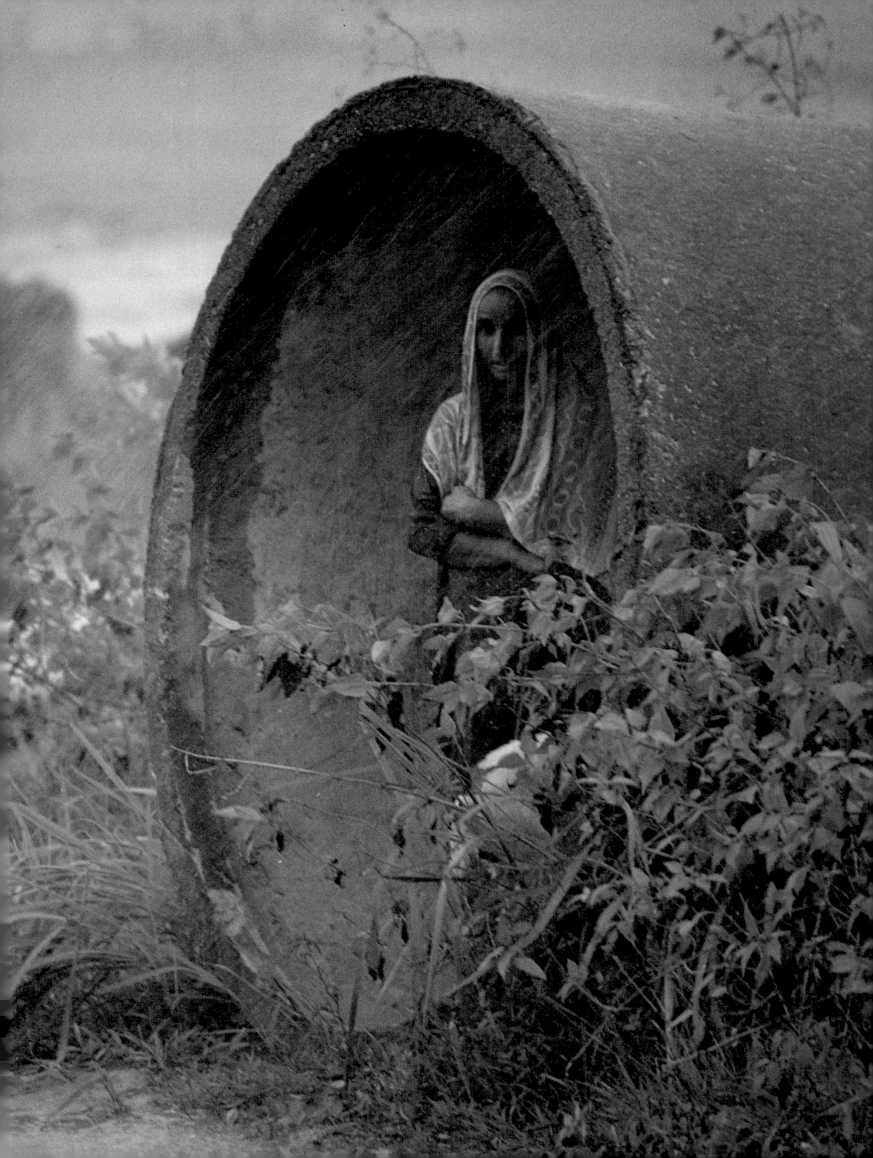

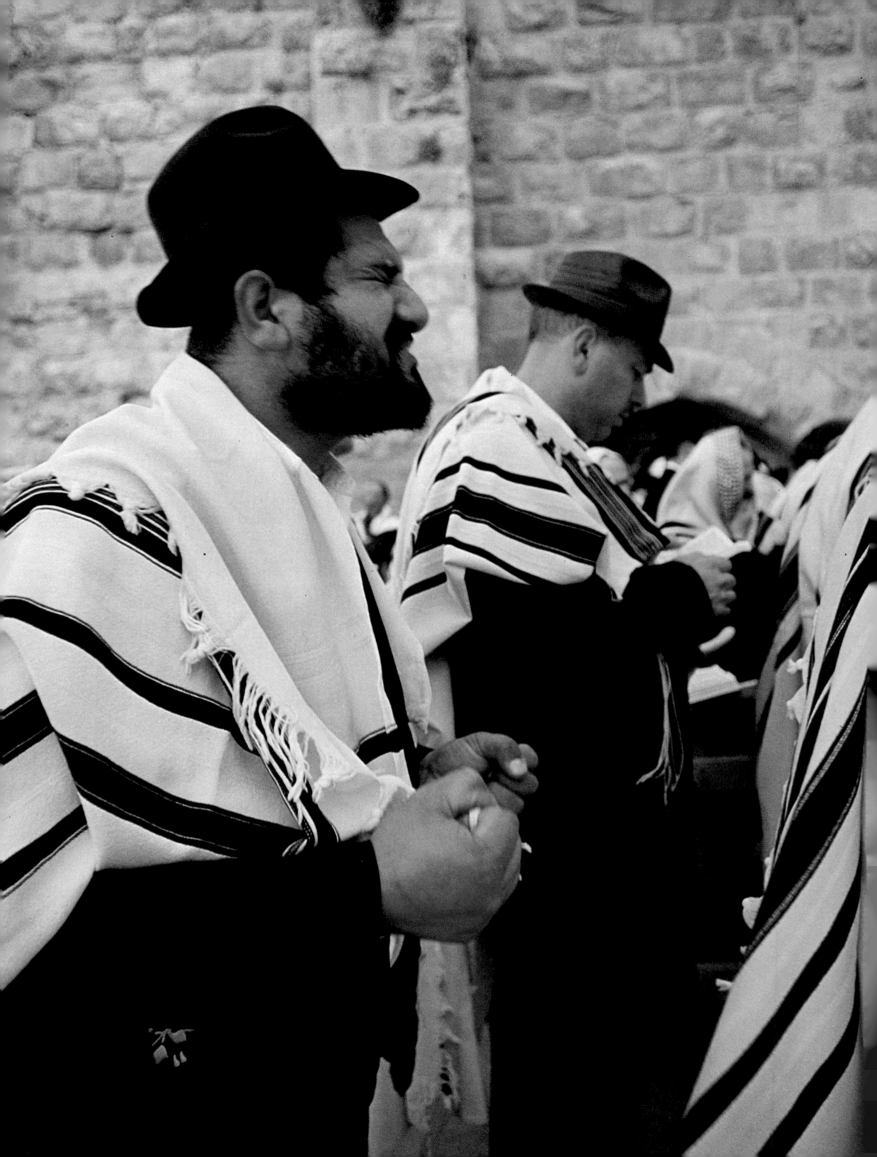

"There's no such thing as stealing a picture. He knew I was there and sensed, correctly, that I was there to affirm our heritage. This is a visual journal entry of faith, shared openly and intimately."
TED SPIEGEL

Where light is not welcome (overleaf), a photographer's greatest ally is his tripod. "With modern color films—and a tripod—almost any situation except fast action can be shot with existing light. Candlelight was all it took to record this 'Day of the Dead' ceremony in Mexico."
WILBUR E. GARRETT

Mass baptism, Virginia: "It was an incredible experience. . . . I worried about getting my cameras baptized with me, but I knew I had to wade right out. It was the only way to get the picture. And it worked."
DAVID ALAN HARVEY

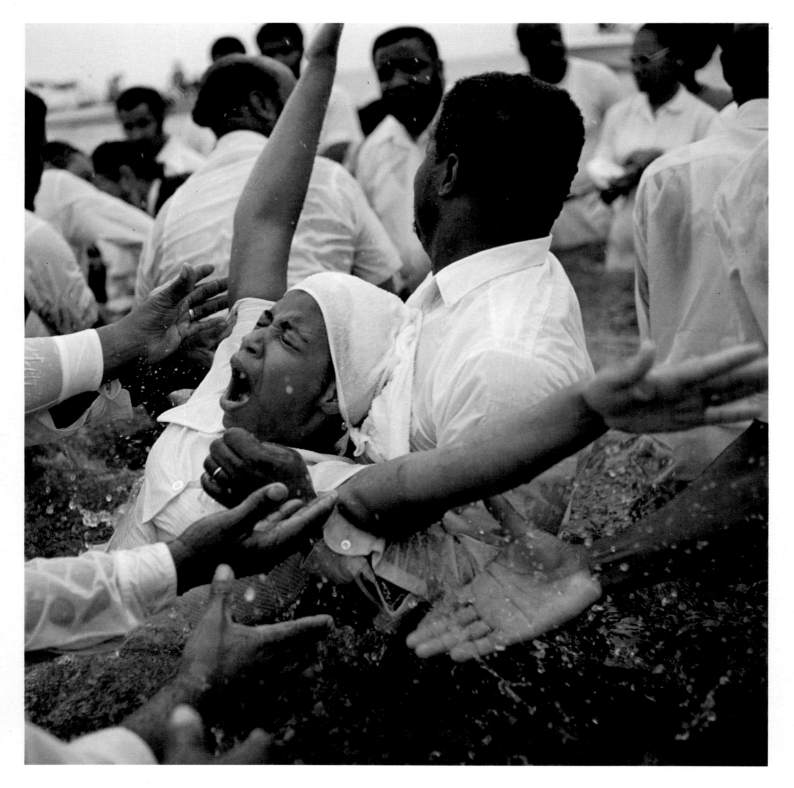

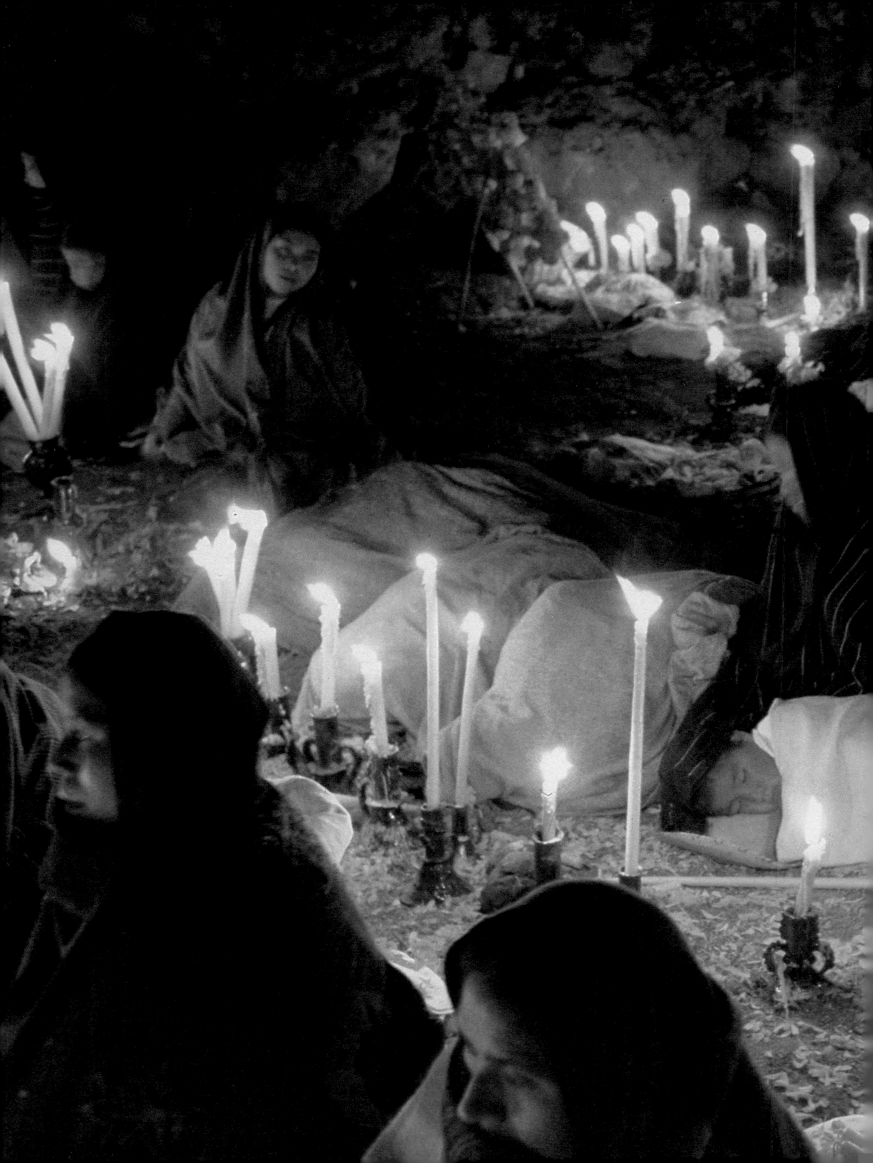

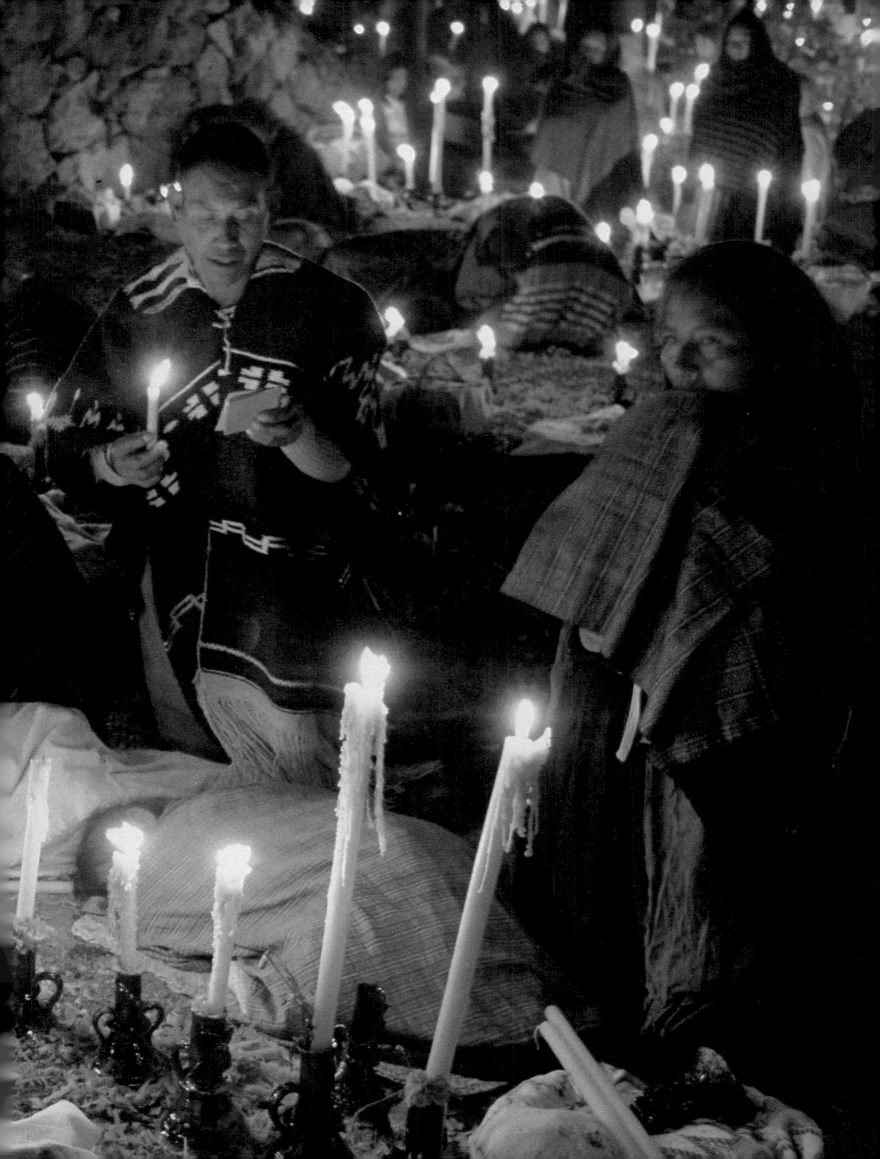

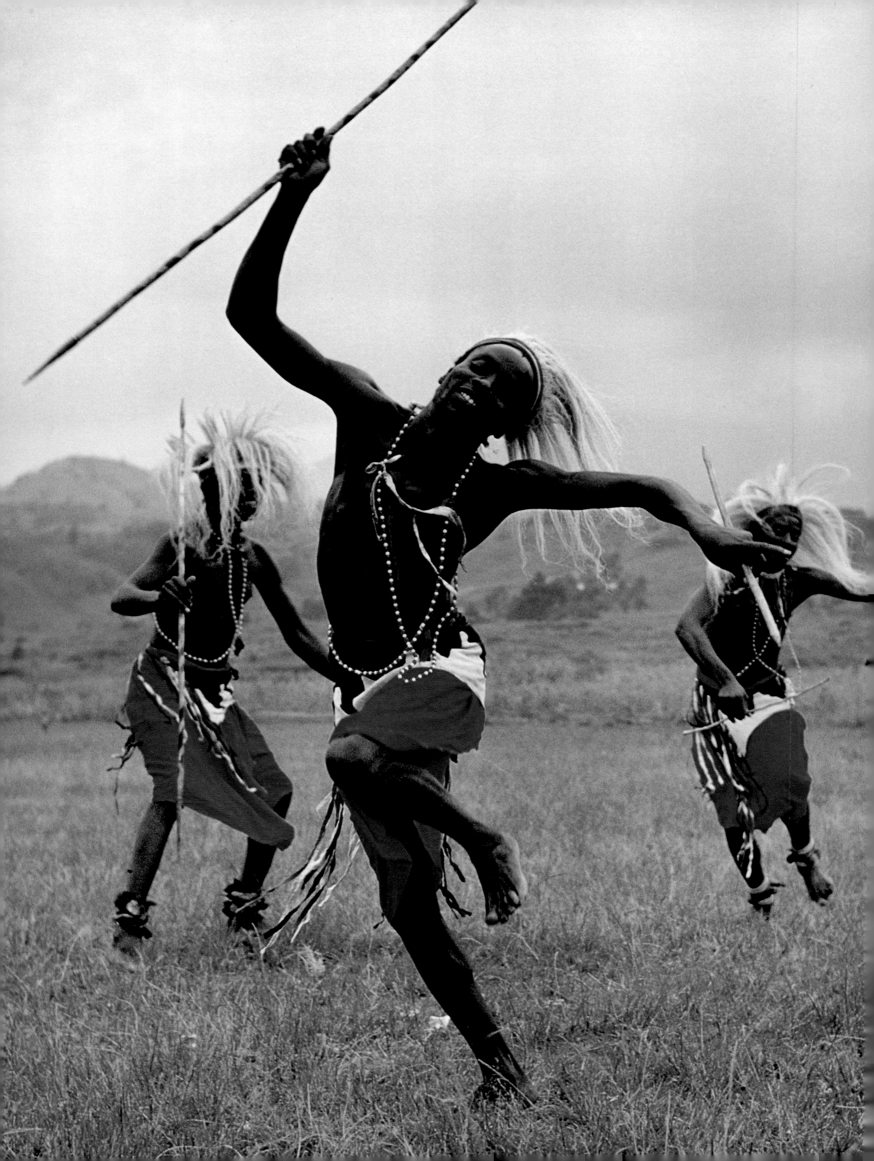

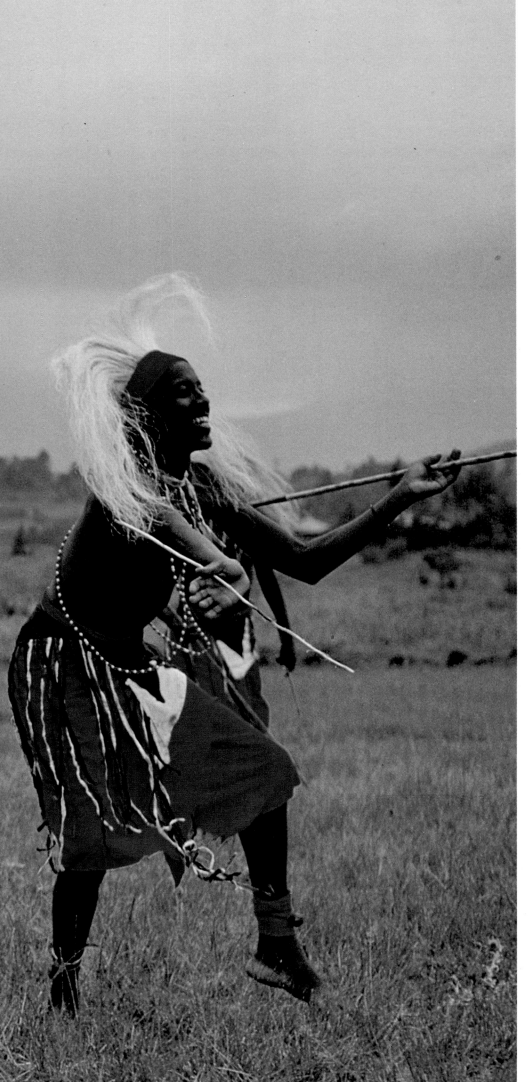

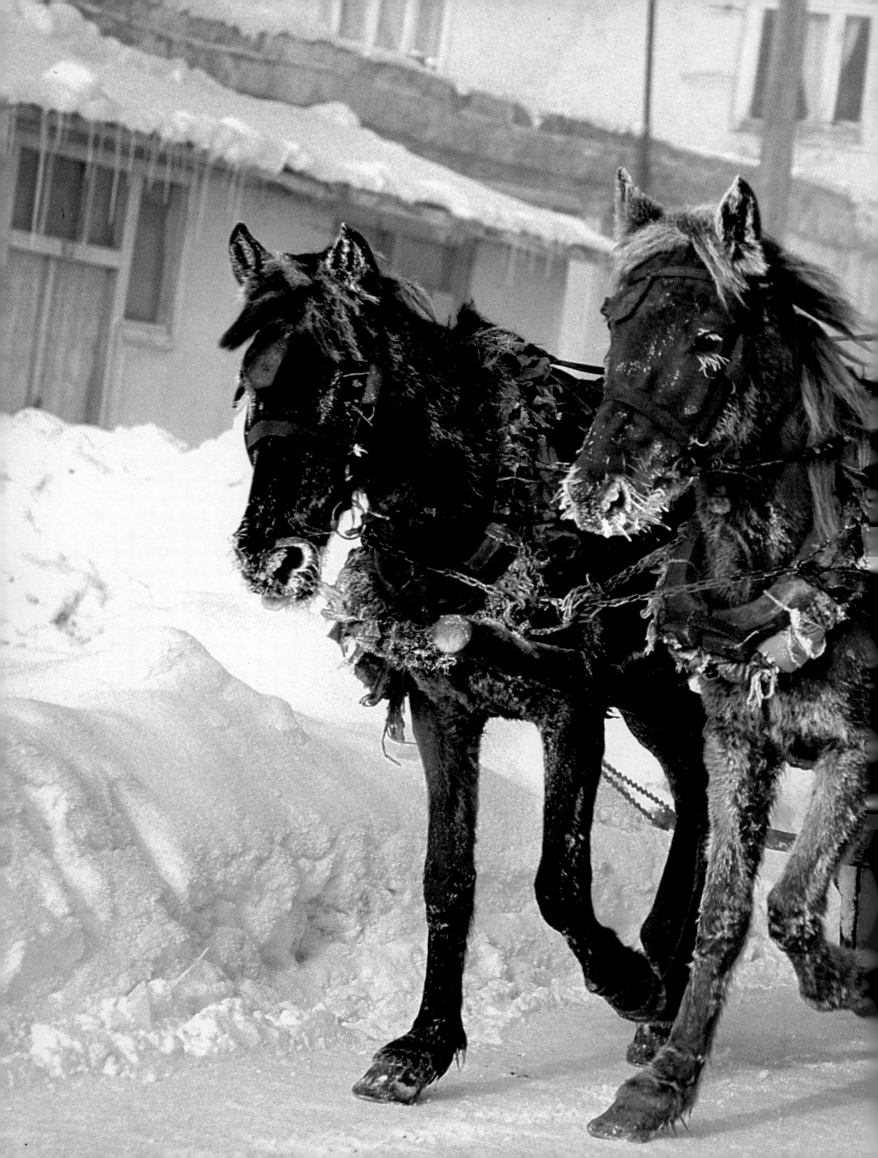

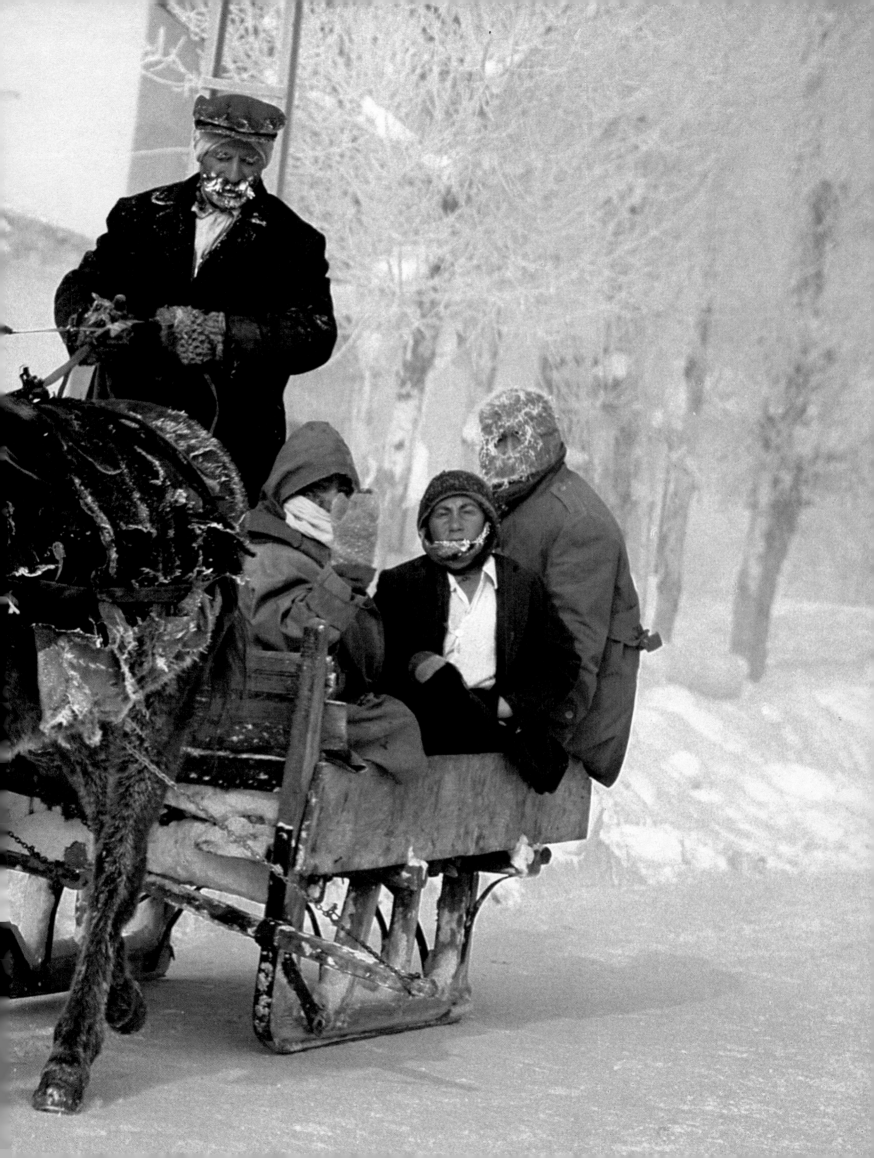

Finding a City in Its People

By Jodi Cobb

It was hard to get a handle on photographing Los Angeles. The city seemed to have no spiritual center, no unifying theme except its very diversity. Where to look for the right images? What was it that made Los Angeles the leading edge of American life and lifestyle, a pacesetter in movies, music, fashion, sports, and religion?

There was no obvious starting point, but the key to the story appeared to be the character of the city's people, for it was they who made their sprawl of concrete into a fountainhead of trends and ideas, the home of Hollywood and the Dodgers, a stronghold of swimming pools and pollution, the spawning ground of fast food and T-shirts. Los Angeles has little sense of community. It is a stage where ambitions and optimism and tragedy are played out by people who pour in from everywhere in pursuit of their dreams.

Materialism permeates the city, fostering a climate of competition. Writing about California in *Dreemz,* Benjamin Stein noted that "in Paris you fall in love. In Boston you go to school. In L.A. you hustle."

But how do you photograph hustle? Materialism? Optimism? Clearly, the city's physical reality would not be as important as it would be in Washington or New York.

My shopping list in Los Angeles was different from what it had been on other stories, where the standard items were Industry, Education, Geography, History, Sports, Social Issues, and Religion. This time I wrote down Fame, Search for Eternal Youth, The New Narcissism, The Good Life, Dreams, Excess, Freeways and Freedom, Lifestyle, and Battle of the Environment.

Jodi Cobb by Sisse Brimberg

I decided to begin with the entertainment industry—Hollywood, the heart of Los Angeles. I learned of an agency that supplies talent when people want a TV or movie star but cannot afford the real thing. So the agency provides celebrity look-alikes for dinners, parades, and events like shopping center openings. Ordinary people with ordinary jobs, but each one blessed or cursed with a face from the screen or the tube.

I got together a small galaxy of pseudo-stars, and had them striding up Sunset Boulevard, six abreast, all of them having a wonderful time. How better to capture the pervasiveness of the fame mentality in Los Angeles than with a picture of people who were paid simply because they looked like somebody else?

We started creating a traffic jam. Drivers were stopping to stare. Henry Kissinger was joking with Raquel Welch, and President Ford was chatting with Shirley Temple. One man stuck a baby out of his car for a kiss from his idol, Jimmy Durante. The traffic jam thickened, and one woman screamed at us, "You're making me late for work!"

Then, the flashing lights of a police car. "What's going on here!" the cop bellowed. But the models just collapsed into laughter. And so did the cop. We all knew he should have been in the picture. The cop was the Elliot Gould look-alike, from the same model agency!

In Los Angeles, the impulse to perform extends even to baseball players, as I discovered on a visit to Dodger Stadium. For sports pictures, the Geographic usually looks for an extra dimension, beyond an action shot. I was photographing coach Monty Basgall and catcher Steve Yeager before a game. Basgall was hunched over a lineup and Yeager sat next to him chewing gum and blowing red bubbles.

I started taking pictures, thinking the red bubbles would turn out well against the blue background. Yeager, horsing around for the benefit of the camera, reached over and plucked Basgall's hat from his head. Then, as the coach serenely continued his work, the burly catcher leaned over and planted a smooch on Basgall's unprotected dome, providing me with a memorable picture and the Geographic with its fresh angle.

In incidents like these, Los Angeles slowly revealed itself. Despite the shapelessness and extraordinary diversity, the city proved rich in irony and humor, a place whose people often were ready for a good laugh in the face of absurdity. Starting with the emperor, the city seemed to say, none of us has got any clothes.

Clowning Los Angeles catcher Steve Yeager tags the pate of unsuspecting coach Monty Basgall during pregame shenanigans at Dodger Stadium.

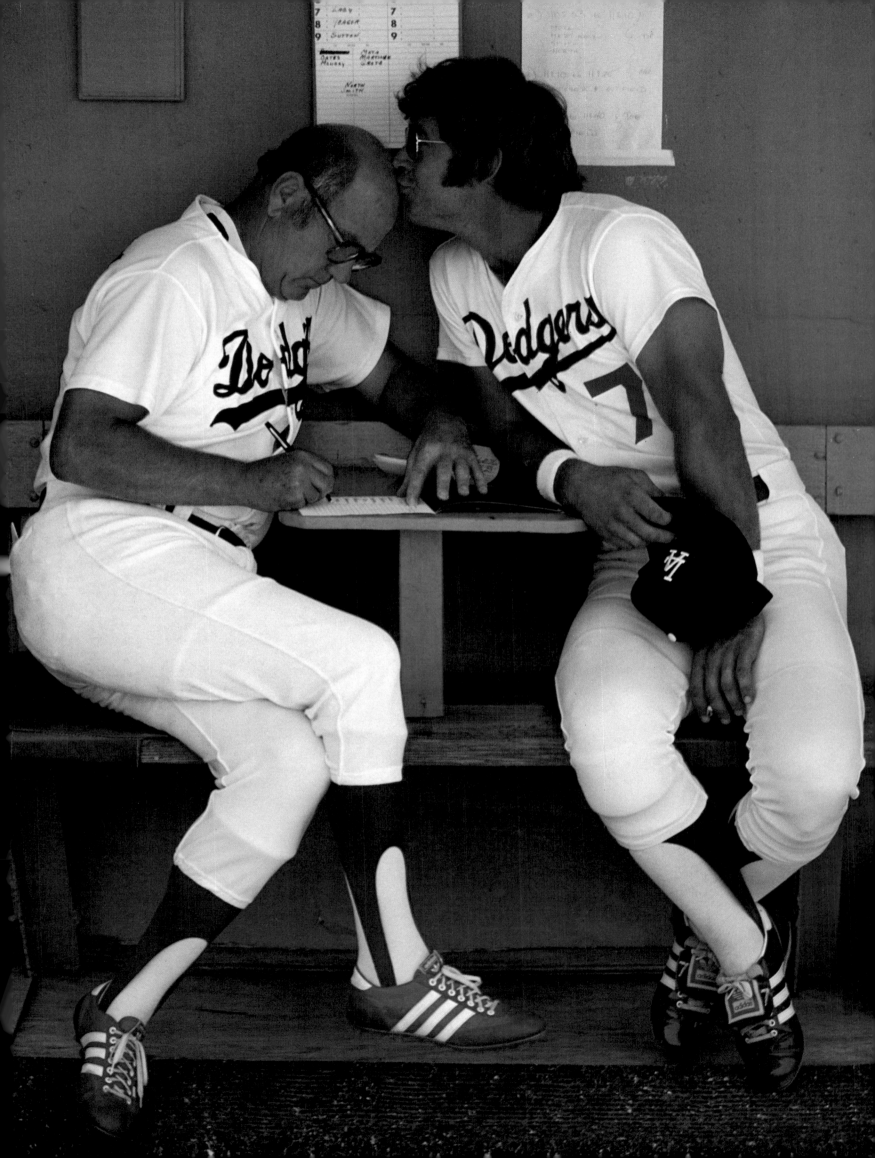

When the Rules Are in Russian

By Dean Conger

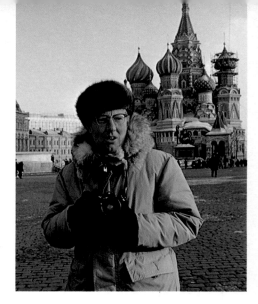

"Impossible! Permission denied." In 29 trips to the Soviet Union, I've learned to expect stringent restrictions, suspicions, and endless surveillance. To start with, there's a PROHIBITED list. You are forbidden to photograph the frontier, military equipment or installations, fuel storage places, hydroelectric facilities, harbors in seaports, railroad junctions, tunnels, railroad and highway bridges, and so on. Nor can you photograph from planes in flight.

Though it is tough to cover a state or a country without aerial photographs, such rules are often understandable. But in the capital city of Kazakhstan, some 100 miles from the Chinese border, I was denied permission to go to the second floor of a building to photograph a street scene. That's how far it can be carried.

I once was denied permission to photograph inside a concert hall where a musical revue was playing, apparently because many military officers were attending. And my visa to visit new settlers out in the countryside was revoked at the last minute. The local party officials had decided that the day was too dry and dusty for good-looking pictures.

Since 1961, I have been through Russia's special kind of red tape a couple of dozen times. Even before I arrived I had to have lined up a Soviet agency to assist in arrangements for interviews and photographs. Someone to grease the skids. I dealt with Novosti Press Agency.

I had to apply for a specific visa for every city on my wish-list. Travel had to be arranged and paid for in dollars in the United States. Imagine trying to plan an itinerary of a dozen cities, having little notion what is there, what the weather holds, what

Dean Conger has focused his cameras on the Russians from Moscow's Red Square (left) to remote corners of the world's largest country. With his constant escort, a Soviet journalist at far right, he attends a dinner in the Yakutsk Republic.

the welcome will be. How could you possibly know whether you wished to remain one day in a place, or ten?

Once we took the train to a town, Ulan Ude, which had what we were told was the largest railway repair station in the world. But my escorts hadn't arranged a visit and couldn't arrange it. That's frustrating. They said, "If you had asked us six months ago. . . ." There is no such thing as freedom of movement, of following a lead wherever it may take you.

Photographing people in any country has little to do with taking pictures. It mainly involves trying to understand people and their culture. It's trying to get "inside" a people.

In Russia's controlled society it is a perpetual challenge to have simple meetings with average citizens, to photograph significant things beyond the official "program." In many cities I could wander at will, but in the countryside, all was regulated. After a dinner in a private home I learned that all the china and silver had been flown in from Moscow. I wondered about the kind of reality I was seeing.

The government and the various agencies that follow government orders offer a visitor a strange mix of hospitality and inconvenience. Officials often *want* visitors to feel intimidated. That tactic helps when the government shows off its accomplishments—schools, factories, hospitals —while subtly hiding its failures.

Their hospitality is one of the problems. They want to feed you and give you a lot to drink. If you don't partake freely, you probably won't get to

On the Trans-Siberian Railroad between Moscow and Vladivostok, Conger jumped off at each stop of four to ten minutes, shot pictures, and then jumped back on.

In Mongolia, wedged between China and the U.S.S.R., nomadic herders—father, mother, sons (left), and neighbors—crowd a tent to welcome and gaze upon their western visitors.

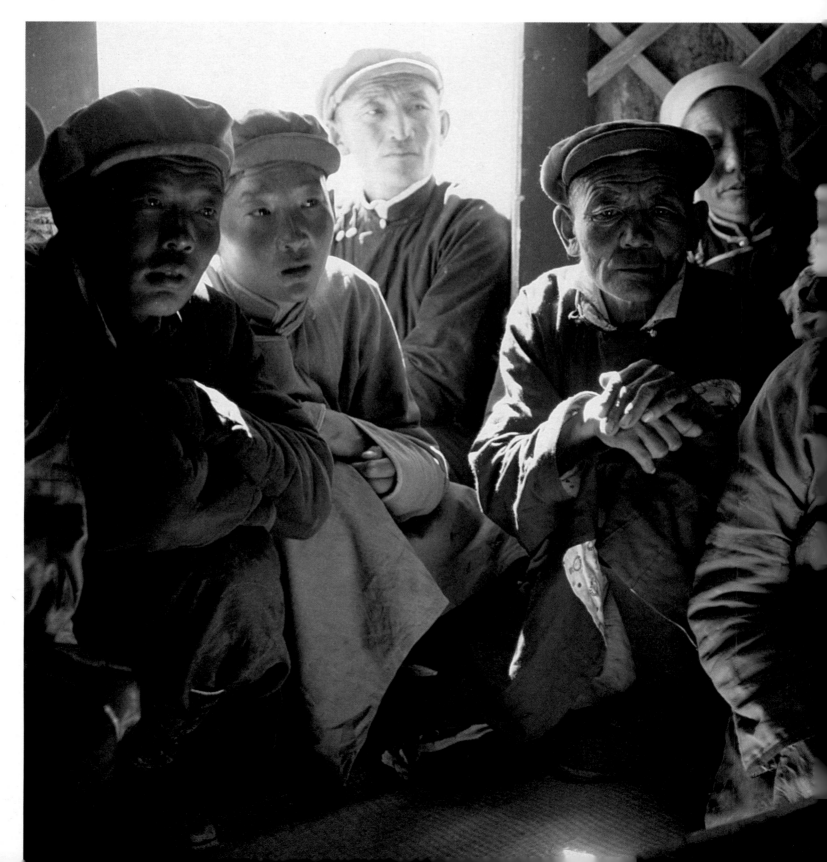

At a leased stall in a Moscow market a woman sells beets grown on her private garden plot. A bystander objected when Conger snapped the picture. "I got run out of the market. They thought it was a demeaning picture. But later, as we traveled around showing tear sheets of the published article, the average person in Russia really liked that picture."

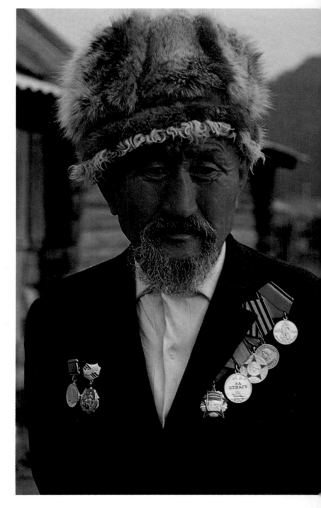

Medals on his chest, some of them earned in World War II, a retired herdsman greets Conger at this log home in the village of Kulada, center for a collective farm. "And we have tractors," he said. "How do people work in your country?"

take your pictures. But if you do, you won't be in shape to take them.

We were in the Georgian Republic, where the people live to be very old. There was a party for us at the home of a Mrs. Lasuria—who was said to be 133 years old. She was proposing toasts with the rest. We started out with village-made vodka and the usual toasts: to peace, to health, to happiness, to visitors. We had to drink each time one of them drank. Now to the photographer again . . . I'm always catching up. It takes a strong stomach. Then they switch to wine and bigger glasses. The party gets going. Soon Mrs. Lasuria's young nephew—about 85 years old—is saying, "What's the matter with you Americans? You don't look so well." I can't frame anymore. I get pictures I don't even remember taking.

Meanwhile, the earth has not stopped turning. Much of a photographer's life is spent waiting for sunrise or sunset, for beautiful warm light as a backdrop for a chosen scene. But sunset, I found, was when my hosts most wanted to eat and drink.

At times, the partying pressed upon the visitor is merely primitive hospitality. At other times, the parties mask the conspiracy to keep you from seeing *anything*. And if they can get you loaded, you won't care. "Dean, Dean, don't worry about the sun going down. It's all right." The guide's words are like a recording.

The official sponsors, such as the Novosti people, both help and hinder. I couldn't work in Russia without them. They set up trips and interviews and protect us from harassment. Their function is also to observe our comings and goings and to

Yakut girl on an antlered mount follows her reindeer herd through a frozen fog of their own breath. It was about –50°F., Conger recalls, when he took this picture near Oymyakon in northern Siberia.

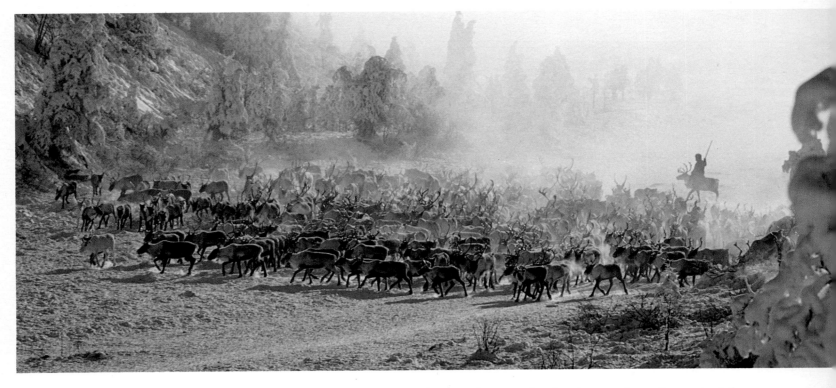

make sure that no Soviet citizens manage to come into contact with us without official knowledge.

You can get into trouble for doing anything people think is anti-Soviet. In Leningrad a citizen complained I was taking pictures that showed a bad side of Soviet life. To me, the pictures just showed people having fun. For one, a picture of people listening to a tape recorder and dancing, my guide and I spent two hours in a police station. I was told the picture had been taken too near the harbor.

When I do get into the right situation, the photography has to be automatic, precise, and unobtrusive. I travel so far and so fast I can't afford to practice or make mistakes. The Soviet Union covers 11 time zones. On one trip from Washington into Russia I crossed 17 time zones in 17 days, working every single day.

Working there reminds me of my early career as a newspaper photographer. Quick assignments, racing to make deadlines. A Soviet trip means hectic travel, short stopovers, interludes of only hours—or minutes—at factories, farms, or other places of interest. Get in. Shoot. And get out. No waiting for sunshine. No getting acquainted. No learning, planning, or penetrating. Just do what you can, then rush to another plane or train, and do it again.

Fatigue—and fears, real and imagined—get to me. Because of the pressures, I tried to remain in the Soviet Union no longer than 30 days at a time. When I had to keep at it much longer, I found that few good images resulted.

Yet, for all the frustrations, working in the Soviet Union is filled with fascination and excitement. I have traveled more than 120,000 miles in the country and probably met more citizens than most foreign journalists have met. I have published three articles and created the photography for a dozen more, and for a book. I have reached the exotic corners of an enigmatic nation and have made many Russian friends.

In a way, I think of my work as a people-to-people project, and my lens as a peephole into a world seldom seen. I know the results have been less than complete. I wasn't always allowed to get the photographs I wanted. But sometimes I was able to penetrate the fears of Soviet people, to dispel some of their suspicions of me, an American.

And maybe I was able to enlighten them a little about me, my country, my way of life. I wish I knew.

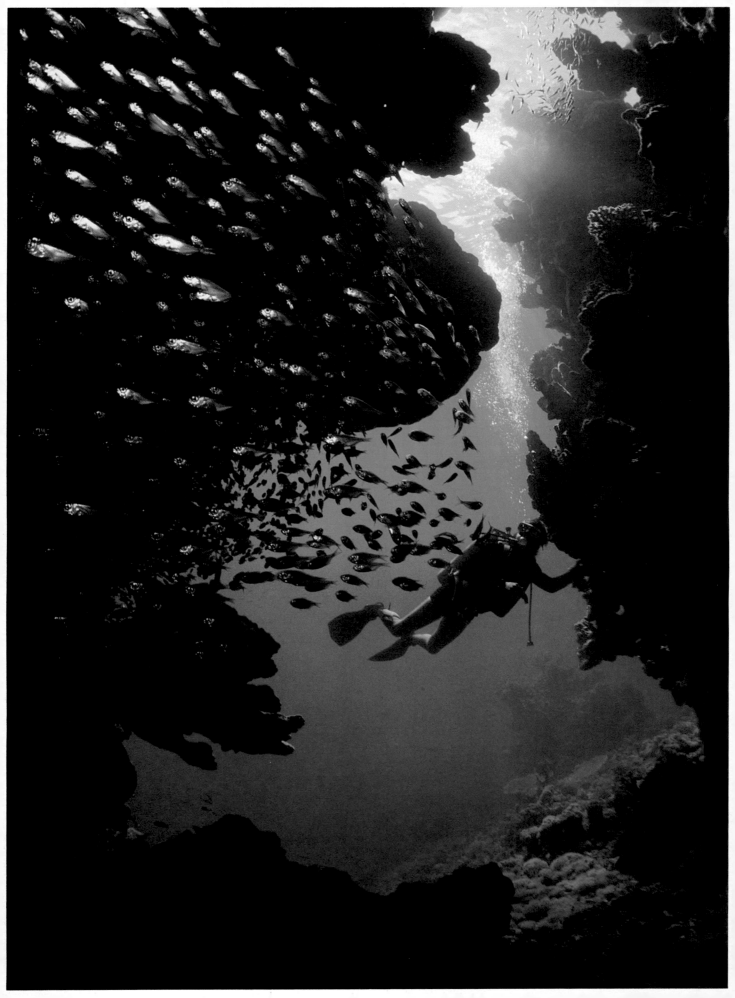

CAMERAS IN THE DEEP

In the underwater world, photographers soon realize what Shakespeare must have had in mind when he described the sea's ability to transform what it holds "into something rich and strange." Earthbound objects, even humans, assume magical qualities of form and grace when immersed in seawater.

But the magic has its dark side. In the dim light, every swimming shadow is a potential threat, every image elusive and hard to catch on film. Water distorts, making the objects submerged in it look larger and filtering out their natural color. Water also imposes a wall of particulate matter, like thin soup, between the photographer and his subject, forcing him to work at close range and restricting panoramic views. And saltwater makes harsh demands on even the sturdiest photographic equipment.

Charles Martin and W. H. Longley knew all this when they journeyed to the clear tropical waters off Florida's Dry Tortugas in 1926, seeking the first color pictures of submarine life. Martin, then director of the National Geographic Society's photography laboratory, worked topside, handling the technical details and making sure that Longley, an ichthyologist, who trudged the ocean bottom in the heavy diving gear of the day, got a steady supply of air.

Staying alive was only half the problem; there were times when it looked as though they would return from their assignment empty-handed, because the natural sunlight was too dim to take pictures 15 feet underwater.

To compensate, Martin and Longley bathed their glass exposure plates in a "hypersensitizing" solution that cut exposure times from one second to $1/20$ of a second. They treated the plates before dawn each day, working in the cool dark so the tropical heat would not melt the emulsion. But the trick didn't work; the images were still much too dim for publication.

So Martin and Longley decided to try magnesium flash powder to provide the extra burst of light they needed. Photographers were then using magnesium for indoor work,

but in small quantities—less than a teaspoon per picture. Martin and Longley thought big: They ignited a pound of the powder for each of their shots, and stockpiled an arsenal sufficient to blow up the pair of them. They were setting the swashbuckling style that would characterize undersea photography for years to come.

Martin wired Longley's underwater camera to a raft carrying the flash powder, so that each time Longley released the camera shutter it set off a brilliant white flash at the water's surface. This flooded the ocean floor with something akin to lightning, freezing scenes from the seabed "at the exact moment of [the] finny subjects' best posings," as National Geographic Magazine reported later.

It was risky business, but Martin returned, limbs intact, with a collection of plates that would make photographic history. In January 1927, the magazine published the Martin-Longley portfolio—the first color pictures from beneath the sea. The photographs were a study in soft pastels: a brown-striped hogfish drifting over a sandy seabed; yellow and blue French grunts loitering among brown staghorn corals; ghostly snappers peering with yellow eyes through pale blue water.

From then on, the Geographic explored the underwater world, sending photographers to swim with sharks and whales, to study corals and kelp forests, and to search for ancient wrecks and lost treasure.

Jacques-Yves Cousteau, one of the first ocean explorers supported by the Society, probed the Indian Ocean and the Red Sea for four months in 1955. He took along Luis Marden, a National Geographic photographer who had been venturing into the deep on his own for a decade, and was already familiar with the sea's quiet beauty and photographic potential. Marden returned from the voyage with a huge collection of photographs by the standards of that day: 1,200 transparencies. The take impressed editor Melville Bell Grosvenor, who cabled his congratulations to Marden in Paris. "Cousteau and I practically danced a hornpipe on *Calypso*'s deck when we got that

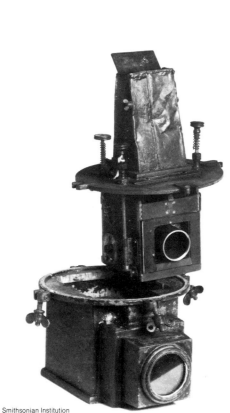

Smithsonian Institution

A camera that made history rests atop its watertight housing. With it, a Geographic team took the first color pictures of underwater life in 1926.

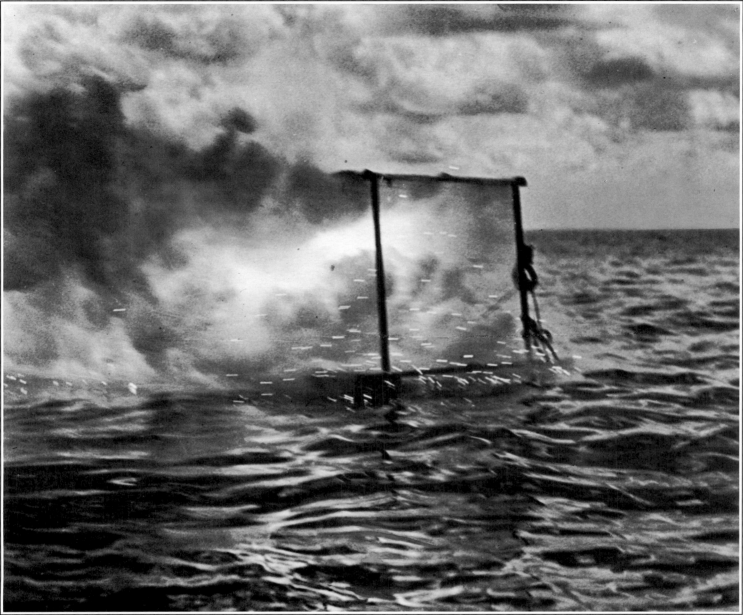

Charles Martin. National Geographic Magazine, January 1927.

Custom-made lightning churns the waters off Florida where Charles Martin and W. H. Longley use flash powder to light up the ocean floor for pictures. The pyrotechnics, often "more than human nerves could stand," ushered in a new age of photography: Martin and Longley brought back the first color pictures made underwater. This one (left) shows fish called French grunts.

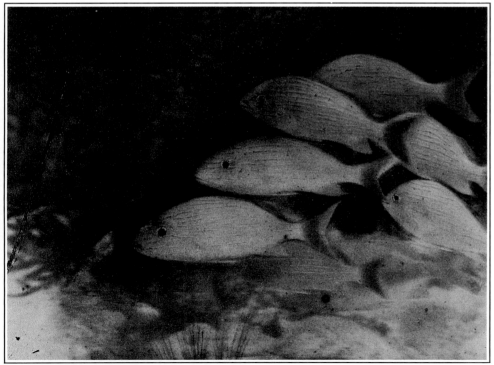

Charles Martin and W. H. Longley. National Geographic Magazine, January 1927.

Dubbed "Papa Flash" for inventing the strobe light, Harold E. Edgerton tests another of his creations, an abyssal camera designed to bring back images from 36,000-foot depths.

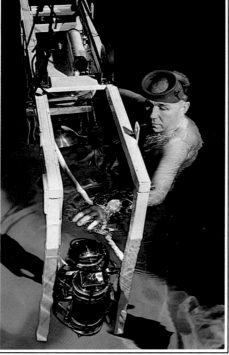

B. Anthony Stewart. National Geographic Magazine, August 1959.

Luis Marden (right, below) joined Jacques-Yves Cousteau for four months aboard the Calypso *in 1955. Marden returned with an extensive series of color pictures of the undersea world.*

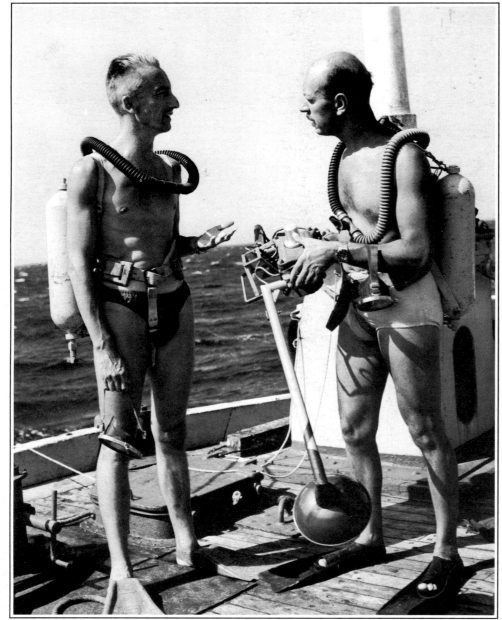

Pierre Goupil. National Geographic Magazine, February 1956.

cablegram," Marden recalls. But Grosvenor's enthusiasm was not the typical response.

"Some of the picture editors were mad as hell at Luis for spending all his time underwater instead of on the boat. They thought he was playing," recalls Bates Littlehales, another Geographic photographer. "But Luis' stuff was so beautiful, they finally came around." In 1956 49 photographs of the Cousteau voyage took Geographic readers into the sea with Marden. His collection was the most extensive series of submarine photographs published since the experiments of Martin and Longley 30 years before.

Marden worked with crude equipment ill suited for use under the water. Because his camera was locked in a waterproof box, all his photographic settings—aperture, focus, and shutter speed—were fixed before he dove into the water. If conditions changed while he was below, he had to resurface, unpack his camera, reset it, seal it up, and dive again. Flashbulbs leaked and misfired or imploded in the intense pressure, gashing Marden's hands. In the spirit of those do-it-yourself days, he improvised. He drafted the ship's surgeon to inject hot wax into the base of the flashbulbs with a syringe, waterproofing the wires of the bulbs. And he persuaded a manufacturer of mesh handbags to produce chain mail gloves for him that would protect his hands when the bulbs shattered.

Pioneers made do. And when they couldn't make do, they invented—or had built for them—underwater cameras, lenses, and lights that were weird mutants created from standard photographic stock.

"You had to have a good eye," Marden recalls. "But you had to be a technician also."

That requirement began to fade as diving became more popular in the 1950s and 1960s. Divers of the new generation began demanding special photographic equipment to take pictures of the ghostly world they had discovered.

In response, one man developed a watertight camera for the commercial market. Others built new lenses to compensate for the optical effects of photographing

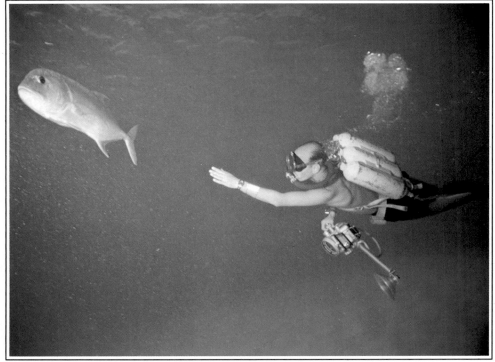

Pierre Goupil. National Geographic Magazine, February 1956.

On the trail of marine subjects, Marden (left) logged 15,000 miles on Calypso's *1955 voyage, using thousands of flashbulbs. Cousteau's divers wondered how a man could go through that many bulbs. Crew member Pierre Goupil (below) was assigned to follow the photographer with a bagful of them.*

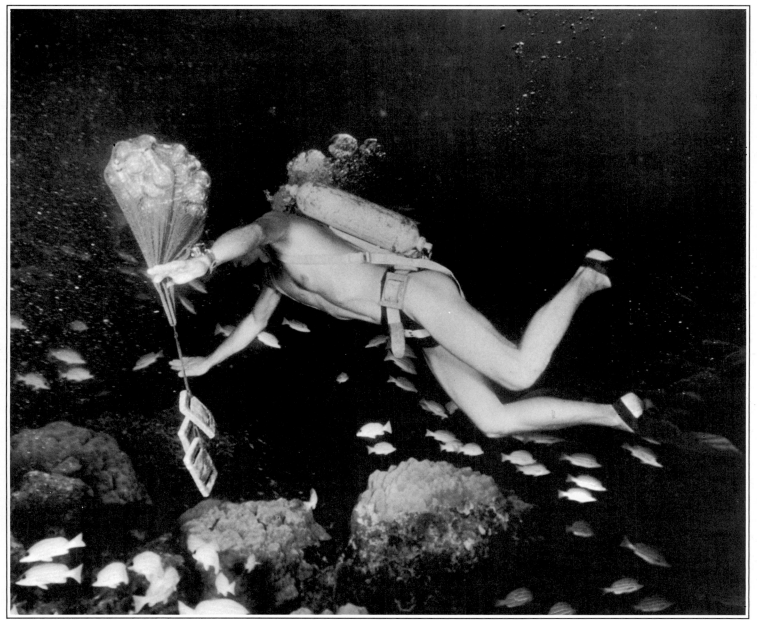

Luis Marden. National Geographic Magazine, February 1956.

From the murk of an ancient well in Dzibilchaltun, Mexico, a diver lifts a relic of Maya civilization. The jar was dropped or thrown into the natural well perhaps 1,000 years ago.

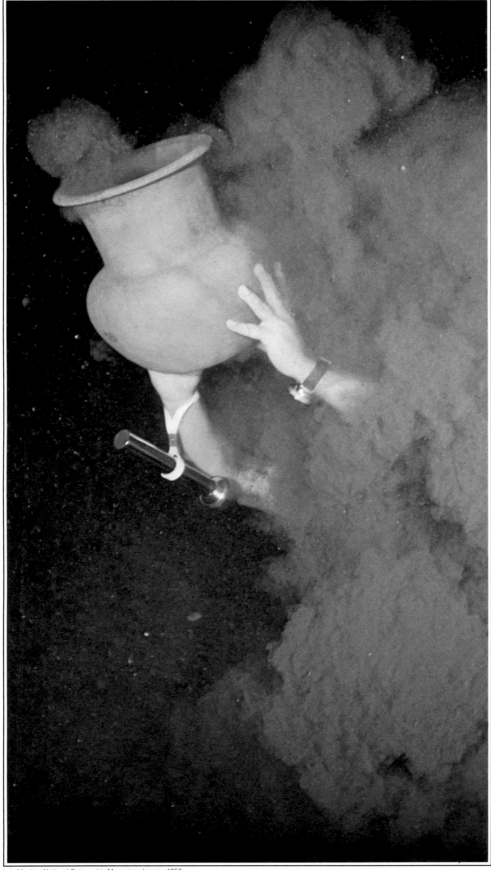

through water rather than air. And new camera housings were introduced. These metal and clear plastic boxes kept cameras dry and let photographers work the camera settings underwater. One such box, the OceanEye 100 housing, was developed by Littlehales, who began diving with Marden in the 1950s.

In those days, photographers could return from beneath the sea with pictures of what it looked like down there; that in itself was remarkable enough. By the 1970s, though, professionals like Littlehales were free to devote more attention to refining their art. Less time was wasted worrying about whether leaky housings or corroded connections would sabotage their pictures. They were also helped by underwater strobes. A development of the portable "flash" lights invented by Dr. Harold E. Edgerton in the 1930s, the new strobes all but eliminated the need for flashbulbs under the sea. Backed by grants from the Society, Edgerton also devised abyssal cameras that could withstand the intense pressures of the ocean's greatest depths.

Thus freed of some technical burdens, the new generation of Geographic photographers—such as David Doubilet, Bill Curtsinger, and Jonathan Blair—took their work beyond illustrative photography. Now the art of the underwater world could take precedence. No longer are the sights a novelty. Now one is struck first by the poetry of the work, its color and composition. Less important is the fact that this art was created from images that lay beyond ordinary perception, in the depths of the ocean, in the shallows of ponds.

Despite the relief from technical distractions, however, some difficulties of underwater photography still endure, as Alan Root testifies.

"The next thing I knew, he had my right leg in his mouth. The hippo then shook me like a rat," says Root, who was attacked by a bull hippopotamus in Mzima Springs, Kenya, while he and his wife Joan were on a Geographic assignment. (After skin grafts, treatment for gangrene, and a month in a Nairobi hospital, Root recovered.)

For those who work long enough in the underwater wild, such attacks are inevitable. Jonathan Blair, on assignment in South Africa, lost part of a camera to a crocodile's bite. Off the Australian coast, Ben Cropp had to wrestle his camera away from a venomous sea snake. And Bill Curtsinger carries scars, shoulder to hand, from the time a gray reef shark raked him in waters off the Caroline Islands.

Geographic photographers today are looking to the future, focusing on a practical side of their art that will extend the camera's reach further into the deep. Emory Kristof, a technical specialist with an interest in underwater problem-solving, is working with Alvin Chandler of the Society's photo department to develop cameras that will take panoramic views of the ocean floor. Kristof and Chandler are also experimenting with deep-water video cameras that will give sharper pictures for television or still photography.

Using techniques developed by Kristof and Chandler, deep-sea explorers send down remote-control cameras to sweep the ocean floor, working at depths where the pressure would crush humans. The remote cameras take a succession of pictures, which are then pieced together in a mosaic. This procedure gave the first complete picture of the wrecked U.S.S. *Monitor* off North Carolina's Outer Banks in 1974. The photos may give us our last glimpse of the crumbling Civil War gunboat.

In the Mediterranean, other scientists have turned underwater photography into a tool, using techniques developed by Society-backed teams to compile exact records of shipwrecks. When scientists prepared to excavate a ship wrecked in the fourth century B.C. off Kyrenia, Cyprus, for instance, they built a grid system of plastic pipes, like scaffolding, above the ship. They took pictures of all the artifacts in place on the ocean floor, using the photographic record to guide them later in the excavation.

Industry is following science. The kind of deep-sea cameras developed by Kristof and Chandler are in demand by natural gas companies, which want to use them to locate routes for new undersea pipelines.

A scientist records life around his undersea laboratory, using an OceanEye 100 camera housing, which keeps the camera dry and corrects water's optical effects on images. It was developed by the Geographic's Bates Littlehales.

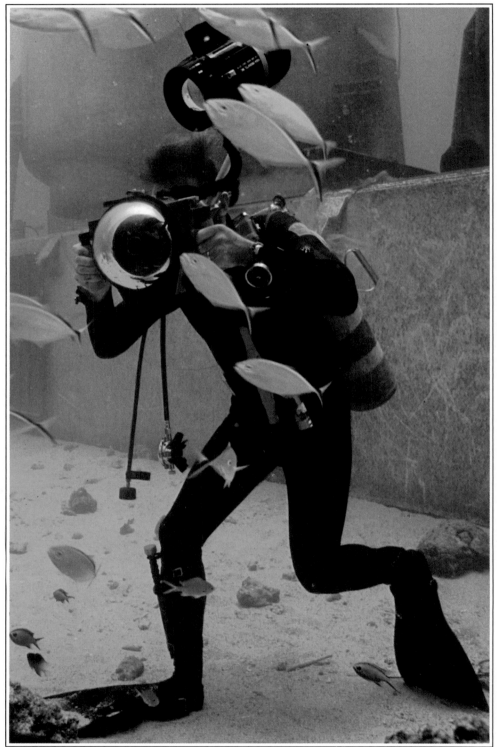

Bates Littlehales. National Geographic Magazine, August 1971.

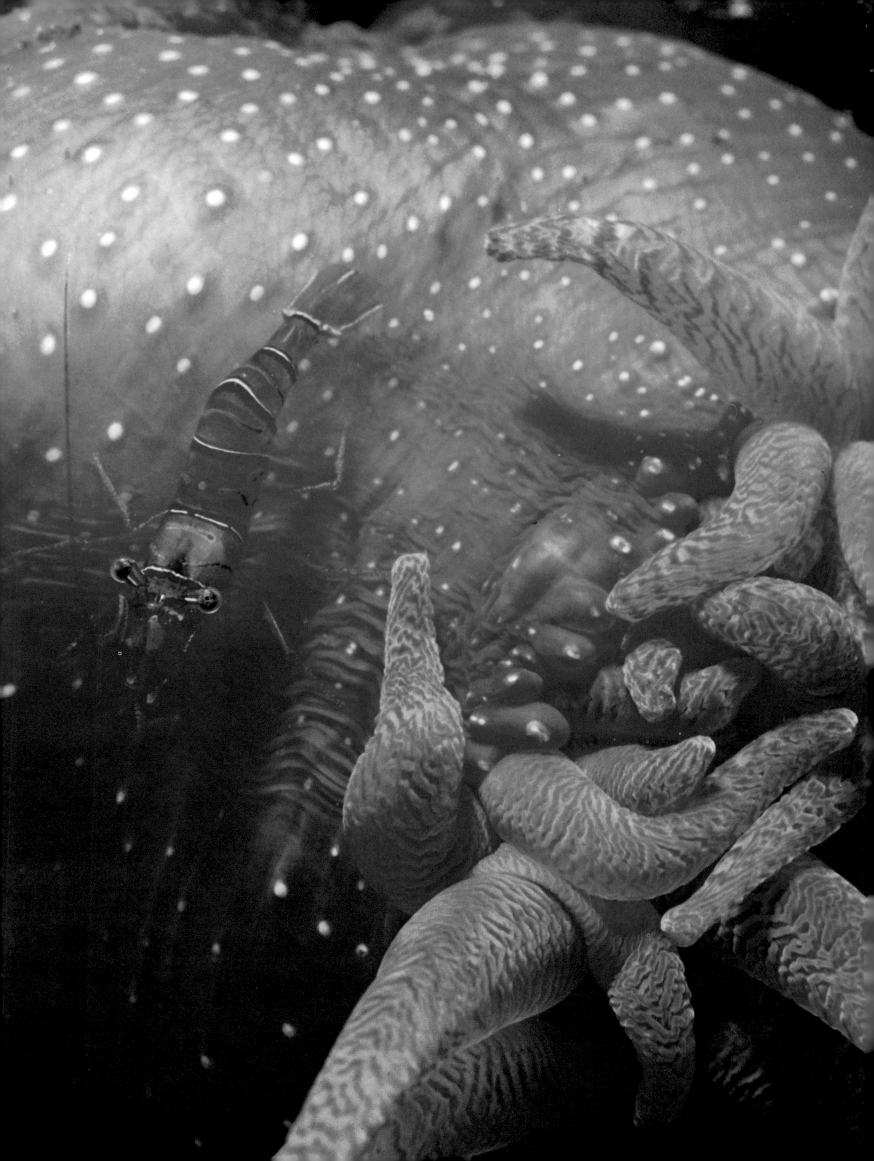

Things aren't what they seem at 12 fathoms in the North Pacific, for seawater filters out most warm colors. To restore the colors and isolate the subject, Doubilet trained a pair of flashes on shrimp and anemone; the powerful lights made the background go black. "I wanted a flowing composition, so the shrimp is set off to the side of the frame."
DAVID DOUBILET

The humpback whales (overleaf) swam past almost close enough to touch. "I felt the wash as they slipped by. My heart was pounding so fast I wasn't sure I got the picture."
SYLVIA A. EARLE

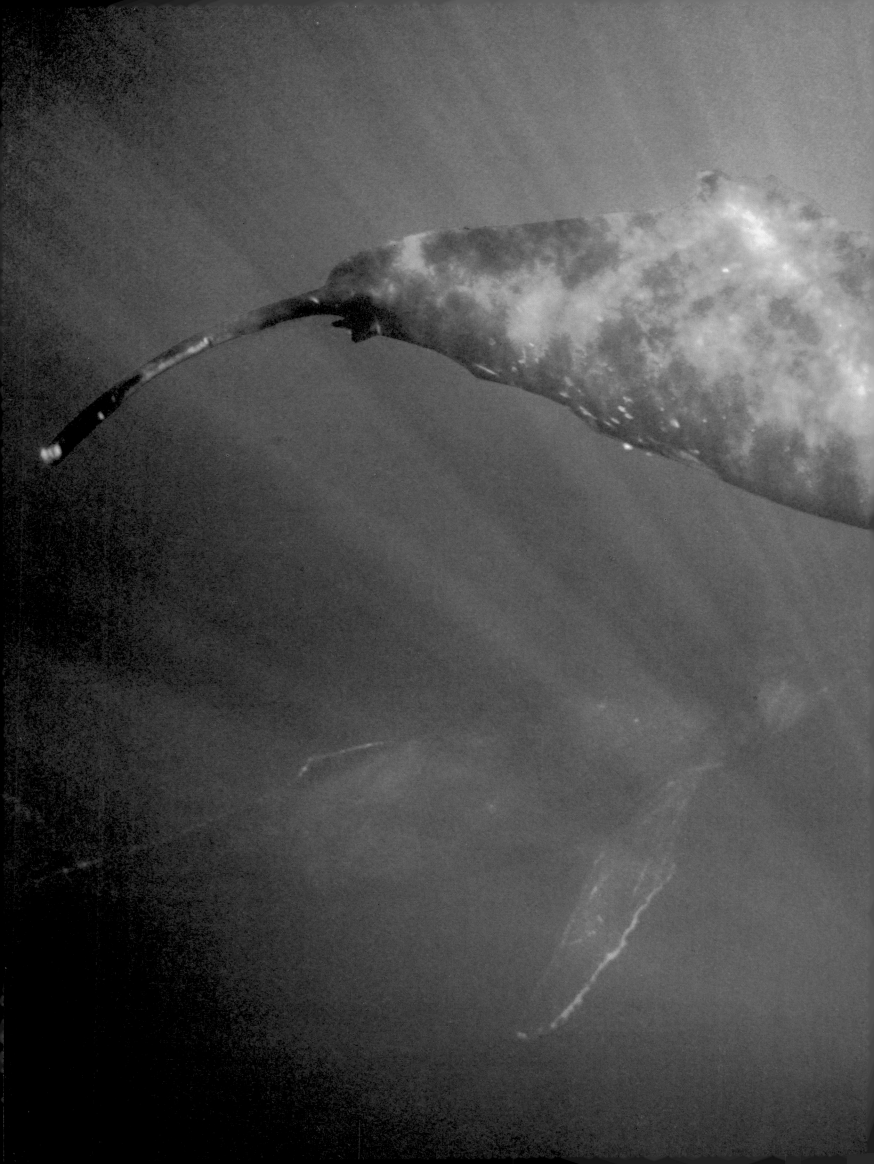

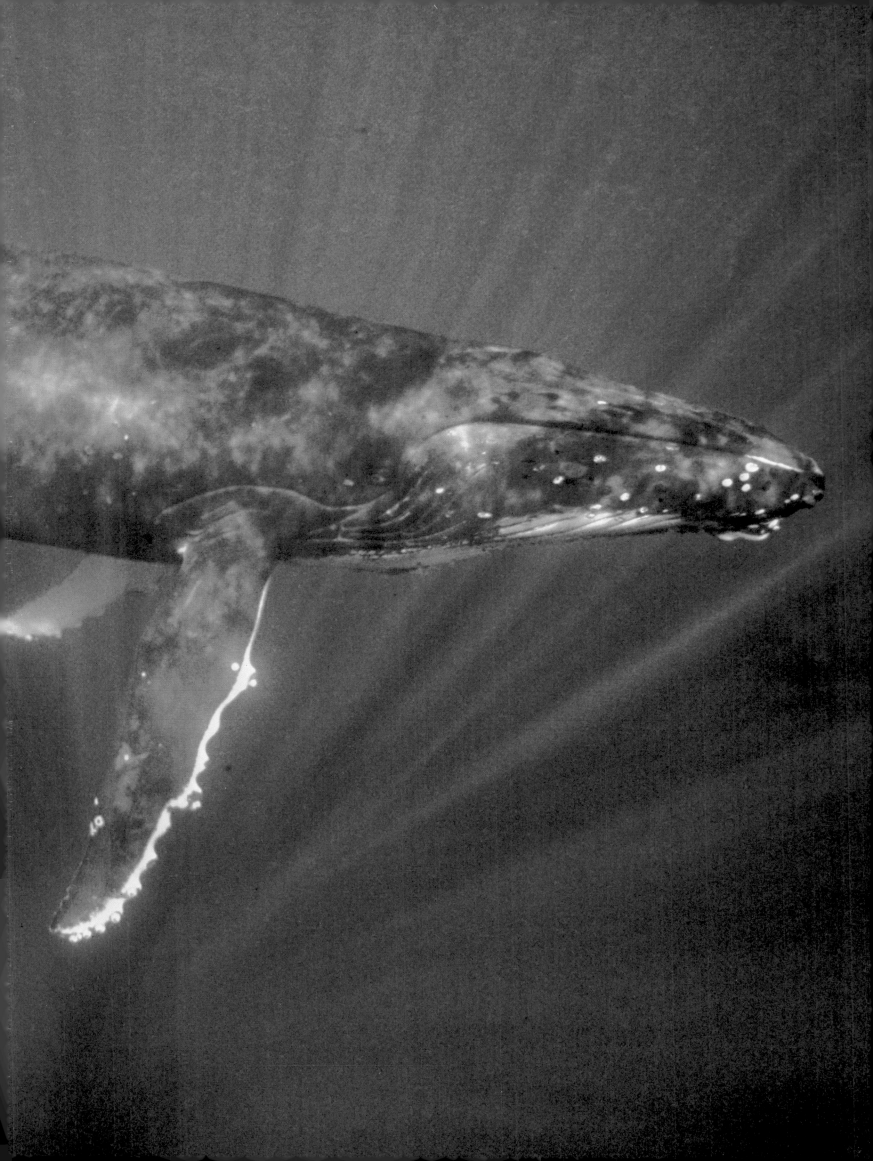

"I like to have the animals swimming against the stage set of their habitat—animals on interesting patterns," says Doubilet. He gave the yellow clownfish the starring role in this picture taken in the Red Sea, dabbing the fish and green anemones with artificial light from the top left of the frame.
DAVID DOUBILET

Suspended over a branch of Gorgonian coral, a red plaid hawkfish set off a color "vibration" that Doubilet seeks in submarine scenes. "It's like a person in a checkered suit in front of a Mondriaan painting," says Doubilet, who kept losing sight of the camouflaged fish. "I was dizzy from the depth. It was a combination of confusion and concentration."
DAVID DOUBILET

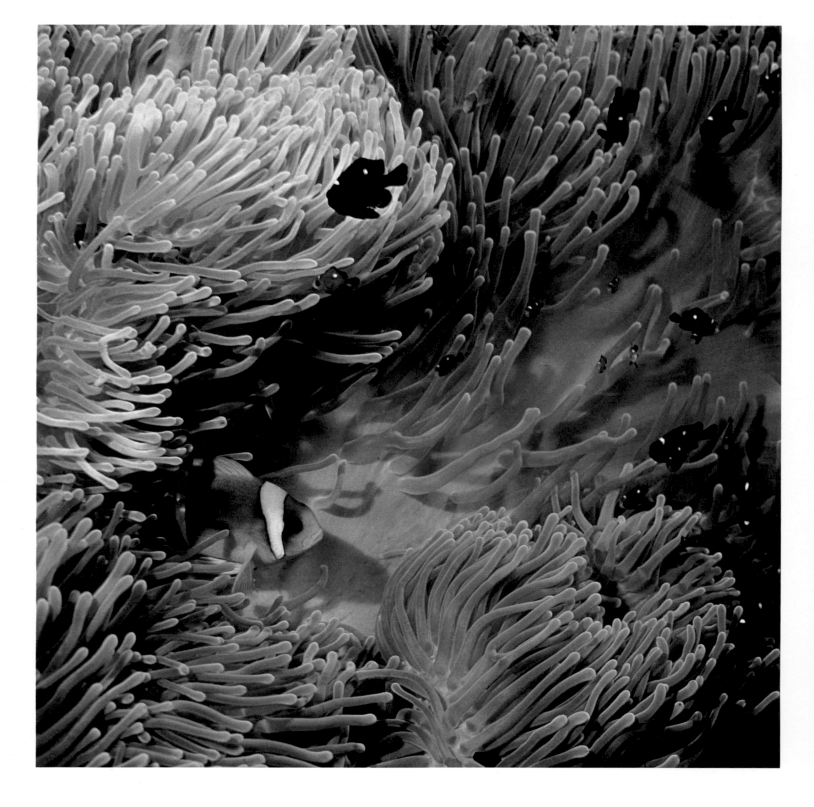

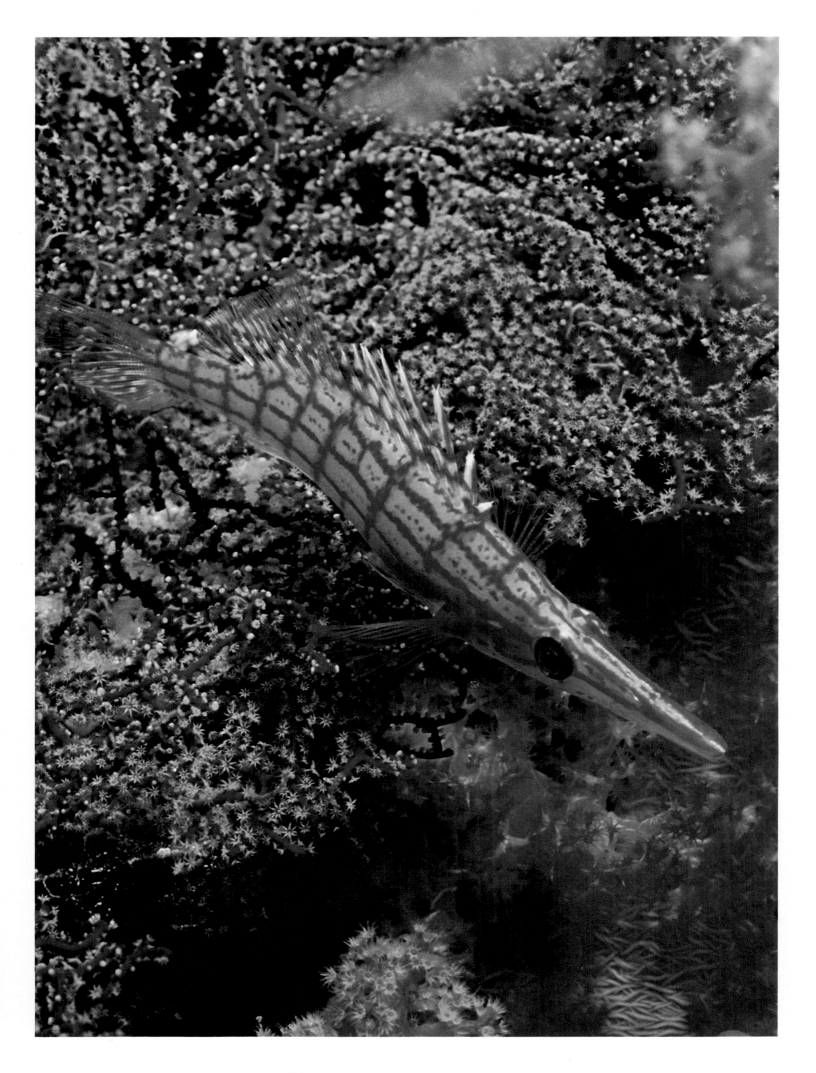

urtsinger looked up. Through the gloom of the Antarctic Ocean, a leopard seal stared down at him, its face spooky and serpentine, floating like a death mask in the green water. Normally a penguin-eater, the seal seemed interested in Curtsinger's flash equipment. "It was annoyed. It was lunging at my strobe. I turned the camera up and got off two or three pictures before the animal swam out of visibility." Then, as Curtsinger began his ascent, the seal reappeared, accompanying him most of the way to the surface.

BILL CURTSINGER

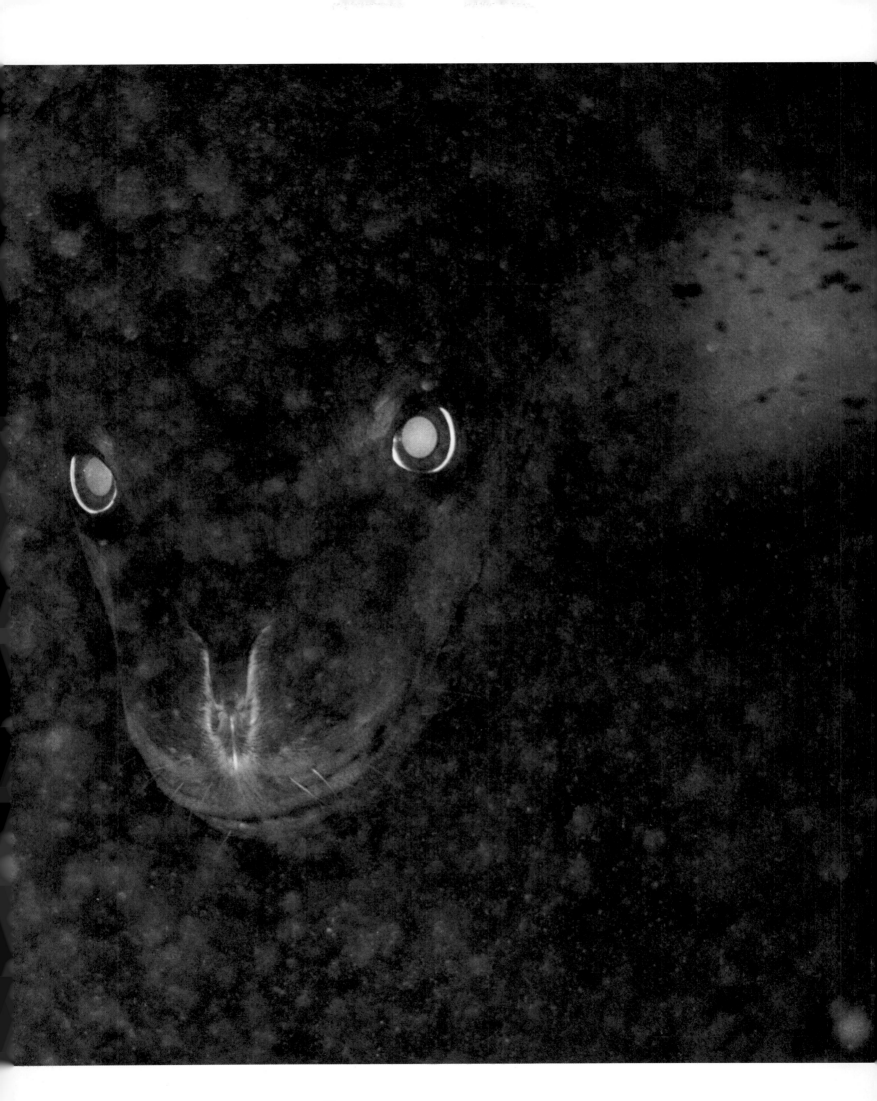

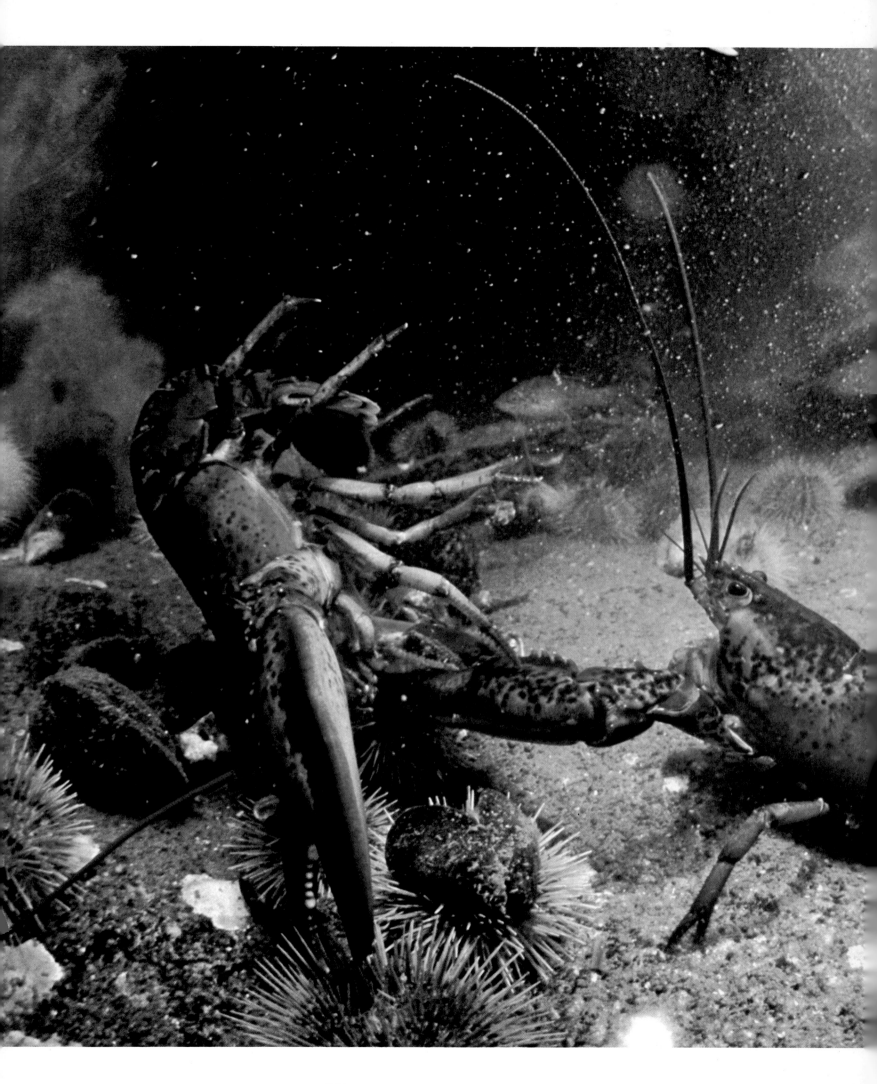

For three months, Doubilet worked the chilly Massachusetts waters, stalking jousting lobsters for four or five hours at a stretch. The territorial crustaceans' claw-wrestling bouts last only seconds. "You need the instincts of a spear fisherman—a quick eye to detect motion in the seascape, a knowledge of the animal and its habits."
DAVID DOUBILET

"You don't just go out and find an octopus," says Littlehales, who happened upon this one (overleaf) in Puget Sound. A diving companion wrestled the octopus, which then turned its attention to Littlehales. "The octopus reached out. It was like a ballet, the tentacles all over me and the camera. The nice diagonal swing of the closest tentacle was pure dumb luck."
BATES LITTLEHALES

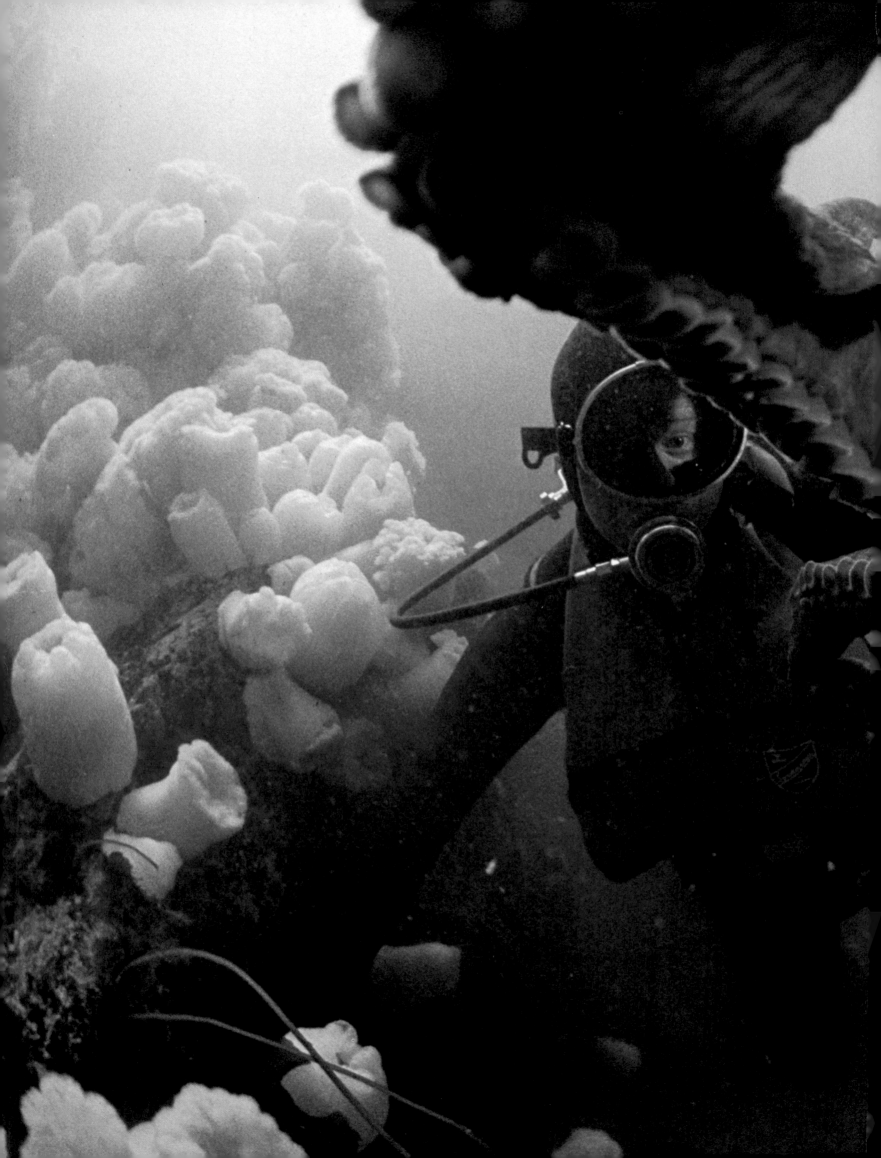

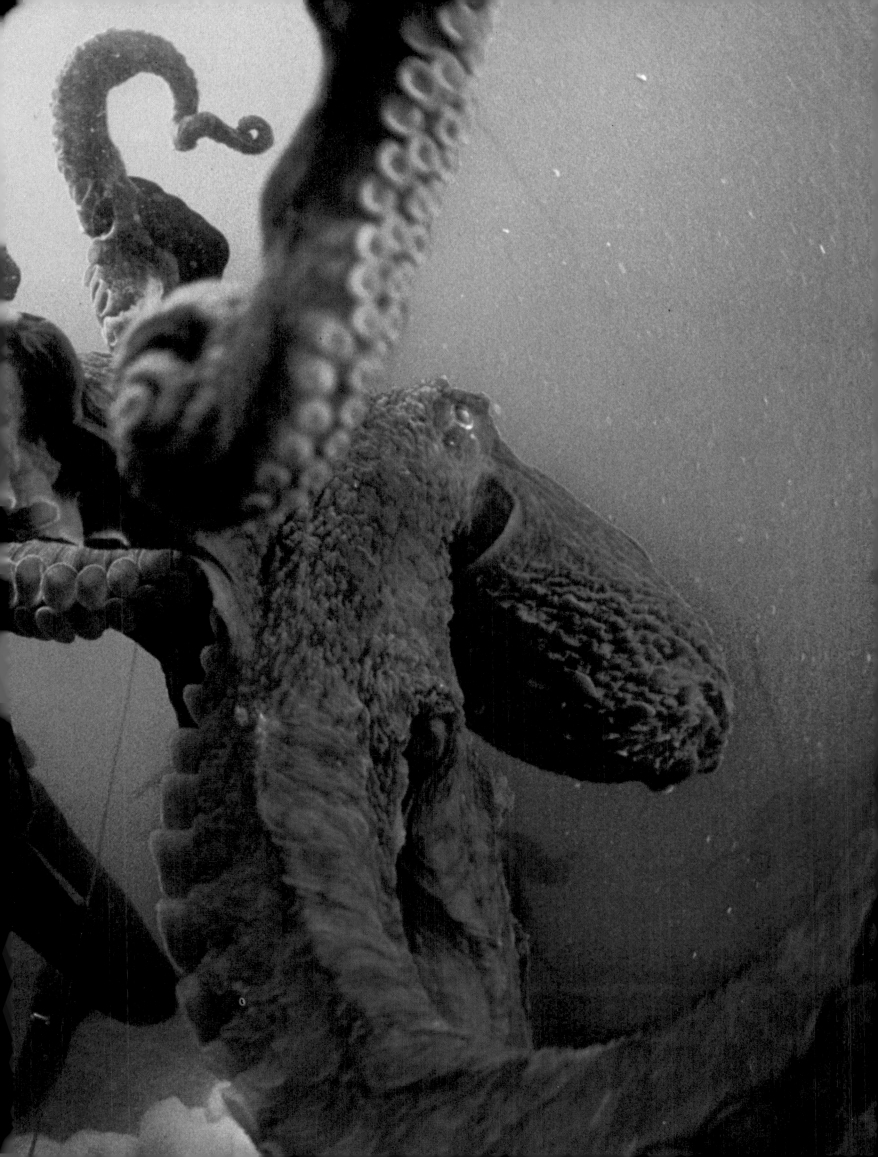

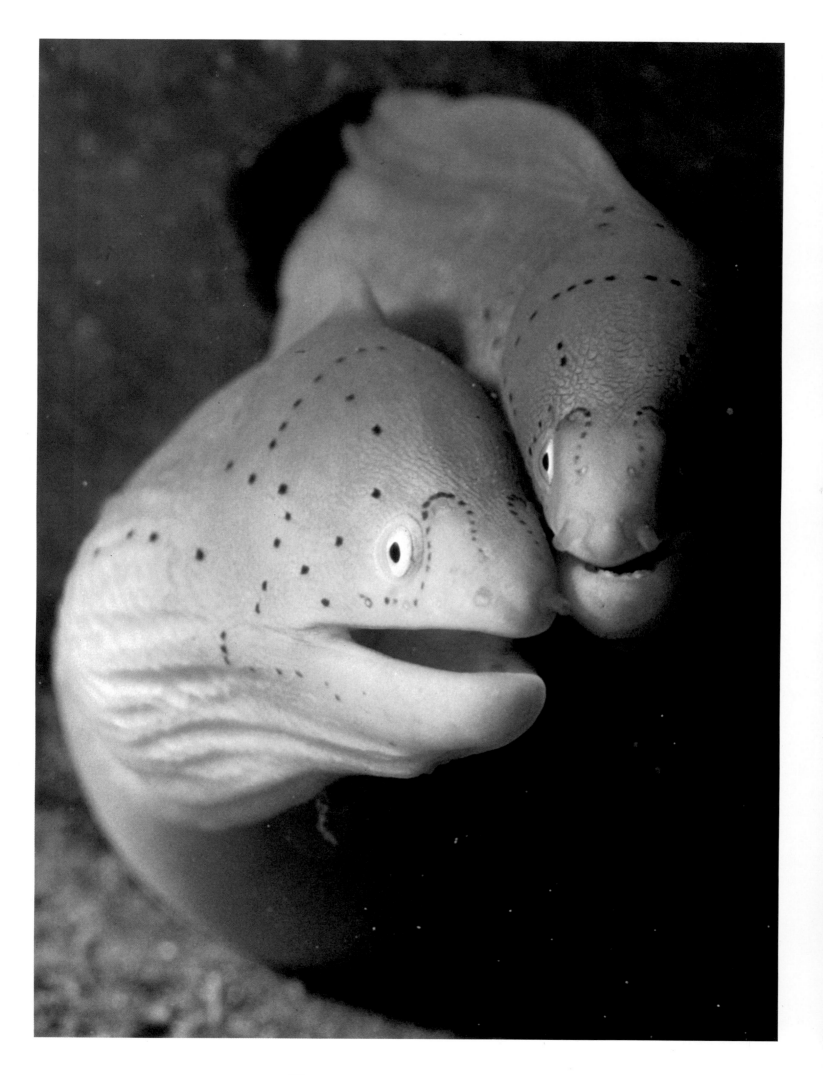

Spotted white moray eels emerge from a sunken buoy in the Gulf of Aqaba. "They looked at each other and rubbed their heads together. I made the image. It was a magic moment."
DAVID DOUBILET

"For a long time, you only saw photographs of fish that looked as if they had been shot against black velvet, like jewels in a display. Another way of doing it is to balance the flash and the ambient light—if there is any—to tickle out the colors and show the animal in its milieu."
BATES LITTLEHALES

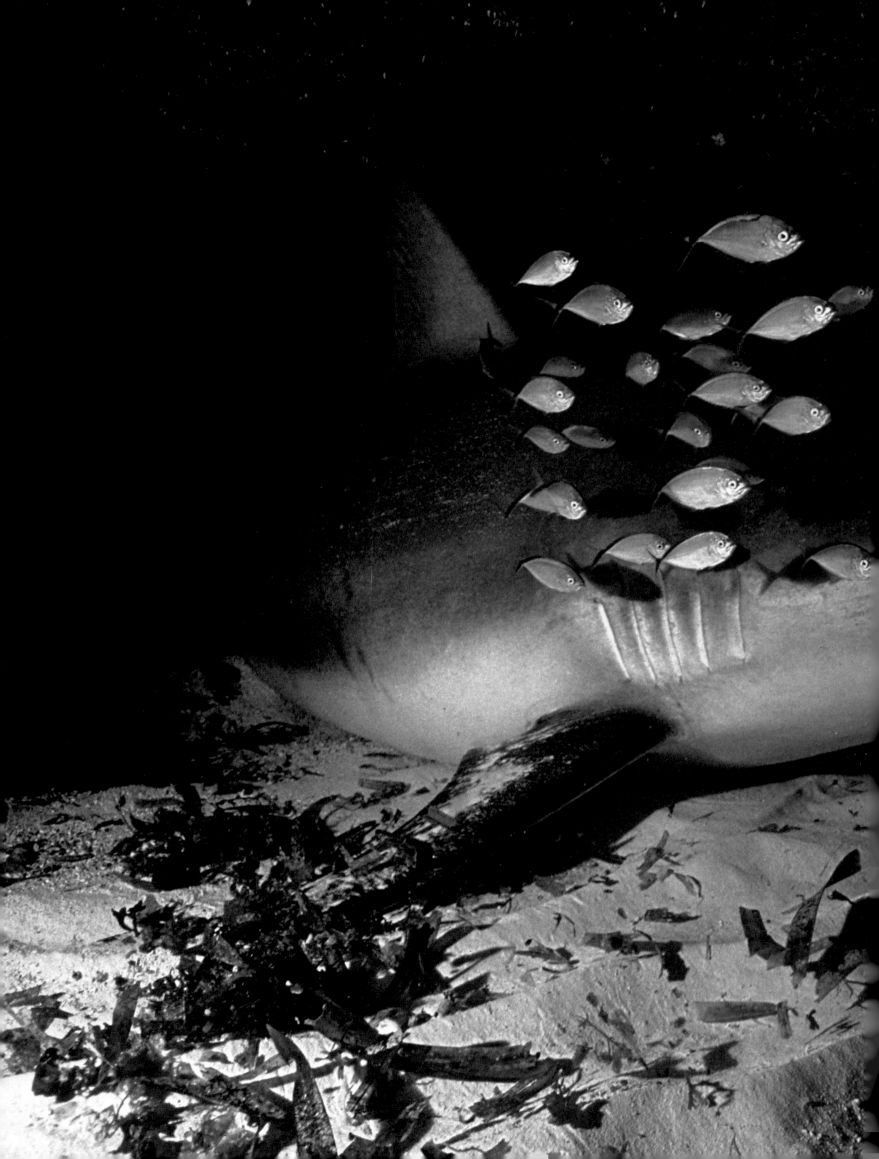

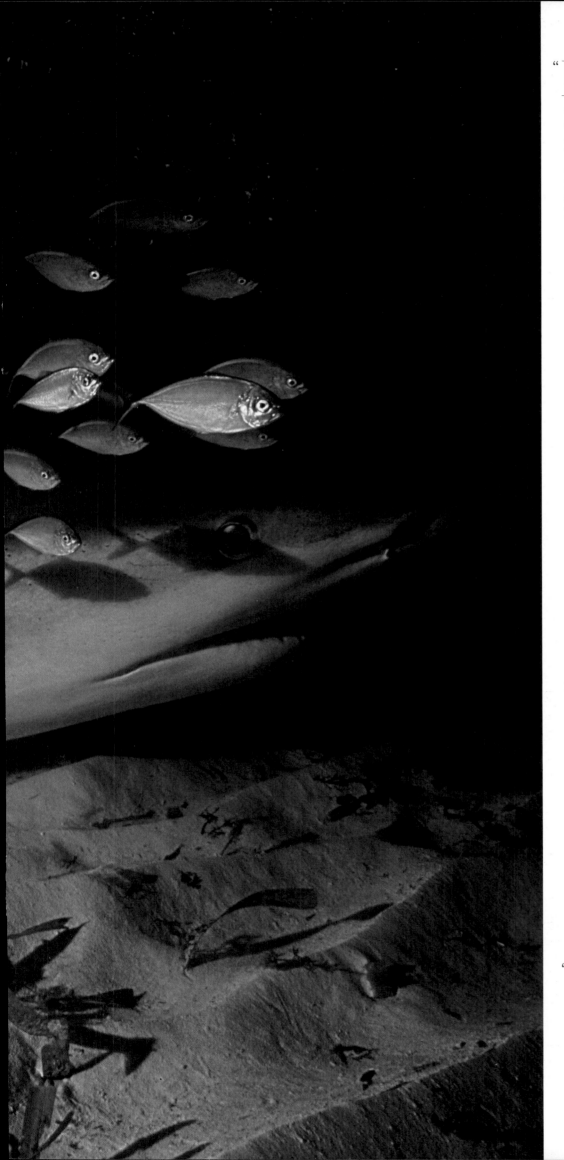

"I had no fear of the shark; I had a fear that I wouldn't capture the picture. The light from above bounced against the sand and illuminated the shark under the eye, creating a feeling of scariness, giving a Bela Lugosi aspect to the picture. Small silvery jacks swam above the shark; it finally sensed my presence, yawned twice, thrashed a bit, sped out of the cave, and was gone."
DAVID DOUBILET

Off the Galapagos, sea lions (overleaf) dance against a curtain of natural light. "The seals jumped in for fun," Doubilet recalls. "They nosed my equipment along the bottom. One even managed to get a camera strap around his neck and swim off. I shook my finger at them, and they looked remorseful. As soon as I turned my back, they were at it again."
DAVID DOUBILET

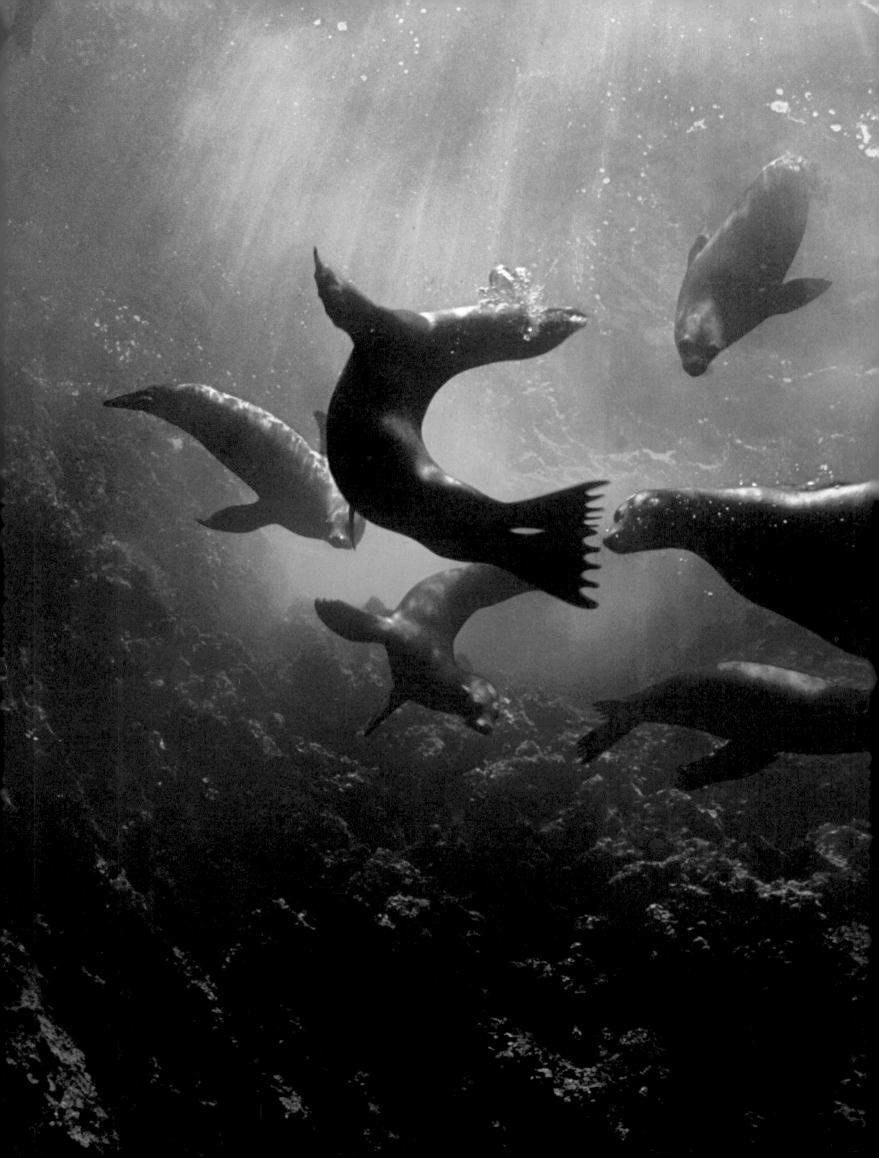

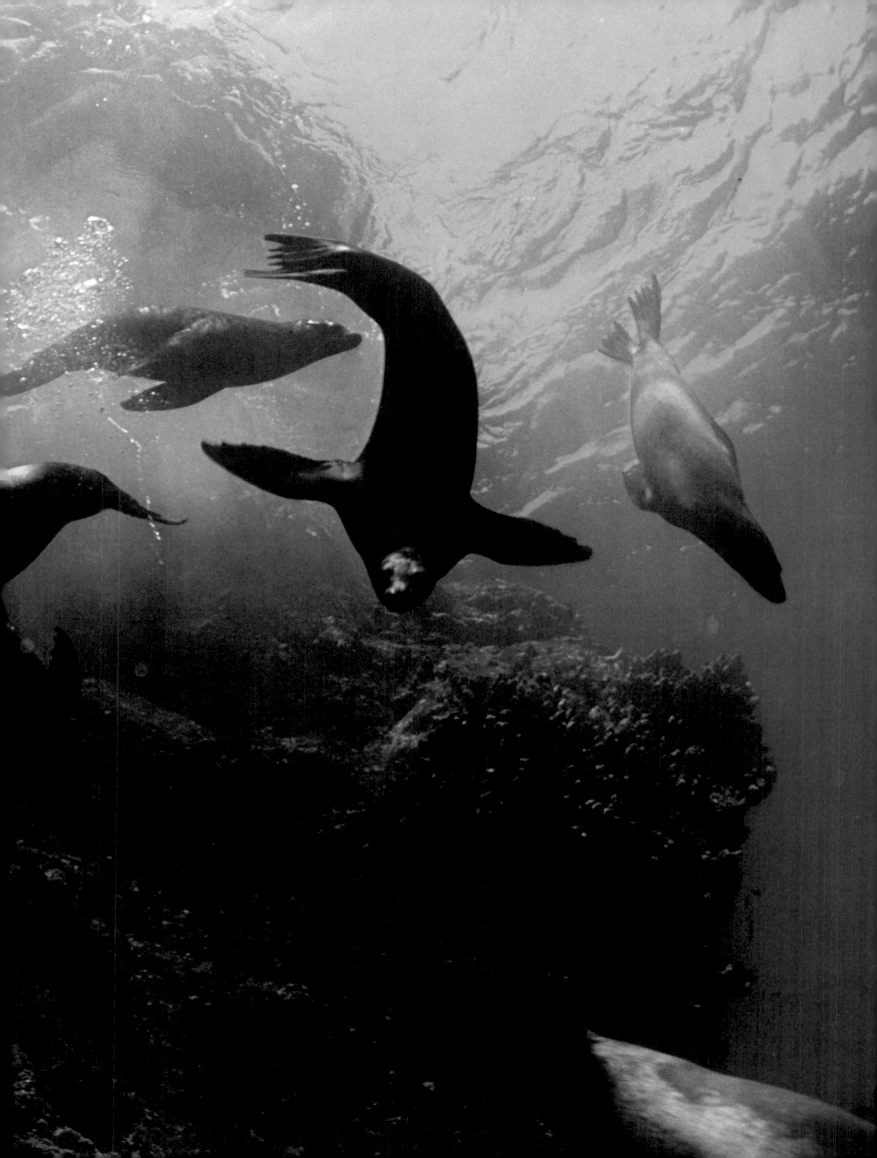

Intruder in the Shark's Domain

By David Doubilet

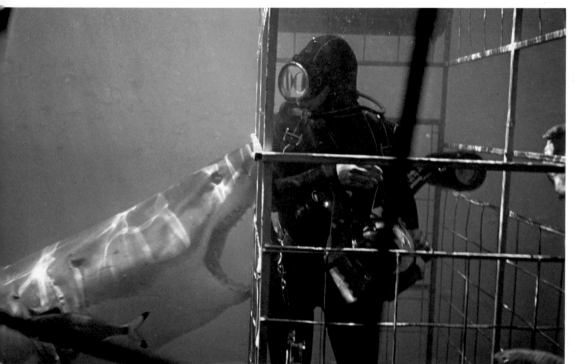

David Doubilet by Eugenie Clark

To attract a great white shark (opposite), Rodney Fox ladled blood and fish trimmings into Australian waters. David Doubilet then plunged in when the shark arrived to eat. "Sometimes you feel as though you would jump into their mouths if it would mean a better photograph," says Doubilet.

At the tip of the Sinai Peninsula the current is strong, a steady underwater wind that causes clouds of small orange fish to billow out from the reef. For weeks, we have been waiting here 60 feet below the surface of the Red Sea, hanging like flies on a coral wall. We are waiting for sharks.

Now they materialize out of the deep blue background—12, 13, 14 of them—far away, swimming in a loose circle, riding the current on their pectoral fins. The circle drifts toward the reef. In a silent sea the curtain is about to go up on a rare and beautiful scene: the courtship of the short-nosed gray reef shark.

There are ten females and four males. Two of the females are pregnant; the others bear the bites and scars of courtship on their flanks and fins. To record details of the scarring,

I raise my 200mm micro lens and begin to shoot the close-up view. The flash pulses a burst of light into the sea. One shark winces, then speeds away, startled by the flash. But it returns. When the sharks are closer, I switch to a 24mm lens to get a broader view of the animals and their environment. My wife Anne and I wait. We must not swim toward the sharks, for to do so would disrupt their natural behavior.

Anne grabs my arm and hands me the camera with a 105mm micro lens. Two males are beginning to chase a female. This behavior is what we came for; it has never been photographed. Suddenly one male breaks away. The other male rushes in, whipping his entire body to gain speed. I shoot. The female tries to escape. The male moves from below and clamps his jaws on the female's lower right flank, thus demonstrating his dominance. I shoot. The female arches her back and swims away.

The circle of sharks dissolves, reabsorbed by the blue of the sea. The actual mating may take place later, most likely at night. It would be impossible to photograph.

But I feel that I have at least recorded a bit of shark behavior, shedding some light on a mysterious animal that swims in and out of man's dreams. For our times, the shark is the perfect mythological beast, a delicate combination of the fear and beauty we see throughout the world of humans.

Red Sea sharks are skittish, wary of humans with scuba gear and underwater cameras. The great white shark, however, is an entirely different creature. With time and patience, it is possible to visit this ultimate predator in its world, on its terms.

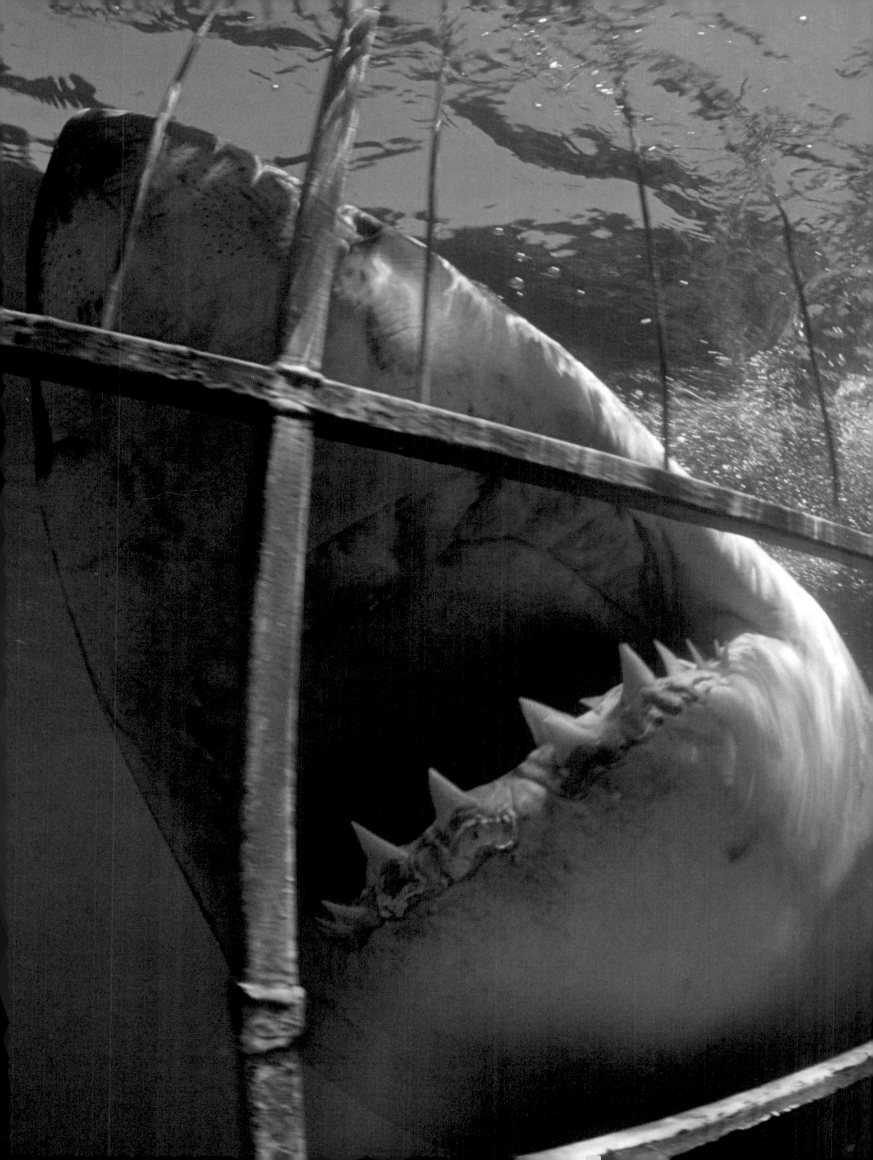

"This shark, fully grown, is 4½ inches long—about the length of an old-fashioned fifty-cent stogie," says Doubilet. He photographed it off the coast of Japan after it was hauled up in fishermen's nets from 1,800 feet.

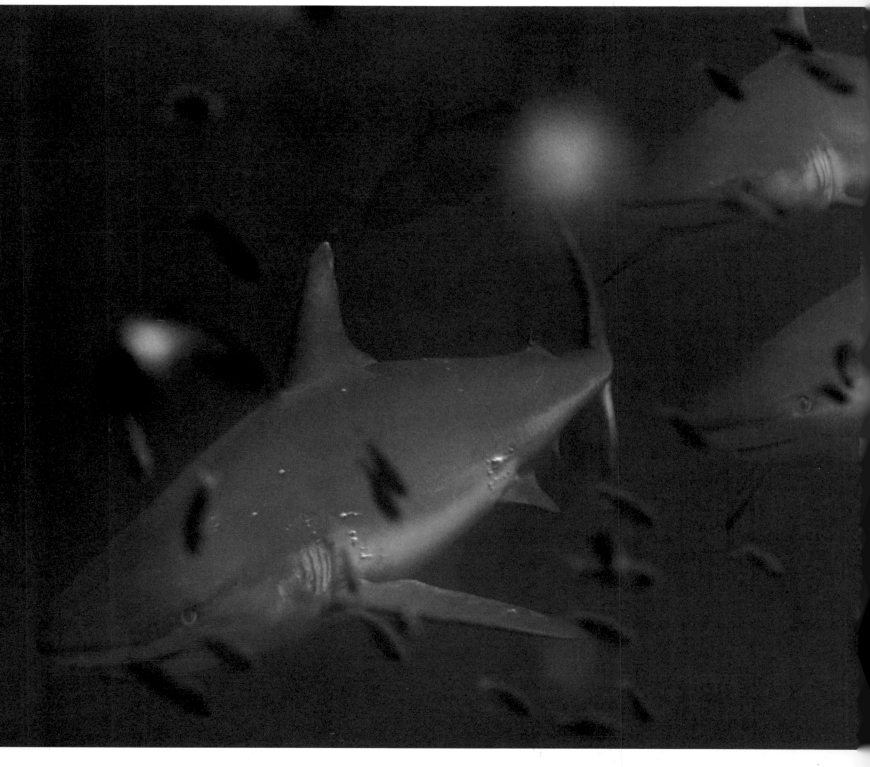

Two male gray reef sharks pursue a female in mating behavior photographed for the first time by Doubilet in the Red Sea. "You look at the shark's eye, and you wonder what it sees, what sort of image you form in the shark's brain as it swims by."

To find a great white shark off Dangerous Reef, South Australia, we have to lure the animal to us, chumming it toward our boat with blood and fish offal. The shark's keen sense of smell, we hope, will do the rest. We start at sunrise, leaking the chum mixture into the sea until it forms a slick on the water.

At three o'clock, a white shark finally appears, a 16-foot, 2,000-pound male swimming lazily in the flat sea under a warm summer sun.

The shark sticks his head out of the water, thumps the side of the boat, and opens his huge maw, displaying an awesome set of triangular teeth. He virtually inhales a 60-pound chunk of bait.

Rodney Fox, an Australian shark expert, feeds him more. It is important to keep on feeding sharks once they have come to you, he explains; otherwise, they lose interest. Our great white shark is definitely interested. He bites the propeller, sticks his head up on the gunwale swimstep, and snaps his jaws.

It is time to launch the shark cage. At this point, with the shark as excited as he seems to be, it would be suicidal to go below without a cage.

The empty cage goes over the side, tethered to the boat by a single nylon rope. The shark immediately bites the cage's steel floats. It sounds like fingernails on a blackboard.

Rodney pulls the cage to the boat and I step in, shove in my mouthpiece, clean my mask. Anne hands me two cameras. An underwater Nikonos with a 15mm lens goes around my neck, an OceanEye housing with a 16mm fish-eye lens into my hands. With a boat hook, Rodney pushes me away from the stern in the cage. As it drifts with me inside it, the cage rolls with a sickening corkscrew motion. For the first time in my life, I am alone with a great white shark.

I see the shark's head easing out of the murk, a pig-faced beast with an underslung grin. Light dapples his back. Slowly he turns away, scattering the few small fish that hang near my cage. Near its top and on all four sides, the cage has a camera port, a horizontal space 24 inches wide between the bars. I lean out as the shark comes close. The wide-angle 15mm lens takes in all 16 feet of the great white. He makes his turn and passes by the cage again.

Then I see the eye, silver-dollar size, black, bottomless. It is not the eye of an animal but the porthole of a machine. The shark bangs the cage with his tail. I whirl, my air tank clanging against the metal bars. The shark is gone. Where? Suddenly he comes again, this time from above, raking his teeth along the yellow floats atop the cage.

The shark sinks to my eye level. The teeth drop down. He is opening his jaws. I am looking down the animal's throat.

Now the shark wants a closer look at me—perhaps a taste. He pushes his head into the cage, coming in the camera port, but though he can get his nose in, the gap in the bars is so narrow that he cannot open his jaws. The shark turns sideways. The pointy nose pushes farther in. The dome of my camera housing is one inch from the shark's snout. For the first time, I take my eye from the camera. I'm transfixed. All I can see is the flat black eye.

Then, inexplicably, the shark is gone, a myth, a black-magical animal vanished in a darkening sea.

Diving with Cameras into the Past

By Jonathan Blair

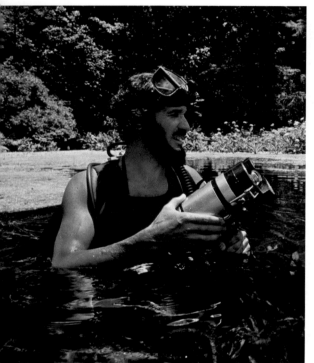

Jonathan Blair by Robert Ewing III

Lingering at a decompression stop in the Aegean, web-footed archaeologists (opposite) haul a basketful of ancient glass toward the surface, past the camera of Jonathan Blair.

I didn't learn to swim until I was almost 20. I was scared of the water. But now, gliding down through the blue ocean off the southern coast of Turkey, I feel very much at home, my cameras floating almost weightless in front of my eyes. Through the water, archaeologists are ferrying priceless glassware from a shipwreck to the surface 110 feet above. I watch, trying to count each breath as I begin work.

Everyone is worried about the change in pressure as the artifacts travel to the surface. Will the fragile glass shatter? The answer comes as the first vase emerges undamaged, sunlight striking it for the first time since the 11th century. It is a moment all the divers will remember—the strong Mediterranean light reflected from a fragment of glass and changed into a delicate color from another age. History was coming back to light.

During the many dives that were to follow, I would feel a kind of vertigo as I floated with my underwater cameras over the wreck below. There are joys to such work. I remember sitting on the bottom of the sea one morning, gazing at the ribs of a ship that sailed four centuries before Christ. Again I had the feeling of somehow falling through a water-filled time tunnel.

Each wreck is like a window on the past. And each time I go below with divers to search for wrecks, I feel a certain bond with those people who took the chance and sailed across the sea toward a new life.

Consider the case of Doña Antonia Franco, a woman whose silver bracelet sank over 250 years ago with the Spanish ship *Conde de Tolosa*. I came across the tiny bracelet, inscribed with Doña Antonia's name, while looking through the remains of the 18th-century wreck in the waters off the present-day Dominican Republic.

It would have been easy to overlook the bracelet among the weightier remains of the ship, whose cannons, anchors, and timbers lay strewn on the ocean. But because the bracelet bore a name, there was a person, and that touched me deeply.

It was a delicate piece—too small to fit on my own wrist—and as I photographed it, I was again transported back in time, wondering what the world was like for Doña Antonia. Was someone carrying the bracelet from Spain to her? Or did she go down with the ship, perhaps in the black of night, on a coral reef far away from home?

We may never know more than Doña Antonia Franco's name. But her spirit has illuminated a discovery in the Caribbean, reminding us of the human dimensions that give life to the footnotes of history.

Despite such discoveries, we still know few details about ancient shipping. Phoenicia once dominated world commerce, but her methods of shipbuilding are still a mystery; no one has ever found a Phoenician trading vessel intact. The same mystery surrounds English Crusaders who fanned out across the Mediterranean in hundreds of ships, now vanished as if they had never sailed at all.

The sea holds in darkness treasures that yield clues to the past. When those treasures are discovered, a shaft of light pierces the darkness, and the ocean's window opens to give us a view of vanished times. The camera, as it has done since its birth, travels with the discoverers, preserving images of new frontiers.

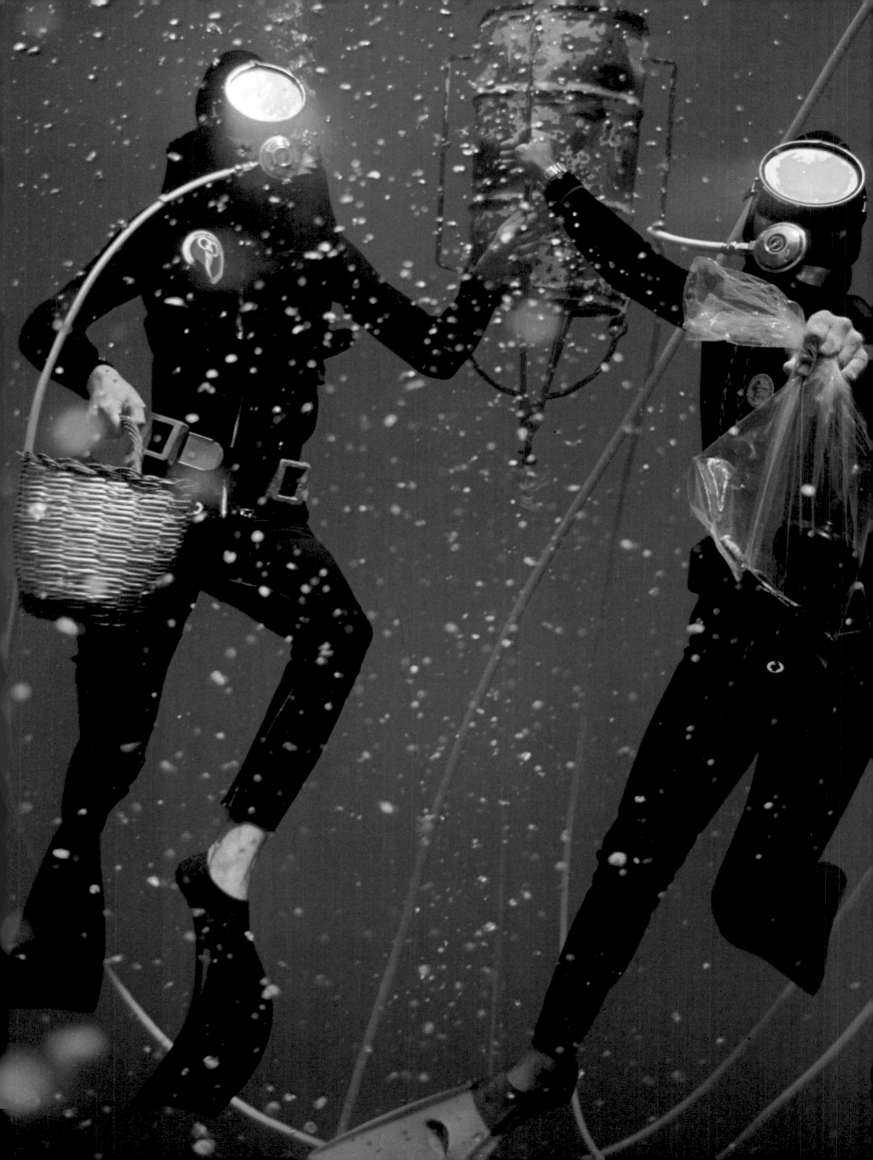

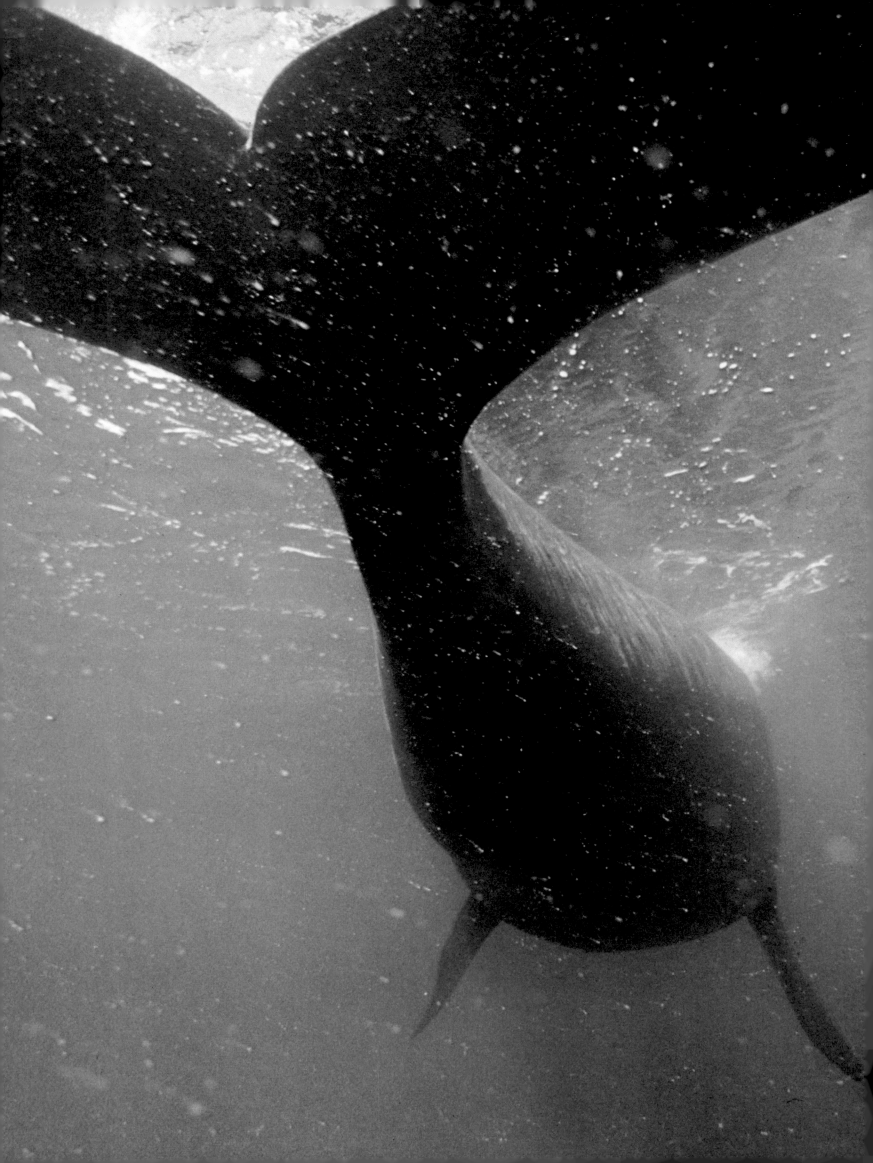

In Pursuit of Swimming Ghosts

By Bill Curtsinger

A right whale (opposite) cruises the cloudy waters off Argentina, well within shooting distance of Bill Curtsinger's camera. "This was one of those moments when the animal was moving slowly and it was possible to keep up with it."

Bill Curtsinger by Charles R. Nicklin, Jr.

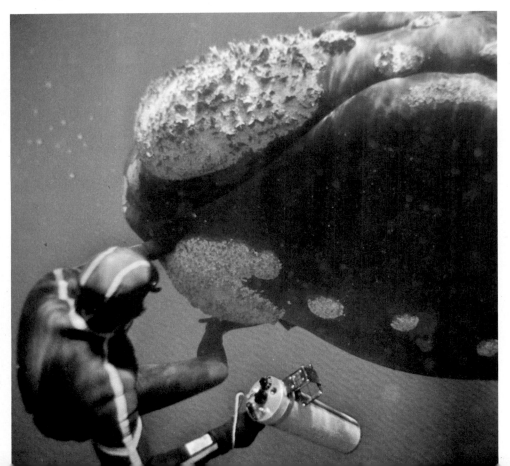

I stalk ghosts: humpback whales, harp seals, killer whales, spinner dolphins, Weddell seals, hooded seals, narwhals, crabeater seals, sperm whales, beavers, and rough-toothed dolphins, to name a few.

I have searched for them in all kinds of water, from Antarctica to Hawaii and from Argentina to New Zealand, researching, traveling, diving—and hoping for luck—to come back with photographs that show the mysterious habits and the underwater habitats of my quarry.

Like all ghosts, most of those on my list are holdovers from earlier times. Some, like the blue whales, are living fossils of an epoch that began more than 55 million years ago; others have a shorter lineage. Almost all predate the emergence of humans on earth.

My ghosts have another trait. They are elusive. They float into view for an instant, then disappear like smoke in a stiff wind, leaving you to wonder if they were really there. Size doesn't matter. A whale as big as a boxcar can be as tentative as a shadow. Underwater visibility, often poor, has a lot to do with it; so does the mobility of these animals. Finback whales, speed demons of the deep, come to mind. They barrel through the water like a train past the station, quick and blurry. You can't jump in front of the whale to stop it any more than you could stop a train.

And you can't keep pace. This 70-ton hulk is speeding off at an incredible pace, vanishing in the gloom, and you're down there kicking away with your little flippers. Once they have

"They have come to you," says Curtsinger (above left)—but on some lucky occasions, as he and Andy Pruna (left) discovered, close-up photographs of whales are hard to avoid.

For three weeks, the beavers of one Manitoba lodge hid from Curtsinger. But they gradually warmed to the photographer, who finally had kits like this one literally eating out of his hand.

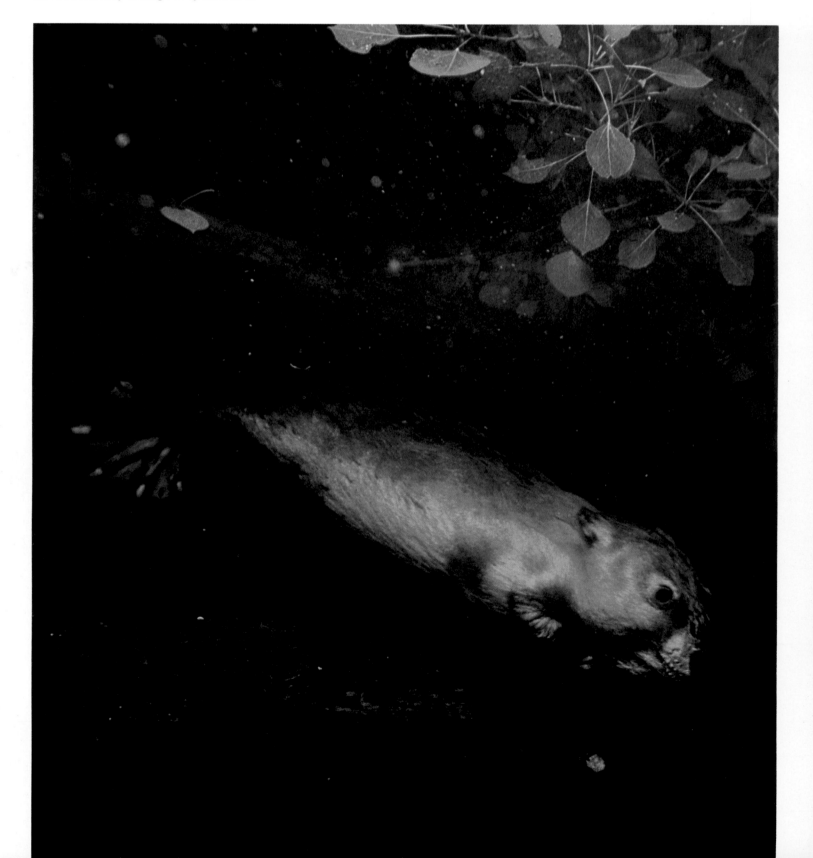

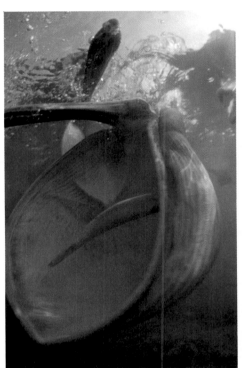

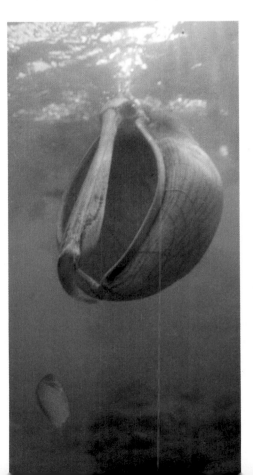

"We were trying to illustrate something never seen before—how a pelican feeds," says Curtsinger. "I sat in the water for two weeks and tossed frozen fish to them." Sometimes (below) a bird misses.

passed you by, you don't get a second chance. So a photographer learns to do things to increase his odds.

I spend as much time doing research on dry land as I will eventually spend in the water. I find out who the experts are, and ask them questions. I investigate the behavior and biology of the creatures I'm after. It's like detective work, collecting a bit of information here, a bit there. I try to figure out where the animals will be at a certain time of year so that I can intercept them on their journeys around the world. And I do my homework so I'll know how they will react to my presence. Sometimes I connect, and I cross the ghosts' paths, cameras in hand, at a revealing moment.

I can recall such a moment. I was assigned to photograph southern right whales off the Patagonian coast of Argentina. The whales, at the peak of their mating season, were exuberant, crashing and cruising around in the calm water of the gulf, so preoccupied with their mating routine that they didn't mind a photographer hanging around. I could shoot a roll of film, leave the water, reload my camera and return. They would still be there, almost as if they were waiting for me. No animal photography since then has been as easy.

Most marine mammals are difficult to photograph because they are so easily spooked. You can't sneak up on them because they have great visual and acoustical equipment that allows them to track your every move. They always know where you are. Sometimes they accept you, sometimes they don't. Their behavior frequently seems to depend on how you approach them. When I enter their

world, I always try to intrude as softly as possible.

Photographing whales, for instance, I sometimes avoid using scuba gear. It makes noise and bubbles, which frighten the animals. Instead, I work with snorkel equipment, though it keeps me close to the surface. I try to blend with the sea.

This is the kind of adjustment one learns to make in my kind of work, which constantly demands patience and flexibility.

Wild beavers in the Canadian province of Manitoba taught me that sort of humility long ago. They were reluctant subjects, and they forced me to abandon my human schedule. I had to live like one of them.

I worked by night, slept by day. I tried to trick them, building blinds at the water's edge so I could photograph them secretly. But they tore the blinds down when I wasn't there, forcing me to work in the open. And so I just sat there. For two weeks, I stayed next to the water near their lodge, catching glimpses of the beavers. Morning after morning, they slapped their tails on the water in warning. I stayed on.

By the third week my patience was wearing. But then one morning an adult came out of the lodge. It turned toward me and swam over to my feet. Its eyes followed mine. Slowly, I raised the camera to focus, and I began shooting. That evening I cut choice poplar boughs (their favorite food) and placed them near my sitting spot. I got my underwater camera, put on my wet suit, and slipped quietly into the lake. That night, I took the first underwater pictures of beavers in the wild.

I was no longer a threat to the ghosts. It was a nice feeling.

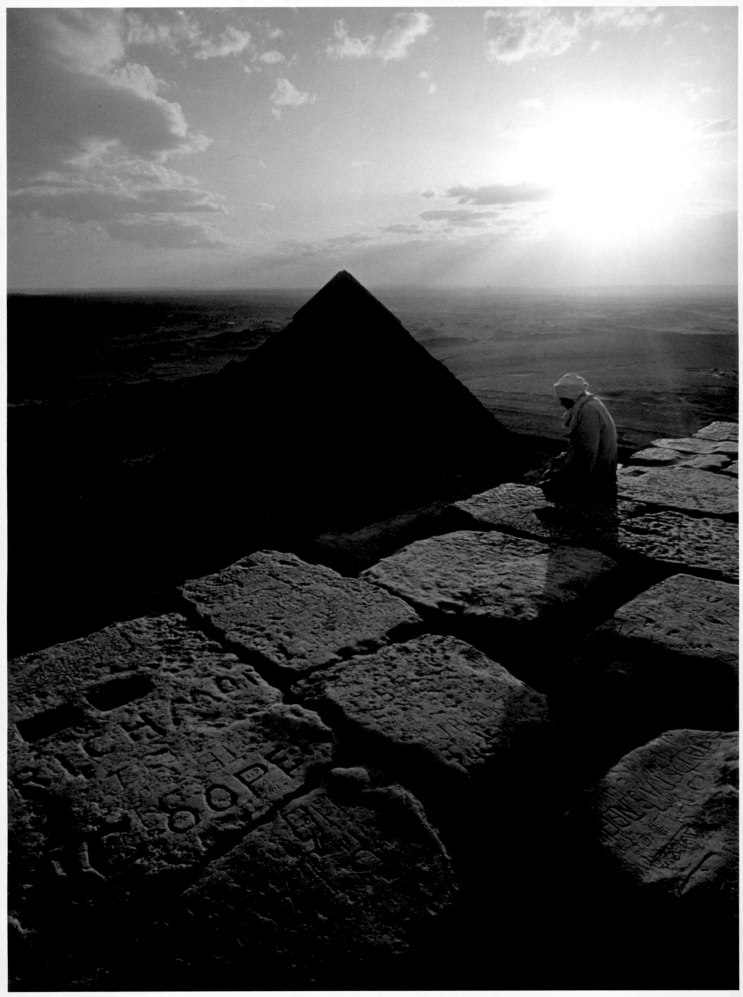

THE LURE OF FARAWAY PLACES

A guide resting atop the Great Pyramid at Giza. By Winfield Parks.

Even after 35 years as a staff photographer, W. Robert Moore could not forget that he had never been to Nepal. In 1924, on a hilltop in India, he had gazed west. "So near it seemed almost as if I could feel the chill of its ice against my cheek, rose massive Kanchenjunga," the mountain bastion of Nepal. Not until a vacation trip years later did he finally see the land that had bewitched him so long ago.

Before the Geographic was very old, a yen for the picturesque and unknown had infiltrated its sober, scientific notes and articles. In 1900 members of a geological team in Alaska became so enraptured as they photographed a glacier in the arctic sunset that the leader quoted Samuel Taylor Coleridge:

We were the first that ever burst
Into that silent sea.

The urge to be first lured Hiram Bingham along a Peruvian jungle trail. In 1911 the young Yale historian, excited by tales of a lost Inca city, made his way to the base of a mountain, Machu Picchu, where he found roaring rapids and a bridge in danger of being washed out. He climbed on all fours through the slippery grass and finally came upon tier after tier of Inca terraces that rose like giant stairsteps.

Bingham plunged into the jungle, "heart thumping. A mossy wall loomed before me, half hidden in trees. . . . I traced the wall and found it to be part of a house. Beyond it stood another, and beyond that more. . . . Down the slope, buildings crowded together in a bewildering array. . . . This beautifully preserved sanctuary had obviously never felt the tramp of a conquistador's boot."

Bingham explored his find, backed by Yale University and the National Geographic. In four years, the expedition took 12,000 pictures, and the magazine published over 300.

Until World War I, the Geographic relied on photo agencies and free-lancers for most of its foreign coverage. But in 1919 Gilbert Grosvenor hired the first staff writer-photographer, Maynard Owen Williams. A 34-year career, with almost 100 articles and some 2,100 published pictures, earned Williams the title "Mr. Geographic."

Early in 1931 the Citroën-Haardt expedition left Beirut, Lebanon, for Peking, China. Maynard Williams, as the only American, rode with the fleet of half-tracks, the first wheeled vehicles to cross the Himalayas.

On the desert trail to Baghdad, the party froze by night and wore layers of dust by day. At a river ford in Afghanistan they struggled for three days, often chin deep in water, with a seven-ton radio car and its 60-foot mast. "May my spit cover your faces!" screamed the Afghan riverman.

"What does he say?" asked the French mechanic.

"That the truck is heavier than you said," replied the translator.

Hampered at times by eager officials and "receptions *ad nauseam,*" other times by days which began at 4 a.m. and ended late at night, Williams averaged only six color plates a day. Ponies packed gear through the mountains of Kashmir, and Williams rode "with the moon casting fearful shadows at which our ponies shied toward a two hundred foot drop to ugly rocks." After one stretch he said, "Never since Beyrouth had I so lived. Adversity makes one feel."

Men, cars, and ponies struggled through deep snow for ten hours to cross a pass. The next day the trail became so narrow that the cars were dismantled and carried in pieces.

The palace of the Dalai Lama still evokes a sense of the faraway. It was in a series of Tibetan photographs the Imperial Russian Geographical Society presented to the National Geographic.

Tsybikoff and Norzunoff. National Geographic Magazine, January 1905.

Photographer unknown. National Geographic Magazine, January 1912.

*The ornate Mosque of Sultan Achmet I
spears the skyline of Istanbul. The
city was called Constantinople—so exotic,
so far away—when Geographic readers
first saw this mosque of six minarets.*

A. W. Cutler. National Geographic Magazine, January 1917.

*"The village is very old and remains
about as it was in Cromwell's time," says
the caption with this British village scene.
In such images of the plain life, readers
still saw something exotic: the past.*

Gilbert H. Grosvenor. National Geographic Magazine, November 1914.

*St. Basil's Cathedral in Moscow glows with
colors based on notes made by Geographic
Editor Grosvenor. His hand-tinted,
black and white photograph is reproduced
here as readers originally saw it.*

Ahead lay China. "Day after day," said Williams, "we rode forward into mystery." They used ancient caravan routes, camping near tiny hamlets or walled towns. In over a month, Williams could get only 24 pictures, all under Chinese supervision.

Further on, restrictions eased, but the tired, cold expedition pushed night and day across frozen desert. Williams typed letters home with fingers cracked from frostbite. He got no color pictures—the pace was too fast. But at a repair stop in Ninghsia, he shot feverishly, making 900 black and white pictures and 150 in color. Definitely, he said, "not tourist stuff."

North of Ninghsia a car broke through the ice of a canal (page 110). Then, a few days later—ambush from behind a hill. Eleven Chinese bullets hit the car Williams rode in. The expedition returned fire with a machine gun. It was "a slight misunderstanding."

At the lavish camp of a Mongol prince, Williams made color pictures of New Year visitors clad in rich silks and furs—a remarkable and unique piece of work, he judged.

On February 12, 1932—7,370 miles from the Mediterranean— the expedition reached Peking. The films and plates had survived heat, cold, flood, and gunfire. Three weeks later, on a boat in the East China Sea, Williams made plans: next year, Tunisia; then Rumania, Austria, Hungary, Poland, Italy, Czechoslovakia. . . .

A 1921 Geographic story, "Persian Caravan Sketches," lured the young Robert Moore to Iran. Encouraged by Geographic editors who liked his pictures, Moore then went to South America. In Peru, defeated by a washed-out trail at the foot of Machu Picchu, he remembered Bingham's difficulties.

On a later trip Moore was assigned to photograph in the Far East, to take charge of Williams' film from the last leg of the Asia trip, and to "follow your nose."

He carried cut film; glass color plates sealed in metal cans; steel developing tanks; chemicals; two cameras; a tripod; plate holders; spare shutters, filters, and screens for color photography; a flashgun and powder; and "new-fangled"

Hans Hildenbrand. Unpublished.

Hans Hildenbrand, one of the Geographic's early free-lancers, was photographed by his son on the job in Austria around 1928. From the free-lancers' bulky cameras came the first extensive color coverage of Europe.

flashbulbs. (When Jim Stanfield went to China in 1980 he took nine cameras, 14 lenses, strobes and floodlights with stands, 500 rolls of film, two light meters, and a tape recorder.)

Moore explored Japan by car, and especially enjoyed the end of each "rolling, jolting" day when he drew up to the door of a quiet inn and a reception by bowing, kimono-clad "nesans." Tea followed, then "the event of the evening, the bath." Moore's blushing refusal to undress before the maids led to many giggles.

When he met Williams in northern China it was so cold that Moore wore his wool swimming suit as extra underwear. In two weeks in a Peking cellar he developed, printed, catalogued, and packed 1,700 plates and films from the Citroën-Haardt expedition, as well as completing his own work on a Shanghai story.

Moore's photographic career ranged every continent. Together, he and Williams logged almost 1,750,000 miles for the Geographic.

The footsteps of Marco Polo draw Westerners often in imagination. Jean and Franc Shor traced those footsteps in 1949 on their assignment along the Afghan-Soviet border. On their first dawn out they awoke "in the real wilderness of the whole world." They rode horseback with a military escort on yaks. In a silent, empty landscape, they passed towering, nameless Pamir peaks.

Two days from China, one escort passed the Shors to another and got a written receipt. Through more lonely mountains they rode, "boot to boot, hand in hand," feeling that they were alone in the world. Near the Chinese border they got lost. With a new guide they faced a steep, mile-long snowfield and fought four hours to cross it, finally on hands and knees, dazed and exhausted. "On we went, five yards at a time, lying in the snow and gasping between those brief advances." A few final steps and they reached the top.

On another trip to China they saw the Caves of the Thousand Buddhas. Authorities warned that no foreign woman had ever made the journey. "That," said Franc, "was all Jean needed." After five weeks and 1,000 miles of the Gobi Desert, they had pictures of the fabulous shrines— 500 sacred grottoes and Oriental art nearly 16 centuries old.

Photographer Maynard Owen Williams peels off his sheepskin to rescue some 800 films and plates. They went down with a tractor that crashed through the ice of a Chinese canal on a trek across Asia.

Citroën-Haardt Expedition. National Geographic Magazine, November 1932.

Maynard Owen Williams. National Geographic Magazine, November 1932.

"I pleaded for months for a proper chance to photograph this effect," a frustrated Williams wrote home. Drab expedition vehicles, chugging across Asia, were "distinguishable chiefly through the dust clouds they raised."

Editor and President Grosvenor, in a faraway place called Bangkok, found this floating market. On the same trip he became the first staffer to field-test a new fast film: High Speed Ektachrome.

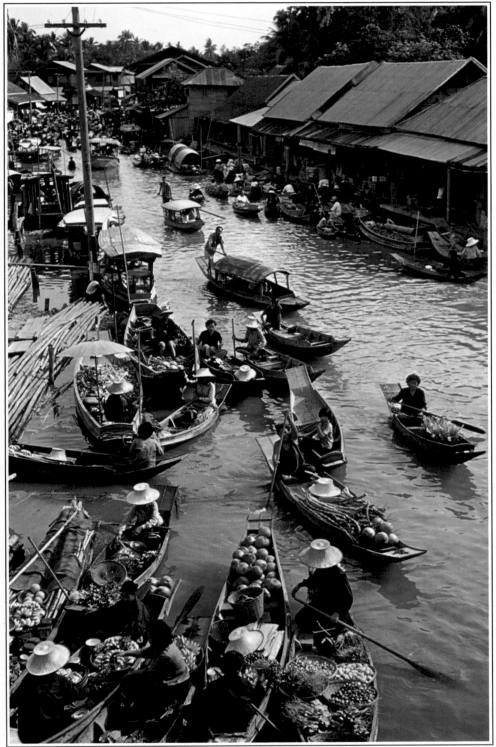

Melville Bell Grosvenor. National Geographic Magazine, December 1959.

At the "world's end"—remote, mysterious Hunza—they found people "whose origins are lost in time." They bounced across a mountain trail in a jeep, and made a rugged pony trip on an ancient trade route, where parts of the path had blown away or tumbled hundreds of feet into the raging Hunza River. A fraying suspension bridge swayed in the wind. "Hurry and cross," pleaded Jean as she photographed her husband. "I don't want to be a bridge widow."

At Baltit the Shors visited the Mir of Hunza. When the Mir presented his guest book they found, among the illustrious names preceding theirs, the signature of Maynard Williams.

Today, when we can fly around the world in a few hours, most places don't seem so faraway. But there are still journeys that lure us. Fred Ward could not sleep on his first night in long-forbidden Lhasa. "My childhood dream had come true," he said on the 1979 assignment. "I was finally in fabled Tibet."

A Geographic photographer who goes out to follow his nose nowadays finds a world less innocent and more suspicious than the one the pioneer journalists explored. Is the romance gone? "Not for me," says Jim Stanfield, as he plans a trip to Namibia. "Africa's exciting— the people, the customs, the colors."

And Earth hasn't run out of places where a determined traveler can say, "I was first." In 1978 the Geographic published the story of Naomi Uemura, the first man to reach the North Pole alone. In photographs Uemura made of his odyssey he wrestles his 1,000-pound sled over great ice ridges; he grimaces against the bright polar sun, his face raw from frostbite; he laughs in triumph beside his red tent pitched exactly on the top of the world.

We have gone to the moon. Several Geographic photographers covered our reach into space. But they were earthbound. The explorers went alone. They brought back pictures which made the silent lunar seas as real as our backyard. Apollo 15 commander David R. Scott told Geographic readers what the memories mean. "When I look at the moon," he said, ". . . I see the radiant body where man has taken his first steps into a frontier that will never end."

Patches of Himalayan sun outline Lamayuru Gompa, stirring the Buddhist monastery and its village to life. "As a guest in this lamasery, 11,000 feet above sea level, I spent several days, rising before dawn to an adagio of gongs and prayer chants. One day, along a nearby trail, an aged shepherdess and her flock grew larger. I exposed one frame—and they passed forever."
THOMAS J. ABERCROMBIE

Win Parks prided himself on his intuition for time exposures, such as the one (overleaf) that brought life to Rome's Colosseum. He also took pride in getting a job done. He wrote to the office from Rome: "The water supply has been cut off; a wildcat strike has stopped the post and telegraph; teachers and civil servants are all on strike; the mayor has resigned; the story is making good progress."
WINFIELD PARKS

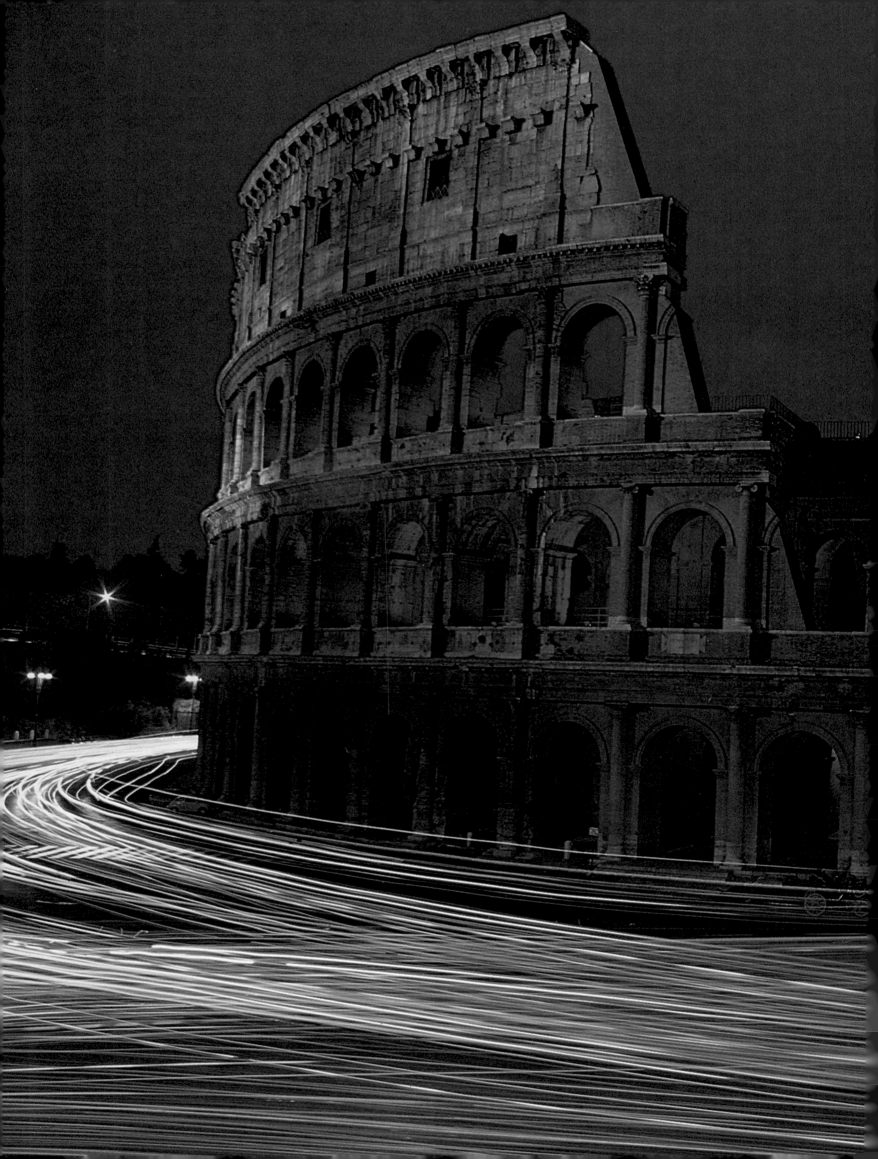

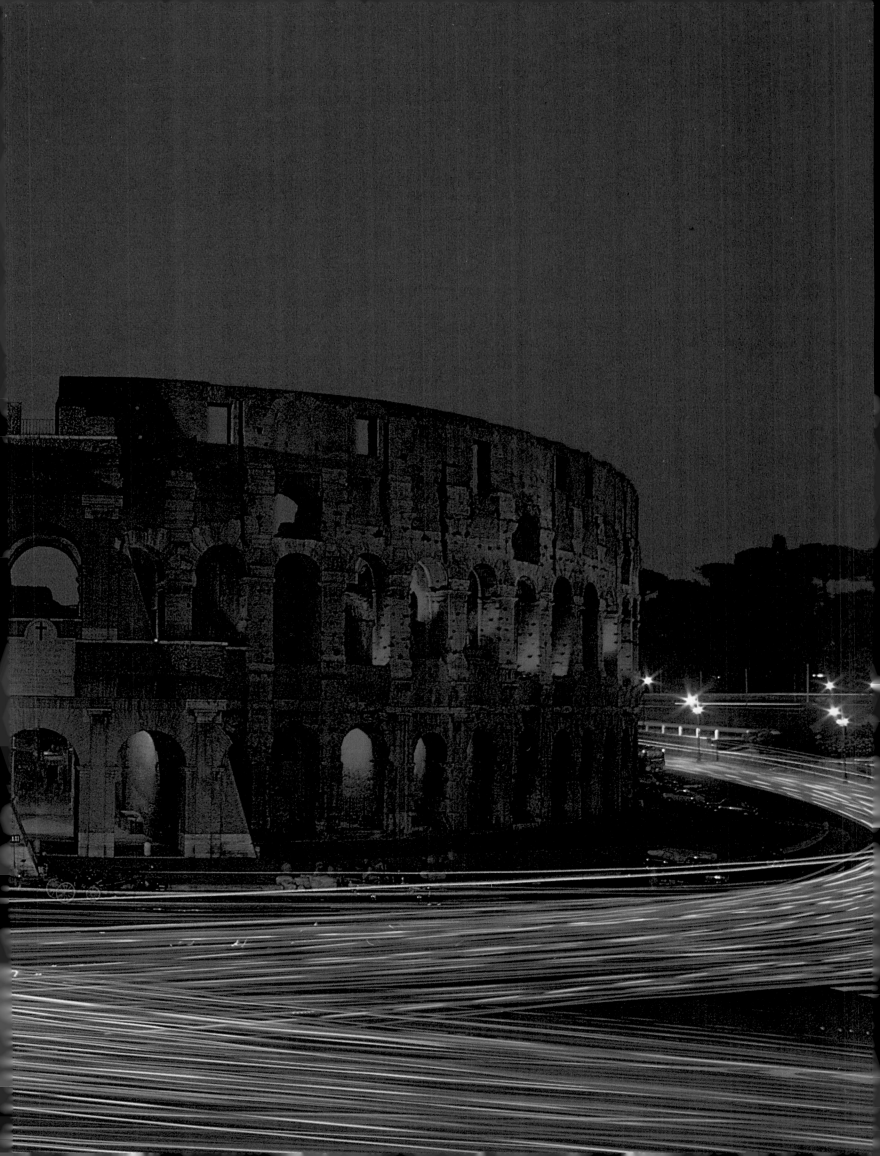

"Renting these 1,200-year-old Christian caves in Cappadocia, my wife and I and our Turkish friend, Can, felt like something out of the Flintstones. Our landlord stood there, hand on hip, shouting for me to walk carefully in his potato patch. He was mystified by a crazy American down there with a black box on silver legs, counting time out loud in the night! What was I *doing?* His peasant friends probably wondered the same thing as they passed me in the morning on their way to 12 hours of work in the fields."

JONATHAN BLAIR

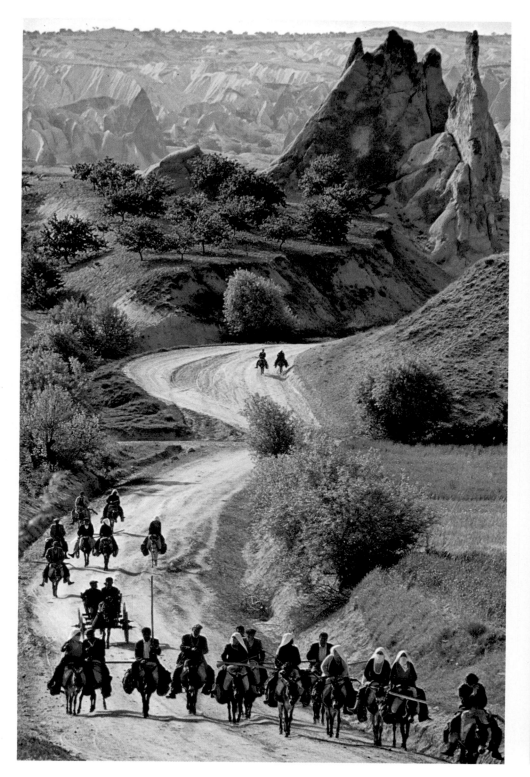

116

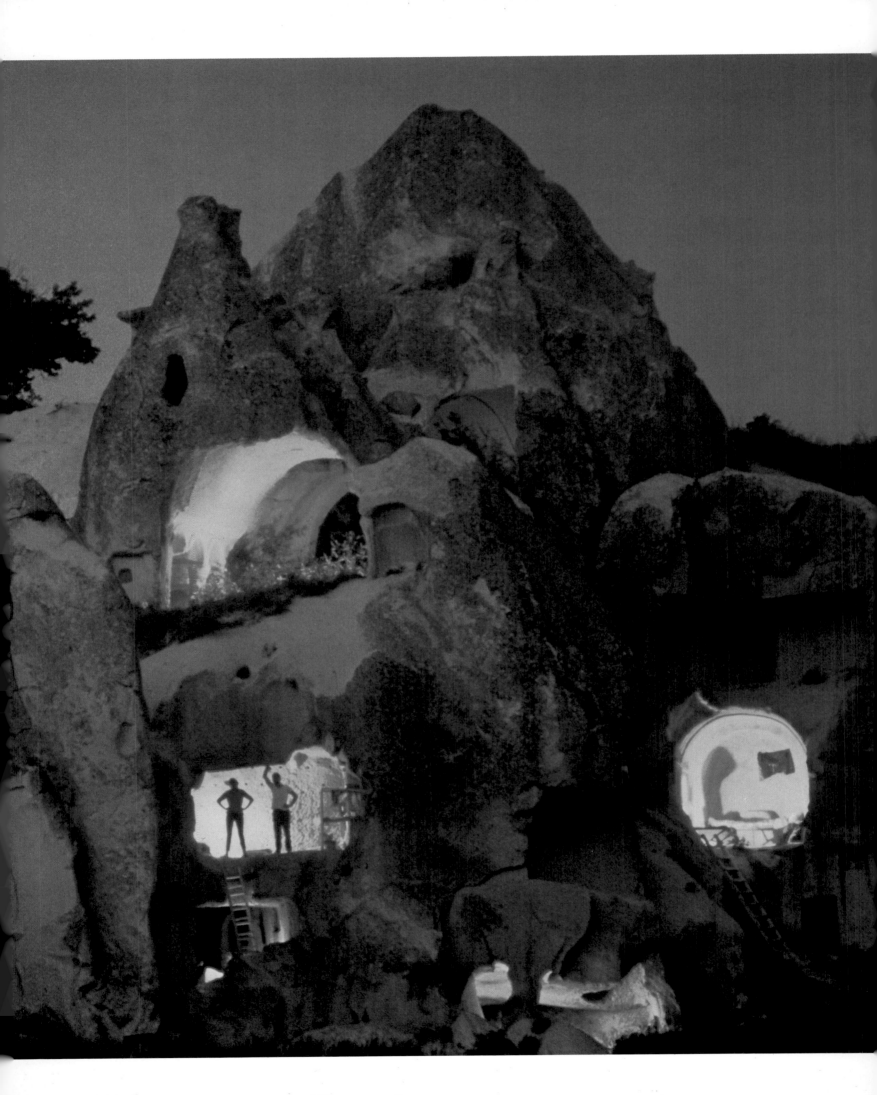

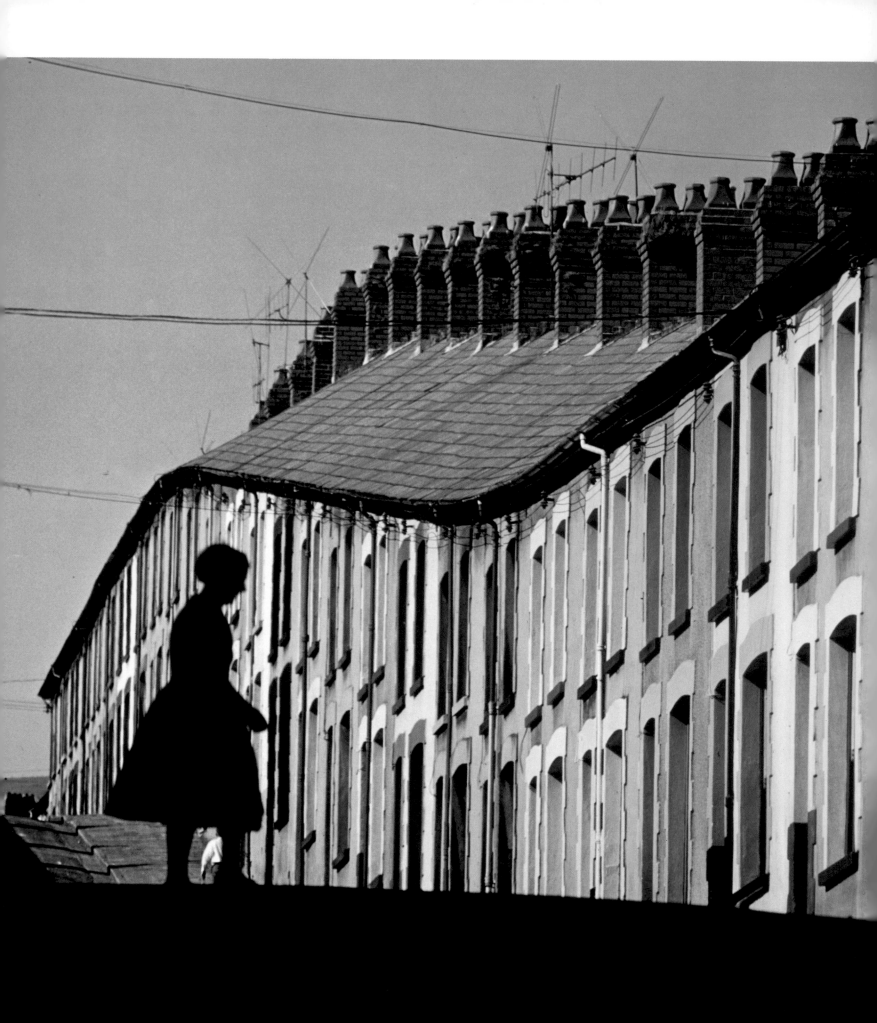

Nebbia first saw the pattern—a bank of row houses following the contour of the Welsh landscape, the housefronts compressed by his 300mm lens. But something was missing, and so he waited. Thirty minutes later, she came along. "She was just walking across the street. By slightly underexposing the shadow area in black, it became a design with more interest. I wanted the human element."
THOMAS NEBBIA

Looking down on rice terraces in Taiwan (overleaf), Helen and Frank Schreider remembered the art in the National Palace Museum in Taipei. "The colors and softness of the shimmer on the water were like celadon, one of the most famous of the ancient porcelains. Celadon has colors like these, and even the same textures. I don't know whether Frank or I took this view. We were both shooting, both exclaiming at the beauty."
HELEN AND FRANK SCHREIDER

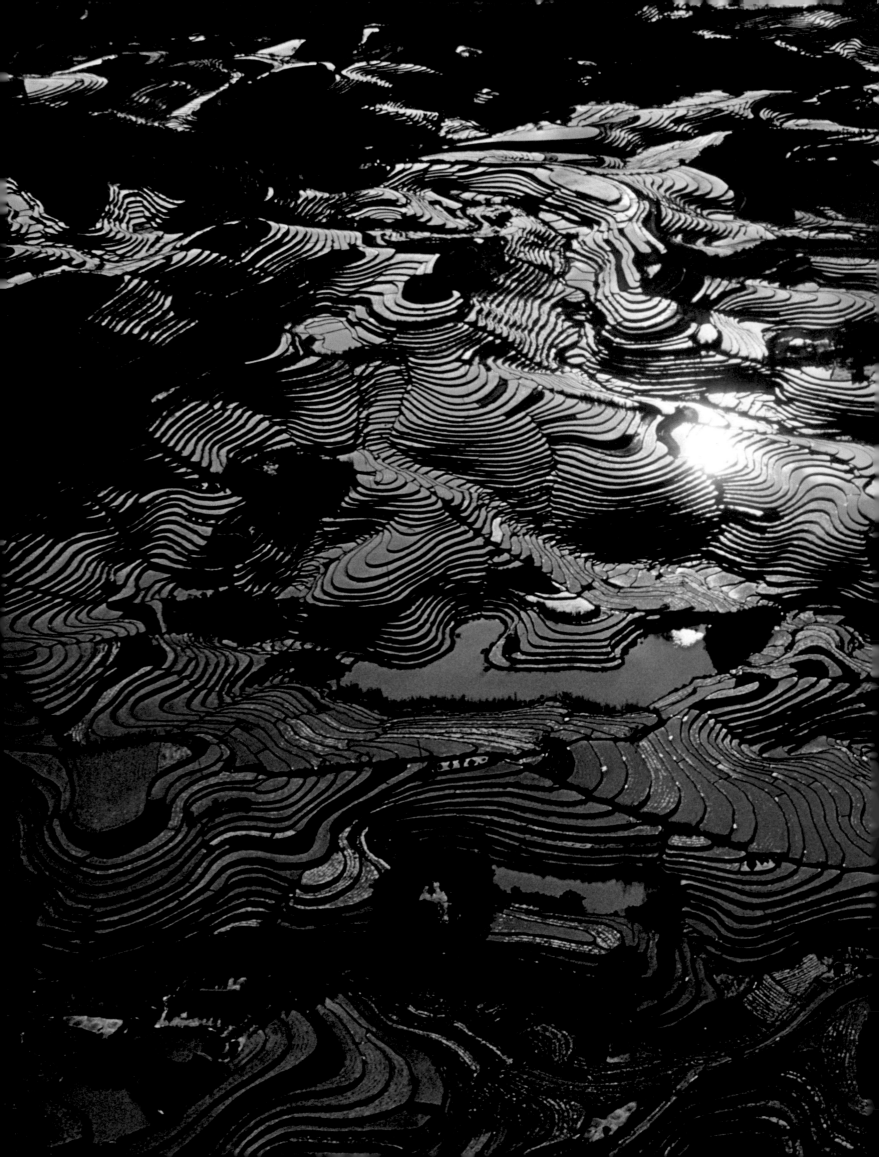

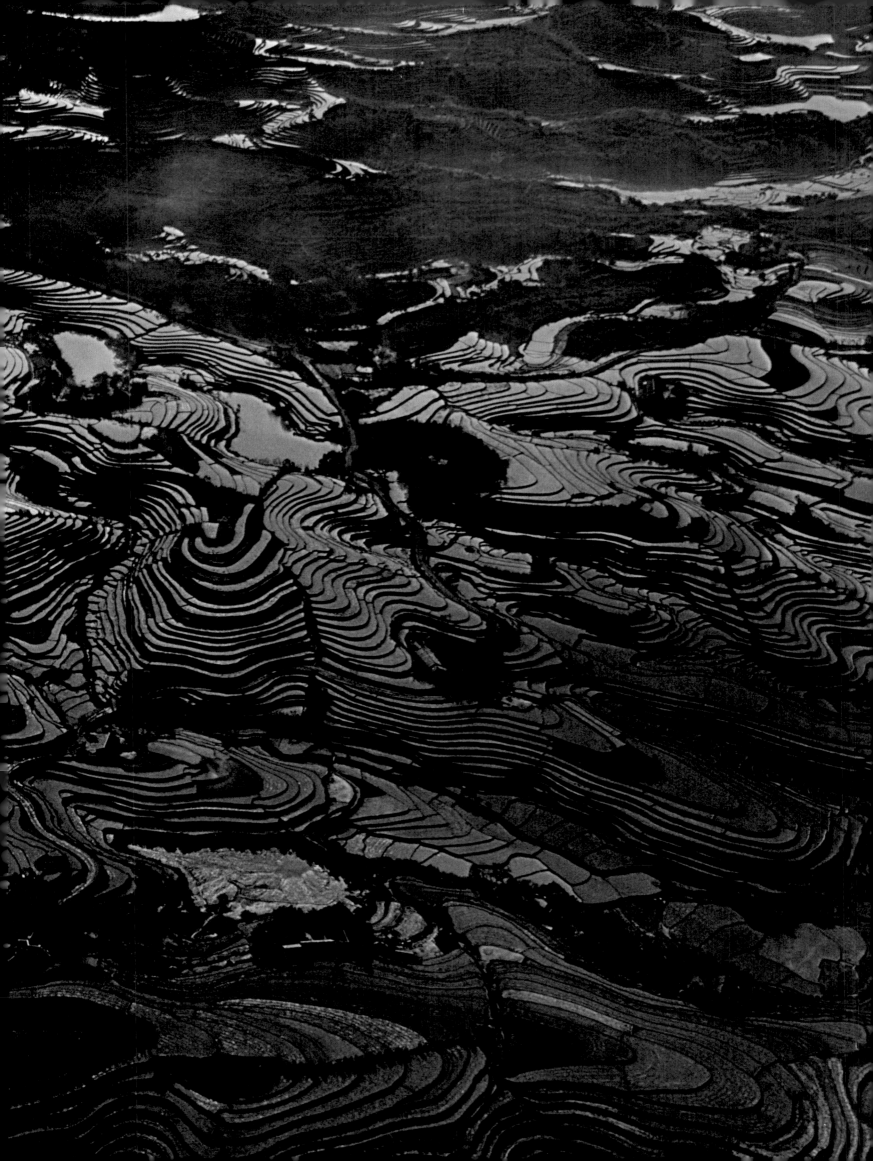

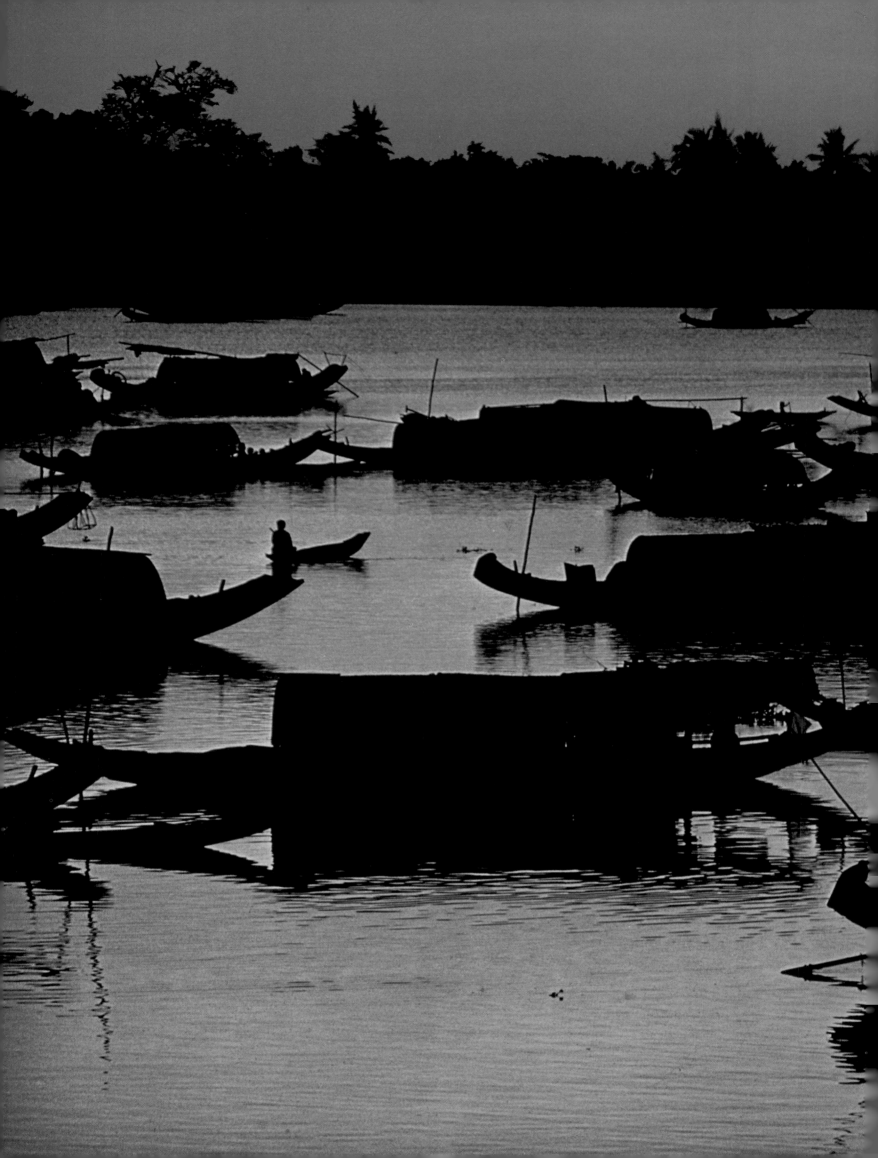

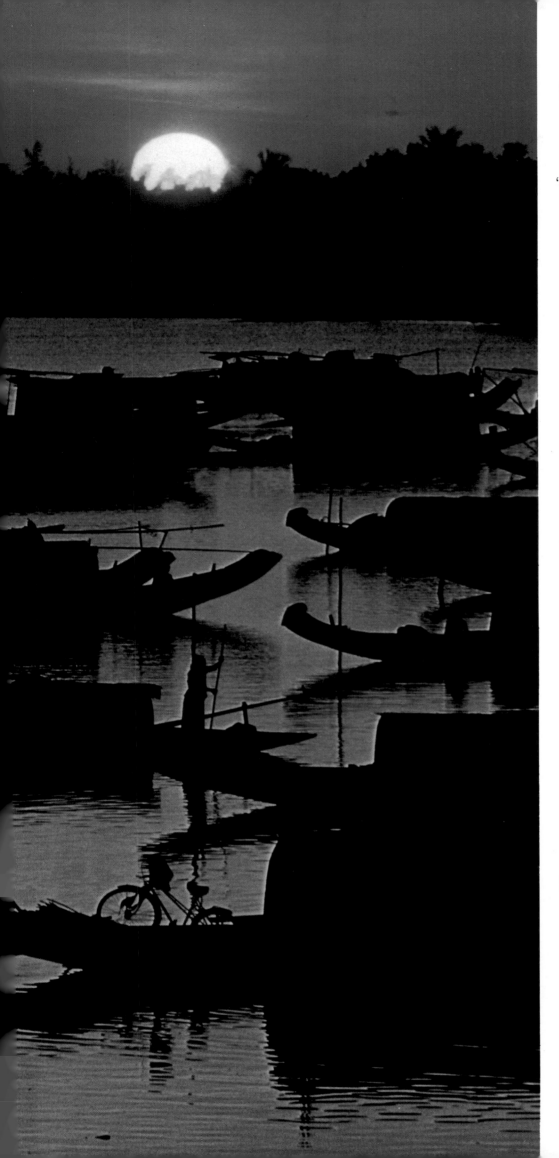

Six months after Win Parks photographed these river dwellers on their sampans, their city of Hue was destroyed and they became refugees. One of the sharpest edges on Parks' sorrow was his memory of the daughters of these boat families. Writer Peter White preserved the memory: "They emerged in the mornings, from these little craft, immaculately groomed in diaphanous white gowns. It was miraculous. As if they were stepping out of palaces."
WINFIELD PARKS

The massive temples of Angkor Wat lose perspective and scale when photographed in their entirety. "By zeroing in on this one section of Angkor Thom (overleaf), and using two saffron-robed figures for scale, the photograph captures the sense of size and grandeur you feel there. I waited hours for a moment of sunlight but found that the soft light of the rainy day was a blessing. The high contrast of sunlight would have made a harsh, less appealing image."
WILBUR E. GARRETT

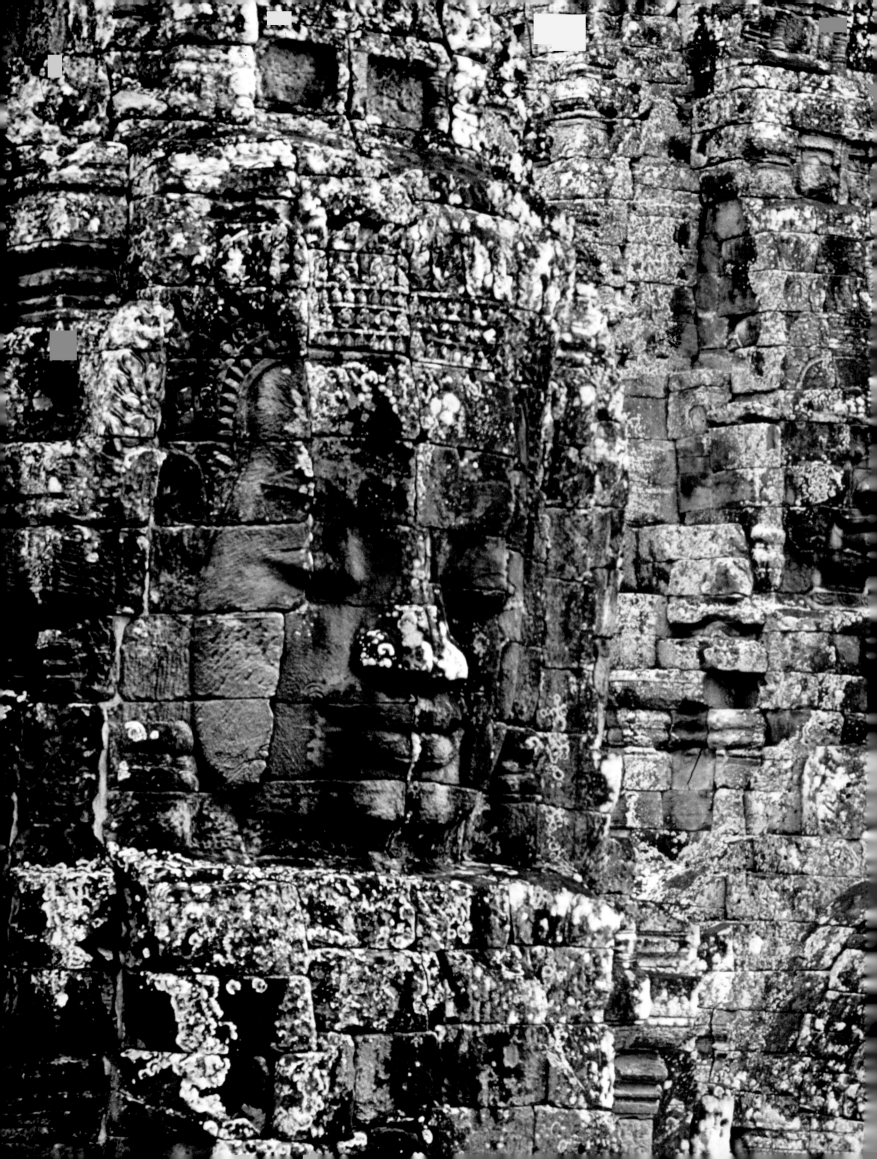

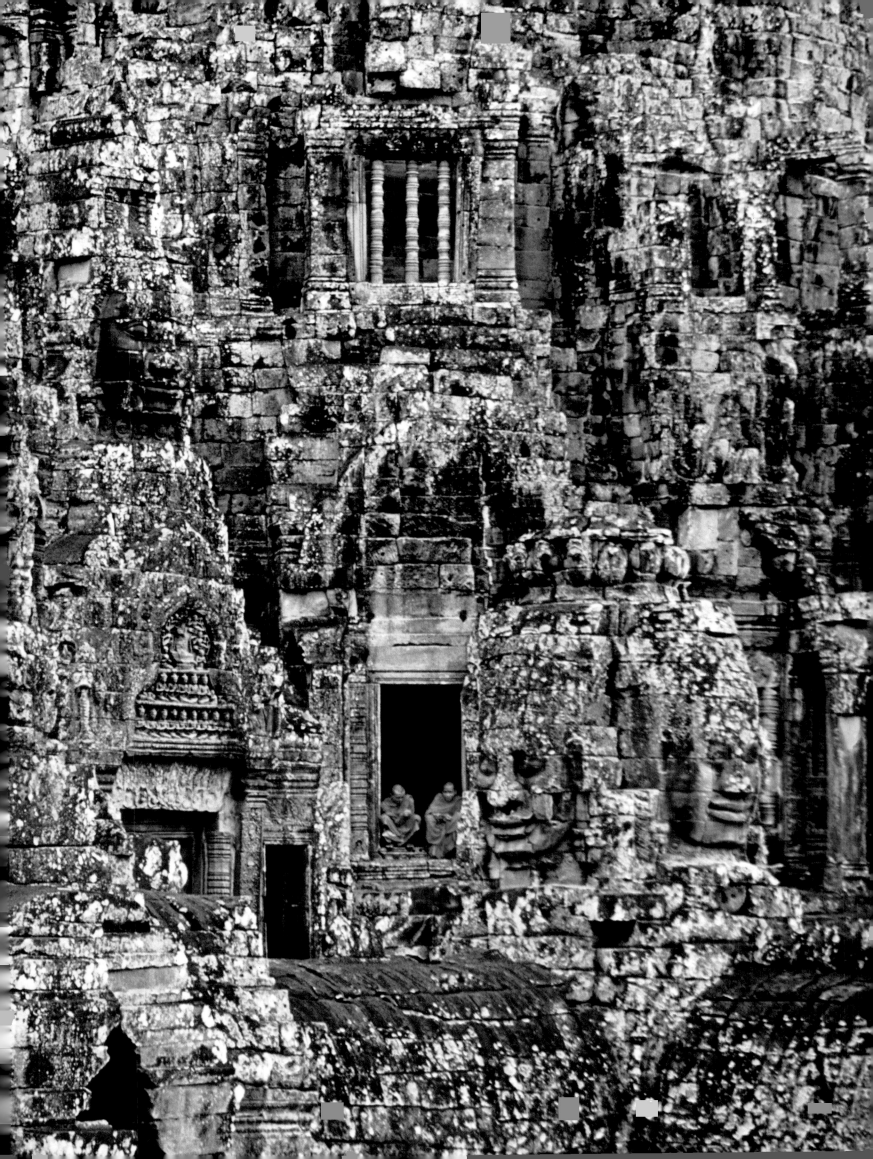

Ancient frankincense caravans on their way from distant Ophir to the Holy Land once trod this paved road through wheat terraces near Ibb in North Yemen. "Here I journeyed on some of the last caravans in Arabia, before the coming of the 'iron camels'— Land-Rovers and Toyota pickups."

Thomas J. Abercrombie

Young men from America and England paddled Japan's Inland Sea (overleaf) on what the National Geographic Magazine called a kayak odyssey. One of the paddlers also managed to be a photographer. He remembers: "We found many moments of beauty, poetry, and hospitality. But none was more golden than sunset behind this watery gateway." It stands as a traditional entrance to a Shinto shrine at Itsukushima.

Christopher G. Knight

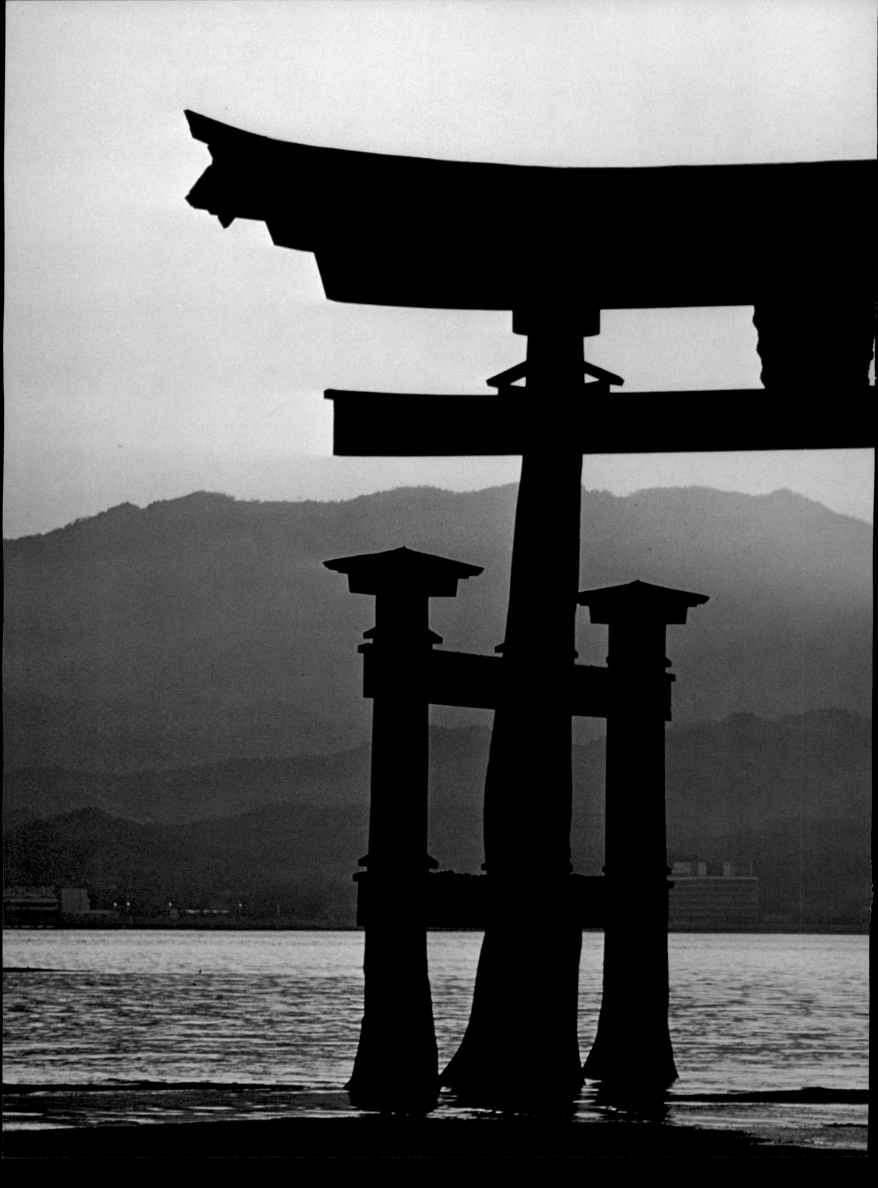

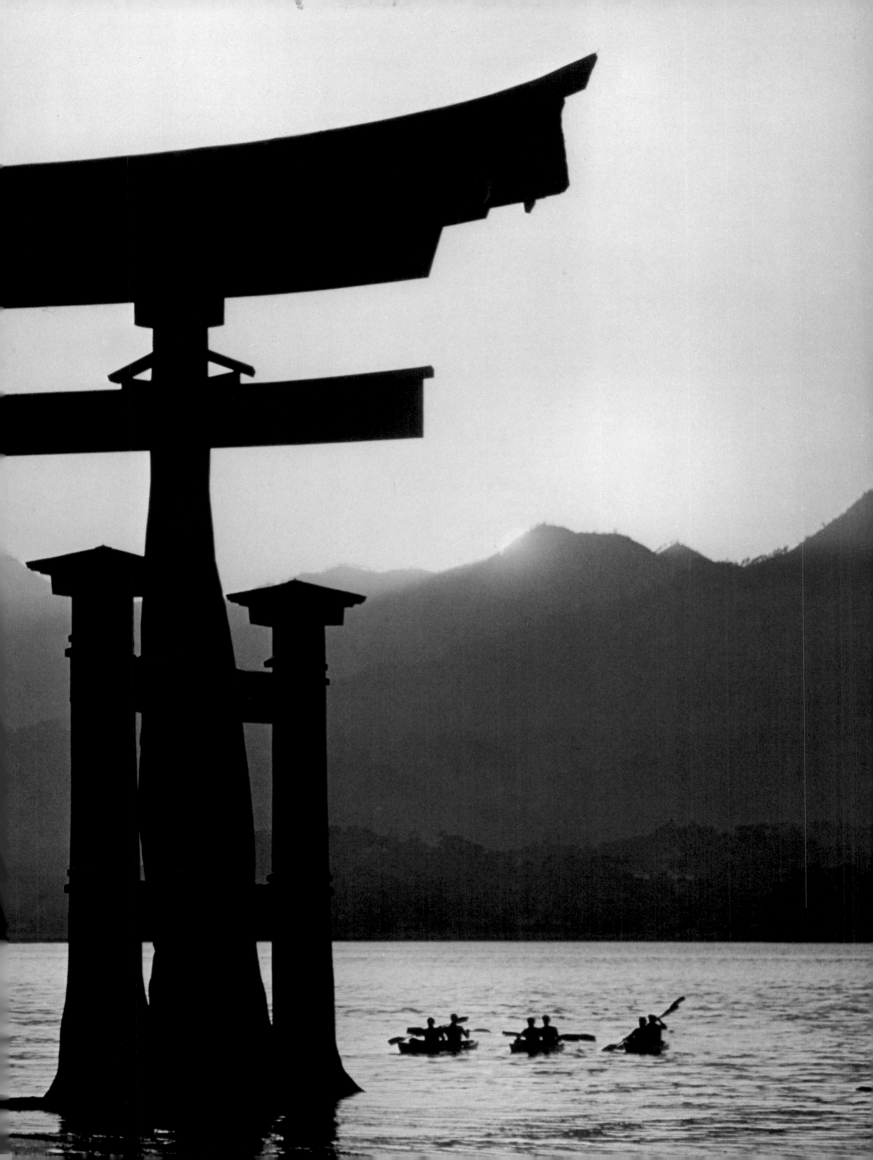

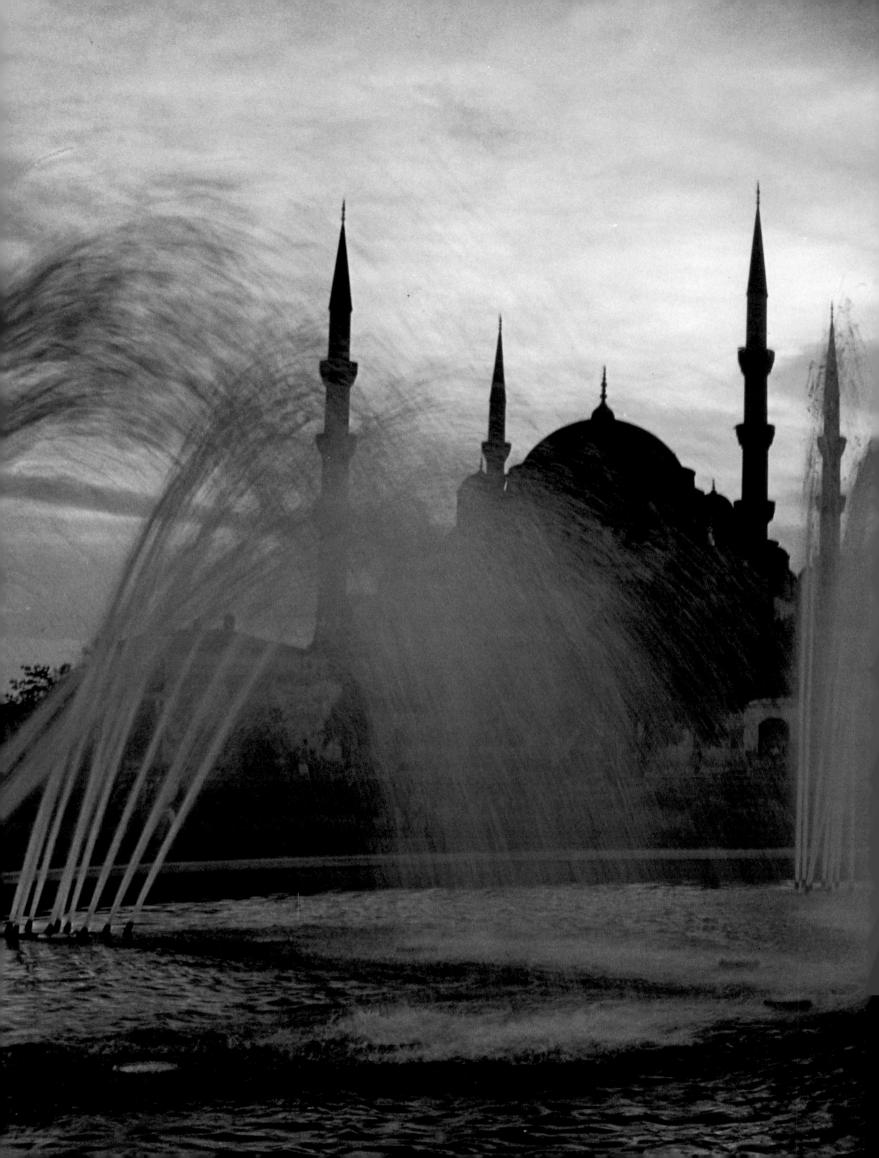

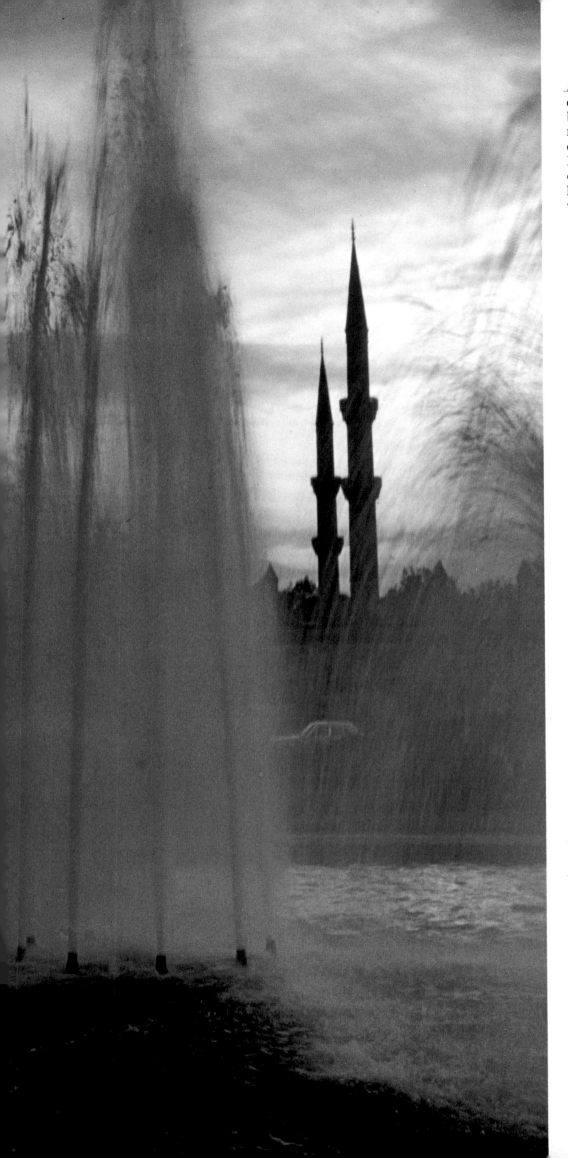

A recollection about Win Parks:
"He was really alive only when he
was looking through a lens. He
existed in a world of fantasy, whether
before such fairy castles as this Islamic
mosque in Istanbul, or anywhere. The
colors he loved most were soft ones.
He lived and breathed through a
camera, and preferred muted days,
like this one."
WINFIELD PARKS

Machu Picchu (overleaf) is a magnet
for tourists, who come to see this
long-lost fortress-city of the Incas.
How to evoke its past without its
present? "My pilot was an American
missionary. The aircraft was a Helio
Courier. It could slow down to 30 miles
per hour and had no wing strut to
obstruct the view of a wide-angle lens.
We could fly very close and almost
low enough to hide the tourist railroad
and the eroded switchback highway
that scars the other side of the
mountain saddle."
LOREN MCINTYRE

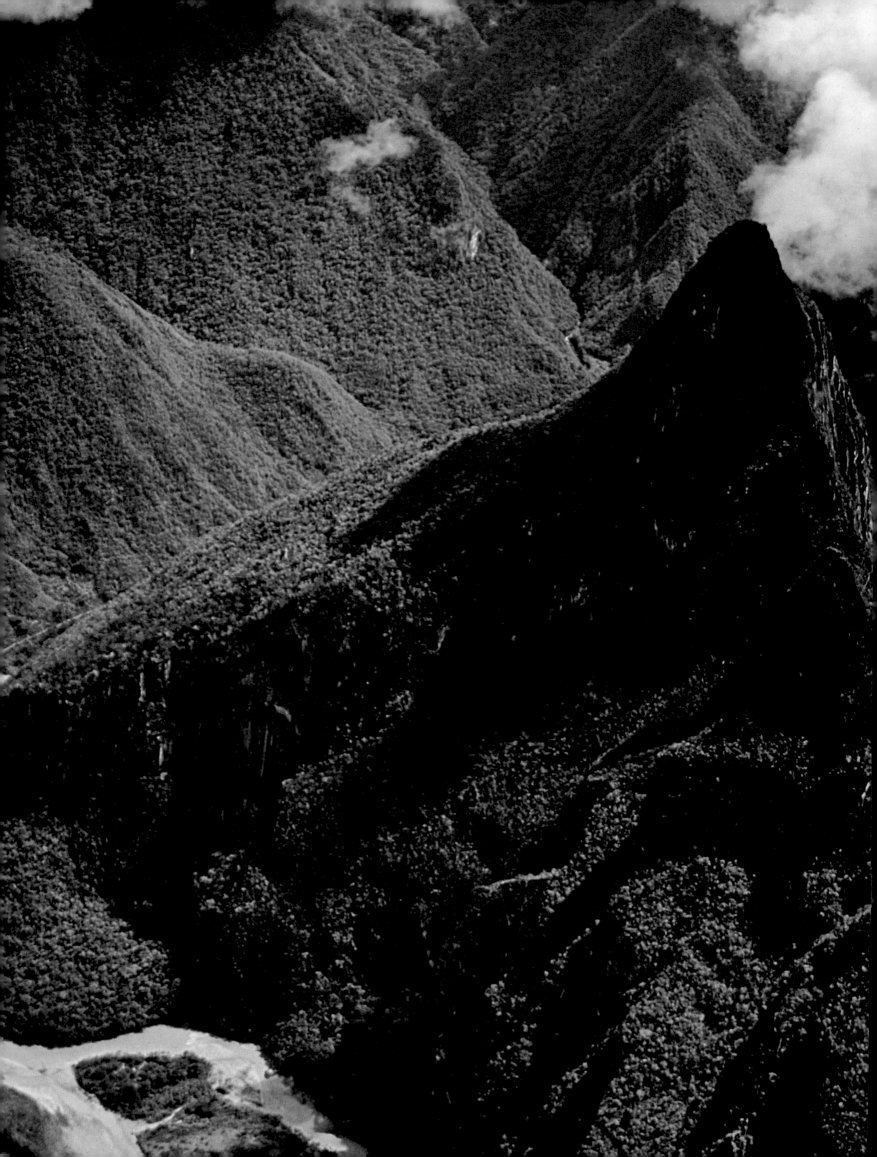

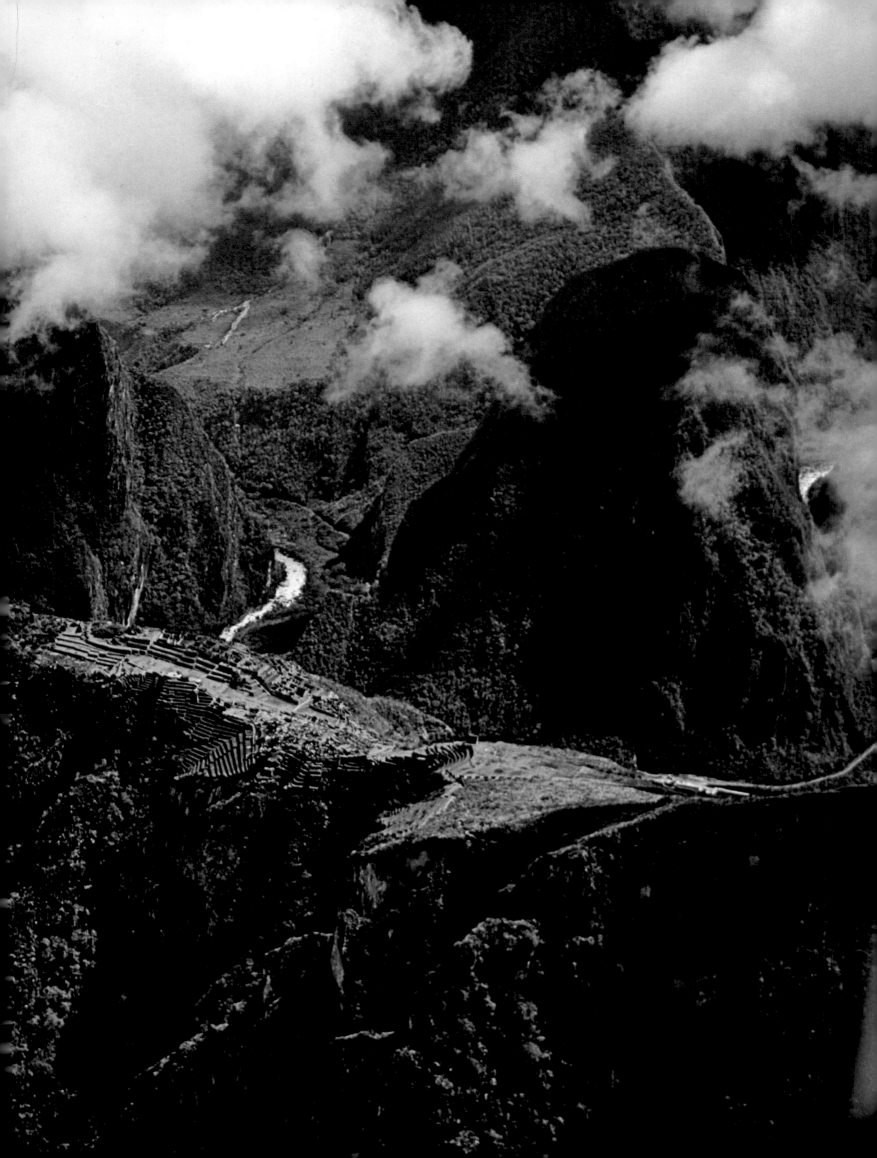

"Every sunrise and sunset, for about two weeks in various kinds of weather, I photographed Windsor Castle. The one day it snowed I worked several vantage points, catching the usual activities of people, along with these horses being exercised among the snowflakes. The carriage slipped by so quickly I could squeeze off only three frames. I thought we had a memorable image, but not until making an enlargement did we realize it was Prince Philip's royal four-in-hand competition carriage, with Prince Philip driving."

JAMES L. STANFIELD

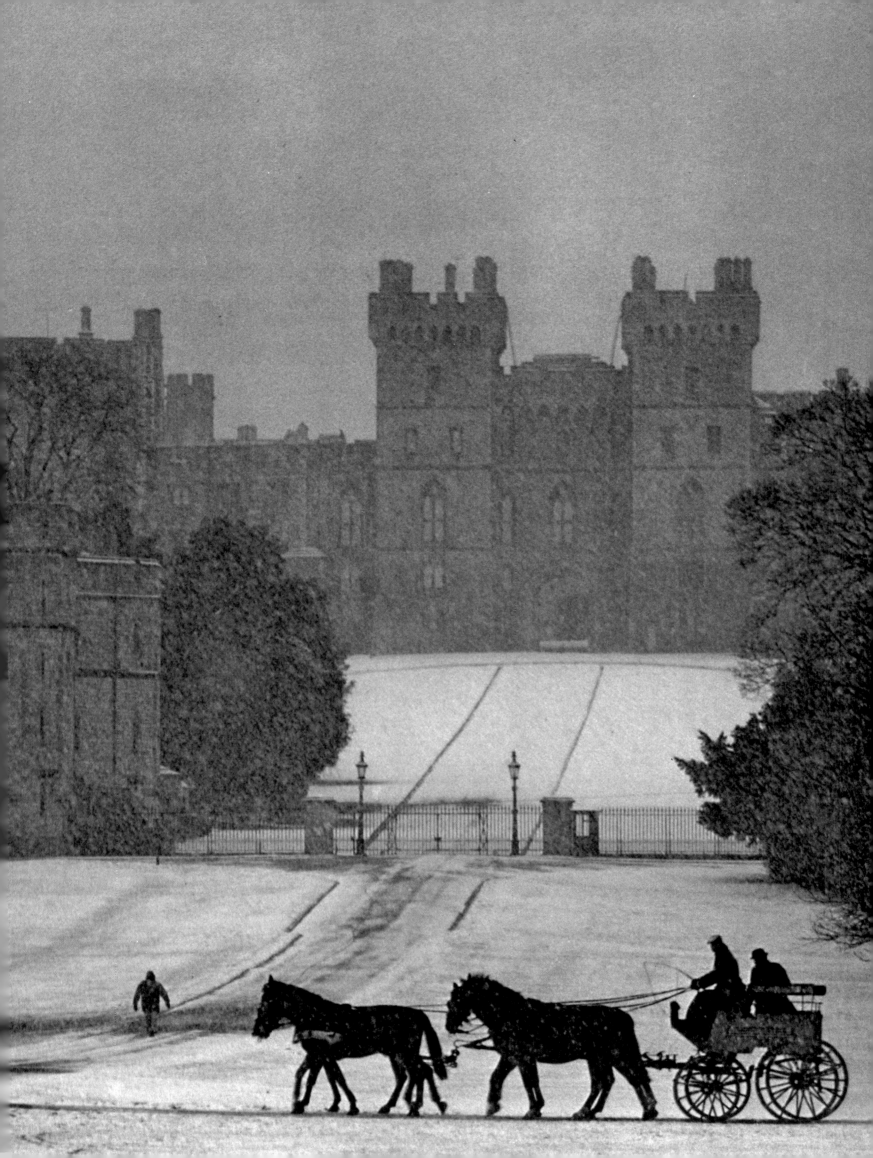

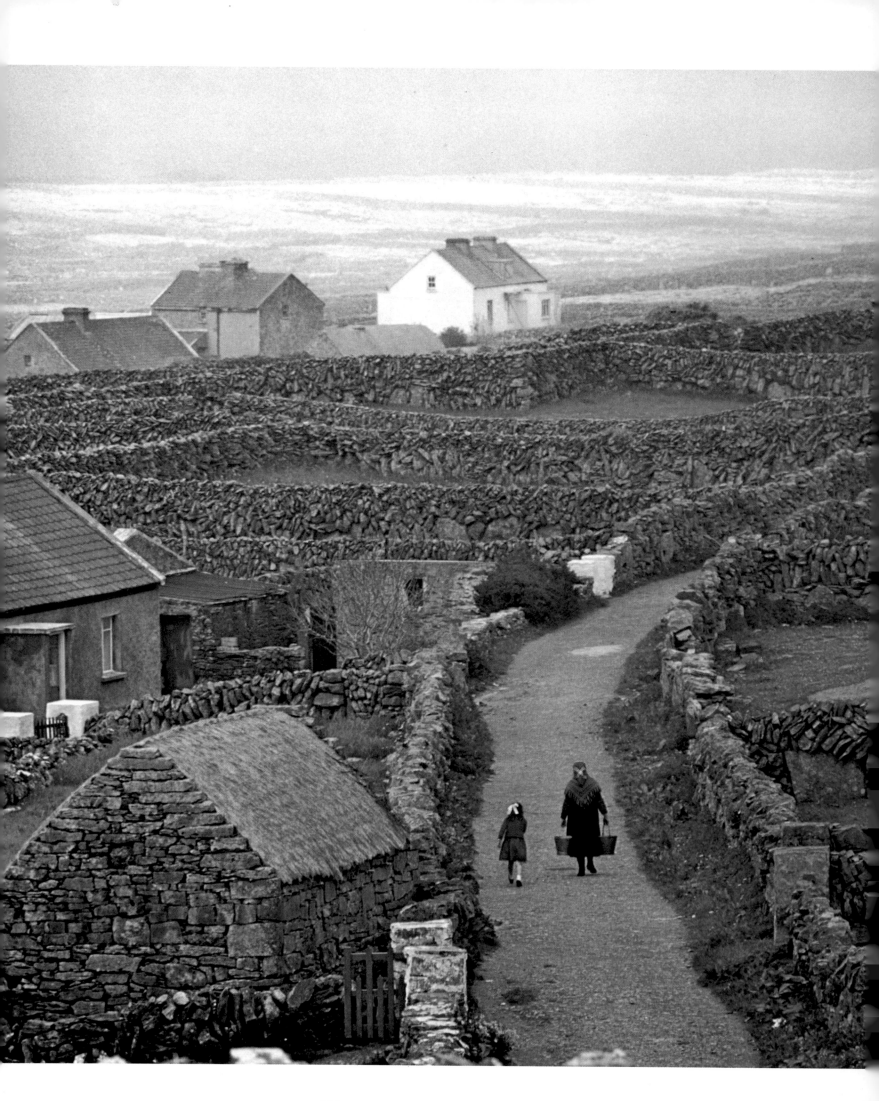

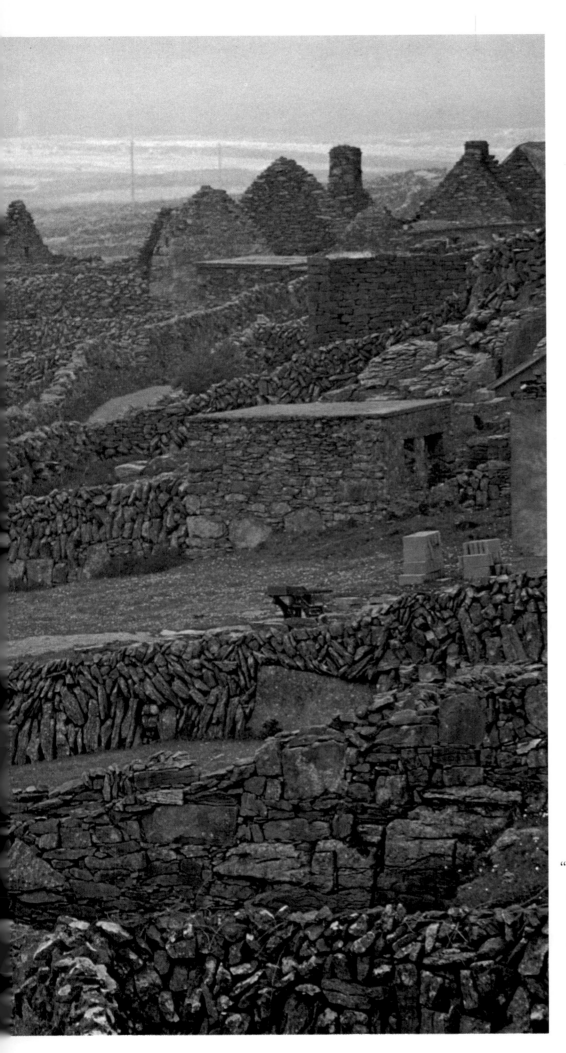

There are some places, Win Parks once said, where "you can't work because it won't stop raining." One such place was this—rocky Inishmaan, one of Ireland's Aran Isles. Parks often drew cartoons of himself on assignment, and in them he always had a dark cloud over his head; he felt pursued by rain. But he managed to overcome the rain— and what came with it. "You get despondent from the isolation, the loneliness," he said. "Enthusiasm is the key."
WINFIELD PARKS

"No license to photograph from the air. No permission to fly or land after dark. But I *had* to record the beauty of medieval Carcassonne by capturing the last touch of sunset (overleaf). I managed two shots. Then I looked down, directly into the faces of four French gendarmes, staring up at us. But they smiled and waved, and we flew off happily to land in a cow pasture by the pilot's house."
JONATHAN BLAIR

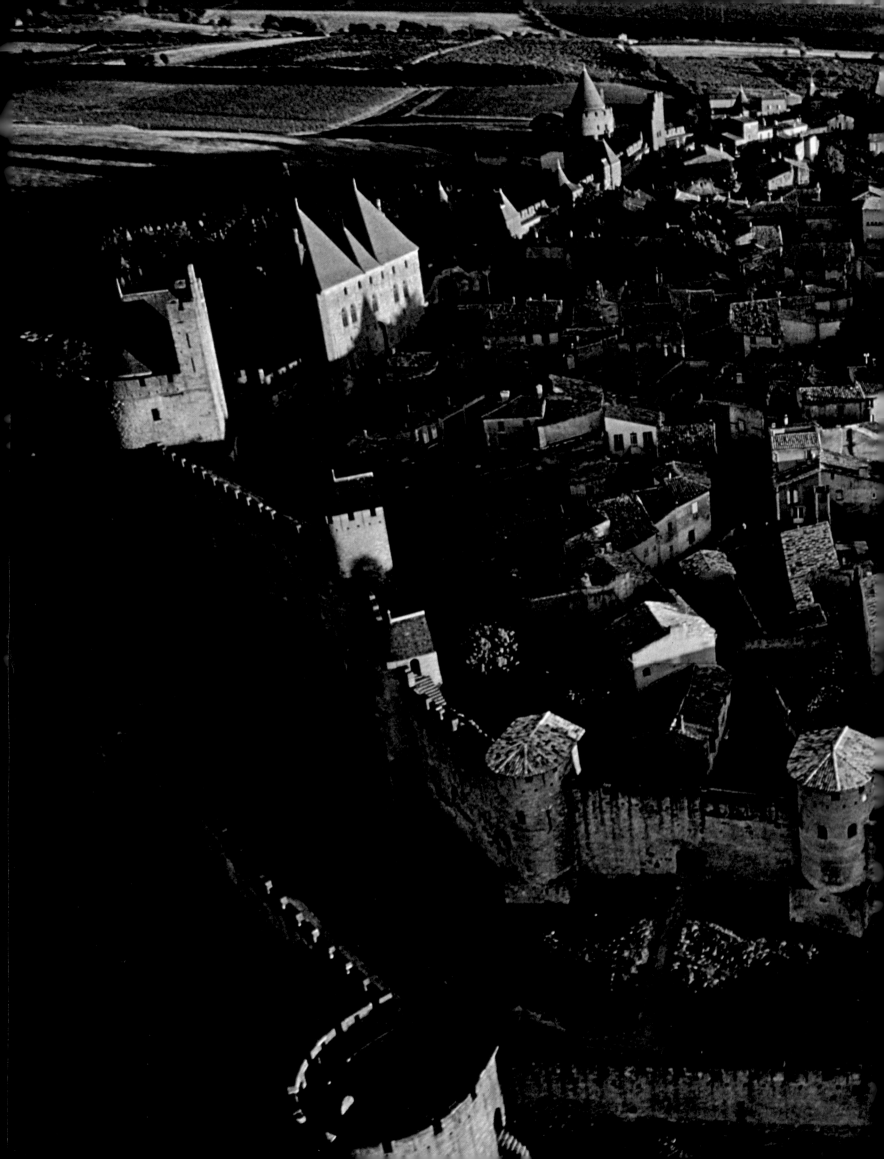

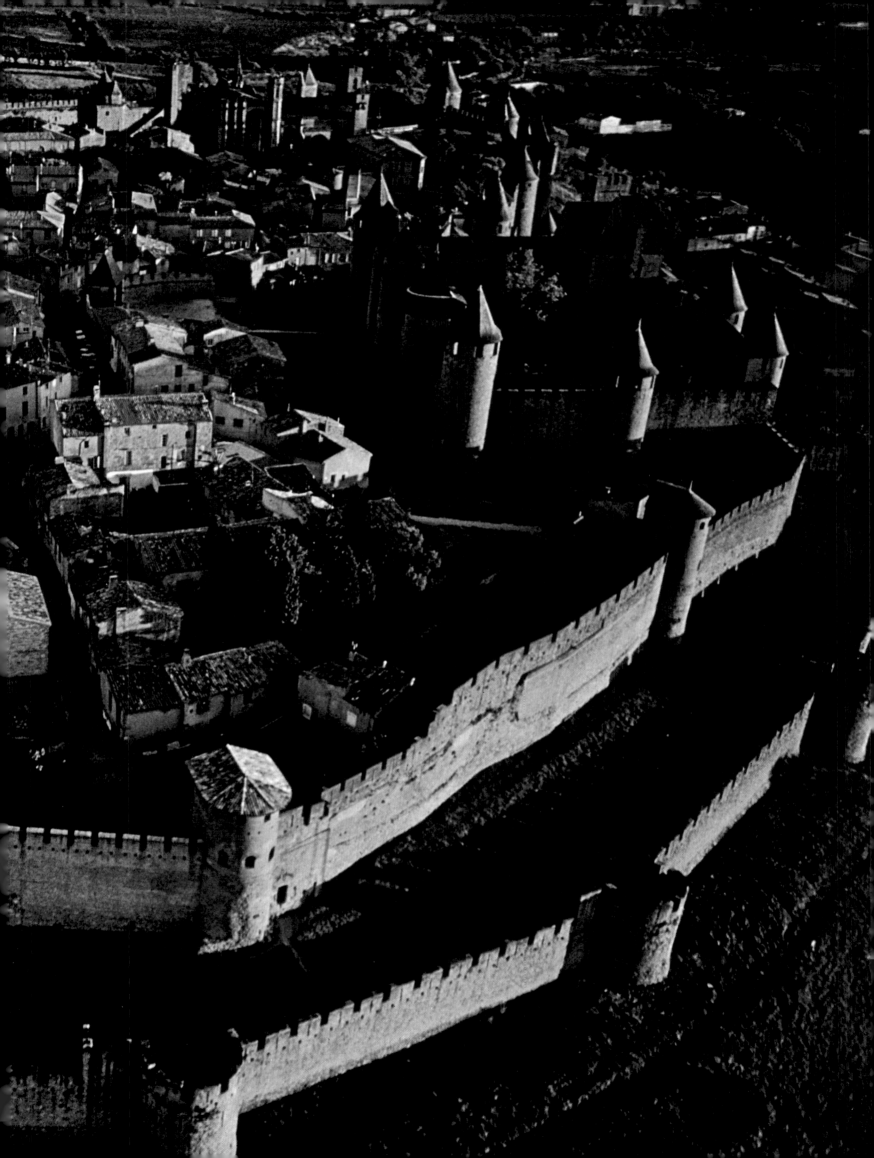

Keeping Reverence in Focus

By Thomas J. Abercrombie

The voice of the *muezzin,* multiplied by loudspeakers on Mecca's minarets, quickens the crowd flowing into the mosque for sunset prayer. I move with a tide of the faithful, each wrapped in simple pilgrim's white, through the marble arches of the Gate of Abraham.

"I bear witness, Muhammad is the Prophet of God . . . ," echoes the call.

From Baghdad, from Damascus, from Cairo, from distant Casablanca or Jakarta, from across the wide Muslim world they come, fulfilling a pious once-in-a-lifetime duty—pilgrimage to Muhammad's Holy City.

"Come to prayer. Come to salvation. . . ." The call grows louder as, veering from the crowd, I start up the dimly-lit minaret. Around and around I spiral on the rough stone steps. At a small window, halfway up, I pause to catch a breath and double-check the camera. Taped to its back is the small handwritten note, permission from the Keeper of the Mosque to make this climb.

Picking my way across lashed scaffolding that bridges a five-yard gap in the stairs, I flush two of the thousands of white doves that inhabit the sanctuary. I scale the last 150 feet in darkness, dizzied, my back pressed against the curving wall. One step toward the center of the tower would mean oblivion.

The dramatic scene I see from the topmost gallery stuns me. Thirty stories below, under the last shades of dusk, the multitudes complete the last bows of prayer.

"*Allahu Akbar!*" Their cries soar to a crescendo: "God is most great!"

The vista recalls some grand design. Marble walkways, radiating from the black-draped Kaaba in the center of the court, cross concentric rings of worshipers pressed shoulder to shoulder and limned by glowing circles of light. Framed by the long, arched galleries of Islam's holiest mosque, the scene traces the patterns of an intricate oriental carpet—an immense, living prayer-rug, made up of 250,000 people woven together by faith. The pattern breaks and scatters, as thousands make their final *tawaf,* or circumambulation around the Kaaba, to complete their pilgrim rites. Surely few but the angels themselves had been privileged to see such a panorama.

And none had photographed it. That thought suddenly jarred me back to the mundane. As a Muslim, I was a pilgrim myself. But, on assignment for the Geographic and traveling under the aegis of the Saudi Ministry of Information, I was also a reporter. Slowly I squeezed off a dozen time exposures of the churning crowds (pages 144-145) before climbing back down the minaret to join the human maelstrom.

For nearly a quarter-century the Middle East has been working its magic on me, ever since my first visit, a trip to Lebanon in 1957. At that time, centuries of foreign occupation and its mixed blessings were drawing to a close; many lands were in turmoil. All seemed down on their luck compared to time past, when Arabs ruled an empire as great as Rome's. But often through the Middle East's almost 6,000 years of recorded history its fortunes had crested, then plunged. Now new oil bonanzas were holding out promise of yet another renaissance.

Today our image of the Arab lands remains largely behind the times, bound up in clichés: sand dunes,

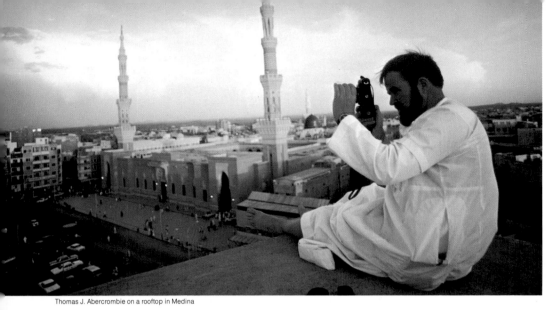

Thomas J. Abercrombie on a rooftop in Medina

"Guardians in this Tehran mosque forbade photographers. I appealed to the imam, who leads the prayers, and then to the congregation. Some members demurred and moved out of camera range. The devotions began, oblivious to my camera."

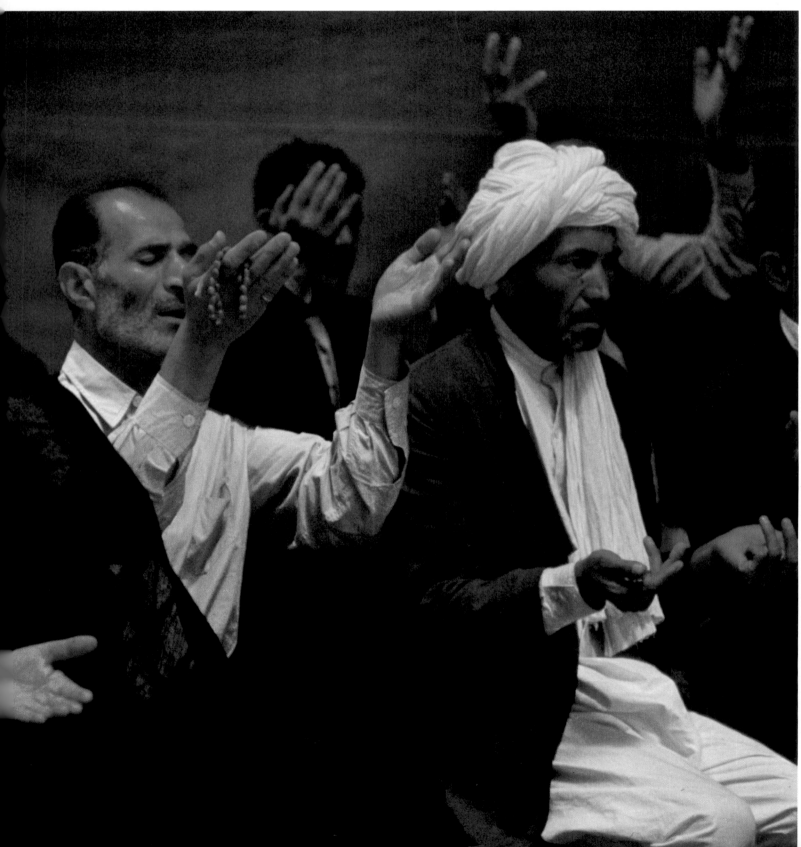

pyramids, camels, sheikhs, the Arabian Nights, and Hollywood parodies. Our daily news treats mainly war and politics. Ironic, that an area so strategically located, so vital to the oil-thirsty industrial nations, so steeped in the history of our own lineage, remains so dimly understood by us in the West.

To my photographer's eye, what makes the Middle East a joy is the time warp. Not yet homogenized by television and mass production, its diverse cultures still flourish on a human scale. Often I found them living out what seemed chapters in the history of mankind.

Over dusty tracks or down four-lane expressways, a Land-Rover became my time machine. I drove across the centuries, from Stone Age Bedouin in the sand mountains of Saudi Arabia's Empty Quarter to the old walled cities of Oman; then back to the computerized refineries of Algeria's Sahara, the Rolls Royce traffic of Bahrain's financial district, or the boutiques of war-torn Beirut.

Photographing in the Muslim lands is, admittedly, not without its frustrations; one needs some special tools in his kit. Four I never leave behind: research, a local contact, the Arabic language, and—above all—patience.

To an American on a first visit, the Middle East is a very different place, but even a modest advance study will provide a wealth of common ground. The earliest seeds of our civilization were planted here, in the homeland of ancient prophets and the wellspring of Christianity. Here great cities shone for millenniums while Europe was still a forest. Arabic-speaking savants of Spain and Sicily, writing on

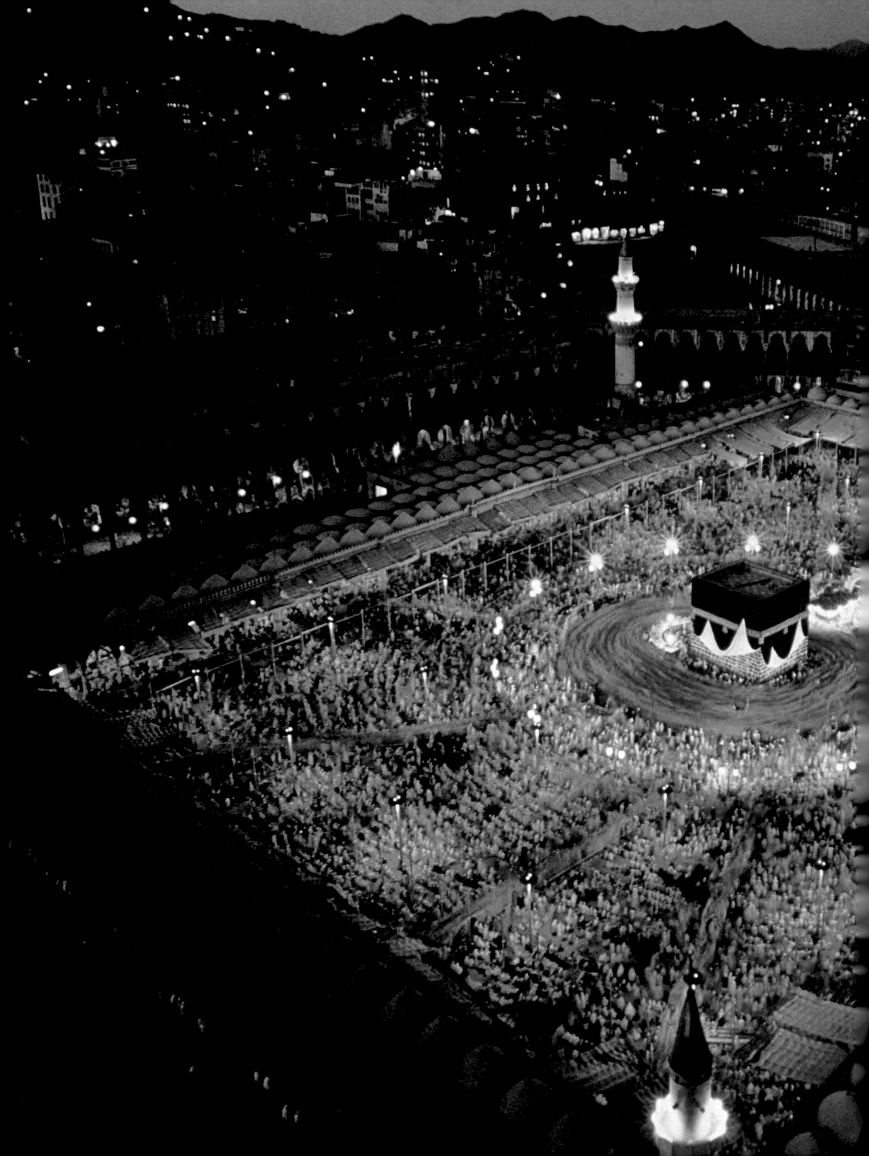

music, medicine, chemistry, mathematics, and astronomy, struck the first sparks of Europe's Renaissance.

The Arab shoulders a cautious sense of privacy—strangers at his door are not always on friendly missions. He has a passionate commitment to defend the family structure that he often projects beyond his house, into the neighborhood where his children play, his women walk. Here a camera can cause more anxiety than a rifle.

The best way to breach the barrier is to carry a proper introduction, a letter from the sheikh or the government. Better still, bring a live one, somebody from that particular tribe, village, or quarter of the city.

Fortunately, an Arab's caution is counterbalanced by compulsive hospitality. Once invited to the campfire, you can talk your way into the tent. This presumes you *can* talk. English and French, although spreading widely, are rarely dependable outside the big city. Without ability in the Arabic language, one stands deaf and mute. The most important gadget in my gadget bag is a small Arabic-English dictionary.

Despite mounting modern pressures, days and weeks measure most transactions, not minutes or hours; a calendar is as good as a wristwatch. Of my nine photographs in this book only one is a "grab shot." (Can you divine which?) The rest were bought with patience, and the time it took to become accepted, an insider.

"As-sabr muftah al-faraj," as Arabs themselves will say: "Patience is the key to paradise."

In its turmoil, the Middle East lies well this side of paradise. Yet for the camera's eye it offers feasts unrivaled in this temporary world.

Portraits of South America

By Loren McIntyre

The best way I know to beat the tropical heat at the mouth of the Amazon is to fly above the jungle crown in a small plane with the door off. The propeller drives a gale past the open doorway, which scoops wind into the cabin. It also scoops in engine noise. I have to signal the pilot by hand to put us into positions I need for picture-taking.

We fly low enough to recognize egrets in the treetops and spot dolphins in the river. We wave to riverboats with red lateen sails.

One day, low over the Amazon, my missionary pilot Paul Marsteller, who had been feverish, began to shiver uncontrollably. And something else was wrong. Neither of us could see Belém, our base. It lay hidden beneath an enormous black rainstorm.

As he circled in the gloom, Paul was getting glassy-eyed and slowly losing consciousness. His teeth chattering, he began to pray. I sat by the doorway with my camera. The sodden clouds opened for an instant, and I took the picture on this page. Paul banked toward the patch of golden light and landed safely. The flight apparently triggered cerebral malaria; Paul was hospitalized for weeks.

The harrowing flight had once again given me a glimpse of South America that I could share with others. And that is pretty much what my life with a camera is all about.

I started at 18 to take pictures in South America. I have lived or traveled there a total of 24 years since 1947. Many of those years have been spent photographing and writing for the National Geographic Society.

One highlight of my career came in 1971 when, together with a British mountain climber and a Peruvian mapmaker of the Inter American

Loren McIntyre, at the source of the Amazon, by Richard Bradshaw

Shrouded until this moment by a storm, the Amazonian city of Belém opens to a burst of sunlight—and McIntyre's camera. His pilot, fighting for consciousness, also gets help from the sun: He can land safely.

On a straw bridge swaying 60 feet above the Apurimac River, a Peruvian farmer cages the sides with small ropes. "The bridge has been rebuilt every year since the days of the Incas. When this is complete, not even a child can fall through."

McIntyre's friend Francisco Erize had set up his camera to photograph wildlife along the Argentine coast. "At first he stood his ground. But when the four-ton elephant seal got this close. . . ."

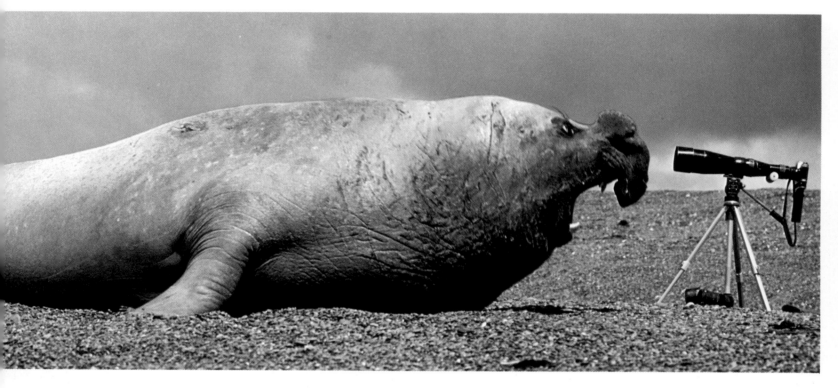

Geodetic Survey team, we discovered the source of the Amazon. Roped together, we climbed to 18,200 feet to reach an ice-covered ridge. We then descended a thousand feet to drink from an icy lake—the first water collected by the Andes to feed the world's mightiest river.

Later, another missionary pilot flew me to photograph the Amazon headwaters from the air. When we climbed toward the snow peaks of the high Andes, it grew colder and colder. Increasingly frigid air poured through the open door and into the backseat, whipping my parka and stealing heat from my body. At 19,000 feet, I snapped my first aerial pictures at the Amazon source.

My head was splitting with altitude sickness. Waves of nausea washed over me as I removed my gloves to photograph the icy source lake, since

named Laguna McIntyre. My gloves fluttered at the ends of a string threaded through the arms of my parka. My hands got so cold I could not pull the gloves back on. Nor could I properly fasten my seat belt. And now the plane was bucking in rough air.

To avoid getting thrown out, I jammed one bare wrist into the narrow crack between the front seats and clenched my fist, virtually handcuffing myself to the plane. I retched and shivered during the long flight back to Cuzco. My temperature fell so low that I had to be helped out of the plane and into a tub of warm water.

I keep returning to South America for adventure, for discovery, and to meet people I'll long remember. I found all those rewards the day I discovered the Inca-style suspension bridge made of braided bunchgrass

fibers (opposite). The abandoned bridge was strung across a gorge at about 12,000 feet. "Don't cross! The bridge is dying!" warned an Indian named Luis Choqueneira. "I am a *chaca camayoc*, a keeper of the bridge. We are going to rebuild it when the New Year comes. . . ." He invited me to come back and see.

I did. For several days I lived in Luis' house. I ate corn and guinea-pig meat with my fingers and slept sitting up, my back against the cold stone wall, like the rest of the family. One day, hundreds of Indians appeared with about four miles of straw rope to braid and hang the new bridge.

Three days later a footing of woven twigs was finished. I stepped out over the swollen torrent. I clutched the wet hand ropes and listened to the loud cheers, and for a moment I felt transported back to Inca times.

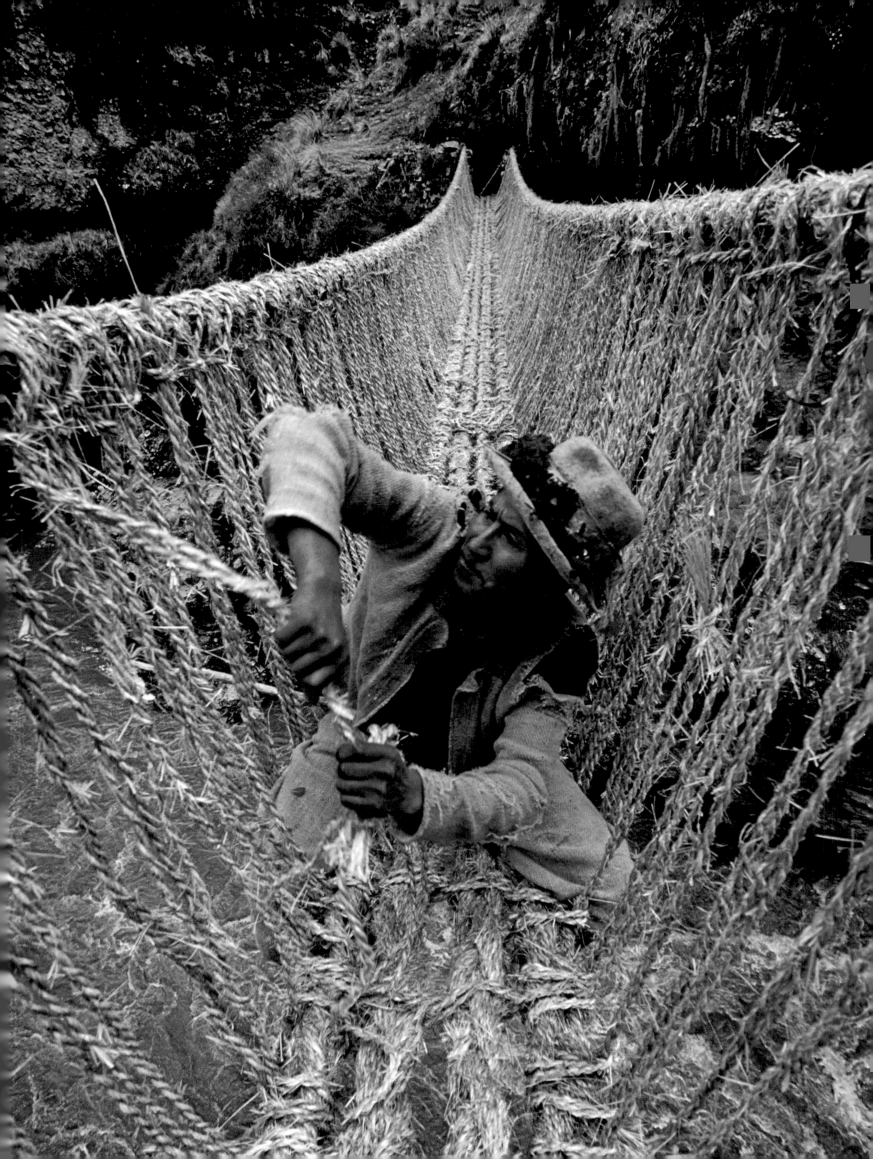

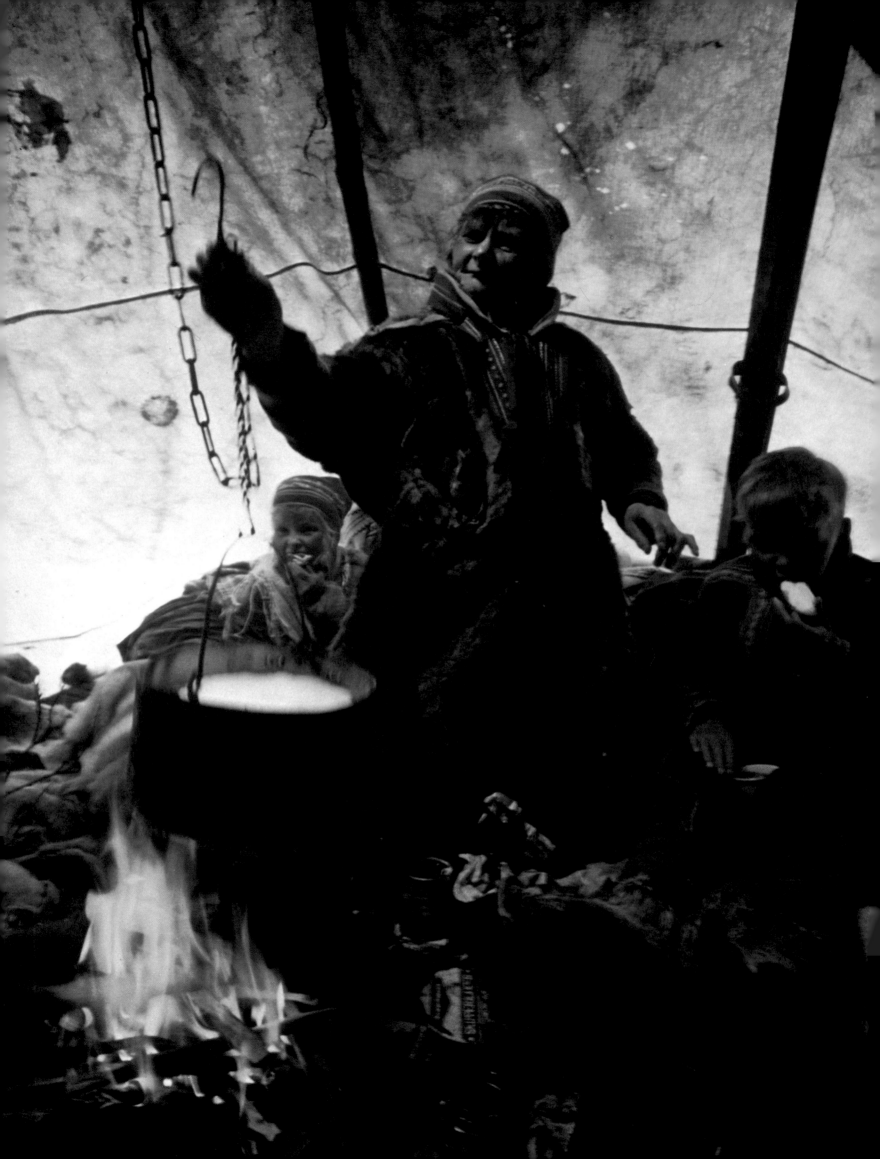

Warm Images in Cold Places

By George F. Mobley

Snow swirled from iced rocks to mingle with freezing ocean spray as our helicopter sought a perch on the narrow, boulder-strewn beach at Little Diomede in the Bering Strait off the coast of Alaska. Two miles away across the agitated sea hulked Russian territory. We brought emergency supplies for the tiny community of Eskimos clinging to the barren flank of this desolate island, and I planned to photograph the operation.

I was no stranger to Little Diomede. Ten years previously I had been marooned here for two weeks by arctic storms that pushed gathering winter ice toward us and threatened to extend my visit to several months.

After a quick greeting with old friends, I slipped a 15mm lens on my camera and proceeded to photograph the activity on the beach. As I looked through the viewfinder, a thick fog obliterated the image. There was no fog in the air, however, so I checked the camera. There, on the inside of the front lens element, was a perfect circle of white; moisture inside the lens had condensed as frost, rendering the lens useless.

It was a minor inconvenience; I had other lenses available. But the experience is typical of the frustrations that have helped turn my many trips to the Far North into a love-hate affair with the Arctic.

I love the Arctic. It's a vast region of sparse habitation, a mosaic of mountain and tundra, meandering river and bare rock, oozing bogs and eternal ice, unfathomable silence and shrieking storm. Here the low, rich light of early morning or late evening, glimpsed so fleetingly at more temperate latitudes, lingers for hours to caress wind-sculptured shapes of ice

and snow during the sun's transition from weeks of perpetual night to weeks of continual day. Here the still, chill nights of the long winter bring curtains of northern lights that dance before a backdrop of crystal stars.

The environment is extremely hostile, yet a small number of hardy souls have managed to adapt and survive: the Eskimos, Athapaskans, Lapps, and others. Many of them are people of great dignity, proud of their traditions and skills.

By dogsled or on foot, by umiak or kayak, they pursue the polar bear and walrus, the seal and the whale, or follow their herds of reindeer from season to season. Newcomers, in remote colonies insulated by modern technology, increasingly probe these desolate regions in a quest for Earth's scarce resources.

For the photographer lured by its beauty, the Arctic poses dangers and frustrations. The intense cold is hazardous to photographer and equipment alike. I can recall treks in the Arctic where all my layers of wool, down, and fur clothing couldn't keep me from chilling to the bone. And I can recall days on end in tents with Lapp reindeer herders in northern Norway or with Eskimos in the Thule district of Greenland, wondering if the howling winds would ever cease their attempts to rip the canvas apart.

The windward side of my body chilled and the leeward side drenched with perspiration, I struggled with Eskimo hunters to help a team of dogs pull a heavily laden sled up a precipitous arm of the Greenland ice cap. With heart pounding, I helped St. Lawrence Island Eskimos drag their heavy boat at a run across thin ice that had frozen on the ocean behind us during a hunt, blocking our

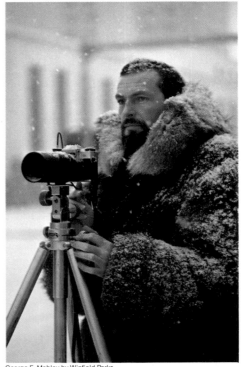

George F. Mobley by Winfield Parks

A Lapp woman (opposite) hangs a kettle over a fire to melt snow as she prepares a supper which she and her family will share with Mobley. "When I tried to imitate the traditional Lapp folk song, one of my friends rolled on the skin floor of the tent in near hysteria."

151

The son of a hunter in Siorapaluk, Greenland, was leaning on his bed and listening to his parents talk to the photographer from faraway. The friendly stranger turned—and the boy became an image of the universal charm of children.

Late-summer ice chokes the harbor of a fishing village in Greenland. After taking this picture, Mobley slipped and fell into the icy water. "Eskimos gathered and had a great laugh while I was swimming."

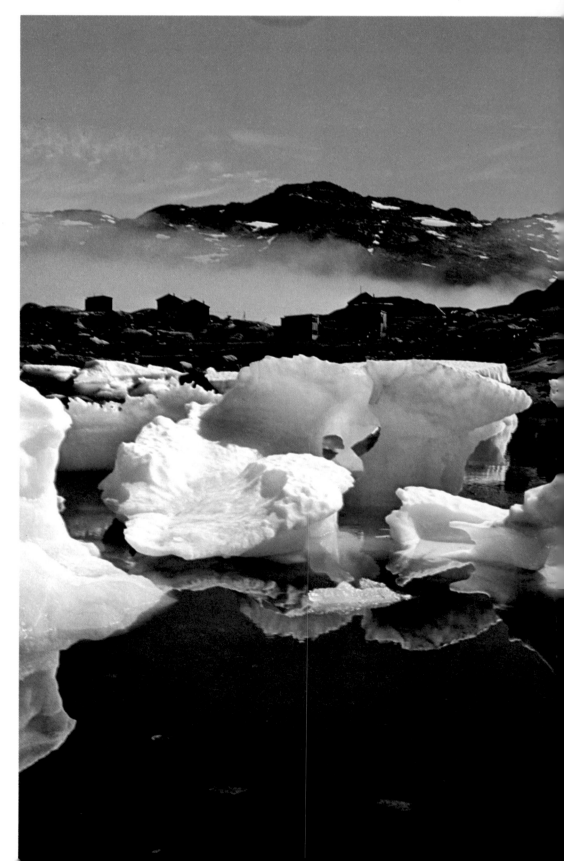

return to land. Often the ice would give way beneath our feet and we would scramble back into the boat to break a channel with oars until we again found ice strong enough to support our weight.

Somehow, after coping with the environment, I find a few moments to take pictures. It is, of course, difficult to manipulate a precision instrument like a camera while wearing heavy mittens and gloves. Yet, as soon as the gloves are removed, my bare hands quickly become numb and stiff and I risk the chance that my bare flesh will freeze to anything metallic. The best solution for me is to wear light wool gloves, whose warmth gives my hands a chance to function longer. I wear mittens over the gloves when I'm not taking pictures.

Cameras become temperamental in extreme cold. Modern electronic cameras become useless as soon as the batteries freeze up, so I stick to cameras with mechanical shutters. I can carry a light meter inside my parka, where the battery stays warm enough for the instrument to work.

Long ago I learned not to make the mistake of blowing dust off the lens. A frosted lens severely impedes clear photography. Sometimes the moisture from my eye will be sufficient to frost over the rear element of my viewfinder, making it impossible to focus until the frost is removed.

Film becomes brittle, and many a time I have sat in the snow clipping a new leader onto a roll of film to replace the one I had broken in my haste to reload. A nice new plastic camera strap, so soft and pliable in St. Louis, may resemble a grotesquely twisted metal spring in the Arctic.

Even the milder seasons are not free of hazards. Probably the closest I

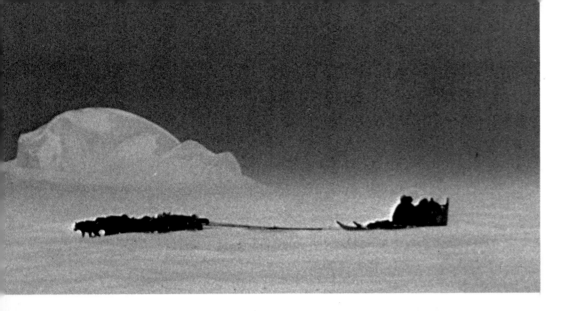

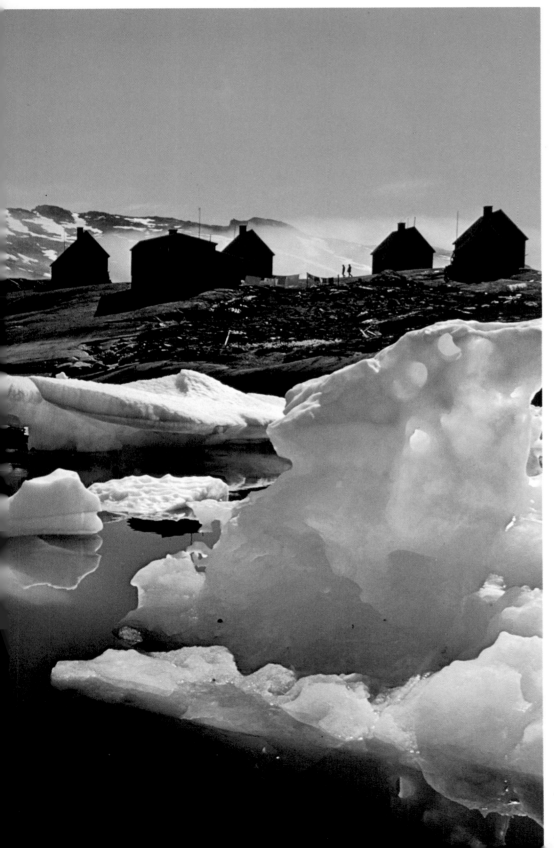

ever came to not returning from an assignment occurred during the spring breakup, that time of the year when the ice breaks up in arctic rivers and they are awash with great floods of melting snow.

Two Lapps, my interpreter, and I were trying to make our way up the flooding waters of an icy river to an isolated Lapp village in far northern Finland. Our riverboat tangled with white-water rapids and sank, carrying all four of us into the violent, freezing current. It is somewhat difficult to swim through white water dressed in heavy parkas and boots. But somehow, by the barest of margins, we all managed to crawl ashore onto the snow. We were numb with hypothermia.

Seized with violent shivers, we gathered dead wood from stunted birches that grew in the area, and one of the Lapps soaked it with a bit of gasoline from a near-empty can he had used as a float in his struggle to make it ashore. But none of us had waterproof matches. In desperation I searched the pockets of my dripping parka. Wrapped inside a spare pair of gloves was a box of matches, damp but not soaked. After several attempts I finally struck a tiny spark, and the gasoline burst into flame.

We pressed close to the fire, slowly absorbing its warmth. For half an hour no one spoke, but we all looked at one another and then we looked at the river. And we all knew how close all of us had come to losing our lives in the Arctic.

Yet time and time again I have returned to the Arctic, and I know, when the opportunity again arises, I will once again be unable to resist its beauty and mystery.

The Photos Tourists Never Get

By Vic Boswell, Jr.

They come by the millions and they travel for thousands of miles. They are the tourists, and they can be found wherever there is something to see—and to photograph: the pyramids and museums of Egypt, the temples and artifacts of Greece, the paintings and sculptures and monuments of Rome.

But in the rush of tourism, people usually don't have time to take more than a few hand-held photographs. Tourist cameras may even be forbidden, particularly in museums. And in some dingy places where cameras are admitted, a tourist may get no more than a smudged view through an unwashed glass case.

As I photograph at the shrines of art and archaeology, I see tourists by the thousands. Some of them, watching me with my lights and cameras at work in the Egyptian Museum in Cairo, the Sistine Chapel in Rome, or the Louvre in Paris, may have even guessed that I'm the most fortunate tourist of all. For I have hours, maybe days, sometimes weeks to spend in the presence of such wonders as Venus de Milo, Donatello's *David,* or Queen Nefertiti (opposite).

Sometimes, though, my assignments are intimidating. Particularly if they're suddenly thrust into my hands the way Nefertiti was.

The day I photographed this 3,300-year-old treasure in the Egyptian Museum, the attendants simply carried Nefertiti to me, placed her on a shaky pedestal in an aisle, and left me there to defend her from an inundation of

The art of Boswell's lighting bathes the art of an unknown Egyptian sculptor. The subject is Nefertiti, the queen of Pharaoh Akhenaten.

Vic Boswell in Egypt by Ahmed el Maghalawi

tourists who came tripping through my cables and spotlights to peer or question or try to touch. Before she was safely back in her glass case, I'd aged nearly a millennium myself.

Sometimes, when I walk into hallowed places, I feel unworthy even to be there. Consider an unreconstructed Protestant like me, for example, being sent to photograph the ceiling of the Sistine Chapel at the Vatican in Rome! Here Michelangelo worked for years, climbing scaffolds and lying on his back some 80 feet above the stone floor, to paint and immortalize his visions from the Bible. For nearly five centuries his frescoes have awed pilgrims to the chapel.

But modern Italian artisans, working beneath Michelangelo's ceiling and in the aura of all the popes crowned in this chapel, do not seem hypnotized into humility. I learned

this when I worked there. My assistants taught me to think of the chapel as they did—as a workshop. Magnificent, but still a workshop.

Rigging scaffolds and lights—20,000 watts of tungsten, hundreds of feet of cable—we worked all night for seven nights, while the tourists slept. I could speak only pidgin Italian; the three electricians did not speak English. But we managed.

To make certain that the cameras were perfectly placed for each segment of the 133-by-43-foot ceiling, we used plumb bobs and levels. We wanted a perfect representation for publication. And the photographs would be reassembled to reproduce the masterpiece, as a ceiling nearly 40 feet long, for exhibition in the Society's headquarters in Washington.

Even surrounded by such inspiration, you can't work all night in Italy without a time for wine and cheese. And where did my Italian friends choose to sit down to share the pizza of our midnight snack? Right on the altar steps! I'm afraid that I had trouble swallowing my first sip of wine. But, when in Rome. . . .

Then the time came to photograph "The Last Judgment." Michelangelo had returned to the Sistine Chapel at the age of 61 to spend seven years painting this panel. His searing vision of the saved and the damned is on the wall behind the altar. Candles and a soaring golden crucifix loomed in the way of my lens when I tried to photograph the mural.

My Italian helpers did not hesitate. They simply dismantled the candles and crucifix, put them on the floor, and then signaled to me, atop a ladder 20 feet high and 50 feet away. I offered up a prayer for forgiveness as I pressed the shutter.

The Past, in Double Exposure

By Gordon W. Gahan

Carrying today's cameras, I walk through history, photographing yesterday's world. I have evoked the past in the National Geographic book *Voyages to Paradise: Exploring in the Wake of Captain Cook,* and in such Geographic Magazine articles as "Captain Cook," "Sir Francis Drake," and "Minoans and Mycenaeans: Greece's Brilliant Bronze Age." To carry out those assignments, I needed more than my camera and my imagination.

I needed to know where to aim my camera. That meant research. I had to go where the past could be found. That meant travel. And I had to take advantage of accidental discoveries. That meant luck—and being prepared for the luck when it appeared.

I am now in the midst of my latest Geographic assignment—Napoleon. Looking back at how I started, I remember my desk piled high with history books. I also remember long talks with the writer and the picture editor assigned to the Napoleon story. We all soon realized that the Battle of Austerlitz would be as important to the story as it was to Napoleon.

I decided that I would put myself on the battlefield on the anniversary of the battle, which was fought on December 2, 1805. So on that day I walked with my cameras across miles of frozen Czechoslovakian farmland. I had two facts culled from my research: it snowed on the day of battle, and the sunrise that day was so spectacular that soldiers called it "the sun of Austerlitz."

In my photographs I was able to silhouette against a blood-red sun the lone tree marking the spot where Napoleon directed his troops. I was also able to photograph snow falling upon a stone cross that marks the mass grave of hundreds of men. I worked hard to find the angles that gave me images without telephone lines, highways, and other intrusions of the modern world.

But sometimes the intrusions aid the photograph. Trying to capture the burning of Moscow, I found a viewpoint that put the historic Kremlin churches against a sky made smoky and red—by steam rising from a power plant early in the morning. Thanks to a modern sight, my pictures of the Kremlin give the appearance of a city put to the torch.

Luck and planning had given me the snow and sun of Austerlitz. Frequently, though, the job of recreating the past becomes much more complicated. For the article and the book on the voyages of Captain Cook, I searched for sights that I could photograph 200 years after he had seen them. I learned, for example, that he had observed walrus herds while he was in the Arctic looking for the Northwest Passage. The walrus are still pursued by Eskimo hunters, just as in Cook's day.

A succession of commercial jetliners got me to the Bering Sea. Sled, snowmobile, chartered aircraft, and finally a walrus-skin boat got me to Little Diomede. There I not only photographed Eskimos at work (pages 284-285) but I also joined them, participating in an event that Cook had experienced.

Often, because I am armed with so much research, I set off for a place quite sure about the sort of photographs I want. But what I see when I get to that place can give me a nasty surprise. This has happened to me enough to make me keep a balanced mind—flexible enough to adjust to

Gordon W. Gahan and friends in Australia by William R. Gray

Evoking the age of Napoleon, Gahan costumes the past. Cadets of the military academy of Saint-Cyr wear authentic uniforms and wield authentic weapons. But Gahan did not ask them to reenact an actual battle. By coming in close to frame a few soldiers, he kindles the imagination but does not strain it.

"The Volcano," Captain Cook wrote, ". . . vomits forth vast quantities of black Smoke. . . ." On one of the islands Cook named the New Hebrides, Gahan finds the volcano, the smoke—and adds human scale to the scene.

real conditions, but firm enough to find a photograph that recreates the mood of times past.

I eagerly anticipated photographing Captain Cook's first anchorage in Australia. Then came the surprise: Charmingly named Botany Bay was nestled between a large international airport and an oil refinery. There seemed little chance to do a photograph recreating the pristine beauty of a once secluded spot.

But, quite by chance, I learned that a local school's botany class was planning a field trip to the bay. This gave me an ideal situation to photograph because the field trip revived the reasons why the anchorage was called Botany Bay. Cook gave it the name for "the great quantity of New Plants . . . collected in this place." Now, so many years later, young Australians were finding, examining,

and tagging some of the same species collected during Cook's voyage.

Photographs of this field trip replaced the ones I had planned. But I have to change my plans so often that I now count on such surprises.

Sometimes I can just turn my camera toward an everyday event and focus on a bit of history. Because a happening is ordinary, at least to the people in it, the very ordinariness of the event keeps it alive. Continuity can be a preservative, keeping the past fresh and vivid.

For instance, Captain Cook had had a great feast on the island of Lifuka, in what is now the Kingdom of Tonga. Dishes he knew—baked pig, fish drenched with coconut milk— were served up to us on the island by the Anga'Unga family. Our host spoke of the living tradition I was photographing. "We are a small

country," he said, "but our pride runs deep and our heritage is strong."

I have been helped many times by people who shared their heritage with me. I have also been helped by people who have studied the past and have been kind enough to guide me there. I especially remember a retired professor from Oxford who took me into his small cottage and told me about his thoughts on Napoleon. As I listened to him, I realized that in a few months of work I had to translate into photographs ideas which this man had developed from a lifetime of study.

I am not a historian. But I know that I want my coverage of subjects to be both historically accurate and photographically successful. For me, the story is a success if the reader can be brought to the same level of curiosity and excitement about the subject that I experienced.

I hope that my photographs bring to the reader what my work brings to me: questions, more questions, and a fascination with history. A grower of taro roots in French Polynesia put it this way: "What you want to know nobody knows. What you want to see cannot be seen. It is gone. But please send me your magazine. Maybe your words will tell it, maybe your pictures will show it. I hope so. For these things interest me greatly."

"They get fire . . . with two peices of stick very readily and nimbly. . . ." From Cook's writing Gahan translated this scene. The Aboriginals are preparing for their own commemoration of Cook's exploration.

In the shadows of Gorée Island, off Senegal, Gahan finds shackles evoking the slave trade. This starkly limned moment recaptures a dark passage in the life of Sir Francis Drake, who once sailed with a slave fleet.

THE EYE OF SCIENCE

A bombardier beetle's hot spray frozen by sound-triggered flash. By James P. Blair.

"I have often thought I should like to go on the banks of Newfoundland and fish with a telephone." The Class of 1914 may have raised an eyebrow or two, but the commencement speaker moved right along. "If you were to send the transmitter down among the codfish with the bait, perhaps you would find something there to hear."

Such was the mind of Alexander Graham Bell—always striking the known against the unknown to see what manner of sparks might fly. As second president of the young National Geographic Society, he bent the twig toward the bright sun of scientific inquiry. Ever since, the pages of the Society's magazine have chronicled the saga of science.

Eleven years before that speech at a school in Washington, D. C., Bell's young son-in-law—then the magazine's new Editor—bought "a 4-A folding Kodak, for which I paid more than my month's salary." With his new camera, Gilbert H. Grosvenor "embarked upon picture-taking, beginning by making . . . photographs of Dr. Bell's kites" as the scientist probed the secrets of flight. Half a century after his budget-bending plunge into science photography, Grosvenor circled the North Pole in an Air Force plane at the age of 77 and became the first to pinpoint the position of the Pole from aloft by photographing the spot from all directions.

In those two missions, Grosvenor touched both sides of science photography. One side is the interpretive, the portrayal of scientific achievement. The other is the investigative, in which the camera becomes an essential tool of the scientist.

Photography, almost since its birth, has been the handmaiden of science. A primitive photograph of the moon was made in 1840. Soon scientists were taking flash pictures by igniting magnesium, and devising techniques to freeze the beat of an insect's wing and the everyday balancing act of a woman descending a stairway.

By the end of the century the Geographic had barely outgrown infancy. But photography had already seen beyond visible light. In the broad spectrum of electromagnetic energy, science had discovered a mysterious emanation that could plunge through the living body and emerge with a ghostly glimpse of structures within. Baffled by his discovery, Wilhelm Roentgen named it the X ray.

Eventually all of the spectrum would be found and photographed—infrared and ultraviolet, just beyond the eye's reach; radio waves and gamma rays at the spectrum's edges.

"With the possible exception of computers," wrote Geographic staffer Rick Gore in 1978, "the camera and newer imaging devices are the most important scientific tools of this past century. . . . Cameras extend our vision immeasurably, showing us what is too fast or too slow, too bright or too dim. . . . Cameras go where we cannot and document what our memories might soon distort or disregard, or what time and progress will destroy."

Cameras extended our vision into the vestibule of space in the mid-1930s. By the oldest means of human flight, the balloon, Army pilot Albert W. Stevens took the first photographs of the curving top of the troposphere, the "dust sphere" at the bottom of our planet's sea of gases. Earthbound eyes could now see in a photograph the actual curve of the globe.

Stevens nearly remained earthbound himself when the balloon exploded in 1934 during its first attempt. Scientists worried; would the Society extend its support for another attempt? Grosvenor replied: "Carry on. Finish the job."

In 1932 Stevens looked earthward from an airplane at 27,000 feet and photographed the moon's advancing shadow during an eclipse of the sun. Eclipses have always caught the eye of the Geographic. A team in 1936 made one of the first color records of the sun's corona at the instant of totality. In 1948, seven teams fanned out from Burma to the Aleutians; the 100,000 frames they shot helped determine the exact size and shape of the Earth. And in 1952 a team photographed the stars surrounding a total eclipse, shot them again in the unobstructed night sky—and by comparison showed that the sun's gravity bends starlight as Albert

U. S. Army Air Service. National Geographic Magazine, July 1924.

Flanked by camera and oxygen cylinder, Army pilot Albert W. Stevens peers from the oxygen mask that let him photograph the Earth from six miles up— a record high for pictures in 1924, but routine for airline passengers today.

Albert W. Stevens, U. S. Army. National Geograph c Magazine, March 1937.

Explorer II floats over South Dakota in 1935. A joint venture of the Army and the Geographic, it reached 72,395 feet and brought back the first color picture from the stratosphere—a view straight up through a gondola port (left).

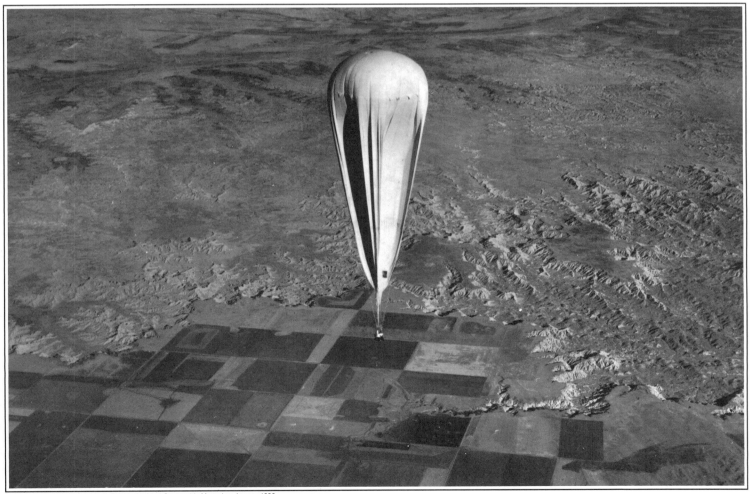

M.Sgt. G. B. Gilbert and Capt. H. K. Baisley. National Geographic Magazine, January 1936.

"Like getting a long-range gun into action," said the Geographic's account of the effort to set up a 14-foot-long telescope on an ancient burial mound in Russia. Its camera took pioneering color photographs of an eclipse; opposite is the first ever published.

Einstein had predicted nearly 40 years earlier.

Millions of galaxies, billions upon billions of stars made their pinpoint images on the 1,758 photographic plates of a seven-year Sky Survey completed in 1956. This joint endeavor with Palomar Observatory mapped the cosmos to a depth of a billion light-years, unveiled new comets and asteroids and clusters of galaxies, and gave science enough data for a century's research.

The eye of science and the pages of the Geographic have peered into space and time to the emergence of life itself. Today the camera and the computer still work at taking apart the innermost workings of life and matter.

Together, a camera and computer precisely charted the subtle temperature ranges of a star 500 light-years away and produced in blues and oranges the most detailed view ever made of a star other than the sun. The feat was like picturing a sand grain a mile away. Incredibly fast "streak cameras" peer into the microworld of subatomic particles to see what happens when they are hit by a laser pulse lasting less than a billionth of a second.

Satellites and space probes show us our planet from afar and its neighbors up close. Cameras record the behavior of humans and animals, the opening of a rosebud, the swirling of a distant storm.

And now the eye of science has begun to see not with film but with "charge-coupled devices"—tiny electronic chips called CCDs. In a new technology known as imaging, CCDs have plunged to the ocean floor and recorded unique life forms in startling detail.

"Right now we are the cutting edge of the imaging technology," writes Emory Kristof, a Geographic photographer and expert in the new science of filmless electronic photography, or imaging. "As the electronic cameras improve, I want to bring them out of the depths and use them on surface assignments. They are our future."

Merriel M. Gardner and (opposite) Irvine C. Gardner. National Geographic Magazine, February 1937.

Gilbert H. Grosvenor. National Geographic Magazine Cumulative Index 1899-1946.

Alexander Graham Bell, sitting in sunlight soon to go dim, prepares to view the eclipse of May 28, 1900. The great inventor helped keep the Geographic attuned to the march of science.

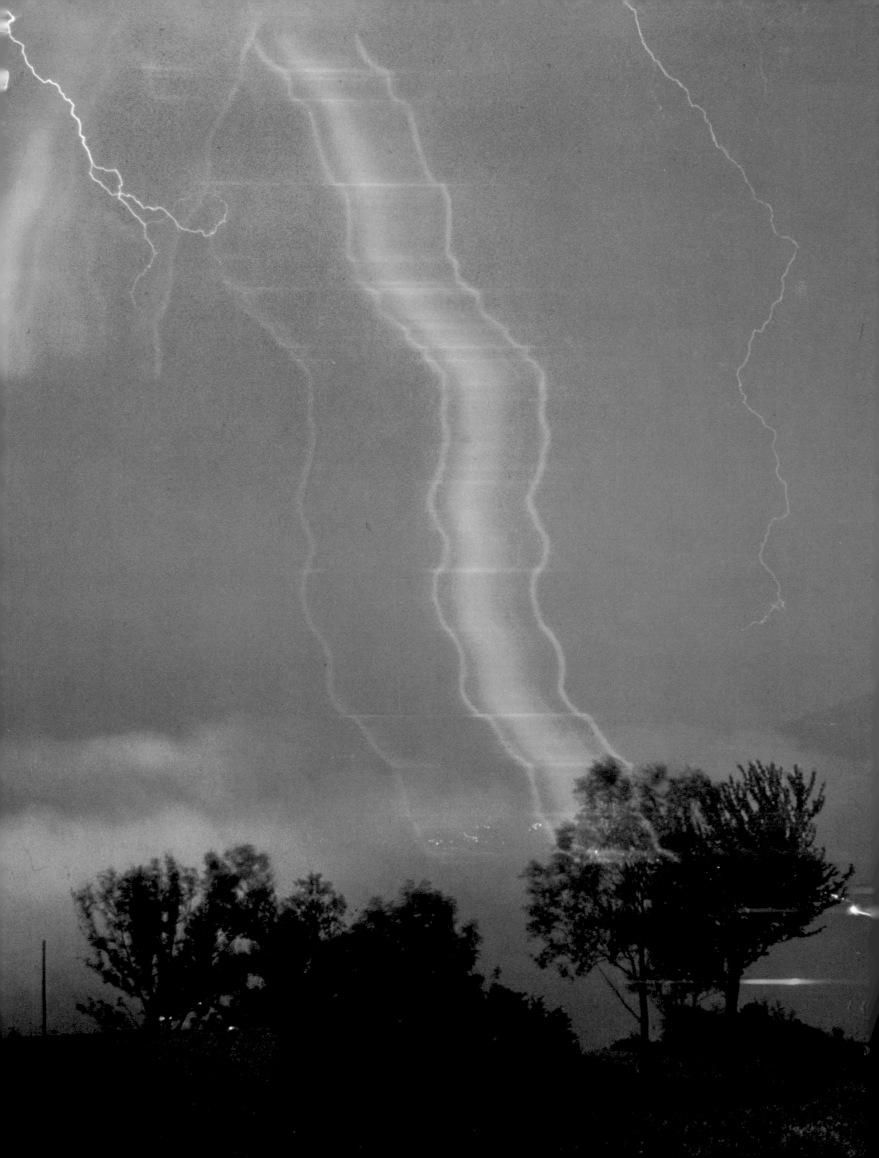

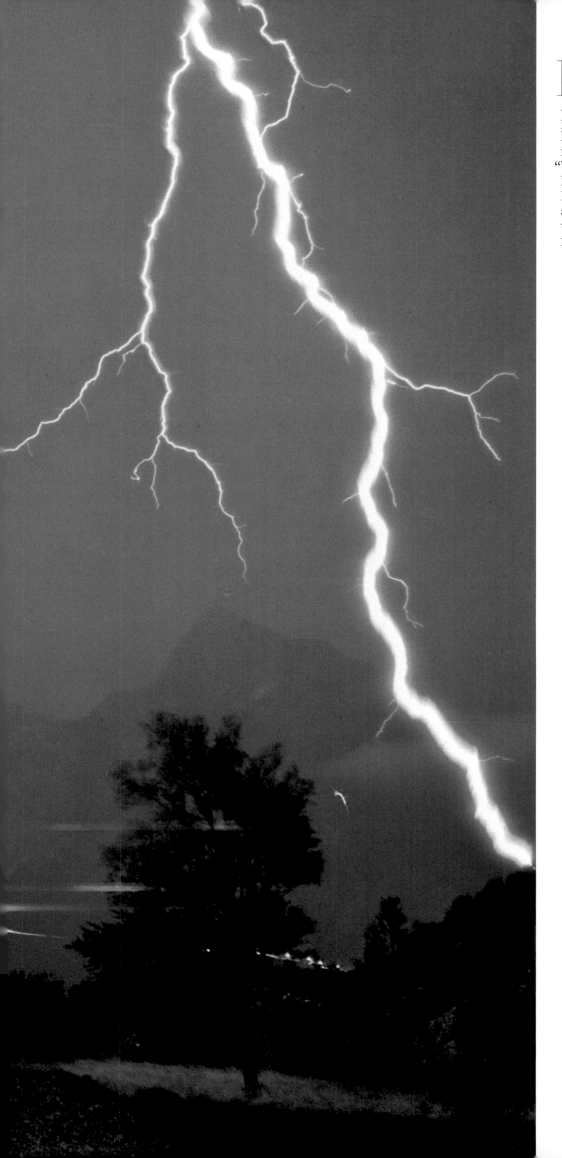

Lightning jabs its forked lance into a hillside in Switzerland—and signs its ghostly autograph for science. In an echo image of reds and blues—produced by a diffraction grating on the lens—the scientist-photographer identifies gases formed within the bolt. "We actually use black and white film," he explains. "It's much easier to analyze. But color produces pretty results. So we also shoot color; it helps us tell people what we're doing."

RICHARD E. ORVILLE

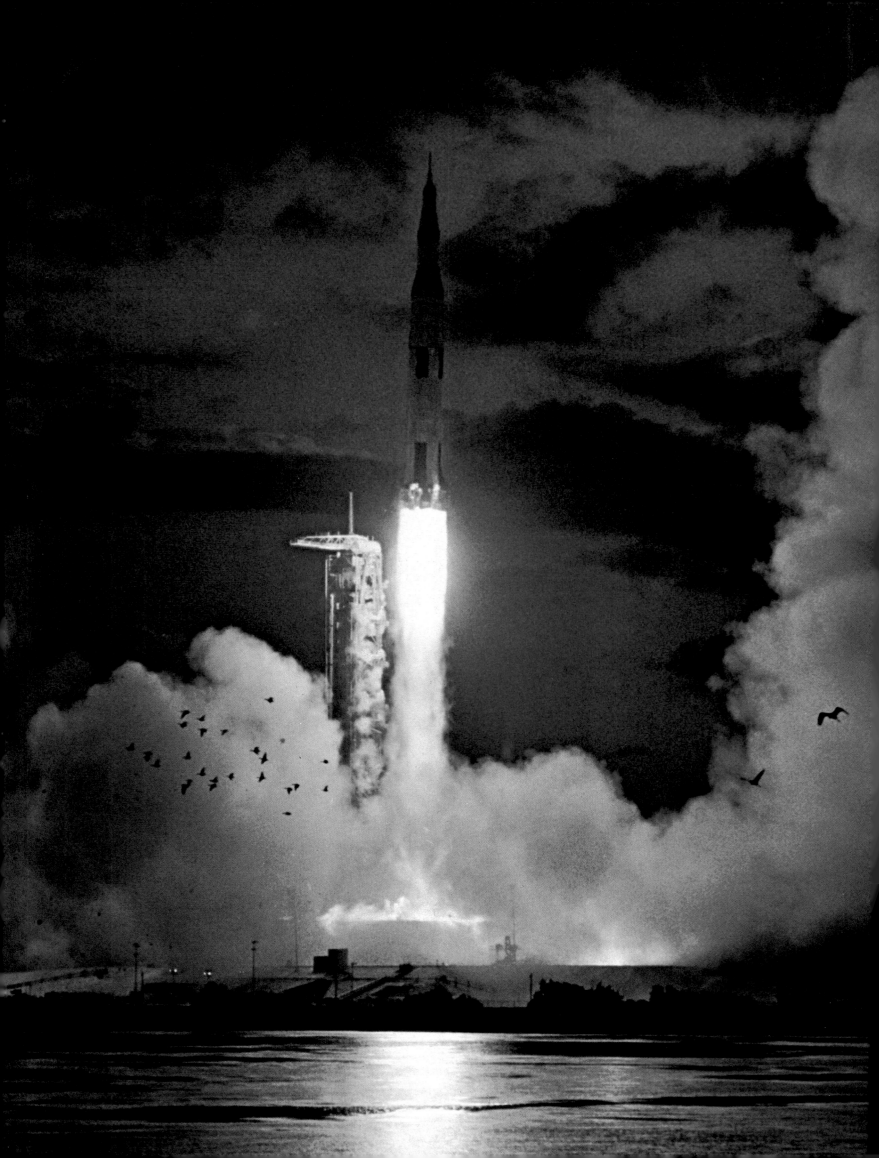

Birds and rocket lift into a Florida dawn. "I chose a spot where birds gathered, hoping the blast would put them to flight. The birds make this shot more than just a science documentary."
JOHN E. FLETCHER

Whirligig chair tests an astronaut's control—and a photographer's ingenuity in capturing its gyrations on film. Dean Conger fitted the chair with lights, made a long exposure, then froze the action with flash.
DEAN CONGER

In one of the first color portraits ever made of the heavens, the Great Nebula of Orion (overleaf) blazes in colors neither an eye nor a telescope can discern. But a camera, its shutter opened for hours, can find such hidden beauty. "Only through the camera's eye," wrote the photographer, are "the beauties of the heavens . . . revealed in unparalleled splendor."
WILLIAM C. MILLER

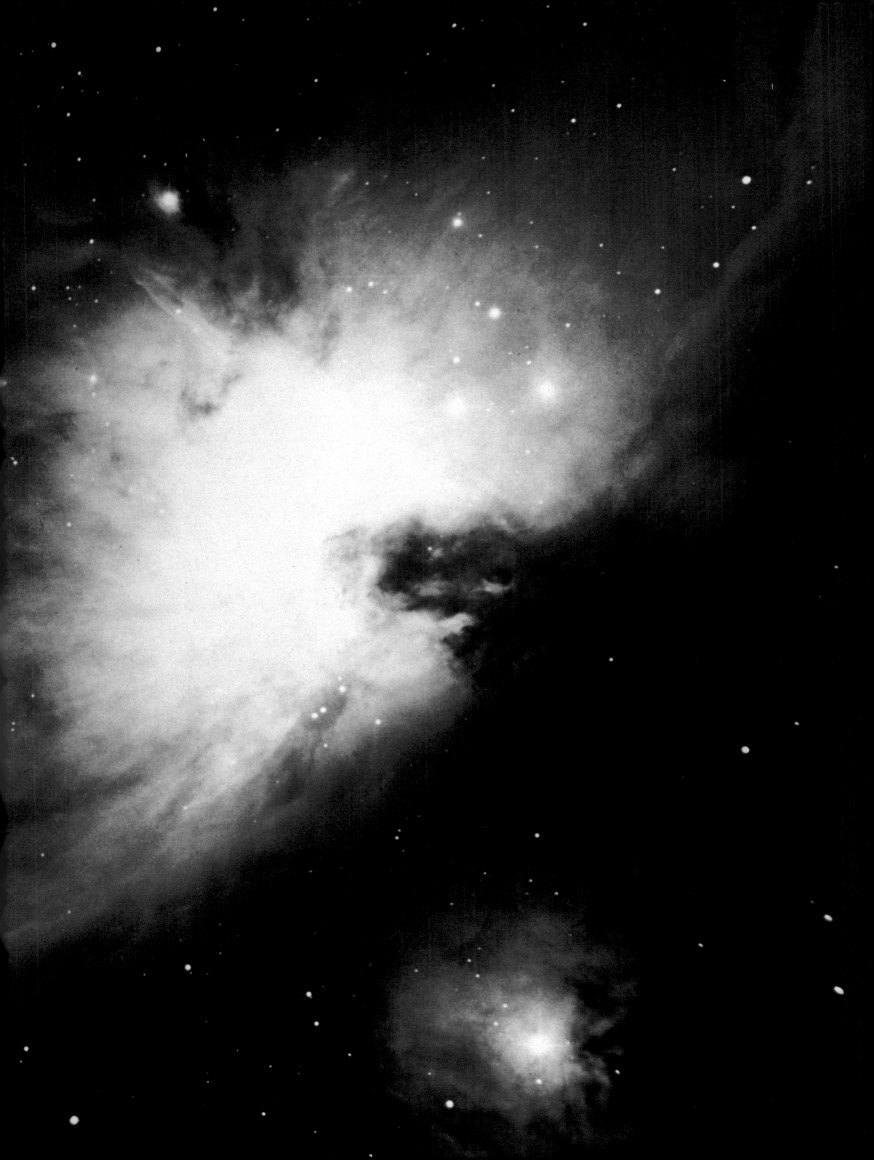

"What's in a laser beam? I had no idea; the concentrated streak of light from this one was invisible until it hit something. That was the challenge: to see the unseen and catch it on film. Smoke blown into the beam turned it into a rod of light; a prism split it into blues and greens; and a strip of poster board caught the colors. The scientist sat still for 40 seconds—and we had a picture."
Jonathan Blair

"I'd worked for weeks on a fiber optics story, but felt I hadn't really shown what these tiny 'light tubes' of plastic or glass looked like. So I taped a bundle to an ordinary flashlight, and then photographed as my own fingers held a gossamer bundle of light."
Fred Ward

From the stacked images of an electron density map came a spidery model of a molecule. Then from careful planning came a portrait of them both—the map lit by a light table, the model set aglow by ultraviolet lights.
BRUCE DALE

"I call this an environmental portrait. Dr. Cyril Ponnamperuma is recreating in a flask the atmosphere of primitive Earth and the lightning that may have triggered life. As in reality, the man and his work are one."
BRUCE DALE

A laser works its dazzling magic on barely a hundredth of a watt from a lofty perch in the Washington Monument. "We had no idea what to expect. We just knew there would be an intense red light from the monument. So teams of Geographic photographers were stationed two miles across the Potomac River to get the shot we needed—a photograph that would give a highly technical story a feeling of down-to-earth human scale. The starbursts come from bright lights exposed at a small lens opening. The halo probably was caused by reflections in the lens from this amazing light source." ARLAN R. WIKER

A cancer detector draws a floating grid of light as a tiny red bulb on its moving head traces its scan pattern in the dark. Strobes lit the room after a 25-minute scan.

Emory Kristof

A utomation lands a jetliner—and the achievement is recorded in a time exposure (overleaf) by a remote-control camera on the plane's tail. Airport and city lights draw a graph of the last 23 seconds of flight.

Bruce Dale

I n the vivid imagery of a computer a human brain yields its inner structure. Scientists can study, photograph, and color-code its parts from any angle or cross section they choose.

Robert B. Livingston

Catching an Airliner by the Tail

By Bruce Dale

It was an interesting suggestion, and I thanked them for it. Why not fly alongside one of their jumbo jets in a helicopter, said the aircraft maker's spokesmen, and shoot my pictures from there as the big plane landed?

Maybe they had a daredevil chopper pilot in mind. But I had no daredevil photographer in mind for the kind of flying it would take to get the picture I wanted—a dynamic picture full of motion and drama from a vantage point right on the jetliner's tail. Not close to it. *On* it.

I had seen movies shot by cameras mounted on airplane bellies. The results are quite dramatic as the plane sucks up its landing gear and the ground falls away. But as picture editor Al Royce and I kicked around ideas for a National Geographic Magazine story on aviation safety, we realized that for a still image what we

wanted was a photograph from the airplane's tail. Would it work?

We took our idea to the airplane manufacturers. One offered us the helicopter idea but could offer little else. It would cost too much, it would tie up an airplane too long, and it probably wouldn't work anyway.

The people at Lockheed were skeptical but intrigued. They lent me a large model of their L-1011 TriStar, and with a wide-angle lens I tried photographing from the model's tail at about the same angle that a camera would see if mounted on the tail of a real TriStar. As I suspected, those trial shots came amazingly close to the real thing.

Next I flew to California to talk about the project with Lockheed. Was it technically possible to mount a camera up there? Would the air be stable? Would the plane "fly right" with a new shape in the slipstream?

What could we expect for airspeeds, temperature changes, vibration?

One by one, the doubts fell away. The plane could take on two cameras with no ill effect. The airflow up there would be smooth. And the pictures could be made on a test flight.

Lockheed went to work on the mounts; the Geographic's equipment shop took on the housings. I got busy on the cameras. Each was fitted with a 250-frame film magazine and motor drive, and housed in a sturdy box with only its 16mm fish-eye lens showing. The cameras were automatic; they would adjust their own exposures in flight. I would trigger them from the cockpit with a control box and cable hookup.

In nearby Hollywood a lab would be standing by to process the film the night it was shot. I left nothing to chance; I even briefed the lab workers and checked their chemicals.

Finally the big day dawned. And so did trouble. At midafternoon the engineers were running back and forth to the hangar with a section of the tail that wouldn't fit on quite right. And when I tested the cameras one last time, they fired like machine guns. Minutes from takeoff, and something had shorted out!

We scrambled to fix it, but the fault eluded us. "Disconnect all that wiring," I decided. "We'll fire them with buttons from the rear of the cabin." So an electrician sat through the flight in the dark on a box in the tail section, pushing buttons as I radioed "left—right—left—left" from the

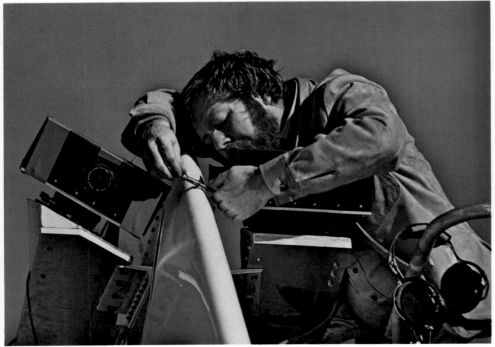

Bruce Dale by Glen Sunderland; Glen Sunderland (opposite).

Rising to the occasion, photographer Dale rides a crane to the top of a plane's tail to mount his cameras. One insect squashed on the lens could have ruined his most ambitious project.

How does popcorn pop? Intrigued, Bruce Dale and his son Greg set up camera, strobes, and infrared triggering beam—and waited. Five images of one kernel show how steam within splits the hull and jets the kernel off the pan.

With compass and sun tables the photographer plotted the sunrise at Buenos Aires; with a sketch he positioned sailors in a ship's rigging. Then a telephoto lens a quarter of a mile away caught the exact moment.

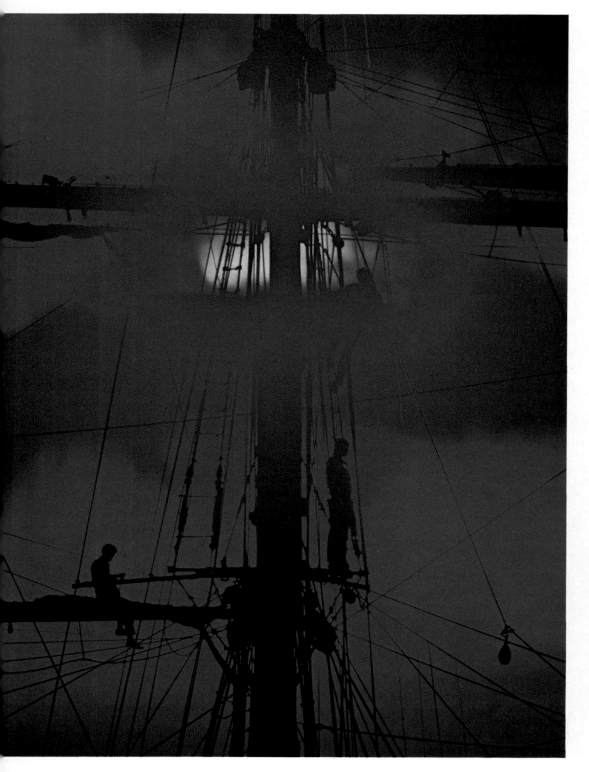

cockpit. My control box had been fitted with frame counters. Now, without it, I could only guess at how many frames were lost to the shorting-out and how many were left for the flight.

Night pictures are tricky. Too early and they look like daytime; too late and they go black. So I had taken light readings at Los Angeles International to fix the best time, with no more than three minutes leeway either side. I had persuaded the authorities to let a test flight land there. And I had cajoled the airport into allowing a touch-and-go so we would not waste time on the ground.

Our timing was perfect. But our navigation wasn't. During the scramble the ground crew had removed some avionics from the tail. When the airport asked our position, we had to get *them* to tell *us*. We made it into our time slot slightly early, shot our touch-and-go, pushed our "left" and "right" buttons, and climbed into the gathering twilight, hoping for the best. But the best still lay ahead, for the Los Angeles shots would prove disappointing.

At flight's end we descended smoothly, on autopilot, toward home base at Palmdale. "Right," I radioed, and high on the tail a camera's shutter flicked open. For 23 seconds the film drank in the pinpoints of light as the plane glided down, flared out, and squeaked onto the runway. Then the shutter blinked shut on the most ambitious picture I've ever made—the shot on pages 180-181.

Whatever the task—be it the sun over the yardarm of a square-rigger, the dance of a kernel of popcorn, or the flight of a huge airliner—I try to map out every detail. Yet often I find my best pictures are unplanned. I go for L. A., but bring home Palmdale.

184

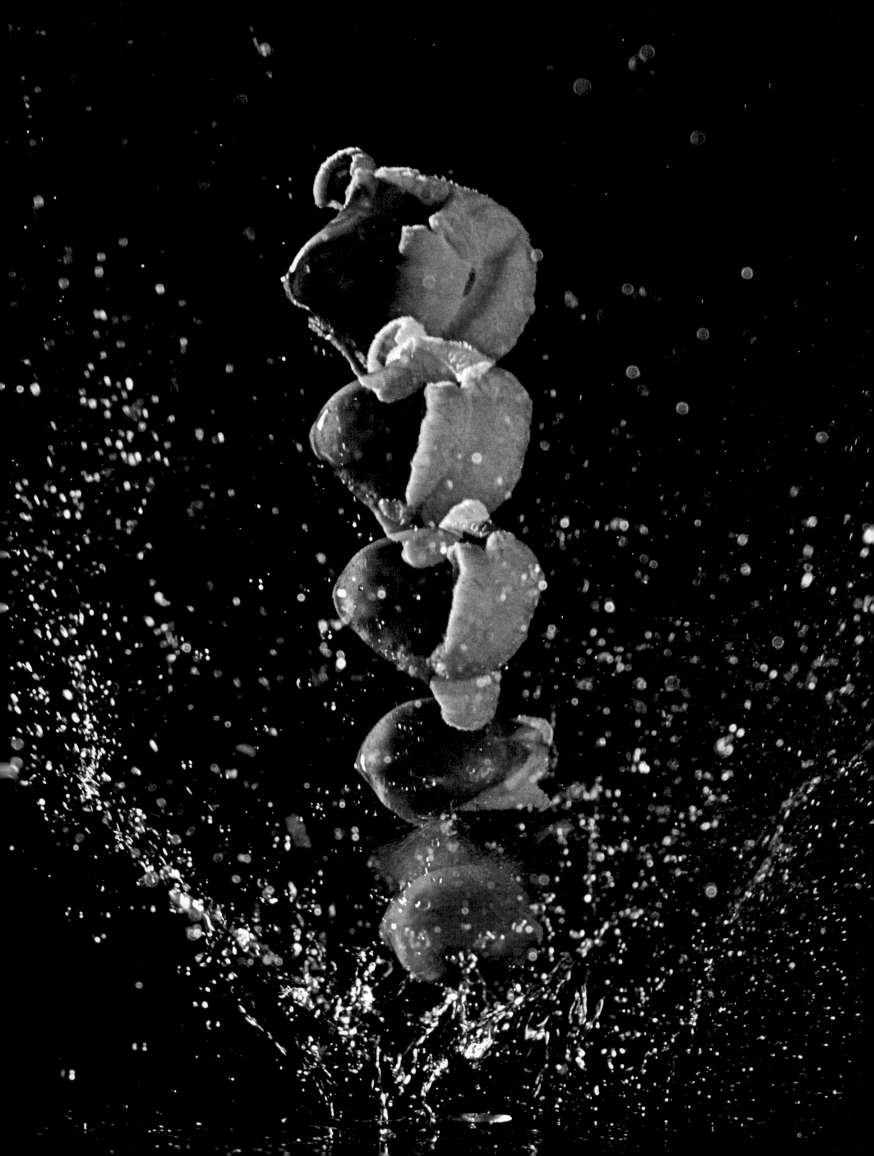

Robot Cameras in an Alien Realm

By Emory Kristof

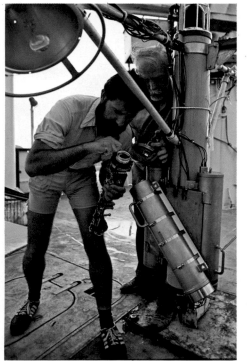

Emory Kristof and technician Alvin M. Chandler by Claude E. Petrone

The divers outside make their final checks, then unplug our phone. Free of this last link to the surface, the research submersible *Alvin* starts the long fall to the Pacific floor, 8,500 feet down.

We descend at a controlled rate of 100 feet a minute. Within two minutes we have passed the safe limits of the air-breathing scuba diver and the depths in which almost all underwater photographs are made. Thirteen minutes later we have gone deeper than any super-deep diver breathing an exotic mix of gases. The sun on this January day in 1979 sheds no light down here. Yet more than an hour of downward travel remains until we enter the largest community of life yet found in the hot-water vents of the Galapagos Rift.

At last, there it is—a science-fiction realm centered about a forest of giant eight-foot-high tube worms. Their red heads undulate in the shimmering hot water. To them, this is home; to *Alvin*'s three-person crew it is a hostile world with pressures of nearly two tons per square inch.

The water is incredibly clear. Through *Alvin*'s portholes we can see farther than 200 feet. But the ports are fixed in *Alvin*'s sides, and the Plexiglas in them is $3\frac{1}{2}$ inches thick. My single-lens reflex is of limited use, for I cannot move in close and must constantly cope with refraction from the heavy plastic. So I turn on the real eye of *Alvin,* an RCA color video camera mounted outside in a casing of half-inch stainless steel.

This revolutionary camera converts light directly to electrical signals. Inside *Alvin* the signals are taped on a broadcast-quality recorder. On a small color-television monitor, the images paint a far more detailed view of this strange world than we can see through the ports.

Fingering the control toggles, I move the camera smoothly on its hydraulic arm to within inches of a small pom-pom of an animal whose many tendrils seem to be tending the lines that moor it to the hardened lava. A mile and a half down, in a community based not on sunlight but on chemical synthesis, I am taking close-ups of a two-inch creature we can only call a "dandelion."

But the tape will let other scientists see and study what we are seeing now. They will classify the "dandelion" as a new siphonophore, a relative of the Portuguese man-of-war. And they will study the behavior of tube worms, crabs, and the "dandelion" in real life, not just topside after the creatures have endured—or perished from—the rigors of ascent.

A dive, like a moon mission, has many tasks. One of mine is to shoot *Alvin* at work. Somewhere outside waits a robot camera package, lowered earlier by cable. But where?

Our sonar finds it, and we ease over to it. Buoyed by floats but held down by weights, it perches by a rift big enough to swallow a freight train. As *Alvin* maneuvers before its lens, I send out a pulse of sound. I'm answered by a wink of its strobe light. Soon the job is done, for the strobe fires faithfully at every command.

Time to go. Another pulse, and the robot sheds its weights and ascends. We rise in its wake, taking home a priceless portrait of an unimagined world, preserved not only on film but in electronic images as well. Already we can make excellent stills from such images. What worlds may we one day see through filmless cameras in the steely hands of robots?

Like smoke from a food factory, mineral-laden water billows from a seafloor vent at more than 662°F. Chemicals from such vents nurture life forms unknown until glimpsed by robot cameras in 1977.

In this first self-portrait, Alvin *dove with a robot camera, set it up with a manipulator arm, and fired it with a strobe. Units like the one on page 186 dive alone and are fired by sound.*

John Edmond

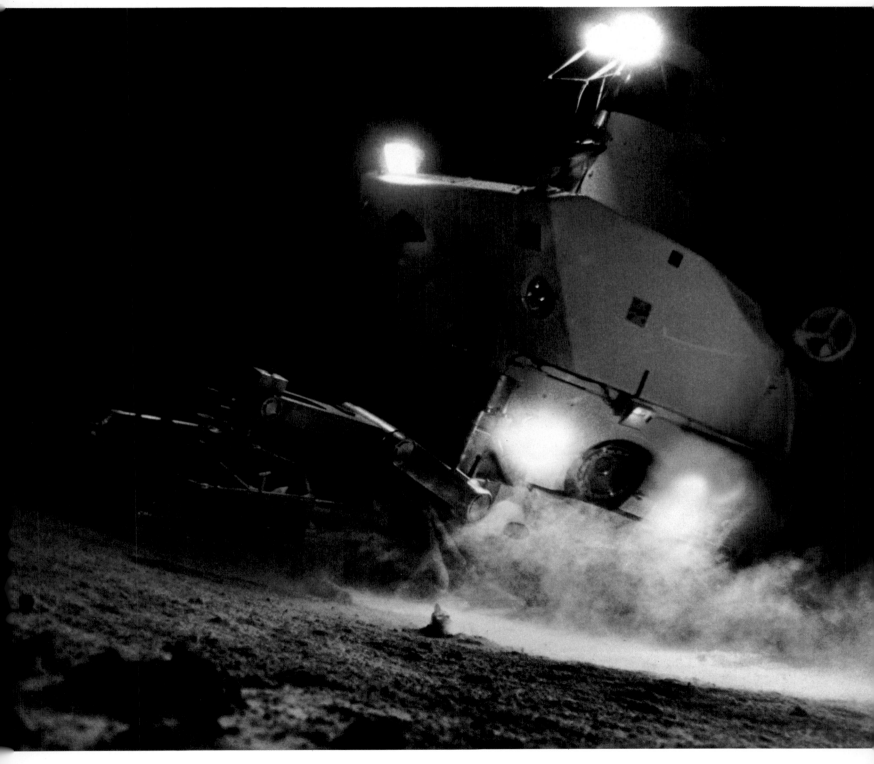

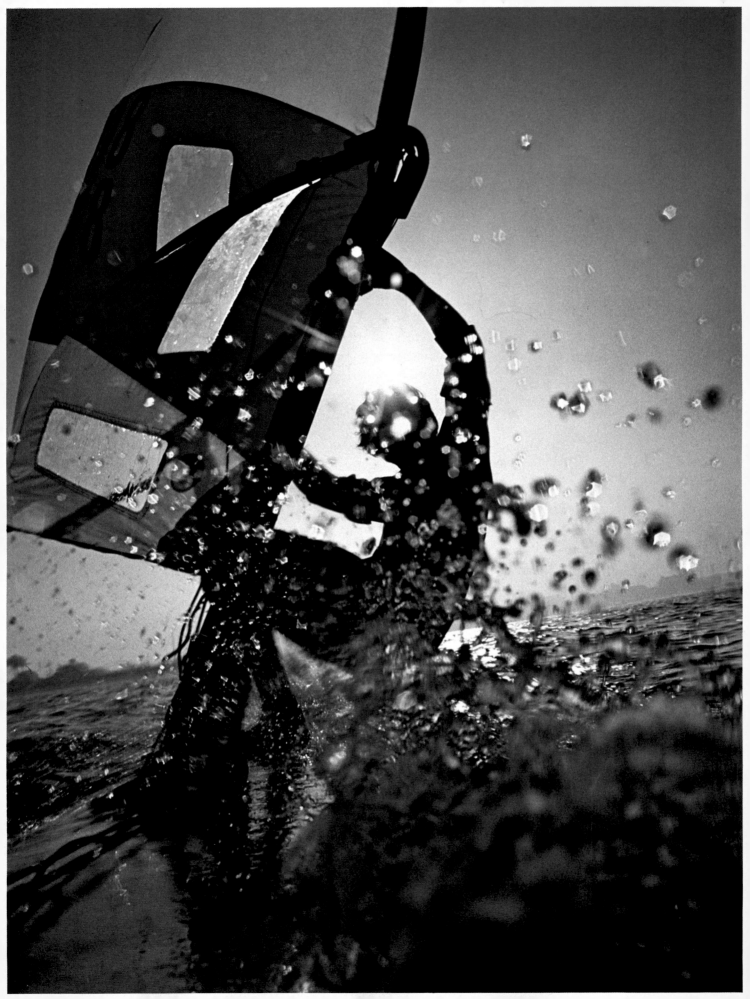

THE WORLD OF ADVENTURE

A windsurfer's ride captured by a remote lens. By James A. Sugar.

"All about me were wild cliffs stretching up toward snow-covered peaks. Now and then avalanches awakened echoes, filling the air with a Babel of tongues. Up a mountainside thick with alder and currant I climbed, often on hands and knees. Then I tramped on across snowfields to a great ridge.

"From here I saw, for the first time, the huge pyramid of St. Elias. Although 36 miles distant, it dominated all other peaks, standing out boldly against the northwestern sky. I drank in the magnificent landscape, endeavoring to impress every detail upon my memory."

The words spill from the descriptive avalanche that Israel C. Russell set down as his impressions of an Alaskan mountain realm. The year was 1890, and Russell, a geologist, had received backing from the National Geographic Society and the U. S. Geological Survey to map the unexplored borderlands between Alaska's panhandle and Canada.

Blizzards and avalanches thwarted Russell in his attempt to scale the mountain. But his reconnaissance produced remarkably detailed maps—and a handful of murky photographs. It also marked the first of dozens of Society-sponsored expeditions to explore and photograph unknown or little-known parts of the globe.

Richard H. Stewart, a staff photographer who took part in numerous expeditions from the 1920s to the 1970s, recalls some of the difficulties he encountered during the early days: "steamer trunks crammed with chemicals, cameras heavy enough to break a mule's back, fragile photographic plates."

"I first used Lumière color up in Alaska in 1928," he remembers. "We had special darkrooms made of heavy tarpaulin that we brought with us. But the darkrooms had no vents. After you were in there a certain amount of time, you had to start hunting around for some air."

The lure of high places beckoned Geographic readers. Many climbers recorded their exploits in the magazine's pages. Walter Woodburn Hyde in 1913 described his feelings on the summit of Mont Blanc: "Do you open your eyes wide in astonishment at the wonderful sight? By no means! You shut them as tight as you can and throw yourself down on the snow in utter weariness of mind and body."

Nearly 70 black and white pictures—including the view of the crevasse opposite—accompanied his article. Actually, most of the photographs had been purchased by the editor two years earlier while he was on a tour of Europe. It mattered little. The scenes of rugged alpine peaks, lush valleys, and dirndl-clad girls were enchanting.

In the 1930s botanist Joseph F. Rock gave the world its first detailed look—in black and white as well as in color—at Minya Konka and other unmapped holy mountains along the China-Tibet border. Bedeviled by bandits and blizzards, he negotiated awesome defiles and razor-sharp ridges to assemble thousands of plants—including 493 kinds of rhododendron.

Rock, a pioneer in the use of color photography, frequently labored under trying conditions. Natives fled his camera and, to dry his negatives at 18,000-foot altitudes, he had to warm them over yak-dung fires. But who could forget the villainous bandit gang led by Drashetsongpen, holy man turned highwayman?

Readers in 1933 skimmed vicariously over Mount Everest's crest with L.V.S. Blacker in a supercharged biplane: "No words can tell the awfulness of that vision. . . . Over the topmost peak, we passed

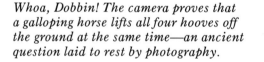
Whoa, Dobbin! The camera proves that a galloping horse lifts all four hooves off the ground at the same time—an ancient question laid to rest by photography.

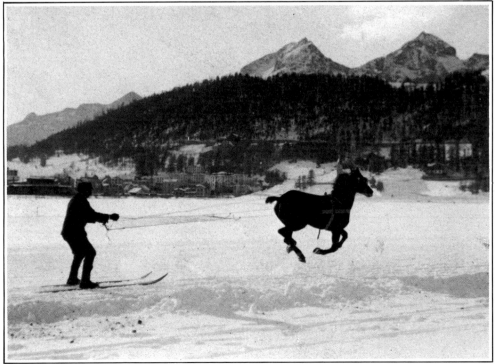
G. R. Ballance. National Geographic Magazine, August 1919.

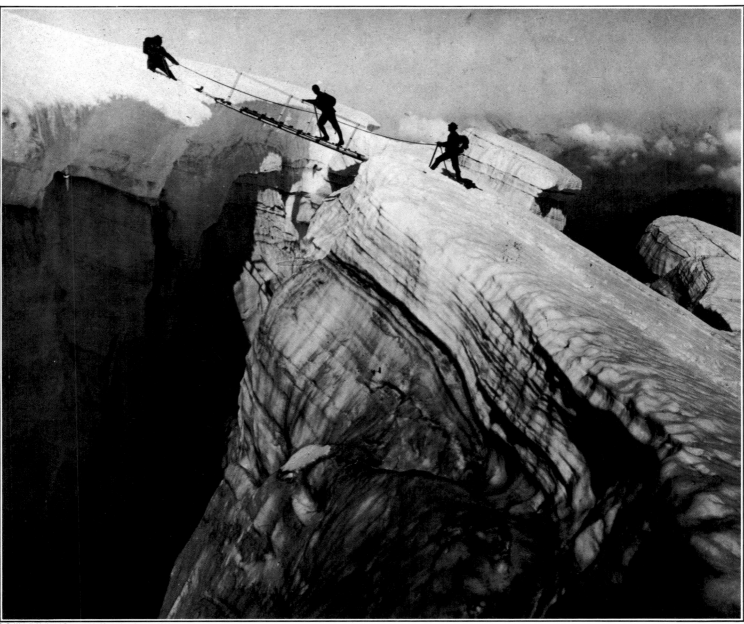

"Of all the dangers on Mont Blanc, that of the crevasse is the commonest," read the caption that accompanied this photo of a climber belayed by companions.

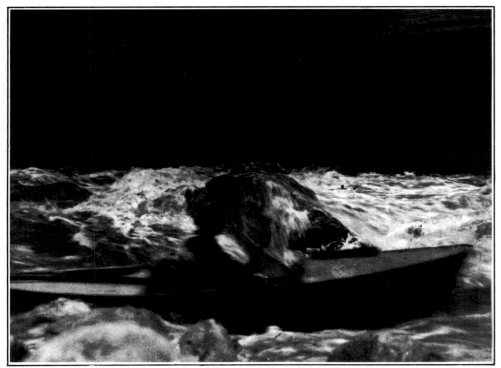

"The marvelous photographs published with this article," noted the editor's foreword, "give a graphic conception of the dangers encountered and of the extraordinary character . . . of this most stupendous chasm," the Grand Canyon. Readers marveled at an even more graphic display with the story—the skeleton of a luckless prospector.

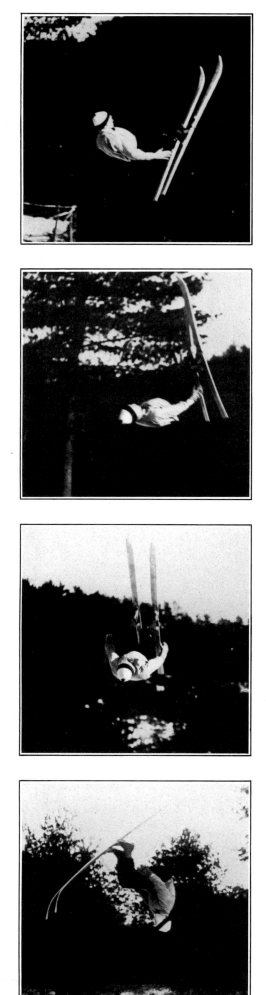

E. G. Dewey. National Geographic Magazine, February 1920.

through the famous plume of the mountain, that awesome, miles-long white streamer which men see and marvel at 200 miles away."

Women proved that a mountain was not a world where only men could marvel. In 1911 Dora Keen told of climbing the Alps "for pleasure, for the wonderful views and the vigorous exertion." In 1934 Miriam O'Brien Underhill became the first woman to scale the Matterhorn unassisted by men. When asked "how a woman can be strong enough for exertion that would tax an 'athletic young man,'" she replied: "technique, knowing how to use strength to the best advantage."

The year 1953 saw the conquest of Mount Everest by Edmund Hillary and Tenzing Norgay. The triumphant photograph shows Tenzing, not Hillary. "Tenzing is no photographer, and Everest is no place to begin teaching him," Hillary later explained.

A decade later there would be a stunning photographic record of an Everest conquest. On that expedition, sponsored in part by the Society, six men made it to the top, including staff man Barry C. Bishop. He carried a small, lightweight, split-frame camera that gave him 72 exposures per roll. This enabled him to shoot one-handed while climbing and also cut down the number of times he had to expose his hands to change film. Beneath his down-filled mittens he wore a "second skin," silk gloves that shielded him from extreme cold.

The North and South Poles were the undiscovered territory of an earlier day, and the race for those legendary points received support from the Geographic. In 1906 President Theodore Roosevelt awarded the Society's first Hubbard Medal to Comdr. Robert E. Peary for reaching a new "Farthest North"—87°06′. When Peary set out on his epochal sledge journey to the North Pole two years later, he did so with a modest grant from the Society.

Then the South Pole beckoned. Already Britain's Robert F. Scott and Ernest H. Shackleton had struggled to within about a hundred miles of that long-sought goal. In 1911 a desperate race began. Scott and Roald Amundsen both headed for Antarctica. Amundsen, landing at the Bay of Whales, sledged straight

south and, on December 14, reached the Pole. Scott toiled across 900 miles of snow and ice only to find the Norwegian explorer's flag already planted at the Pole. On the return journey, 11 miles short of a supply cache, cold and starvation claimed the lives of Scott and his companions.

"The dog sledge must give way to aircraft," Lt. Comdr. Richard E. Byrd told a National Geographic audience in 1926, fresh from a flight over the north polar regions. And three years later he proved his point—with the first flight over the South Pole. The expedition also photographed some 160,000 square miles of Antarctica from the air.

Attempts to blaze new trails in the sky were faithfully chronicled in the Geographic. As early as 1877 Alexander Graham Bell, the Society's second president, concluded that a heavier-than-air machine was feasible, and that it "should be supported by the revolution of a fan wheel or screw."

Orville Wright undertook his historic airplane flight in December 1903—and within 20 years a squadron of camera-carrying adventurers soared into the blue.

"The aeroplane is the nearest thing to animate life that man has created," wrote Sir Ross Smith in the March 1921 issue of the Geographic, after an 80-mile-an-hour flight from London to Australia in an open-cockpit plane.

"Wings!" exulted Comdr. Francesco de Pinedo, recording his 60,000-mile seaplane flight to six continents in September 1928. "Sindbad, tied to a roc's foot, flew over no stranger sights than I. . . . In 26 years Marco Polo made less mileage than I in a few weeks."

A year earlier Charles A. Lindbergh had soloed across the Atlantic in the *Spirit of St. Louis* and had received the Society's Hubbard Medal from President Calvin Coolidge. Five years after Lindbergh's flight Amelia Earhart duplicated his feat. She recalled that as a passenger on an earlier transatlantic flight she had been called a sack of potatoes. "That," she said, "probably as much as any other single factor, inspired me to try going alone."

During the era of the great dirigibles, Americans turned out to follow the *Shenandoah*'s course from coast to coast. The 1924 flight was covered by the Geographic in a firsthand

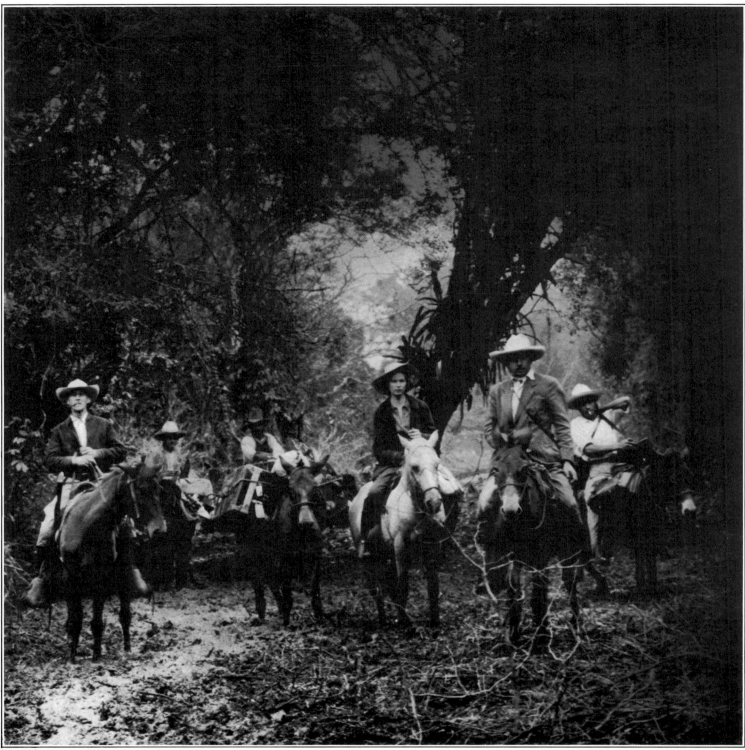

*On the trail of a vanished civilization,
Marion and Matthew Stirling lead
an expedition through the jungles of
Mexico. Several seasons of digging
unearthed a trove of ancient Indian
artifacts, including carved altars
and colossal stone heads.*

*A Dartmouth skier (opposite), "one of
America's foremost adepts in the
performance of this 'stunt de luxe,'"
flipped several times to give the camera
enough good images for one seemingly
uninterrupted somersault sequence.*

193

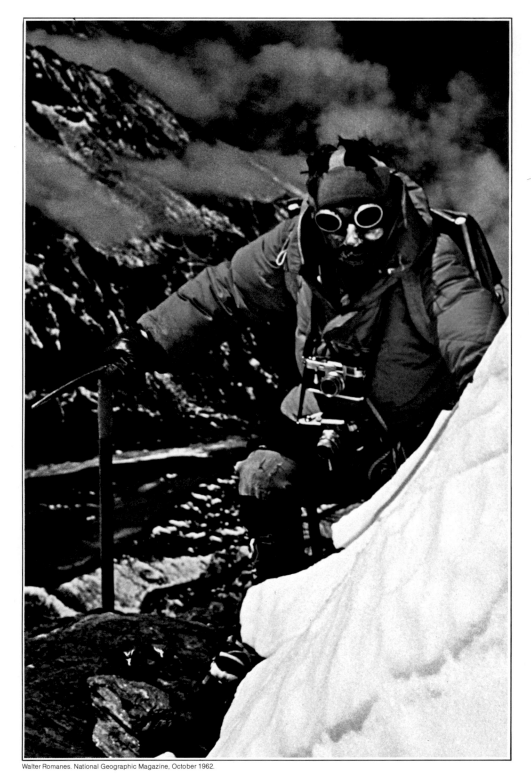

Walter Romanes. National Geographic Magazine, October 1962.

National Geographic's Barry Bishop negotiates a ledge at 19,000 feet on a flank of Ama Dablam. "I also used my camera for scientific purposes—to help map Mingbo Valley," he recalls.

Plumed with snow, Everest's mighty pyramid (opposite) looms above climbers traversing Lhotse's face at 25,000 feet.

report abundantly illustrated with aerial photographs. Hugo Eckener circled the earth in the *Graf Zeppelin* in 1929, and related his adventure to a Geographic audience.

Nuclear power ushered in an era of undersea exploits, and the Geographic reported them in word and in picture. In 1960, the nuclear submarine *Triton,* following in the wake of Magellan, made naval history by circling the earth submerged. Her saga was told by the skipper himself, Capt. Edward L. Beach. And the images of her saga were made by a veteran Geographic photographer, J. Baylor Roberts, a naval reserve officer recalled to active duty to record the voyage.

There was no way to put a staff photographer aboard Robin Lee Graham's boat; the teenager was sailing around the world alone. But the Geographic managed to record that voyage by clamping cameras to various strategic points on the boat. Lines leading from the cameras tripped the shutters and advanced the film, enabling Graham to produce action shots of himself as he sailed.

Graham carried cameras supplied by the Geographic. At several landfalls he was met by Geographic photographers who gave him lessons and sent him on his lonely way.

In simpler days, the Geographic sometimes relied upon words to produce images. Here is M.E.L. Mallowan (archaeologist and husband of mystery writer Agatha Christie) writing about the "death pits" of Ur, in Iraq, in 1930: "As we cleared the shaft to the level of the floor, it appeared almost as if we were treading on a carpet of gold. . . . The 68 women, lying in ordered rows, were decked out after the fashion of the principal occupant of the domed chamber." With the words were black and white photographs; the golden splendors had to be imagined.

In 1960 the magazine published news and pictures of another treasure unearthed. "The teeth," wrote L.S.B. Leakey," projected from a rock face. . . . the remains of the earliest man ever found!" And there, in color, were the fragments of *Australopithecus,* who helped to start the human story. There was not much left of him, but he was the oldest toolmaker ever to be photographed.

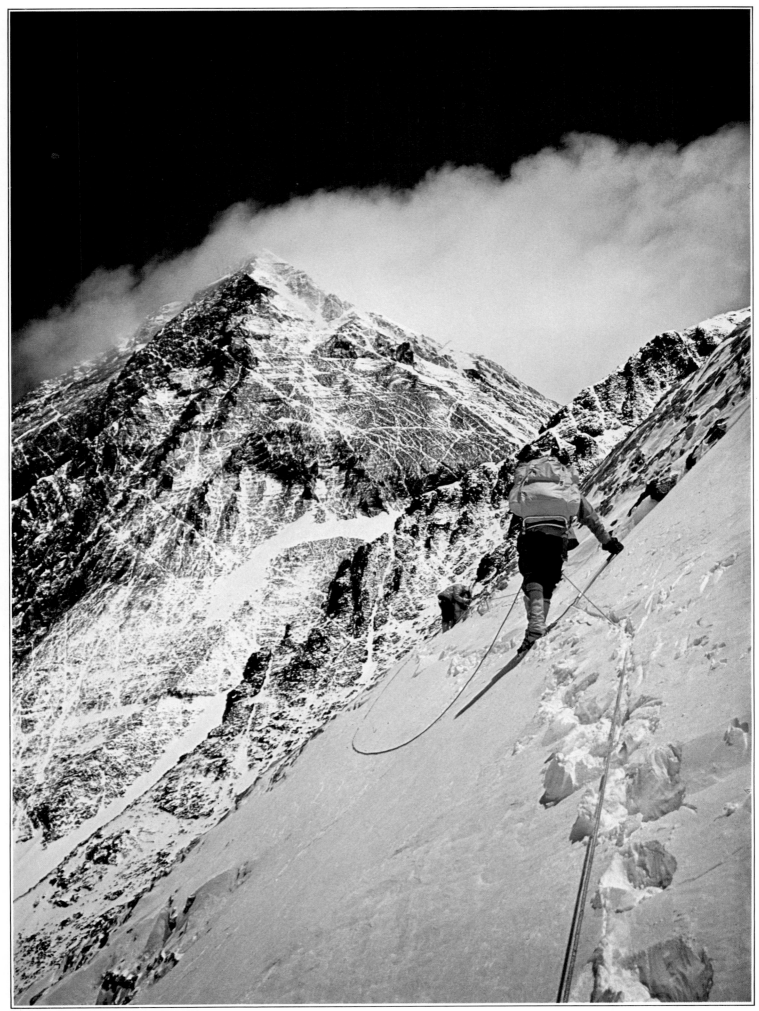

Barry C. Bishop. National Geographic Magazine, October 1963.

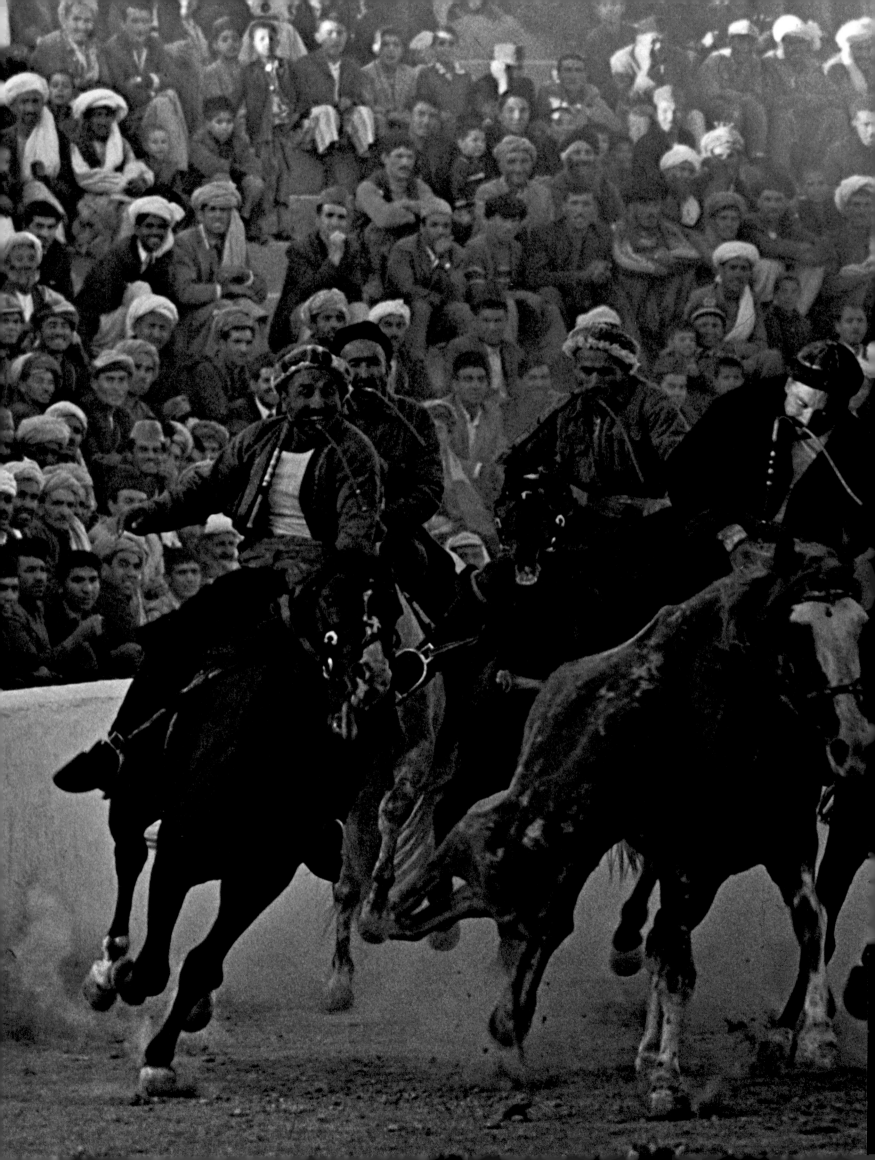

Galloping toward Abercrombie's camera are horsemen playing *buz kashi,* a wild version of polo that uses a headless calf for a ball. "Afghanistan's national sport is no game for the timid, as you can see. Knives and chains have been outlawed recently, but sudden death on the playing field is not uncommon. It's a fitting sport in a country where only men of iron can survive at all."
THOMAS J. ABERCROMBIE

This Colorado balloon race (overleaf) was a totally visual experience. "I didn't hear a sound as the sun rose over those gorgeous mountains and the ground dropped away. I knew a long lens would pull the balloons closer together, so I put it on the camera and shot as fast as I could. It was one of those days when I just couldn't shoot fast enough."
ANNIE GRIFFITHS

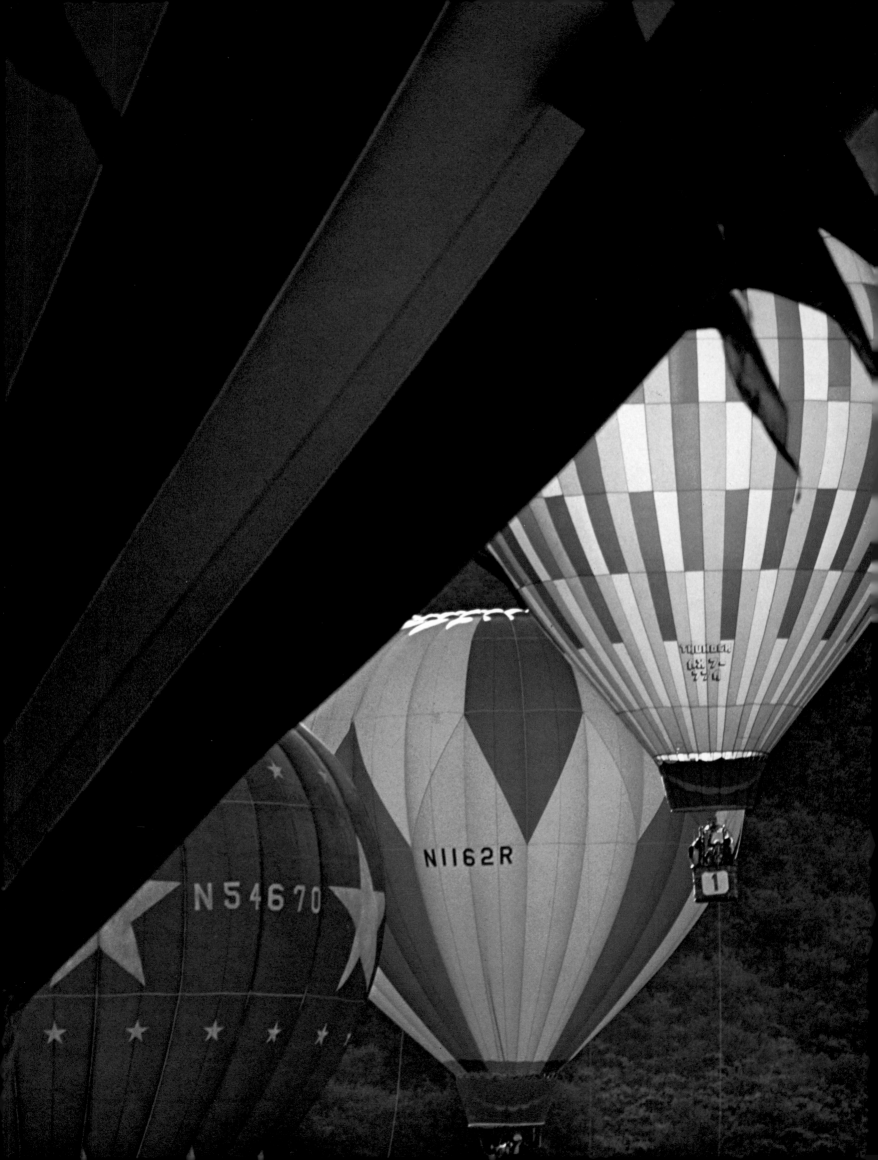

"That's it. Perfect!" the coach shouted. He was referring to the girl's feat on the bars, but that's also the way Bailey felt about the picture. "My partner and I had spent hours setting up. We hung black paper from floor to ceiling along the length of the exercise area. Then we set up five strobes, four power-supply units, a number of hand and foot switches, three tripods, four cameras, three lenses of the same focal length—and probably other things I've forgotten.

"The lights were set to flash eight times a second. The movement took just 2.6 seconds. And all the strobes had to be operated by foot or hand."

JOSEPH H. BAILEY

200

A slow shutter speed can capture the feeling of motion. "By panning with the action—much like a hunter leading a bird in his sights—the raft remains reasonably sharp."

WILBUR E. GARRETT

The picture (overleaf) was taken at dusk, with the *Brendan* heading west toward Greenland. "I was in a rubber dinghy tethered to the craft and had been warned that if the line parted there was no way the crew could swing around and rescue me. The feeling of cold and isolation was almost overwhelming. The seas look fairly calm here, but that's only because I was shooting with a wide-angle lens."
COTTON COULSON

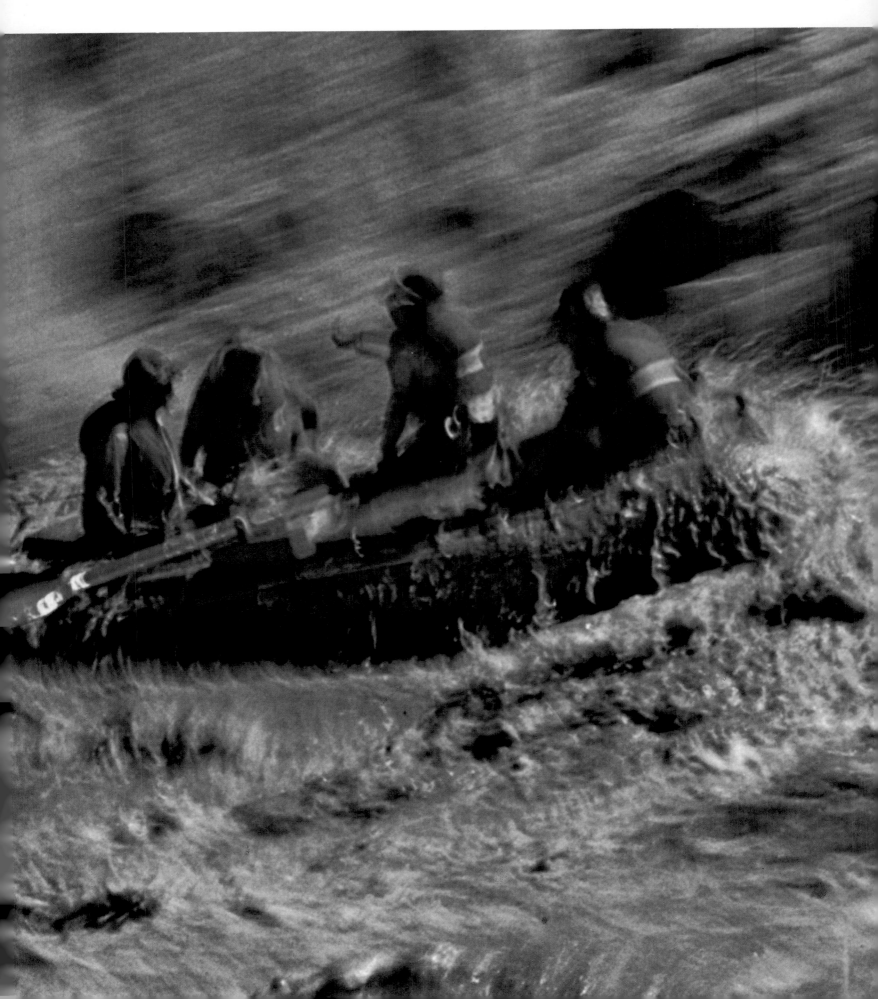

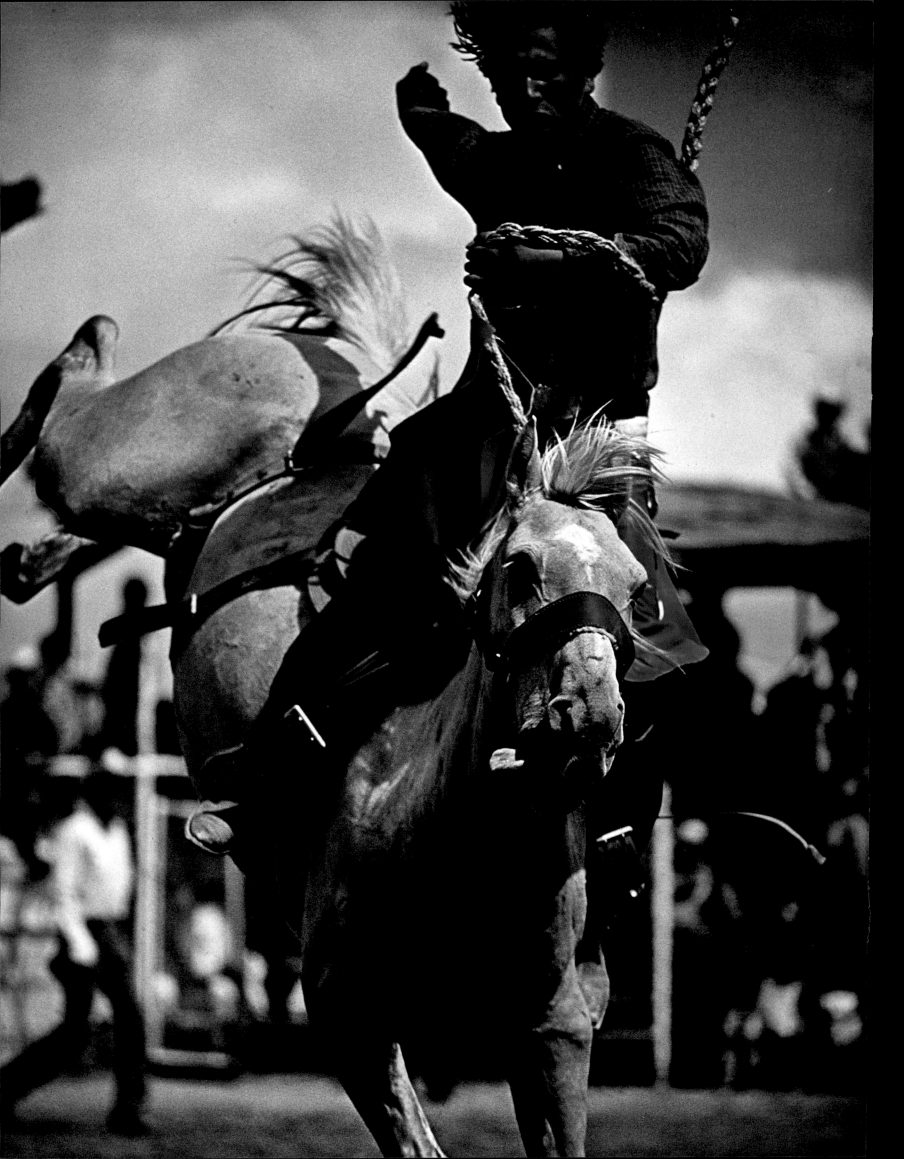

On his first major U. S. assignment, English photographer Adam Woolfitt duly recorded the action of a western rodeo. But what most impressed him between events was "a beautiful sense of no-time—like the last bus just left forever."

ADAM WOOLFITT

As the Australian surfer dropped into the wave about 160 feet away, McCausland swam into position. Strapped to his chest was a camera in a vinyl housing devised by the Geographic's custom equipment shop. "As he rode through the tube of the wave, he would pass within inches of the camera. This particular wave breaks over a shallow rock shelf against steep cliffs. An error would have had disastrous consequences."

BILL MCCAUSLAND

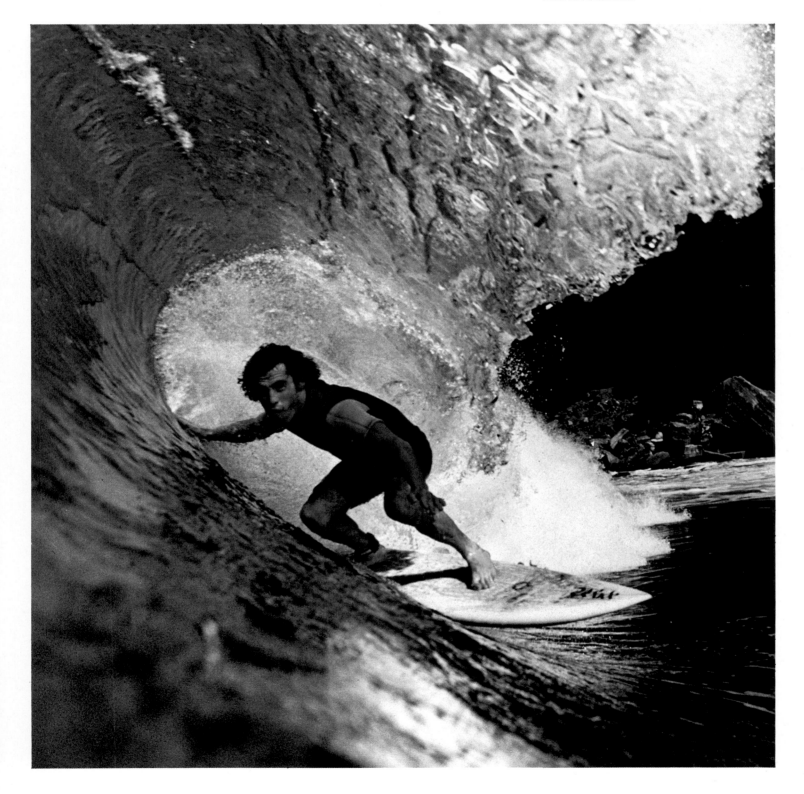

207

How do you capture the feel of hang gliding in a still picture? "I hung an electronic camera on the wing and asked the flyer to trip the shutter whenever she went into a tight banking turn. The motion of the maneuver, combined with a relatively slow shutter speed, blurred the ground to produce the soaring effect I wanted."

ROBERT W. MADDEN

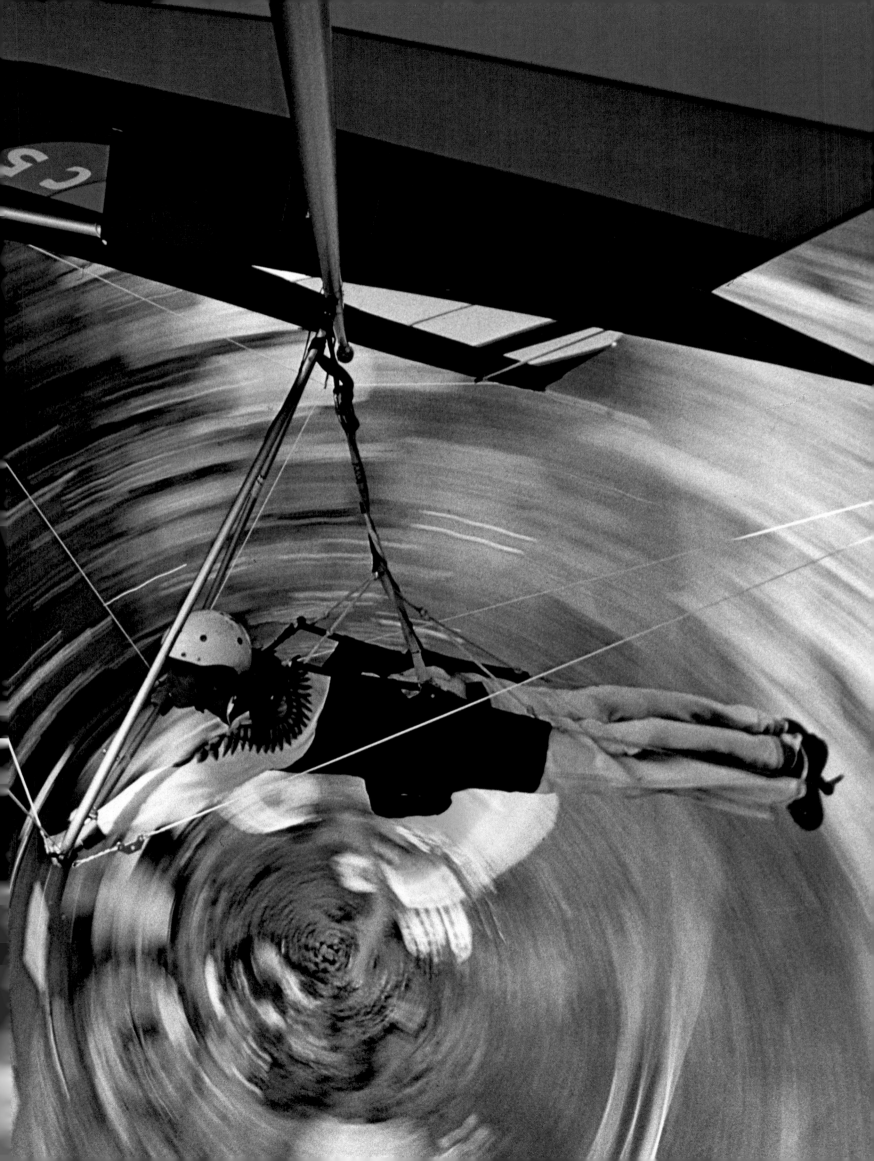

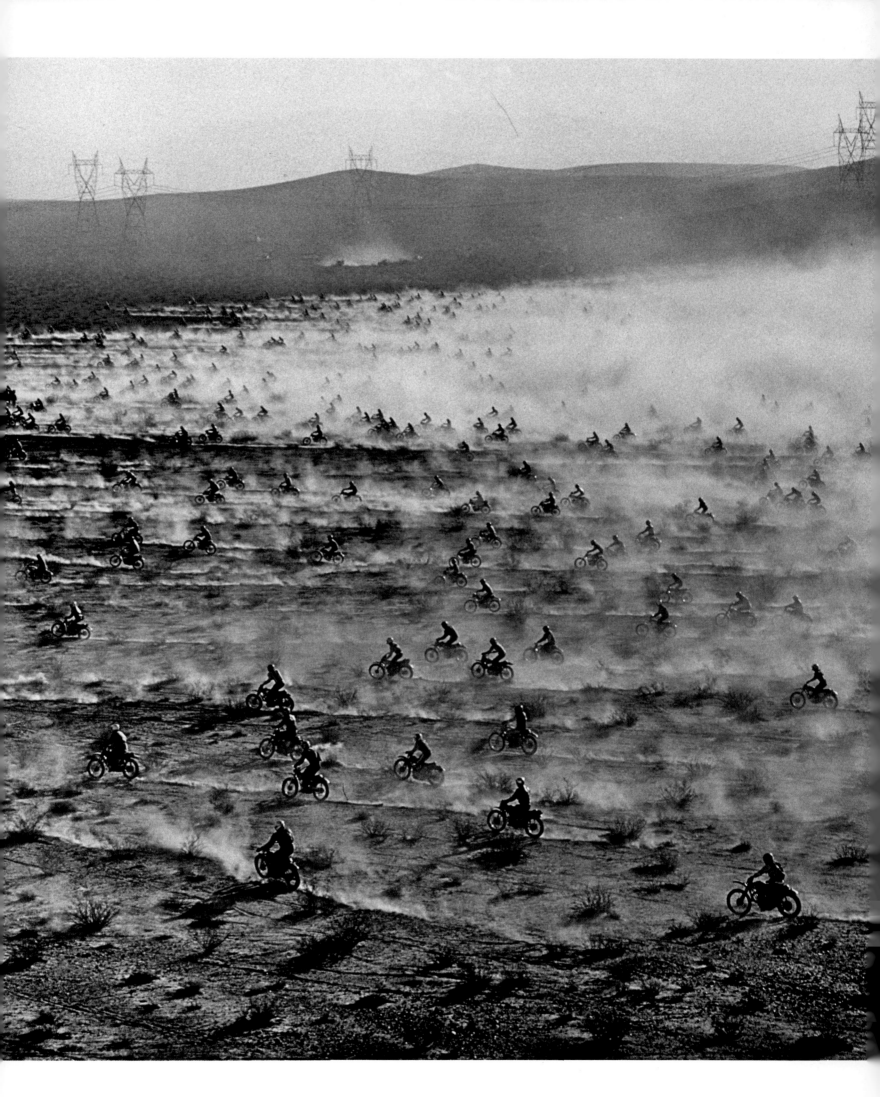

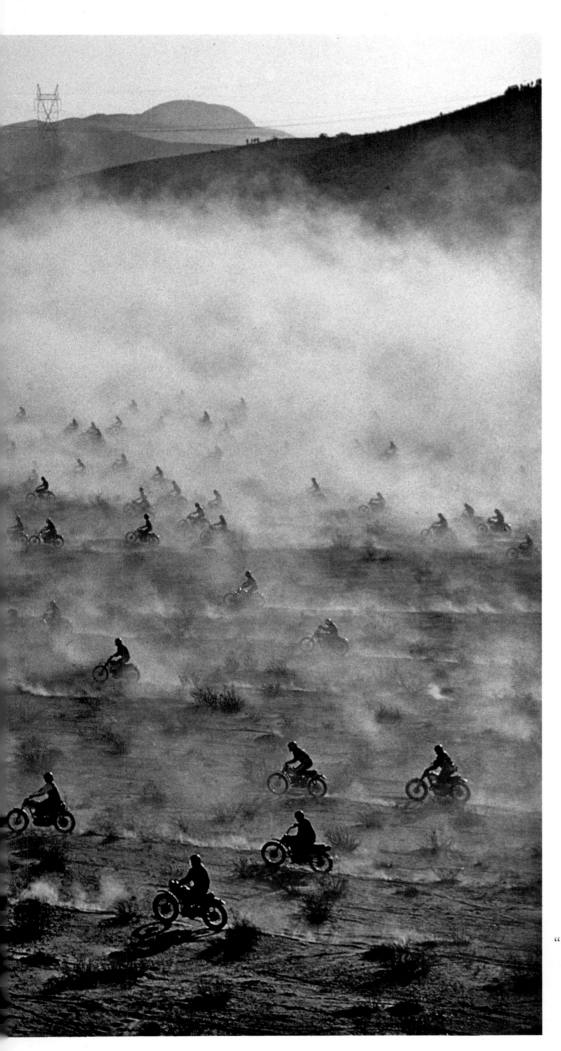

The adventure was devastating—to the fragile environment. Photographing this 150-mile motorcycle race from California to Nevada, Toppy Edwards also recorded man's war on the desert. "I shot this from a helicopter, across the pilot's chest, with a 40-knot wind blowing from behind the cyclists. The desert decidedly was the loser."
WALTER MEAYERS EDWARDS

"Most glaciers seem sterile and hostile, but this branch of Ruth Glacier on Mount McKinley (overleaf) comes alive. The play of light on those sensuous shapes makes it inviting . . . almost warm and friendly."
NED GILLETTE

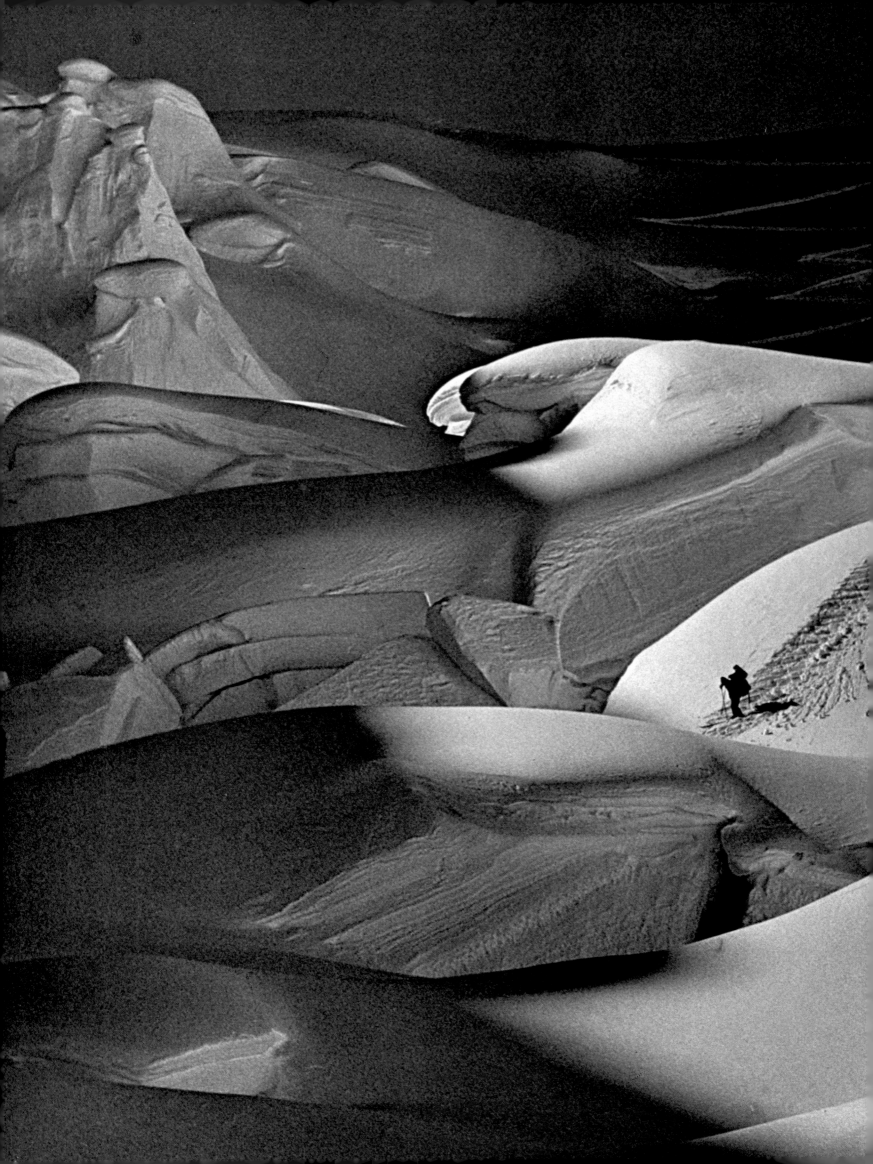

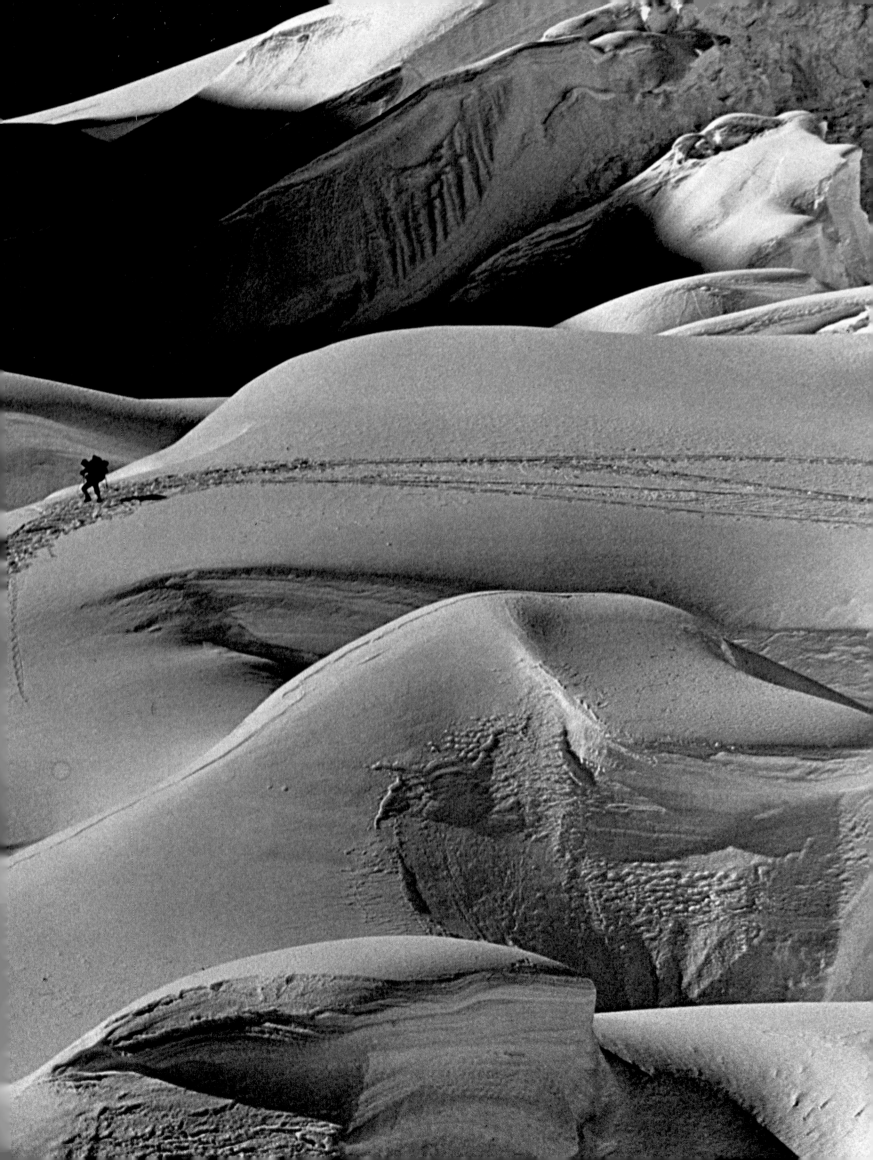

The Case of the Missing Photographer

By James A. Sugar

How do you take a picture that has been shot a thousand times before? A lot of Geographic assignments raise that question in a photographer's mind. The sailing scenes on these pages are a good example of a subject that has been covered exhaustively before. Innumerable photographs of catamarans have been made, mostly showing them from water level or from the air, using a helicopter.

This time, for a Geographic book, *Sunset Coast,* the editors felt that new treatments of often-seen subjects were needed. As a result, I decided that a series of pictures using remote-mounted cameras would provide fresh viewpoints. I have found that a camera placed in an unusual location gives enough of a different perspective to sometimes create a new and powerful photograph.

The picture on the right shows the beginning of the race. The wind has died and the boats are becalmed—that's why they are all grouped so closely together. The boat below, with me leaning over the side, is under sail. One reason I decided to pilot the boat myself is that I've sailed enough to know when the dramatic moments occur. And it was easier for me to sail the boat and trip the shutter at the same time. I was able to steer the catamaran so that the sun lit it from the front.

The camera itself was mounted on top of the mast. Hobie Cat masts have a flat place on top that makes it easy to secure a remote camera. It's almost as if they were designed with that in mind.

In this kind of photography, the challenge is to figure out exactly how to mount the camera—and how to

New slant on an old subject: By mounting a motor-driven camera on the mast of a catamaran, photographer Jim Sugar can snap his own portrait (left) and produce a surrealistic view of a regatta held off Long Beach, California.

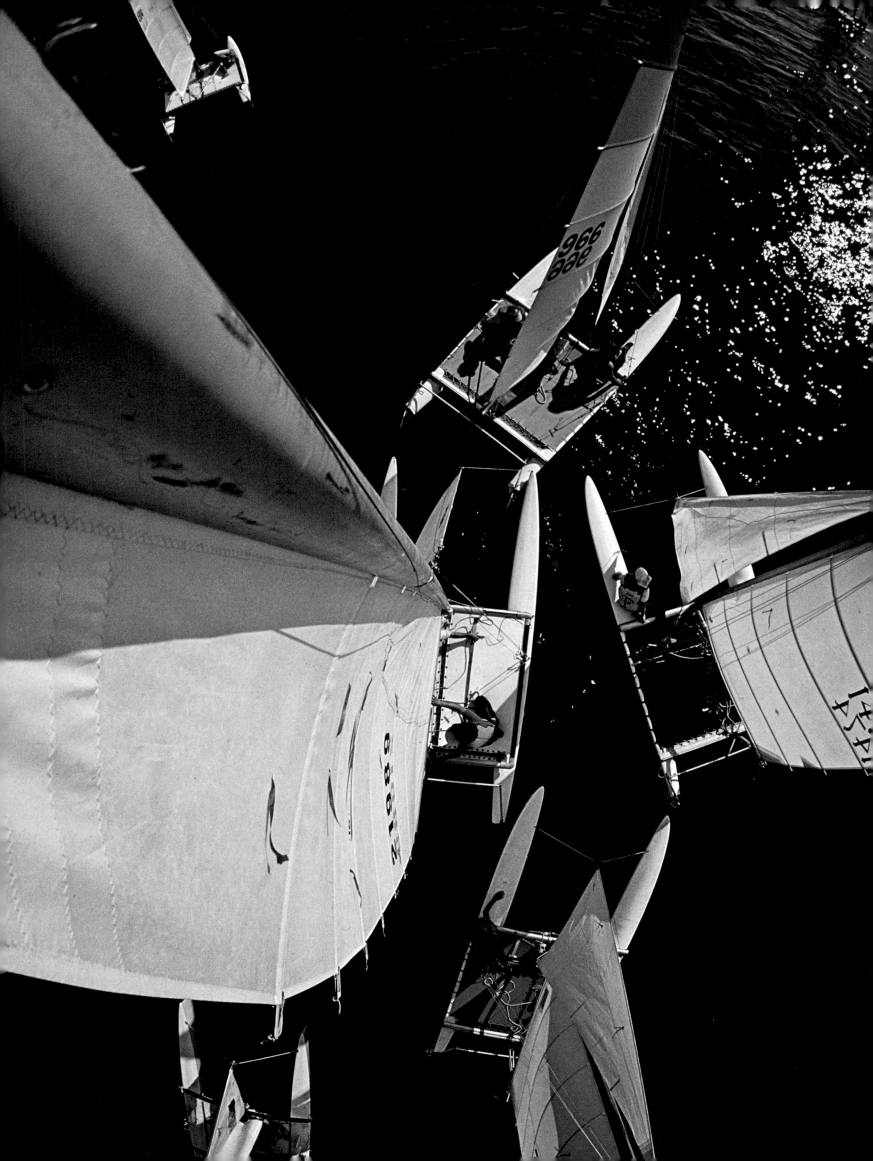

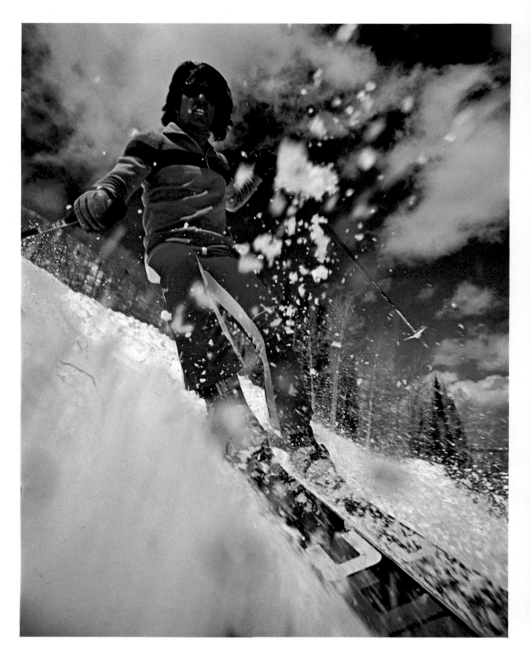

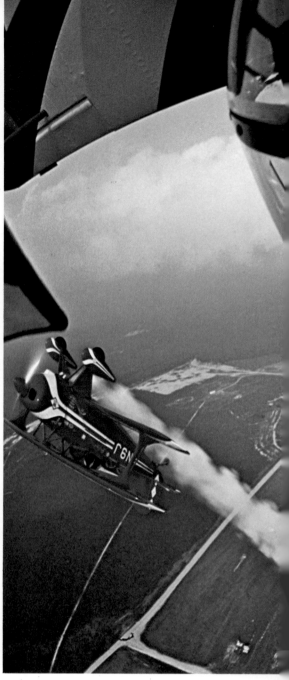

An Aspen skier races down a slope . . .
or does he? In fact, he is moving at
slow speed while Sugar runs alongside,
firing the camera. Real speed would
have thrown too much snow.

High, wide, and upside down at the
apex of a loop (opposite), the Red
Devils aerobatic team thunders
through its tricks at an air show
near Atlantic City, New Jersey.
A wide-angle lens bends the edges
of the picture and enhances
the stomach-churning quality
of the maneuver.

protect it from being battered by
wind, water, or vibration.

The skiing picture above illustrates
the problem of vibration. It was tak-
en in Aspen, and the fellow on skis is
a friend—an instructor at the Aspen
Mountain Ski School. While we were
preparing to take the photograph, we
realized that a ski throws a lot of
snow and that at normal speeds the
tip vibrates furiously. A ski-mounted
camera would produce only a blur.

We had to distort reality a bit. The
skier is actually going at a crawl, even
though the photograph makes it look
as if he's doing 30 miles per hour. Yet
the picture is accurate, because that's
what skiing looks like—at reduced
speed. I was running alongside him,
down the hill, tripping the shutter.
All we had to do to make the photo-
graph work was produce one gentle,
sweeping turn.

Every time you take a picture like
this, you learn something. Nothing
ever turns out quite the way you orig-
inally thought it would. You have to
make changes as you go along.

The airplane picture above accom-
panied a story on the Experimental
Aircraft Association's air show in
Oshkosh, Wisconsin. The incredible
event lasts a week and draws more
than 425,000 people.

I wanted something that would
capture the spirit and the excitement
of the show. I had no doubt that the
shot I was planning had to be taken
from the airplane itself. The photo-
graph would also have to include the
ground and would have to be taken
from the pilot's point of view.

What you see here is a photograph
of an aerobatic stunt team trailing
streamers of smoke from their Pitts
Special biplanes. But I needed to do

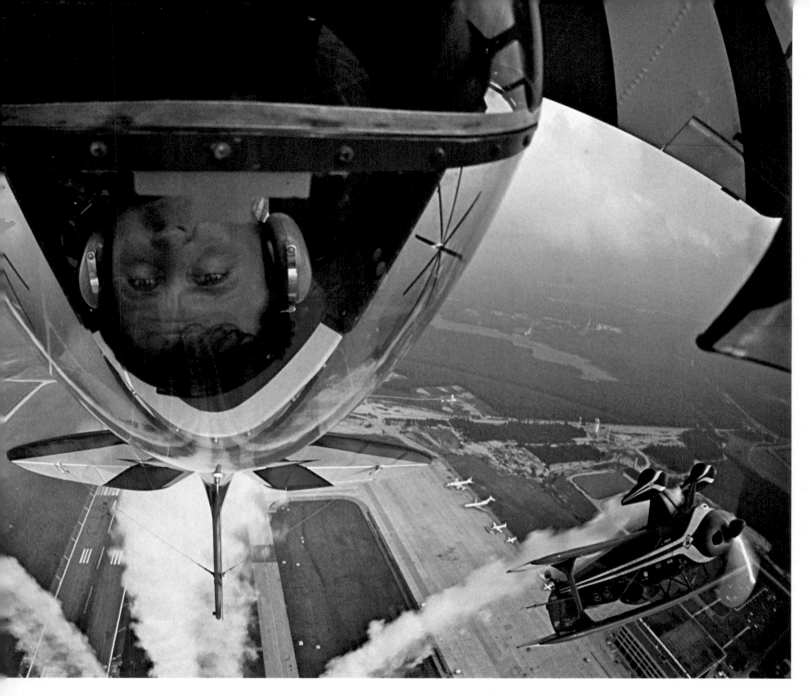

more than come up with an idea. I had to figure out how to do it—and get the men to cooperate with me.

The camera was rigged to the top wing of the flight leader's plane, and the tripping mechanism was passed through into the cockpit so that the pilot could trip the shutter. I spent quite a bit of time on the ground explaining to the pilot when to trip the shutter and what kind of maneuvers would work best for the photograph. Once the pilot knew what I wanted, the picture was all but taken. The actual shooting was no problem.

One of my cardinal rules when I take this kind of picture is never dent, scratch, or mar the object to which the camera is attached. I have to mount the camera so that when it is detached the object that supported it is in exactly the same condition as when I started.

When I set up the airplane picture I was lucky. One of the wings had been modified earlier to hold a movie camera for a feature film. I measured the mounting bolts so that they would attach to a specially-built camera box. The shutter cable for the camera was run into the cockpit out of view of the camera. The installation produced no problems. Neither did the shooting, which took about 15 minutes. I used a motor-driven camera with a 250-exposure back.

I almost always use a very wide-angle lens—a 16mm or 18mm—when I take such remote pictures. If everything works, the pictures can have a lot of impact, a lot of power. The combination of wide-angle lens and unusual perspective lends an abstract quality to the photograph. The thrown snow or splattered water often creates spectacular highlights or patterns that never could have been predicted in advance.

Whenever I approach an assignment like this, I try to show an ordinary subject in a new way. I say to myself, What haven't I *seen?* Is there something here I can look at in a different way that will change the subject for me?

I try to foresee difficulties and find ways to circumvent them. My advice is to plan as much as possible. If you try to tackle the whole problem at once, it can be overwhelming. But if you attack it one step at a time, and if you answer each question as you go along, the setting up of the photograph becomes easier and more manageable. Once you have the idea, the work itself may seem rather mundane—almost boring. But the final result can be beautiful.

Tripod Floating in the Sky

By Otis Imboden

Digging into the past holds a special fascination. Glittering treasures of gold and jade! No, the archaeologist quickly tells you, the digging is not for price-less relics. It is for threads of information that will help piece together the faded tapestry of a "lost" civilization.

The camera today plays a vital role in scientific excavations throughout the world. Many archaeologists begin their search with photographs that were taken from earth satellites or high-flying aircraft.

I too use aerial views to record ancient ruin sites—but my camera platform is a wicker basket slung beneath a hot-air balloon.

Why a balloon? Why not? Hasn't every photographer longed for a tripod that would raise a camera 30 or 40 or 60 feet off the ground? But the best reason for using a balloon revolves around time: Daybreak and sundown are special times for photography—and times of low winds, when balloons fly best.

Helicopters vibrate; airplanes demand high shutter speeds, but the balloon floats gently, allowing time for suitable shutter speeds. Even with slower color films a sharp picture can be taken at $1/8$ or $1/4$ of a second, making it feasible to work at dawn or dusk, the time of "gentle light."

The balloon also provides the time for thoughtful composition, time to wait for the right mix of shadow and light, time to make a better picture.

Balloon reconnaissance is not a new idea. T. C. Lowe used balloons as "eyes in the sky" in the Civil War. French photographer Félix Tournachon took cameras aloft over Paris in 1858. And in 1930 balloon-borne cameras employed by the Breasted expedition to the Holy Land provided bird's-eye views of Megiddo, site of the battle of Armageddon.

My own interest in balloons grew from a meeting with architect Julian Whittlesey and his wife, Eunice, who have flown balloons over virtually all the major excavation sites of Italy, Sicily, and the Near East.

Other photographers are continuing the Whittlesey tradition. So, if you visit the ruins of a long-lost temple and see a bright balloon at the end of a long line, it may be an archaeologist using today's camera techniques to peer into the ancient past.

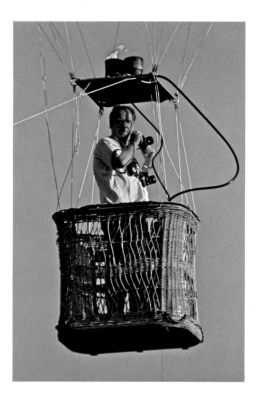

Gently aloft at dawn, a tethered hot-air balloon provides a steady platform for Otis Imboden, on assignment over Mayan ruins at Palenque, Mexico. From an earlier flight across the Swiss Alps came the self-portrait at left.

Otis Imboden by Manuel León Tovilla

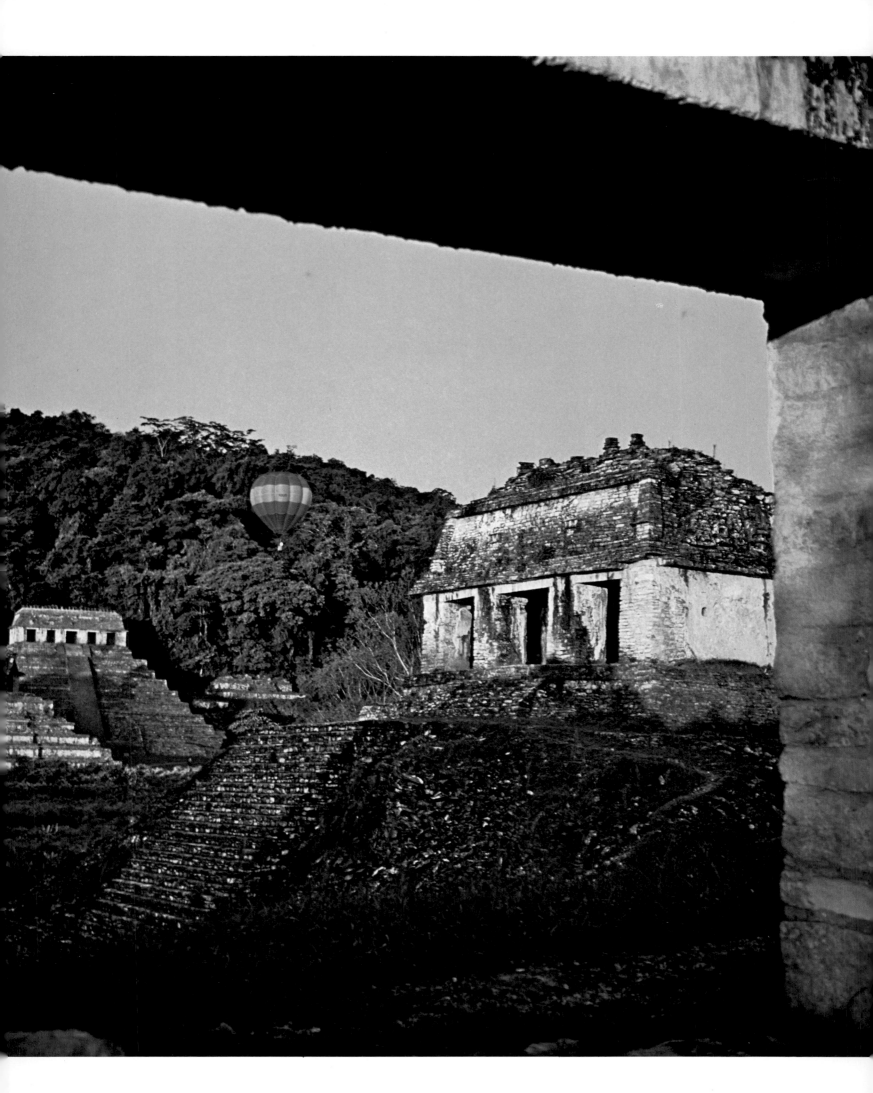

ALL THE GREAT OUTDOORS

Lucent fern in deep woods. By Farrell Grehan.

Long before we Americans took up touring our continent by automobile, Gilbert H. Grosvenor realized just how far away most of it was to the average person. "The mind must see before it can believe," he said, and in 1911 gave readers a dramatic spectacle. More than 20 magnificent peaks of the Canadian Rockies unfolded from National Geographic's June issue in an eight-foot panorama.

To make the picture, geologist Charles Walcott had mounted on his tripod a Kodak Cirkut camera that rotated to scan the horizon. As the camera turned, each section of the film remained exposed for $\frac{1}{10}$ of a second.

It took two men to carry Walcott's ingenious but awkward gear to the rocky perches from which he worked, often hindered by dust, smoke, clouds, and summer haze. Walcott considered half a dozen small pictures and "one really great panoramic view" to be a successful season's work.

From its founding, the Geographic has focused on the interplay between people and nature, reminding readers of what Henry David Thoreau discovered: "Nature is full of genius, full of divinity."

In search of that genius, Geographic photographers have gone to deserts and swamps, through tropical rain forests and polar ice fields, down wild rivers and up lonely mountains, looking for the scenes that would convey the sense of enchantment Thoreau once found at the edge of Walden Pond.

They have literally followed in the footsteps of Thoreau—and of John Muir, Robert Frost, William Bartram, John James Audubon, and Daniel Boone—hoping to see the world as those before them had.

Recording those visions on film has never been easy. Because photographers cannot rearrange the mountains and trees on command, they are slaves to the natural elements—wind and cloud, rain and light—which shape the landscape. So they must be able to move quickly when a picture begins to take shape.

In the Geographic's early days, the mobility of photographers was limited by cumbersome, heavy camera equipment. (In 1934, a photographer on assignment in Australia wrote to his boss complaining that the weight of his camera was flattening his feet.)

Photographic plates were easily ruined by damp weather. And the wilderness was inaccessible to all but a handful of hardy daredevils like Ellsworth and Emery Kolb.

The Kolb brothers spent 12 years photographing in the Grand Canyon on foot and muleback. The result was one of the magazine's first major articles on outdoor America. Published in 1914, it had 70 black and white pictures in its 85 pages.

Though well known today, the canyon was then a vague spot in the immense landscape of the West, at least in the minds of most who lived outside the region. An editor expected the Kolbs to change all that: "Their primary object has been to obtain a complete photographic record of the unequaled scenic wonders of the Southwest," he said, "for the enjoyment and instruction of the millions of Americans who are unable to visit them."

In the field, the Kolbs must have wondered if their cameras would survive. They recalled trudging through an Indian village, "one of us astride a mule as weary as ourselves, the other walking, while one of our two pack-burros, with his precious load of cameras and dry plates, stampeded down the road, trying to shake off some yelping curs that were following at his heels."

They regained control of the burro, but their problems were not over. Before they could camp for the night, they had to coax the burros across several fords in a mountain creek, and like all their colleagues then and now, they worried about their equipment. "It was with difficulty that we persuaded the burros to make the crossing, and when they did . . . it was with a violent scramble for the opposite shore," they recalled. "We wondered many times how our plates were faring."

O. D. von Engeln, a contemporary of the Kolbs, was plagued by damp weather during National Geographic expeditions to Alaska in 1906 and 1909. On one trip, the wooden casing of his

George R. King. National Geographic Magazine, June 1912.

Photographer unknown. National Geographic Magazine, January 1910.

The Jeffrey pine on Yosemite's Sentinel Dome has beckoned photographers for decades. This view of the tree, twisted by winds and time, is from days of black and white. On pages 228-229 the same tree stands in near-abstract color.

On an early expedition to Alaska, the photographer washed film in seawater, with no harmful effects. "Develop in the field . . . as soon as possible after exposure," O. D. von Engeln advised.

Jasper D. Sayre. National Geographic Magazine, April 1919.

A photographer takes aim at the fuming terrain of Alaska's Valley of Ten Thousand Smokes. The Geographic called the valley "one of the greatest wonders . . . of the natural world." President Wilson agreed, and created a national monument there.

Following in John Muir's footsteps to explore the Mt. Rainier region, A. H. Barnes proclaimed its lilies "the most spectacular flower of the mountain. . . ."

A. H. Barnes. National Geographic Magazine, June 1912.

camera swelled with moisture, pushing his lens off-center and putting his pictures out of focus. In northern latitudes, round-the-clock sunlight made it difficult to prepare fresh plates, which had to be loaded in the dark. Von Engeln tried working under a blanket to shut out the bright light, but it sometimes leaked through anyway.

For the Geographic's next Alaskan expedition, he ordered a portable darkroom, hoping it would provide a safe place to handle the plates. The tent, an eight-foot cube of black duck lined with red cotton, looked functional but inelegant. He called it the "dog kennel."

The tent was useless. It wasn't waterproof, and soon the black exterior faded to dingy brown, which admitted too much light for von Engeln safely to use it as a darkroom. "The old blanket expedient had again to be resorted to," he reported.

On such scientific expeditions, photographers like von Engeln were the record-keepers. Their pictures showed where the explorers had been. The emphasis on documentary work, combined with adverse working conditions, restricted "very narrowly such aspirations as the photographer may have for doing pictorial work," von Engeln said.

Traveling with scientists was frustrating too. "The scientific notes and observations at any one site . . . require much less time to secure than is necessary for the exposure of the requisite number of plates. The party . . . is ready to move on as soon as the photographer has . . . shouldered his camera and tripod," von Engeln said.

Despite such difficulties, the early photographers endured, turning out pictures that reflected the diversity and raw beauty of America's wilderness. They were encouraged by the magazine's Editor, Gilbert H. Grosvenor, who had developed his own taste for outdoor life during a trip to the West in 1915. It was a trip that would profoundly affect the magazine's handling of nature stories in the future.

Visiting the High Sierra with the conservationists of the day, Grosvenor was so impressed at the sight of the "majestic and friendly" sequoias that

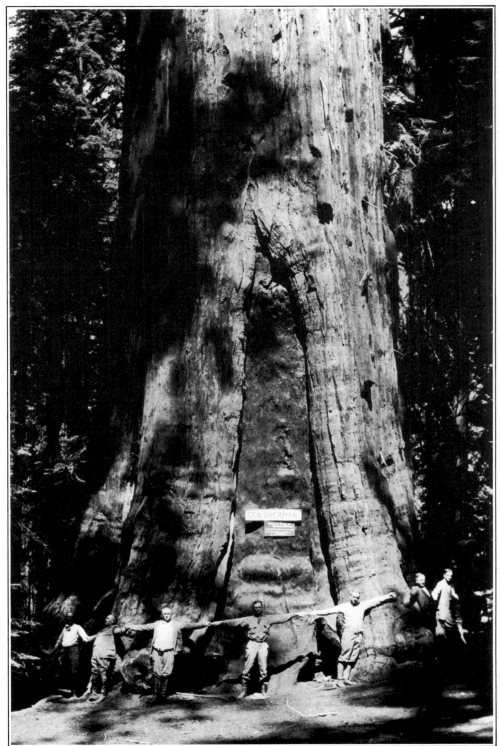

Gilbert H. Grosvenor. National Geographic Magazine, April 1916.

Twenty men encircle a giant sequoia, one of many threatened by lumber interests in 1915. Conservationists of the day, including the Editor of the Geographic, helped establish a park to preserve the endangered forest.

225

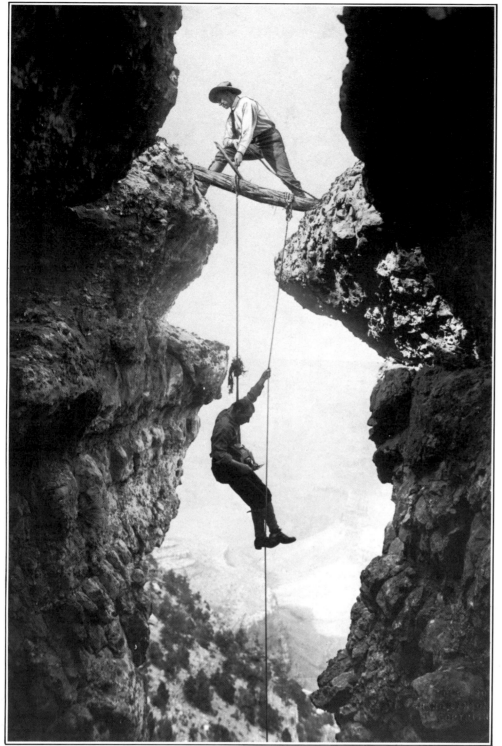

Photographer unknown. National Geographic Magazine, August 1914.

Trust: Ellsworth Kolb suspends his brother Emery over a 300-foot drop for a better angle on the Grand Canyon. Theirs was one of the first extensive nature stories in the Geographic.

he moved his sleeping bag to the base of a giant tree. This alarmed his hosts. "A small branch falling from that height could kill a man," one companion recalled. "But Mr. Grosvenor said he'd take the chance."

He survived unscathed and returned to Washington, convinced that the scenic wonders of nature were not only pretty to look at but also eminently worth preserving.

This was a turning point for the Society, which before had been content to describe the wilderness, to document what it looked like. Now Grosvenor crossed the line from reporting into advocacy, pulling the magazine with him. In 1916, he persuaded the Society to donate $20,000 to preserve a stand of sequoia trees, now a part of Sequoia National Park. And he began writing about the value of wilderness. His special report, "The Land of the Best," filled the entire magazine in April of 1916.

"As playgrounds for recreation and instruction our national parks are without rivals on any continent," he wrote. In the wilderness of America, he said, "there is a majesty and an appeal that the mere handiwork of man, splendid though it may be, can never rival."

After the Grosvenor story appeared, Congress voted to establish the National Park Service, a new section of the Department of the Interior designed to watch over the scenic or endangered lands of the Nation. Backers of the legislation said that the magazine—sent to each Congressman before the vote—influenced the outcome.

From those days, the Society developed a special relationship with the National Park Service, whose directors served as trustees of the Society and, over the years, often wrote articles for National Geographic.

In a 1958 story, accompanied by 48 pages of color pictures, Conrad L. Wirth wrote about the parks' expansion to 24 million acres during his term as Park Service chief. And in the 1960s Wirth's successor, George B. Hartzog, Jr., described the government's plans for further growth. The future of the parks looked hopeful.

Gradually, however, it became clear that the parks were in trouble. Many were showing the effects of

overuse. Others had financial problems. Some were endangered by pollution. The Geographic sounded a warning. In 1972, the 100th anniversary of Yellowstone National Park, the magazine published a story about America's oldest park, "invaded by city woes." The story featured the obligatory photographs of scenic wonders, but there were also scenes of trouble in paradise—pictures of traffic jams, house trailers, crowded bus terminals, and overflowing parking lots—"the pitfalls of success," said the story.

In 1977, Wilbur E. Garrett (now Editor of the magazine) returned to the Grand Canyon of the Kolbs. They would have been envious. For with his modern cameras he found new color and new moods in the starkly beautiful landscape they had captured in their black and white photographs.

Though impressed by the enduring grandeur of the canyon, Garrett was also concerned. "Are we loving it to death?" he asked.

What was happening in the parks was happening to all of our outdoors in the 1970s: The American landscape was changing, and it was becoming a scene of battle between the conflicting forces of development and preservation.

"Lonely beaches . . . sprout condominiums . . . where spoonbills once nested," Society President Gilbert M. Grosvenor wrote. "The desert night blazes with the garish neon of cities. On western hills and northern lakes, the cries of coyotes and loons give way to the snort of road-building . . . machines."

Society publications began to investigate, taking a dual approach to stories about environmental degradation. Photographs showed ugly things humans had done to nature: oil spills off the Brittany coast, destruction of the tallgrass prairies at home, air pollution in the Southwest. But the Geographic also continued to photograph the unspoiled places—to remind readers that many spots on this battered earth are still worth seeing, and much of our world is still beautiful.

In the gallery that follows you will see images that reflect the beauty of that world, and the essence of what Thoreau found to be full of genius and divinity.

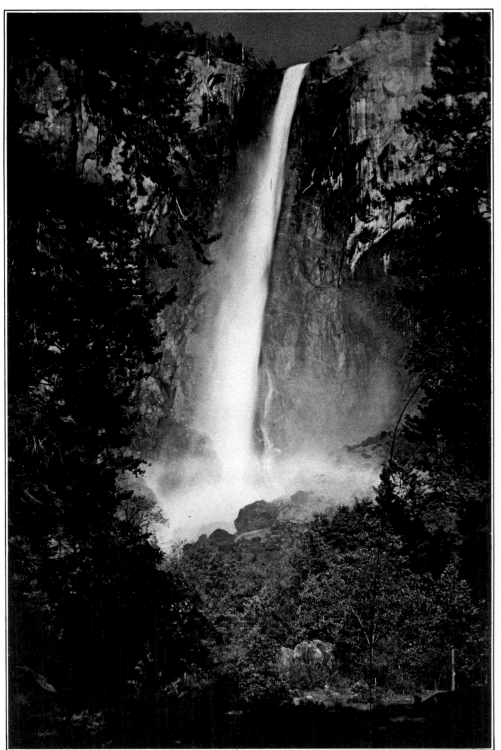

Franklin Price Knott. National Geographic Magazine, April 1916.

Natural-color photography was introduced in the Geographic in 1914. This photograph of Bridal Veil Falls, Yosemite, was part of the magazine's first natural-color series.

227

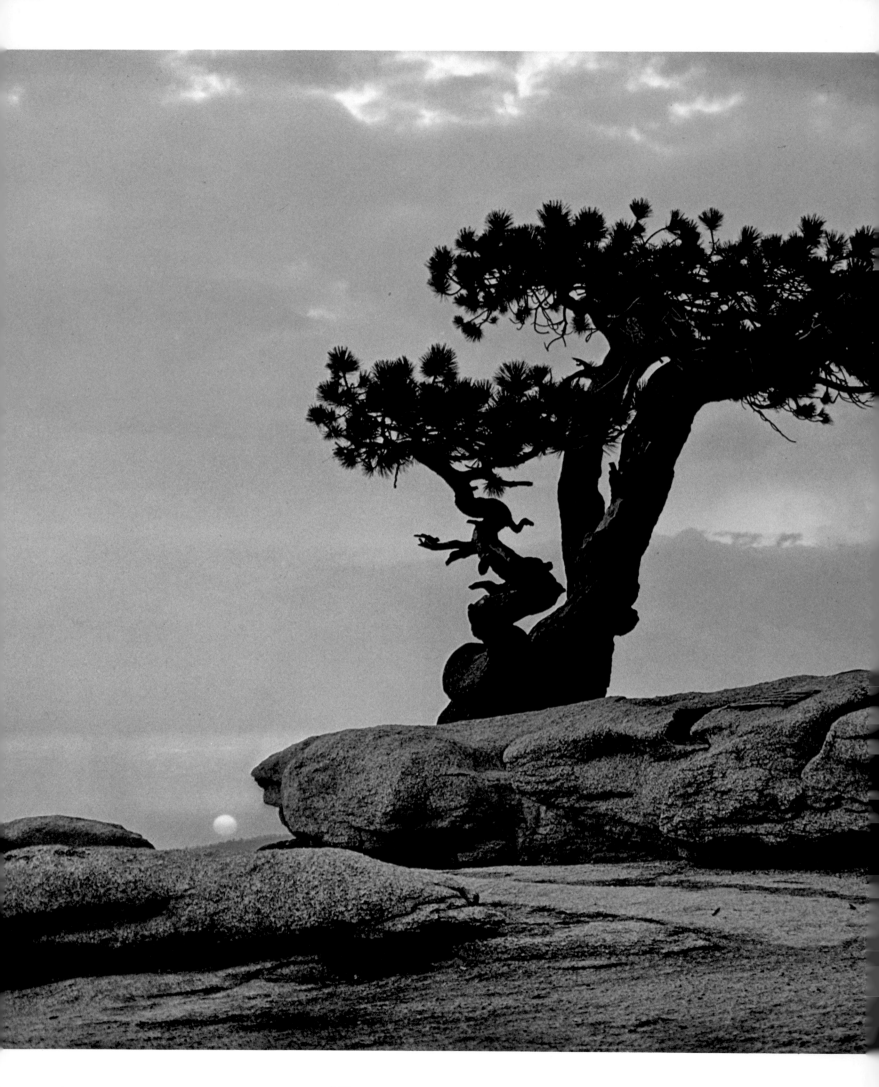

"It was gray and it was awful: not a pretty day at all," Dewitt Jones recalls. But, trusting his intuition, he went to the Sentinel Dome high in California's Sierra Nevada, where George R. King had taken a similar picture (page 223) some 60 years before. When Jones arrived, the sun broke through the clouds. He shot. "I sat there knowing I had a great photograph . . . the essence of John Muir in tree and light and cloud."
DEWITT JONES

In the Canadian Rockies (overleaf), Brandenburg played the sun's fire against the ice to show the subtle balance of nature. "A few degrees warmer and this could all melt. It shows us we have to be careful with our planet."
JIM BRANDENBURG

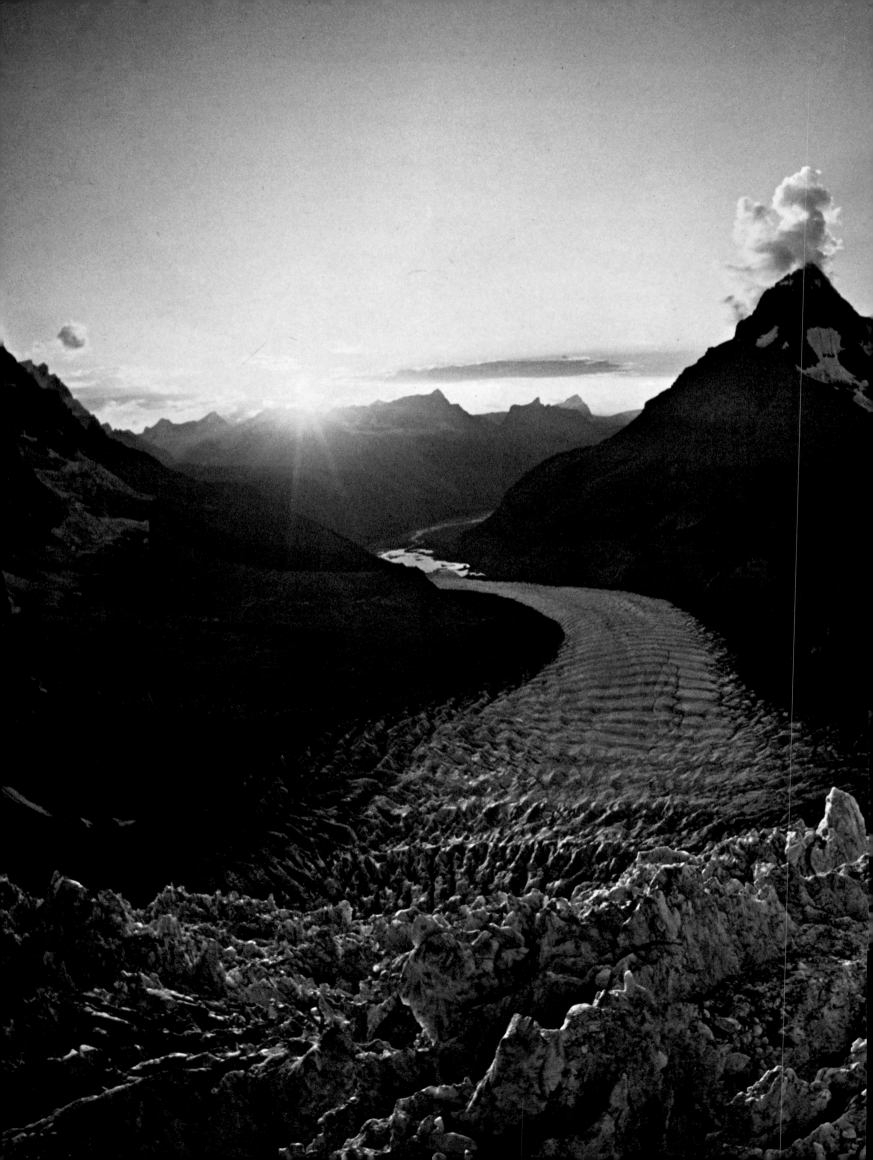

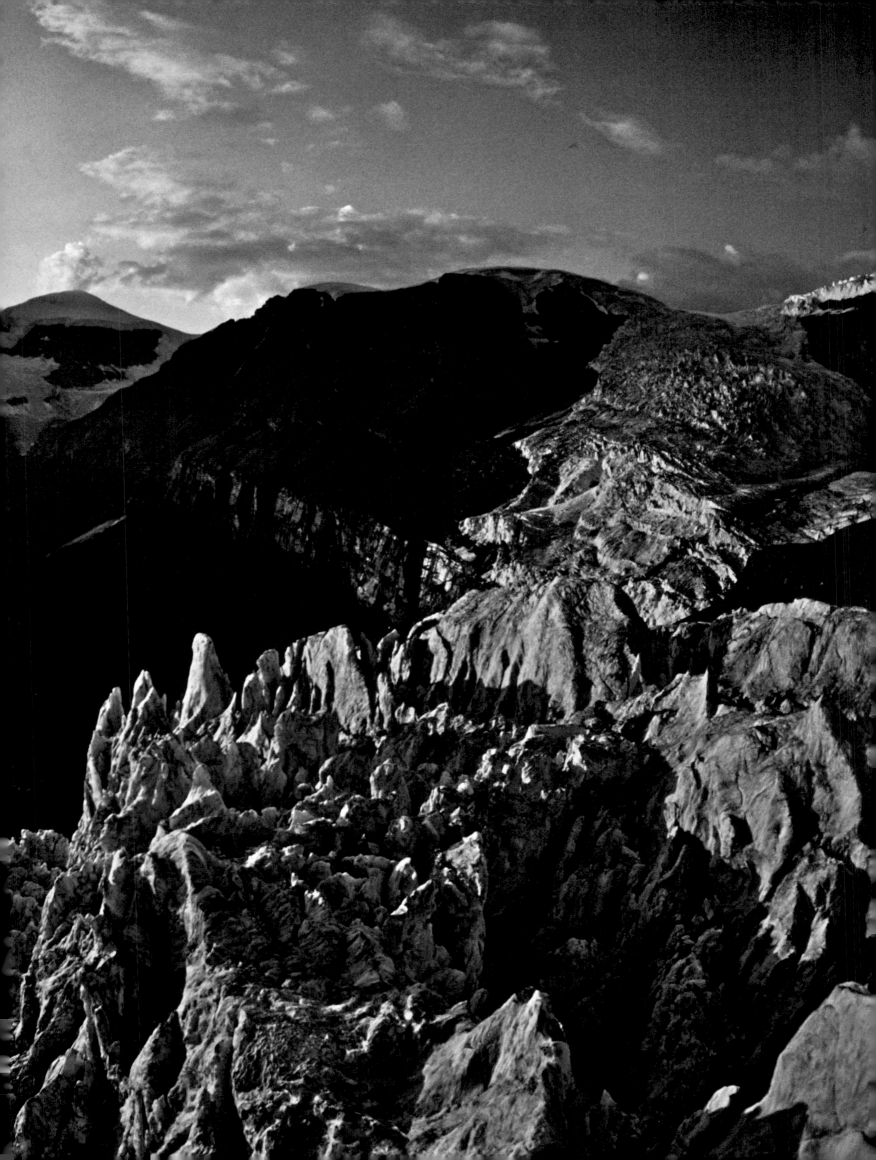

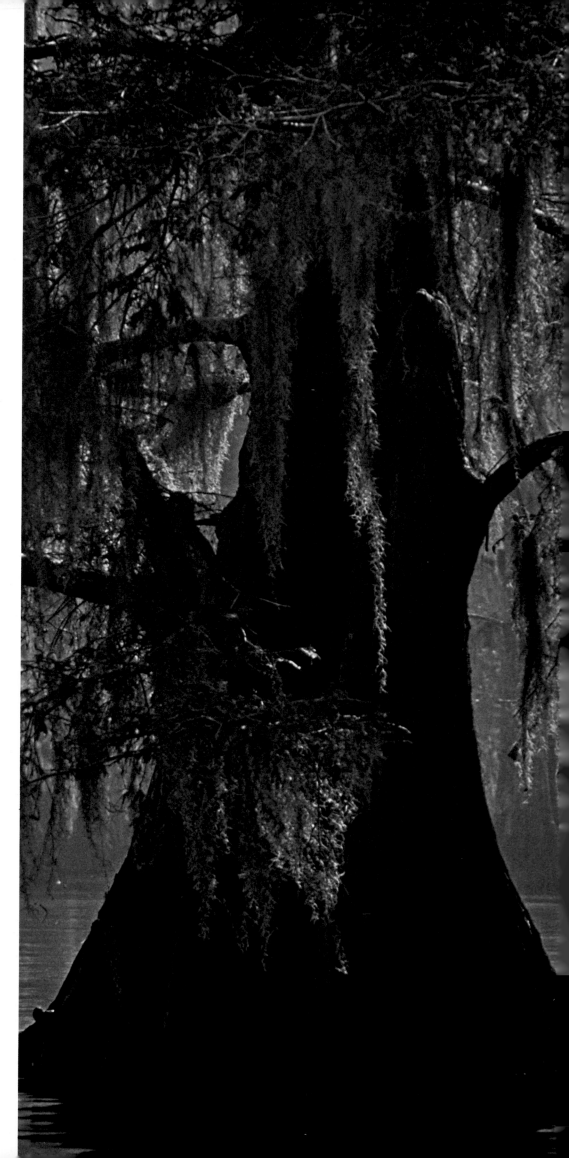

Near the end of three months of work in Louisiana's Atchafalaya country, Yva Momatiuk and John Eastcott relaxed, getting in tune with the dreamy mood of the place. They glided around Lake Verret in their canoe, thinking about how the swamp must have looked to the first settlers. About noon, the mist went ragged in the sun, forming this tapestry of moss, cypress, and water.

YVA MOMATIUK AND JOHN EASTCOTT

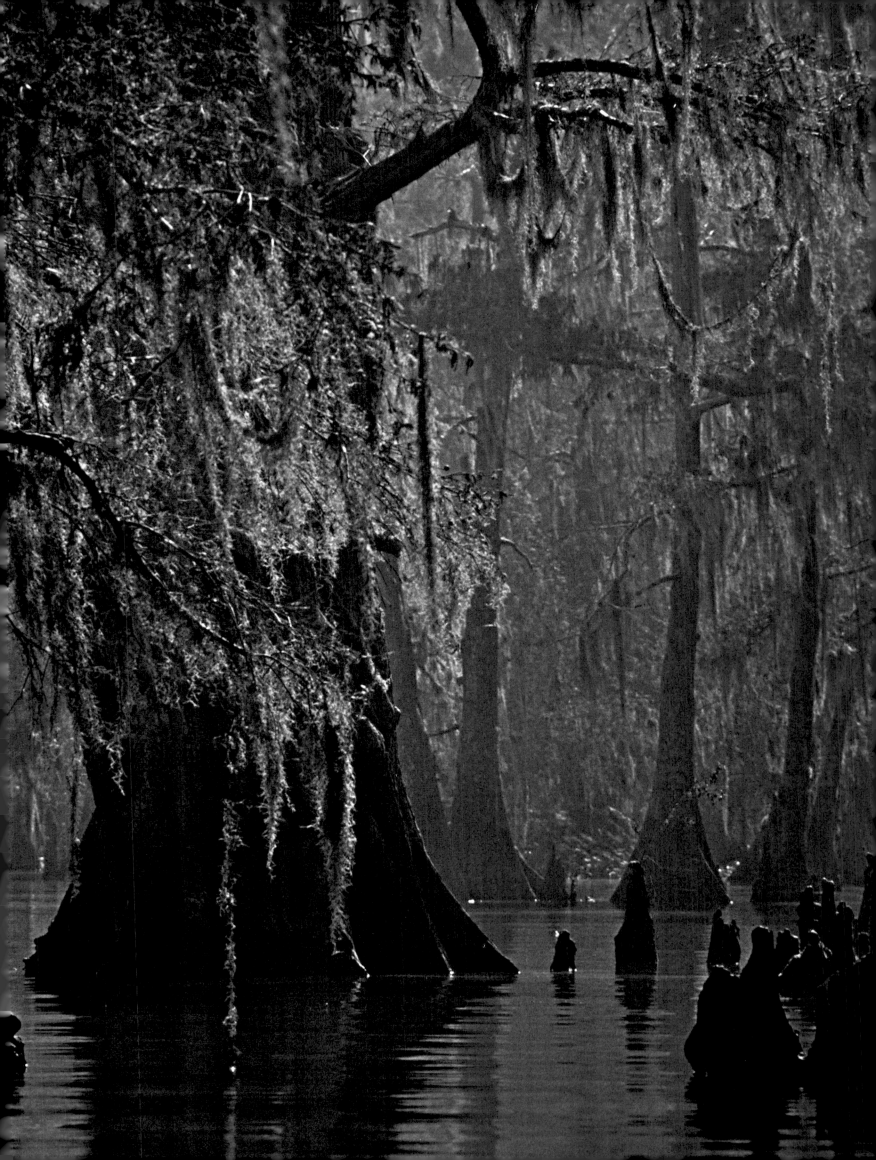

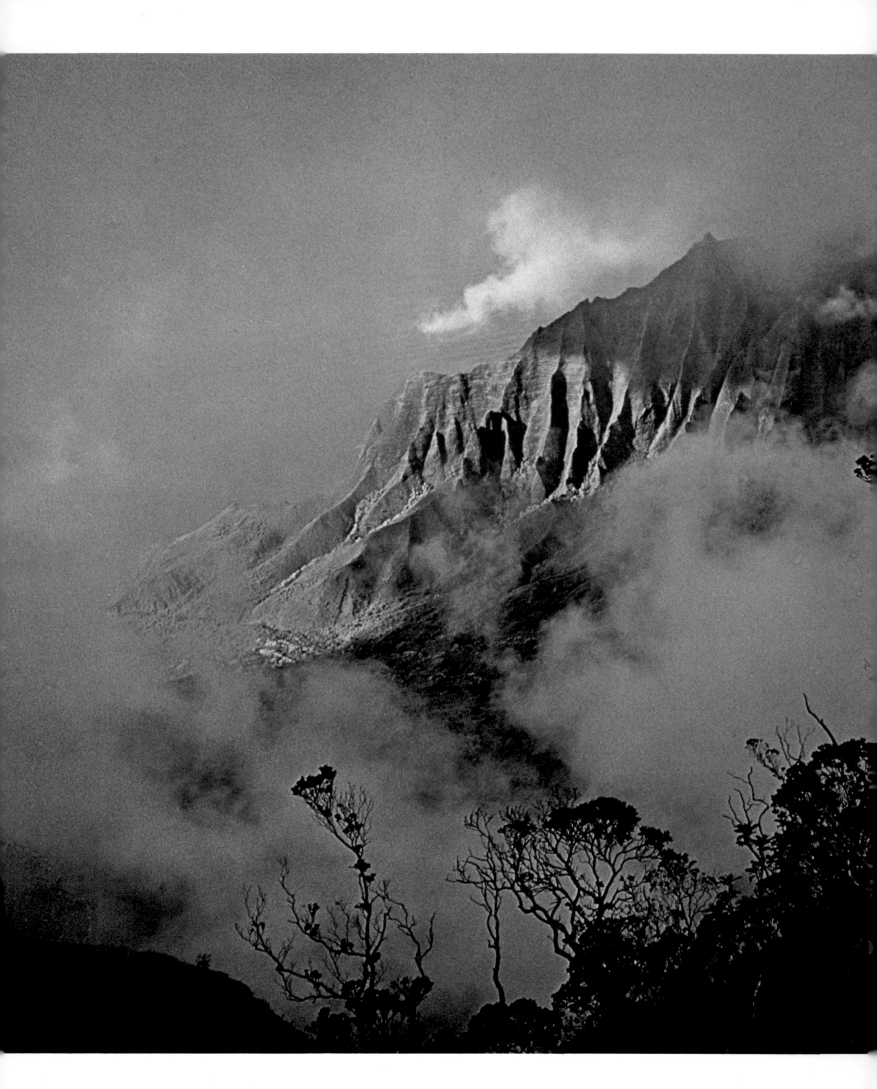

"It was absolutely socked in, a solid bank of clouds" when Jim Amos went to Hawaii to photograph the cliffs of Kauai. "I had a hunch, so I waited. The clouds opened up. It was just a question of being there and being patient."
James L. Amos

The Grand Canyon (overleaf): "I took the cliché view and angle. A thunderstorm came along, allowing me to make use of the light and clouds. It was a bit of luck. I shot this on my birthday."
Farrell Grehan

235

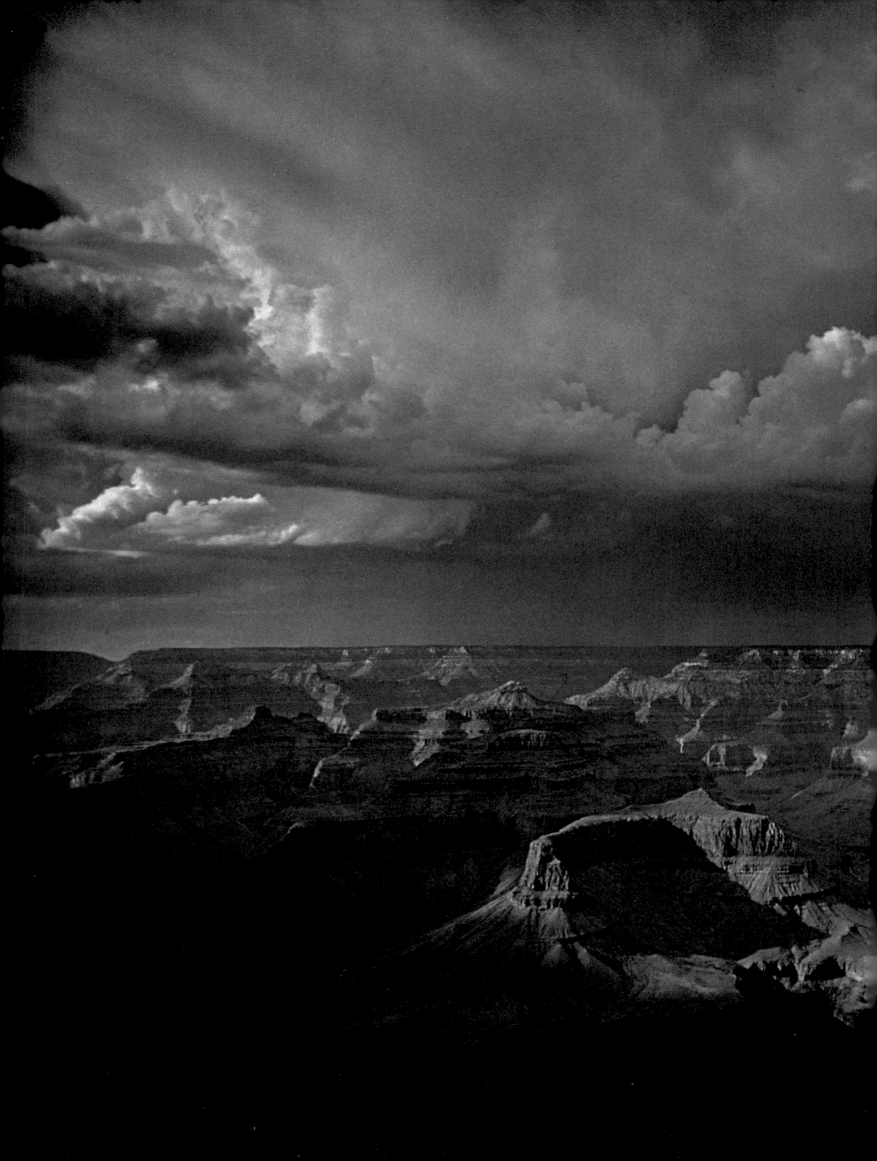

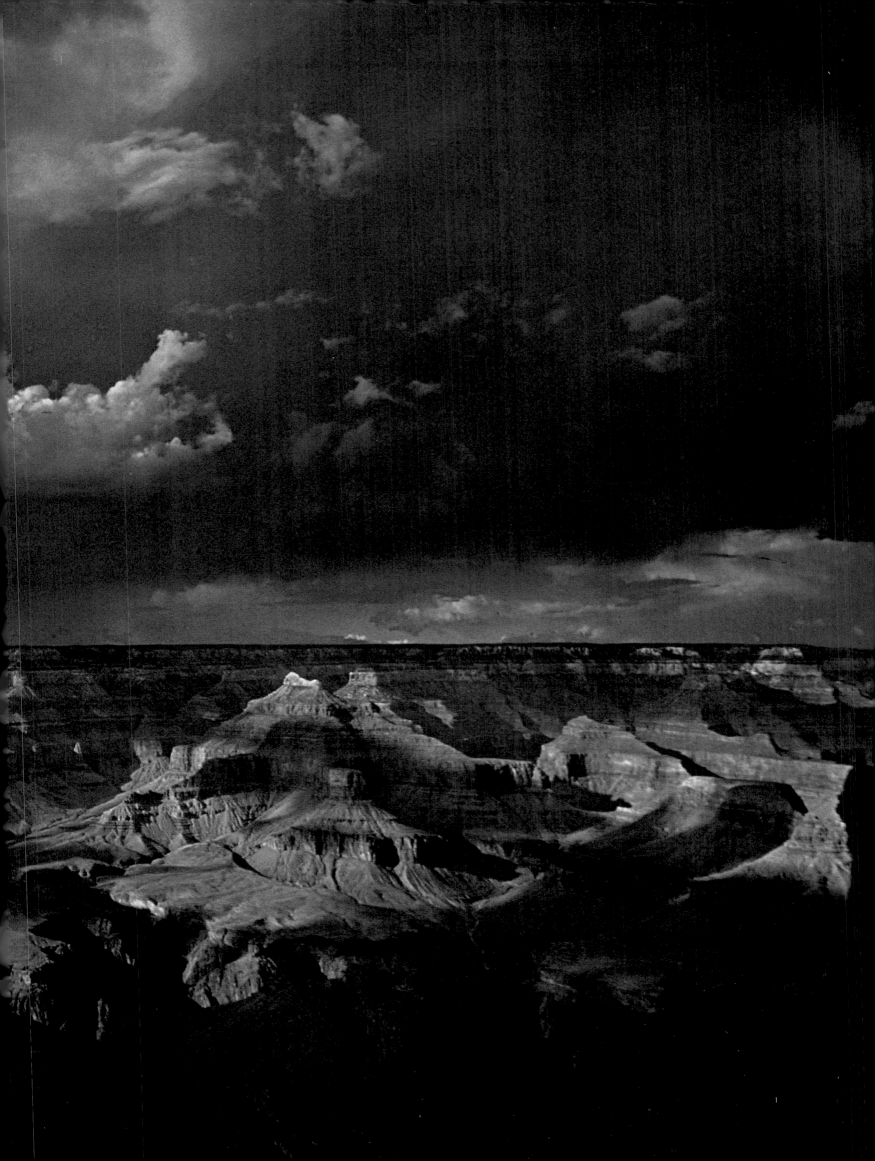

"I carried this snail around in my pocket until I found the right leaf," says Wilson, who finally settled on an alder leaf covered with slime. "I wanted a detail, something to show life growing in the dark rain forest."
STEVEN C. WILSON

Shooting in Yosemite (overleaf), Rowell says, "I wanted to get that fleeting moment when you know a storm is breaking, and you get that whole transition from storm to sunshine."
GALEN ROWELL

"In nature photography, you're always looking for a variety of colors—there's so much green around. This attracted me because it looked like children's candy. I'd never seen anything like it before. It's in Alaska."
FARRELL GREHAN

239

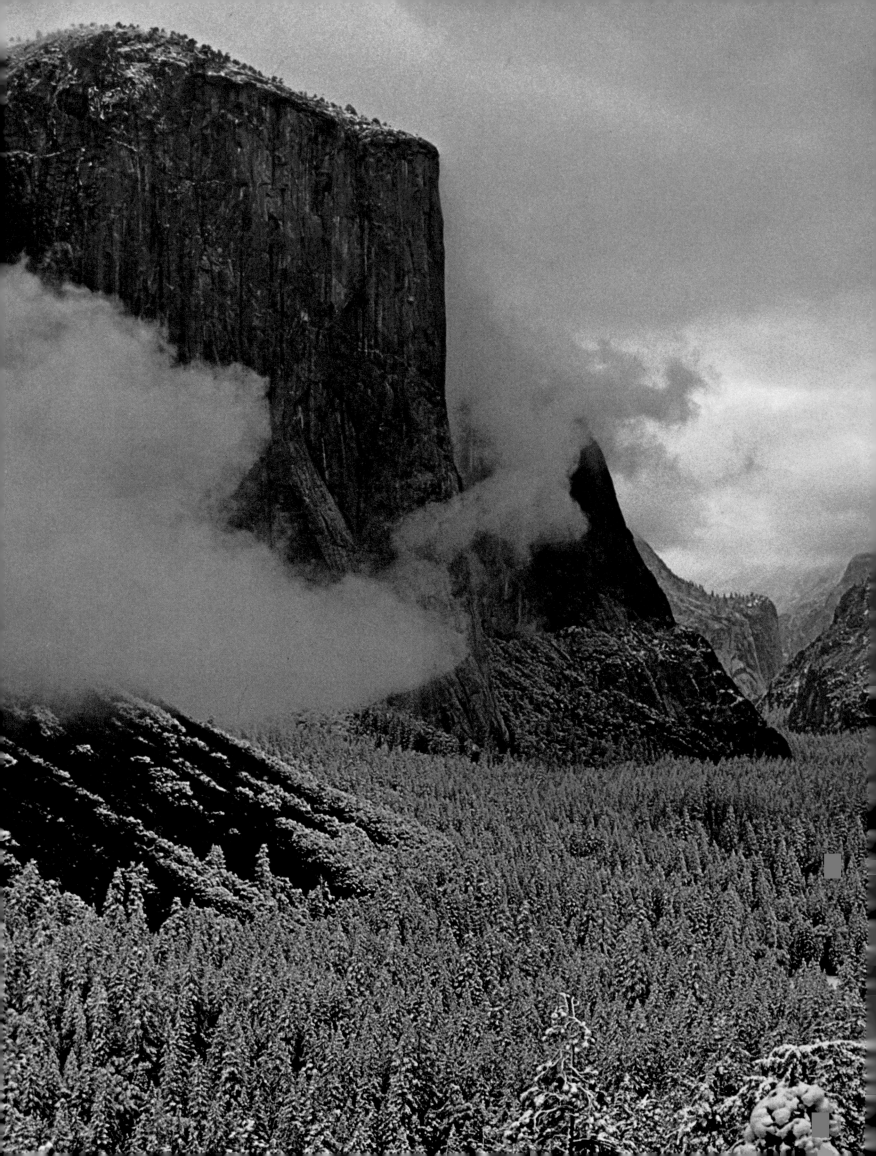

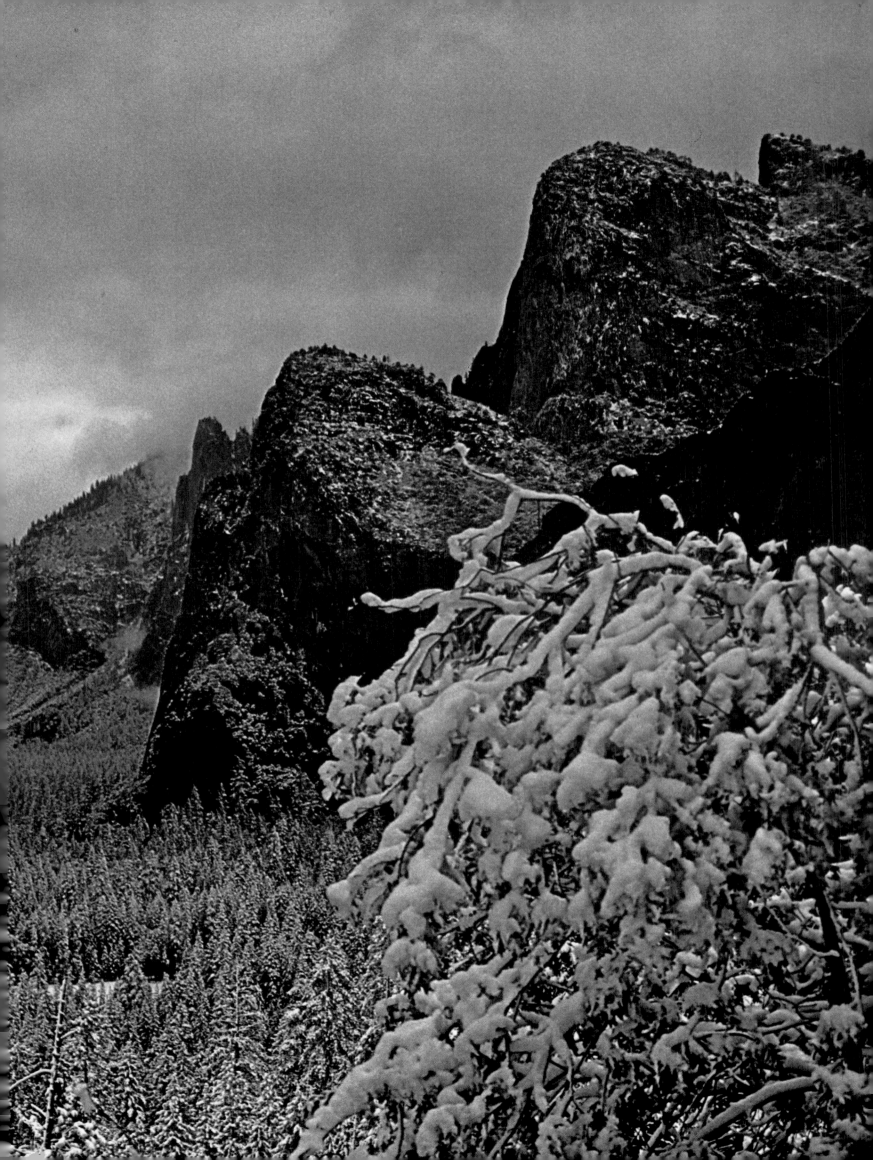

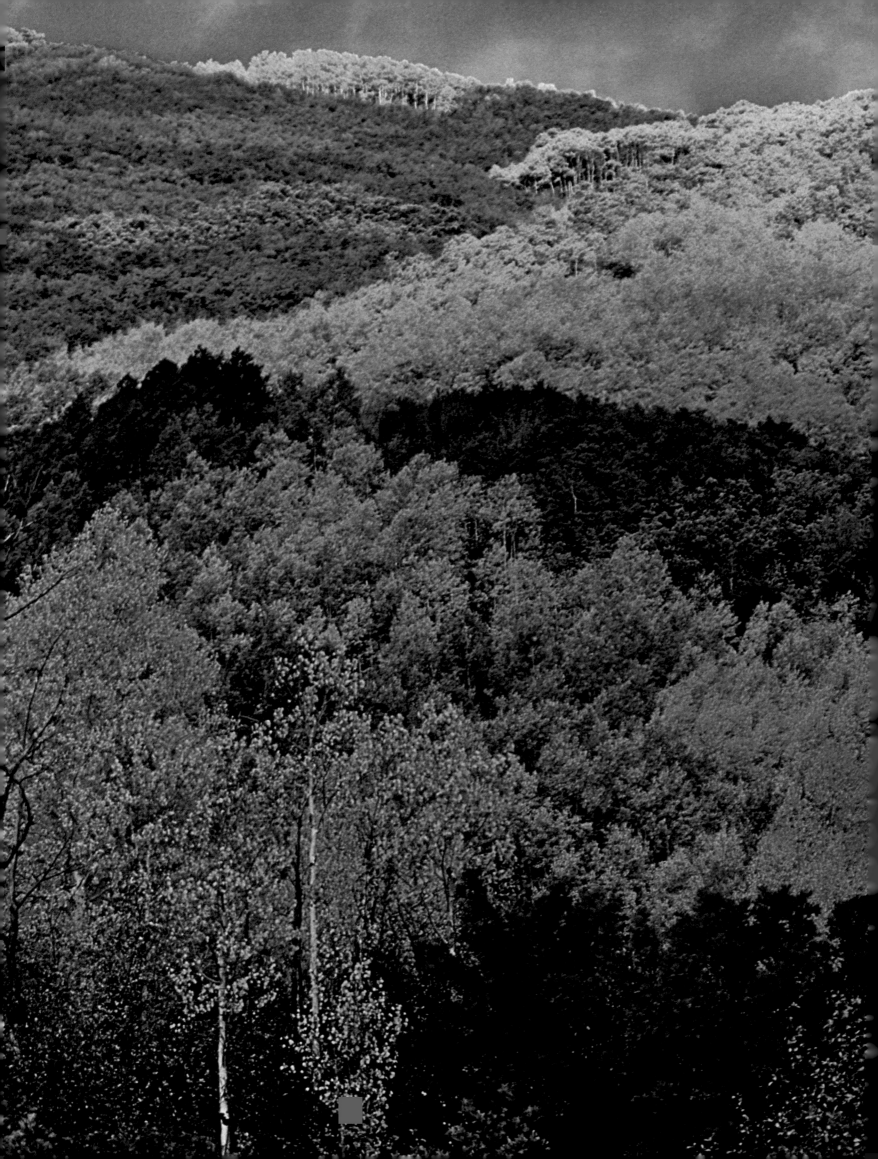

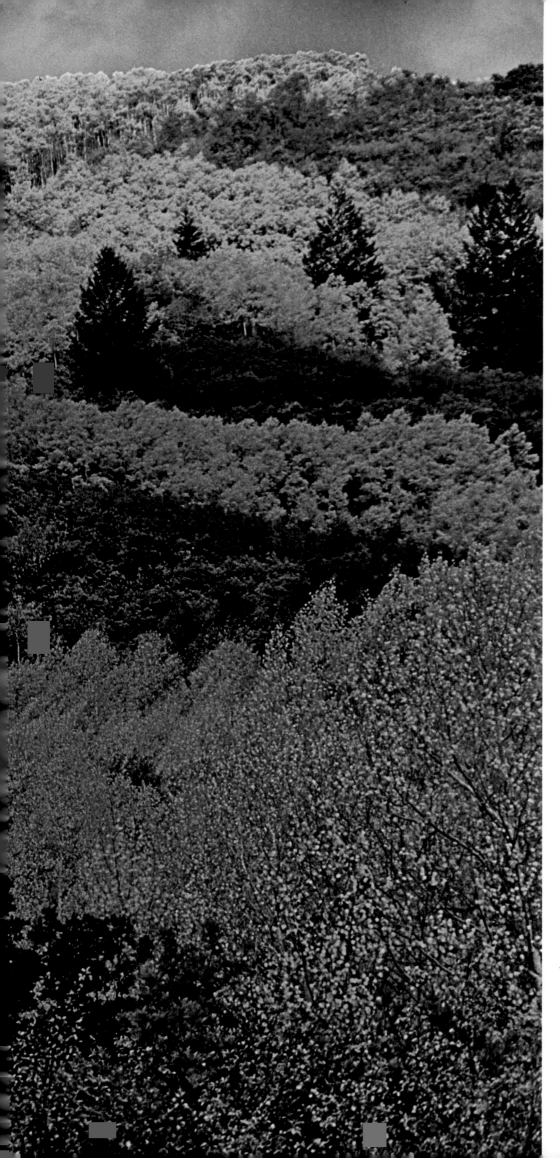

It takes scouting and luck to find the right picture, and the right instant, when all the elements of the image—pattern, light, and color—fit together. "So you're forever riding in this state of tension. You can drive thousands of miles just to find one thing . . . then suddenly, there it is." This time, *it* is a view of the Colorado Rockies after a thunderstorm.
DICK DURRANCE II

Winfield Parks was always on the move, looking for "photographs of lasting meaning." He found this one (overleaf) in Alaska's Valley of Ten Thousand Smokes, where Mount Katolinat broods in silhouette.
WINFIELD PARKS

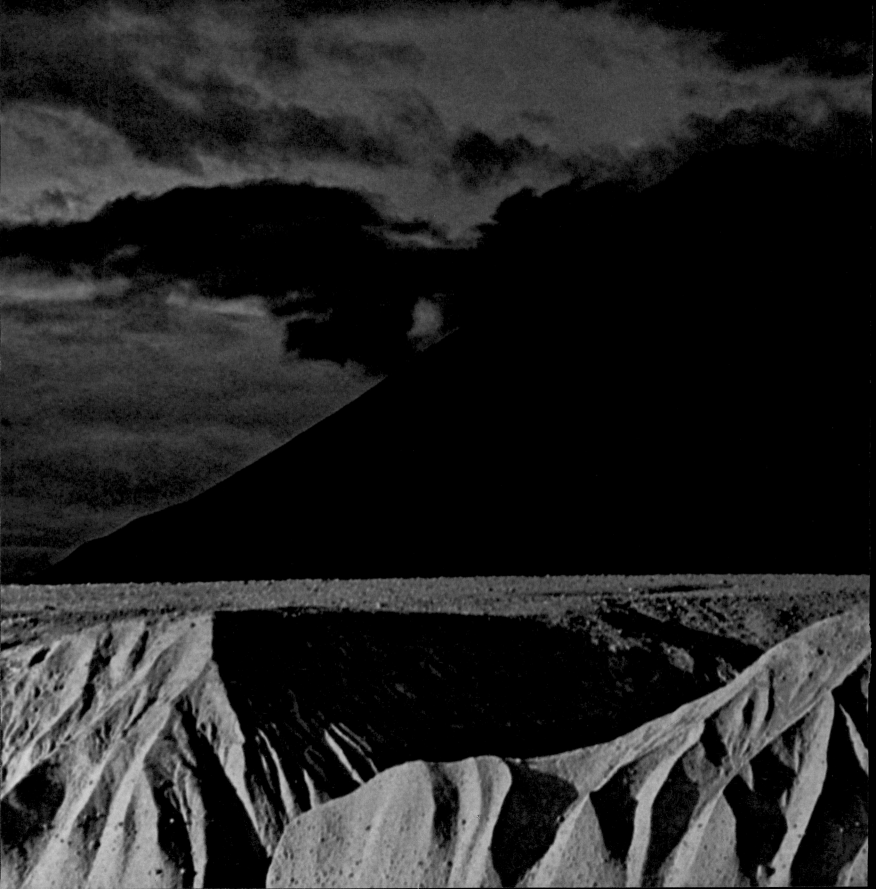

Jones knew that Redwood National Park was "a good place, a place where things could happen. I took a few pictures, good pictures, but I just couldn't leave. There was something unfinished. I kept standing around on this trail. Then I found myself getting on the ground under this rhododendron, looking up at the redwoods from the rhododendron's point of view."

DEWITT JONES

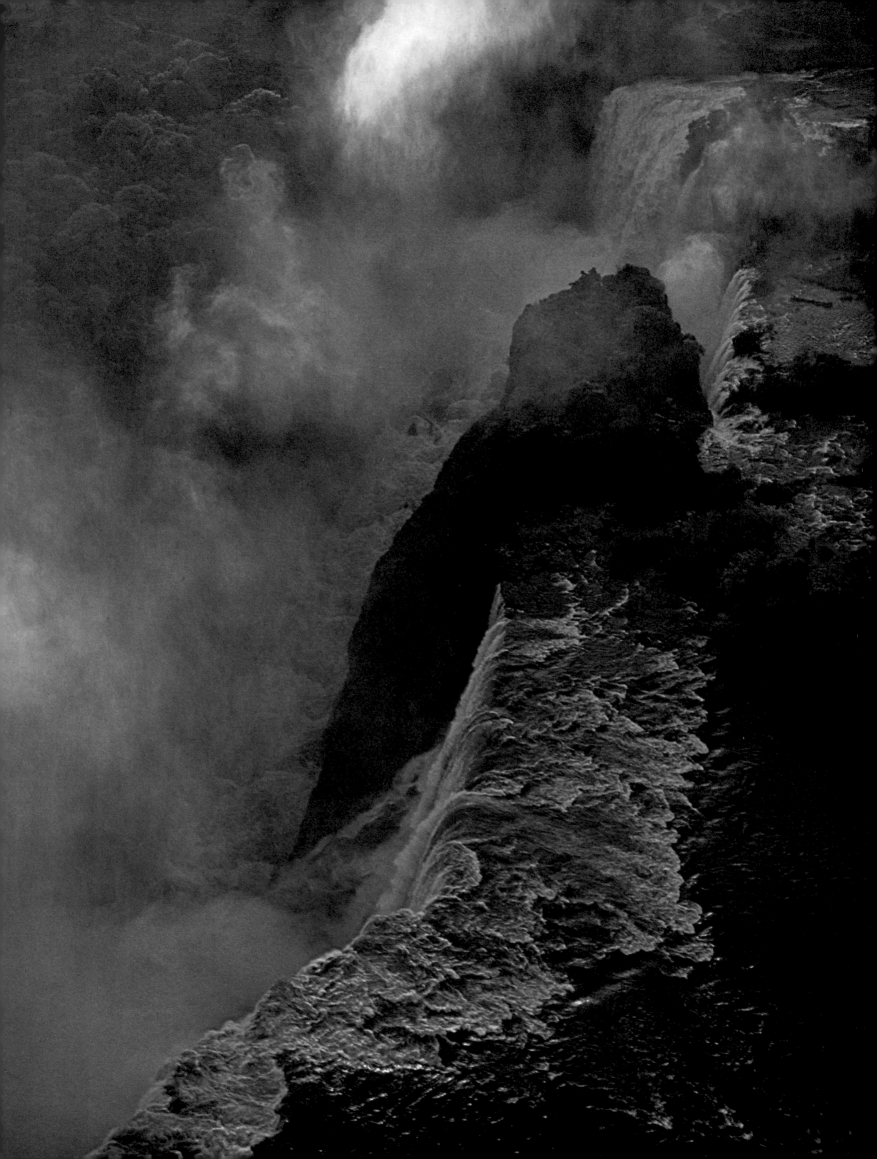

For two hours, Edwards circled
Victoria Falls in a small plane with
one door removed. "On this pass,
for two seconds, the sun set the mist
afire, and my camera captured it."
WALTER MEAYERS EDWARDS

"These climbers had already started
up when I arrived. I was trying to
climb too, so I didn't have the
luxury of taking time to choose lenses.
This first shot proved to be the best."
BRUCE DALE

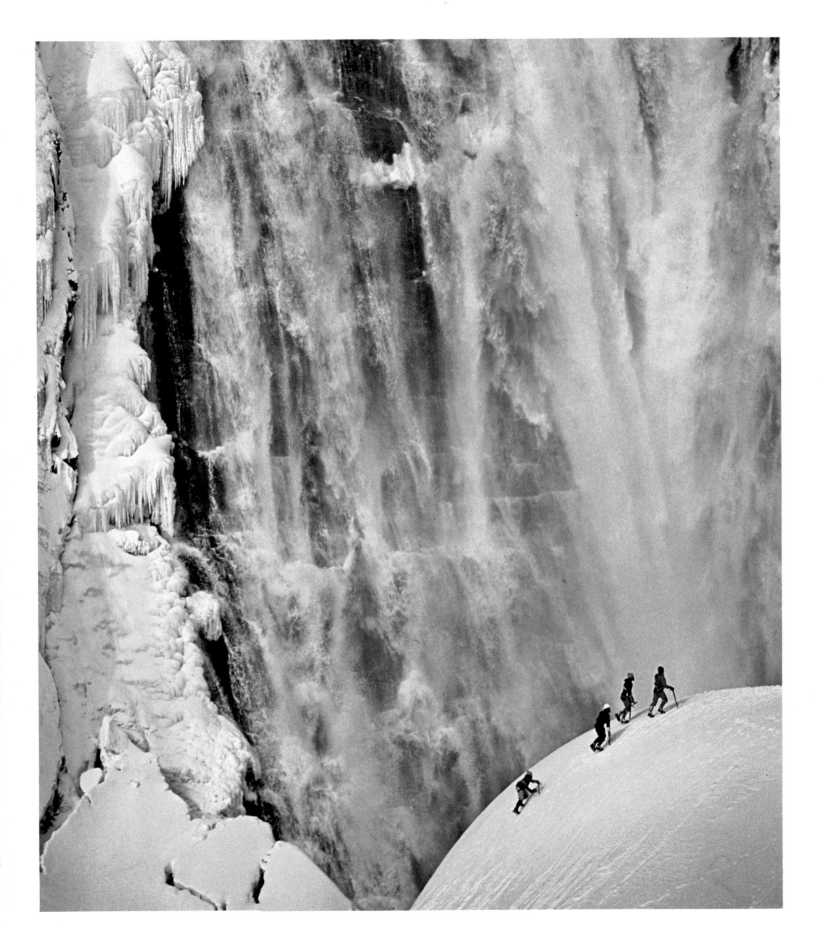

Trained in sculpture, Grehan saw the dunes of Death Valley as a study in shape and shadow, a landscape that seemed to melt as sunlight rolled across it. "The slanting light and those brooding mountains made the picture."
FARRELL GREHAN

The winds blow hard in southern Chile (overleaf). "You could hardly stand up. I had to lie on a rock to steady the camera. I shot fast. In five minutes, the clouds came down again and the mountain disappeared."
GEORGE F. MOBLEY

251

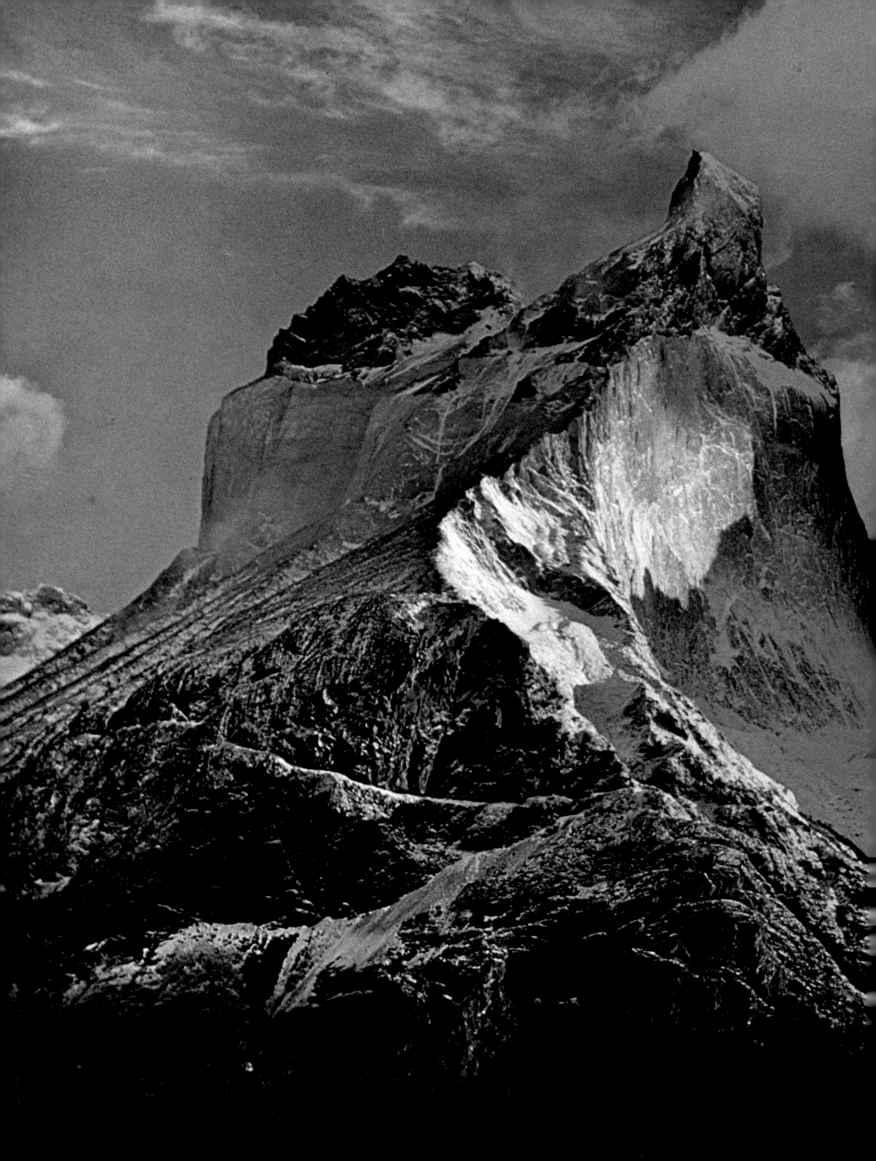

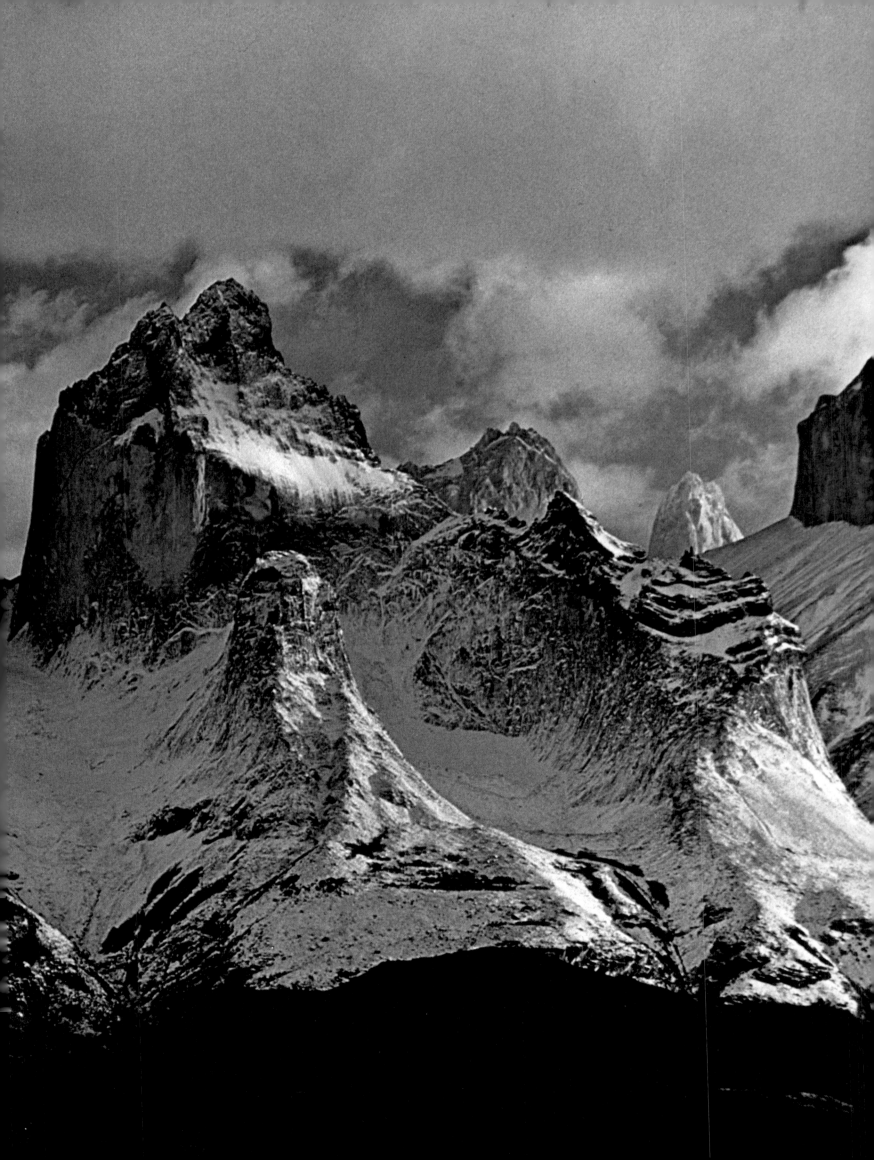

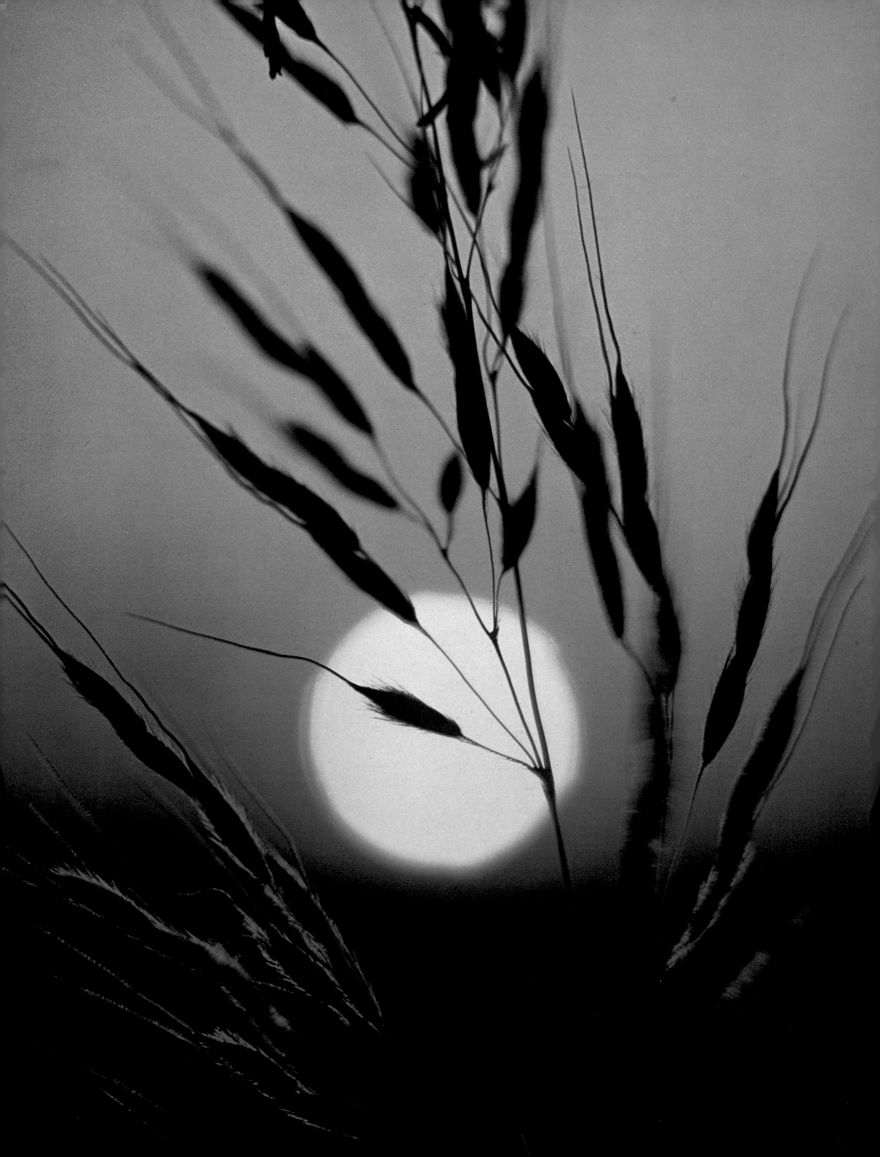

Walking on the Wild Side

By Jim Brandenburg

People always look surprised when I tell them I like big cities. After all, I am a nature photographer. But I can't help it. Manhattan at night is as exciting to me as a jungle. Any city gives me the same kind of charge, like a shot of adrenaline. Walking through the city at night is like walking through Yellowstone on the lookout for grizzlies. In both the city and the wilderness, there is a danger that tests your perceptions, your moves—all of the things your ancestors learned when they were still hunters a few million years ago. It has not been long enough for those hunters' genes to die out—or for humans like me to change. My obsession with nature photography springs from that heritage.

I began as a hunter, first with a slingshot, then with a bow. Later I switched to traps, and then to guns.

And I learned at a very early age to think like an animal, to move through the wilderness in a special way, at once a detached observer of the landscape and yet a part of it.

Friends who join me in the woods notice it right away. I begin to move differently. I watch the leaves. I walk where they are soft so they will not crunch like cornflakes. Those who haven't spent much time in the wilderness talk too loudly, and step on branches—things I avoid automatically. My voice gets softer. Somewhere inside me, some gears begin to shift, without my thinking about it.

If I had been born 50 years earlier, I might have been a professional hunter. But somewhere along the way, I began to bring a camera on my childhood hunting excursions. I remember times when it was difficult to decide whether to shoot an animal or

"It is hard to make a scene come to life," says Brandenburg. "All you have is light." Here he placed the sun behind a symbolic lonely shaft of Indian grass to convey a stunning warning: America's tallgrass prairie is vanishing.

Jim Brandenburg by Annie Griffiths

255

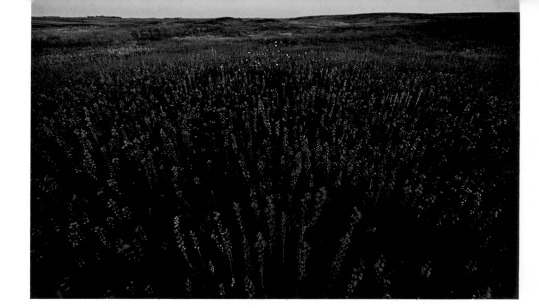

"It's serendipity," says Brandenburg. "Some days, the world looks flat; on others, the pictures leap out of the landscape." On one of the good days, a burst of blazing stars (right) caught Brandenburg's eye on the prairie, also home turf for this aster (below).

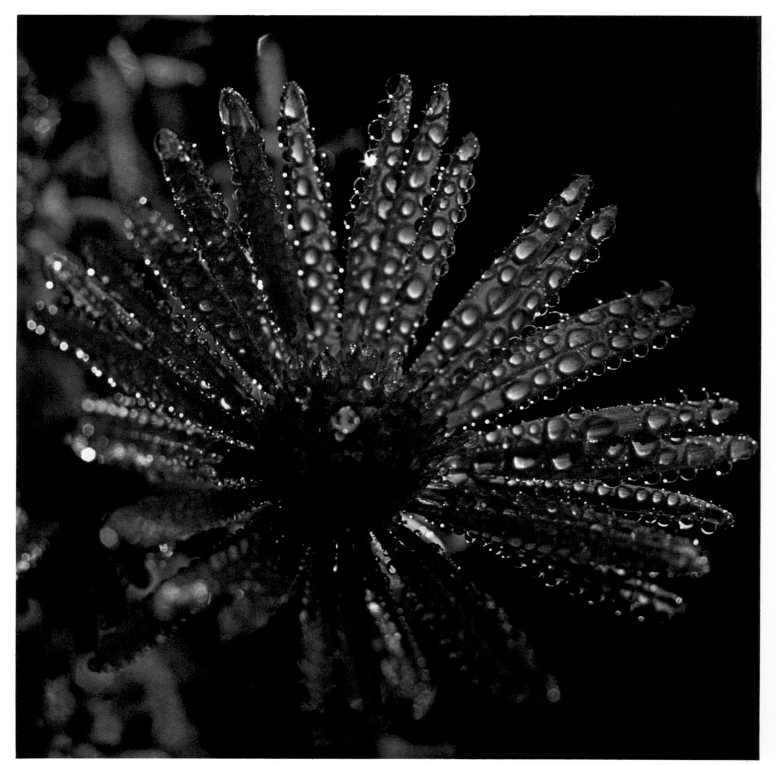

In nature photography, little things mean a lot. "Focusing on a detail may say as much about the character of a place as shooting a wide-angle view." Brandenburg's portraits include a grasshopper on a thistle (top) and a crab spider on a coneflower (bottom).

make a picture of it. One could not do both. Eventually I chose photography. And soon I was hunting all wild things, animal and vegetable.

But the pictures I was making then were trophies, not art. I could spread the transparencies before me and think: "Ah, now I have my elk, my antelope, my pasqueflower."

When time came to choose a career, two major interests surfaced: wildlife biology and art. But the demands of a career in wildlife biology sent me packing for art school. Though I never had a photography class, the art training gave me a new sense of texture, mood, and light. Suddenly, when looking through the viewfinder of my camera, I would imagine myself seeing as Monet or Seurat saw. For the first time, I realized that the most important part of a photograph was not the subject matter. Vision—or how you viewed things—was the important part.

From that soft, impressionistic world of art school, I made the unlikely leap to a daily newspaper, to the harsh realities of deadlines. For the first time, I learned the joy of photographing a species I had never hunted before—people. As I had done when photographing wild animals, I tried to strike the balance between intrusion and restraint when photographing people.

Though my first love had been natural-history photography, the newspaper work gave the diversity I would need as a journalist. Now I could begin to compile stories. Journalism became a vehicle to promote natural history. I discovered a new dimension of photography: When natural things are presented artfully, viewers are moved to preserve the living museums of the natural world.

Seeing
and Shooting
Straight

By Sam Abell

Sam Abell by Linda G. Gray

The photographers in this book have one thing in common: They were first drawn to photography because they could see in a special way. Long before learning to solve technical photographic problems, they discovered the satisfaction of looking carefully at their world and using the camera to make a record of what they saw.

In our time, photography has become a highly technical tool, often far beyond the simple interaction of eye and camera. We now see remarkable photographs of places that were once completely inaccessible, scenes that are often far removed from where the photographer actually stood. These remote photographs, whether from the sea, or from space, or from within our own bodies, have added immeasurably to our understanding of our world and others. We will see more such images in the future.

But many of the photographs in this book are a result of that satisfaction originally felt by photographers who saw—and took—pictures in a straightforward way.

You know you are seeing such a photograph if you say to yourself, "I could have taken that picture. I've seen such a scene before, but never quite like that." It is the kind of photography that relies for its strength not on special equipment or effects but on the intensity of the photographer's seeing. It is the kind of photography in which the raw materials—light, space, and shape—are arranged in a meaningful and even universal way that gives grace to ordinary objects.

My first priority when taking pictures is to achieve clarity. A good documentary photograph transmits the information of the situation with the

Sam Abell found this scene at the end of a two-day journey. "The place is the Okefenokee Swamp, where the water has great reflecting quality. I was trying to capture that quality when I took this picture."

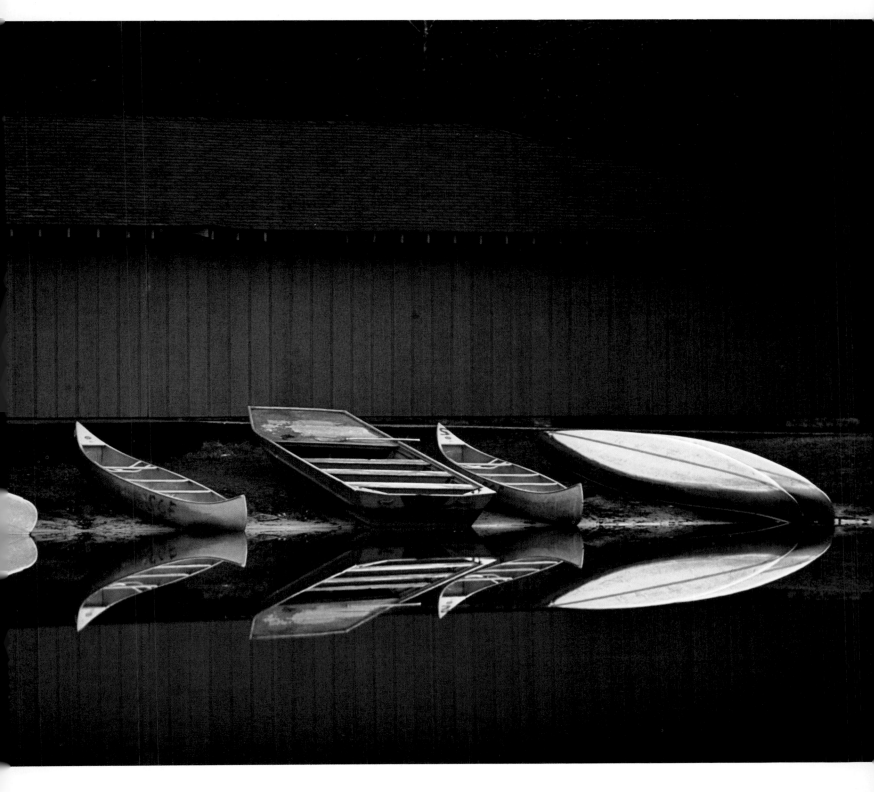

"We came across this snake on the upper Missouri River. My partner lifted it onto the paddle. There's a tension that shows in the picture, a beauty and a danger."

not, photographers are looking, seeing, and thinking about what they see, a habit that is both a pleasure and a problem, for we seldom capture in a single photograph the full expression of what we see and feel. It is the hope that we might express ourselves fully—and the evidence that other photographers have done so—that keep us taking pictures.

I have worked mainly in the out-of-doors, which lends itself to straightforward photography. There is an abundance of varied, natural light and no shortage of subjects. Walking while working automatically restricts the amount of equipment one carries, which is pleasant. More than one good picture has been lost because the photographer was over-equipped and under-experienced, and uncertain which film, lens, or camera to use.

Experience teaches us to use a manageable, medium-size array of equipment. This way, many situations can be handled without too much gear, an important point for those who must balance the needs of mobility with the needs of photography. It matters little how much equipment we use; it matters much that we be masters of all we do use.

In my work, the most elaborate—and essential—accessory is a standard tripod. For spiritual companions I have had the many artists who have relied on nature to help shape their imagination. And their most elaborate equipment was a deep reverence for the world through which they passed.

Photographers share something with these artists. We seek only to see and to describe with our own voices, and, though we are seldom heard as soloists, we cannot photograph the world in any other way.

utmost fidelity; achieving it means understanding the nuances of lighting and composition, and also remembering to keep the lenses clean and the cameras steady.

But there is more to a fine photograph than information. We are also seeking to present an image that arouses the curiosity of the viewer or that, best of all, provokes the viewer to think—to ask a question or simply to gaze in thoughtful wonder. We know that photographs inform people. We also know that photographs move people. The photograph that does both is the one we want to see and make. It is the kind of picture that makes you want to pick up your own camera again and go to work.

And that desire—the strong desire to take pictures—is important. It borders on a need, based on a habit: the habit of seeing. Whether working or

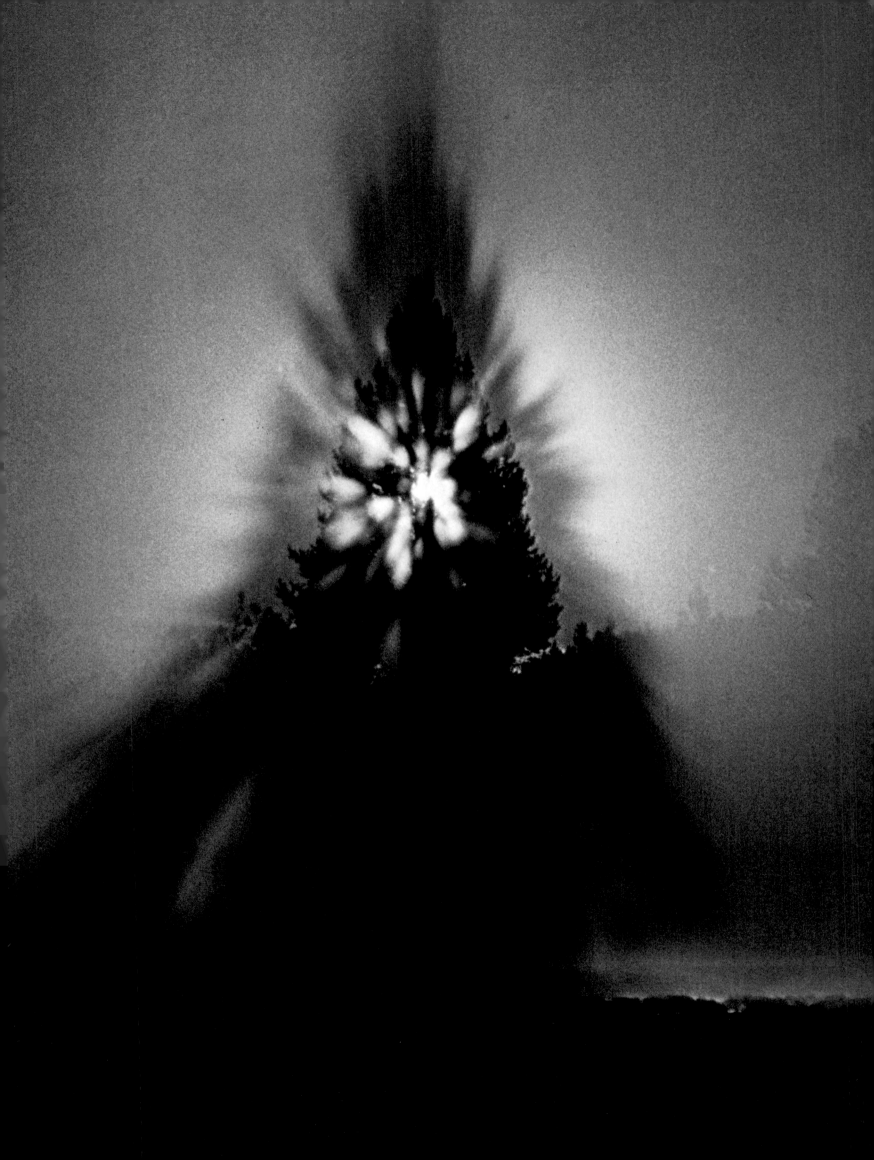

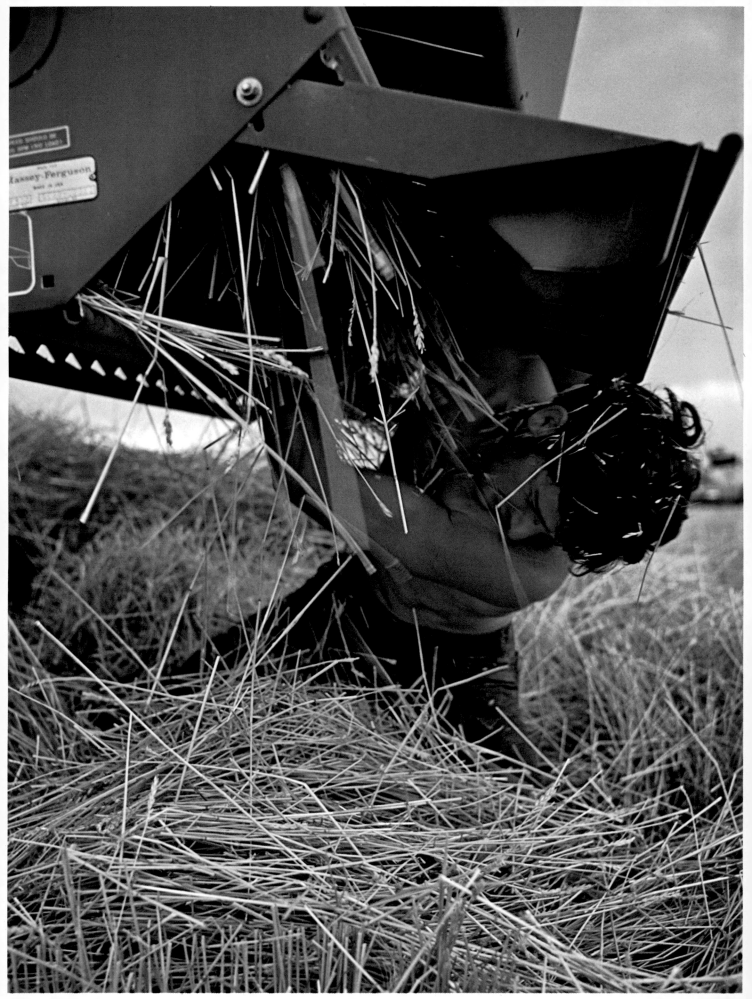

WORKING FOR A LIVING

Seven women, pausing at their work, innocently gazed from a page of the January 1897 Geographic. With their waists wrapped in sarongs, and each head supporting a basket or jar, they were the first of hundreds of such figures to plod, pace, and toil across the face of the earth and into the imagination of Geographic readers. In Nigeria, heads carried grain; in Haiti, bananas; salt in Pakistan; fish in Portugal. Women of Madeira balanced five chairs each. In Barbados, a tea vendor's head sprouted a five-gallon drum with a spigot. The bizarre ones were good for a laugh, but the figure persisted. It became an icon, a symbol of work in a sleepy, faraway world.

In early stories of Mexico,

color, workers in nondescript clothing were relegated to black and white. A caption complained of Breton peasants in "meaningless modern dress." Color plates were saved for a flower vendor or a weaver who could be hired to dress up for a costume portrait at the loom.

Williams saw "Unspoiled Cyprus" in 1928. In black and white he pictured women bent under crushing loads of rock. He showed them "straining their eyes over . . . intricate needlework." He met Helene, a girl so fair that twice he posed her in costume for Autochromes. Wearing a gold-filigree jacket and flowered kerchief, she pretends to put bread into an old stone oven. A third picture he got by accident. He discovered Helene at work, breaking rocks, her feet bare, hands horny from her task, the fine clothes put away.

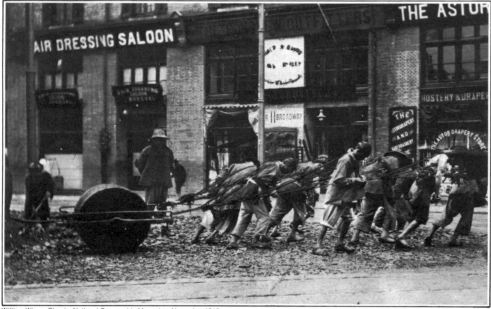

William Wisner Chapin. National Geographic Magazine, November 1910.

This melancholy record of coolie labor on a Shanghai street was part of a landmark series from China and Korea. Chapin used black and white plates and made color notes. An artist hand tinted many of them, producing scenes showing vivid costumes and oriental architecture.

Panama, and the Philippines, many workers were bustling, spic-and-span, uniformed U. S. citizens "redeeming the tropics." Others were laborers—peons carrying firewood, girls making pottery. Over the years, pictures and text reassured readers that people "still live, work, and dress as their ancestors did," and that in some places "the centuries have seen no progress." From the clamorous bazaar of Lahore, photographing a snake charmer and "the shameless street of the harpies," Maynard Owen Williams cried in 1921, "If the East would only remain unchanged!"

When photographers began to use

Dave Harvey, photographing people at work nowadays: "I wind up being a worker myself." Jim Sugar, with a gang of wheat cutters in 1972: "I lived with these guys for the summer. I was in the fields, right beside them. And I always had a camera."

In the old days, cameramen used different methods. A picture sent to the magazine in 1911 shows handsome, alert Filipino police, with badges hung from what the photographer called "their *gee-strings*." Later he admitted that he had chosen men to pose who were much better looking than the genuine policemen.

When William Wisner Chapin visited Korea, he strolled the streets "waiting to kodak" such curiosities as "three coolies each bearing a live pig." Chapin tipped his "victims."

Ellsworth Huntington traveled in Turkey in 1909 "as the natives do"— almost. Hiring a gruff mounted guard to dignify his party, he took his meals with the nomads he'd come to study, and photographed their work. His pictures are informative but aloof.

Red-bearded Hamoudi of the "hot heart" bossed a crew of diggers in ancient ruins near the Syrian Desert. He taught men fresh from reed and mud huts to excavate brick walls. Hamoudi stands out from a legion of nameless colleagues because archaeologist C. Leonard Woolley wrote a 1928 article to pay his "debt to the humble delvers." It was a rare salute

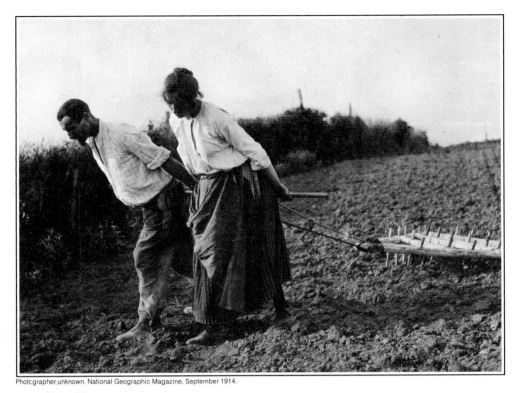

"In the sweat of thy face shalt thou eat bread." Thus peasants of Brittany illustrate a story published as World War I spread across French soil. Readers were told that Bretons "live as our people lived a hundred years ago."

Because photography required good light, street and market scenes abounded. Candid pictures had not yet evolved. The Neapolitan pasta vendors seem puzzled but willing to please. Why does the photographer want us to hold up the macaroni?

Photographer unknown. National Geographic Magazine, September 1914.

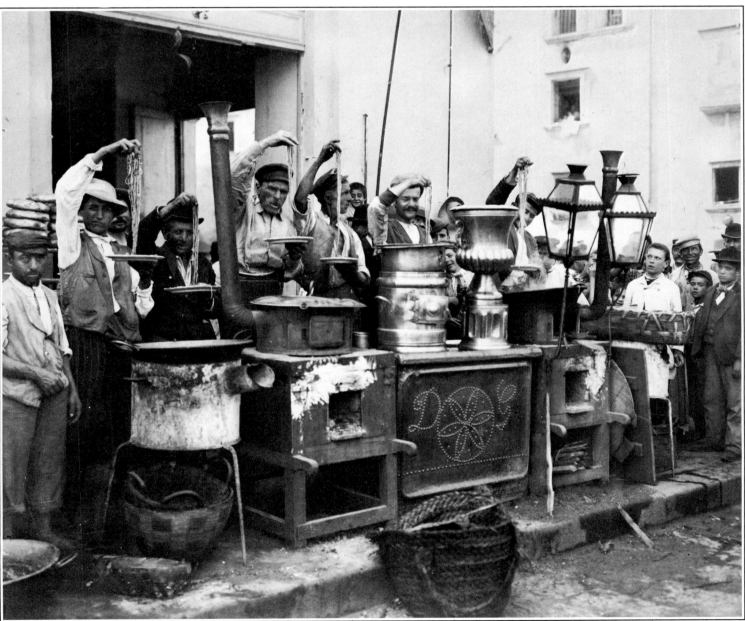

Photographer unknown. National Geographic Magazine, June 1915.

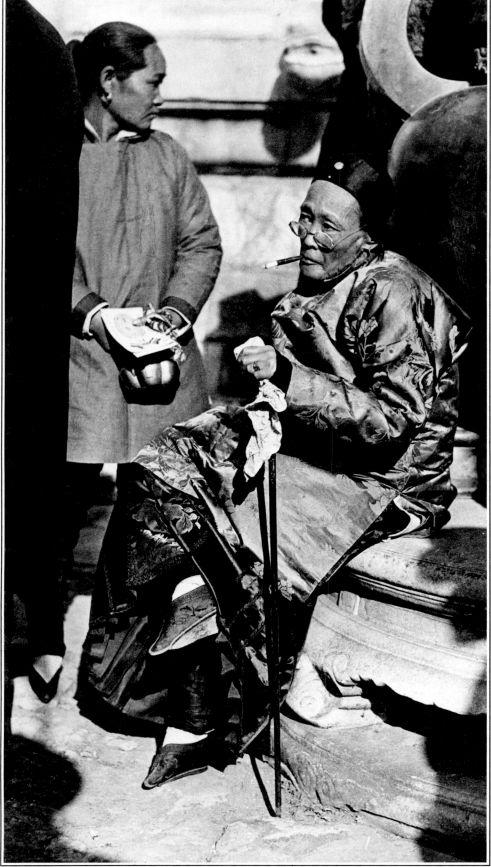

Sidney D. Gamble. National Geographic Magazine, June 1927.

Mistress, servant, and bound feet signify a way of life on the wane. A series of Geographic articles reflected headlines of the time and explored the China which emerged as Nationalists, Communists, and warlords battled.

to the laborers and human pack animals who had fetched and toted for expeditions on every continent. Pictures show the diggers with respect. "A photograph would puzzle them completely," said Woolley, "and they could not tell whether it represented a building or a man, so unused were they to pictures of any sort."

In Jerusalem, Williams "haunted favorite corners, begging Arab, Jew, and Christian to pose for an instrument whose very look they dreaded." A. W. Cutler felt that the only way to "handle" the reluctant Portuguese peasants was to pester them. Farmers and market women stare grumpily from his pictures. W. Robert Moore coaxed smiles from the buxom fishwives of Marseilles by convincing them that his camera would make them look like movie stars.

In Iran, Thomas J. Abercrombie sat in a jeep to focus a telephoto lens at veiled women gathering fodder. They spied him and fled. In Chile, some Indians fear that a picture can steal their souls. A photographer after candid shots there, as Kip Ross was, risks confrontation. "How dare you take a picture behind my back?" demanded an Indian market woman, jabbing a finger into Ross' chest. "I have a right to my own self."

Respect and gentle persuasion made it possible for Bill Allard to document the reclusive Hutterites and Amish (pages 290-293), and gave Jim Stanfield the story of Carolinas Peyton, an 88-year-old black man. To work with people, Stanfield says a photographer must enter "the flow of their lives." Stanfield spent a week on the Peyton farm along the lower Potomac River. He went to church with the family and chatted in the barnyard as his host fed the chickens and tended the mules. Stanfield's pictures record cherished moments.

During World War II, Geographic coverage highlighted women on the home front, from San Francisco's streetcar "conductorette" to brawny Soviet hod carriers. Tony Stewart and his Leica followed gaggles of "government girls" in Washington, D. C. He and others went into factories to show that American women could weld, rivet, and operate monster machines with one tiny finger. Industry stood ready for the

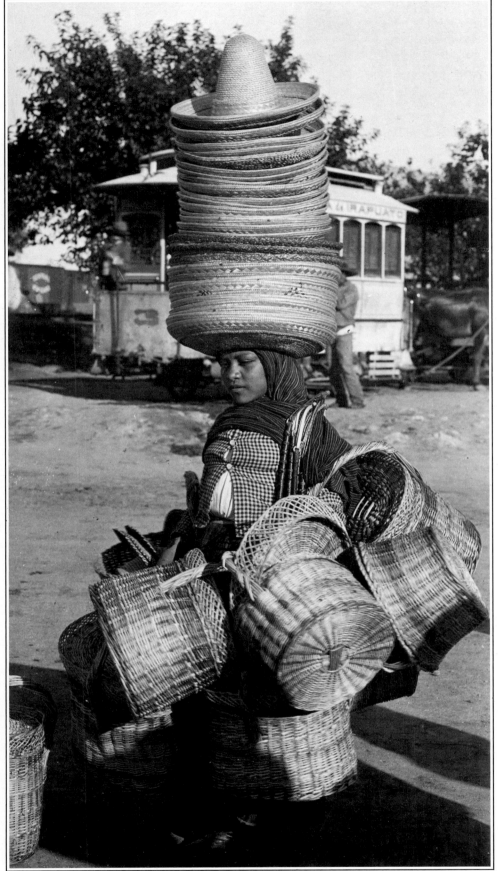

Resigned to our scrutiny, this Mexican woman could testify that posing was work. Photographers once saw their subjects as "types." Today they share the lives they document. They picture workers as individuals, caught at significant moments in life.

photographer who went out to shoot color. U. S. factories glowed with red drums, red typewriters, red-handled brooms, red toothbrushes.

In Iowa, Tony Stewart got 600 red tractor wheels and 30 red tractors all in one picture. Willard R. Culver posed a pretty, frowning teakettle-whistle tester, her ear cocked for a sour note from a red spout.

Culver specialized in industrial photography, with elaborate setups of lights, reflectors, cameras, and models. These photographs themselves were part of the war-born love affair with technology. For a series about glass, "From Sand To . . . Servant of Man," readers saw behind the camera when Luis Marden took a picture of Culver taking a picture of a smiling girl draped with glass fiber.

Harold E. Edgerton and Edwin L. Wisherd photographed the circus. With a ton and a half of equipment, they lighted the Boston Garden from the center ring to the farthest balconies. Photoelectric cells synchronized eight xenon-filled quartz flash tubes. Reflectors stood around the arena and hung high under the roof. Flashes brighter than sunlight froze the action of clowns, acrobats, tigers, and a bicycling dog.

Some photographers present the *idea* of work. From a helicopter the camera views a plowed field and asks us to contemplate the earth rather than the farmer. The great vista of a railroad yard evokes the might of industry. Culver took his camera into a Gary steel mill. As we stand with him under the roaring blast furnaces, the ground seems to throb in unison. In such pictures the camera shows more than the eye alone can see.

Tom Nebbia wants a photograph to make us look again and again. Nebbia took a picture of the hands of a Mexican refinery worker, cupped and brimful of oil. We recall other hands we have seen, overflowing with golden grain, or cradling precious gems, and we realize that Nebbia makes a witty comment: Here are 20th-century riches, shimmering in a small black pool that mirrors our oil-dependent world.

In Haiti, Nebbia met a woman with a burden on her head, and turned an old tradition topsy-turvy. He posed her indoors. She sits on a chair, smiling straight into our eyes, her strong brown arms folded across the basket of fruit that rests—on her lap.

267

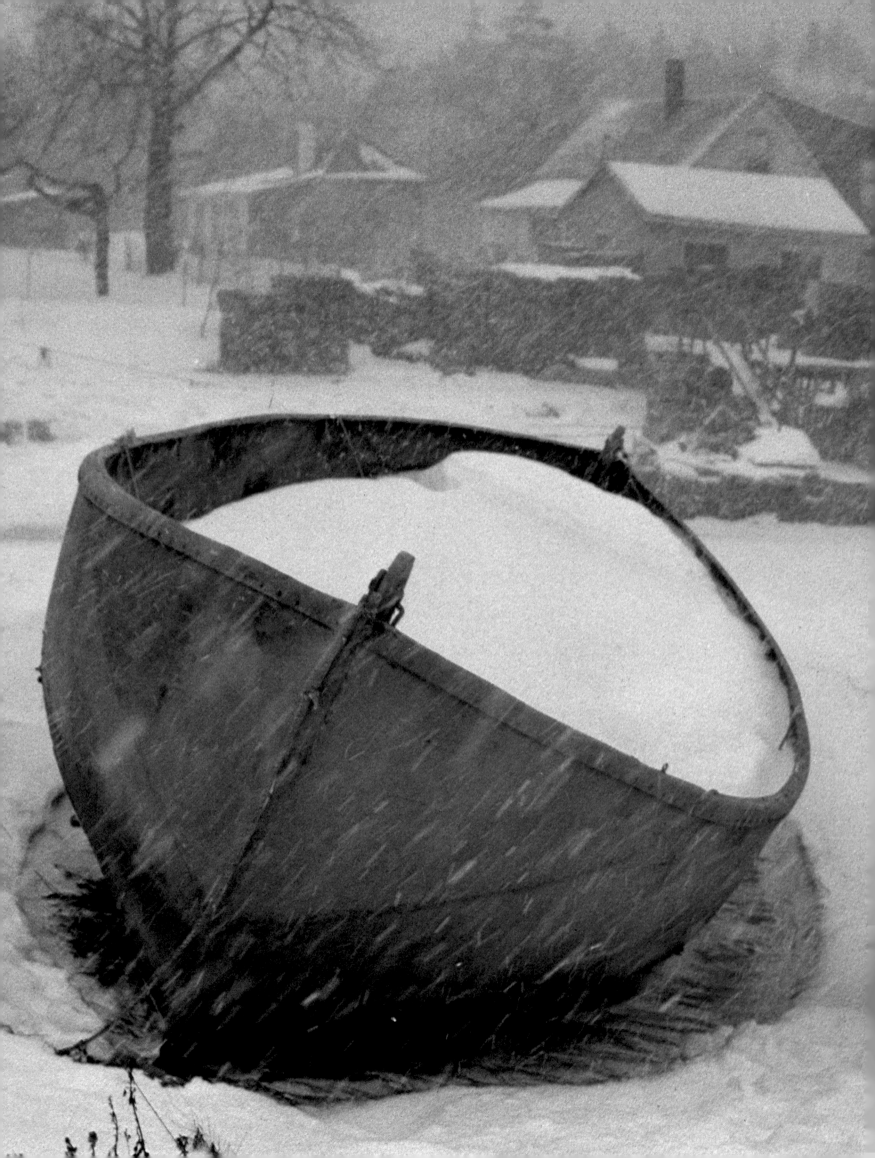

A veil of midwinter snow gave the photographer exactly what he needed to emphasize the cold-weather chores of a Maine lobsterman. Stewart was known to his associates as the photographer with "young eyes." He learned to use unusual weather to enhance a scene.
B. ANTHONY STEWART

"I wanted to express the warmth of a working homestead in Maine." Wolinsky came upon the horse that toils there (overleaf). At rest in a stall in the old barn, the horse gives the photographer a serendipitous moment— "a little gift of the assignment."
CARY WOLINSKY

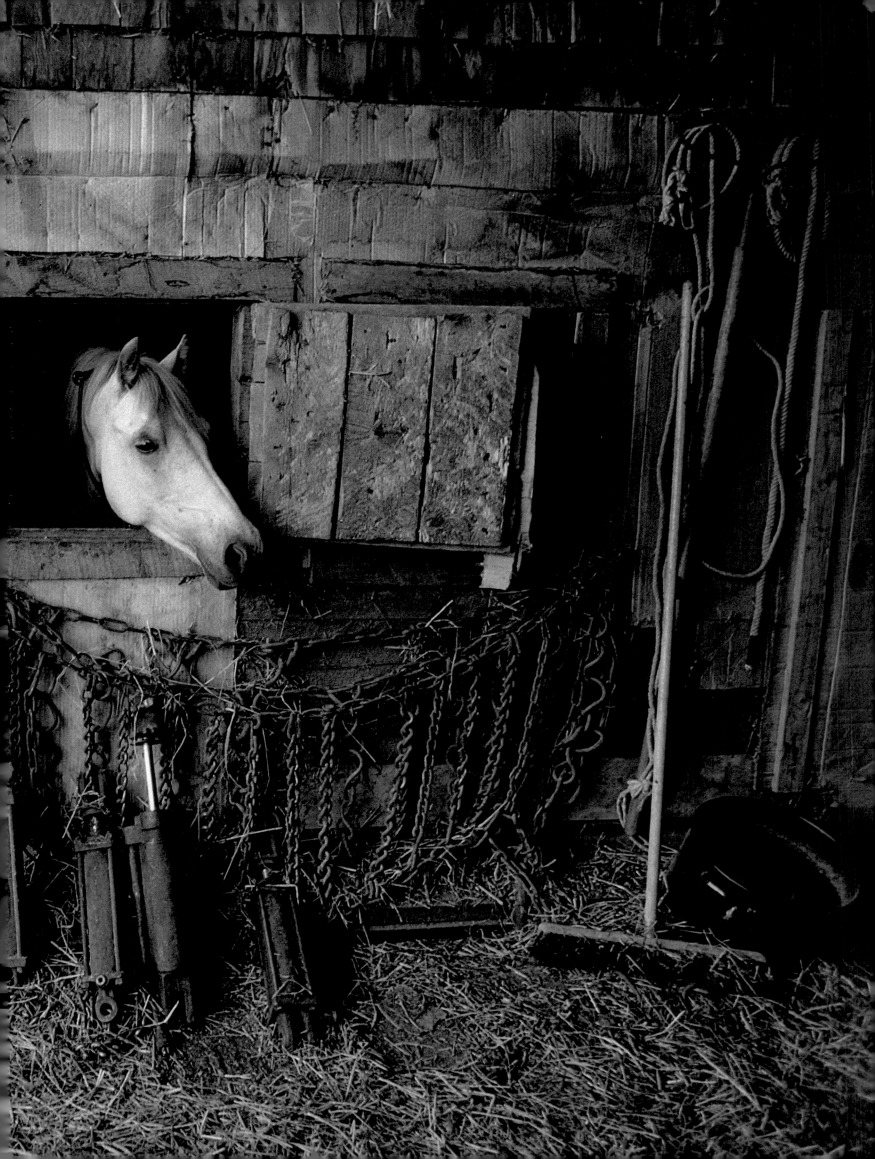

"First," says Nebbia, "I get the image in my head." Brainstorming, he hung planes above the California cotton field, aligned crop rows with the cotton-candy contrails, weighted the foreground with a human figure. Then he took to the air with his camera.

THOMAS NEBBIA

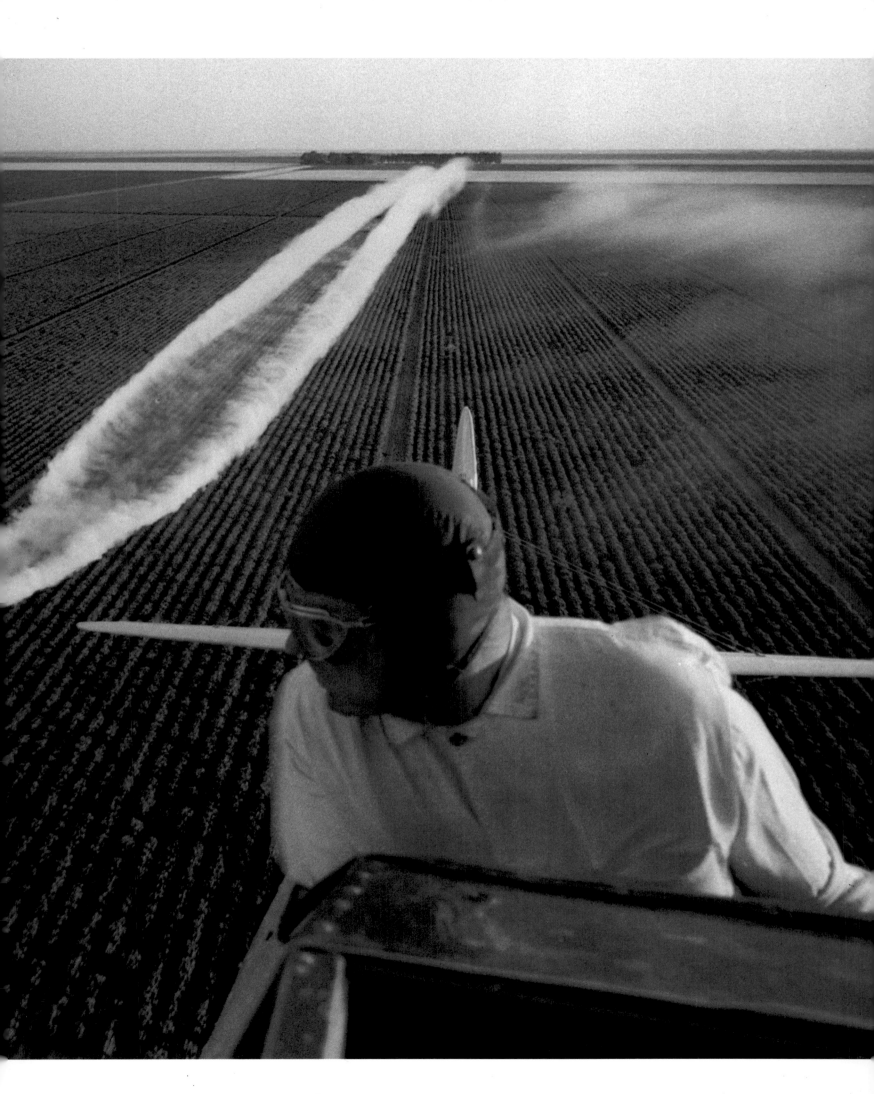

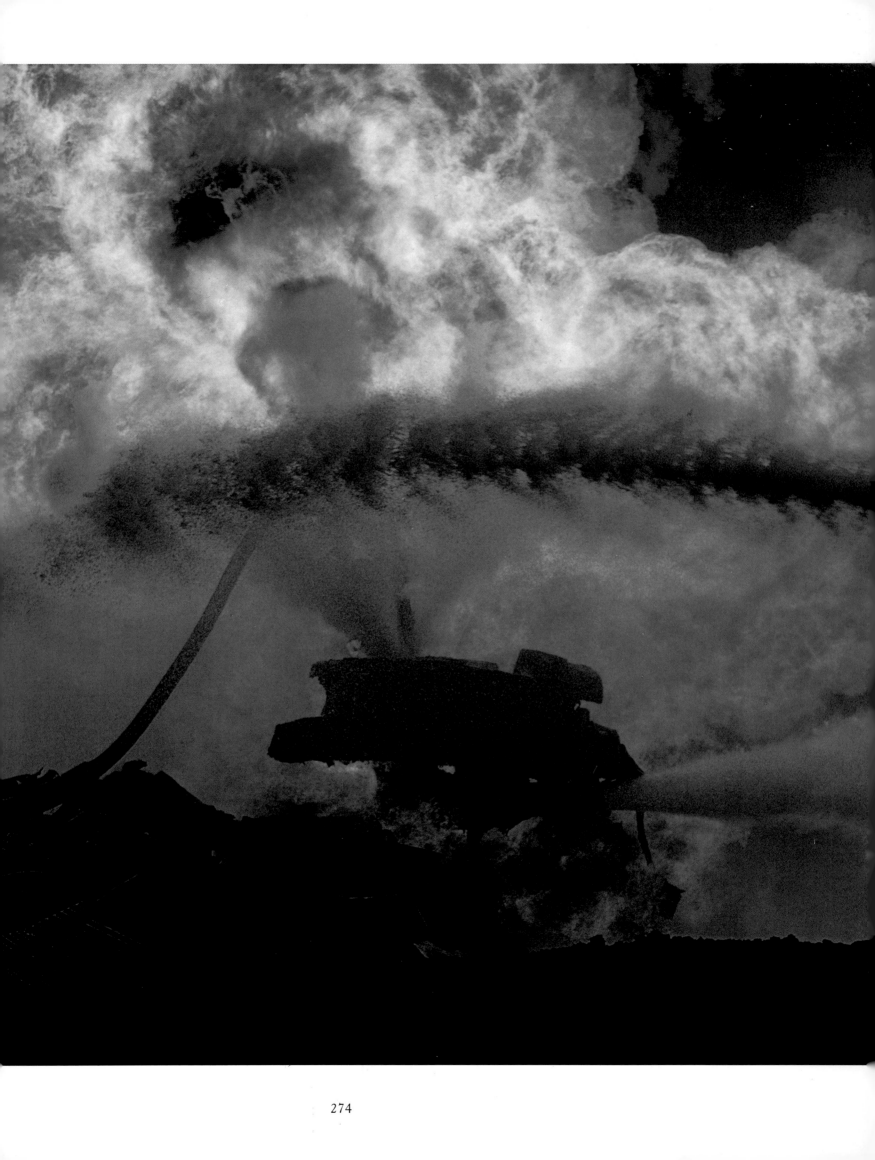

The inferno blazes with "one hell of a roar," and the ground shakes under your feet. You focus the telephoto lens to enter the whirlwind of a gas well blowout. Heat reaches 1500°F where the earth's fire consumes itself. "You're so close to so much power."
LOWELL GEORGIA

Before he went up, he knew what he wanted (overleaf). The contours of a Kentucky tobacco field lured Baumann to a helicopter from which he used a telephoto lens to "compress and dramatize" the flowing ribbons of black soil and green grass.
J. BRUCE BAUMANN

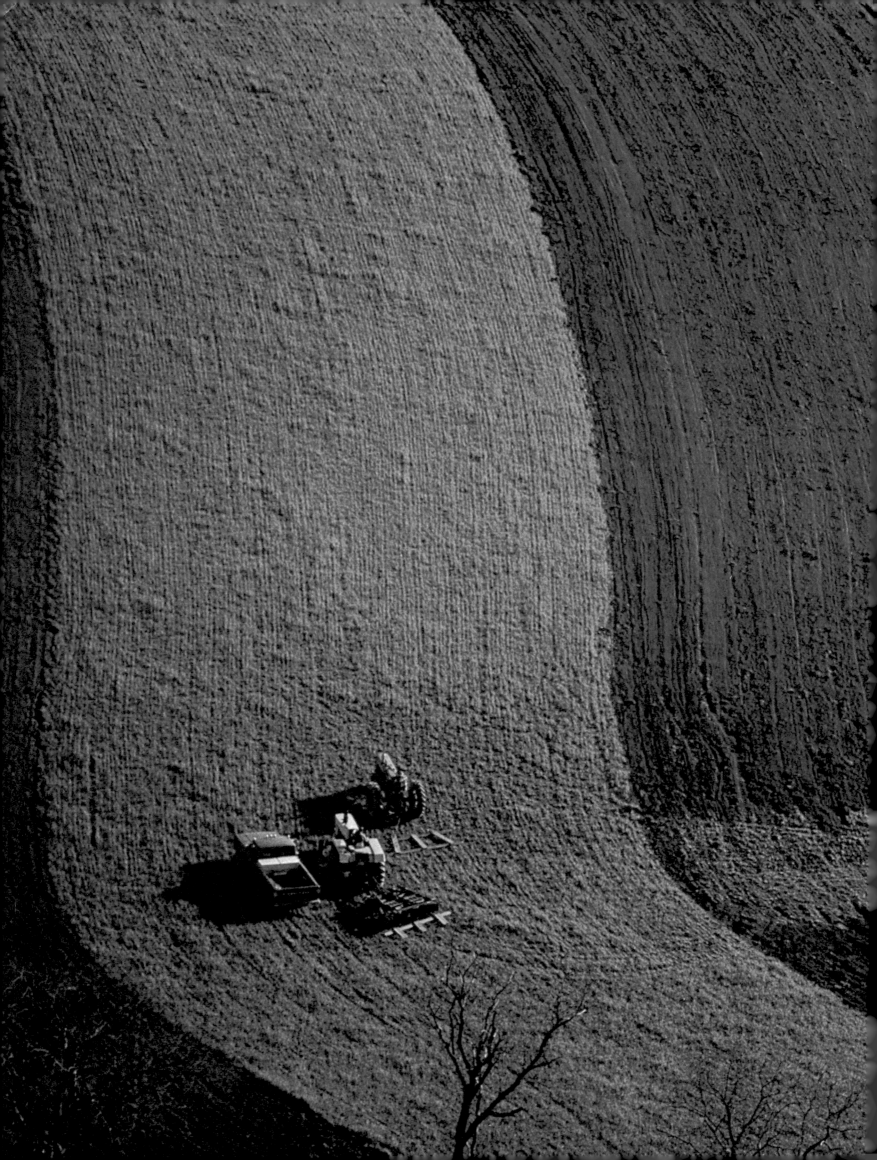

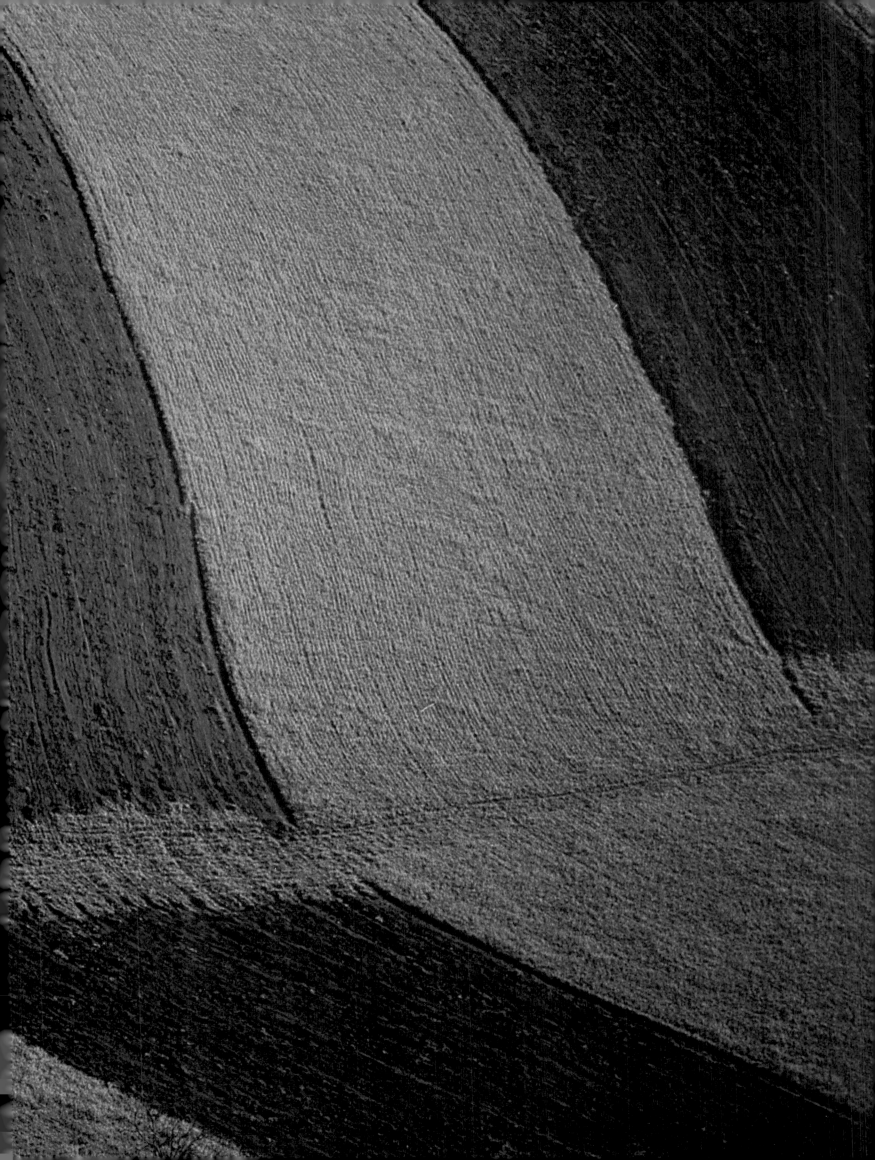

"There was electricity in the air," tension between the cowboy and the fleeing horse, that told Scherschel something was about to happen. He got down low behind the fence to shoot. "It's the kind of thing you have to be ready for, catching the moment."
Joseph J. Scherschel

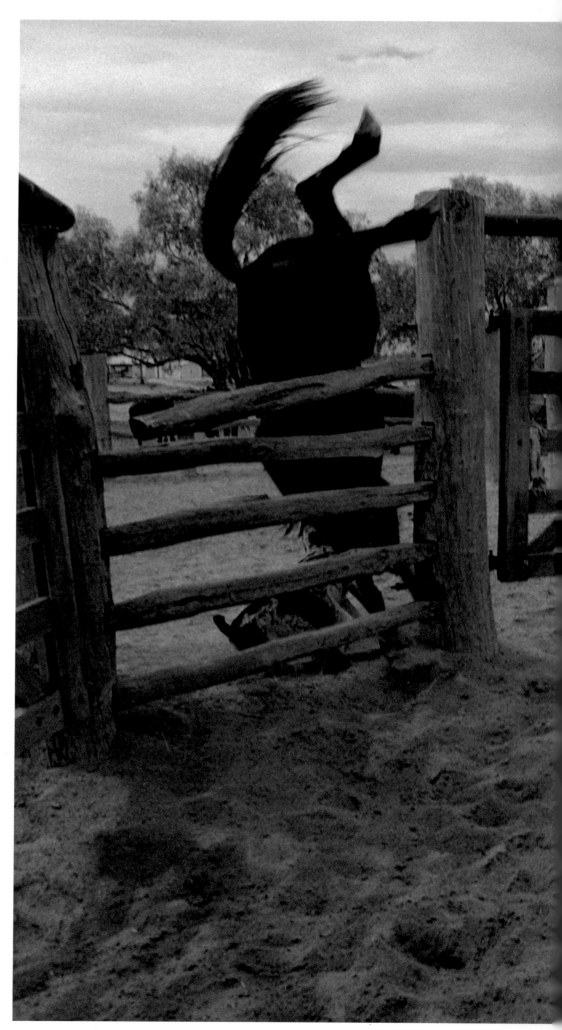

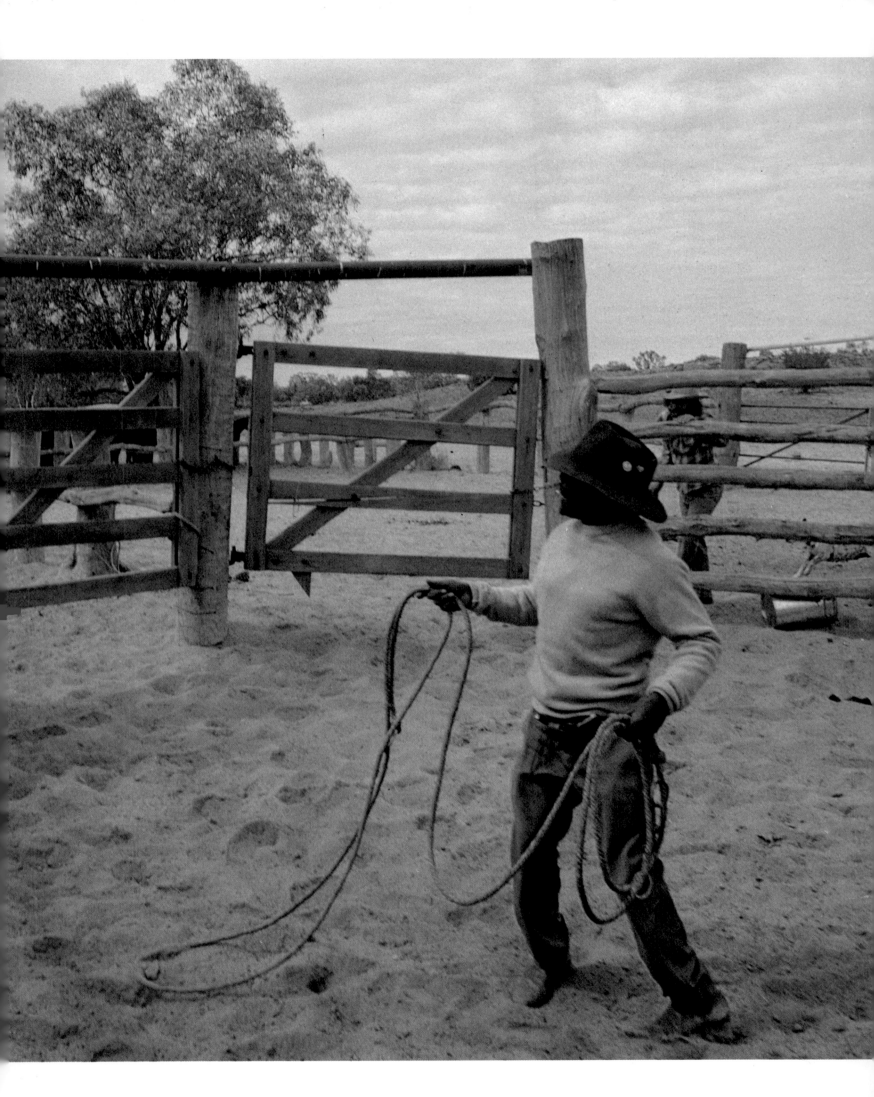

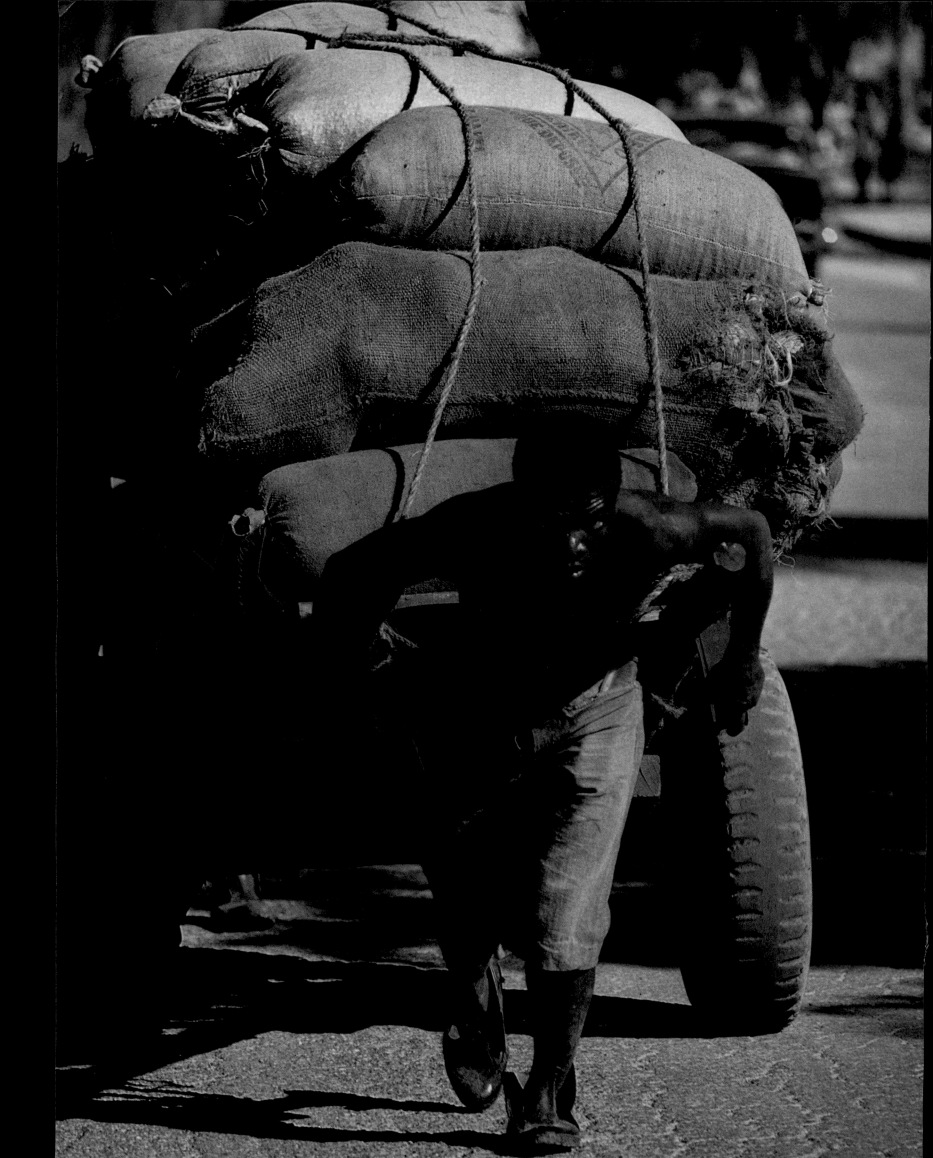

Each time Nebbia aimed at the camera-shy Haitian, he put down his wagon. Nebbia's third attempt succeeded. "You think of the image. The world's full of them. You've got to find them."
THOMAS NEBBIA

"I spent two days on my knees in the mud." That amused these Malaysian women panning for tin. Harvey held his camera barely above the water, with its wide-angle lens only a hand's length from the cascade in the foreground.
DAVID ALAN HARVEY

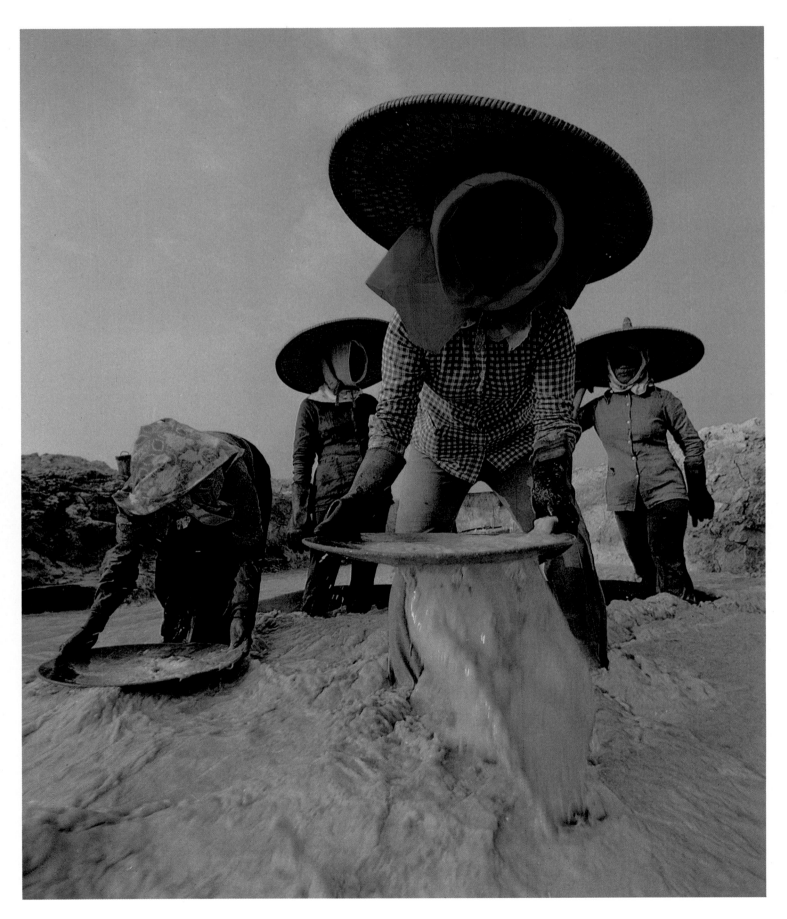

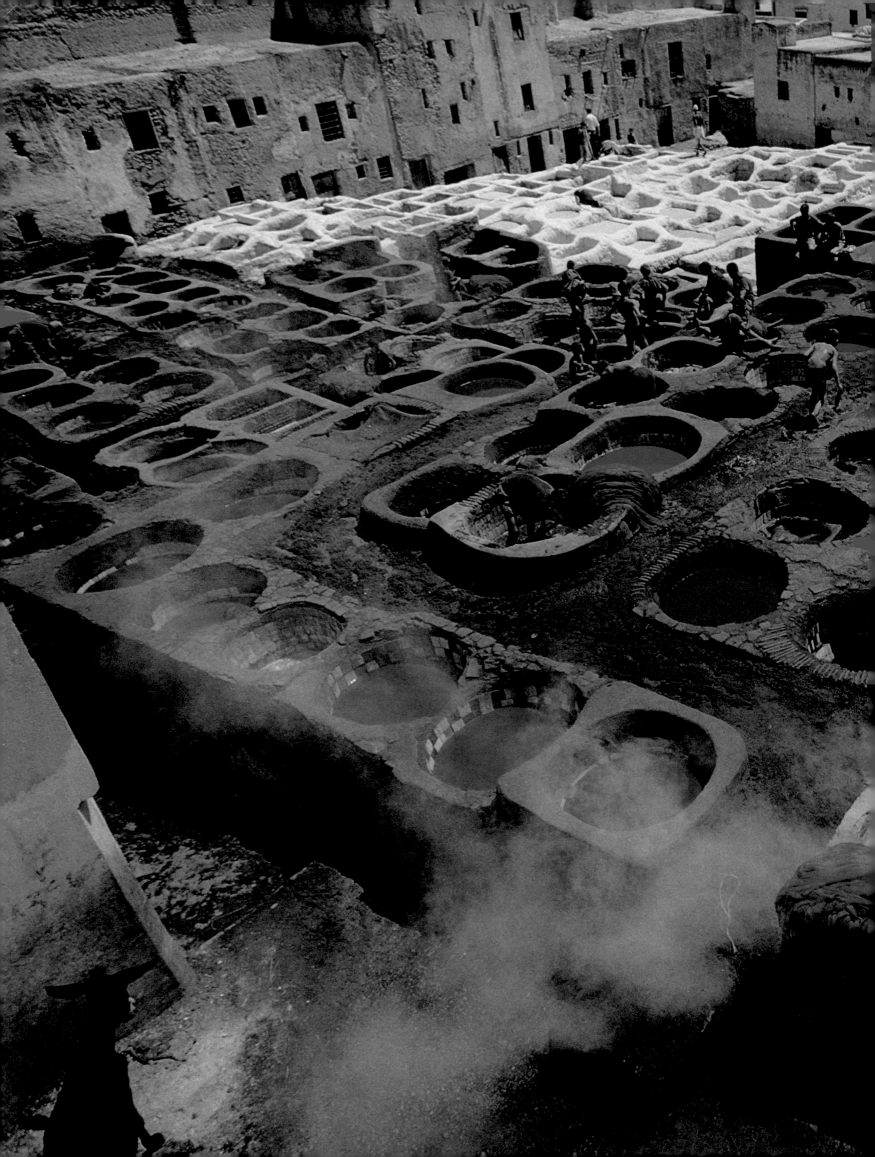

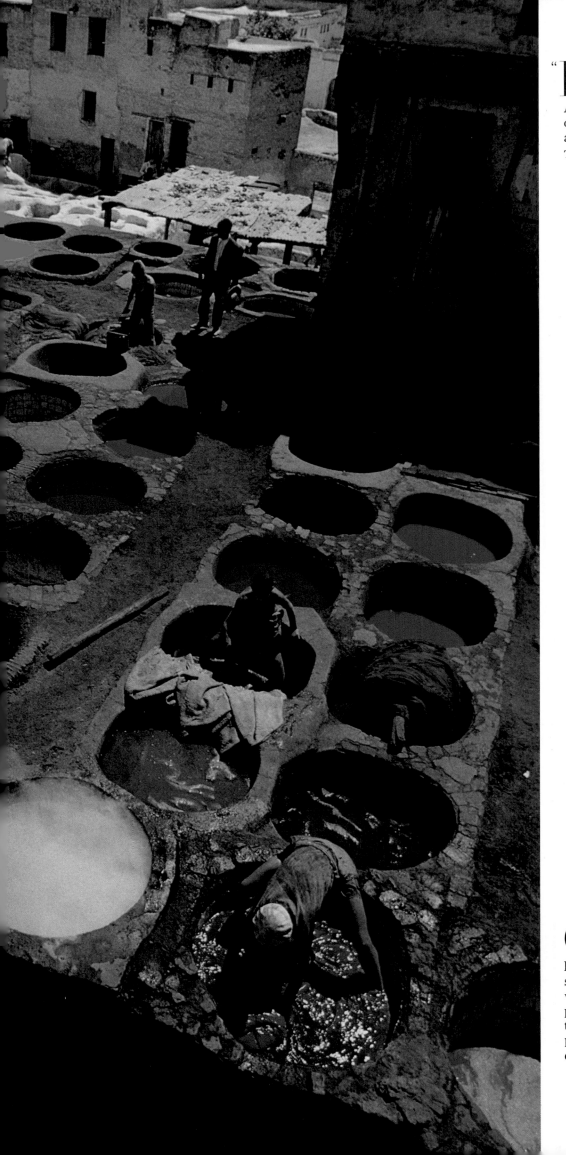

"It smelled like a thousand dead goats, but it was an essential scene to document the life of old Fès." Abercrombie hiked rooftops above the dye pits, looking for an exciting pattern and a view that would tell the story.
THOMAS J. ABERCROMBIE

On the hunt for a picture to document old Eskimo ways (overleaf), Gahan followed, leaping where his guide directed. A false step could have meant death. Against white ice and a white sky, Eskimo and photographer did their work. Food was the reward for one, for the other a picture of "a day I'll always remember."
GORDON W. GAHAN

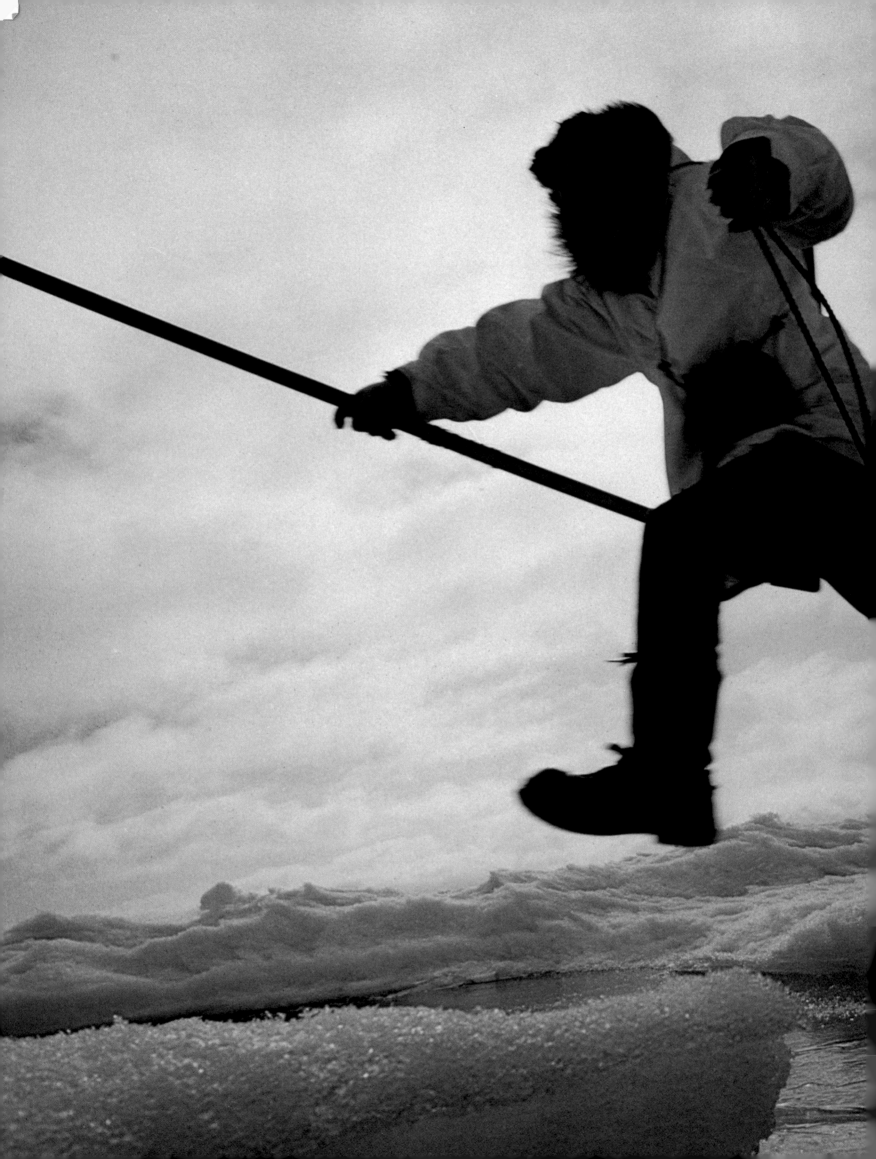

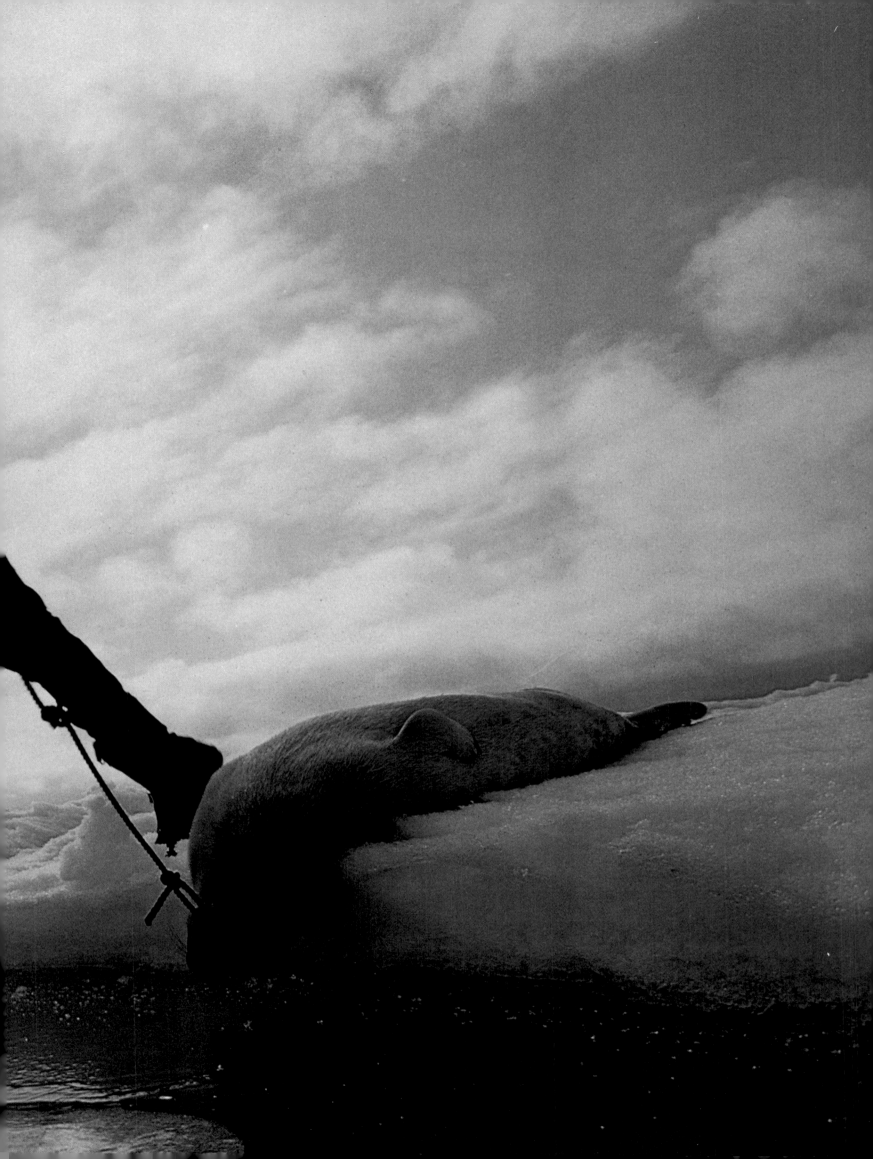

Searching Out
the Hidden
Possibilities

By James L. Stanfield

James L. Stanfield by Joseph H. Bailey

The photographer's gear is an extension of his emotions and imagination, says Jim Stanfield. He tries to become so familiar with his equipment that using it becomes as automatic as driving a car.

Work. To Bantu-speaking tribesmen in low-roofed rock chambers two miles below the earth's surface, work means operating pneumatic drills with their feet from an almost prone position. Work means that they spend their days in the steaming bowels of the earth, often in danger, and poorly paid by white standards.

The hardest day I ever worked was the day I photographed the face of a deep-level gold mine. I carried underwater electronic flash units, a battery of cameras, and wide lenses to show this man-made hell. On hands and knees I dragged myself between rock shelves. Jagged edges shredded my clothes, and I sweated.

But even the worst place has its comforts and here, miles from the nearest pub, they serve up a chilled bitter lime and water mix in a half-gallon plastic bucket. It sounds a bit puckery, but it spelled new life.

After setting up ten waterproof flash units, I found that the synchronization cord to the camera was no longer moistureproof. My sophisticated flash units were shorting out.

So I used an old-fashioned method. Nine miners helped me activate the flash manually. Meanwhile, the timber men, pipe and panel workers, and machine operators (who drill holes for explosives) kept at their work, inching along the face. For the fourth time I rearranged the lights. I gulped more lime water. Six hours after entering this netherworld, when I was finally ready to expose film, water destroyed three cameras—I was working next to the machine operator and his water-cooled drill.

The temperature of the shaft had risen beyond 112°F. Two workable cameras remained, but they averaged

only four pictures per 36-exposure roll before succumbing to the heat and water seepage. The first shift ran out of lime drink, and the workers all looked accusingly at me.

Here, at a mine research center in Johannesburg, South Africa, I found a black man in a coat of black paint in an eerie chamber. He turned out to be Neibis, a Xhosa tribesman. Doctors watched Neibis being bombarded with light. He simulated various working positions so his body area could be measured to help determine how it would withstand heat.

On this story of gold, I sailed with smugglers of the Arabian Gulf, and photographed the grave-robbing *guaqueros* of Colombia. It took weeks to convince smugglers in Dubai that I would not picture their faces. We settled on a photographic essay of their hands—"importers, exporters, and merchants" at work. Once on board their dhows, I found that all of them, including their skipper, *wanted* to be photographed. The grave robbers, or "treasure seekers," also showed caution in the beginning. But after I gained their confidence, they too agreed to have their pictures taken.

Photography is both easy and difficult—easy because technique can be mastered by anyone with a few instructions. The camera is only a witness. It easily produces an image of truth.

Photography is difficult because a good photograph is a reflection of those who make it. When a photographer looks at his subject, he sees with everything he is, with everything he has lived. Knowledge, experience, and imagination enable him to do powerful, sensitive work. My greatest tests have been assignments on

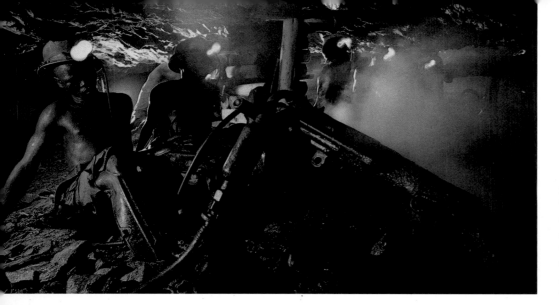

Two images of work, one a product of painstaking hours spent underground with South African gold miners, the other technically simple but artistically startling. A silhouette awash in golden light . . . the pattern of diagonals and circles . . . a test chamber and its human guinea pig achieve Stanfield's purpose—to make us question. What? Why?

very different subjects: gold and rats.

For months the office had snickered about which photographer might draw the short straw on a story about rats. The rat—perhaps the number one "turnoff" in the world? Mankind's worst enemy?

So I had mixed feelings. But the rat story presented the challenge of high-speed electronic equipment. With radio-control units I could trigger hidden cameras from beyond the sight and smell range of my cunning subjects. I set out around the world, carrying 18 suitcases of this sophisticated paraphernalia.

I needed a "rat man." I found Dr. William Jackson, director of the Environmental Studies Center at Ohio's Bowling Green State University. "We're dealing with the most numerous and successful mammals on earth, excepting only man himself," Professor Jackson told me. "Like man, the rat is a generalized animal, able to eat almost anything and live almost anywhere."

I was determined to show wild rats in their natural habitat, and to convey their relationship with people. I began in the Philippines, where some rice farmers lose 50 percent of their crop to rats. When harvesting, the farmers arm themselves with sickles and sticks. They can kill one rat per square yard—a harvest bonus and a partial answer to protein deficiency in the Philippines. The farmers who had killed rats all day for my pictures invited writer Tom Canby and me to dinner. We watched the rats being prepared, preparing ourselves with eight or ten bottles of ice-cold San Miguel. The awful little critters were dropped into coconut oil, with onion, garlic, and ginger. They came out tasting like squirrel or rabbit.

In one of Bombay's oldest neighborhoods, I was introduced to house "gullies"—yard-wide alleys between four-story tenements. Tenants "airmail" their garbage out the windows, and the rats wait below.

Health department officials guarded me for three days as I tried to record this grisly scene. The residents threw verbal garbage as well. They said we should be photographing the Taj Mahal, not rat-infested slums. Later our Geographic editors agreed. They killed the pictures, saying they were too strong.

I shot a fourth day alone. The health department men hadn't been able to stand the abuse, or the stench, or the tension. None of us had been able to take it for more than four hours at a time. Each day we'd wound up with splitting headaches. Every night brought nightmares.

At the temple of goddess Bhagwati Karniji, we made friends with thousands of sacred rats. They are thought of as living beings which reside in holy places. Worshipers who believe that the rats are their reincarnated forefathers bring the rats gifts of sweets, grain, coconut, and milk.

To enter the temple, you must remove your shoes. I was terrified that I'd step on a rat. I shuffled along the grimy floor in my socks (and burned them each day, promptly after leaving). For three days I had rats crawling up my tripod and my light stands, chewing through the light cords, shorting out my electronic flash units, and building nests in my camera bag. On such days, you wonder about the whole idea of being a Geographic photographer.

Wherever there is food, there are rats. U. S. cities are full of them. In some sections of New York, garbage is airmailed just as it is in Bombay. To photograph men trying to clean up the mess and kill the rats, I set up motorized, electronically triggered cameras along the rats' paths of travel. I got pictures too grim to print.

In Rome, I gingerly crept the narrow ledges of 16th-century sewers along the Tiber River, roped to an exterminating team. They collected dead rodents and tossed out fresh packets of poisoned cheese. At the U. S. Fish and Wildlife Service's research center in Denver, I photographed experiments with electric fences designed to keep rats out of fields. When the rat touched the hot wire, it triggered the electronic flash on my motorized camera. To catch the rat thrown clear by the shock, we built in a 200-millisecond delay between the response of the hot wire and the firing of the camera.

I spent six months on the rat trail and ten months on the gold story. On both I faced the biggest challenge of my work: making sure that I do not get into a rut. The minute any of us tackles a job with the idea of doing it the same old way, at that minute we are beaten.

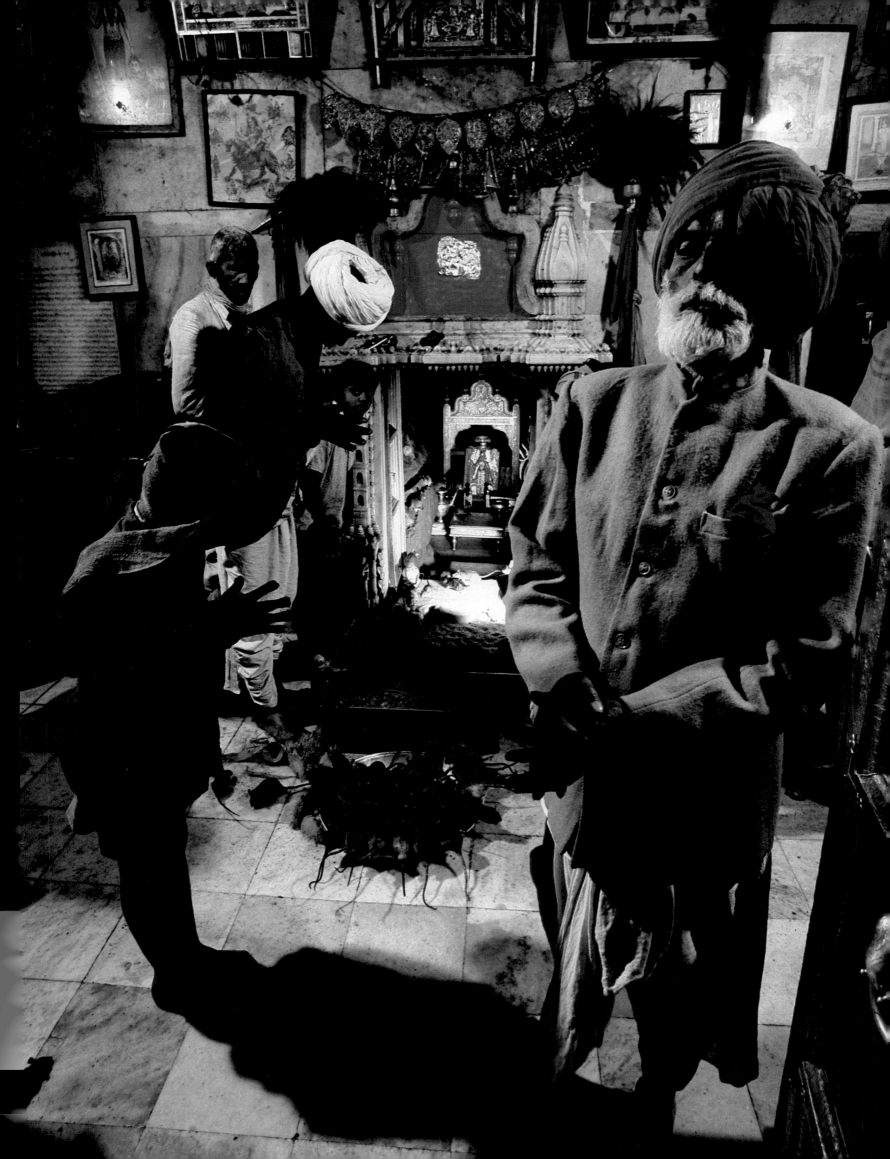

The Space Around the Face

By William Albert Allard

Almost all of us work. The lucky ones enjoy it. As I work with my cameras, wherever they take me, I feel that I am one of those lucky ones. It was the human face that first drew me to photography, but I try to go beyond the face and bring in the environment—the space around the face.

The great documentary photographer, Walker Evans, spoke of "the making of images whose meanings surpass the local circumstances that provided their occasion." That's the kind of picture I go after.

To document the communal, Old World life of Hutterites, I went to Montana, where they farm and ranch and raise large families. One spring morning I rode out on roundup with eight young Hutterite men. Heading toward the mountains in the crisp, sweet air, I saw the snowy peaks far above us, the limitless deep blue of the sky. I'd wandered this country before, and with each return it seemed surer than ever that this was the way people were supposed to live, free in a place where they can breathe deeply and work with the earth.

To find images that would show the gentleness of the Hutterites, I stayed around the barn while the men and boys worked. One little guy (page 293) sat in the hay, waiting for the lamb to have its tail docked. He didn't know I had made the picture.

Someone once told me that the branding scene (page 293) doesn't give up its story all at once. It shows how the Hutterites brand a calf. When you look at it again, I was told, other things emerge. Adults take charge of the work, and the kids seem to identify with the calf. The picture also says that they will grow and someday take over from their fathers.

A picture can be pretty. It can be dynamite, technically. But, for me, it has to have the sense of the place. The Amish barn raising (right) was chosen to go in electronic form on the Voyager spacecraft because it documents a cooperative way of life on Earth. It also shows how Amish men resemble each other, in their suspendered trousers, plain shirts, and homemade straw hats. And its lines reveal the spareness, neatness, and order of Amish life. That symbolism helps to give the picture a sense of place.

During the weeks I spent with the Hutterites, I made many visits to the preacher, Paul Walter. I often found him in the garden, turning the earth that would produce food for his community. The Hutterites labor for the common good, and all jobs are equal.

I'd read Hutterite history. I constantly search for material that I can digest for my work. When I go out on a story, I immerse myself in the area, haunting places that will reveal its temperament. That's how I started my Amish story when I got to Pennsylvania. I had no idea where to go to make pictures because the Amish, like the Hutterites, seldom allow photographs. As I talked with people, they came to trust me. I wander around a lot, making myself available for those moments one can't anticipate. Serendipity. That's what makes photography exciting for me.

On my motorcycle trip along the Mexico-U. S. border, my film was taken away one day by a Mexican officer who thought I had illegally photographed his guardhouse. Later he returned the film, and we spent a fine evening at a cantina. There, as in many spots along the way, I talked with people

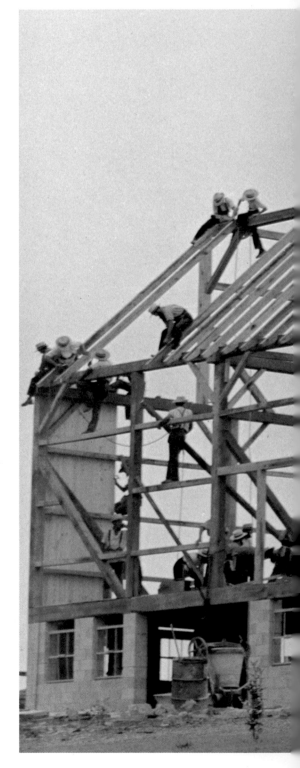

Self-portrait of the photographer at work: William Albert Allard on his motorcycle pursues an assignment along the Mexican border. In Pennsylvania, his camera captures the Amish pattern of work as farmers join to build a barn.

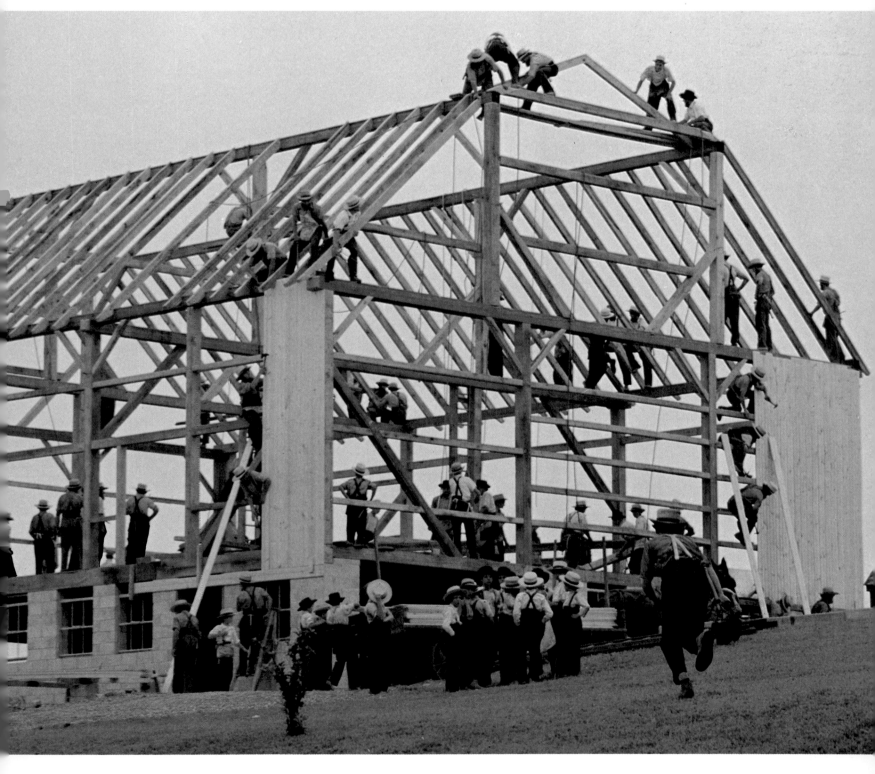

*Allard sought to document a cowpuncher's
work tending a winter herd: his gear,
the hoof-churned snow, the wild eye of
a frightened calf, a good dog's teamwork,
the roughness of rope and hide, the
union of man and horse. "I want you to
hear it, smell it, touch it."*

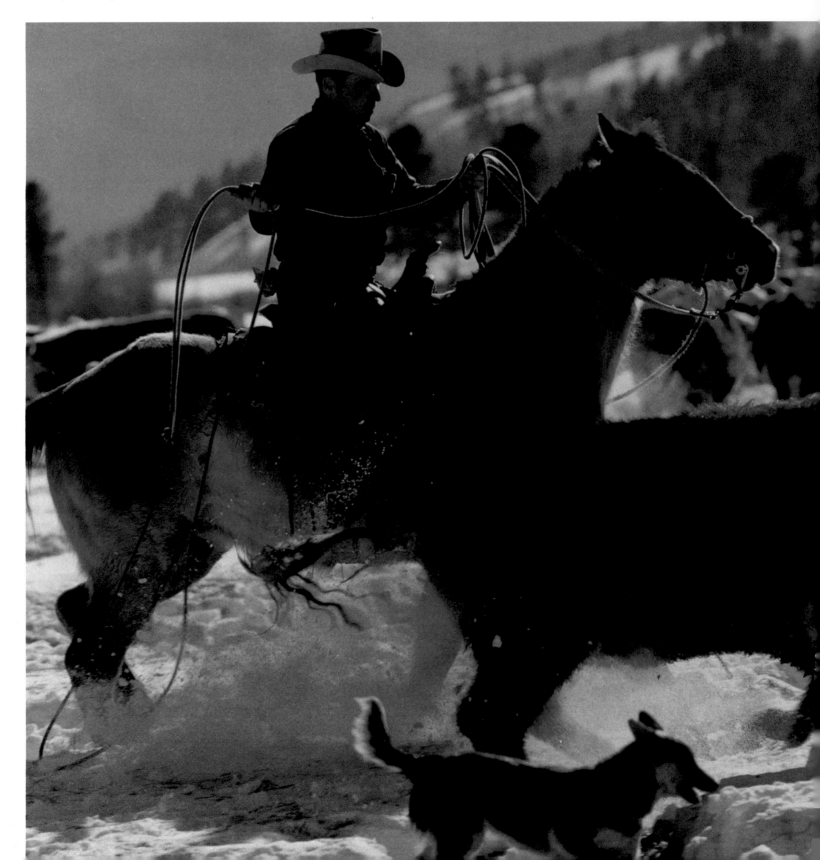

still working the land of their fathers.

The people I meet make my work rewarding. But I'm a loner too. As I rode into the desert the next morning, the highway stretched before me, and I was alone in the country.

A few years later, back in the northwest, I followed a trail of history through the Wallowa Valley, once the domain of Joseph, last chief of the Nez Perce. I watched a chestnut mare and her foal, drinking side by side from a shining stream. I flew to the backcountry of the Salmon River to visit Frances Wisner, who lived with her one-eyed Boston terrier in a 72-year-old house. Was she lonely?

"There's a million miles of difference between being alone and being lonely," Frances said. That night, as I fell asleep upstairs beneath hand-made quilts, I could hear Frances in the kitchen, cooking plum jam. Outside my window there was a rustling in the orchard. The bears were coming for fruit.

As I followed the Nez Perce trail, I spoke with farmers and ranchers who could barely meet the cost of working the land. I'd heard that before. I've seen development take more and more range and farmland. The grass is being covered up.

I photographed the small house of a 78-year-old Nez Perce. His ties with the earth had been broken in war with the whites. "The remembering hurts," he said. I took his picture as he dozed before his television set.

On a chill September morning I walked out to photograph a battle-field. I thought about the Indians, and animals, and the free people I'd known. I thought: We must will ourselves to grow with humanity and to renew our dedication to the earth. I still believe that.

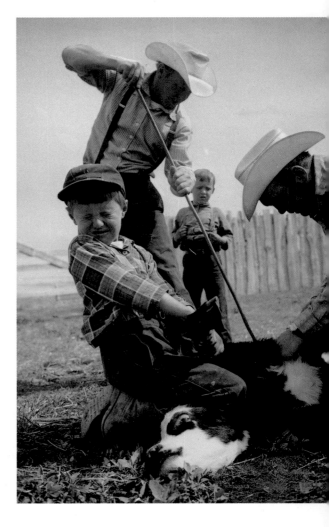

LOOKING FOR TROUBLE

Kicking up a curtain of fire on Mauna Ulu, Hawaii. By Robert W. Madden.

The worst winter storm in memory swept down upon New York and New England in March, taking more than 400 lives and burying cities under drifts as high as 20 feet. The tales of heroism and tragedy came next, putting the Blizzard of '88 into American folklore. In October 1888, the first issue of the National Geographic Magazine appeared, and in the slim volume was a scrupulously documented report on the storm. Pages bulging with statistics contained a meteorological history of the blizzard.

But threaded into the scientific account was the saga of the *Charles H. Marshall,* a pilot boat flung out to sea by the icy gales: "She had been driven 100 miles before the storm, fighting every inch of the way, her crew without a chance to sleep, frost-bitten, clothes drenched and no dry ones to put on, food and fuel giving out, but they brought her into port without the loss of a spar or a sail. . . ."

At 8:32 a.m. on May 18, 1980, Mount St. Helens exploded in a massive eruption. For weeks, on television and in newspapers, people witnessed the cataclysm and its ash-strewn aftermath. Not until the following January did the National Geographic Magazine report on

Mount St. Helens. The 64 pages ranged a spectrum from geology to human emotion, carrying on a tradition of thoroughness begun with Vol. 1, No. 1. "Rather than rush into print," explained Editor Wilbur E. Garrett, "we opted to wait until we felt we had the most complete and best documented account. . . ." And in 1981 there was a difference: color photographs, page after page of them by 21 photographers.

For years the Geographic's images of disasters were as gray as the ash spewed by Mount St. Helens. Precious color was reserved for scenic landscapes and the wonders of the natural world. War and other disasters were not photogenic. In April 1941, a year after the Nazi invasion of the Netherlands, the Geographic ran a glowing color photo of a Dutch tulip garden with five skipping, costumed girls. "War in Europe," the magazine sighed, "may mean no more photographs like this in a generation."

The war did not last that long, but the prophecy about color photography did come true. Color reproduction was technically too difficult for spot-news coverage. Black and white became the medium for chronicling the war, in newsreels as well as in publications.

Immediately after Pearl Harbor, the Geographic began extensive coverage of America's war effort. Strategic industries and daily life in a wartime world appeared on magazine pages again and again. Combat-zone photographs from the U. S. Army and Navy took readers into theaters of war from Italy to the Burma Road.

The magazine frequently used the derogatory term "Japs," breaking a cardinal rule set down by Editor Gilbert H. Grosvenor in 1914: "Only what is of a kindly nature is printed about any country or people, everything unpleasant or unduly critical being avoided."

The Geographic had never flinched from unpleasant acts of nature. The blizzard narrative in Vol. 1 had launched a continual and timely record of natural disasters. The magazine published three scientific articles on the San Francisco earthquake of 1906 the month after it happened; the next

What was once the California Hotel gives testimony to the San Francisco earthquake. "The illustrations," said an editorial note, ". . . picture very vividly the devastation wrought . . . and need no further explanation."

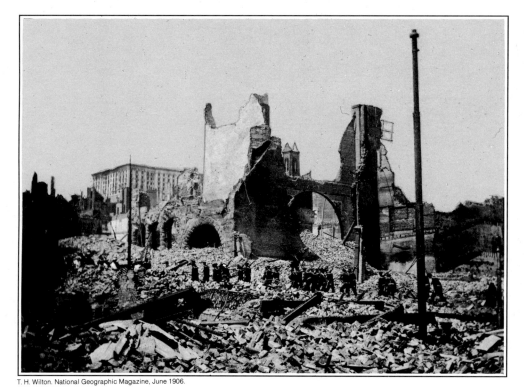

T. H. Wilton. National Geographic Magazine, June 1906.

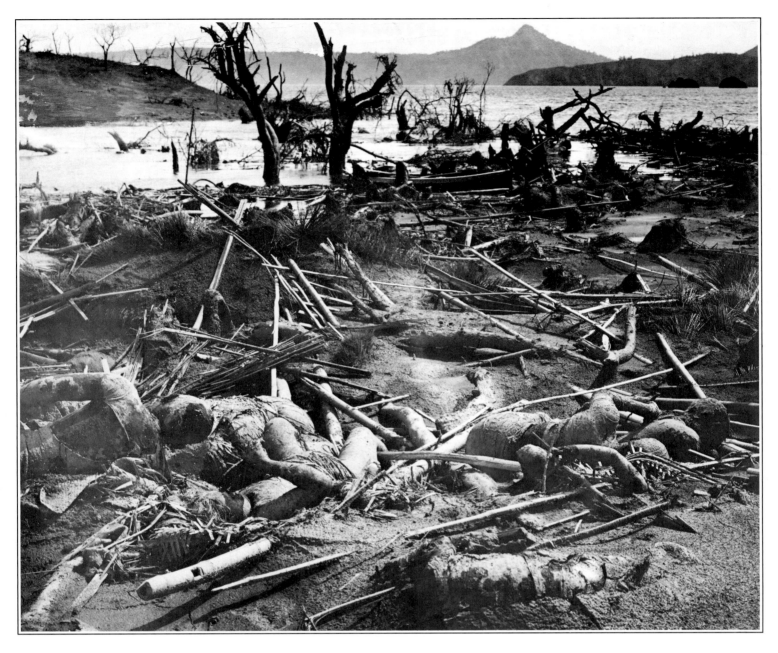

Charles Martin (behind camera) and a geologist document Taal Volcano on Luzon in the Philippines. Fifteen minutes after they and Dean Worcester left, "there occurred a tremendous explosion, sending forth a cloud of mud and fumes which rolled down the slopes of the volcano, enveloping the island completely." Next day (above), ash and mud entomb the dead.

Charles Martin (upper); Dean C. Worcester. National Geographic Magazine, April 1912.

issue carried 17 pages of photos of the shattered city.

In 1919 a journey through Armenia—"The Land of the Stalking Death"—produced a horrifying word-and-picture story of famine. The caption to a photo of emaciated women says, "They will be dead in two days." Starving children stare blankly at the camera. The author sees a "hideous ox-cart, whose driver went about, shaking recumbent children to learn if they were dead or not."

Earthquakes in Central America, volcanoes in the West Indies and Alaska, the Mississippi in raging flood—the Geographic was there. But the magazine usually avoided coverage of modern American troubles. In 1930 the Geographic celebrated "New York! Man's incomparable feat!" Amid color photographs of "business temples" and a "cathedral of commerce," the reality of the Depression intruded in the form of a black and white photo of jobless men getting handouts of food. The caption says, "In great cities, even during good times, idle men are inevitable. That is an aspect of social maladjustment." Such photos were rare in the Geographic, though the era was documented elsewhere in stark black and white— haggard faces, soup lines, abandoned Dust Bowl farms.

To cover, seemingly, was to condone. During the cold war the magazine displayed America's might with color-filled articles on the U. S. Navy and Air Force. But no article appeared about the Soviet Union from 1946 to 1959, when, in an editor's note, the Geographic declared that "this large and populous country cannot simply be omitted and ignored."

With the 1960s came change, at least partially inspired by the war in Viet Nam. The Geographic had looked at strife-torn Indochina in the 1950s. But the new decade brought intensive coverage—and vivid color photography of a ravaged land and the wounds of war.

Between 1961 and 1971 the Geographic published 11 articles focusing on the tragedy of Southeast Asia. Never before had the Geographic moved in so close to the realities of war: the dying and the wounded, the enemy pursued and

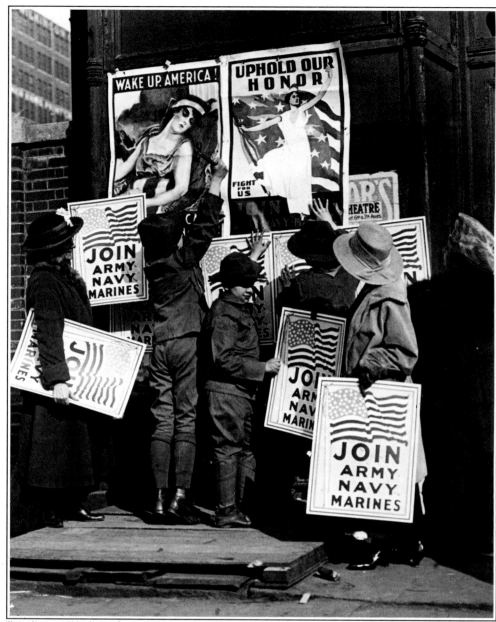

Western Newspaper Union. National Geographic Magazine, June 1918.

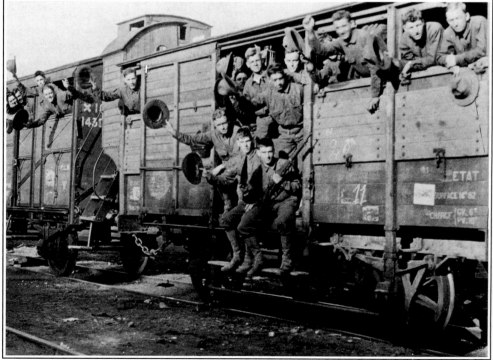

Committee on Public Information. National Geographic Magazine, February 1918.

298

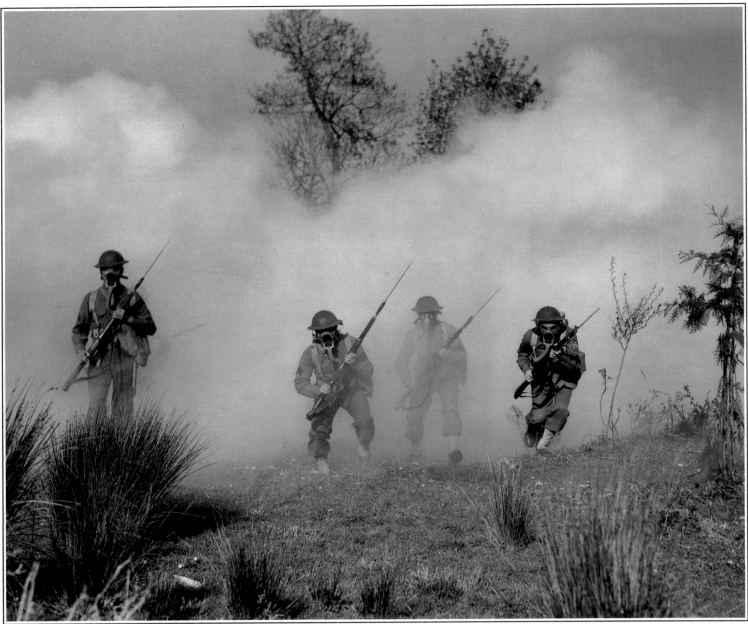

J. Baylor Roberts. National Geographic Magazine, October 1942.

Women and children (opposite) flock to the flag in a fervor of World War I patriotism. Echoing the mood, the magazine caption said, "The Prussian masters of Germany do not possess the physical might to impose their will on the human race."

The Marines land in France (opposite). Jammed into a troop train, they head for a training camp. Photographs of doughboys and dreadnoughts, and articles extolling "The Health and Morale of America's Citizen Army," dominated the wartime magazine.

One war and one generation later, soldiers (upper), "like masked demons, with bayonets fixed . . . plunge through a gas cloud"—in training, and in color.

captured, the homes in flames, the faces seared by grief. Getting close, staff photographer Emory Kristof was wounded; a mortar fragment cut his right eye.

Dickey Chapelle, a free-lance writer and photographer, produced two articles. "The war in Viet Nam," she wrote in her last piece, "marked the first time in more than twenty years as a war correspondent that I had carried a weapon in the course of my work." By the time that was published, she was dead, the first woman war correspondent killed in action in Viet Nam.

The troubled world was changing, and covering it meant, more than ever, coverage of war, poverty, starvation, riot—and the modern realities of apartheid and pollution.

The coverage would be in color, for no longer was black and white

the medium of documentation. Color, Garrett wrote in 1975, conveys "the full, disgusting reality" of pollution and poverty. "We have seen," he said, ". . . that war pictures with their red blood and green slime nauseate and repel powerfully —as they should; that color properly used does not romanticize or glorify war, but degrades it. The ills of society . . . can be communicated more powerfully and creatively in color than in black and white."

In the pages that follow, troubles are chronicled at special moments. The still photographer sees those moments and captures them. In this age of fleeting video images, photographs on the printed page give us and posterity a permanent record of what was, what is, and what will never be again. The special moments endure.

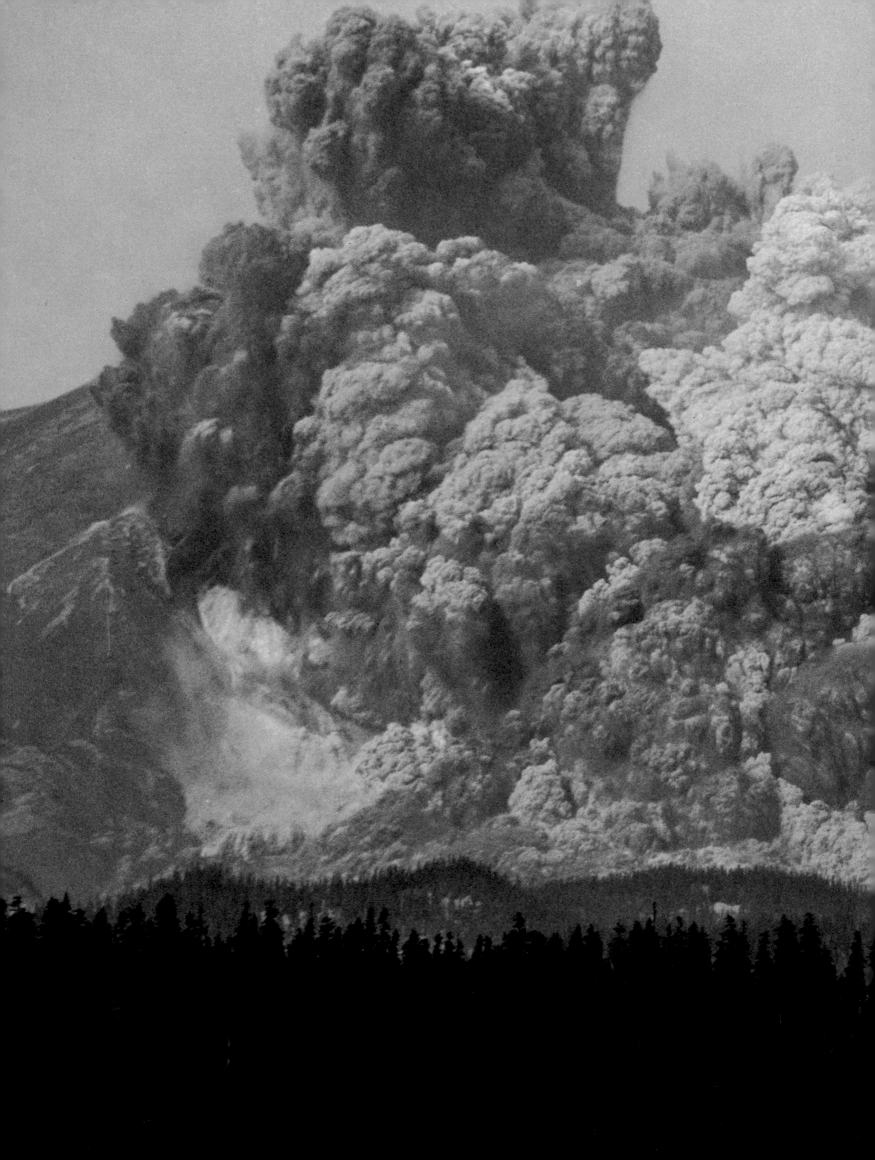

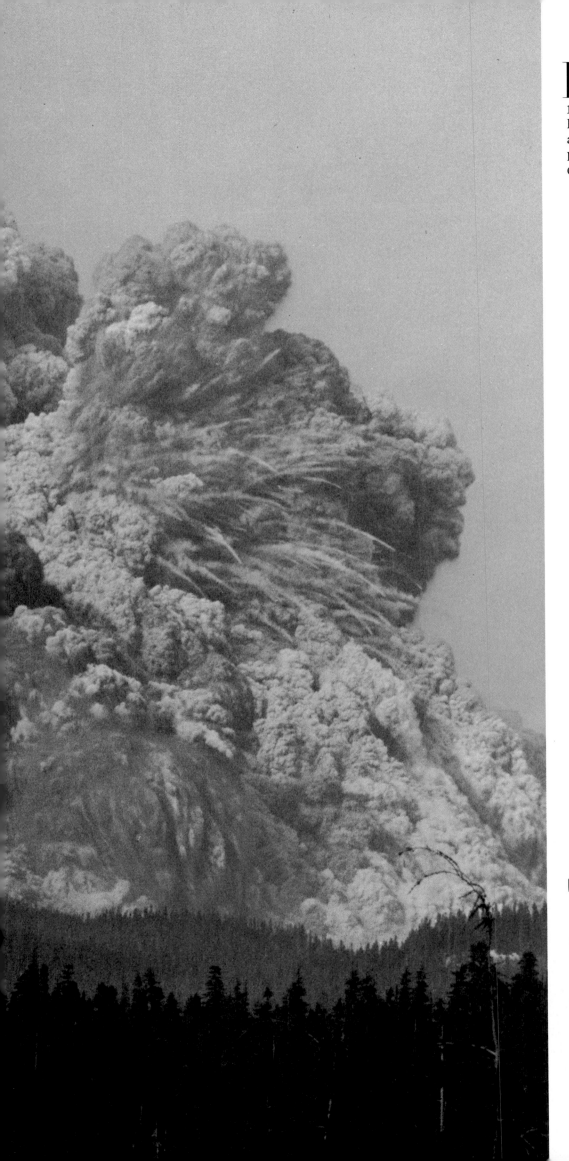

He is an amateur. He had never had a photograph published. At dawn on May 18, 1980, he set up about 12 miles from Mount St. Helens. "I just happened to be there with my camera and the tripod when it blew up. Nothing planned. We got out of there real quick."
GARY ROSENQUIST

The supertanker *Amoco Cadiz,* grounded off the Brittany coast (overleaf), spews some 69 million gallons of oil. Rogers is in a French military helicopter. "By the door there were spots for only five photographers to shoot. I knew everyone would crowd in. I sat by the open door. It was impossible for me to get up. I just kept shooting. I nearly got pushed out. But I had plenty of time to work the situation. I used at least three cameras."
MARTIN ROGERS

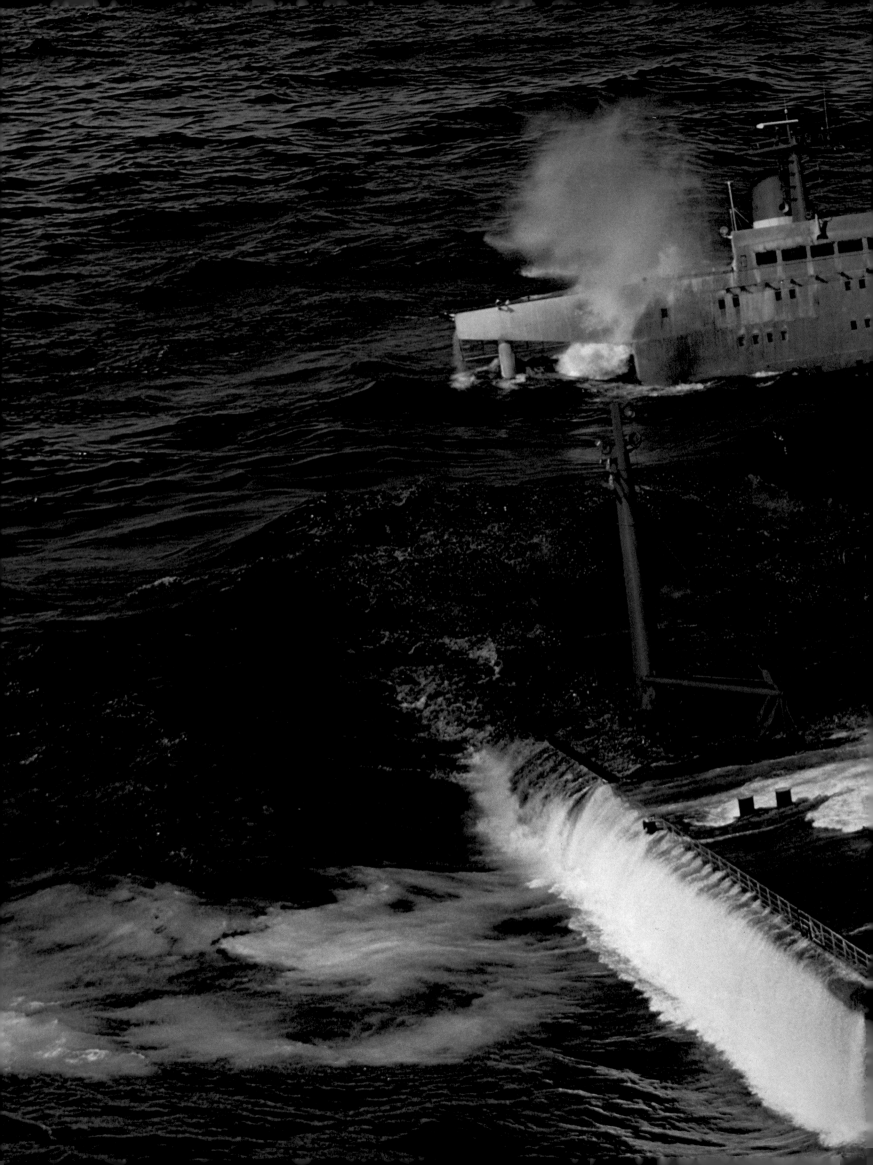

Los Angeles—after the rains came. "I was in that house the day it happened. I photographed the owners—with tears in their eyes— making jokes about how they had always wanted a sunken living room."
JODI COBB

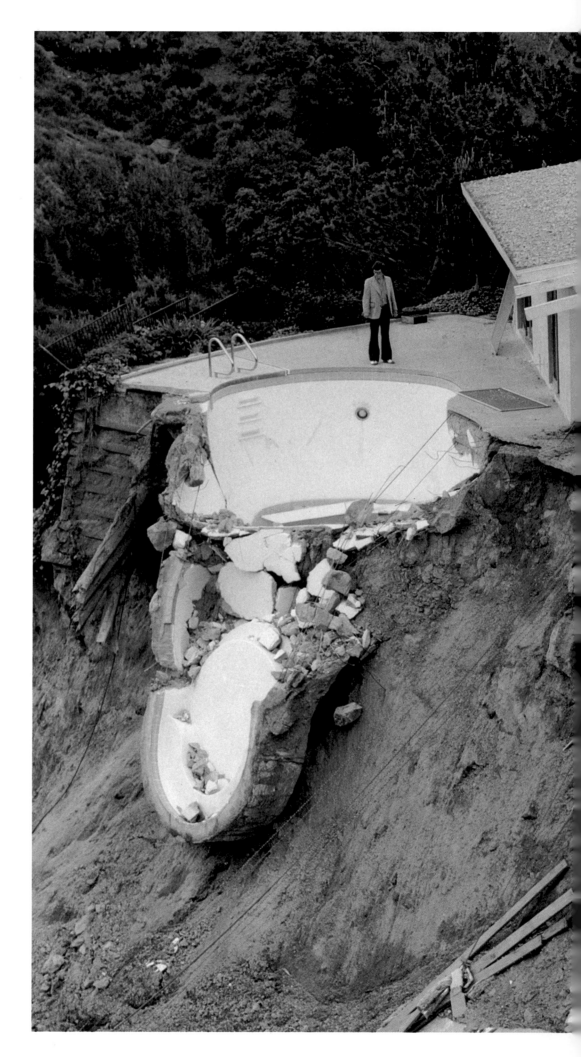

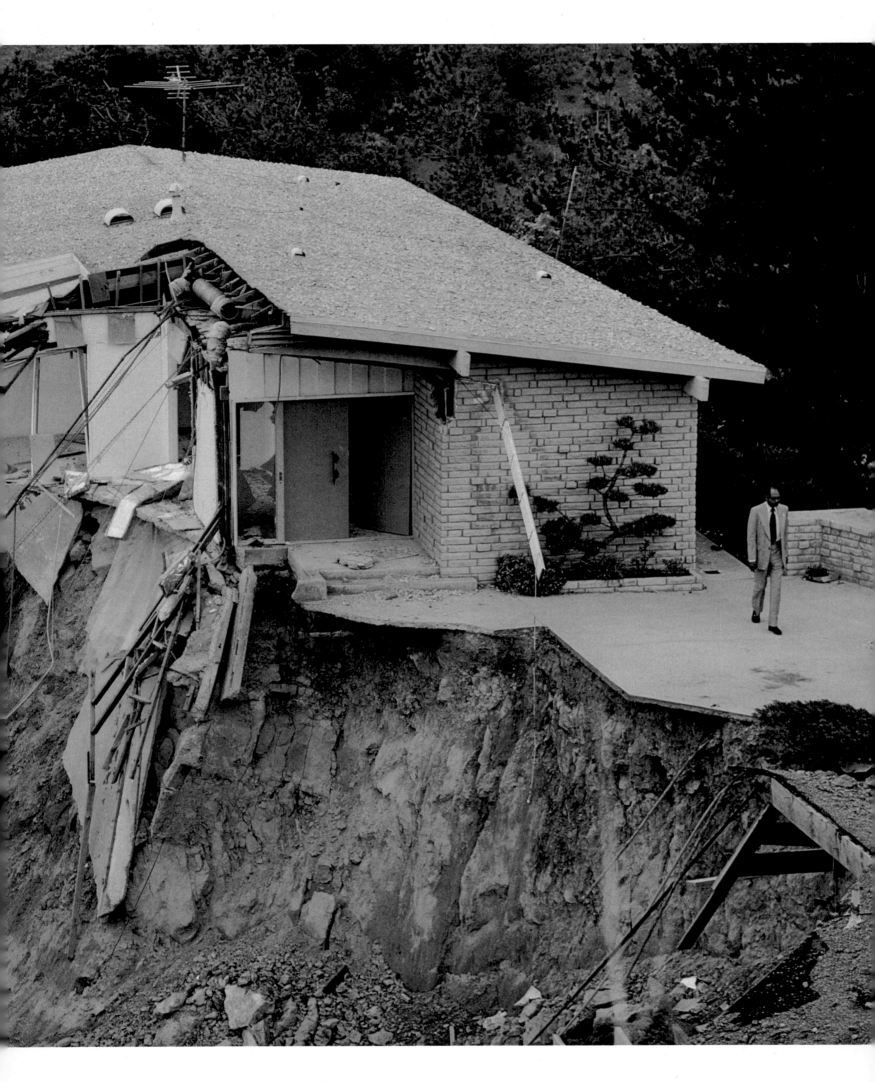

Viet Nam, 1967. "They're firing out on the perimeter to discourage anybody from wanting to come around. Those are 40 millimeters." Kristof was on a year-long assignment for a story on the U. S. Army. Four days after he took this picture, a mortar fragment cut his right eye. He lay in a paddy field for 15 hours before a helicopter took him out. "The only picture ever published on the army story was a rest-and-recreation shot of a young couple in Hawaii."
EMORY KRISTOF

Skyrocketing lava builds a black mountain of ash that will blanket this Icelandic town and destroy hundreds of its homes. Kristof's tripod catches fire when its legs pierce the crust concealing red-hot lava. He is covering a disaster—yet: "We'd get together after a hard day's work and would party with the townspeople, sing songs, look at the volcano, drink, and laugh a lot. It was about the greatest party I've ever been to. Everybody was singing old Norse songs and a few American songs. It was kind of a Viking scene."

EMORY KRISTOF

June 1979. Boat people of Viet Nam fill a government warehouse in Hong Kong (overleaf). "When you are on the floor of the warehouse, you don't get the feeling of the mass of people. That image won't give the information that this one will. This was a picture I had to make. It's a very informative picture, and in a historical sense it has value."

WILLIAM ALBERT ALLARD

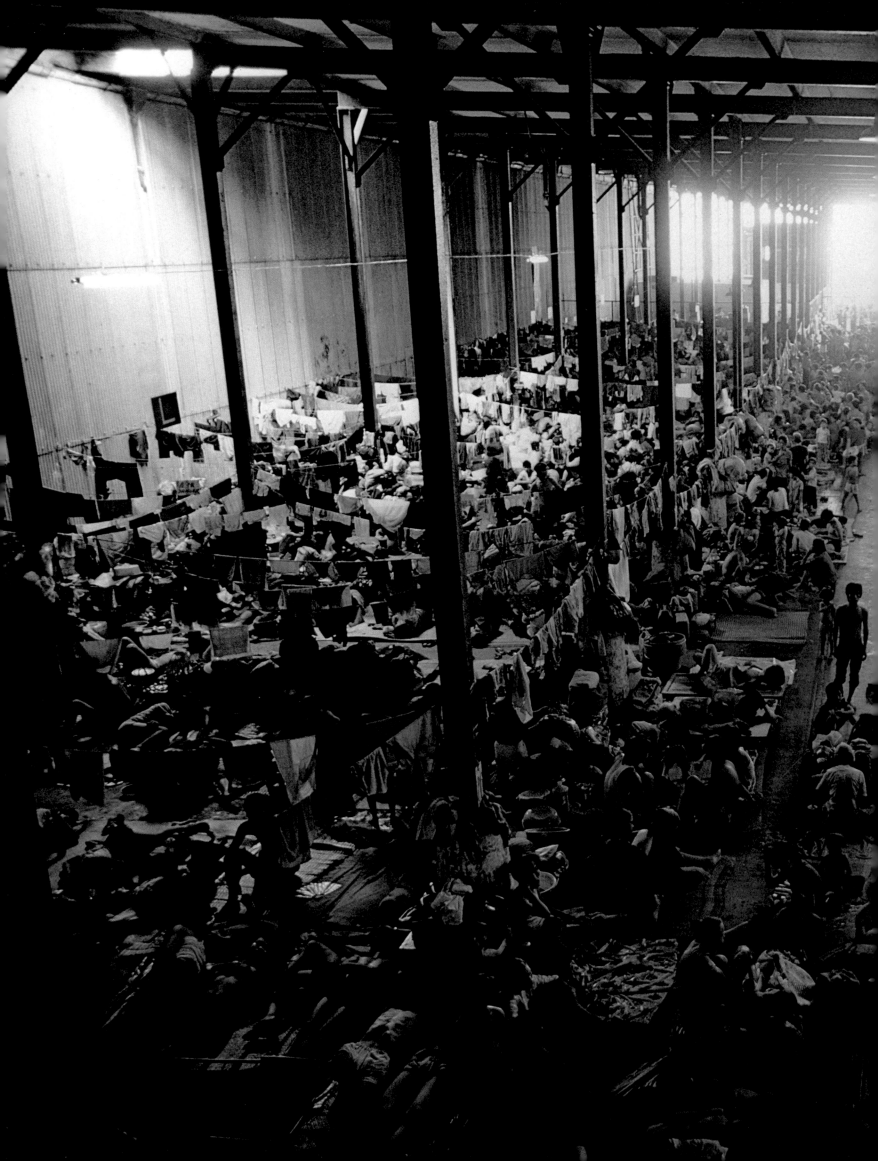

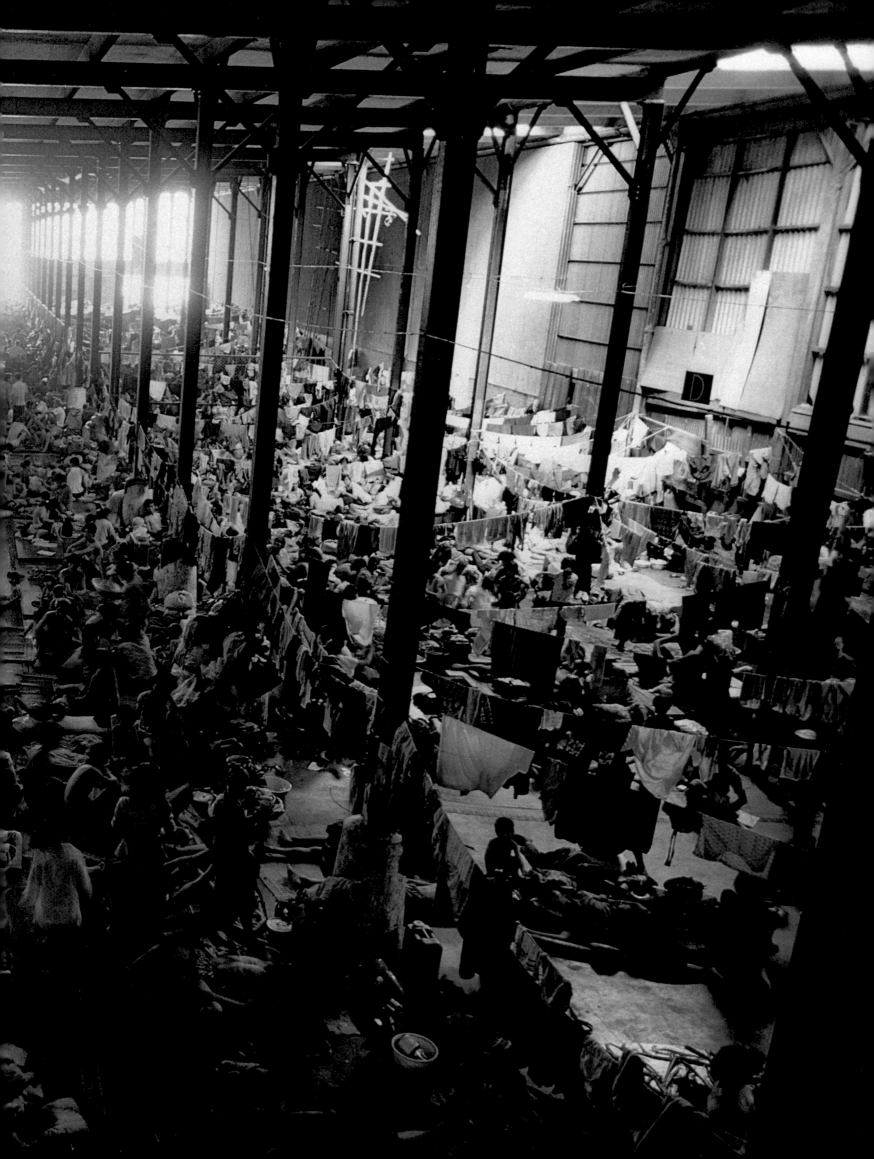

Earthquake: the Camera as Witness

By Robert W. Madden

It all happened in 30 seconds. A major earthquake shook the night of February 4, 1976, rumbling along the Motagua Fault that slices across Guatemala. Much of the countryside lay devastated. The human toll was appalling: some 23,000 people killed, thousands injured, millions homeless.

Alerted to the disaster, the worst ever recorded in a Central American nation, Geographic editors geared up to cover the story, and within hours I found myself wedged between boxes of plasma aboard a rescue helicopter. We were headed for the mountain village of San Andrés Itzapa, about 35 miles from Guatemala City.

Dust from the earthquake-churned earth still filled the air. Backcountry roads that once had clung to hillsides had collapsed into the valley. As the helicopter crested a bare hilltop, the ruined village appeared below. Survivors appeared and began to gather on a grassy field—our landing area.

Ducking beneath the rotor blades, I found myself in the midst of a confrontation between the townspeople and nearby villagers over the distribution of the food and medicine. The small field became a sea of pushing humanity pressing in from all sides.

Suddenly a man broke from the crowd. Leaping onto a pile of boxes, he called for silence and told the villagers that they must share equally what the helicopter brought. His words broke the tension, and the villagers began to divide the supplies.

In my work for National Geographic I have photographed fires, floods, volcanic eruptions, earthquakes, hurricanes, and tornadoes. (I also photograph flowers.)

The logistical problems encountered while covering natural disasters can make the job extremely difficult. Essential services are gone. There is no food and, many times, no water. If power lines are down, all electrically powered machines shut down—including the gas pumps. When Hurricane Frederic hit Mobile, Alabama, I had to rent a series of three vehicles just to get full tanks of gasoline, and I was forced to abandon the "empties" along the road.

Communications are tenuous. Rumors sweep the area. One village in need of doctors is sent food; another, with two doctors on the scene, is sent four more.

The photographer covering a fast-breaking story must decide quickly what subjects to photograph and how best to get them before the immediacy of the situation disappears. The disaster story demands that the photographer be resourceful and prepared to use unconventional methods.

The photographer must be sensitive to human suffering. He or she should not use a camera as a shield for protection from the tragedy at hand.

Several days after the earthquake in Guatemala, I came upon a man picking through the remains of his house in Chichicastenango. I climbed up on what was left of his bedroom wall. Hands deep in adobe dust, the man suddenly looked up at me, a scant three feet away. Immediately I lowered my camera. I felt I had intruded upon a private moment.

"Are you from the press?" the man asked. I replied that I worked for an American magazine.

"You are seeing our country at a bad time," he said. "You must return when it is rebuilt, because our country is very beautiful."

How could I capture the spirit of his words on film?

Robert W. Madden by Wilbur E. Garrett

Caught in a crosswind, a rescue plane crashes into a truck while attempting to land on a mountain road in Guatemala after the 1976 earthquake. "If you carry a camera every day of your life—or almost every day—you're going to come across something like this every few years."

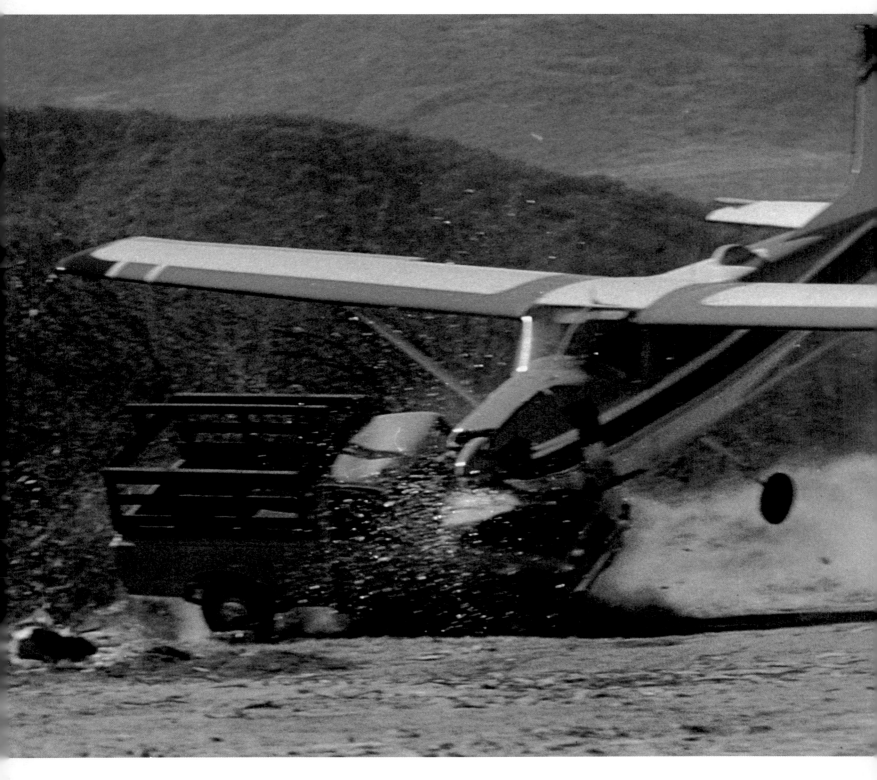

Seeking the Moments of War

By Wilbur E. Garrett
Editor, National Geographic Magazine

Can any subject have inspired more words, more photographs, more books, more movies—even more statues—than war and its heroes? I doubt it. War has been called the ultimate immorality, the failure of politics. War has been called a game, a contagion, a biological necessity, but it has never been called off.

Not a moment passes that doesn't see a war someplace on earth, and it's a sorry war that doesn't have its retinue of reporters and historians in attendance. Each generation has its unique fashions, music, and political and philosophical causes. So, also, in our ultimate perversity, each has its own major war.

"The War" for my grandparents was World War I—called "the War to End War." For many "The War" still is World War II. For my generation, the war was Korea; for my children, it was the Viet Nam War.

The Geographic was there for all of them, plus a few that most people have never heard of. World War II alone generated more than 100 Geographic stories. Even war dogs have rated four stories since 1919.

Why does the Geographic cover wars? The obvious and perfectly valid answer is this: because no event so shapes national boundaries or so affects the peoples of this earth as war. And it is our function to inform our readers on such matters.

But beyond this call to duty lurks the usually unspoken hope that we can have an influence in destroying the romantic fascination for war which continues to infect mankind—whether soldier or civilian, whether writer or reader.

On seeing the Yankee forces pushed back at Fredericksburg, General

Wilbur E. Garrett by Chu Quoc Trang

"When I joined Viet Nam Marines in a sweep in the Mekong Delta in 1968, the leeches, snakes, stagnant water, ooze, and entrenched Viet Cong made this claustrophobic swamp a special hell."

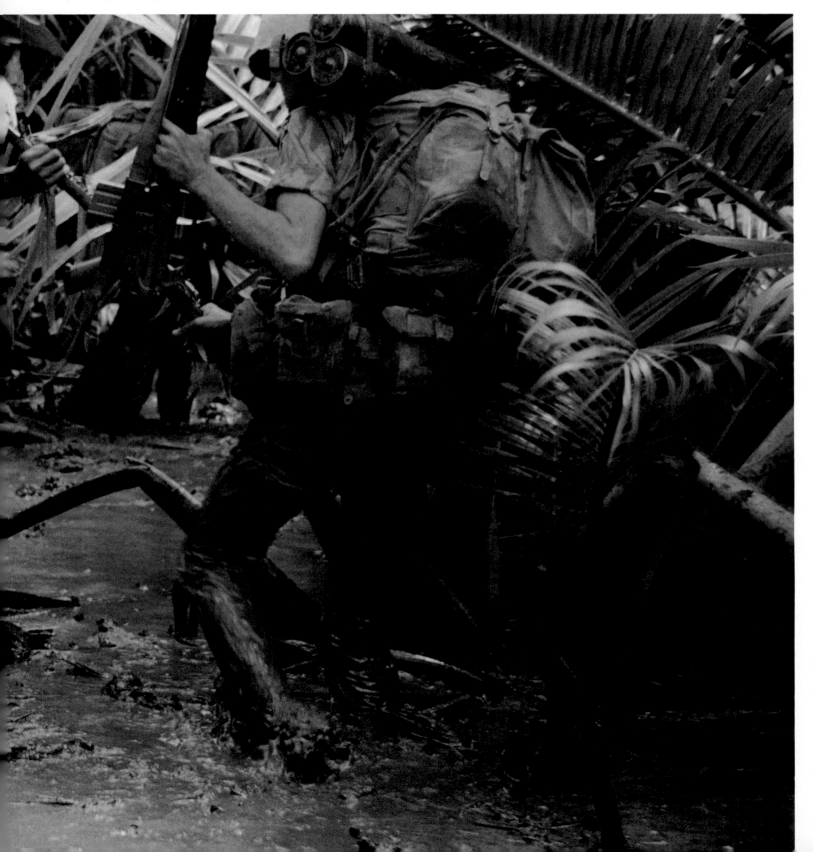

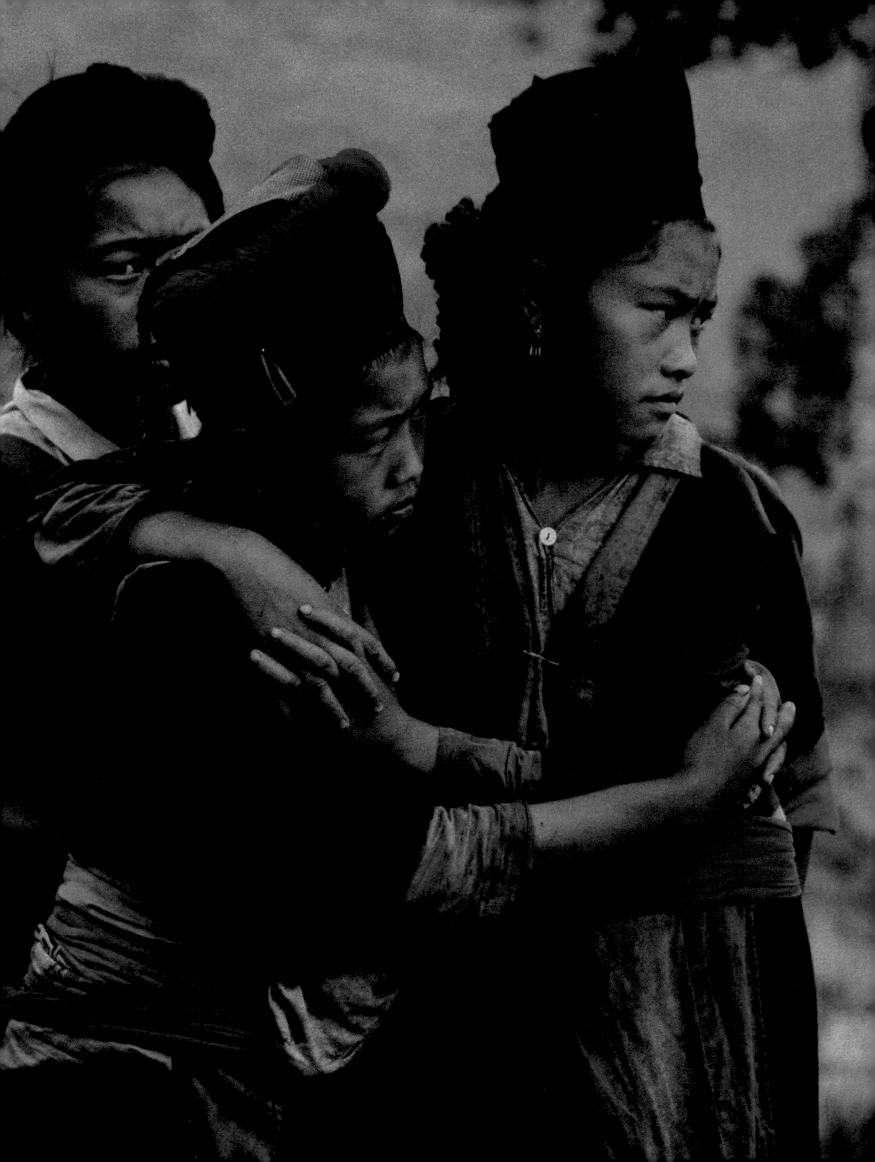

Robert E. Lee said, "It is well that war is so terrible, or we should grow too fond of it."

As children, we played war—killing and being killed in fun. For me, the fun and fascination faded to fear and revulsion in Korea 30 years ago as one-third of the pilots of our Navy squadron—all friends—were shot down to a sometimes speedy, sometimes slow, but always real, death.

In numerous journalistic assignments to war zones since, the fascination and the fear have not gone away. But the experiences have left me with an overriding reason—perhaps naive—for covering war and for publishing stories about it. By stripping away romantic notions and exposing war as a horrible, futile depravity, we might help temper, at least for one generation of readers, the fascination, the excitement, and the glory too often associated with war.

It's ironic that the only photographer working regularly for the Geographic in Viet Nam to be killed was a woman, a Quaker, and a pacifist. Dickey Chapelle's mother taught her that violence in any form was unthinkable. Probably it was the shock of her first assignment—photographing the horror of Iwo Jima and Okinawa—that led her to dedicate her life to "telling the folks back home" how cruel war could be.

Having worked alongside her in Cuba, Viet Nam, Laos, and during the China-India border war, I never doubted her courage, her professionalism, or the perverse attraction which war held for her. She was always brave, though not always careful. Captured smuggling penicillin to Hungarian freedom fighters, she was placed in solitary confinement for six weeks by the Russians.

Dickey knew the dangers and hated the violence but, like a moth hypnotically challenging a candle until it falls into the flame and perishes, she covered every major conflict from World War II to 1965, when she was killed while with a Marine patrol on her fifth trip to Viet Nam.

In her last Geographic article, published posthumously, Dickey asked: "Why was it that humans still got along so badly that conflicts were settled like this, by young men betting their lives at hide-and-seek? Did I truly think that I could, with the camera around my neck, help end the need for the carbine on my shoulder?" Yes, I think she helped.

Dickey was the closest of a dozen journalist friends killed in Viet Nam. None was paid enough to take the risks involved. Of course, war is exciting, and the chance for quick professional recognition is never greater. But I like to think that beneath the bravado, daring—and the often self-conscious cynicism displayed by most—was a bit of the same dedication that Dickey felt for telling what war is really like.

Often I've been threatened by soldiers. Once I was locked up by government forces in Laos, and later, in the same country, I was captured and held by Communist guerrillas. The first time, I was released on the condition I leave the area immediately because they didn't want their story told. In the second instance, when their checking proved I really was a reporter, I was released—because they wanted their story told. I was lucky. In those days journalists enjoyed a certain immunity. That no longer seems to be the case. Increasingly, journalists are targeted.

In the hands of a dedicated photojournalist, war's best witness is the camera. But even with the realities of color film, the camera is inadequate. It is mute to the echoing screams and blind to the green stench of a decaying battlefield. With the rarest exception, the camera is, mercifully, bunkered down when the ultimate quivering moments of death strike. Too often the camera sends home photographs of a movie-macho, pain-free, heroic distortion of war.

But the camera can succeed in portraying war's true horror—as it did in Eddie Adams' photograph made in a street in Saigon of a South Vietnamese general shooting a bound Viet Cong prisoner in the head. When the camera captures such a moment, it does affect history. If there was any one recorded instant that led to America's eventual withdrawal from Viet Nam, I believe it was in this photograph. A truly decisive moment. It drove home to Americans the cruel futility that the war had spawned.

Perhaps such photographs can eventually lead readers as parents to find diversions other than war games for their children. It might not be too much to hope that a new generation of politicians and statesmen might try harder to live and negotiate, with John F. Kennedy's 1961 warning to the United Nations in mind:

"Unconditional war can no longer lead to unconditional victory.... Mankind must put an end to war or war will put an end to mankind."

Until that millennium comes, we of a Society devoted to geography will continue to report on the effects of war. But until that time, can there be a higher calling than that of exposing war as the maximum and perhaps final human failure?

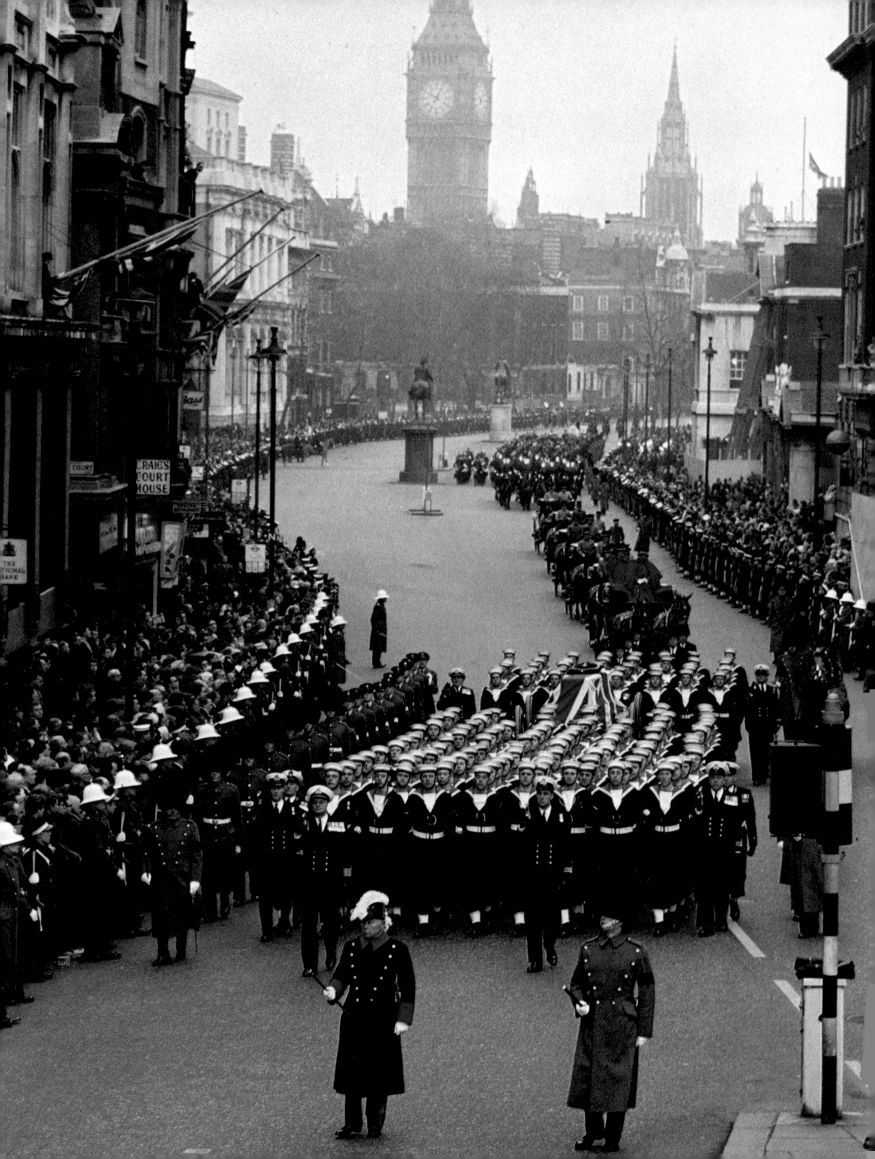

Stories that Become History

By James P. Blair

Dawn. The wind makes the gray, empty streets still colder. I have rushed to get here, first so I could view the bier of Sir Winston Churchill lying in state at Westminster Hall, and now for the moment when his remains will be drawn slowly through the streets of his beloved London.

For days the old bulldog had clung to life, giving his countrymen time to ponder the glories of empire and the trials of war with which he had long been associated. Now, on January 30, 1965, Britons by the thousands came to pay their respects. As did the world. Photographers and reporters had converged on London from everywhere. I had been assigned to the press stand at Whitehall, looking out past the Houses of Parliament where Churchill had presided as prime minister for nine crucial years.

We photojournalists are a pushy lot, so I had arrived six hours early to get the best spot on the stand. By nine, the streets are packed and photographers are elbowing each other for a fractionally better view.

The procession appears. Just time for a last check of lenses and cameras and light meter. Now the gun carriage on which the coffin rests comes into the viewfinder. Focus, shoot, change exposure, shoot, shift to shorter lens, shoot, shoot, and shoot again. It's over in a matter of minutes. The street is still lined with people. But it is empty now of history.

For a photojournalist, the most important question is "when"—when to take the picture that will capture not only the moment but also something of its meaning. The search for meaning is inevitably subjective, which explains why photographers, though standing cheek by jowl, can come up with quite different pictures of the same scene. Personally, I look for a quality that is without artifice and makes a strong statement.

I suppose that my concern for the "heart" of a story grows out of my beginnings. As a young photographer, I worked for Roy Stryker, one of the great influences on American photojournalism. He led the famous team of Farm Security Administration photographers who documented the Great Depression in the 1930s.

I met Roy Stryker in 1953, when he was in charge of documenting the economic and cultural renaissance of my hometown, Pittsburgh. Roy was a great teacher. He taught me to care, to try to contribute something to the understanding of whatever I was photographing. Ever since, I've been interested in assignments that reveal some element of concern for the world we live in.

The time when "news" and the meaning of news came together most clearly for me was undoubtedly during my National Geographic assignment to cover South Africa in 1976. While I was there, accumulated black resentments over the racial policies of the white Afrikaner-led government exploded into a rebellion of strikes, and demonstrations in the segregated township of Soweto. The rebellion was put down at a cost of hundreds of lives, but it was a portent of things to come for that troubled land.

At the National Geographic, I have a worldwide beat. One day South Africa; another day, Hurricane David or distant China. That's what makes my job so rewarding. And that's why I keep my cameras repaired, my passport up-to-date, and an ear cocked for the telephone call announcing the next assignment.

James P. Blair by Wilbur E. Garrett

Whether on assignment in London (opposite) or Washington (above), Warsaw or Johannesburg, James Blair aims at the mood and reality of the time and place. Of a favorite assignment, he says, "I think that the magazine's story on South Africa helped readers to better understand the reality behind the headlines."

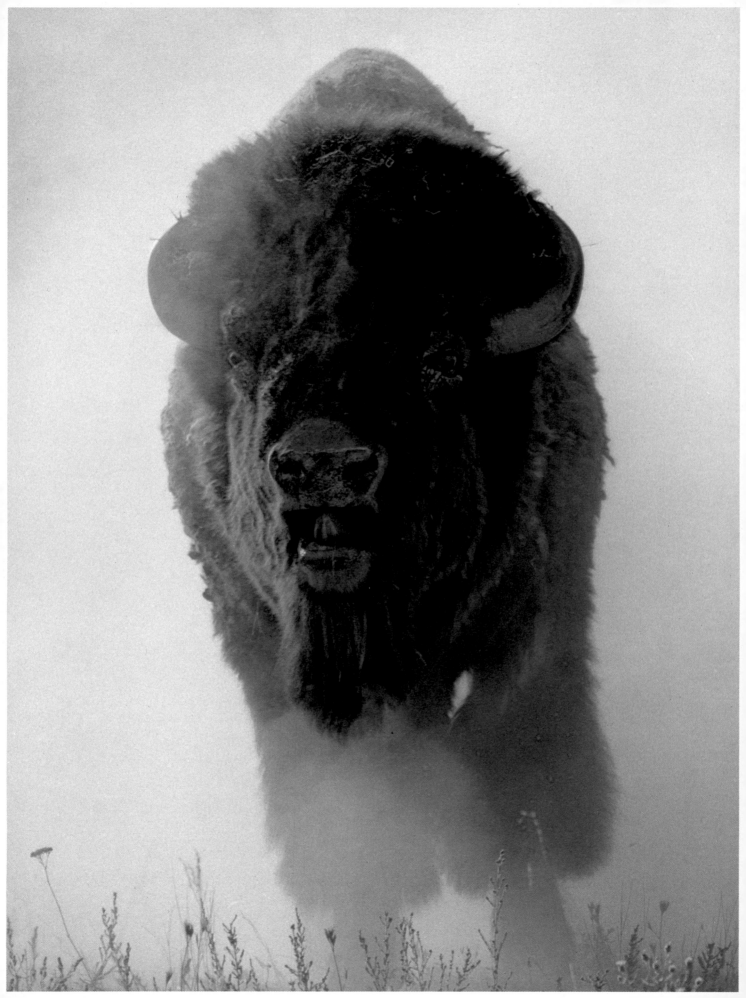

IN THE KINGDOM OF THE ANIMALS

A grass-roots view of a bison bull. By Lowell Georgia.

"Straight toward the mark of the shining eyes the canoe is sent with firm, silent strokes. The distance is only seventy-five yards, now it is only fifty. . . . Twenty-five yards now, and the question is, Will he stand a moment longer? The flashlight apparatus has been raised well above any obstructions in the front of the boat, the powder lies in the pan ready to ignite at the pull of a trigger. . . . Fifteen yards now, and the tension is becoming great. Suddenly there is a click, and a white wave of light breaks out from the bow of the boat—deer, hills, trees, everything stands out for a moment in the white glare of noonday. A dull report, and then a veil of inky darkness descends. Just a twenty-fifth of a second has elapsed, but it has been long enough to trace the picture of the deer on the plates of the cameras. . . ."

That word-picture was painted in 1906 by George Shiras III, congressman and later trustee of the National Geographic Society. And with his words the Society's magazine published a bestiary unprecedented in its pages—more than 70 of his photographs of birds, mammals, even butterflies, by day and by night, going about their business not in captivity but out in the wild. From Shiras' pioneering work came today's art and science of animal photography.

The magazine had run pictures of animals before. In 1903, Editor Gilbert H. Grosvenor borrowed photoengravings from a government bureau for an article on Alaskan reindeer. But when Shiras proffered a boxful of pictures—a bit hesitantly, perhaps, since another magazine had looked through the box and had used only three—he watched amazed as the young editor selected photo after photo.

"The pictures aroused tremendous interest in natural history," Gilbert Grosvenor recalled later—but not all of the interest was favorable. His board of managers chided him: "You're turning the magazine into a picture book," two of the managers complained—and thereupon resigned.

But readers were enthusiastic.

"Nobody had ever seen pictures like that of wild animals . . . of birds," Grosvenor related.

Shiras, an amateur, had been among the first to photograph wild creatures in natural haunts, and for a decade he trailblazed with his camera in the night.

Some of his setups were marvels of making do—clever contrivances of door locks and gun-cocking devices, of springs and cords and toppling weights. Many of his animal subjects took their own pictures by touching a string that tripped the shutter of a concealed camera. Shiras, who might be miles away at the time, would not know what he had photographed until he processed the plates. This time a falling twig; next time, perhaps, a mountain lion or an albino porcupine.

His earliest attempts at night shots had been disappointing. The magnesium powder then used for flash lighting worked well in studios but not outdoors in wind or damp. And it flared up so slowly that wary animals often bounded out of the picture before an image registered on the plate.

In July 1892 Shiras and a helper tried again. As they stalked a likely subject by canoe, an errant elbow toppled lighted lamps and all the powder into the bottom of the boat. "At once came a tremendous explosion," Shiras recounted, ". . . with a cloud of stifling smoke, compelling me to leap overboard in order to extinguish the blaze on my boots and later that in the boat." His "little camera floating about in the murky waters" was later retrieved from a sandbar.

A faster powder from Germany solved the illumination problem. And blank cartridges triggered just before the flash added action to the pictures by startling the subjects.

The camera lenses of Shiras' day had little light-gathering power, and the plates they exposed were not very sensitive. Thus Shiras could leave the shutter open as he hid nearby and let an animal fire the flash by the trip cord. He would then emerge to close the shutter.

But if the wait were too long, daylight would fog even those slow emulsions. So Shiras rigged a rubber band to the flash unit. When the powder went off, the band would

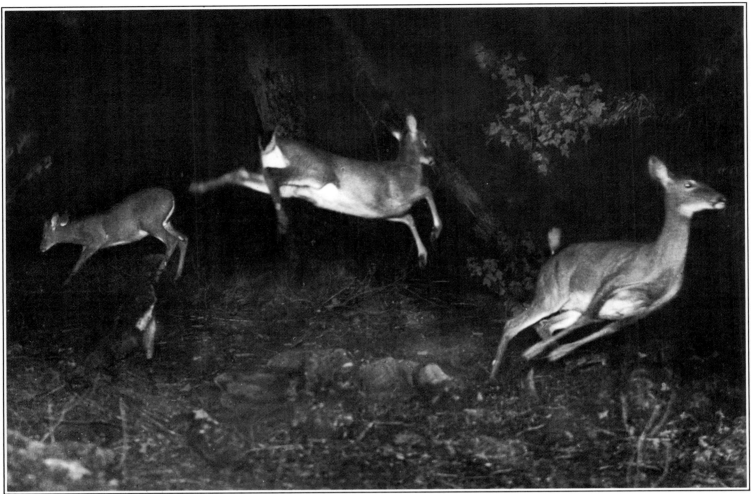

George Shiras III. National Geographic Magazine, August 1921.

George Shiras III. National Geographic Magazine, June 1911.

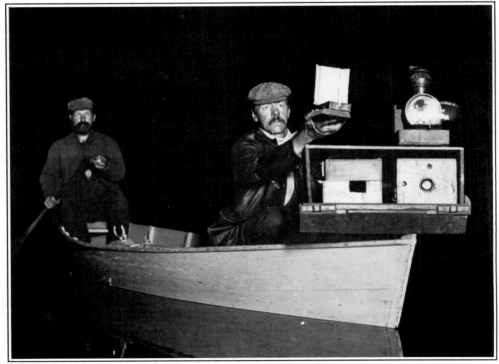

George Shiras III. National Geographic Magazine, July 1906.

Self-portraits all: Three deer, a raccoon, and pioneering wildlife photographer George Shiras III tripped shutter and flash with a string. At a tug of Shiras' hand, a camera ashore recorded his method in 1893: Transfix an animal with lantern light, glide in close by boat, aim the camera box, and trigger a hand-held pan of flash powder. Bait on a string induced the raccoon to pull it. To add action to the shot of the deer, Shiras triggered a blank cartridge an instant before the flash, startling the animals into frightened flight.

A nearly fledged great blue heron chick surrenders its nest to the camera and cameraman near San Francisco Bay in 1917. Early wildlife photographers had to challenge the wild with equipment better suited to the studio.

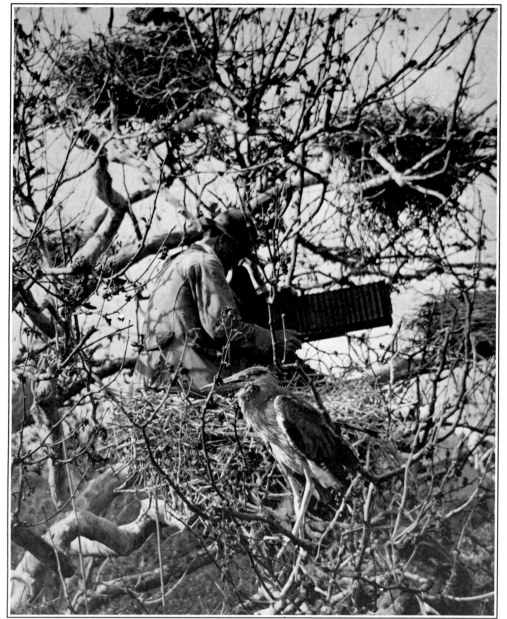

William L. Finley and H. T. Bohlman. National Geographic Magazine, August 1923.

trigger the shutter—an early attempt at shutter-synchronized flash.

From the very beginning of animal photography, Shiras was guided by a principle upheld to this day by photographers in the wild. "In this branch of photography," he wrote, "one should have a fair knowledge of the habits and range of the animals sought." A hunter who had swapped gun for camera, he was familiar enough with most of his wild subjects to know where to site his cameras and string his trip cords, and his pictures show it.

One of the frustrations of trying to photograph an animal, whether bee or bison, is that it behaves as it pleases. It will neither stand still nor pose like a person—least of all when the photographer wants it to—nor will it always be where the photographer expects to find it. In days of huge, heavy cameras and slow emulsions, the cameraman's options were discouraging. He could lug all that gear in pursuit of his quarry. He could set it up and hope the animal wandered past. Or he could try to lure the animal to him.

Many wildlife photographers shun the latter solution. An animal lured away from its normal routine, they feel, is not behaving naturally; the picture will be essentially a fake.

Yet setting up a situation often spells the difference between a picture taken and a picture missed. Even the best animal photographers sometimes shoot a setup—but only to recreate natural behavior, to record something that does happen but is not happening now. The gallery that begins on page 328 includes several such shots. And getting them when they are needed is one of the skills of a National Geographic photographer.

In 1938 and 1939, Lucie and Wendell Chapman trailered to the Rocky Mountains and brought back for Geographic readers the first Kodachromes of big game in the wild. Grizzly bears proved especially difficult to photograph, for they roam mainly at night and follow no predictable routine. So Chapman set out some oats beside his trailer in Yellowstone and soon attracted a crowd of bears. But when the oats ran out, the grizzlies scented the Chapmans' larder within the

324

Flash powder brings an instant of day to a cave's eternal night as Shiras and his helpers demonstrate how they photographed bats in the Canal Zone. The powder was "exceedingly explosive," said the Geographic, so "the expression . . . of the operator is not to be wondered at."

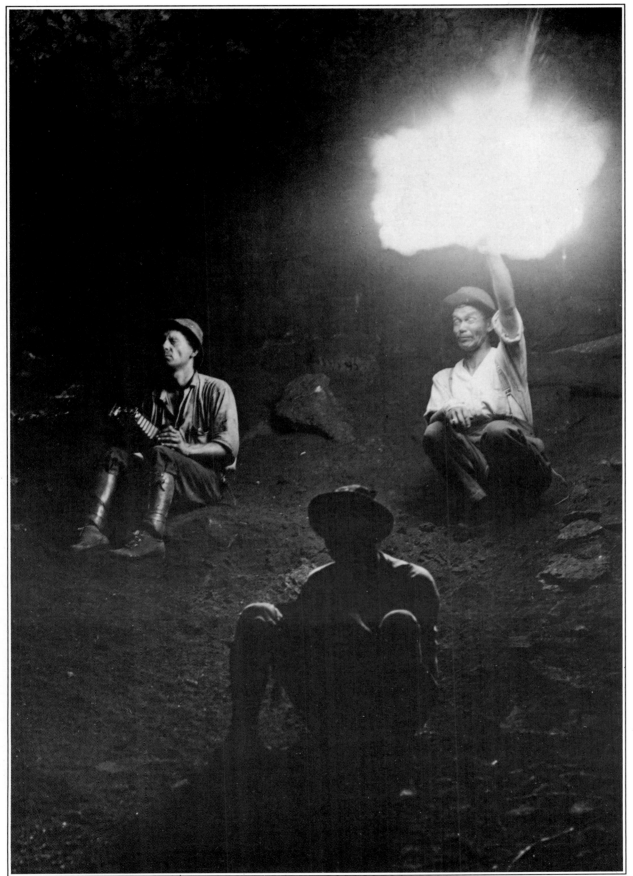

George Shiras III. National Geographic Magazine, August 1915.

Lance Craighead. National Geographic Magazine, August 1966.

Biruté Galdikas-Brindamour and the orangutans—each woman spent months and even years in the wild, gaining the acceptance of the apes she sought to study. Each is a scientist, yet the photographs they and others have contributed to the pages of National Geographic include some of the most affecting wildlife portrayals ever made—and some of the most significant as well. Jane Goodall's camera showed conclusively for the first time that chimps too are makers and users of tools.

Such work can sometimes demand yet another asset: strength. "Have you ever tried to change film," Fossey once asked, "with a 150-pound gorilla sitting on your back?" At one time she could distract the apes with gifts of film boxes; now they "insist upon the lenses or the camera itself."

Photographing apes in captivity can be no less demanding. Outside a primate research center in Louisiana, photographer Martin Rogers waited in a fenced yard for a group of chimps to emerge from a session with scientists. When the chimps spilled into the pen—full of tension from a stressful experiment— they beat him up.

As photography aids the scientist, so science enriches the world of the wildlife photographer. In the 1930s scientist Harold E. Edgerton worked with the Geographic's Edwin L. Wisherd to adapt the electronic flash to bird photography, and ornithologist Arthur A. Allen used it to make breathtaking pictures.

Science continues to open the camera's eye to wonders of wildlife once beyond our vision. Computers help design telephoto lenses far smaller and lighter than their older equivalents, and easier to hold steady for an image free of camera shake. And from the science of animal behavior come new insights and understanding for the photographer preparing to seek out snake or snipe or snow leopard.

In a photographer's workshop an elaborate rig takes shape. Between two vertical mirrors a light beam shuttles back and forth. Later, far afield, a bat breaks the beam—and an electronic flash freezes the bat's image. It's a long way from George Shiras' piece of baited string.

"When releasing grizzlies," counsels Frank Craighead, Jr., "point them away from you." His twin brother John finds out why, as a half-drugged yearling chases him around a tripod. The two scientists shot scores of grizzlies—not to kill but to tranquilize the bears for study.

thin trailer walls and closed in. Photography forgotten, Chapman made a desperate dash for the car and roared away, with Lucie in the trailer jouncing behind.

Getting close to grizzlies became a way of life for biologists Frank and John Craighead, whose wildlife photographs have enlivened the magazine since 1937. Armed with tranquilizing darts, they pioneered the use of radio collars to monitor the great bears' travels. The brothers located the animals with portable receivers, until space-age satellites became available to check them.

A wildlife photographer's greatest asset can be a trusty pair of legs. Frederick Kent Truslow, the great bird photographer of the 1960s, once angered an amorous moose and had to sprint to a lean-to and hide until the big bull turned back to his cow. Truslow was an expert at holding still. For the sake of a photograph, he once sat immobile in a lake for 13 hours; virtually paralyzed, he had to be rescued.

Another asset is patience. Jane Goodall among the chimpanzees, Dian Fossey with mountain gorillas,

Derek Bryceson. National Geographic Magazine May 1979.

Years of study among wild chimpanzees won Jane Goodall the respect of her fellow scientists, the trust of the chimps—and, for the camera, rare views of chimp behavior and personality.

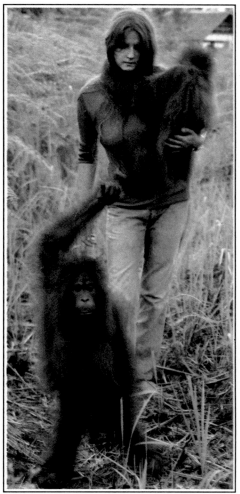

Rod Brindamour. National Geographic Magazine, October 1975.

Living among orangutans in Borneo, scientist Biruté Galdikas-Brindamour created a moving portrait of the world's rarest ape, whose name in Indonesian means "forest person."

Koko. National Geographic Magazine, October 1978.

Cover gorilla for National Geographic Magazine, zoo-born Koko took this self-portrait in a mirror—hence the reversed image. Adept at sign language, she showed herself to be a true animal photographer by signing "Love camera."

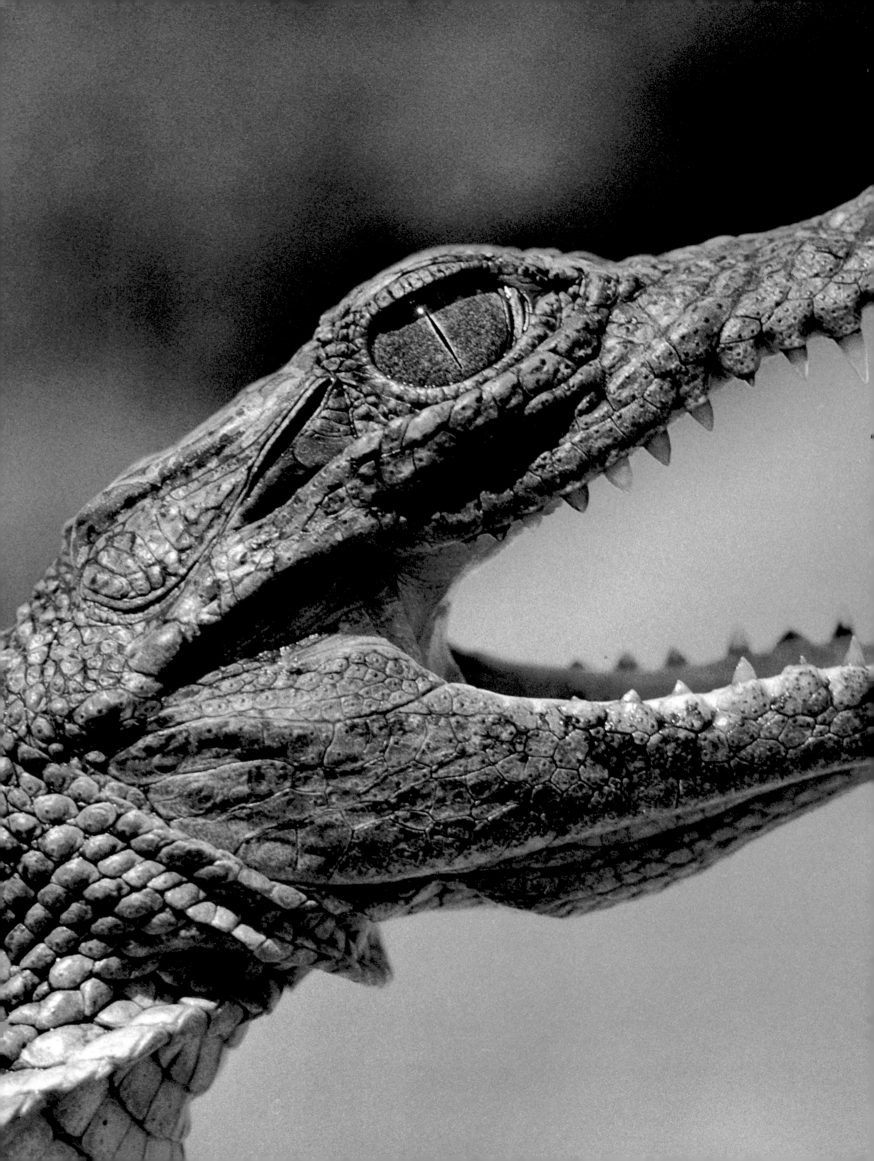

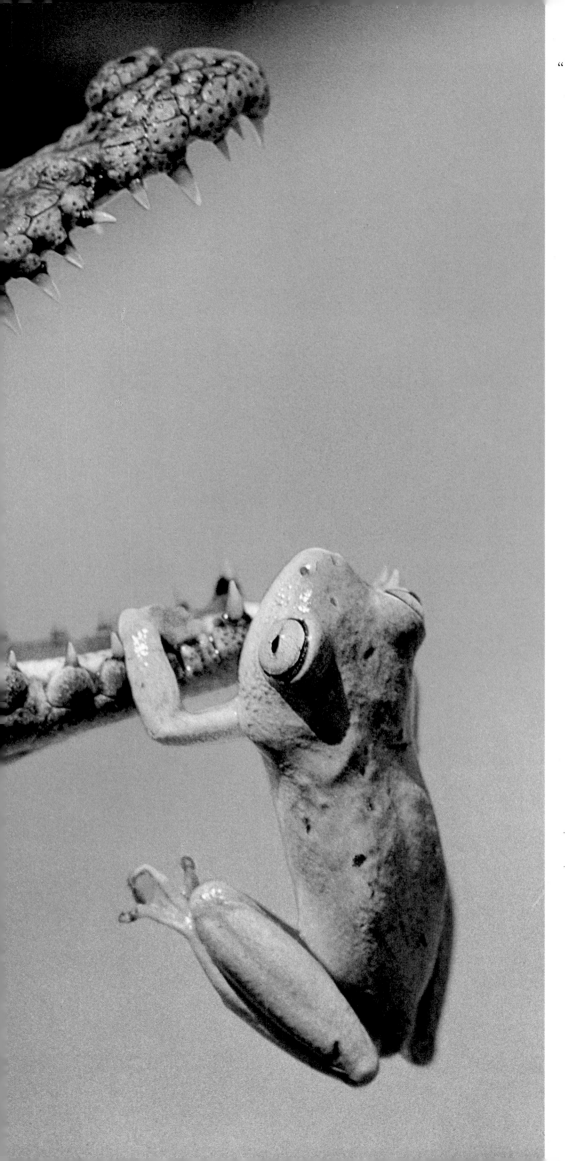

" I love crocodiles. They are a link to the era of the dinosaurs. This one is only a baby; he's still learning how to be a crocodile. He seized the frog, but then seemed unsure about what to do with it. The frog froze in self-defense, the crocodile froze in uncertainty, and I snapped the shutter. This behavior happens all the time, but it took 18 months of planning and waiting before I saw it happen. In the click of a camera, the moment lasts forever."

JONATHAN BLAIR

For centuries hunters have waylaid migrating caribou at river crossings (overleaf) and speared them from boats. "We scientists use the same approach, but only to fit them with collars for research. Sometimes we come away with a good picture as well, but everything has to come together: the lighting, the weather, the action. Then it's a matter of knowing how to shoot quickly, sizing up what's needed to catch the drama. Small herds usually swim in single file, but this one was bunched—so I used a telephoto to emphasize that."

GEORGE W. CALEF

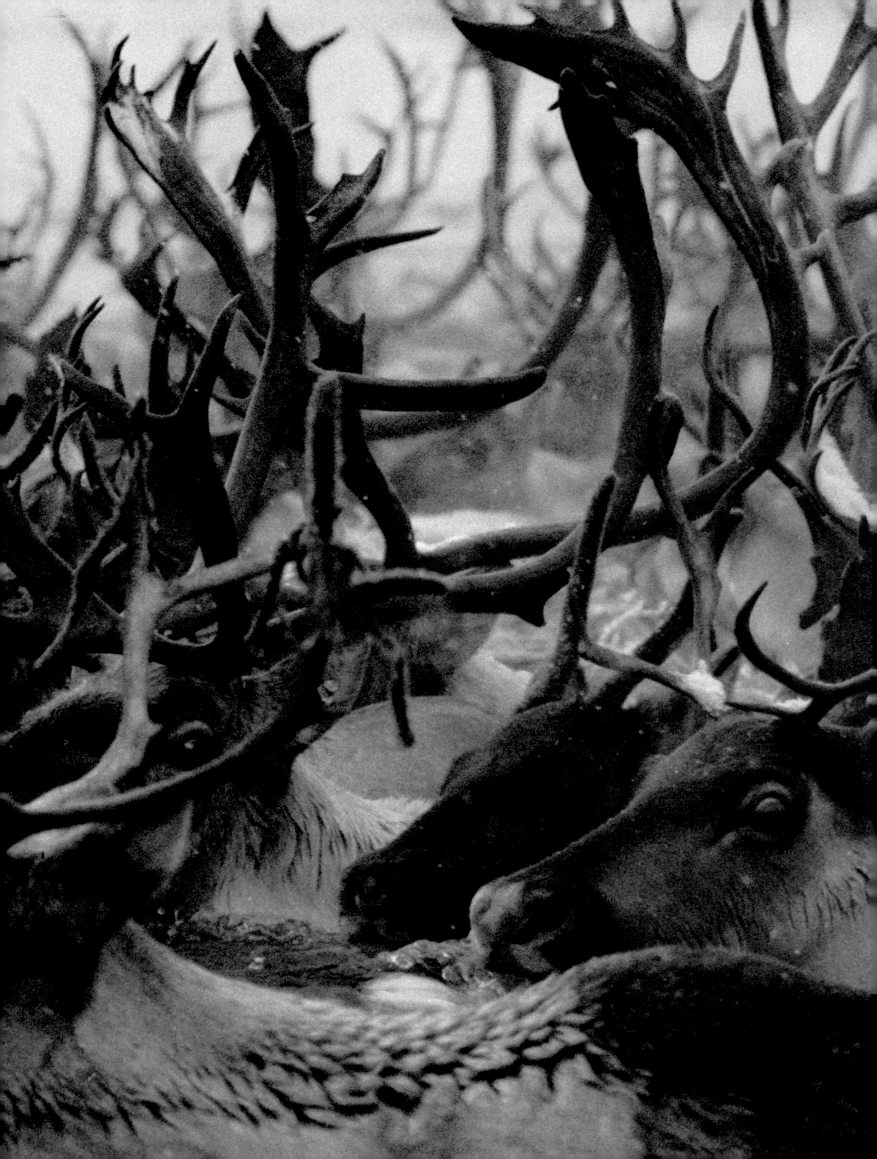

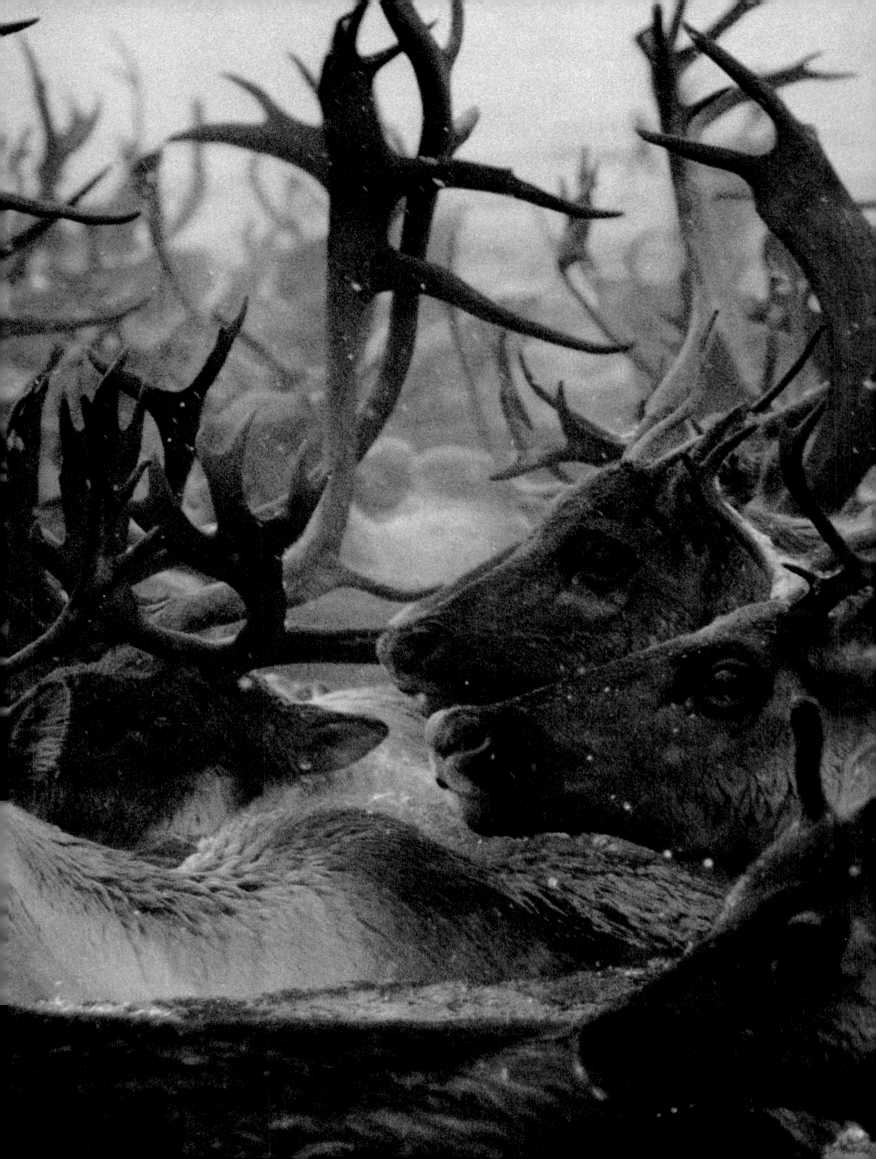

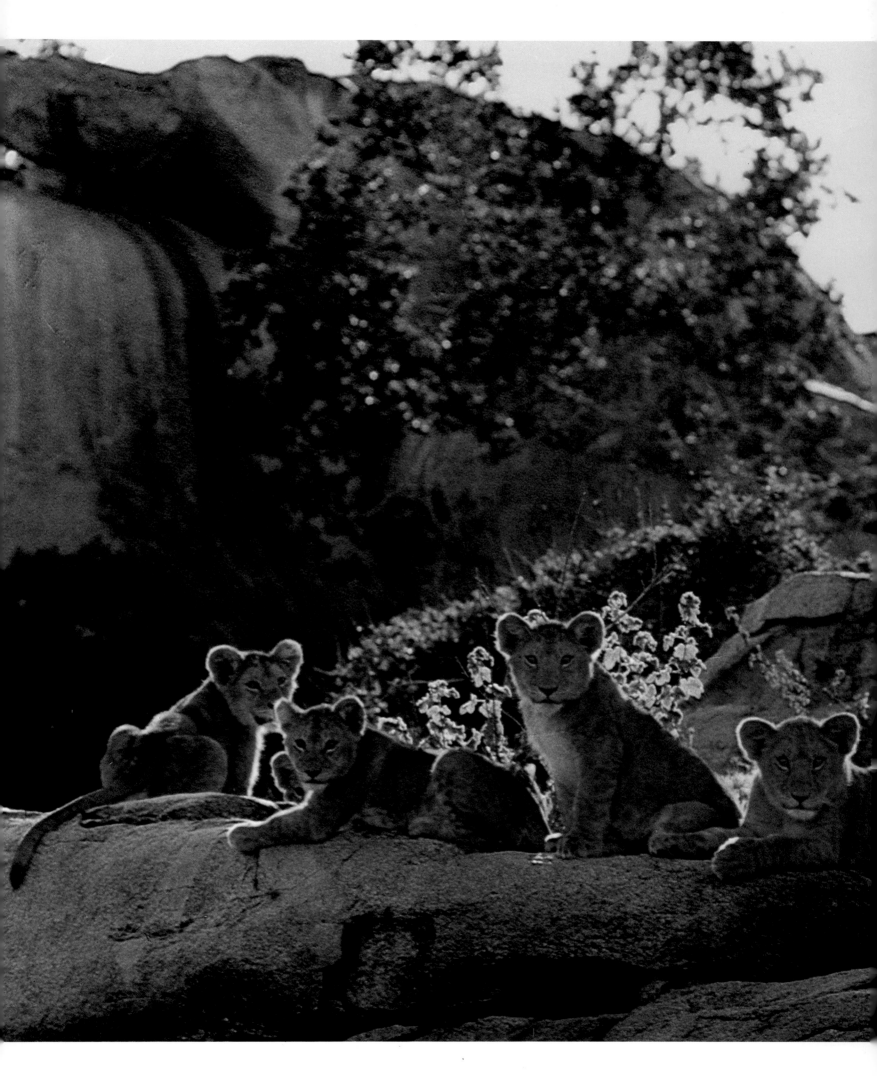

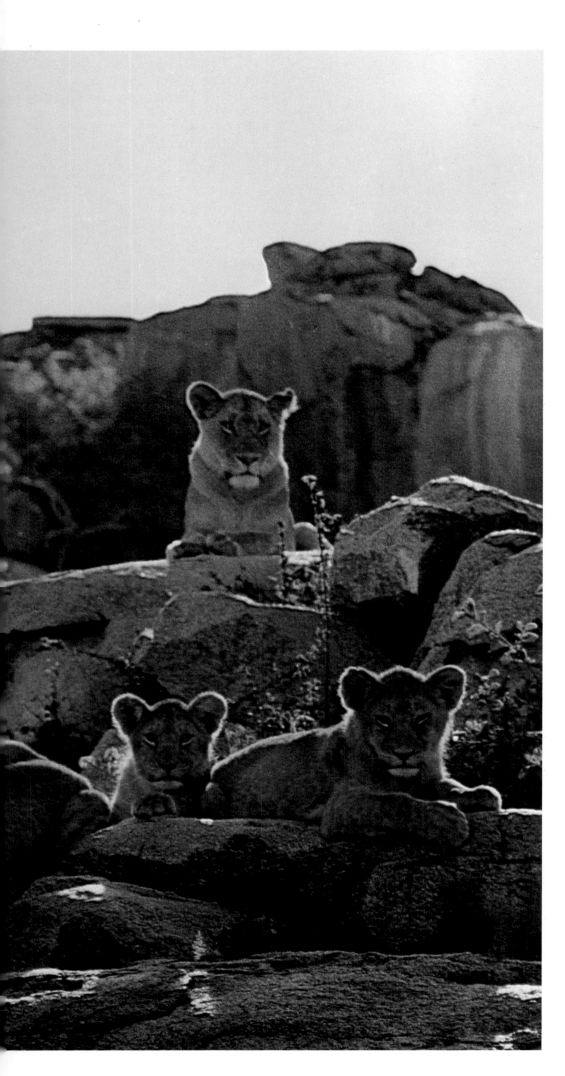

Good as gold, cubs set aglow by a backlighting sun seem to pose for the camera as a lioness watches over the pride's day care center. A pride of lions patrolling its vast territory can be elusive, but Root revels in "driving out at dawn through silhouetted herds, locating lions by looking for tracks, listening for roars, and searching with binoculars. . . ." For the record, Root says, "I am very content with the company of lions."

ALAN ROOT

Three wild chimpanzees—mother and children—allow the photographer a close approach for a family portrait, but trust between chimp and man can be fragile. A big male bore van Lawick a lasting grudge because he threw a stone to deter the chimp from chasing Jane Goodall.
Hugo van Lawick

Throughout an assignment in Spain, Harvey searched for a way to capture the proud spirit of the Spanish men. "I hoped to find it on this roundup in Galicia, where wranglers prove their machismo by throwing the horses bare-handed. I found it instead in these stallions."
David Alan Harvey

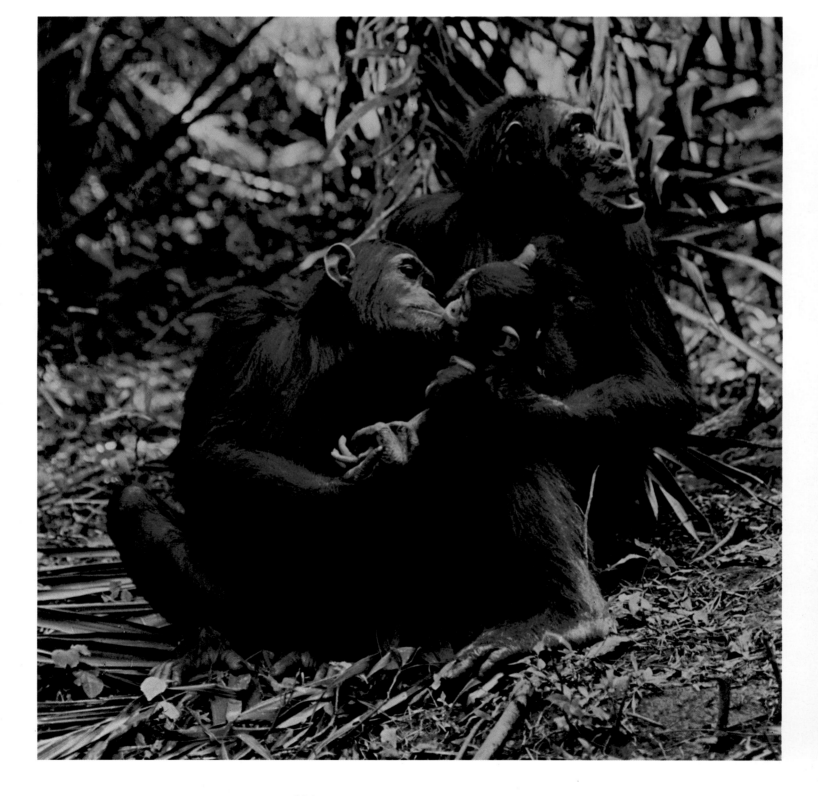

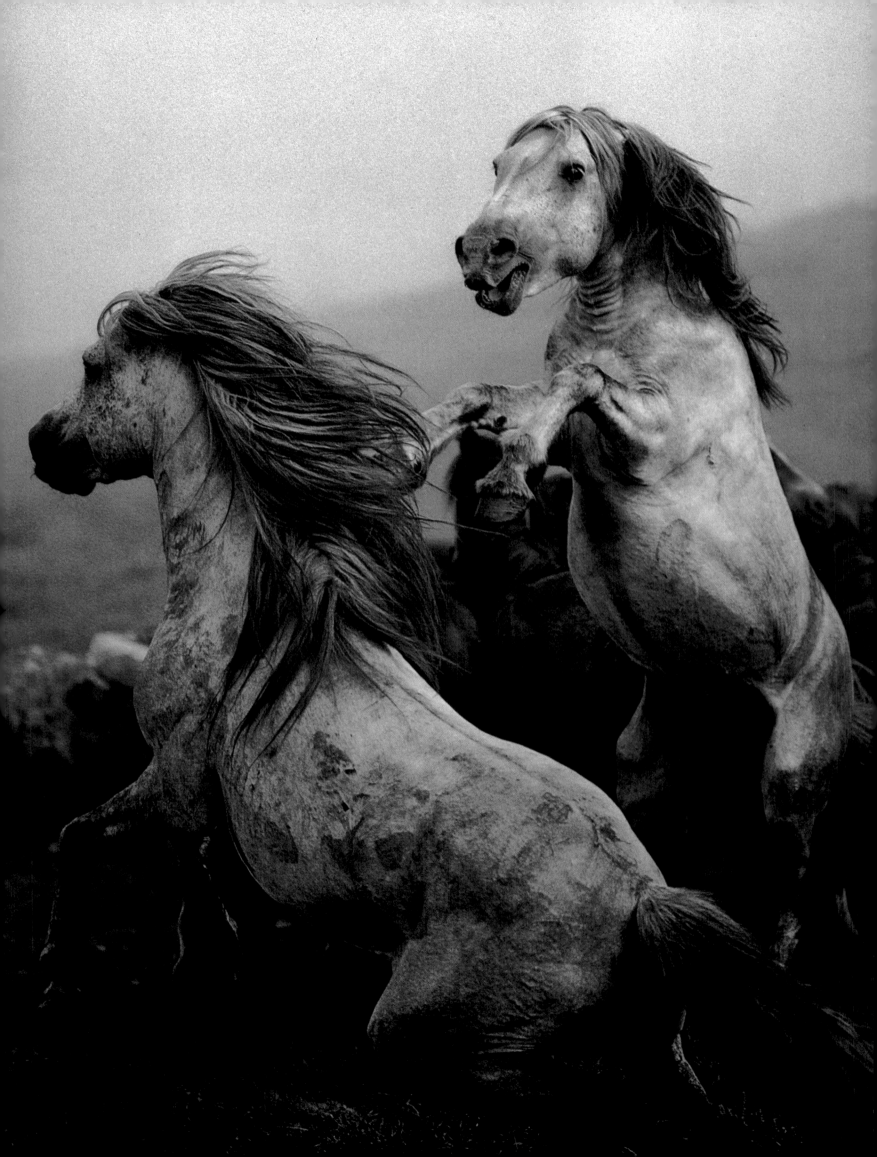

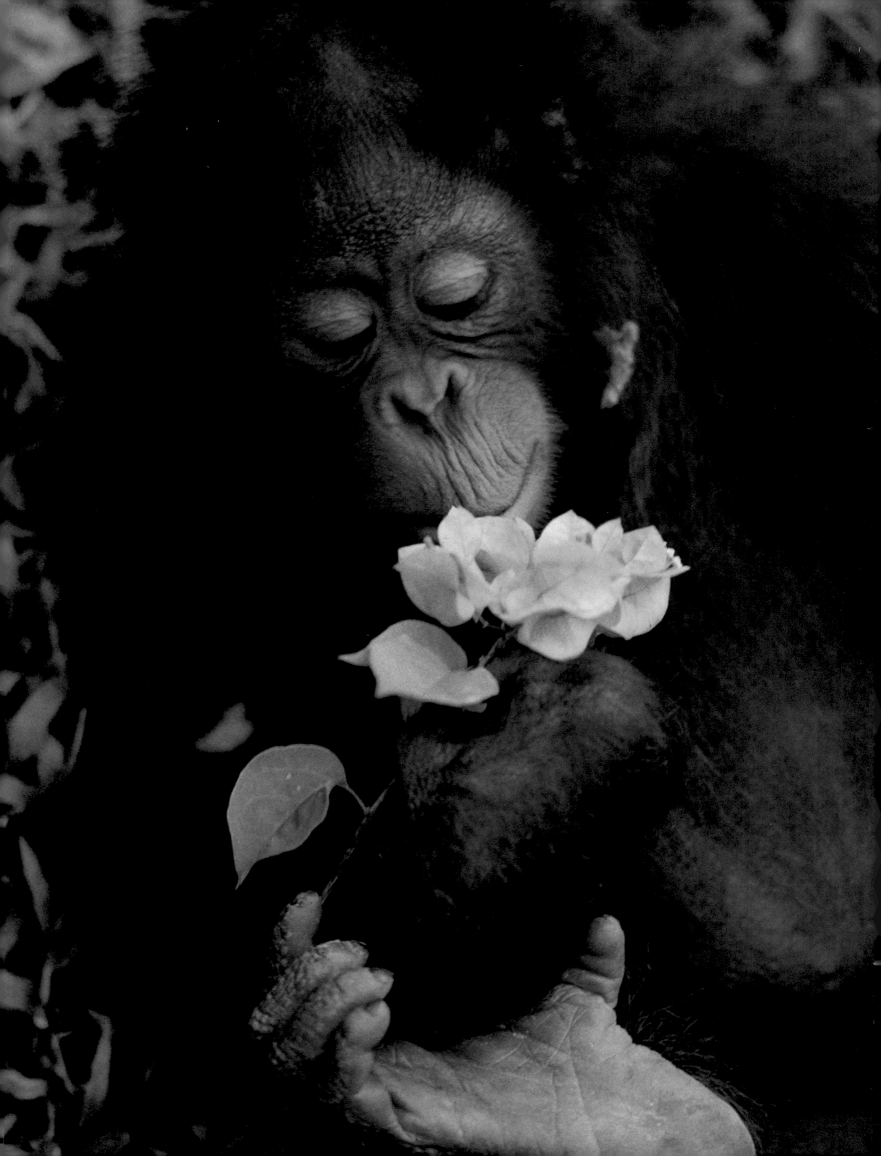

"It's uncanny how 'human' animals can be. I photograph them as I would photograph people—studying their personalities, anticipating their moves, even talking to them. This is a wild orangutan. But couldn't it be a person?"
DAVID ALAN HARVEY

Jaguars are rarely photographed or even seen in the wild today. "I focused on this one in a moated enclosure of a Brazilian zoo—and waited. Four hours and many frames later, patience paid off in one perfect instant."
LOREN McINTYRE

Few scientists had ever seen a live Mexican fishing bat (overleaf). Tuttle—tutored in photography by National Geographic's Bates Littlehales —went in search of the rare night hunters. "I located the bats' fishing grounds with a night-vision scope, netted a few, and let them fish in an enclosure. They dragged their sharp claws through the water until they gaffed a small fish. Then this one broke the infrared light beam that fired my strobes—and froze itself in flight with a silvery mullet in its mouth."
MERLIN D. TUTTLE

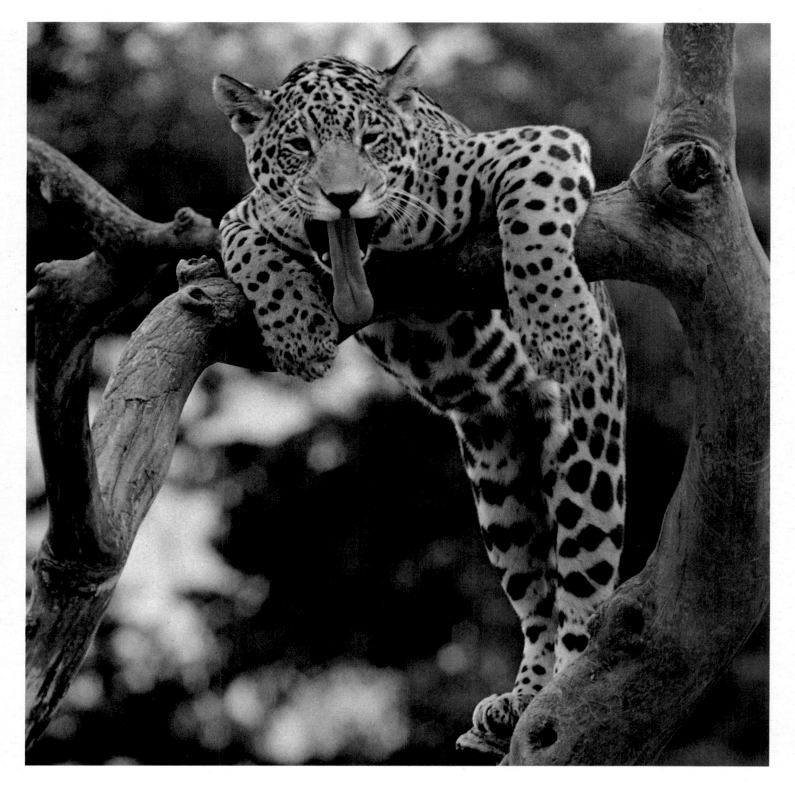

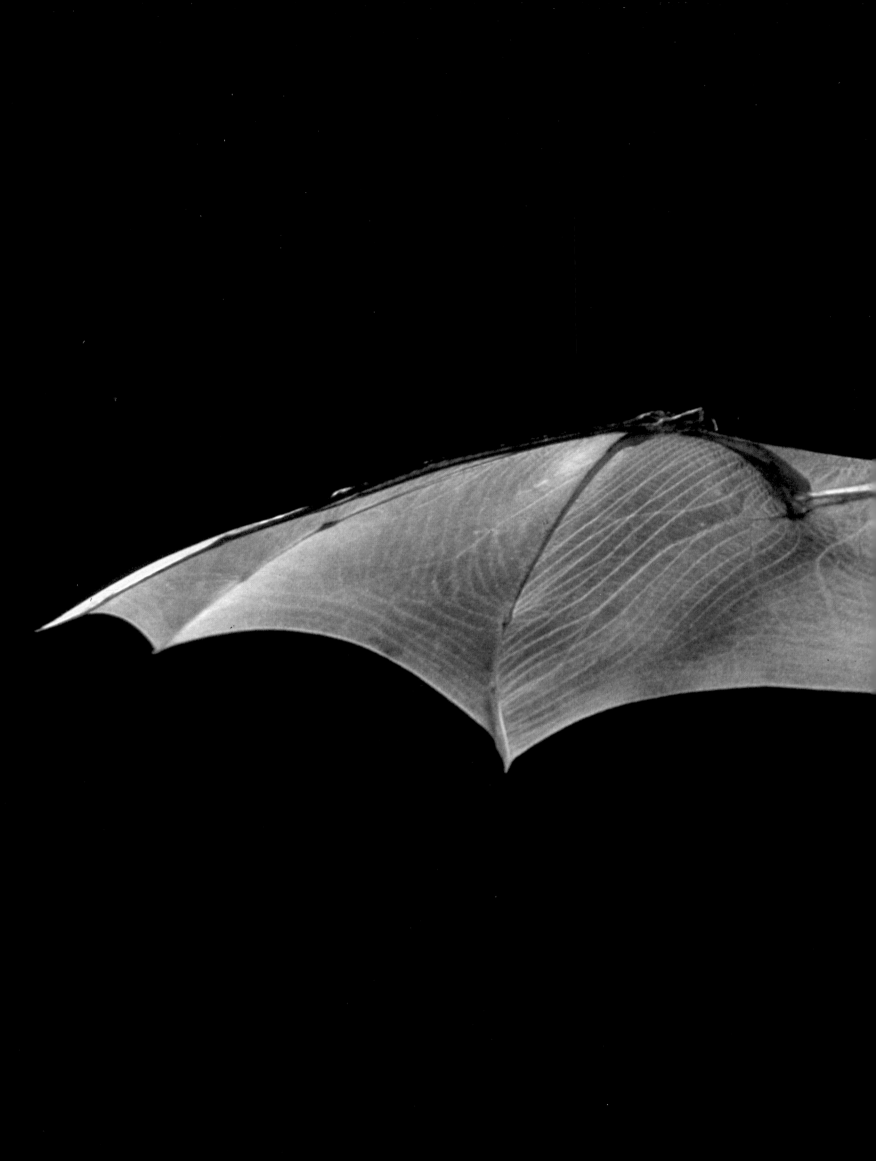

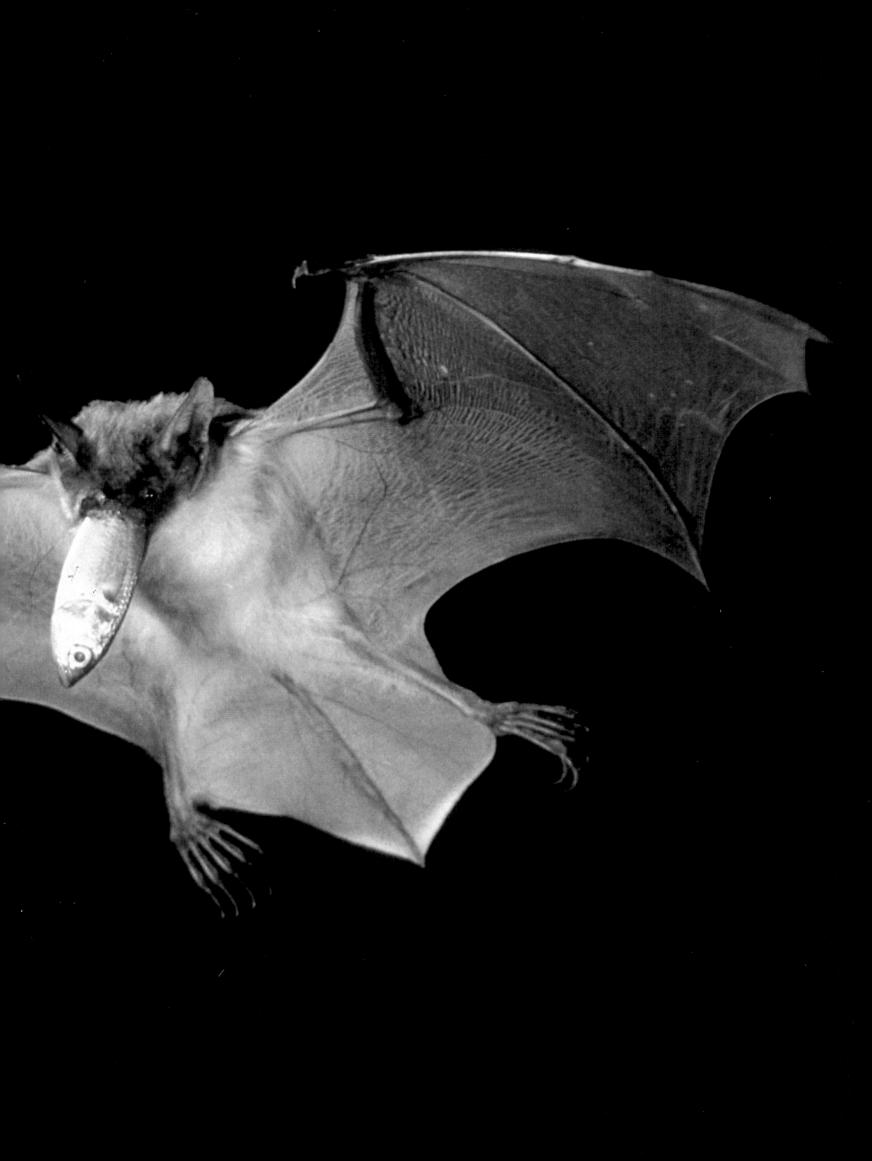

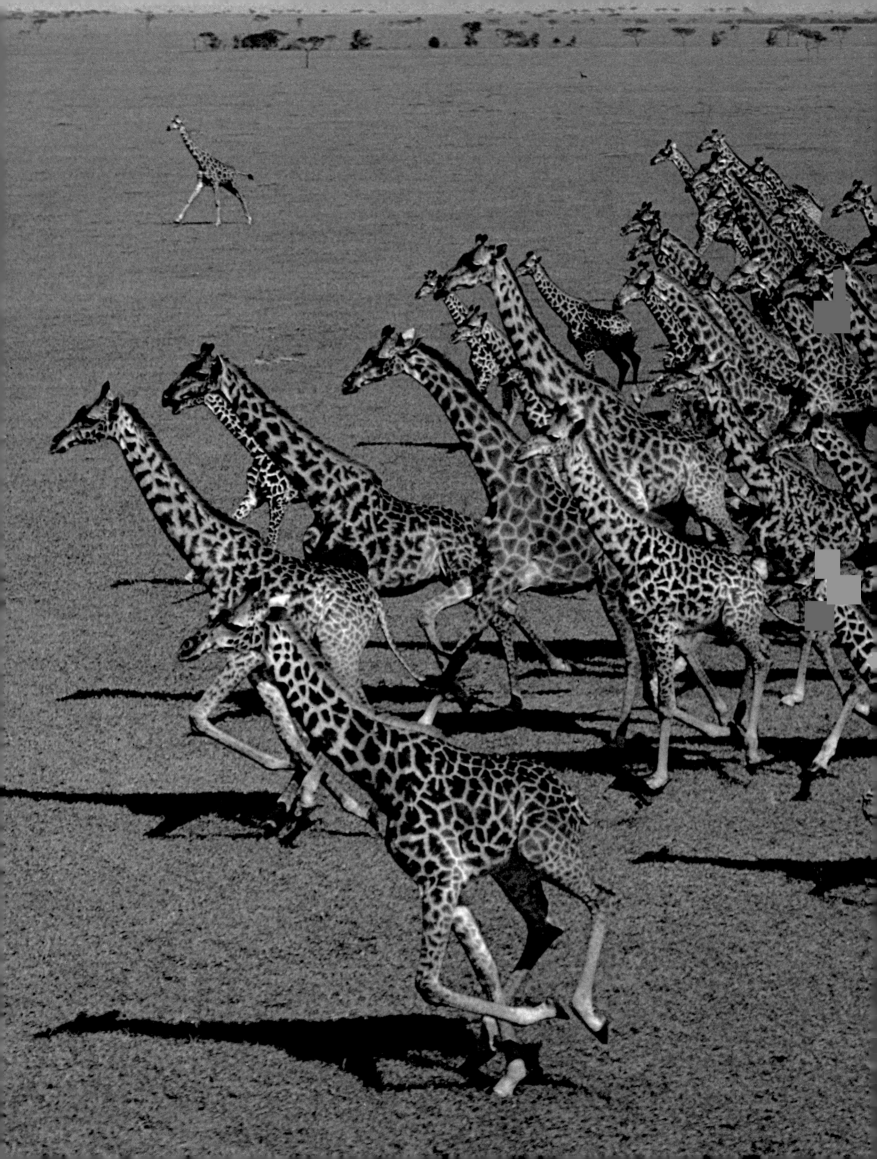

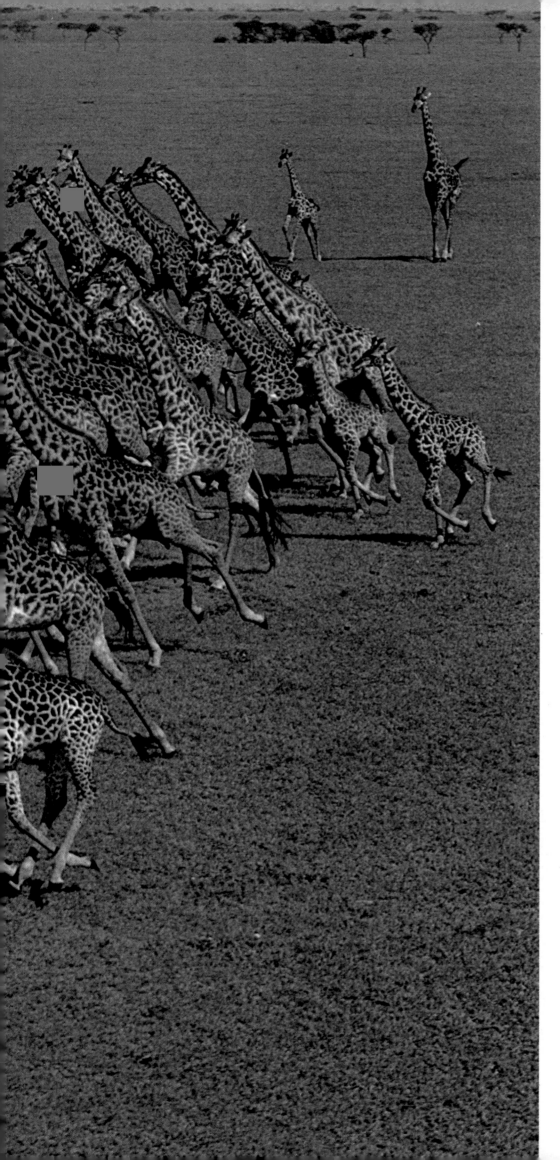

"One giraffe would not do; my picture assignment called for a herd. There were plenty of giraffes on the Serengeti Plain that day, but they were scattered among the trees. So I hired a helicopter and we rounded them up, shooing them one at a time into the open. In about half an hour, we had our herd. The pilot brought the chopper in low and we fell in beside them as they ran. Sometimes the only way to get a picture at the time you need it is to create it. And creating this shot was one of the most exciting things I have ever done."
THOMAS NEBBIA

Careful planning and sophisticated equipment went into this picture (overleaf), but not as Dale had intended. "Hidden in those trees are two cameras wrapped in plastic, fitted with radio controls, and aimed back toward my vantage point in Kenya's famous Treetops Hotel. But each click of the cameras scattered the animals. By morning the radio batteries were dead. And at one point I saw two jubilant baboons swinging on my delicate equipment. Then at dawn I glanced out from the hotel into a misty rain—and grabbed the camera at hand for this unexpected tableau of the wild."
BRUCE DALE

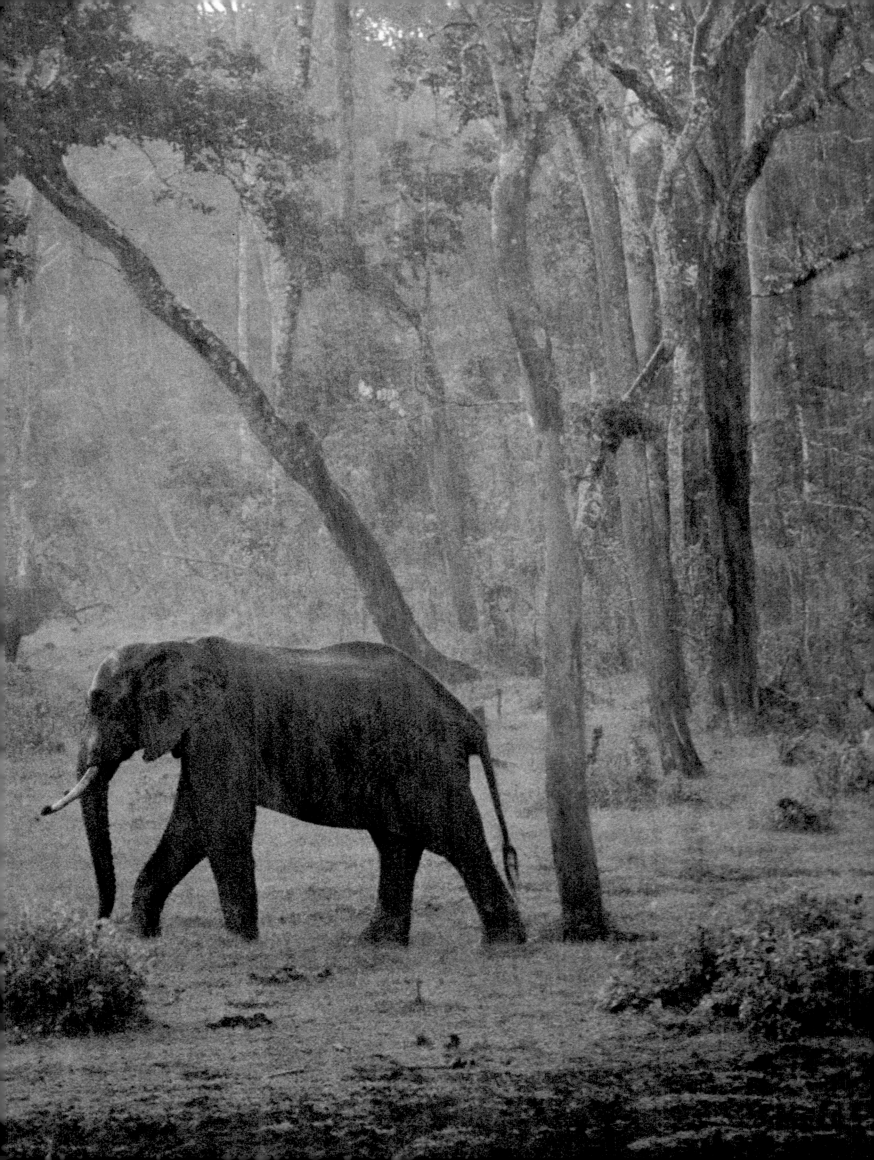

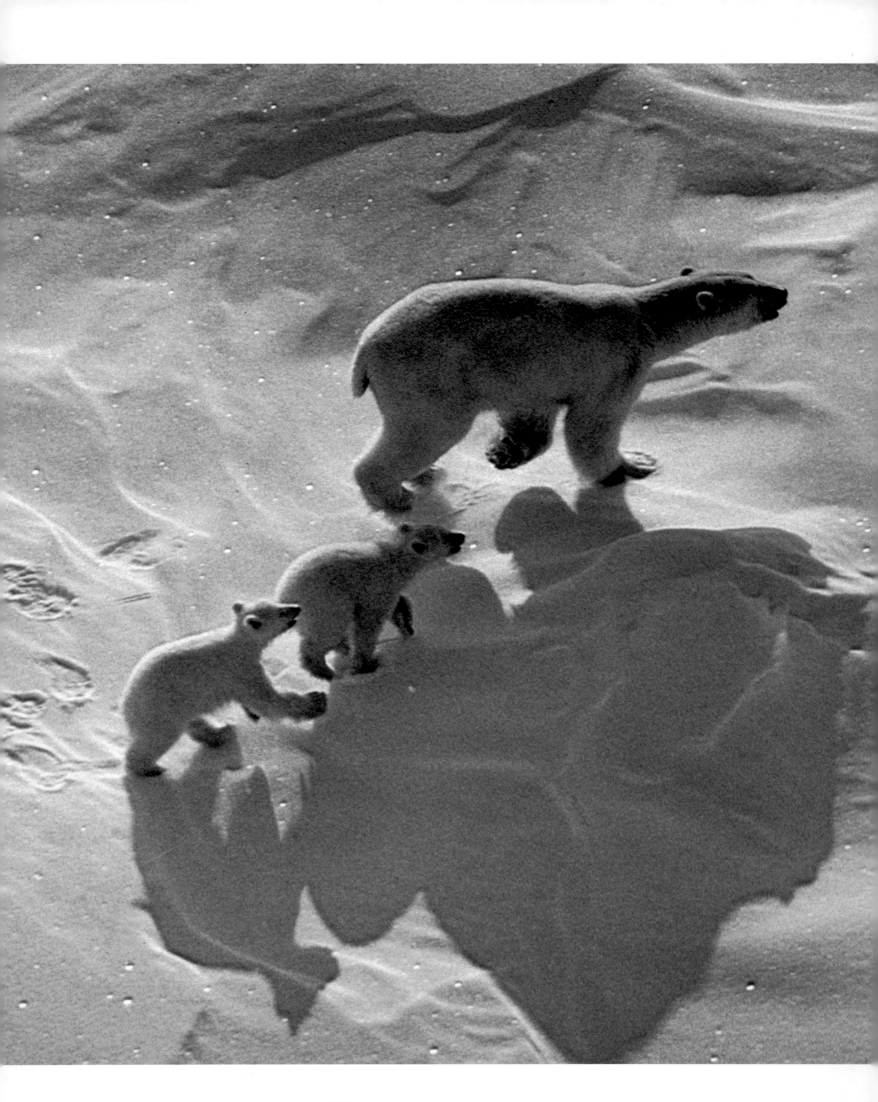

Two passes in a light plane, two or three shots per pass—Rogers' two weeks of searching for polar bears had come down to that. "With the plane's windows off, a motor drive on the camera might freeze up. So I cranked it by hand. We had to pass north of the animals to keep the sun behind them. But the pilot misjudged; we flew right over the bears. Last chance—and this time bears, plane, sun, and camera fell together perfectly."
MARTIN ROGERS

When photographers go after a deer or (overleaf) moose, they usually concentrate on the males. "They're bigger, often have impressive antlers, and they can be less wary than the females. This time a cow moose steals the show. She's feeding, but keeping an eye on me. Each time she dunks, I sneak closer. Then up she comes. The look, the splash, the touch of humor—these make the picture."
JIM BRANDENBURG

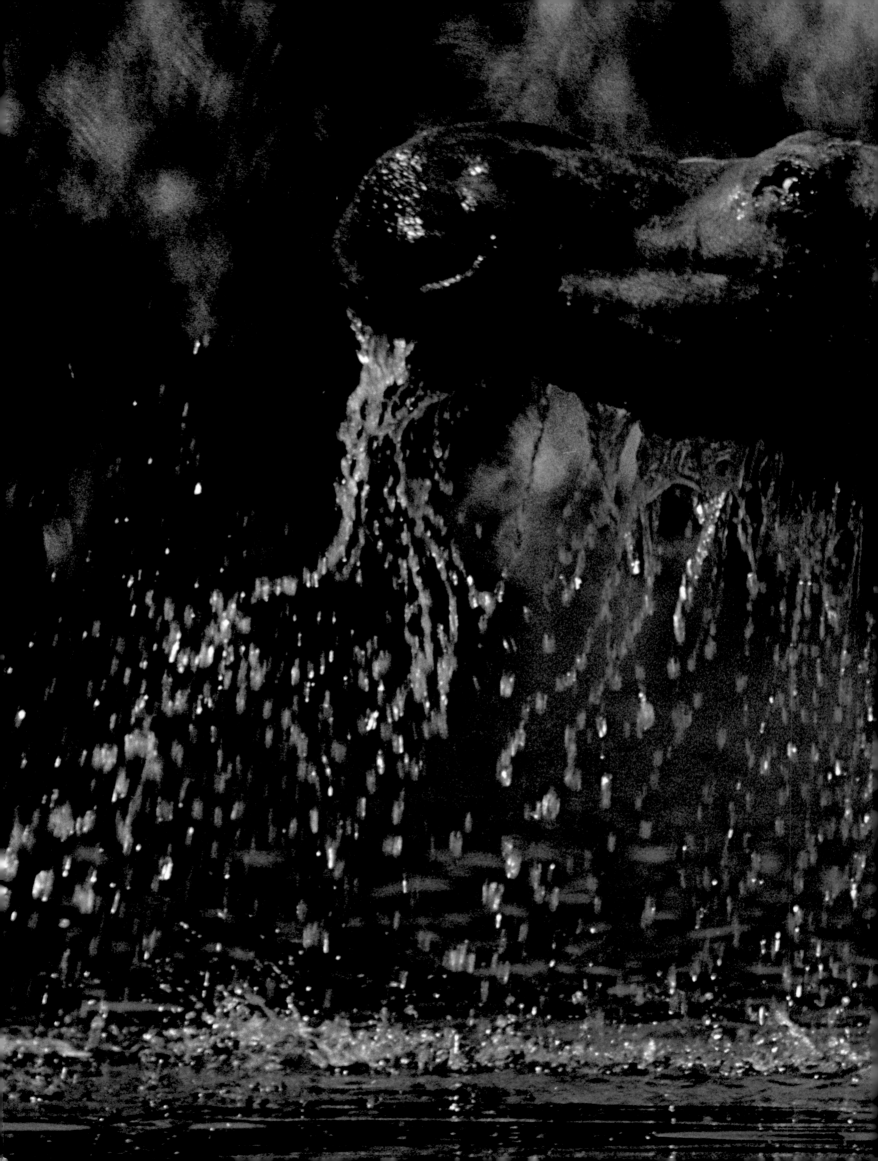

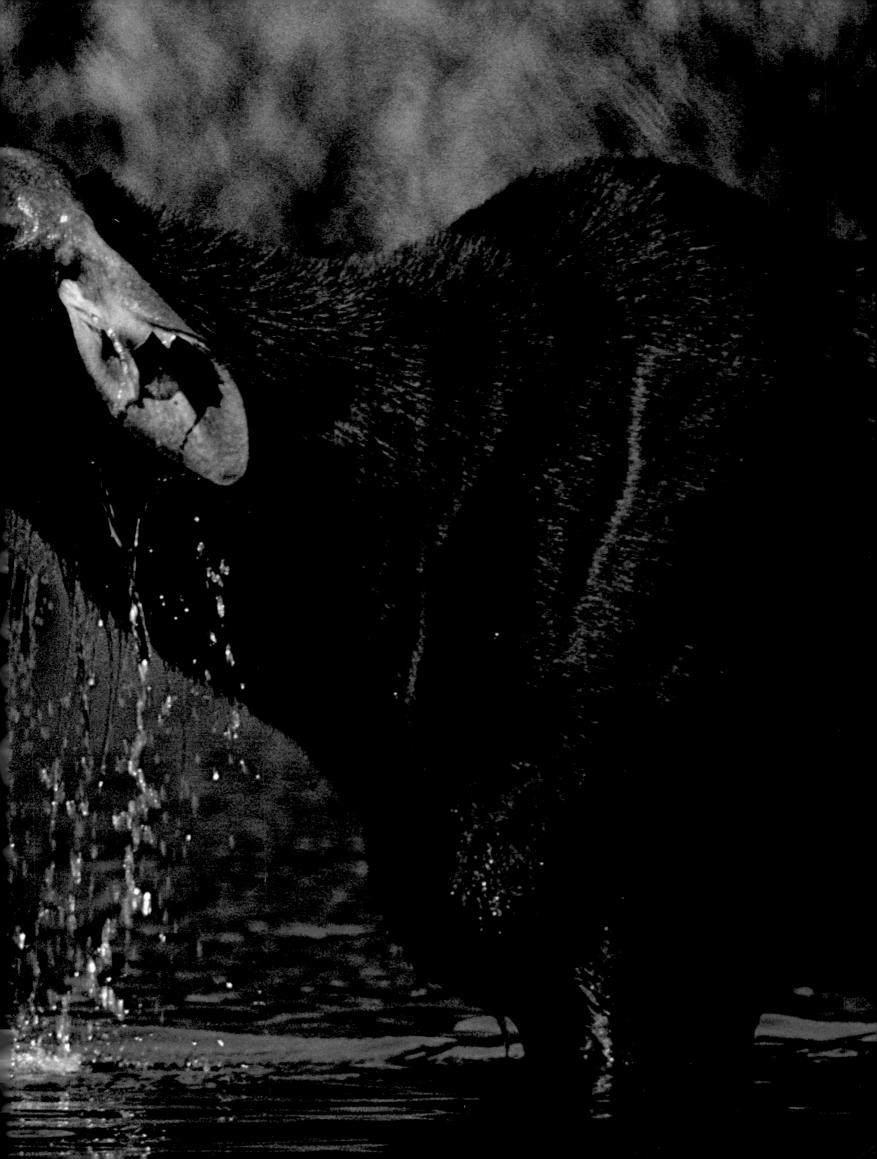

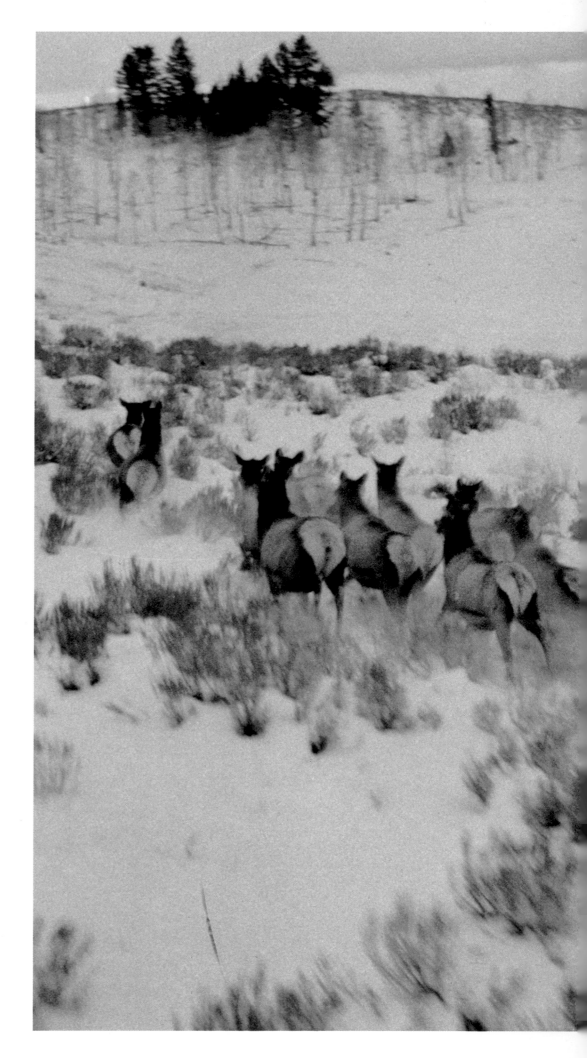

Wintertime in Yellowstone. The park belongs to the animals. "One early morning I watched and shot as this bull elk ran from the helicopter's roar with his harem loping ahead. The result is a glimpse of the animals in winter, not in classic poses, but in the color and motion of life."
WILLIAM ALBERT ALLARD

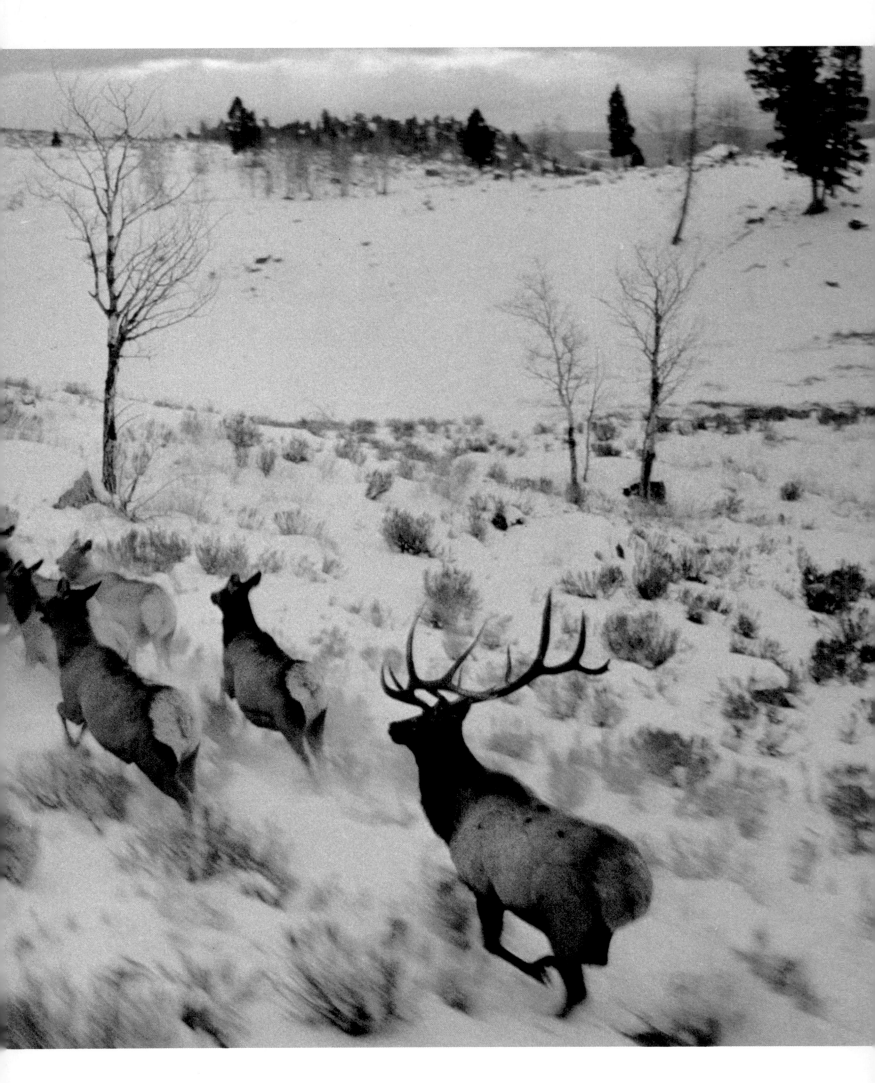

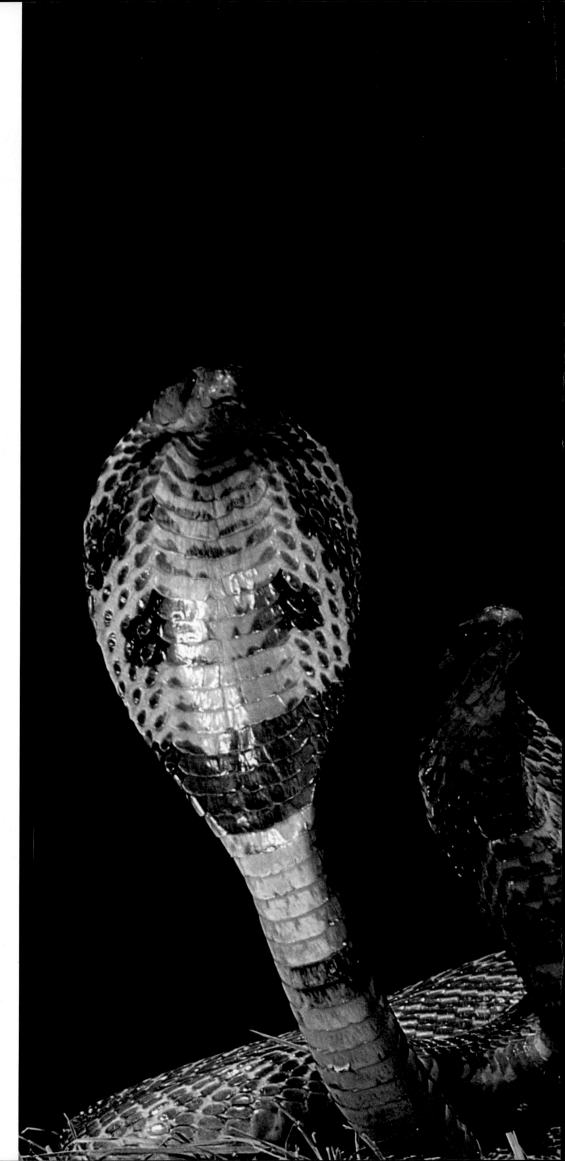

" I stretched out prone on the grass and stuck my lens through a hole in the side of my homemade plywood snake pit. I was ready for the cobras. In they spilled, four of them, and up they reared in the typical defense pose of the Indian cobra. I shot a few frames, and suddenly—here came the snakes, right toward me, full of venom and eager to get out through the oversize lens port. It took everything I had to stay there and keep the lens blocking the hole. When the cobras finally retreated, so did I—to wipe their venom off the lens."
JAMES P. BLAIR

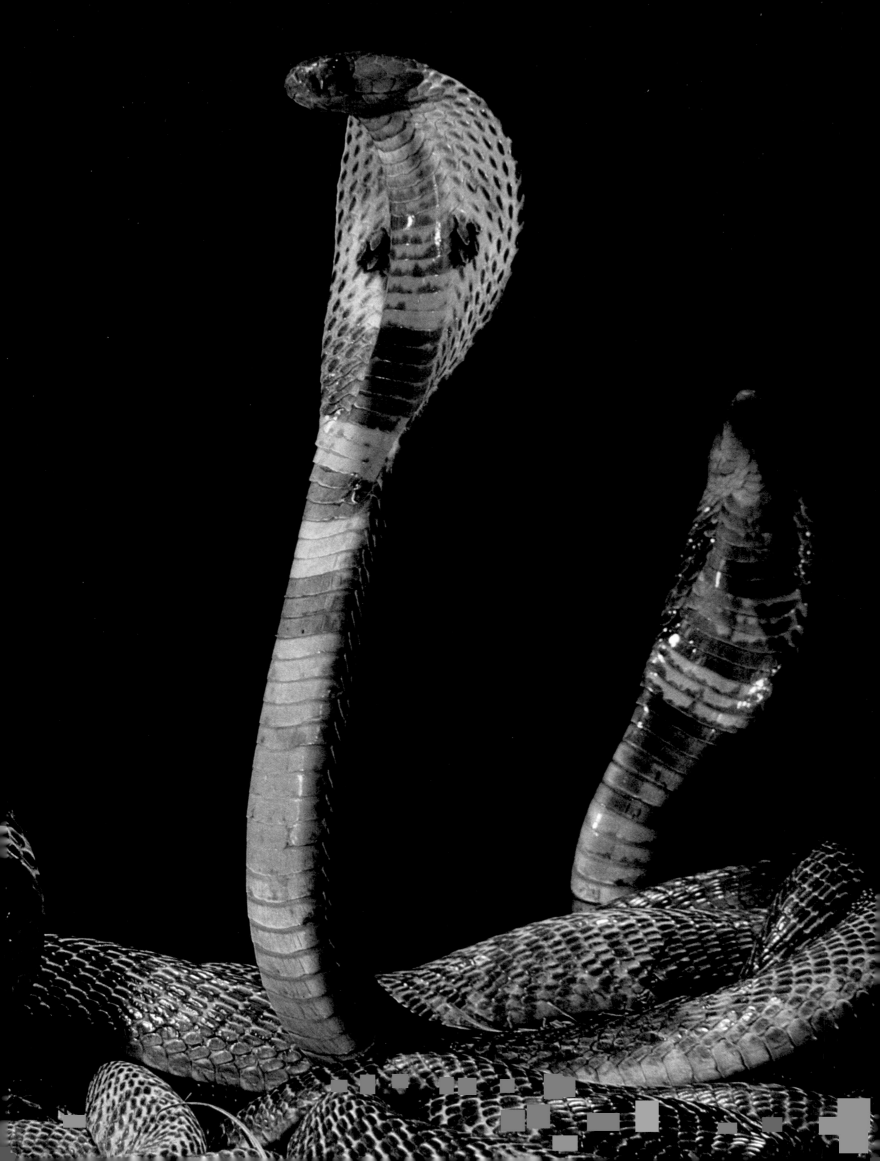

S tationed with the Navy in the Aleutians, Elison was in a place professional photographers rarely go. "I watched the bald eagles as they rode the wind currents over a sea cliff. For several weeks I worked; you can burn up a lot of time and film trying for an eagle in flight. But then one soars past, screams at the right instant—and all the planning and the patience pay off."
GLENN W. ELISON

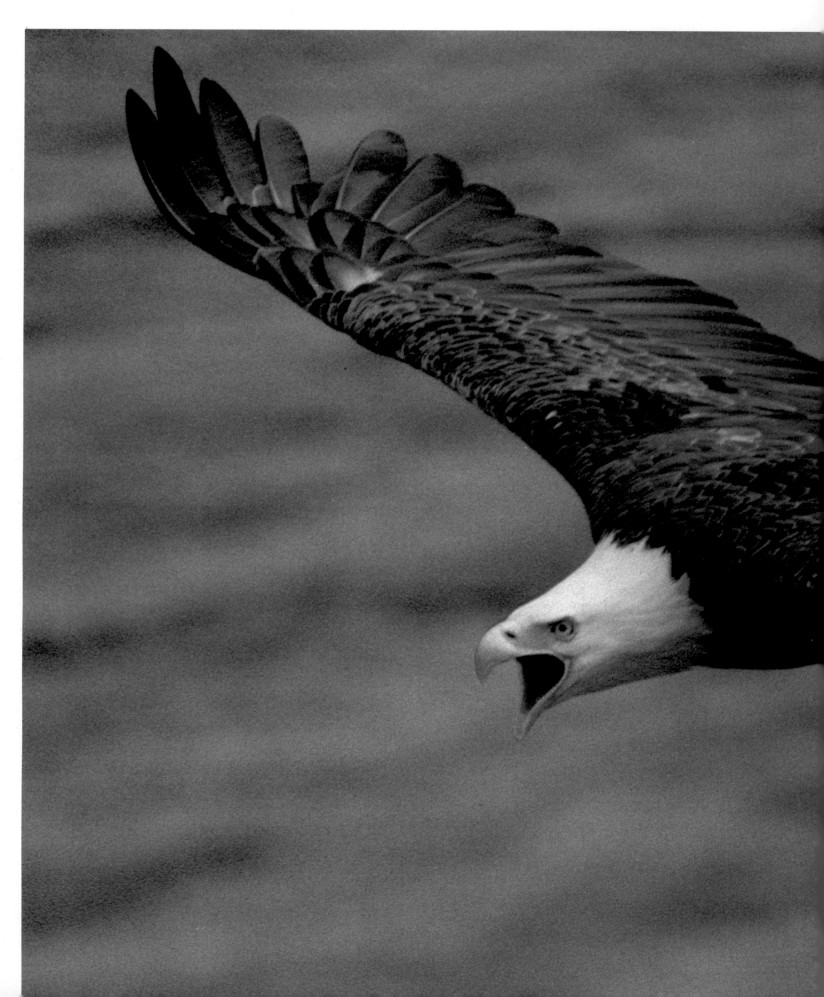

Audubon of the camera, the late
Fred Truslow began bird
photography with the "pinks"—
roseate spoonbills—of Florida. "I had
never seen a pink before," he wrote.
"When I set up my tripod and the
rest of my gear, I still didn't know how
to work it." Better results came from
this later encounter with pinks in a
Texas rookery.
FREDERICK KENT TRUSLOW

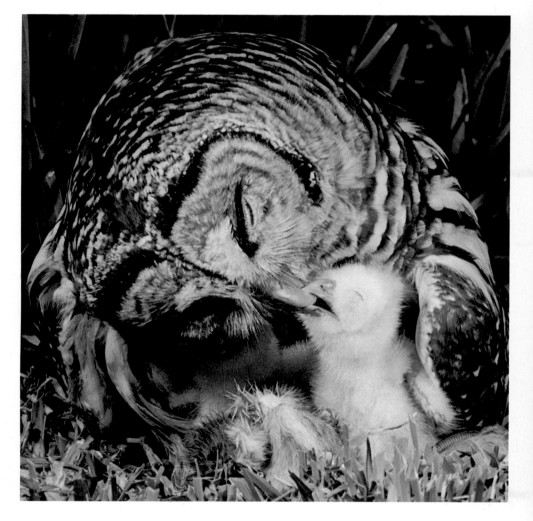

Barred owls usually nest in trees, but
this one in Florida chose the
ground. Through four nestings
Truslow won her trust; she even let him
pick her up. Then a downpour filled the
nest. "As a rule I never interfere," he
wrote. But "the little fellows were about
to drown." So he moved them. "The
next day I sauntered over to the nest . . .
and wham! That old owl hit me . . .
slitting my scalp from back to front."
FREDERICK KENT TRUSLOW

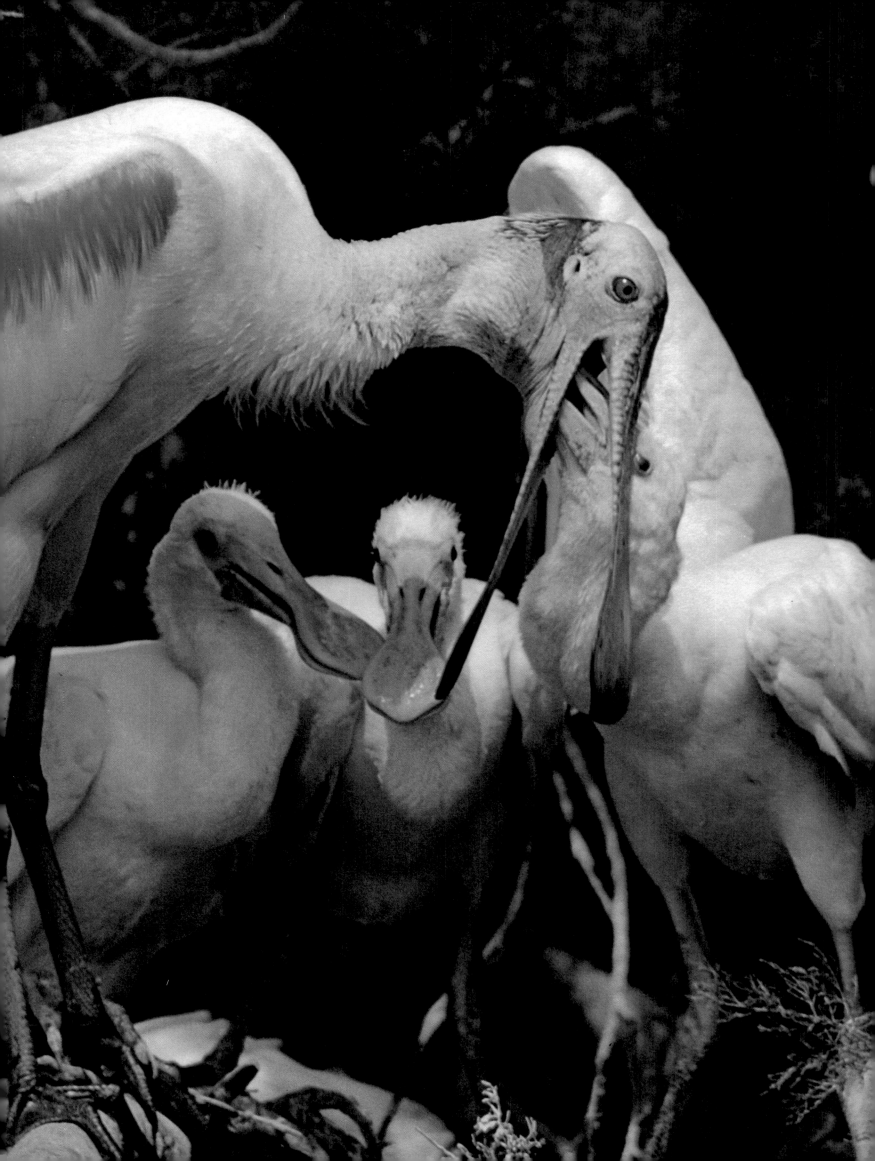

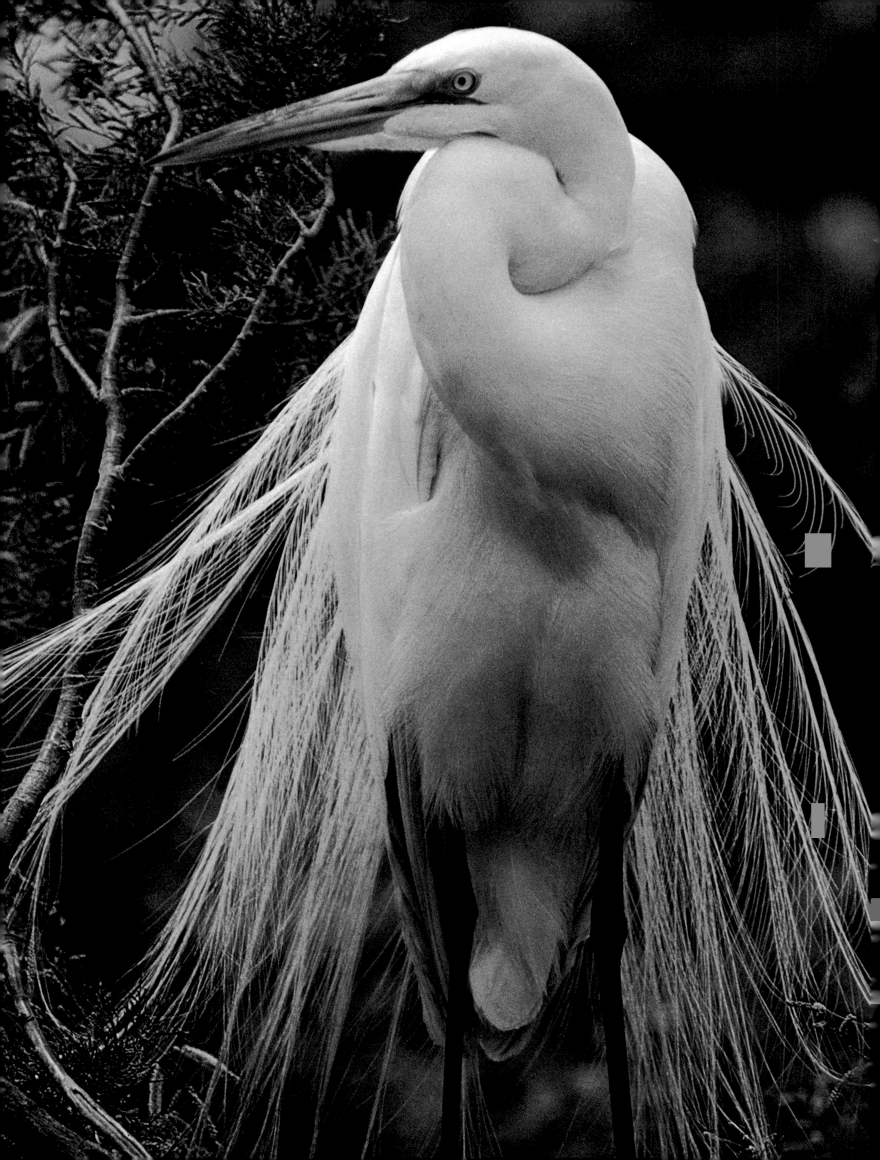

In boyhood Truslow wrote of egrets imperiled by fashion's thirst for plumes. In maturity he sweltered in a blind as hot as 138°F to portray them— as he did this backlighted beauty—in mating plumage.

FREDERICK KENT TRUSLOW

"How could I focus on him, flashing past so fast?" Truslow pondered as a black skimmer skimmed a lake. So he focused on a leaf and shot when bird and leaf lined up. Two days and 150 passes yielded eight good frames.

FREDERICK KENT TRUSLOW

White pelicans fill the sky over the Great Salt Lake (overleaf). As Amos watched them, an airliner caught his eye. With a telephoto lens he tracked the plane penciling a contrail through the flock. "I had time to record the moment, but not to absorb it. Thus a picture can have more impact than the event."

JAMES L. AMOS

Eye to Eye with Snakes and Spiders

By Bianca Lavies

"You want me to do *what?*" I had heard the assignment quite well; the difficult part was accepting it. There are snakes in Manitoba, it seems, which congregate in huge numbers in limestone sinks each autumn to hibernate. My job: Join the congregation and come back with photographs for a National Geographic Magazine story on the snake pits.

Like many people—and even some nature photographers—I had a deep fear of snakes. "Are they poisonous?"

Reassured that they were not, I packed off to Winnipeg to meet Dr. Michael Aleksiuk, the story's writer. "Harmless red-sided garter snakes," I kept reminding myself, "so what am I scared about?"

Dr. Aleksiuk introduced me to the snakes. "I will give you three," he said. "Take them back to your hotel and get used to them before you meet them by the thousands in the pits."

That night I sat on the edge of my hotel bed. I pulled on a pair of gloves and, with bouncing heart, carefully opened the box.

No hissing, no writhing, no fearsome show of fangs—just three small snakes looked back at me from the bottom of the box. Two seemed just as nervous as I, but the third was more relaxed, almost friendly. She curled up in my lap, and soon I found myself stroking her under the chin. She seemed to enjoy it; more likely it was my body warmth she enjoyed, for snakes have no way of generating their own. Whatever the attraction, she got me over my fear of snakes and became my pet for the next six years. She showed me that a snake, like many other creatures, can have its own distinct personality.

A frog flies, a dragonfly sits—and electronic flash freezes them both (opposite): The frog broke a beam of infrared light and took its own picture. For her work among nature's smaller creatures, Bianca Lavies must see and shoot at their level, even when the subjects are snakes (right).

Bianca Lavies amid garter snakes by Michael Aleksiuk

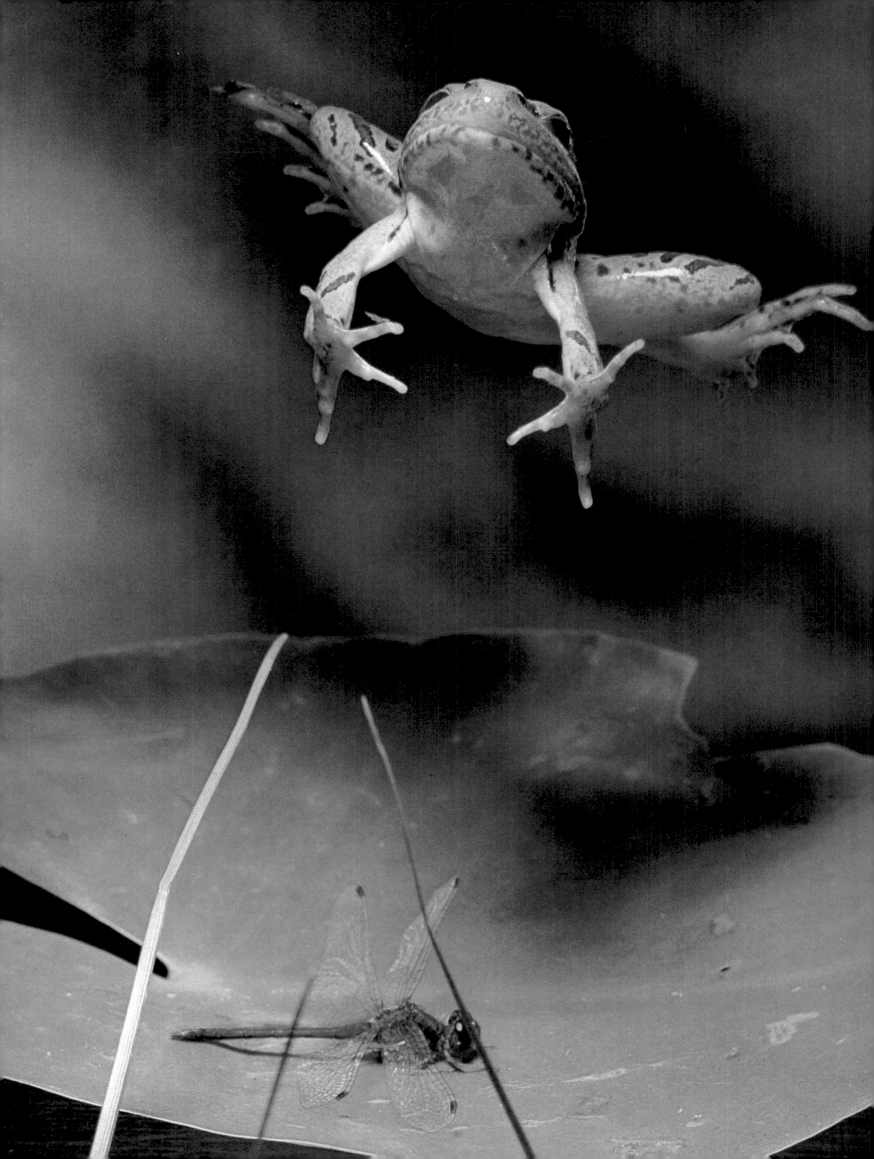

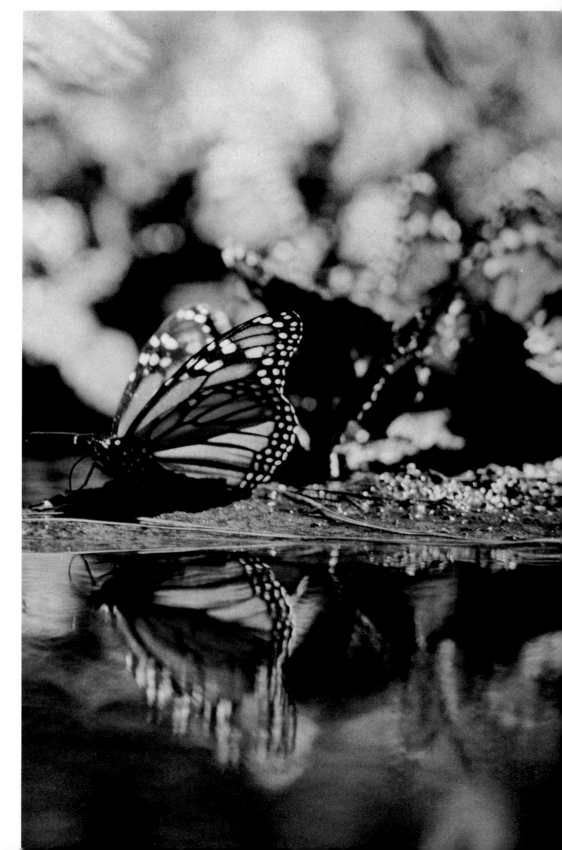

A monarch butterfly drinks from a cool mountain stream. Bianca, her lens at water level, captures the insect and its shimmering reflection. Selective focus blurs others in the background.

I worried again when I brought 34 pregnant snakes back with me for a birth picture—but about my neighbors, not my snakes. I lived in a very small one-room apartment, and I was trying to keep my assignment unobtrusive, but several books told me that these snakes would bear between 30 and 50 babies each!

It turned out that only three of the snakes gave birth, and I missed two of them. Finally, when I feared I had wasted my time, the third gave birth, and I was there to photograph it.

I had begun the assignment in fear, but my snake-in-the-box had won me over completely. I had also begun with an idea: to photograph the snakes at their level. When the time came for me to lie facedown in those pits in Manitoba, while a tangle of little serpents crawled all over me, I could feel I was among newfound friends. At least, almost.

That's how most of my assignments as a nature photographer begin: with an idea. Think, for a moment, about life around a lily pad. Does an image quickly come to mind? One did for me—the mental picture of a frog jumping over a lily pad and apparently right into the lens.

When I began the assignment, the picture existed only in my mind's eye. And since frogs don't jump on cue for a photographer, part of the planning was to devise a setup to snap the frog at precisely the moment the unpredictable acrobat chose to jump.

Fortunately, the hardware was already at hand: Greg Dale, talented son of National Geographic photographer Bruce Dale, had developed the "Dale beam." In the early days of wildlife photography, animals took

From a camera in a half-submerged casing, a single frame (right) captures the two worlds—air and water—of the mangrove tree. With a long lens, Bianca portrays a frigate bird and its chick.

their own pictures by tripping a wire or pulling a string; today many animals—including my frog—shoot self-portraits by jumping into an invisible beam of infrared light.

I never knew until that assignment that a frog could become so accustomed to a human's presence that it would allow me to hold it in my hand. In all wildlife photography, gaining the confidence of the animals is the most important task.

I once even had to gain the confidence of a spider! Each time I approached its lily pad, the spider would gulp down a lot of air bubbles and zip under the pad to hide. I knew I could not come up under the spider in scuba gear: It would simply hide on top of the pad instead. Time finally did the trick; once we had "made friends" I was able to take the spider's portrait on both sides of the pad.

When I photograph wildlife for the National Geographic Society, I *can* take time—an entire summer with the snakes, a winter among swans, many weeks with butterflies preparing for migration. But to photograph nesting frigate birds for a story on the mangrove swamps of Florida, I was given special permission by the U. S. Fish and Wildlife Service, an escort, and very little time. A protected rookery on the Marquesas Keys is the birds' only known North American nesting ground, and I had to wade through shark-frequented waters to get to them. I was allowed only three visits of a half hour each, but it was enough to get the picture at right.

I have learned to live and work in a world of wild creatures, both underwater and above. And so I live in a world of beauty that I never knew before. I am often cold, or wet, or tired—but I am always happy.

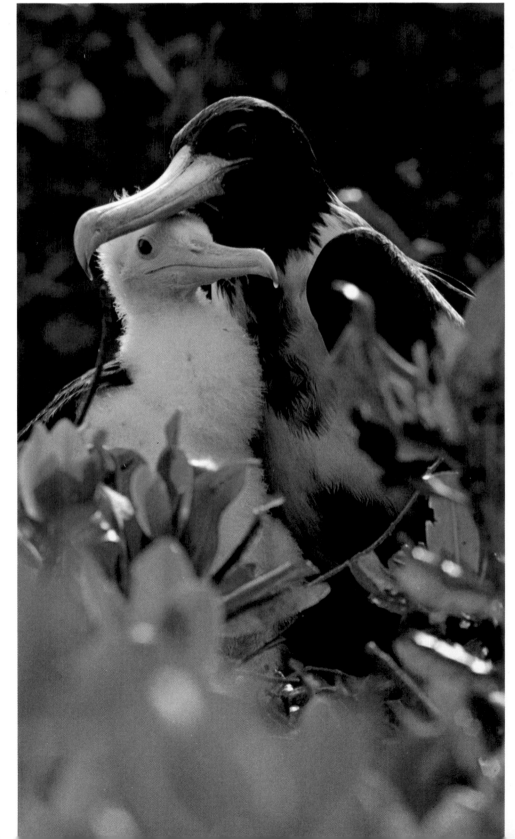

In the Footsteps of Audubon

By Bates Littlehales

It was a cantankerous old grinder of a car, but at least it moved at a steady pace as I scouted for birds along a wildlife refuge road. Suddenly I spotted a sparrow on a reed and braked to a gentle stop. I turned off the ignition—but the engine kept chugging and clacking.

The sparrow would have none of that. I muttered an oath as it flitted away. But then a secretive clapper rail ventured out of the thick marsh undergrowth—more than a fair swap for a sparrow any day. Did curiosity lure the rail to my lens? Or did it perceive in the clacking some elemental invitation? I shall never know.

Nor shall I quite understand what has turned me from a generalist into a photographer specializing in birds. Assigned to a story on John James Audubon, I wondered how a sensible man could have become obsessed with painting every species of bird he could find in North America. By the time I was well into the assignment, the ghost of Audubon had reached out to me and had created another "ornithofanatic."

Unlike Audubon, I was blessed with many books and magazines about birds. Binoculars, not a shotgun, brought specimens close to me for study. And as I retraced his travels around the country, I met "bird people" glad to teach me local lore.

I began in August—and quickly learned it was the worst month. Nesting was over, molting was in progress, migration had barely started. The woods were quiet because the

A rare bird in a rare solo flight: Days of patience won Bates Littlehales this single glimpse of a whooping crane winging alone over a Texas marsh.

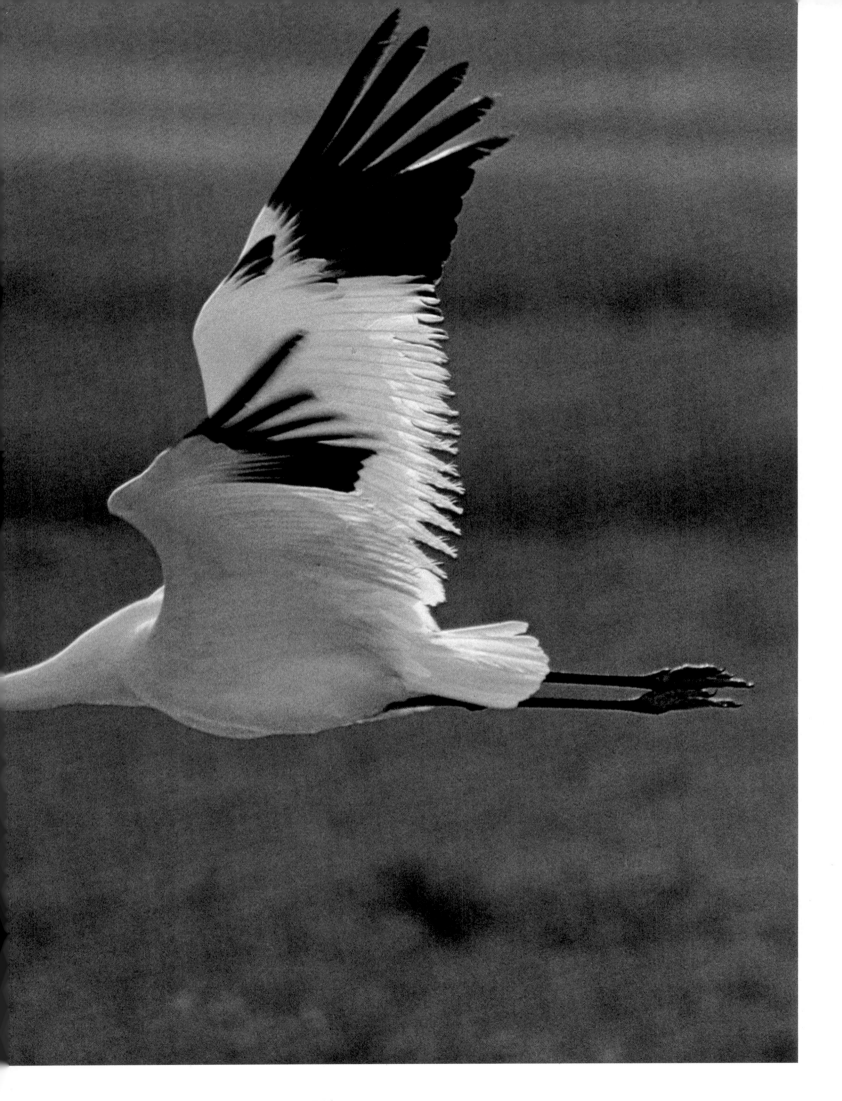

males no longer sang to establish a territory. A blind by a nest would be as useless as the nest itself had become. The birds were out roving, so I had to learn to prowl and stalk and, using only my hands, hold steady a camera with a 600mm stovepipe of a lens. I developed new muscles.

Wildlife photographers soon learn that a car makes a great camera platform. A long, heavy lens rested on a car's windowsill is steadier than on any but the heaviest tripods. Many refuges have "wildlife drives," and birds that will not tolerate a human on foot often will ignore one who approaches in a vehicle.

Stay in the car, move slowly and quietly, and with patience you can shoot feeding, flocking, courtship, and other activities without disturbing the birds. But if joggers or bikers come along—as they are entitled to on most wildlife drives—you can probably quit for the day. And the athletes love precisely the early morning and late afternoon hours that the wildlife photographer needs.

Stalking birds on foot is a matter of soft movement, of knowing the quarry, of feeling out the tolerances of various species in various locales. It is hard to outwit a bird. But the few triumphs are well worth the effort.

One fine May morning I stalked a northern parula during its spring migration. The warbler and I worked out his distance of tolerance, and from then on my only problem was how to focus an 18-pound telephoto lens on a small and nervously active bird. Long hours and aching muscles were translated into a sharp image on the ground glass for just the time I needed—a fraction of a second.

A feeding northern parula lets Littlehales move in close; a telephoto lens pulls the tiny warbler even closer. Usually, the busier the bird, the closer the photographer can stalk.

Along the Eastern Shore of Delaware in winter, large flocks of red-winged blackbirds gather in cornfields to feed on fallen kernels. Once I drove slowly along the roadside to watch a flock rhythmically feed and flare up, alight and rise again. Suddenly my binoculars picked out a yellow-headed blackbird—a straggler from far out west—among the hundreds of red-wings. With a 400mm lens I worked the flock, from both inside and outside my car, until the birds finally swirled away. Not until the film was processed could I know I had captured the lone stranger in that blizzard of birds.

When I set out to photograph the whooping crane, the wild population of this gravely endangered species was less than 60. Such imperiled animals impose an added imperative, for the photographer must never let his eagerness to portray a rarity push him to harass or disturb it.

Day after day I sprawled on the bow of a quiet, slow-moving boat near the whoopers' Texas wintering grounds. I had seen shots of them flying in flocks. I wanted to photograph an adult flying alone. Migration time was approaching and the birds were trying their wings, but the sight of one in full flight was still a rarity. During all those long days of waiting and hoping, of cruising and shooting, I got many frames of the whoopers wading and feeding, and finally that priceless single frame of a whooping crane flying alone.

I never stop tinkering with improvements to my blinds, my remote hookups, my cameras and lenses and lights. Above all I continue to study the ways of birds.

We photographers are all hunters. How good it feels to hunt and let live!

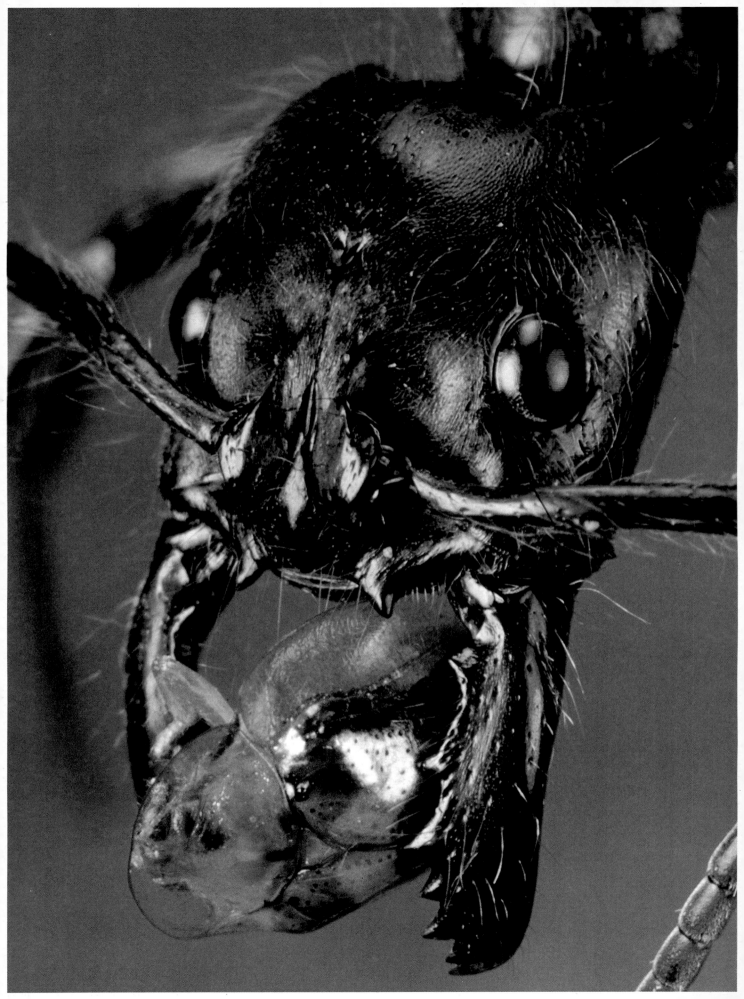

WORLDS WE SELDOM SEE

The world's largest ant and its prey, a beetle. By Paul A. Zahl.

From the infinitesimal to the merely very small, the camera can open up a world ordinarily unseen by the naked eye. Like a magnifying glass, a camera's lens can enlarge and clarify, revealing images of intricate detail, concealed beauty—and sometimes startling surprise.

An early observer of the close-up world was David Fairchild, a longtime trustee of the National Geographic Society who was, by profession, a "plant explorer" for the U. S. Department of Agriculture. In the early 1900s, Fairchild improvised a 12-foot-long camera out of boards, darkened its inside, and fitted one end with a lens and the other with a piece of ground glass.

On "the Fourth of July, a boiling hot day . . . we tried to make the thing work," he wrote, "shoving the box around on the grass . . . as I lay prone with my head under a suffocating cloth." While his wife put one grasshopper after another in front of the glass, Fairchild worked to get them in focus until "suddenly . . . when I was pretty well worn out, there appeared on the ground glass a king grasshopper so marvellous, so enormous, that it startled me."

Thus began a hobby that would consume the Fairchilds' spare time and result in a series of what they called "monster" pictures—common insects enlarged up to 20 times. They photographed their subjects head-on or side-on, rather than from above, because "every creature has a right to be portrayed from its own level."

To capture a monster's image on a 5x7 photographic plate that required exposing for a minute or so was laborious. But that was easy, Fairchild felt, compared with making his subjects stand still. This he could do only by killing them with ether and imbedding their feet in hot wax. "You can have no idea of the perversity of these six-legged beasts," he wrote. "The way the contracting muscles of a grasshopper's back legs will pull the other four legs loose, or the way the hornet will refuse to hold its head up, or the way long flexible antennae will droop are exasperations which lead straight to profanity."

David Fairchild's 1913 insect close-ups were not the first of their kind to appear in the National Geographic Magazine. He credits Dr. N. A. Cobb with pioneering this field in a 1910 article by showing "what the face of a fly looks like."

But Cobb's aim in photographing insects was different. Far from opening to Geographic readers "a door into a world as full of romance as the fairy tales of Grimm or Andersen," which Fairchild professed to do, Cobb's photos accompanied a deadly serious discussion of the habits of houseflies. To prove his point that they are among "our worst enemies," Cobb included a detailed "defecation record of a well-fed fly." His conclusion: "The number of specks in even the best-kept houses is simply appalling."

The Fairchilds' pastime culminated in the *Book of Monsters,* published by the National Geographic in 1914. As noted in the magazine's advertisement for the book, the authors added a "charming touch of human interest" to each monster's "biography." From the caption accompanying a grasshopper photo, for instance: "If you raise the wing of a full-grown grasshopper and look behind its big fat thigh, you will see a strange hole into its body. This is supposed to be its ear, but what it hears and what it does not hear, who can tell?"

To David Fairchild, taking larger-than-life-size pictures of insects was "a game of quickness, ingenuity, and patient skill." His successors

David Fairchild and helpers ready "Long Tom," his improvised camera. Add to the equipment "a great deal of patience," he wrote, "and you have all that is needed." Fairchild's patience paid off in hundreds of lifelike "monster" photos, among them the king grasshopper (opposite, above) and the orb-weaving spider (opposite, lower).

Photographer unknown. *Book of Monsters*, National Geographic Society, 1914.

370

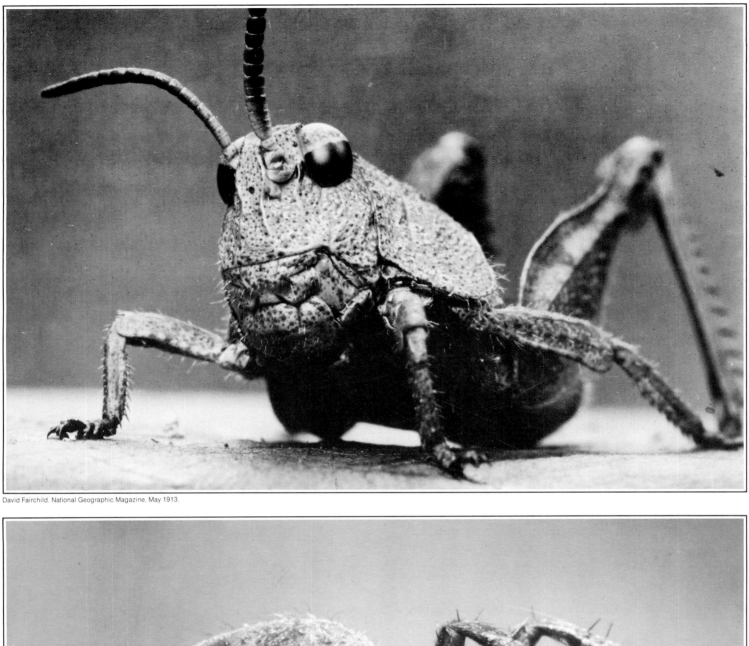

David Fairchild. National Geographic Magazine, May 1913.

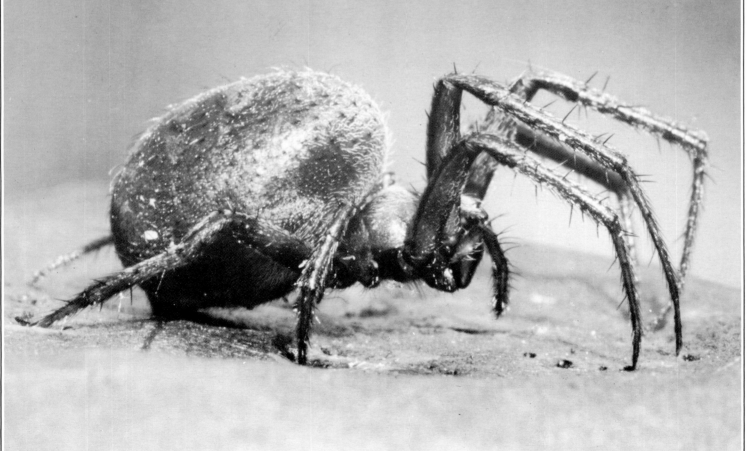

David Fairchild. National Geographic Magazine, May 1913.

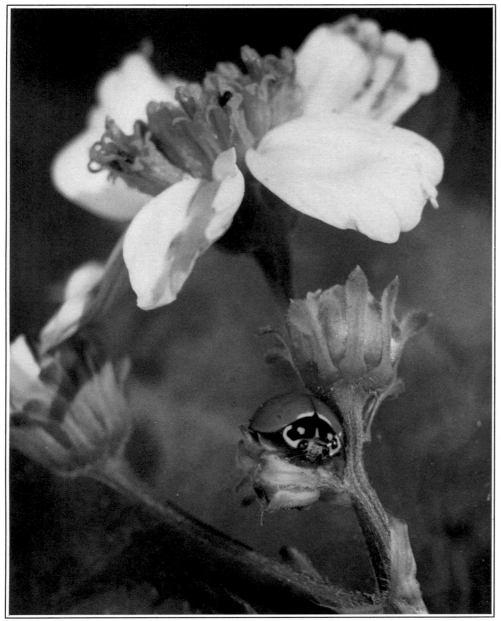

in this field would strongly agree even though some 30 years later, when the magazine published its first color photos of live insects, developments in technique had radically changed—and simplified—the picture-taking process.

In the mid-1940s, Willard R. Culver, a staff photographer now retired, accompanied entomologist-writer James G. Needham to Florida to photograph tiny insects that lived in flower heads. Culver's "miniature" 35mm Leica bore little resemblance to the cumbersome contraption that Fairchild had devised. Instead of long boxes, extension tubes now were fitted onto the camera's lens to magnify the subjects. The key development, however, had been Kodachrome film. Slow by today's standards, the Kodachrome of the 1940s was nevertheless fast enough to make color pictures of fleeting creatures possible for the first time.

Culver, an expert on lighting, had photographed a wide range of subjects, but never living insects. "It was a new experience," he remembers. "Needham would catch them in his net; we'd give them a little whiff, and we'd go ahead. We never killed them." The biggest nuisance to Culver was wind. "The least little bit upset everything."

In July 1946, just before Culver's insects appeared, the Geographic published a series of bat pictures taken by Robert F. Sisson and Donald R. Griffin, who used high-speed electronic flash lighting. The action-freezing strobe, invented by Harold E. Edgerton in the 1930s, could fire thousands of light pulses from one bulb while giving off almost no heat. It was a boon to natural-science photography, particularly to close-up work with small creatures. Six years later, with enlarged color "monster" photos, Paul A. Zahl showed how the use of strobe lights sharpened up insect photographs.

Zahl, a biologist as well as a photographer and writer, took his first insect picture by accident. One

Willard Culver, with entomologist James Needham, prepares to photograph an insect, such as the ladybug above. Culver used extension tubes to magnify, a tinfoil reflector for lighting, a wind screen, and an umbrella to keep everything from wilting in the sun.

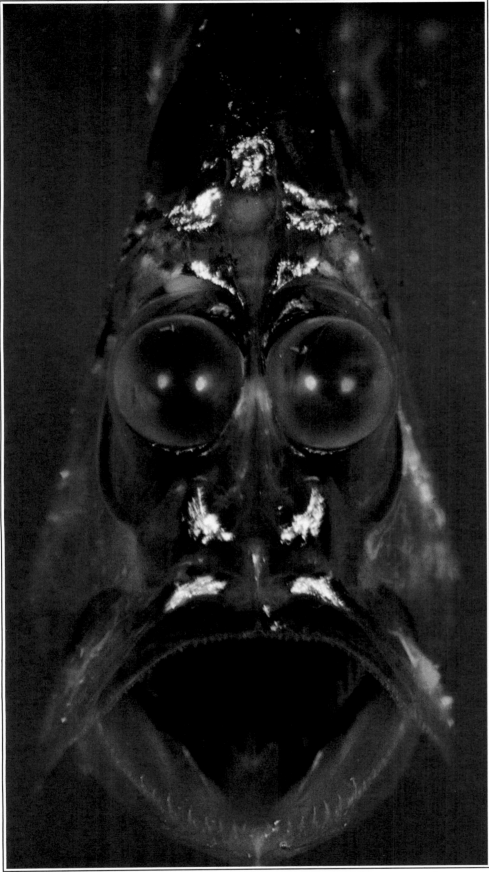

Paul A. Zahl. National Geographic Magazine, November 1953.

A silver hatchetfish displays the light organs and bulging eyes common to many fishes from the depths. For living portraits, Zahl managed to catch them and photograph them. The hatchetfish's "strange appearance," he wrote, "would make even artist Dali wince."

day, while photographing tropical birds in a Manhattan pet shop, an "immense brown cockroach appeared on the perch. As Broadway would put it, he stole the scene." Zahl later joined the magazine staff, producing more than 50 articles on natural-history subjects.

Unlike David Fairchild, Paul Zahl, for the 1952 article, did not have to kill and mount his subjects. Strobe lights and other advances in the state of the art enabled him to show many tiny creatures in action in their natural surroundings, although sometimes it was necessary to "decelerate" them. "We would either place the specimens, bottled, in an ice bucket for a time, or give them a whiff or two of ether," Zahl wrote. The difficulty with the ice-bucket method was that as soon as the insects warmed up under the lights, they would spring to life and take off.

Zahl's curiosity led him down many avenues of the hidden world. From "monsters" and minuscule fish and frogs to microscopic diatoms, his camera again and again showed Geographic readers things too tiny for the human eye to see. He also took some of the first color pictures of live fish from the depths.

Periodically, whirling tidal currents in the Strait of Messina, off Sicily, sweep fish up to the surface from deep in the Mediterranean. The fish are tiny and translucent. Their multi-colored light organs glow with extraordinary brilliance.

To take photographs of these fish, published in the magazine in 1953, Zahl waited for the right combination of tides and wind to fling up the fish in a spot where they could be collected. Then he scooped them up fast—before they died or the birds got them—and rushed them to laboratory tanks on shore to be photographed in living colors. To capture the luminescence of the fish on film, Zahl had spent months improvising equipment, including a box that focused three strobes into the aquarium to light it uniformly. Getting these pictures took "hours and hours and hours of work," Zahl remembers, "because 80 percent of the shots would be out of focus, or the animals wouldn't be behaving."

Another Geographic milestone in the history of close-up photography was an unusual series on animal eyes by

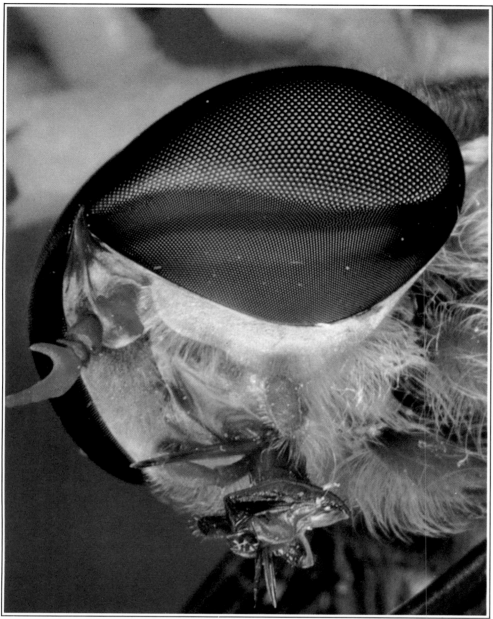

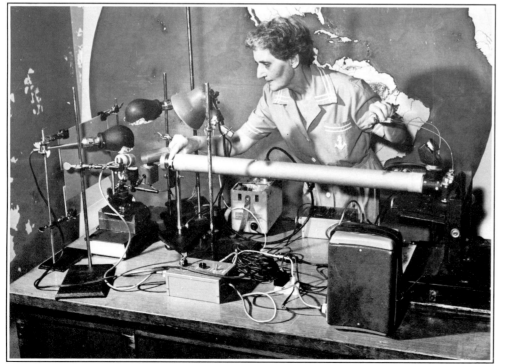

Constance P. Warner, published by the magazine in 1950. After years of work as a nurse specializing in human-eye care, she became curious about the eyes of other creatures. "Nature's eyes," she wrote,". . . long ago anticipated . . . counterparts of venetian blinds, tinted glasses, and windshield wipers, as well as features of the finest cameras."

Officials at the National Zoo in Washington were especially helpful when they learned of Mrs. Warner's interest. One of them invited her to the zoo, showed her how to take pictures, and gave her space for a "photographing cage," where she would spend much of her time over the next dozen years. When Edwin L. Wisherd, chief of the Geographic's photo laboratory, heard about her project he lent her special lenses and offered technical advice.

But conventional equipment was not always able to capture animal eyes on film. That task "comprises, for me at least, about 10 percent photography and 90 percent improvisation," Mrs. Warner wrote. "My 'photographic' equipment includes not only the marvelously versatile Leica camera, but also doorstops and coat hooks, kitchen utensils and curtain rods."

When she tested equipment to take her pictures, some minor mishaps inevitably occurred. One experiment Mrs. Warner described came to a sad end: "I placed a pair of the lights, equipped with special concentrating reflectors . . . two inches from my subject and pressed the shutter. A wisp of smoke proclaimed I had broiled a horsefly's wings in $\frac{1}{2000}$ of a second!"

Some images are so small that no number of special lenses or extension tubes can magnify them enough to be seen. Often in such cases a close-up photographer will turn to a microscope that can magnify on film up to 1,300 times life-size.

Robert F. Sisson, the Geographic's present natural-science photographer and close-up specialist, also makes

Amid a jumble of improvised equipment, Constance P. Warner tests a cardboard extension tube she will use to magnify a subject's eyes. The horsefly's compound eye (above) mirrors many facets of its world and is quick to detect movement.

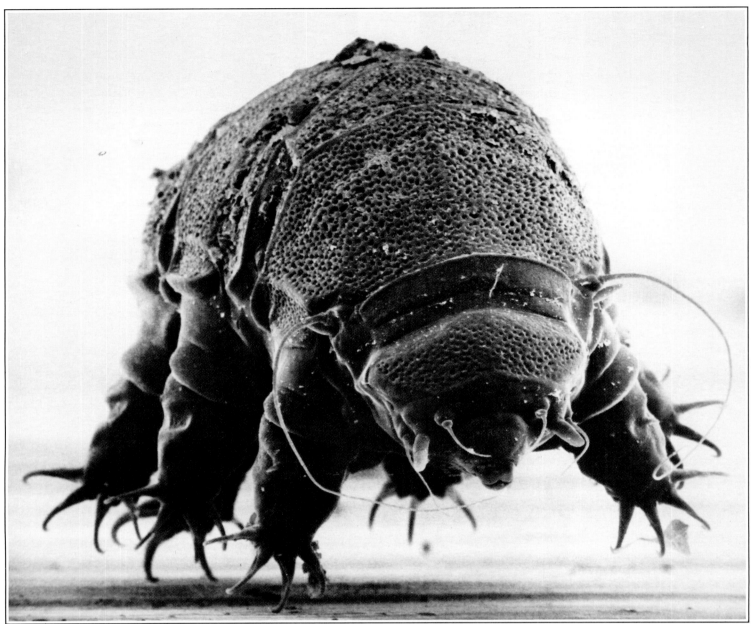

photomicrographs. The snowflake picture on page 380 is an example of his skill in this highly specialized field. To take that picture for the magazine's January 1970 issue, Sisson chilled to outdoor temperature the microscope, the lenses, the slides—everything, including himself. "It meant a lot of standing around and shaking," he remembers. When he had caught a good snowflake on a collector, he transferred it with a dental probe to a slide under the microscope. "As soon as I turned the light on to focus, the countdown started."

Photographing through an optical microscope is not only difficult (Sisson needs about two hours of preparation to take one picture) but it also has limitations: The higher the magnification, the harder it is to achieve sharpness and depth of field.

Another relatively new tool, the scanning electron microscope (SEM), is not so limited. But cost and size are among the factors that make it impractical to use in many kinds of close-up work.

By sweeping an exceedingly fine beam of electrons across a subject, the SEM can produce images that are far beyond those that an optical microscope can see.

Revolutionary as a research tool, the SEM also gives us photographic glimpses startling in their realism. Sisson, working with a team of scientists, made a series of ant portraits through the SEM in 1974. Wonder-struck at what he could see under the new microscope, Sisson wrote: "Never again will I step on an ant—I will step around, for now I have looked long and hard into their many faces."

A tardigrade, which lives in water drops on plants, looks like this under the scanning electron microscope. Ultimate window on the minuscule world we seldom see, the SEM reveals amazing details, but does not show images in color.

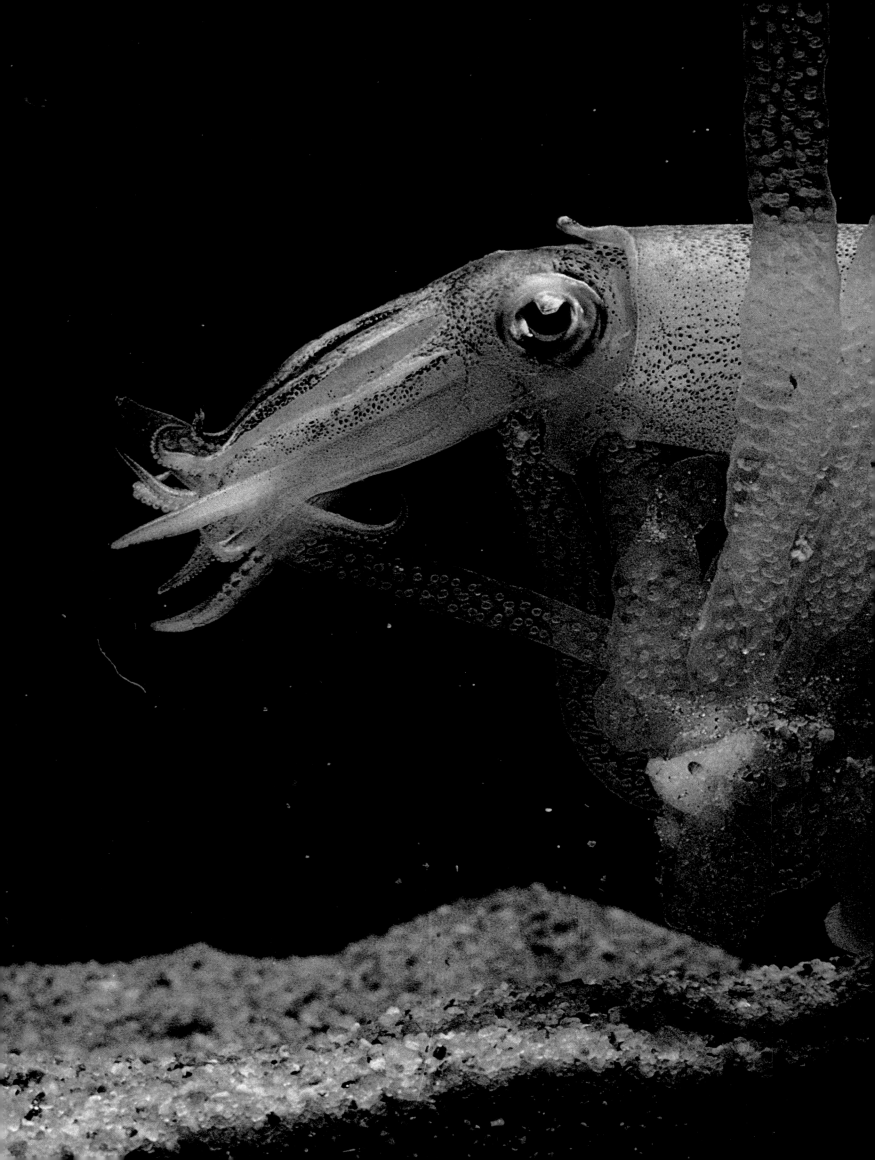

B ob Sisson had spent weeks at the
Woods Hole Marine lab, trying to
photograph an egg "mop," the
clustered egg pods that female squids
deposit. No luck. Sisson's complaints
were finally overheard by a scientist
who cut some rubber tubing into
six-inch lengths, bound them with a
wire, tied his "mop" to a rock, and
threw it into a tank.

"Within five minutes two females
were over there laying eggs." It seems
squids lay eggs communally. "No one
was laying eggs in my tanks because
they were all waiting for somebody
to go first."
ROBERT F. SISSON

S pecial high-speed strobe lights
freeze a cobra's venom in mid-jet
as it sprays (overleaf) toward
a handler wearing safety glasses.
"The first time we did it, I was looking
over the top of the camera and I saw the
snake look at me. I just put my head
right down behind the camera again."
ROBERT W. MADDEN

Off Australia's coast live sea dragons (overleaf) with leafy fins that mimic their habitat. "Few people have ever seen these things alive because they live where only an expert diver would go." This one was photographed in an aquarium.
PAUL A. ZAHL

"I called this 'death of a snowflake.' In less than two seconds under the microscope, all I had left was a drop of water." Perfect flakes are rare. "When they fall, it's one huge traffic jam; they all bump each other and break up."
ROBERT F. SISSON

To preserve a snowflake like this, Sisson catches it on a chilled glass pane coated with a polyvinyl resin solution that hardens quickly. The flake melts, leaving a permanent cast. "They're fun to look at in July."
ROBERT F. SISSON

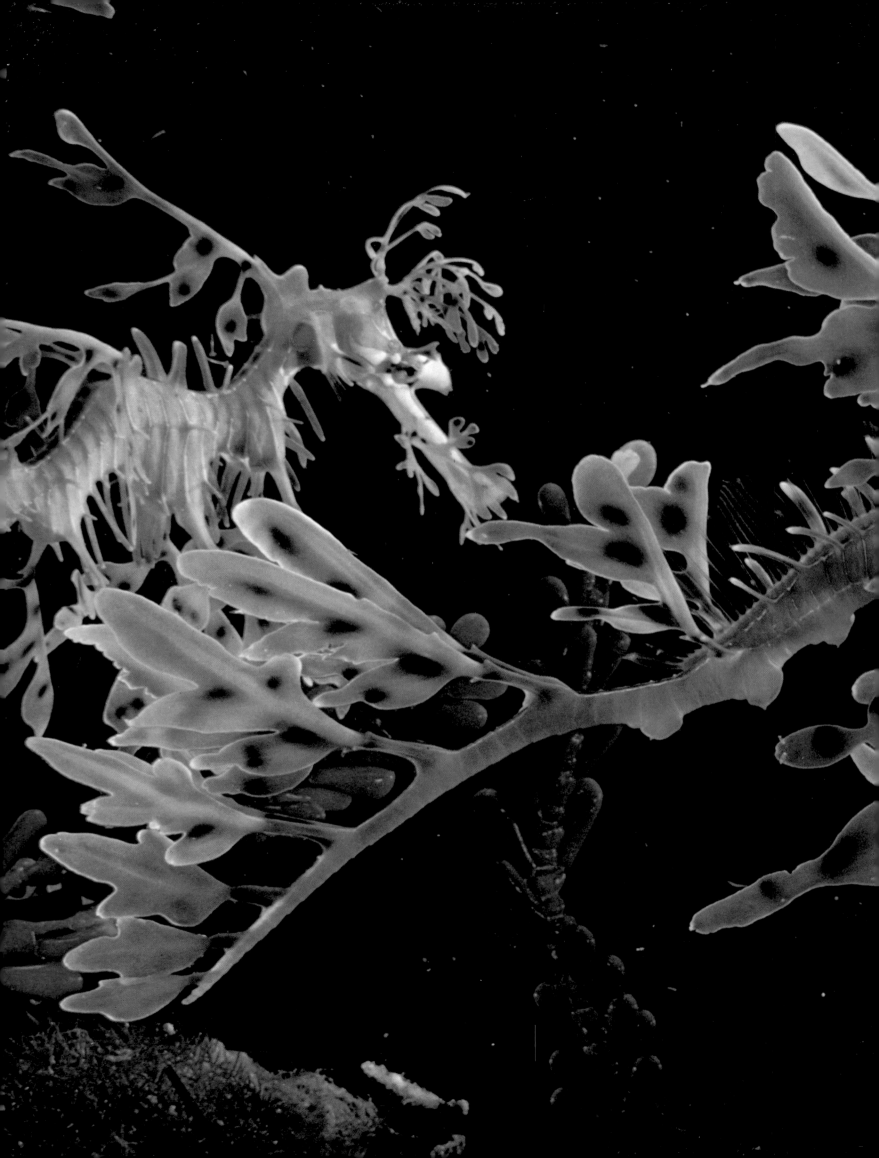

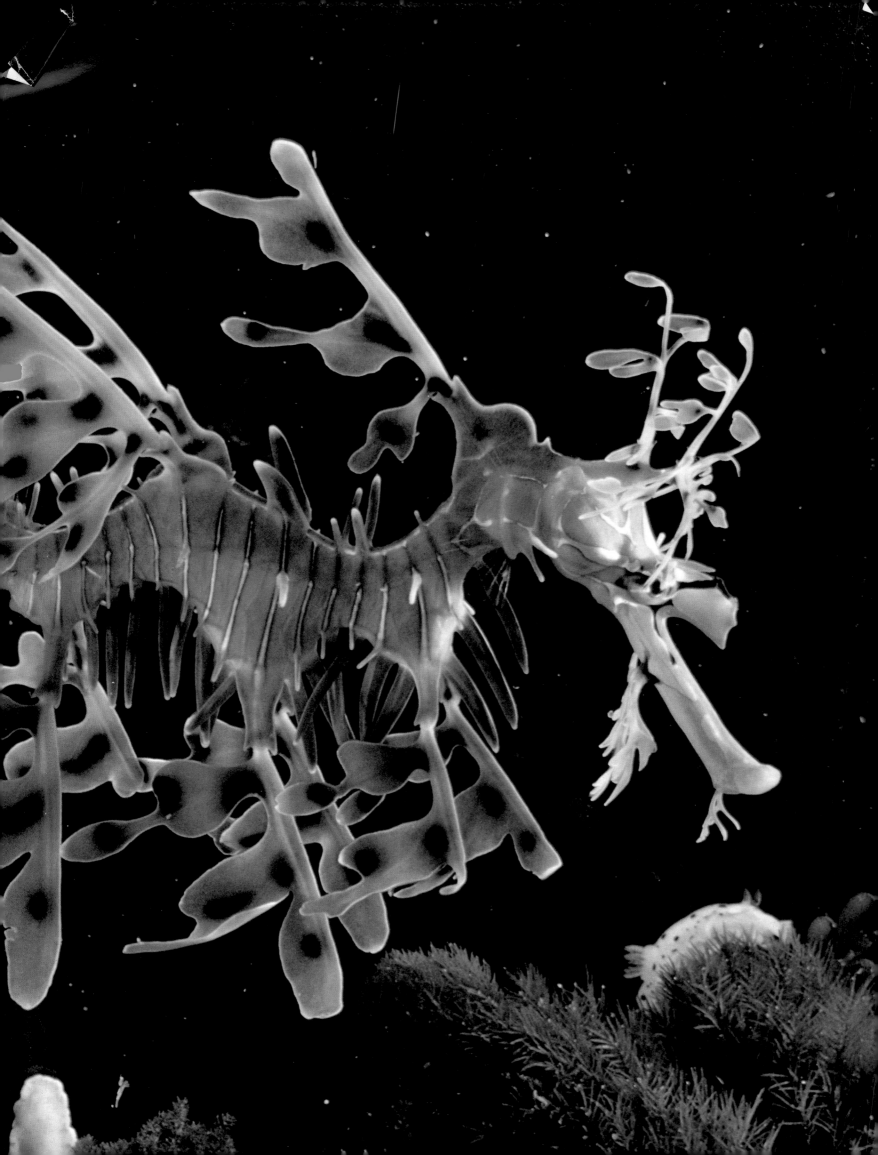

A tiny Costa Rican frog peers back at Zahl. "I kept a lot of them in my laboratory down there. They'd jump around and then just sit and watch. Easy to photograph. But don't eat them!" Indians once daubed the frogs' poisonous secretions on blow-gun darts.
PAUL A. ZAHL

The sea horse shares an unusual trait with its rarer relative, the sea dragon. "The male of the species carries the young through the hatching period. This 'pregnant' father's eggs are concealed in a pouch under his tail."
PAUL A. ZAHL

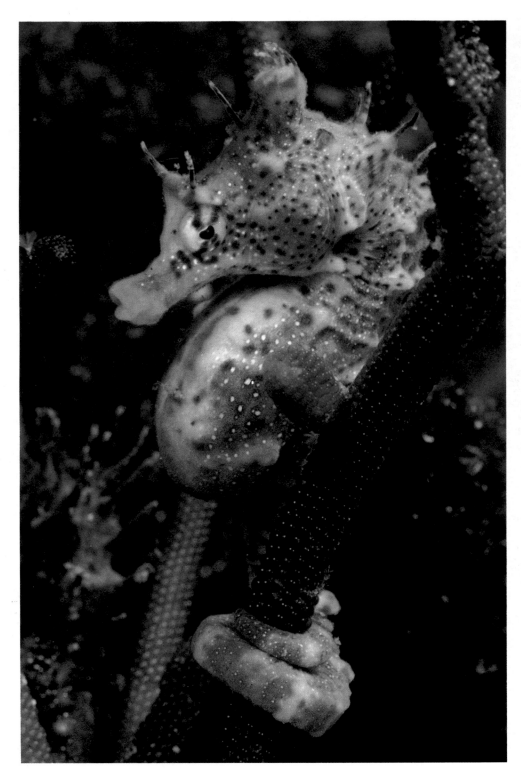

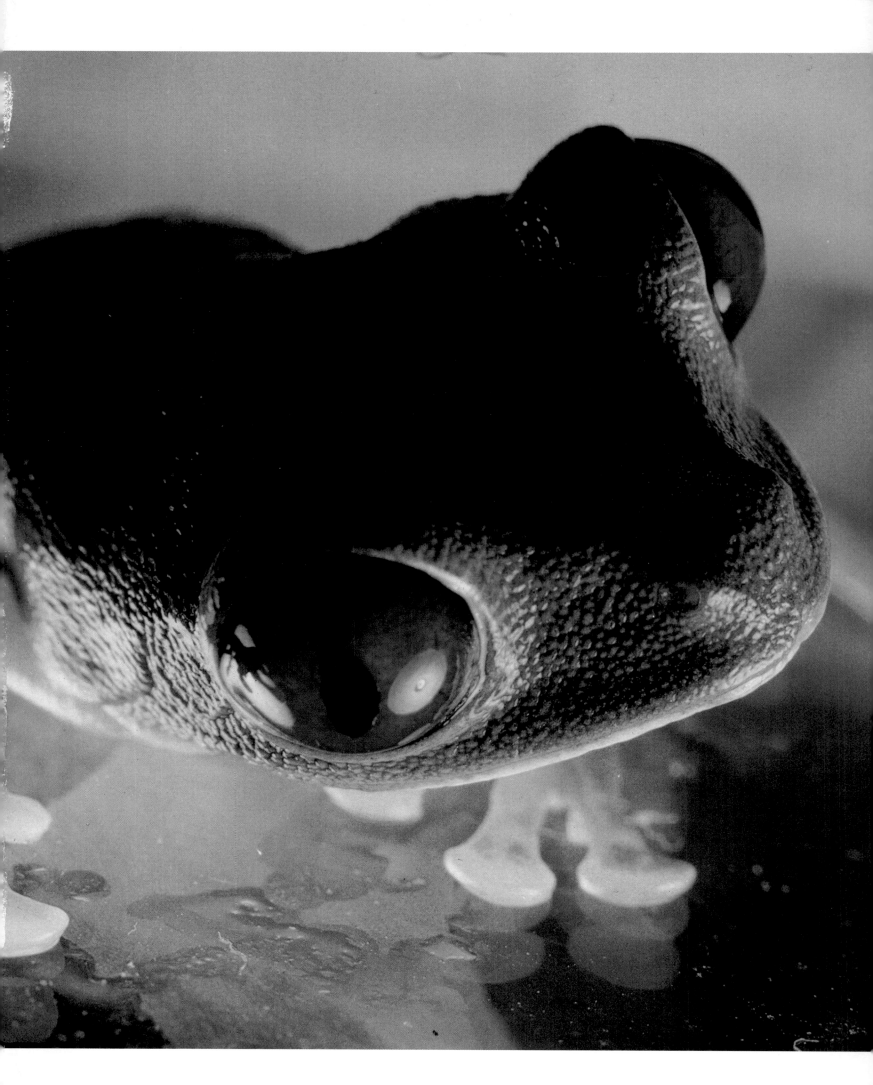

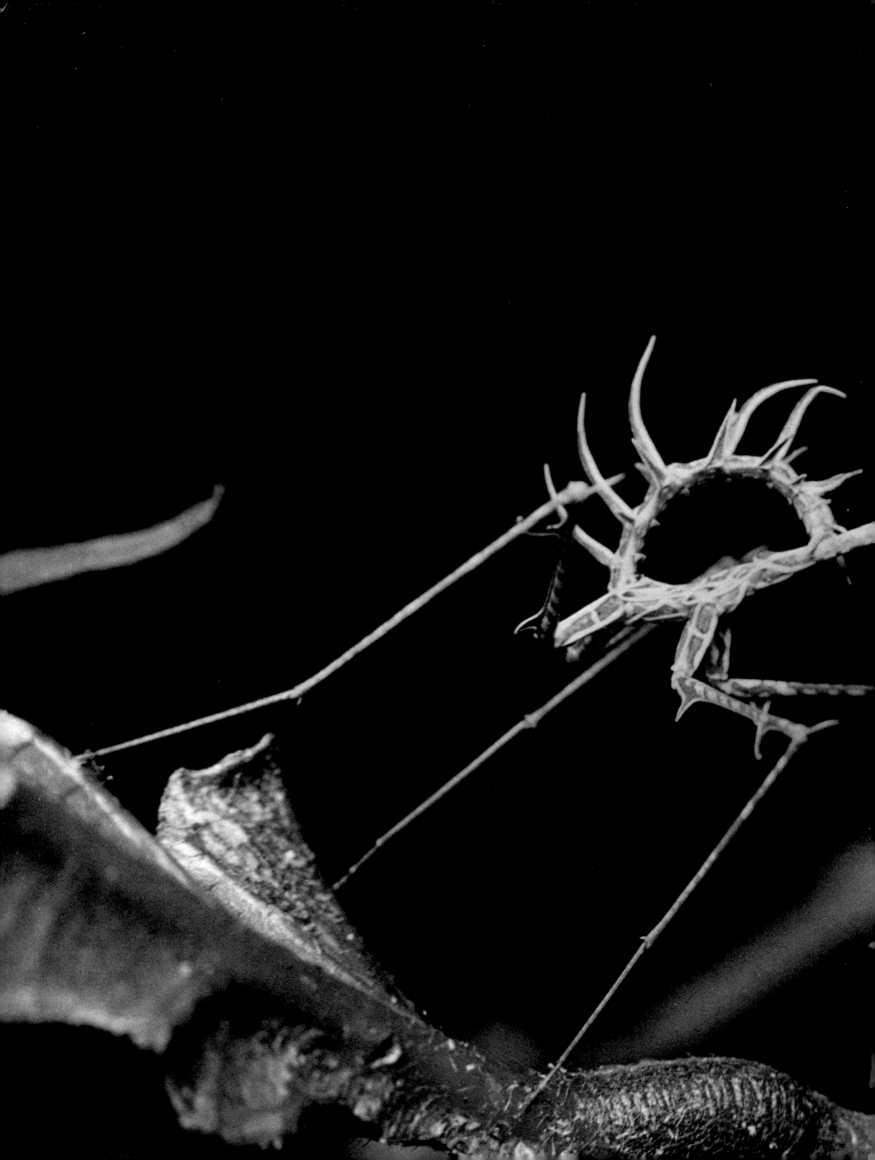

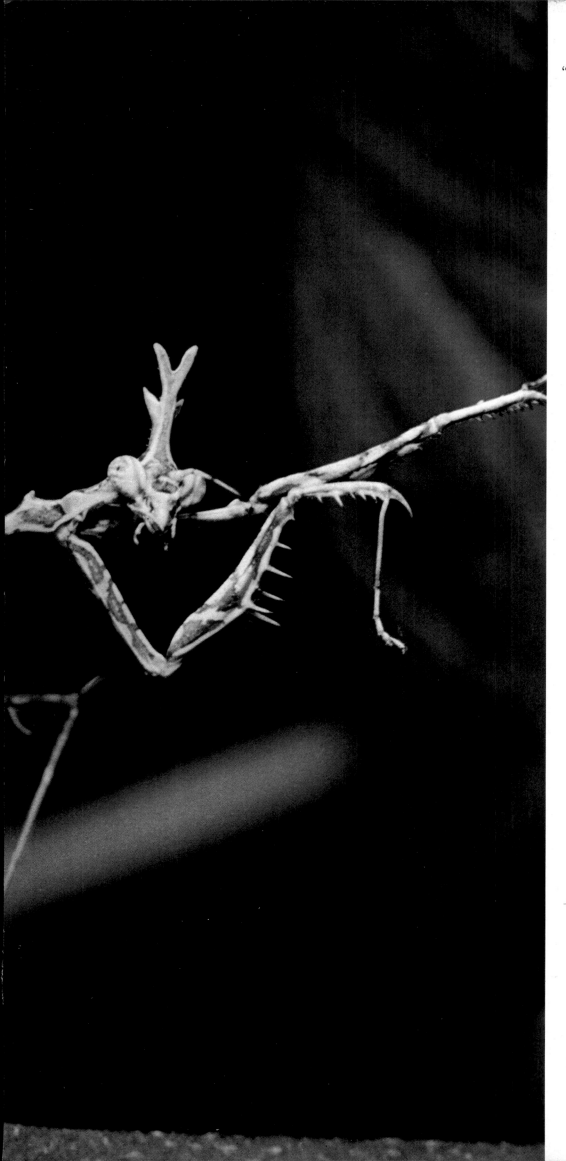

"Much to my delight I was able to break through the camouflage of this marvelous praying mantis. It makes me think of an orchestra conductor, poised with baton in hand, looking over his shoulder at the first violinist. I had no idea that such a thing existed, but that's the great adventure of what I do. You go down the trail never knowing what you're going to run across. The tropical forest, especially the Congo, is like a candy store to the naturalist because every few minutes you're seeing something very odd, and sometimes things that have never been photographed."
EDWARD S. ROSS

At some moment, the three-eighths-inch octopus would jet from its egg. To catch that moment (overleaf), Sisson, on watch at the aquarium, used a motor-drive that shot four frames a second. "That enhanced 100 times the chances of getting a good photograph. When you see these little guys moving around the sacs and stretching, you know they're getting ready. But when they decide to pop out, *bang,* it's over. Most people's reflexes aren't that fast."
ROBERT F. SISSON

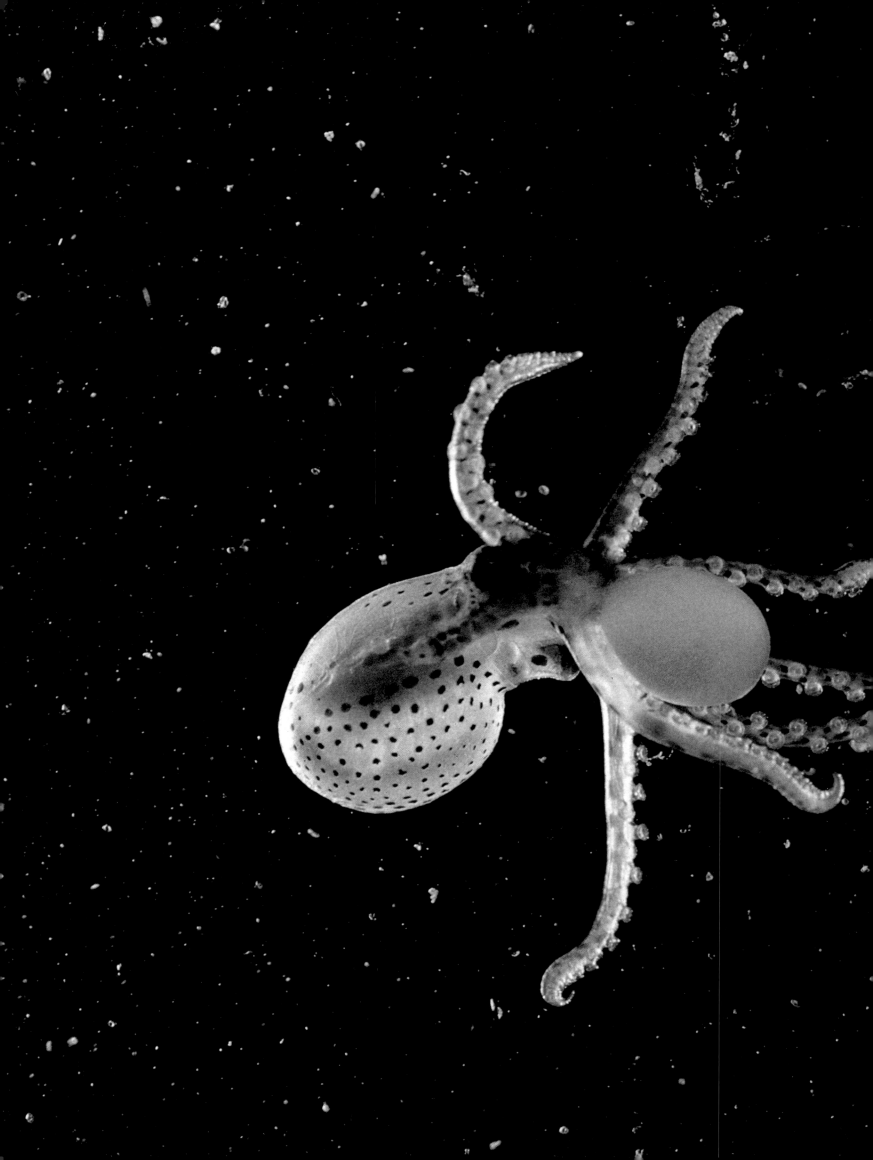

Thinking Like an Animal

By Robert F. Sisson

Yesterday, as I was coming in closer and closer with my 90mm macro lens to a butterfly sampling the nectar of a blossom, a breeze started up. While I waited for a lull, I sat watching the delicate insect drink its fill, and I started thinking back to days when I would cut school and escape to my favorite pond in the woods—a great "watching" place. Love of nature gave my life focus, and I've been watching nature ever since.

People in a hurry miss so much. There are things to see in flowers, in grass, in trees—even in sidewalk cracks—if you take the time to look.

One day I was sitting in a field of desert marigolds in Arizona watching a little crab spider in the center of a flower. Since both spider and flower were the same yellow color, the spider was nearly invisible as it sat qui-etly waiting for its prey. While I was thinking where to put my lights for the picture, I saw out of the corner of my eye something move in the center of another flower. That's odd, I thought, there's no spider in that one.

When I looked again, the center of the flower was moving up and down like an inchworm. I looked again and realized it *was* an inchworm—with bits of petal stuck on its back. It was an inchworm camouflaged to look like the center of the flower! While I was watching, up over the petals climbed a crab spider that had come up to see what was going on. When the spider stopped to look around (right), it was standing on the inchworm. On that one flower I had seen two ways animals deceive one another to survive. If you teach yourself to stop and look, you'll be amazed at the things you will see.

The secret of good natural science photography is to be there when the animal does its thing. You need a curious mind and the ability to sit for hours or days waiting for the right moment. But to know that moment when it arrives may take weeks of research into the life of your subject. Only when you can *think like the animal,* anticipate its movements and reactions, are you ready to use your camera. Learning this lesson cost me five bucks.

In the mid-1960s, I worked with Ed Boehm, one of the world's great porcelain-bird artists. Ed watched me for days, maybe weeks, trying to get one of his birds to perch on a certain branch for a picture. It was a rare South American bird, and I had made the effort to get the type of food and foliage the bird was used to so that it would feel at home.

But the bird flew around and

"I try to light the little 'beasties' the way the better portrait photographers light their portraits. That way they look most natural," says close-up expert Sisson. Here, at a marine laboratory in Florida, he prepares to photograph life inside a sponge—while photographing himself. He took the spider picture (opposite) for a magazine article on animal camouflage.

Spider (opposite) magnified 15 times.

A coral polyp, builder of reefs, reaches out with tiny tentacles to snare passing food. For his story on the life of a coral Sisson raised the polyp on a glass slide in his Great Barrier Reef aquarium.

This "feather duster" is actually a marine worm that Sisson photographed in a Florida lab (page 390). "Each time the flash went off, back it would go inside a channel in the sponge."

Polyp magnified 35 times, fanworm 55 times.

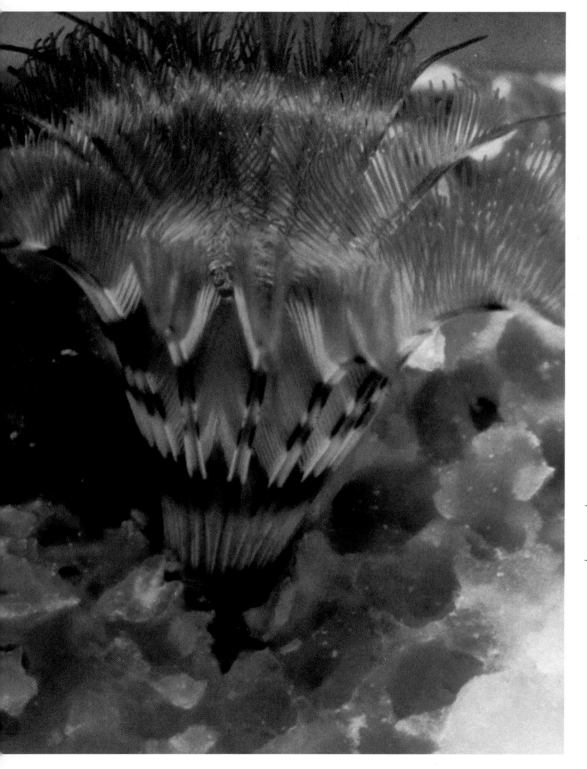

around and then perched everywhere but where I wanted it. It even sat on one of the five strobe lights I had set up. Finally Ed could stand it no longer. He walked into the cage and asked me what in the world I was trying to do to his bird.

"I'm trying to get your darn bird to perch on this branch so I can take its picture," I replied.

"Well, you've got to think like the bird," said Ed, "I'll bet you five dollars I can get it on the perch."

When I agreed, he told me that the bird was a "forty-five degree angle percher" and replaced the branch with a properly angled one. Then he stepped back and said, "Get ready." The bird was so tired of not having the right branch to perch on that it broke all speed records in getting to the spot—and I got all my pictures.

As my fiver went into his pocket, Ed said, "Bob, you've got to get to know your subject well; watch it eat, sleep, walk, fly, everything it does. Read all you can about it before you pick up your camera. Then think like your subject." That advice has been of great help to me over the years.

I specialize in picture stories about the life cycles of tiny animals. That often means a photographic expedition to a faraway place, such as Australia, to do the life of a coral polyp (left, above), one of the little fellows that built the Great Barrier Reef. I had been warned to bring everything I might need because the island lab was empty except for tables and sinks. So, besides my usual cameras and close-up attachments, I included a microscope and some other equipment—35 cases weighing about 1,100 pounds in all. At the end of my two-month stay, I had used every-

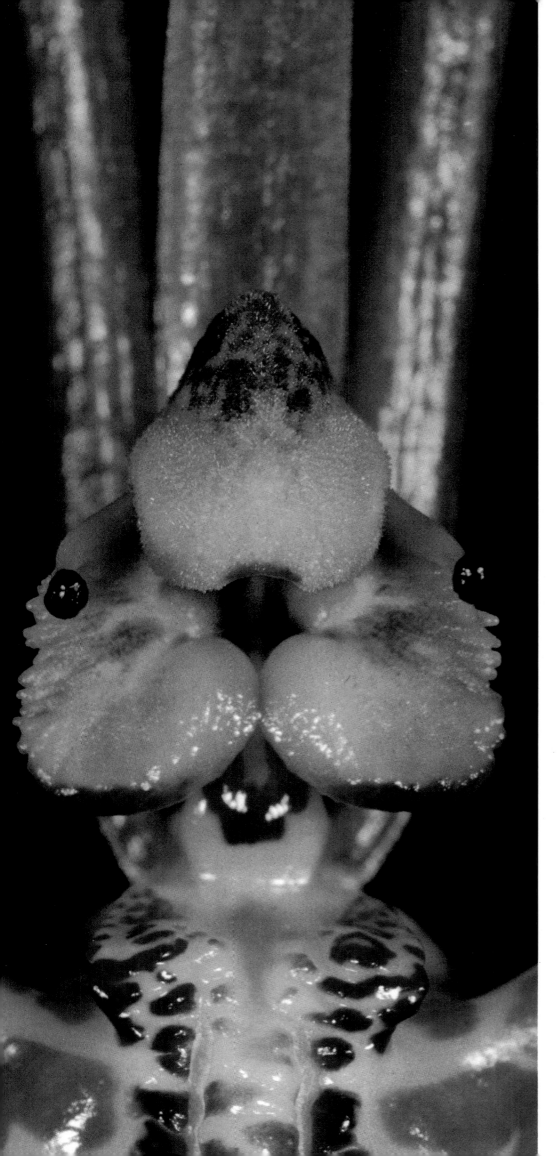

An orchid with a face? "I was photographing orchids that attract insects with ultraviolet signals when I saw this face inside the flower."

Orchid magnified 20 times.

thing I had brought and could have used even more spare equipment.

I wasn't on the island long before discovering that salt mist and spray, in combination with the ever-present blowing sand, had wreaked havoc with every water pipe and electrical outlet in the lab. This caused problem after problem with the equipment.

My aquariums' saltwater pump stopped, my transformer broke, and the first time I threw the light switch for night viewing, a big flash and then darkness told me that salt had gotten into both the wiring and the sockets. I can laugh at these mishaps now, but at the time they weren't funny. Expeditions are like that; either everything works and you keep waiting for a bomb to explode, or the bombs keep going off each day.

But at least I got my story of the reef-making corals—including photographic proof that corals are able to capture live fish. Other expeditions have turned out less well.

I once went to Ecuador with 1,000 pounds of gear, lived in the jungle for a month, and never got a picture. What I had gone to see—a butterfly fighting with a flower that looked like a butterfly—never happened. I sat by that flower for 19 days. From there I went to the Dominican Republic to photograph a bee trying to mate with a flower that looked like a female bee. For that event I spent two weeks sitting in the desert. And nothing happened that time either.

What this proves is that no matter how much preparing you do, how much studying, how much planning, how much adapting or redesigning equipment, how much thinking like the animal—how much *you* control the situation—if you don't have luck, it isn't going to work.

Photographers' Biographies

Sam Abell's work for the Society includes articles on Ontario and Newfoundland, and the books *The Pacific Crest Trail* and *Still Waters, White Waters.* A Geographic contract photographer since 1970, he also lectures, exhibits his photographs, and conducts summer photographic workshops.

Thomas J. Abercrombie has traveled to every continent since joining the staff in 1956, but his greatest interest lies in the Islamic world, in which he specializes. One Geographic assignment took him to some 25 Muslim nations. Twice named Photographer of the Year, he also won the Overseas Press Club Award for best photographic reporting from abroad in 1972.

William Albert Allard left the Geographic to free-lance after three years as a staff photographer. Though the subjects of his assignments have varied from the Amish to the refugees of Hong Kong, he has an abiding interest in the American West. He is the photographer of *The American Cowboy.*

James L. Amos, a staff photographer since 1969, was named Magazine Photographer of the Year in 1969 and again in 1970. His work has included stories on Michigan, New Zealand, and Williamsburg, and the books *America's Inland Waterway* and *Hawaii.*

Joseph H. Bailey came to the Society from NASA as a laboratory technician. He joined the photographic staff in 1972, and his work has appeared in *Explore a Spooky Swamp,* in National Geographic World, and in many of the Society's special publications. He has photographed Bermuda and Yosemite, and the last four presidential inaugurations.

J. Bruce Baumann was a picture editor at National Geographic for five years. As the director of photography and art at the *San Jose* (California) *Mercury News,* he runs the nation's only interdisciplinary conference for photographers and editors, "Photography and Journalism." He was 1980's Newspaper Magazine Picture Editor of the Year.

James P. Blair, a former television photojournalist, joined the staff in 1962. Since then his pictures have illustrated more than 35 articles in National Geographic. His coverage of South Africa won the 1977 Overseas Press Club Award for the best photographic reporting from abroad.

Jonathan Blair, a contract photographer for the Geographic, has carried out assignments in the Mediterranean, Africa, and Europe as well as the Americas. His favorite work has been with birds and crocodiles. He also follows undersea archaeology.

Vic Boswell, Jr. has traveled the world, photographing in museums and art galleries and at archaeological sites. Since joining the magazine staff in 1961, he has photographed the White House, the Sistine Chapel, and art treasures of Dresden. He has lectured on photography at the Smithsonian Institution.

David S. Boyer, formerly a writer and photographer for the *Salt Lake Tribune* and instructor in photojournalism at the University of Illinois, joined the Society's staff in 1952. His many assignments for the National Geographic have included London, Micronesia, Jerusalem, Egypt, and Canada.

Jim Brandenburg's assignments as a National Geographic contract photographer have included Canada, China, Namibia, and Nepal. In 1980 he was named Magazine Photographer of the Year, and he recently photographed and designed a new series of U. S. wildlife postage stamps.

Sisse Brimberg, a native of Denmark, managed her own photography studio in Copenhagen before coming to the Society to study. A contract photographer since 1978, her work has included stories on Hans Christian Andersen and Ellesmere Island.

George W. Calef of Environmental Services North is a wildlife biologist and a specialist on caribou. He uses photography to document his research and to illustrate his public lectures. The author of a forthcoming book, *Caribou and the Barren Lands,* he lives in the Yukon Territory.

Jodi Cobb, a staff photographer since 1977, has photographed Helsinki, Nashville, Los Angeles, and China's Sichuan and Yunnan provinces among her National Geographic assignments. One of her photographs is in space aboard the Voyager 2 spacecraft.

Dean Conger, an assistant director of photography, joined the Geographic staff in 1959. Besides assignments in other countries, he has made 29 trips to the Soviet Union. Named Photographer of the Year four times in the 1950s and 1960s, he also received the World Understanding Award in 1977 and a citation of excellence from the Overseas Press Club in 1978, both for his coverage of the Soviet Union in *Journey Across Russia.*

Cotton Coulson, a contract photographer for the Geographic since 1977, followed the voyage of the leather boat *Brendan* from Ireland to Newfoundland. His assignments have included Estonia, Oregon, and both East and West Berlin.

Willard R. Culver, a Geographic staff photographer and lighting expert for 24 years, explored Chesapeake Bay in a diving chamber, photographed such notables as Franklin D. and Eleanor Roosevelt, and on one assignment was said to have been bitten by an armadillo. He retired in 1958.

Bill Curtsinger, a Geographic contract photographer since 1971, specializes in marine mammals and has photographed them all over the world. He was the first to photograph a narwhal underwater; his pictures illustrate *Wake of the Whale.*

Bruce Dale, once a medical photographer in Cleveland, has been on the Geographic staff since 1964, and has worked in more than 50 countries. Two of his favorite assignments were the books *Gypsies* and *American Mountain People.* In 1967 and 1973 he was named Magazine Photographer of the Year.

David Doubilet began diving and taking underwater photographs at the age of 12, and since 1971 has been doing both for the Geographic. His favorite assignments have been sharks and the Red Sea coral reefs. He lives in New York City with his wife, Anne, also a diver and photographer.

Dick Durrance II served a Geographic internship and then joined the magazine staff for seven years. His pictures illustrate *In the Footsteps of Lewis and Clark, The Majestic Rocky Mountains, The Appalachian Trail,* and numerous articles. He now works as a free-lance advertising photographer.

Sylvia A. Earle is a marine biologist at the California Academy of Sciences and a trustee of World Wildlife Fund and the Ocean Trust Foundation. She has dived to record depths in a self-contained diving system, is co-author of *Exploring the Deep Frontier,* and has written several Geographic articles.

Walter Meayers Edwards retired in 1973 after 40 years with the Society, during which he served as author, photographer, picture editor, and chief of the illustrations division. His photographs illustrate *Great American Deserts* and *America's Beginnings.*

Glenn W. Elison is manager of a national wildlife refuge in Utah, which gives him fine opportunities for the close observation that he finds essential for wildlife photography. Birds of prey are his favorite subjects.

John E. Fletcher, an expert on electronic flash, has lit Piccadilly Circus, the Vienna State Opera, St. Paul's Cathedral, and a joint session of Congress for Geographic photographs. Head of the photographic equipment division until his retirement, he now teaches and acts as a consultant.

Gordon W. Gahan began his career as a UPI photographer in Minneapolis, and was a bureau chief at age 19. He joined the Society staff in 1972 after four years as a contract photographer. His pictures illustrate *Voyages to Paradise* and a dozen Geographic articles on places including Paris, Israel, and Brazil.

Wilbur E. Garrett, Editor of National Geographic Magazine, has contributed 27 articles since joining the staff in 1954, including coverage of Mexico, Viet Nam, and Southeast Asian refugees. He has received the Sprague Memorial Award, a Newhouse Citation, and the University of Missouri honor award for distinguished service in journalism; in 1976 he shared the Overseas Press Club Award for the best photographic reporting from abroad.

Lowell Georgia, Newspaper Photographer of the Year in 1962, worked for *The Denver Post* and for National Geographic before deciding to free-lance in 1969. His pictures illustrate *The Playful Dolphins* and *Into The Wilderness;* recent Geographic assignments include Alaska, the Chesapeake, and China.

Ned Gillette learned photography in the field in order to share his ski-mountaineering expeditions with the public; he polished his style by trial and error. His expeditions have taken him to China, South America, Alaska, and New Zealand, and to the Himalayas and the Arctic. He has written and photographed two National Geographic articles.

Farrell Grehan, originally a painter and sculptor, found a new career in 1953 when he began photographing city life in New York. A free-lancer, his photographs have graced National Geographic articles on Thoreau, tulips, and roses, and the Geographic's *John Muir's Wild America.*

Annie Griffiths joined the staff of the *Worthington* (Minnesota) *Globe* after her graduation. Now a free-lance photographer, her assignments for the Geographic have included the Red Cross, the Twin Cities, and the Colorado Rockies. Her pictures have also appeared in National Geographic World.

David Alan Harvey became a Geographic contract photographer in 1974, was named Magazine Photographer of the Year in 1977, and joined the staff in 1978. His photographs have illustrated many National Geographic articles and one entire issue of the Magazine, as well as Geographic books.

Otis Imboden has covered such events as the cross-Channel flight of the man-powered *Gossamer Albatross* and a 1,000-mile glider flight; he has also served as an official photographer of the U. S. space program, including the Gemini and Apollo flights. His pictures appear in *The Mysterious Maya.*

Dewitt Jones is a free-lance motion picture and still photographer whose pictures have appeared in Geographic articles on New England and California. One of his books on the outdoors, *John Muir's America,* is in the White House library, and two of his films were nominated for Academy Awards.

Christopher G. Knight photographed his Dartmouth classmates on a 1,685-mile canoe expedition down the Danube. He became a Geographic intern, and then toured Japan's Inland Sea in a kayak. Today he produces documentary films and slide shows, and takes photographs to illustrate children's books written by his wife.

Emory Kristof's keen interest in 20th-century science and technology has brought him assignments on computers, nuclear power, and energy. A staff photographer since 1964, he is responsible for many innovations in the photographic equipment used in scientific exploration of the ocean.

John Launois was 17 when he began working as an assistant to *Life* magazine

photographers in Paris; he has been a photographer ever since. In 1972 he won the first World Understanding Award for his coverage of the Tasadays, a Stone Age tribe of Mindanao.

Bianca Lavies, born in the Netherlands, began her career as a yachting reporter and photographer in South Africa. Since joining the Geographic in 1969, she has specialized in natural-science photography. Her subjects have included swans, butterflies, bees, and life in and around a mangrove tree, a lily pad, and a compost heap.

Baron Hugo van Lawick's association with the Society began in 1962, when he worked with Louis S. B. Leakey and Jane Goodall in East Africa. His television films on wildlife have won four Emmys; his books include *Savage Paradise, Innocent Killers,* and *Solo: The Story of the African Wild Dog.*

Bates Littlehales has done underwater and natural-history photography since joining the staff in 1952. He has worked with Jacques-Yves Cousteau, with Edwin Link's "Man-in-Sea" experiments, and with the ocean habitat research project Tektite II. Other assignments have taken him to the Tuamotu Islands and the Bolivian Andes.

Robert B. Livingston, M.D., is professor of neurosciences at the University of California at San Diego. A member of the American Neurological Association, he is the author of more than 160 articles and film scripts.

Bill McCausland is a photographer for the county council and operates a surfing school in Sydney, Australia. He has worked with the University of Auckland (New Zealand) in a wave-dynamics study, and his photographs have appeared in many surfing magazines, as well as in National Geographic and National Geographic World.

Loren McIntyre, a specialist on South American Indians, accompanied a National Geographic-supported expedition that found the source of the Amazon in 1971. A free-lance writer-photographer for the Society since 1962, his works include numerous articles and the book *The Incredible Incas.*

Robert W. Madden joined the Society as a contract photographer in 1969. Now on the staff, he was named Photographer of the Year in 1971 and Magazine Photographer of the Year in 1976. Also in 1976, he shared the Overseas Press Club Award for the best photographic reporting from abroad for his coverage of the Guatemalan earthquake.

Luis Marden, one of the world's foremost underwater photographers and a pioneer in 35mm color photography, joined the staff in 1934. He dived with Jacques-Yves Cousteau from *Calypso,* recovered Maya artifacts from a sacrificial well in Yucatan, and discovered the remains of Bligh's *Bounty* off Pitcairn Island. He retired in 1976.

William C. Miller, a pioneer in the use of color photography in astronomy, headed the photographic research laboratory at the Hale

Observatories for 26 years before he retired in 1975. His photographs are on display in museums and planetariums, and appear in many textbooks and scientific publications.

George F. Mobley's assignments for the National Geographic have taken him to the Arctic, China, Africa, and the Amazon. A staff photographer since 1961, he made the first authorized photograph of the U. S. Senate in session. His pictures illustrate books on *The Great Southwest* and *Alaska.*

Yva Momatiuk and **John Eastcott,** free-lance photographers and writers, have worked for National Geographic since 1976. A husband-and-wife team, they have lived with Eskimos and the mountain people of Poland and New Zealand. They are authors of a book on New Zealand's *High Country.*

W. Robert Moore joined the Society's staff as a writer and photographer in 1931. A pioneer in natural-color photography, and chief of the foreign editorial staff for 11 years, he retired in 1967 with 69 Geographic articles to his credit. He died in 1968.

Thomas Nebbia, a combat cameraman in Korea, joined the National Geographic staff in 1958 and carried out assignments in many different parts of the world. Since he left the Geographic in 1969 to free-lance, his work has appeared in leading publications and museum exhibits.

Richard E. Orville is professor of atmospheric science at State University of New York at Albany. He has been involved in lightning research since 1961.

Winfield Parks joined the Society's staff in 1961 after many years with *The Providence* (Rhode Island) *Journal.* He traveled hundreds of thousands of miles on National Geographic assignments and worked in some 40 countries, including Malaysia, Viet Nam, and Egypt. He died in 1977 at age 45.

Steve Raymer joined the Geographic photographic staff in 1972. His interest in investigative journalism has brought him assignments on the world illegal wildlife trade, the Alaskan pipeline, and North Yemen. In 1975 he was named Magazine Photographer of the Year for his coverage of the world hunger crisis.

J. Baylor Roberts joined the staff of the Geographic in 1936 and photographed in the Middle East, Southeast Asia, Australia, and across America. A World War II naval officer, he was recalled to active duty in 1960 to film the first submerged voyage around the world aboard U.S.S. *Triton.* He retired in 1967 as assistant director of photography.

Martin Rogers, a full-time newspaper photographer at 16, became a Geographic contract photographer in 1972. In 1979 he received a citation of excellence from the Overseas Press Club for his coverage of the 69-million-gallon *Amoco Cadiz* oil spill off the Brittany coast. His other assignments

have included the Dominican Republic, Belgium, and a penguin chase in Antarctica.

Alan and **Joan Root,** photographers and naturalists who grew up in Kenya, make wildlife documentary films. *Castles in the Clay,* about life in a termite mound, won a Peabody Award and was nominated for an Academy Award. Their latest film is *The Great Migration: The Year of the Wildebeest.*

Gary Rosenquist studied photography for two years, but considers it a "once-in-a-while thing" that he uses "to better my vision—to help me be more aware of the world." His photographs of Mount St. Helens have also appeared in *Life.* He lives in Tacoma, Washington.

Edward S. Ross, curator of entomology at the California Academy of Sciences from 1939 to 1980, felt that insects were often improperly portrayed in staged photographs of dead subjects. He determined to take pictures of live insects in undisturbed habitats, and has led over 20 expeditions to six continents. In retirement, he continues to lecture and engage in research.

Galen Rowell has been a member of many mountaineering expeditions, including the first American expedition to the People's Republic of China. A free-lance writer and photographer, his most recent book is *Many People Come, Looking, Looking.*

Joseph J. Scherschel, an assistant director of photography since 1972, began his career in photography at *The Milwaukee Journal* and later worked for *Life* for 15 years. He joined the Geographic's staff in 1963. His photographs have illustrated articles on Corsica, Hungary, and Guatemala, and on the first explorers to cross Australia.

Frank and **Helen Schreider** began their journalistic careers with their journey from Alaska to Tierra del Fuego in an amphibious jeep. Exploring widely for the Geographic, they photographed the Rift Valley, traveled down the Ganges and the Amazon, crossed the Indonesian archipelago, and retraced the victorious path of Alexander the Great.

Robert F. Sisson, chief of National Geographic's natural science division, joined the staff in 1942. He has covered subjects from giant squid to snowflakes as writer and photographer, and is responsible for many innovations in the photographic equipment used in the natural sciences. His pictures have often provided scientists with valuable new information about their subjects.

Ted Spiegel, drafted into the Army, left basic training with camera and fishing rod in hand. He found he was better with lens than lure, and emerged as a photojournalist in 1959. He has worked for clients like the Geographic and the Rockefeller Foundation on historical and ecological subjects.

James L. Stanfield photographed for *The Milwaukee Journal* and Black Star photo agency before joining National Geographic

in 1967. His assignments have taken him to 48 countries, and his photographs have appeared in Geographic books and in the exhibit "Photography in the Fine Arts" at the Metropolitan Museum of Art in New York.

B. Anthony Stewart, whose Geographic career spanned 42 years, was one of the magazine's most prolific contributors of photographs. He retired in 1969 as assistant director of photography, and died in 1977.

Richard H. Stewart's 42-year career as a Geographic photographer took him to cover eclipses in Brazil and on Canton Island, archaeological expeditions in Mexico and Panama, and volcanoes in Alaska. Officially retired in 1966, he nonetheless remained active in additional expeditions.

James A. Sugar, a contract photographer since 1969, has traveled to Iceland, Ethiopia, and Ireland on assignments for National Geographic; he illustrated the Society books *America's Sunset Coast* and *Railroads.* A self-taught photographer, he was named Magazine Photographer of the Year in 1978.

Frederick Kent Truslow, at the age of 53, gave up an executive position in a New York corporation to pursue a new career as a wildlife author-photographer. His work has appeared in the magazine as well as in the Geographic's two books on North American birds. He died in 1978.

Merlin D. Tuttle, curator of mammals at the Milwaukee Public Museum since 1975, uses photography to document his research on bats. He is the recipient of two National Geographic Society research grants.

Fred Ward, a free-lance photographer and writer for National Geographic since 1964, has contributed articles on diamonds, fiber optics, Cuba, and Tibet to the magazine. He also wrote and photographed *Inside Cuba Today* and *Golden Islands of the Caribbean.*

Volkmar Wentzel joined the Geographic's staff in 1937. A writer and photographer, he has been a guest of Mahatma Gandhi, Albert Schweitzer, and the High Lamas of Tibet. Among his memorable assignments were two years in India and Nepal, and sojourns with the Zulu and the Swazi in southern Africa.

Arlan R. Wiker, an electronics and lighting technician, built specialized equipment used by Geographic photographers on subjects ranging from shrimp to rocket launches. His own photographs have also appeared in Geographic articles and other publications.

Maynard Owen Williams joined the staff in 1919 as a photographer and writer. In 1923 he witnessed the official opening of Tutankhamun's tomb; in 1925 he joined the MacMillan Arctic Expedition. Chief of the foreign editorial staff for 23 years, he traveled "not less than 625,000 miles" in his career. He died in Istanbul in 1963.

Steven C. Wilson sold his first photograph at age nine. Today he heads Entheos, a firm that consists of a communications division

and a mountain agricultural institute; he also does environmental research and wilderness photography. He is author and photographer of a forthcoming book, *A Natural Collection.*

Cary Wolinsky worked for *The Boston Globe* before deciding to free-lance in 1972. Now a contract photographer for National Geographic, his photographs have illustrated articles on the Wisconsin Ice Age, England, Madawaska, and Northern Ireland.

Adam Woolfit, a free-lance photographer and a partner in a London photo agency, has contributed photographs to the Geographic and to many other publications. He has also worked on motion pictures, including *2001.*

Paul A. Zahl, a senior natural scientist for the National Geographic Society since 1958, has taken part in expeditions to Australia, the Caribbean, South America, Asia, and Africa. He retired in 1975, and now serves as a consultant and a member of the Society's Committee for Research and Exploration.

Robert E. Gilka, National Geographic's director of photography since 1963, has served as chairman of the William Randolph Hearst photojournalism competition for college students since 1970, and introduced the Society's summer intern program for young photographers. Formerly picture editor of *The Milwaukee Journal,* he joined the staff of the Geographic in 1958.

Gilbert M. Grosvenor, President of the National Geographic Society, has been a member of the Board of Trustees since 1966 and served as Editor of the magazine from 1970 to 1980. He developed and introduced the Society's magazine for children, National Geographic World, and serves as its overall editorial director. He was named Editor of the Year in 1975 by the National Press Photographers Association.

Type composition by National Geographic's Photographic Services. Color separations by Chanticleer Company, Inc., New York, N.Y.; Beck Engraving Co., Inc., Philadelphia, Pa.; Offset Separations Corp., New York, N.Y.; The Lanman Progressive Companies, Washington, D. C. Printed and bound by Kingsport Press, Kingsport, Tenn.; Paper by Mead Paper Co., New York, N.Y.

Library of Congress CIP Data
Main entry under title:

Images of the world.

 1. Travel photography. 2. Photography, Documentary. 3. National Geographic magazine. I. National Geographic magazine. II. National Geographic Book Service.
TR790.I45 778.9'991 81-11096
ISBN 0-87044-394-1 AACR2